Dear Stieglitz, Dear Dove

The American Arts Series/University of Delaware Press

THE INLANDER: Life and Work of Charles Burchfield, 1893–1967
By John I. H. Baur

EDWARD HICKS: His Peaceable Kingdom *and Other Paintings*
By Eleanore Price Mather and Dorothy Canning Miller

ERASTUS D. PALMER
By J. Carson Webster

J. ALDEN WEIR: An American Impressionist
By Doreen Burke

SCULPTURE IN AMERICA
By Wayne Craven

ARTHUR DOVE: Life and Work
By Ann Lee Morgan

JOHN QUINCY ADAMS WARD: Dean of American Sculpture
By Lewis I. Sharp

ARTHUR FITZWILLIAM TAIT: Artist in the Adirondacks
By Warder H. Cadbury and Henry F. Marsh

JOHN LEWIS KRIMMEL: An Artist in Federal America
By Milo M. Naeve

ARTHUR B. DAVIES: A Catalogue Raisonné of the Prints
By Joseph S. Czestochowski

BRONZE CASTING AND AMERICAN SCULPTURE, 1850–1900
By Michael Edward Shapiro

POETIC LANDSCAPE: The Art and Experience of Sanford R. Gifford
By Ila Weiss

THE ART OF THOMAS COLE: Ambition and Imagination
by Ellwood C. Parry III

DEAR STIEGLITZ, DEAR DOVE
Edited by Ann Lee Morgan

Dear Stieglitz, Dear Dove

Edited by
Ann Lee Morgan

DELAWARE

THE AMERICAN ARTS SERIES
NEWARK: UNIVERSITY OF DELAWARE PRESS
LONDON AND TORONTO: ASSOCIATED UNIVERSITY PRESSES

8800004537

Associated University Presses
440 Forsgate Drive
Cranbury, NJ 08512

Associated University Presses
25 Sicilian Avenue
London WC1A 2QH, England

Associated University Presses
2133 Royal Windsor Drive
Unit 1
Mississauga, Ontario
Canada L5J 1K5

The paper used in this publication meets the requirements
of the American National Standard for Permanence of Paper
for Printed Library Materials Z39.48-1984.

Library of Congress Cataloging-in-Publication Data

Dear Stieglitz, Dear Dove.

(The American art series)
Bibliography: p.
Includes index.
1. Dove, Arthur Garfield, 1880–1946—Correspondence.
2. Painters—United States—Correspondence. 3. Stieglitz,
Alfred, 1864–1946—Correspondence. 4. Art patrons—
United States—Correspondence. I. Morgan, Ann Lee.
II. Series.
ND237.D67A3 1988 759.13 [B] 85-41049
ISBN 0-87413-292-4 (alk. paper)

Printed in the United States of America

TO CWG

Contents

List of Illustrations	9
Preface	11
Introduction	21
1 Before 1914	25
2 1914–1917	39
3 1917–1925	57
4 1925–1929	120
5 1929–1933	183
6 1933–1938	281
7 1938–1946	400
Glossary of Names	497
Cited Works by Arthur Dove	507
Bibliography	512
Index	521

Illustrations

Facsimile letter from Alfred Stieglitz to Arthur Dove	12
Facsimile letter from Arthur Dove to Alfred Stieglitz	14
Alfred Stieglitz, *My Father*	27
Frank Eugene, *Stieglitz and Emmy*	28
Edward Steichen, *Kitty and Alfred Stieglitz*	29
Alfred Stieglitz, *Paula (Sunlight and Shadow)*	30
Alfred Stieglitz, *The Steerage*	31
Arthur Dove clowning in Paris	34
Arthur Dove, *Bridge at Cagnes*	35
Alfred Stieglitz, *Arthur Dove*	36
Arthur Dove, *Plant Forms*	37
Alfred Stieglitz, *Lake George Parlor*	44
Alfred Stieglitz, *Marsden Hartley*	47
Arthur Dove, *The Cow*	63
Alfred Stieglitz, *Waldo Frank*	71
Alfred Stieglitz, *Hedwig Stieglitz*	74
Alfred Stieglitz, *Apples and Gable, Lake George*	81
Mona	91
Georgia O'Keeffe, *Abstraction*	94
Alfred Stieglitz, *Equivalent*	96
Arthur Dove, *Alfred Stieglitz (Portrait)*	100
Alfred Stieglitz, *Peggy*	109
Alfred Stieglitz, *From the Shelton*	122
Arthur Dove, *Golden Storm*	123
Arthur Dove, *George Gershwin's "Rhapsody in Blue," Part I*	129
Arthur Dove on the dock at Halesite, New York	131

Arthur Dove, *Goin' Fishin'* — 132
Reds (Helen Torr) — 135
Arthur Dove, *Distraction* — 169
Arthur Dove, *Sand Barge* — 212
Alfred Stieglitz, *Dorothy Norman* — 256
Arthur Dove, *Red Barge, Reflections* — 257
Arthur Dove, *Bessie of New York* — 270
The Doves moving to Geneva, New York — 282
Helen Torr, *I* — 328
Arthur Dove, *Cows in Pasture* — 351
Reds (Helen Torr) — 360
Arthur Dove — 369
Arthur Dove, *Grandmother* — 375
Arthur Dove, *Rise of the Full Moon* — 377
Dorothy Norman, *Alfred Stieglitz* — 381
The Doves' home after the 1938 hurricane — 409
Arthur Dove feeding ducks — 412
Alfred Stieglitz with O'Keeffe painting — 432
Arthur Dove, *Willows* — 444
Arthur Dove, *Lattice and Awning* — 453
Arthur Dove, *Through a Frosty Moon* — 454
Arthur Dove, *Untitled Drawing* — 475
Bill and Aline Dove — 479
Arthur Dove, *Quawk Bird* — 484

Preface

THIS NARRATIVE, BASED ON THE CORRESPONDENCE BETWEEN ALFRED Stieglitz and Arthur Dove, is the only one of its nature that might be published about either of them. No other exchange of letters between Stieglitz or Dove and any other historically significant person is so nearly intact and of such long and regular duration.

Stieglitz hoarded letters he received. Of the fifty thousand extant letters to him,[1] more than three hundred are from Dove. Not such an archivist, Dove did not save everyone's letters, but he scrupulously kept Stieglitz's. Hence, the Stieglitz-Dove interchange is nearly intact. A few letters are missing, but by and large, the flow of ideas and news is coherent.

Some of Stieglitz's other correspondents also saved the photographer's letters, but Stieglitz's correspondence with Dove is unique in two respects. First, it extends over nearly the entire 1908–46 period during which Stieglitz was directly involved with the promotion of painting and sculpture. Only the first few years of his activity in the art world are not included. No other intact set of Stieglitz correspondence with any major personality covers nearly so many years. Second, Stieglitz and Dove wrote to each other year round, whereas other sets of correspondence are heavily weighted with letters written during the summer when Stieglitz was at Lake George. There, in upstate New York, he wrote as many as two dozen letters a day, mostly to people he saw or telephoned frequently when he was in the city. However, Dove lived in New York during only a few of the years he knew Stieglitz, so letters were their regular means of communication. Hence, the Dove-Stieglitz correspondence has greater continuity than other Stieglitz

Feb. 5 – 25.

Dear Dove: A classic right off
the bat. Truly a wonder. – We
have "literature" now that will
count — a solid front of four
strong. — Some photographs have
been made so the matter for
the Catalogue is nearly ready
for Kennerley. – The Show will
be a wonder. May the Stars
be favorable! –
Our love to you & Reds

Stieglitz.

Letter from Alfred Stieglitz to Arthur Dove. (Collection of American Literature,
Beinecke Rare Book and Manuscript Library, Yale University, New Haven,
Connecticut.)

interchanges. In addition to these unique aspects of Stieglitz's letters to Dove, his correspondence with the painter is noteworthy for its candor. Within a few years of their first letters, Dove had become one of Stieglitz's closest friends.[2]

The preserved exchange of letters is also unique in Dove's case. Though he wrote letters frequently, Dove did not correspond with nearly so many individuals as Stieglitz did. He saved some letters, and some recipients saved his, but there are no other long-term, two-way interchanges with Dove. Among Dove's preserved letters, the ones to Stieglitz cover a fuller range of experience than most others, quite naturally so since they wrote about esthetic and professional matters as well as personal ones. Thus, the correspondence between Dove and Stieglitz provides a unique view into the lives of two figures who enriched American culture in the first half of this century.

After Stieglitz's death, his widow Georgia O'Keeffe donated his papers, including the letters from Dove, to the Collection of American Literature of the Beinecke Rare Book and Manuscript Library at Yale University. Although the letters from Stieglitz to Dove were divided after the painter's death, in the mid-1970s the last of them came to Yale, where all but two are now housed in the same library collection. (The two exceptions, dated 20 March 1931 and 21 April 1934, belong to the Archives of American Art in Washington, D.C.)

Because Stieglitz nearly always specified day, month, and year, his epistles are arranged in files at the library in proper chronological order. However, having no such eye on history, Dove almost never dated anything he wrote. After the majority of his letters had arrived at Yale, some attempt was made to arrange them chronologically, but the sequence of numbered pages is faulty, in places haphazard. The provisional dates noted on many of the letters are unreliable, sometimes even years wide of the correct date. (The conditional dates were supposedly transferred from postmarks on the envelopes, which were then discarded.) Thus, although scholars can peruse the two sets of correspondence at the Beinecke Library, it is impossible to read back and forth between the two sequences of letters in the order in which they were written. This volume therefore presents the first opportunity to read an extensive portion of the correspondence in serial format.

Collateral material that facilitated chronological arrangement of the Dove letters included diaries kept by Dove and by his second wife Helen Torr, additional sets of letters between Dove or Stieglitz and other correspondents, and published works. By comparing such evi-

Dear Stieglitz

Have a long letter written
for you which will be sent
later. This is just an
Announcement
 of the marriage of
Reds and me.

We have had to do so many
things twice in the last few
years that we decided to
try once last night and
went right to city hall

Letter from Arthur Dove to Alfred Stieglitz. (Collection of American Literature, Beinecke Rare Book and Manuscript Library, Yale University, New Haven, Connecticut.)

dence with the letters, I was able to position virtually all of them in sequence and to date most of them to a specific day.

At the top of each letter in this volume, place of origin and date are given as they appear on the original or in brackets when they are mine. For the sake of clarity, I have standardized format and position of this information in the heading of each letter. Whenever I could not establish an exact date but could define the limits of possibility, I have given the earliest and latest possible dates and separated them with a slash. A dash between dates indicates that the letter was begun on the earlier date and finished on the later one. When I have been unable to find unquestionable evidence to support a given date, I have indicated that my date is probable.

In this book the number of words actually exchanged by Stieglitz and Dove has been reduced by eliminating short letters and parts of longer ones, but the character of their interchange remains. Besides occasional subordinate topics that impede the narrative flow, my deletions consist almost entirely of the following sorts of material:

Conventional greetings and conclusions to the letters. Both writers were inclined to open with inconsequential inquiries about the other's health and happiness and to end their letters with two or three sentences conveying greetings to other people and wishing the recipient well.

Weather reports. Both writers often commented on the weather with remarks that are of limited interest today. When he was in the country during the summer, Stieglitz frequently expanded these reports into more generalized descriptions of nature. I have eliminated some of these; however deeply he felt about nature's beauty and power, Stieglitz expressed those feelings within the conventions of nineteenth-century Romanticism. Lacking original expression and fresh perception, these passages only illuminate Stieglitz's inability to evoke in words the very subjects he so beautifully photographed.

Financial information. Because Stieglitz acted as Dove's agent for the sale of his paintings, many letters include references to financial matters. Most of such deleted references are vague, often for instance just indicating that a check is enclosed or inquiring after the whereabouts of a payment. I have also taken out some of the cumbersome accountings of moneys owed by Duncan Phillips, particularly in the 1930s when this patron of Dove's work caused bookkeeping problems.

Exhibition information. Because Stieglitz assumed responsibility for sending Dove's paintings to exhibitions, many letters mention shows or note that a painting had been sent. The deleted references of this nature are not accompanied by substantive commentary.

Repetitious material. Most of these deletions are from Stieglitz's letters. He often repeated the essence of something Dove had written to him and added a predictable comment—for instance, that he was glad to hear of some good news.

Finally, I should like to point out that typography cannot reproduce the expressiveness of these correspondents' handwriting and page layout. Each wrote in a large and forceful cursive, and both preferred a fountain pen with black ink. The two habitually used spacing on the page and dashes of varying lengths to suggest the pauses, emphases, parenthetical interjections, and subject changes of spoken language. In this volume, conventional paragraphing replaces their eccentric spacing, and dashes substitute somewhat weakly for the flowing pen lines of the original letters. For clarity, I have corrected occasional misspelled words or names and have added normal punctuation where it was forgotten or simply ignored because spacing substituted for it. Here and there, I have spelled out words when I thought abbreviations that appear in the letters might be confusing.

In my notes, I have documented points that seem to me to require substantiation, but I have attempted to avoid cluttering the pages with numerous notes relating to straightforward biographical information. All such details are unequivocally recorded in the primary sources (at least one and often more) and are not, to my knowledge, contradicted by any other sources. Most of the detailed information about Dove's life comes from the diaries he and Helen Torr kept. (William C. Dove, the artist's son, inherited these records; along with other documentary material in William Dove's possession, they have been microfilmed by the Archives of American Art.) The facts of Stieglitz's life were largely pieced together from the numerous extant letters he wrote to other people besides Dove; these are usually the source of exact dates of his journeys between Lake George and New York and other comparable specifics.

For making this book possible at all, my deepest thanks go to William C. Dove and the late Georgia O'Keeffe for their permission to publish the letters. Particular thanks are due also to David Schoonover, curator of the Collection of American Literature at the Beinecke Rare Book and Manuscript Library, who gave permission on behalf of Yale University, and to his predecessor Donald Gallup, who encouraged this undertaking at the outset.

Many individuals responded generously to my queries about the lives of the two individuals and thus helped me to date the Dove letters, to decipher obscure passages, and to provide context for the correspon-

dence. The artist's son, William Dove, and his wife Aline have been particularly helpful, as well as hospitable, over a long period of time. I learned much about Stieglitz and his world in long discussions with Sue Davidson Lowe, who shared her thoughts while she was writing her own superb memoir/biography of her great-uncle "Al" Stieglitz. Others who have my gratitude for their recollections include Mary Rehm, Dove's sister-in-law; Dr. J. Clarence Bernstein, Dove's physician in Centerport, and his wife Julia; Lila Howard, a Westport artist who knew Dove in the years he lived there; John Marin, Jr., who knew both Dove and Stieglitz; the photographer and writer Dorothy Norman, mainstay of Stieglitz's American Place gallery; and Emmet O'Brien, an upstate New York newspaperman who knew Dove in Geneva. Georgia O'Keeffe shared her memories of the two correspondents in a long interview. Dr. Mary Holt, Herbert J. Seligmann, and the artist's brother Paul Dove—all of whom knew both correspondents—also provided insights during interviews before their deaths in recent years. Although we never met, Charles Brooks wrote to me about his memories of Dove and Stieglitz and graciously allowed me access to letters he had saved.

The staff of the Beinecke Rare Book and Manuscript Library deserves much gratitude for daily attention to my research during a year spent at Yale. The Archives of American Art also aided my work at many points. The Yale University Library and the Research Board of the University of Illinois at Urbana-Champaign granted funds to duplicate the letters for me—a necessary prerequisite to the editorial work—for which I am most grateful.

For assistance with illustrations, special thanks again go to William Dove. Mary Rehm, Dorothy Norman, the Terry Dintenfass Gallery, and the Graham Gallery also were helpful.

Howard Risatti, Bruce Butterfield, and my parents, Joe and Jeanne Morgan, read early drafts of the manuscript and made suggestions that I deeply appreciate. Thanks are due also to many colleagues and friends who gave encouragement. Finally, loving thanks to my husband, who understood when this book frequently came first.

NOTES

1. Estimate by Laurie Lisle in *Portrait of an Artist: A Biography of Georgia O'Keeffe* (New York: Seaview Books, 1980), 268.
2. This impression was seconded by Sue Davidson Lowe, who told me

before her biography of Stieglitz was published that she found Stieglitz's letters to Dove to be among the most revealing. In her book, she indicates the special nature of their relationship several times; see, for example, Sue Davidson Lowe, *Stieglitz: A Memoir/Biography* (New York: Farrar Straus Giroux, 1983), 323, where Dove is counted among Stieglitz's "closest friends." Even so, Stieglitz was not always totally candid when it came to subjects that were emotionally difficult for him.

Dear Stieglitz,
Dear Dove

Introduction

THE LETTERS IN THIS VOLUME REVEAL FIRSTHAND TWO INDIVIDUALS WHO produced landmark works of art and who were instrumental to the growth of the modernist esthetic in America. The better known of these two, Alfred Stieglitz, was one of the great creative artists in the history of photography, as well as the most important spokesman for modernism in America during its early years. His younger friend Arthur Dove made headlines in 1912 with his first gallery show, which presented the most abstract paintings ever publicly exhibited by an American artist. After that, he continued to work experimentally, producing works of great originality and beauty.

These two individuals became acquainted toward the end of 1909 (or possibly very early 1910) when Dove, then an untried painter, sought out Stieglitz, who directed a gallery. Their ensuing relationship always had a professional aspect, as do their letters, which span the years from 1914 to 1946; but more interestingly for most readers today, the correspondence tells us about their personalities and reveals how these figures of exceptional achievement lived from day to day. On a broader level, the letters demonstrate what these two men contributed to American consciousness, for along with others who were reacting against history, tradition, and established values early in this century, Stieglitz and Dove were among those who shaped the central myths of modern artistic identity. Because they were in such fundamental agreement about the purpose of art, much remains unsaid in the letters; yet, their operative assumptions can be extracted from the correspondence.

Creativity, in their understanding, is the finest human capacity. The true artist is bound to be misunderstood, for society as they saw it is

incapable of appreciating the nonconformity inherent in the truly creative act. Nevertheless, the artist lives by his ideals and risks everything on his own perception of the truth. Beyond this general strategy for the artist-life, Stieglitz and Dove affirmed three central ideas:

1. Self-expression is fundamental. However, they avoided the potential narcissism of this position by assuming that the "self" is "impersonal," not ego-centered but intrinsic to human experience. Therefore, to be genuinely true to one's self, or to one's most profound level of humanity, could deepen communication. Dove and Stieglitz emphasized self-knowledge as a prerequisite to self-expression; conversely, they saw their respective oeuvres as the progressive revelation of individuality, as a sort of spiritual autobiography.

2. Emotion or intuition, as opposed to reason or rationality, is the source of the creative act, and indeed of the ability to "live." Stieglitz and Dove felt that this "spiritual" part of the human psyche was insufficiently valued by modern industrial society, and they saw art as a tool of its recovery. Thus, by its very nature, art was seen as subverting the dominant materialistic rationalism. Unfortunately, their respect for intuition was so strong that it inhibited sustained and logical articulation of their ideas. As a result, their interest in contemporary thought has been somewhat obscured, but their letters counteract the previous impression that they were intellectually isolated.

3. Idea or concept is superior to technique. Although both Stieglitz and Dove adhered to the highest possible standards of craftsmanship in their own work, they believed that art cannot be taught and that the expression of the idea in a work of art is unrelated to medium or to the mastery of technical skills. This emphasis on idea was allied to their general espousal of abstraction as the modern way in painting, although not in photography. Sometimes they equated "purity" in painting with release from representation, a liberation they valued because representation was too closely related in their minds to both materialism and tradition to be viable for the elevated, revolutionary purposes of modernism.

On a personal level, the letters illuminate major themes of the two lives. Their mutual interest in people is reflected in the news—and sometimes gossip—they shared with each other. However much both of them were committed to their work, they equally valued personal relationships. Nevertheless, as the letters demonstrate, both were capable of exhausting persistence. Through his gallery activities, Stieglitz put tremendous energies into the promotion of his artists and his "Idea." Often relying on the rhetoric of combat, he obstinately de-

fended their work and his principles. In addition, he was a perfectionist in his photographic work, as is revealed in the frustrations so often voiced in these letters.

Believing that his artistic work was central to his life, Dove continued to be devoted to painting despite poverty; public indifference and even hostility to his work; financial and psychological pressures from a conventional family; and, eventually, an illness that gradually killed him. At the same time, he did not disdain to earn a living by whatever means was necessary, be it farming, magazine illustration, or management of inherited family properties.

Both Stieglitz and Dove found so much satisfaction in their routines centered on art that they were disinclined to travel. Both also loved the beauty and variety of the outdoors, though Stieglitz in his last years came to prefer the bare cell of his gallery to the raggedness of nature at his Lake George summer home.

Stieglitz's letters disclose a gregarious soul; comfortable in the public eye, he was innocent of the need for privacy that ran so strongly in Dove, as well as in Georgia O'Keeffe and Helen "Reds" Torr, their respective second wives. Not needing an ordinary home life or a conventional daily routine, Stieglitz lived for years with relatives or in hotels and thrived on eccentric schedules. By contrast, Dove tried to protect his solitude, though he could not always effectively do so. The routine of his life was ordinary and middle-class, despite sometimes unconventional habitats: boats, a former roller-skating rink, an old post office. The only bohemian gesture of Dove's life was leaving his wife to live with Reds. Yet, until they were able to marry more than a decade later, they were often anxious about how other people might react. Stieglitz often delighted in scandalizing people—most of the time, only verbally; and living out of wedlock with O'Keeffe, as he did for six years, seems not to have particularly bothered him, although they too married as soon as they were legally able. Dove and Reds were more intensely interdependent than Stieglitz and O'Keeffe; however deeply the latter couple felt about each other, they maintained more separate lives, especially after O'Keeffe started traveling extensively in the late 1920s.

Stieglitz's generosity comes through clearly in the letters to Dove—which often accompanied personal checks—as do his openness and gentleness. However, we also see in Stieglitz's letters another trait that contemporaries sometimes found tedious: a flair for tragic melodrama, often displayed in conjunction with his hypochondria or in relation to his self-image as a beleaguered and misunderstood but heroic "fighter"

for his "cause." Stieglitz had little sense of proportion about illness, especially his own or O'Keeffe's, and his exaggerations made all ailments sound almost equally serious. In his histrionic view of his public role, he sometimes became a complainer, harping humorlessly on his own sacrifices—which, as he repeatedly admits, were self-imposed and willingly undertaken.

This melancholy streak in Stieglitz's personality was completely foreign to Dove, who used comedy as a defense against his woes. Dove's basic optimism saw him through even the most difficult days. Despite lack of recognition and sales, Dove never expressed doubts about his work; although he occasionally admitted that the creative process has dark moments, he saw continual progress in his art. Even in the last years of his life, when he was desperately ill, his sincere desire to bolster his own and other people's spirits prevents the reader of the letters from knowing (as Dove wanted to prevent Stieglitz from knowing) how much he suffered. Dove's positive outlook was accompanied by an active sense of humor; he was amused by life and amusing in recounting his observations.

A level-headed personality, Dove never denigrated himself, but he was free of pretense. On the other hand, although he too had a sense of humor, Stieglitz was prone to puffs of self-importance. For a long time, people had told him that he was a great man, and sometimes he believed it. In his letters, Dove himself contributed to this syndrome with heartfelt but occasionally extravagant compliments. Whereas Stieglitz overdramatized life's reverses in terms of tragedy and torture, Dove's fine sense of irony warded off self-pity. He was an easygoing person who did not assert himself. Several incidents recounted in the letters show Dove withdrawing from competition or confrontation, and he even left the fate of his paintings entirely to Stieglitz.

Besides revealing values and personal characteristics of the two correspondents, the letters also illustrate, on the level of personal experience, the social role of the modern artist in the period before modern art had ceased to be widely reviled. The letters suggest the psychological and financial costs of commitment to ideals that were at variance with those of society at large.

Overall, because they are unguarded writings, these letters permit us to observe multiple aspects of the writers' lives. As the letters enrich our understanding of these artists, they bring home the point that the gift all artists share is the special ability to objectify in their art their personal experience of life.

1

Before 1914

WHEN STIEGLITZ AND DOVE FIRST MET LATE IN 1909 OR EARLY THE NEXT year, Stieglitz was just turning forty-six. Dove was not yet thirty. Stieglitz, already a spokesman for avant-garde art, was rapidly becoming a New York celebrity, while Dove was known only as a magazine illustrator. Stieglitz had already completed enough photographic work to assure his permanent reputation as a major creative artist, whereas Dove had yet to produce a single painting that could be called truly original.

The outward differences between the two men were no more striking than the disparity in their backgrounds, which represented polarities in American culture. Dove came from the mainstream—Protestant, middle-class, Anglo-Saxon, provincial. Stieglitz, on the other hand, was in several ways typical of the outsider. His parents were foreign-born, and his Jewish, well-to-do, cosmopolitan background was at variance with typical late-nineteenth-century experience. Comfortable in French and German, he knew Europe well and was broadly conversant with the arts.

Stieglitz and Dove presumably met for the first time at 291, where they normally saw each other during the next seven and a half years. Supervised by Stieglitz, this diminutive showcase for modern art, including photography, was located on the top floor of an unexceptional commercial building on Fifth Avenue between Thirtieth and Thirty-first Streets. Diffused light from a skylight in the windowless fifteen-foot-square display room augmented the shrinelike ambience created by the decor. Reflecting Japanese-influenced ideals of the turn-of-the-century esthetic movement, the meticulous arrangement and

25

subtle, earthy colors gave the gallery an uncluttered and rarified appearance. Above a curtained dado, which concealed storage space below the narrow shelf that ran around the room, photographs or other works were positioned with delicate respect for each as an individual art object and, simultaneously, with concern for a harmonious ensemble. Visitors pivoted about a large brass bowl centered in the room on a small platform and filled, according to the season, perhaps with autumn foliage, or with bare branches and pussy willows.[1]

Stieglitz had lived in this atmosphere for several years. To Dove, it was new, and in this little gallery he would soon confront art crucial to the rapid development of his own style. Here, too, he became acquainted with important new ideas, including Henri Bergson's philosophy and Wassily Kandinsky's theory of art. At first, the elder man was teacher and guide. Later, as Dove gained artistic stature, he became a colleague instead of a follower, and, before long, a confidant.

Stieglitz's serious work in photography had begun during his student years in Germany, where his German-born parents arranged the education of all their six children. Alfred was the eldest, born in Hoboken, New Jersey, on New Year's Day of 1864. He spent his formative years in an up-to-date brownstone just off Central Park in New York City, where his father was a woolen merchant. Edward and Hedwig Stieglitz brought up their children in an atmosphere of appreciation for the arts, intellectualism, individuality, and close family ties. The children received no formal religious education.

In 1881, when Alfred was seventeen, the entire family departed for Germany, so that the children could go to school there. In Karlsruhe and Berlin, Alfred at first directed his studies toward engineering, but soon discovered that his vocation lay in photography. He studied with Dr. Hermann Vogel, then probably the world's leading expert on the chemistry of the photographic process, although his own amateur photographs were esthetically conventional. Thus, Stieglitz's instruction in photography was scientifically but not artistically advanced. His nonacademic esthetic education was broad, embracing music and literature as much as the visual arts. He learned from his family, from travel in Europe, and from fellow students; he read widely, visited art galleries, and attended concerts, operas, and plays. The range and pace of his activities in Europe suggest the energy and enthusiasm that he later converted into unremitting labor on behalf of photography as a fine art.

Upon returning to New York in 1890, Stieglitz received financial assistance from his father to enter a photoengraving business, but after five years, the young photographer decided to live without the com-

Alfred Stieglitz, My Father, *c. 1894*. (Alfred Stieglitz Collection, Art Institute of Chicago.)

Frank Eugene. Stieglitz and Emmy, *Tutzing, Bavaria, 1907. Autochrome.* (Alfred
Stieglitz Collection, Metropolitan Museum of Art, New York.)

mercial income. Although not wealthy, he could afford this choice
because the family resources were substantial and his new wife's, even
more so.

In 1893 Stieglitz had married twenty-year-old Emmeline Obermeyer,
the sister of one of his old friends who was now a partner in the
photoengraving business. Nine years younger than Alfred, his con-
ventional wife had no enthusiasm for photography, but their marriage
endured a quarter of a century. Their only child, a daughter named
Katherine (Kitty, for short), was born in 1898.

During these days of business responsibilities and early married life,
Stieglitz nonetheless devoted himself intensely to photography.
Through his efforts and those of a few associates in the years before and
after the turn of the century, photography steadily gained acceptance as
an artistic medium. Even before Stieglitz had left Europe, he had won
major prizes in photographic exhibitions. Subsequently, through ex-
hibitions and competitions on both sides of the Atlantic, he continued
to win acclaim for his work; in 1894 he was among the first Americans
elected to the prestigious Linked Ring, a British association of the most
advanced art photographers of the day.

The work for which Stieglitz first won recognition was technically

more distinguished than it was original. Generally, it adhered to the pictorial esthetic that approximated the conventions of painting to express refined sentiment. Nevertheless, from the beginning, the work also foreshadowed his creative growth into maturity, for even then Stieglitz preferred greater directness in his work than did most other prominent photographers of the day. The well-known *Paula (Sunlight and Shadow)*, for instance, a picture made in Berlin in 1889, is an essay in vision, notwithstanding its genre subject.[2] After 1900, Stieglitz played down sentiment as he became more interested in documenting life around him. His *Steerage* of 1907, which he himself considered among his finest works,[3] epitomizes this phase of his work.

Meanwhile, in New York, Stieglitz was active in photographic or-

Edward Steichen. Kitty and Alfred Stieglitz, *New York, 1905.* (Alfred Stieglitz Collection, Art Institute of Chicago.)

Alfred Stieglitz, Paula (Sunlight and Shadow), *Berlin, 1889. This photograph represents the best of Stieglitz's work at twenty-five, while he continued his studies in Europe.* (Alfred Stieglitz Collection, Art Institute of Chicago.)

Alfred Stieglitz, The Steerage, *1907. Stieglitz captured this near-perfect photographic moment while en route to Europe in June 1907. He always regarded it as one of his best works. (Alfred Stieglitz Collection, Art Institute of Chicago.)*

ganizations and first became involved with publishing in 1892 as contributing editor of *American Amateur Photographer,* of which he became coeditor two years later. From 1897 to 1902, he edited *Camera Notes,* the quarterly journal of the Camera Club of New York. In 1902 he founded the Photo-Secession, a loose organization of art photographers, and at the end of the year he brought out the first issue of its sumptuous journal, *Camera Work.* In November 1905, with the photographer Edward Steichen, who was also a painter, he opened the Little Galleries of the Photo-Secession to show the best photographic work from all countries. Shortly, the gallery came to be identified with Stieglitz, its on-the-spot proprietor. The gallery's address, 291 Fifth Avenue, gave the place a nickname, "291," by which it became better known as Stieglitz expanded the gallery's purpose to accommodate advanced art in all media.[4]

The first nonphotographic exhibition was held in 1907. For five years beginning in January 1908, 291 was the only public gallery in America where adventurous modern art, then generally known as "post-Impressionist," could be seen. Before Arthur Dove became an habitué of 291, Auguste Rodin (represented by his figure drawings, not his sculpture) and Henri Matisse had been the only prominent Europeans shown there. American exhibitors had included John Marin, Alfred Maurer, and Marsden Hartley, all soon to become leaders of the modern movement.

In contrast to Stieglitz's background, Dove's was quintessentially American. Born in Canandaigua, New York, in 1880, he grew up in the nearby town of Geneva, at the head of one of the Finger Lakes. His father, William, was a building contractor who elevated the family's social respectability with financial success. Dove was twelve years old before his brother Paul was born. (A sister had died in infancy.)

Through a neighborhood truck-farmer who was a naturalist and painter by avocation, Dove became interested in painting when he was a child. However, his life was otherwise typical of children growing up in the small towns of late-nineteenth-century America. He played baseball in high school and went on to Hobart College in Geneva, then transferred to Cornell University in Ithaca, New York, for his final two years, in order to study law. He also studied art there, and by the time he graduated in 1903, he had decided against a legal career. Instead, he moved to New York City and soon achieved success in the competitive field of magazine illustration, then in its heyday. In 1904, he married "the girl next door," the likable and sociable Florence Dorsey, who lived across the street from his parents' home in Geneva.

Dove spent about five years in New York illustrating on a free-lance basis for major periodicals, including *Cosmopolitan, Pearson's Magazine, McClure's Magazine, Century, St. Nicholas,* and *Illustrated Sporting News.* In his spare time, he also painted in a subdued Impressionist style. In 1908, when he had saved enough money, he left for France to devote himself seriously to art. Abroad with his wife, he spent much of his time painting in the countryside and lived for several months near Nice, at Cagnes-sur-Mer, where his palette brightened. In Paris, he met other young artists who were in touch with the latest developments in art, and his own work began to reflect the unnaturalistic colors and vigorous compositions of *fauve* painting. Among those of his new companions who also knew Stieglitz was "Alfy" Maurer, who became Dove's closest friend. Stieglitz gave Maurer's work a joint show with Marin's at 291 in the spring of 1909 while they, like Dove, were in Europe.

Stieglitz traveled to Europe during the summer of 1909, but he and Dove did not meet until both were back in New York. The following March, one major painting by Dove was included in a 291 group show, *Younger American Painters,* in company with paintings by Maurer, Marin, Steichen, Hartley, Max Weber, Arthur B. Carles, Daniel Putnam Brinley, and Laurence Fellows.[5] After that show, the names of Paul Cézanne, Pablo Picasso, Abraham Walkowitz, Marius de Zayas, Weber, Carles, and Dove himself were added to the roster of distinguished European and American modernists who had one-person shows at 291 before the general introduction of modernism to the American public with the Armory Show of 1913. Although 291 had initially promoted modernism through European work, starting in 1909 Stieglitz began to give approximately equal attention to Americans. Later, he became a champion of American artists and showed them almost exclusively.

Dove's show in February and March of 1912 was the professional high point of his career for more than a decade. He exhibited ten pastels so abstract in their interpretations of nature and landscape themes that he was identified by a lively press as the leading radical American artist. After the 291 exhibition closed, Dove took the work to Chicago, where it was shown at Thurber's Gallery (designed in 1909 by the local architect Frank Lloyd Wright), and again achieved journalistic notoriety.

A year later, during the winter of 1913, the Armory Show provided New York with a dramatic public event. Organized by the ad hoc Association of American Painters and Sculptors, the sensational exhibition at the Sixty-ninth Regiment Armory traced the evolution of modern art from its sources in the nineteenth century to the present

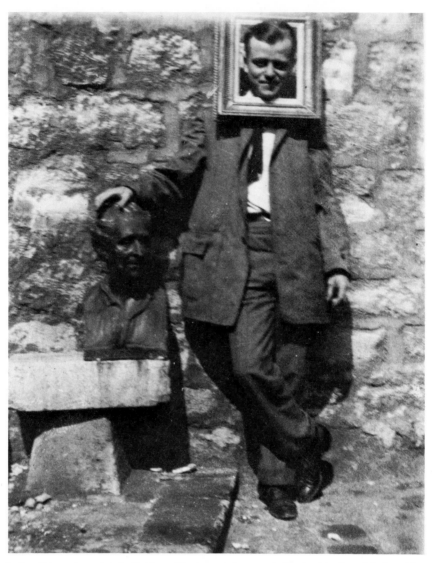

Arthur Dove clowning in Paris, with portrait bust probably by his friend Jo Davidson, 1908–9. (William C. Dove, Mattituck, New York.)

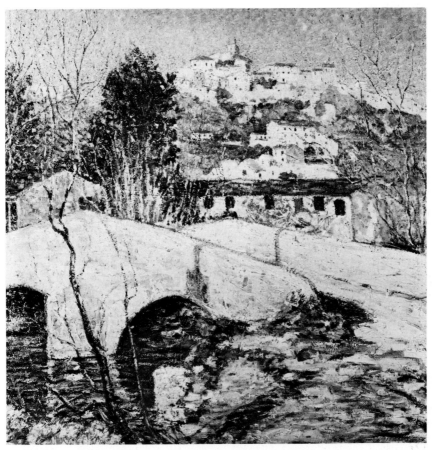

Arthur Dove, Bridge at Cagnes, *1908–9. Dove painted for several months in this hilltop town on the Mediterranean between Nice and Antibes.* (Herbert F Johnson Museum, Cornell University, Ithaca, New York. Jon Reis photo.)

moment. To all but the handful of Americans who had seen Stieglitz's gallery shows, the comprehensive survey introduced the very idea of modernism in the visual arts.[6]

Although Stieglitz was only marginally involved in planning the Armory Show, he lent works from his own collection, bought the only Kandinsky painting exhibited, and aided publicity efforts. Public recognition confirmed that he led the modernist movement and gave him the satisfaction of knowing that his work to date had meant something. He wrote to another artist about three weeks before the exhibition opened: "The [Armory] show has resulted in a bombardment of myself from all over the country; everybody wants something from me. Of course I

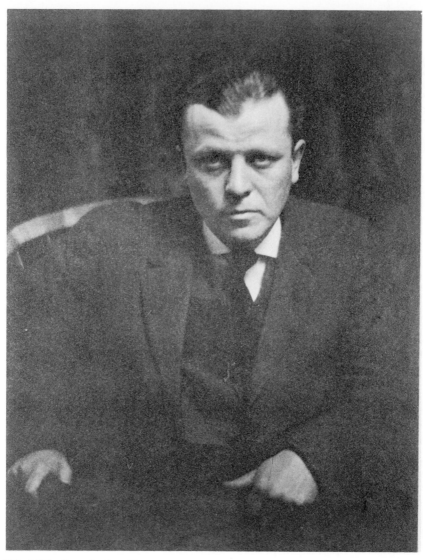

Alfred Stieglitz, Arthur Dove, *1911.* (Alfred Stieglitz Collection, Art Institute of Chicago.)

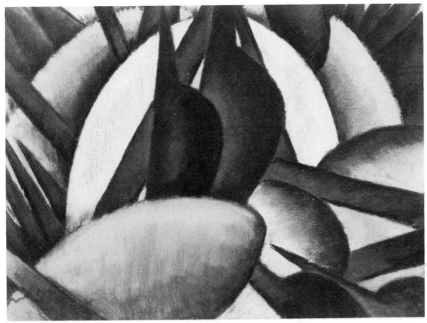

Arthur Dove, Plant Forms, *1911/12. Pastel on canvas. This work was probably one of the ten abstractions included in Dove's 1912 exhibition at 291.* (Whitney Museum of American Art, New York. Gift of Mr. and Mrs. Roy R. Neuberger, 1951. Geoffrey Clements photo.)

ought to feel delighted, for it shows that '291' has actually done some work in the eyes of the community."[7] To balance the excitement over modern art with a statement about the achievements of modern photography, Stieglitz held a retrospective exhibition of his own work at the same time as the Armory Show. These thirty prints constituted his only individual show at 291.

Although Dove did not exhibit in the Armory Show, his artistic reputation as an extremist survived the event. Dove had been living in Westport, Connecticut, since the summer of 1910, shortly after the birth of his only child, William C. Dove. Intending to support himself by farming, he had purchased acreage in Westport, then a summer resort but beginning to develop into the artists' and writers' colony it was a decade later when Dove left.[8] Westport was an hour's train ride from New York City, so Dove was able to be a frequent visitor at 291 but not a constant attendant as some of the other artists were. In Westport he participated in the convivial society of creative and intellectual people who lived there, though many were resident only during

the summer. Among them he was known for his gentle demeanor and was affectionately nicknamed "the whispering kid."[9]

NOTES

1. For descriptions of 291, see William Homer, *Alfred Stieglitz and the American Avant-Garde* (Boston: New York Graphic Society, 1977); Dorothy Norman, *Alfred Stieglitz: An American Seer* (New York: Random House, 1973); and Ann Lee Morgan, "An Encounter and Its Consequences: Arthur Dove and Alfred Stieglitz, 1910–1925," *Biography* 2, no. 1 (Winter 1979): 35–59.

2. Rosalind Krauss, "Alfred Stieglitz's 'Equivalents,'" *Arts Magazine* 54, no. 6 (February 1980): 135; Julia Ballerini, "The Incomplete Camera Man," *Art in America* 72, no. 1 (January 1984): 106.

3. Norman, *Alfred Stieglitz,* 77.

4. In 1908, around the time that 291 became the gallery's accepted nickname, the gallery itself moved into the adjacent townhouse, which was actually numbered 293. Although the arrangement of the gallery was altered somewhat by the move, the appearance of the main exhibition area remained nearly identical to that of the original.

5. Brinley and Fellows did not become well-known painters. All the others were leaders of the ensuing modernist movement.

6. For a general account of the Armory Show, see Milton Brown, *The Story of the Armory Show* (New York: Joseph H. Hirshhorn Foundation, 1963).

7. Stieglitz to Arthur B. Carles, 21 January 1913, Collection of American Literature, Beinecke Rare Book and Manuscript Library, Yale University, New Haven.

8. Dove purchased the Westport place before the end of 1909 *(Westporter-Herald* [Westport, Connecticut], 10 December 1909), but he and Florence were in New York City when the baby arrived.

9. Interview with longtime Westport resident Lila Howard, July 1976. The widow of an artist and herself a sculptor, Mrs. Howard thought that the originator of the phrase was probably the witty Clive Weed, the first husband of Helen Torr, who became Dove's second wife.

2
1914–1917

THE SURVIVING DOVE-STIEGLITZ CORRESPONDENCE BEGINS IN 1914, WHEN 291 and *Camera Work* were riding the crest of interest in modernism in the wake of the Armory Show hullaballoo of early 1913. Yet, there must have been intimations of difficulties soon to come, for within three years both the gallery and the quarterly journal had come to an end.

The relatively few letters of the 1914–17 period give only hints of complexities in both men's lives, but they do reveal the growth of trust and friendship. In the earliest letters, the tone seems formal—a polite young man corresponds with an encouraging advisor. Soon the distance diminishes, and an easy give-and-take commences.

★ ★ ★

The first extant letters, written in the autumn of 1914, follow by about a year and a half the Armory Show and simultaneous Stieglitz retrospective. The vitality of 291 after the Armory Show had persisted with numerous and varied shows. In the spring of 1913, Picabia and de Zayas followed Stieglitz with one-person exhibitions. In the 1913–14 season, starting the next fall, Stieglitz showed Walkowitz's works on paper; Hartley's paintings, along with a bronze by his German friend Arnold Rönnebeck; the second 291 exhibition of children's drawings; Brancusi's sculpture; and paintings and drawings by Paul Haviland's younger brother, Frank Burty.[1] The 1914–15 season opened with an exhibition of African sculpture, the first important presentation anywhere of such material as art.[2]

Dove at this time lived in Westport with Florence and four-year-old

Billy; his first surviving letter was written from there about two weeks before the opening of the African art show. This letter is particularly revealing; it illuminates the basis for what was to become the sustained friendship with Stieglitz, showing as it does the young painter's admiration for the photographer and for what he represented.

However, Dove's letter was not spontaneous. Stieglitz had written to many people besides Dove, asking them to write on the question "What is 291?" for publication in a special number of *Camera Work*. Stieglitz used Dove's letter, beginning with the third paragraph, as the painter's contribution.

Dove's letter shows that he conceived 291 to be a metaphor as well as a gallery in the literal sense; 291 was the indefinable, idealistic climate of the place, a meaning of 291 that outlived the gallery itself. Long after it had closed, both Stieglitz and Dove used the name to invoke the gallery's spirit of excitement, excellence, and camaraderie. Additionally, 291 could be Stieglitz himself, an identification that appealed to the photographer; though apparently only later, he sometimes signed his letters "291."

While revealing certain of his own values, Dove also points out three particularly important aspects of the spirit of 291. First, he notes the nonstylistic basis of 291 activity, thereby affirming the notion (also held by Stieglitz, as well as others) that modernism was a matter of attitude rather than a particular set of forms. Second, he indicates the particular importance of the "elimination of the non-essential" at 291; this principle was a major theme of Dove's own life and work. Third, he comments favorably on the noncommercial and noncompetitive aspects of 291.

Stylistically, this letter is typical of Dove's formal writing about art and other serious matters. Although striking turns of phrase occur, Dove avoided sustained intellectual analysis and did not often draw logical conclusions. Though evocative and clever, his thoughts often remain imprecise. Frequently, he expressed himself with incompletely realized metaphors. Dove's vagueness, the consequence of his intention to be suggestive rather than concrete, is a cultivated style derived from Imagist poetry specifically and more generally from late Symbolist thought. It is unlikely that here (or in Dove's other theoretical writings) the unresolved quality of his prose is the result of haste or carelessness. Just as he was a conscientious craftsman in painting, Dove labored over written statements. Often, he rewrote letters two or three times—especially if the content was substantive. Thus, we may assume that this

solicited letter on a topic important to his mentor was carefully worked out.

1. Frank Burty (1886–1971) dropped his surname, Haviland, when he exhibited as a painter. He and his brother Paul Haviland were sons of the head of the French company that manufactures the fine porcelain of that name. This was Burty's first exhibition. His Cubist manner was derived from Picasso and Braque, who were personal friends.
2. Robert J. Coady had shown a few examples of African art at his Washington Square Gallery several months earlier.

Westport, Conn.
19 October 1914

My dear Stieglitz,

I have been trying to answer your question ever since your letter came but found it rather difficult to express satisfactorily my ideas. Your request that as little reference be made to yourself as possible makes it doubly difficult. One might almost say that Stieglitz is 291.

It will seem fine to see you all again and I hope to get in shortly after the first, but have so many responsibilities now that there is very little time left. I have been doing some work however and hope to do much more this coming month or two.

The question "What is '291'?" leaves one in the same position in explaining it as the modern painter is in explaining his painting. The modern painting does not represent any definite object, neither does "291" represent any definite movement in one direction, such as, Socialism, suffrage, etc. Perhaps it is these movements having but one direction that make life at present so stuffy and full of discontent.

There could be no "291 ism." "291" takes a step further and stands for orderly movement in all directions. In other words it is what the observer sees in it.—An idea to the (nth) power.

One *means* used at "291" has been a process of elimination of the non-essential. This happens to be one of the important principles in modern art; therefore "291" is interested in modern art.

It was not created to promote modern art, photography, nor modern literature. That would be a business and "291" is not a shop.

It is not an organization that one may join. One either belongs or does not.

It has grown and outgrown in order to grow. It grew because there was a need for such a place, yet it is not a place.

Not being a movement, it moves, so do "race horses," and some people, and "there are all sorts of sports," but no betting. It is more interesting to find than to win.

This seems to be "291" or, is it Stieglitz?

This is as little reference to you as I can seem to make. With best wishes for the whole year.

<div style="text-align: right">

As ever
Arthur G. Dove

</div>

Stieglitz's first surviving letter to Dove seems restrained, even impersonal, compared to the tone of later communications. Like only a handful of other letters in the entire correspondence with Dove, it was typewritten—this one, presumably, by Marie Rapp, the 291 secretary.

<div style="text-align: right">

291 Fifth Ave., New York
5 November 1914

</div>

My dear Dove:

I thought I had written to you immediately upon receipt of your delightful letter and MS. But somehow or other I seem not to have, so Marie[1] says when I asked her. I can imagine that you are hard at work. Nevertheless I hope you will manage to get into town soon and let me see what you have done or are doing in the way of your painting.

There is a wonderful show on now by Negro savages. It will be open until November 27th. It is possibly the most important show we have ever had.

The fellows are all back. Hartley is the only one not here.[2] He is still in Berlin.

The "291" Number is really going to be a wonder. Your contribution is very fine. I like it immensely.

With greetings,

<div style="text-align: right">

Your old
Stieglitz

</div>

N.B. Haskell just sent a corker too. He is still up in Maine.[3]

1. Marie Rapp, later Boursault, a twenty-year-old music student, was the part-time secretary at 291. She remained friendly with Stieglitz throughout his life.
2. Hartley was in Europe from 1912 to 1915; Stieglitz was instrumental in arranging financing for this sojourn.
3. Ernest Haskell (1876–1925), the American painter, etcher, and illustrator, had a summer home near Bath, Maine.

After the African show in the fall of 1914, Stieglitz sponsored a three-part show of Picasso and Georges Braque paintings, archaic Mexican pottery and carvings, and "Kalogramas" by the obscure Mexican artist Torres Palomar.[1] This work was on view from December into the new year. Between January and April 1915, the gallery presented Picabia's latest paintings;[2] works by two women, Marion Beckett and Katharine Rhoades;[3] Marin's watercolors, oils, etchings, and drawings; and another show of children's art. In the middle of this season, another activity was grafted onto the gallery, as the magazine *291* began publication in March. A more daring journal than *Camera Work,* it was issued monthly for only one year. The initiative for this venture came more from Stieglitz's younger associates, Marius de Zayas, Paul Haviland, and Agnes Ernst Meyer[4] than it did from Stieglitz himself, but he participated wholeheartedly in producing it.

In the summer of 1915, Stieglitz made his habitual journey to Lake George, where years before, his parents had purchased property. Edward had died in 1909, but his widow—until her death in 1922—and children continued to vacation there. In the fall, when Stieglitz returned to New York to open the 291 season, he also, albeit reluctantly, helped his younger friends open the Modern Gallery, which was conceived by Marius de Zayas, its director, as a commercial extension of the 291 idea. (Paul Haviland, Picabia, and Agnes Meyer were, for varying lengths of time, the other principals.) Hoping to promote modern art to a wider audience than Stieglitz was willing to do, they were ultimately defeated by lack of sales and by the United States' entrance into World War I. Dove's work was included in the Modern Gallery's initial group show in October and November of 1915, but he had no further involvement there.

At 291, Stieglitz began the 1915–16 season with the first American exhibition of the colorful, semiabstract work of the German immigrant artist Oscar Bluemner. Sculptures and drawings by the Polish artist Elie

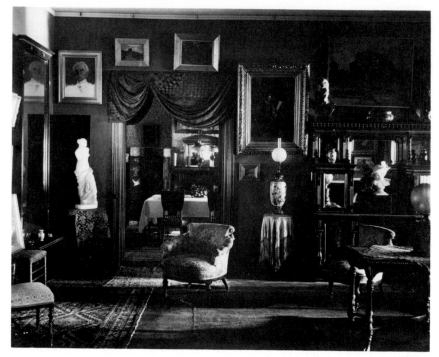

Alfred Stieglitz, Lake George Parlor, *1907(?). This view shows the interior of the Stieglitz family summer home at Lake George.* (Alfred Stieglitz Collection, Art Institute of Chicago.)

Nadelman, recently arrived after ten years in Paris, were on display during the Christmas season. After the new year, Marin's watercolors were followed by an exhibition of Walkowitz's drawings and watercolors. During these shows, Stieglitz also helped art writer Willard Huntington Wright organize the *Forum Exhibition,* a major invitational presentation of American modernist work, including Dove's. Sponsored by *Forum* magazine, the show was held 13–25 March at the Anderson Galleries, with which Stieglitz was to maintain close contact through the 1920s. The opening day of the *Forum* display of advanced developments in American painting was also the opening day at 291 of Paul Strand's first exhibition of photographs. These included startlingly abstract, unmanipulated images that Stieglitz also published in *Camera Work.* Strand's show was followed by an exhibition of Hartley's oils. The last exhibition of the 291 season presented the watercolors and drawings of Charles Duncan, the oils of René Lafferty,[5] and drawings by Stieglitz's most recent discovery, "a remarkable young woman,"[6] Georgia O'Keeffe. O'Keeffe was at this time studying with Arthur

Wesley Dow at Columbia University's Teachers College. Although she regularly saw exhibitions at 291 and also visited the *Forum Exhibition,* where she admired Dove's work, she did not yet know Stieglitz well.

1. Torres Palomar's birth and death dates are unknown. "Kalogramas," or "kalograms," decorative designs incorporating a name or initials, were widely popular in the period.
2. Picabia's 1915 show consisted of three large abstract oils. Soon after, he began to produce his better-known, proto-dadaist mechanical abstractions. Of the three paintings in the 1915 show, *I See Again in Memory My Dear Udnie* has belonged to the Museum of Modern Art for more than thirty years. The other two, lost for many years, were recovered in 1974 and joined the third in 1980 at the museum. See Hilton Kramer, "Rediscovering a Quintessential Dadaist," *New York Times,* 3 February 1980, sec. D, pp. 25 and 27.
3. Marion H. Beckett was an obscure American painter. Her friend Katharine Rhoades, painter and poet, is somewhat better known. (See Glossary of Names.)
4. Agnes Ernst (1887–1970) was a glamorous young newspaper reporter when she met Stieglitz in 1908. Punningly referring to the newspaper that employed her, Stieglitz nicknamed her "The Sun Girl." As a result of their ensuing friendship, she became a proselytizer for modernism and a financial supporter of 291 after her marriage to financier Eugene Meyer in 1910. Besides serving as an editor of *291,* she was a founder of the Modern Gallery. In 1917, her husband received a government appointment, and they moved to Washington. There, she wrote and developed a collection of Asian art, while he later owned and published the *Washington Post.* Their daughter, Katharine Graham, subsequently became chairman of the board of the Washington Post Company.
5. Charles Duncan (1892–?) was an obscure American painter and poet. René Lafferty was an American painter about whom even less is known.
6. Stieglitz to A. J. Eddy, 28 March 1916, Beinecke Rare Book and Manuscript Library, Collection of American Literature, Yale University, New Haven.

291 Fifth Ave., New York
31 March 1916

My dear Dove:
Enclosed please find check for $50.00 and also $75.00 for the picture sold to Cosgrave at the Forum Show. You see the thing has worked out pretty much as I had figured, as far as the Cosgrave transaction was concerned. I feel you have received a fair price for the picture. And I know that you feel the same way. What a pity it is that Americans will

insist in dealing indirectly in practically everything. I loathe this manner more than ever. It must inevitably lead to so much that is unfine, even in fine people.

Spring has come at last!

Remember me to the family and to Maurer, always.

Your friend,
Stieglitz

Dove's next letter was written around the time Hartley's show opened in the spring. As the letter indicates, the exigencies of making a living on a small farm were taking much of Dove's time. Partly because farm work sapped his energy, but probably also because of psychological factors, Dove's creativity had been virtually extinguished by this time. It was to be several years before he again became a productive artist.

Beldon Pond Farm
Westport, Conn.
[Probably 5 April 1916]

My dear Stieglitz

Thank you very much for the letter and checks. It is fine to be able to *enjoy* this spring weather. The amount was quite satisfactory.

[Willard Huntington] Wright speaks in his letter of wanting to buy one of my things for himself. If he says anything to you about it, use your own judgment and treat them as though they were your own as you know you are welcome to any of them at any time to do with as you think best.

Hartley's [exhibition] notice came today and is very good. I am anxious to see them, and hope to get in before the fifteenth when all of my young chicks come out of their eggs like popcorn, about 700 of them this year.

There is a great deal to do this spring as the season has opened so suddenly.

Have heard some amusing things about the Forum Show, which will keep until I come in.

My best to you all

As Ever
Dove

Alfred Stieglitz, Marsden Hartley, *1915.* (Alfred Stieglitz Collection, Art Institute of Chicago.)

Dove's next letter was written just after Stieglitz had left for his usual summer vacation at Lake George. In it, he told Stieglitz about Henry Raleigh's abrupt decision to quit farming. One of the highest-paid illustrators of his day, Raleigh was an impulsive person who, over the years, showed great affection for Dove, although he could be cantankerous, even abusive, to his family and other friends. The letter also indicates that by this time Stieglitz was already helping Dove financially, as he would—irregularly, as needed—through the rest of his life.

<div align="right">

Beldon Pond Farm
Westport, Conn.
[July 1916]

</div>

Dear Stieglitz

I knew you would manage to do something fine like that. It will please my other "old man" to death, but I haven't had a chance to let them know as yet.

As usual with your accomplishments it happened at the psychological moment to equip the farm here with its full quota of stock. About an hour after your letter came my neighbor's man left him and he offered me all his stock for a ridiculously small amount, $50. I beat him up to $75 so that the bargain would not seem so stupid and arranged to pay beginning in January.

He, Raleigh, is "through with farming" and got through so quickly that I had to take all of the things Saturday and couldn't get in to thank you & see you before you left. Walkowitz said you were to leave Monday, when I called up so was afraid of missing you.

I have things systematized now so that the extra work takes almost no more time than before and I hope by the first of the year to have the efficiency of the place doubled.

Ullman[1] has just been here, came back a week or so ago from Paris and says that the French papers are coming out in open admiration of German efficiency and are wondering why they cannot have the same. They (the women) have taken a "skinner" on the English and their bathtubs so that the soldiers have been put in Rouen. He said he had heard them saying "je préfere même les boches." Ullman, by the way, is very strongly pro Ally. Did you see this morning's "Tribune" on German & English hatred? I seem to smell something going on and am interested to see what form it will take.

It has been raining women for the last two days. The house seems to be full of them so haven't had a chance to finish this.

I gave Maurer your message. He is working hard "plugging" at the same paintings over & over which will do him good, more good than so much of the spontaneous.

Walkowitz expects to come out about the fifteenth. We will drop you a line then.

I know you will understand my appreciation of what you have done

As Ever

Arthur G. Dove

1. This probably was Eugene Ullman, a painter who had been a friend of Maurer's in Paris, but it might have been Albert Ullman, a writer and newspaperman. He and Dove could have known each other in New York in Dove's pre-Paris days, when both were associated with a convivial circle of illustrators and writers for newspapers and magazines.

Stieglitz began 291's last season in November 1916 with a "retrospective" of the work of his ten-year-old niece, Georgia Engelhard; this show was supplemented with works by members of the 291 group. The remainder of the 291 season was an exceptionally strong one; only major talents appeared in the succession of individual one-person shows: Walkowitz, Hartley, Marin, Gino Severini,[1] Macdonald-Wright, and O'Keeffe, in that order.

Dove's next letter, written early in that season, is the first to suggest the perpetual difficulty he had with his family in Geneva. Neither his disapproving parents, before their deaths, nor his brother, who remained a resident of Geneva all his life, was willing to provide any significant financial support to their errant artist.

1. The Italian Gino Severini (1883–1966) showed only this one time under Stieglitz's auspices. His was the only European show in the last two seasons at 291. The twenty-five paintings in the exhibition were primarily from the artist's earlier Futurist period, but some were in his more recent style derived from Cubism.

Beldon Pond Farm
Westport, Conn.
[December 1916]

My dear Stieglitz

Father's address is W. G. Dove, 512 So. Main St., Geneva, N.Y. It was very thoughtful of you to remember it with so many other things on your mind. As usual it comes at the p——l moment as I have just had a letter asking me if I could not get along on less as the cost of living is so high that they are not "laying by" as much as usual. Logic! Artists are supposed to be immune. Please let me know how much they are so that I can send a check or else charge it to me on the books.

The enclosed letter came yesterday from Dr. Weichsel[1] and I have referred him to you. Personally, I am not interested in churches, but suppose there must be something quite worthwhile about it or Dr. Weichsel would not be doing it. Do as you think best with that and the Gamut Club also. I will tell Mrs. Frazer [Laura Gardin Fraser][2] to write to you when I see her.

"291" seemed in much better spirits the other day, I am very glad the atmosphere has cleared. Didn't see the cat photograph [by Frank Eugene in *Camera Work*] until I got on the train.

Hoping to see you soon.

As ever
Arthur G. Dove

1. Dr. John Weichsel sent a form letter dated 6 December 1916 to artists he wished to include in an exhibition at the Church of the Ascension, Fifth Avenue and Eleventh Street. Dove showed a painting sent from 291 along with others by Hartley, Maurer, Walkowitz, Marin, and O'Keeffe. Weichsel was head of the People's Art Guild, which was dedicated to bringing the new art to ordinary people.
2. Laura Gardin Fraser, a sculptor who died in 1966 at the age of seventy-seven, and her husband, the prominent traditional sculptor James Earle Fraser (1876–1953), were Westport acquaintances of Dove's.

Beldon Pond Farm
Westport, Conn.
[27 December 1916]

My dear Stieglitz

Would it be possible for me to have some of that money by the first? The interest on my mortgage is then due and several grain bills, so have been forced to bank on what is coming.

Am all fixed for a session of work, but Mrs. Dove & Billy have decided to have the whooping cough. So we have had a strenuous week of it. However it keeps a certain type of "friends" from absorbing your time and about balances up now as they are both better except that we have to watch the boy so carefully at night.

I was delighted with the things I saw the other day of Walkowitz's and Hartley's. It makes another year quite worthwhile—especially with what you say Marin has been doing. From now on I hope to have more time to hold my end up.

Shall be in to see you as soon as I have something to bring, perhaps before.

With best wishes to all the fellows.

I am

As Ever
Arthur G. Dove

291 Fifth Ave., New York
28 December 1916

My dear Dove:

Here is a check for you: One Hundred and Fifty Dollars. Is it enough? If not wire me and I will send more at once. . . .

I am glad you liked the Walkowitzes and Hartleys and I am sure you are going to like the Marins. That means pleasure for the few of us at any rate. Real pleasure. And a great pleasure primarily for me.

Maurer was in this morning and brought me his very latest. Undoubtedly a development and I am mighty glad of it. I think later on I will give him a chance to see his work on the walls.

Night before last I was examining the things of yours I have at home. They wear splendidly. And they mean more to me today than they ever did. All of them.

Heartiest greetings,

Stieglitz

Beldon Pond Farm
Westport, Conn.
[Probably 6 January 1917]

My dear Stieglitz,

Your letter had the master touch. I mean you seem to know so well

how to make one feel the opportunity for work. It is a gift which I know all the fellows have appreciated.

The whooping cough is better but it is a slow process.

Scientific bookkeeping has been occupying the time for the last two days. It is one of those evils which though not absolutely necessary has taught me a lesson, the same that you spoke of the other day about extravagance consisting in spending more than you have.

The farm has done very well, much better than we expected.

Am glad Alfy has been doing things. He seems to have given up going back [to Europe] indefinitely on his mother's account. He has advanced a great deal in the last few months and seems to have his old enthusiasm back.

With sincere appreciation and my best to you all,

<div align="right">As ever
Arthur G. Dove</div>

Continuing to struggle with farming through this spring, Dove sent earlier work to the first annual exhibition of the newly founded Society of Independent Artists in April 1917. Also in the spring, his wife Florence, in partnership with another artist's wife,[1] opened the Turnpike Tea House in Westport.

In his next letter, Dove voices his unfulfilled longing to get back to painting. His offhand remark about Stieglitz's unsatisfactory "outlook at home" indicates an awareness of longstanding strains in Stieglitz's marriage.

1. Ann Mazzanovich was the wife of the little-known post-Impressionist Lawrence Mazzanovich (1872–1959).

<div align="right">Beldon Pond Farm
Westport, Conn.
[Probably 22 May 1917]</div>

My dear Stieglitz

Are there any more of those notes of [Charles] Daniel's due?[1] I have been trying to avoid bothering you while you were troubled with so many disagreeable things, but with interest on my mortgage, taxes and a note all due within the next few days, I hardly know where to turn.

Father held back with the same old story again this month so that direction is closed for anything further at present.

I hope what happened in Washington brightened your outlook at home. It looked very dubious when I saw you. Do you think it will be permanent?

I hope to be painting again by the first of June, if things go no worse, but the future for anything here doesn't look very bright.

Maurer has just been here for over Sunday. He has been doing quite a little work.

Please let me know how things are going with you. I have been very much worried about you since the other day.

<div style="text-align: right">As ever
Arthur G. Dove</div>

1. Charles Daniel (1878–1971), proprietor of the Daniel Gallery, was one of the first gallery owners to be sympathetic to modernism.

For Stieglitz, the very last show at 291 was freighted with consequences: It was the first one-person exhibition for Georgia O'Keeffe. Soon he would be hopelessly in love with her. After her show came down in May, Stieglitz closed 291 for good. Financial instability, the existence of other outlets for modern art, dissolution of the group spirit that had earlier mobilized enormous energies, and the dislocations, both literal and psychological, of World War I doomed its survival.

Suffering the same vicissitudes, as well as the disapproval of its photographically oriented subscribers who were not interested in modern art, *Camera Work* also succumbed. The war especially affected the publication because many of its high-quality illustrations had been printed in Germany. More pointedly, when the last number was issued in 1917, *Camera Work* had fewer than forty subscribers.

<div style="text-align: right">291 Fifth Ave., New York
24 May 1917</div>

My dear Dove:

I have your letter. Of course I knew your situation when you were in the other day. But this time I could say nothing. I couldn't help you. No, there is no note due as far as Daniel is concerned. As a matter of

fact, I have advanced moneys on several notes without your knowing it. Daniel is behind time. It is all very trying. I am really more distressed than I can tell you that you should be in such a miserable position. I wonder if your bank, if you have any, would not discount some of the Daniel notes, due in the future, for you. That is the only way I can see out. If you think this can be done I'll mail you the notes by registered mail. Banks do such things. At least sometimes.

As for myself nothing is changed. I am getting things well under way to move out [of 291]. The fellows are helping. Working hard. It's rather a heart breaking job. The worst of it all is I see no future. At least for myself. But I am quieter. And that is something. My thoughts of course do not centre on myself. It is not easy for me to send you this letter. I'd rather not write. But I don't want to leave you in uncertainty. As ever,

<div align="right">Your old
Stieglitz</div>

<div align="right">Beldon Pond Farm
Westport, Conn.
[25 or 26 May 1917]</div>

My dear Stieglitz

I can't yet forgive myself for having made the strain harder for you. I realized from your remark about Hartley that things were quite distressing but hoped there might have been some change for the better on reading the later news.

Please do not worry about my position now. I am in the last trench but hope to be able to hold it, somehow one fights better when his back is against the wall. I have arranged with the bank to take a small amount on the note I had in—and shall pay interest on the taxes until fall when there will be some stock ready for sale.

As to the Daniel notes, I should not think of doing anything with them that would destroy his belief in our ideal or leave the slightest trace of materialism on it.

It must be terrible for you to give up the Gallery after fighting there for so many years. I shall try to get in Monday to help if possible. Things are so strenuous here now that it may be impossible. Up at 4 A.M. as we have a cow that has to be milked three times a day. This season seems to keep me on the run until 8 at night.

Your part in the whole thing has been wonderful. I shall not try to

thank you. Please say nothing to Daniel of this as he is probably hit harder than the rest. And would only be uncomfortable—unless you care to give him back the notes. Do whatever you think best.

I somehow feel that something fine is coming out of all that is going on now, "291" is not a place you know.

I, too, *see* no future, but do *feel* one and know that your idea has and will have a large part in it. We must be cheerful (not as stupid as it may sound).

Pardon my making you write that letter. I might have known.

<div style="text-align: right">As ever

Arthur G. Dove</div>

Besides his own difficult financial situation, the subject uppermost in Dove's mind when he next wrote to Stieglitz was Paul Strand's impending conscription into the army after the United States' entry into World War I at the end of February 1917. Dove's eagerness to protect Strand by getting him started in agricultural work came to nothing. Strand was drafted, but not for more than a year. By then, the autumn of 1918, the war was nearly over, and Strand was never sent abroad.

<div style="text-align: right">Beldon Pond Farm

Westport, Conn.

[Probably 24 July 1917]</div>

My dear Stieglitz

Has Strand been drafted? I have been trying around here to find some place where he could fit in but find I cannot say anything very definite without knowing more of the circumstances.

My first idea was for us to get some land and work it on shares with the owner together. It is almost too late for any late crop now. Cabbage might do but would not pay to plow, buy plants, etc. at this time of year.

A flock of poultry was sold here lately quite cheaply. I knew of it before but when I came back that night it had been sold. Poultry will be very doubtful this winter.

Has Strand any capital to invest in some cows or stock? I know of some possibilities if he would care to accept the conditions. The only way would be as I said for him to come out and talk it over. Please let me know all the circumstances.

Don't get his hopes up on farming. It is a damn sight harder than the trenches unless it is done on a large scale. . . . Tell Strand he is welcome to use this place in any way he can but it is absolutely necessary to start on a small scale.

When you see Daniel will you ask him if he would mind paying interest on those notes if we put them through the bank. In February I borrowed $500 from the bank on the strength of those notes but did not want to worry you with it. Your talk the other day put things in a somewhat different light so think this attitude would be justified. We could get those notes cashed if he cared to assume the responsibility.— You spoke of a judgment but do not think that would be advisable as it would interfere with his credit in a business way in the future.

I was trying to finish this when the R. F. D. man brought your letter [now lost]. Thank you. I will send this anyway. I thought there would be a few more days before Strand's examination.

Would farming protect him? Send him out to talk it over.

Told Mrs. Dove yesterday that I could probably make you call up if I thought hard enough about it. I see you wrote instead. I understood they had ten days after the draft, so tried to phone.

As ever
Dove

3

1917–1925

DURING THE EIGHT AND A HALF YEARS AFTER THE CLOSING OF 291, THE interval during which Stieglitz did not have a gallery, neither he nor Dove was much in the public eye, except when Stieglitz showed his own work in three solo exhibitions. Yet both grew creatively, even as they also went through upheavals in their personal lives during these years.

Stieglitz developed new friendships as a result of his reputation as a leader of the avant-garde. Although 291's inner circle was never replaced by artists, young writers saw him as a culture hero and began to gravitate to him. Paul Rosenfeld, Waldo Frank, Sherwood Anderson, Hart Crane, Jean Toomer, Alfred Kreymborg, Lewis Mumford, Herbert Seligmann, and others sought him out, benefited from his encouragement, and began to propagate his ideals through their writing. Most of them also knew Dove and some, notably Rosenfeld and Anderson, became personal friends.

Because of hard times for agriculture during World War I, Dove returned to illustrating for his livelihood. Through the rest of the 1920s, he supported himself with commissions from such mass-circulation magazines as *Life, Pictorial Review, Collier's, Everybody's, Youth's Companion, American Boy, Success,* and *Smart Set.*

Most of the letters from the 1917–25 period were written in the summers, when Stieglitz was at Lake George. Dove could often see or telephone Stieglitz during the rest of the year because his illustration assignments demanded frequent trips to the magazine offices in downtown Manhattan. Thus, the letters do not fully document the remark-

able changes in the lives of the two men during these years, but they clearly reveal a new level of unrestrained candor.

<p style="text-align:center">★ ★ ★</p>

During the winter after the closing of 291, Stieglitz, without editorial or gallery responsibilities for the first time in fifteen years, devoted more time to his own photographic work than had been possible in preceding years. Yet the exceptionally cold winter seemed leaden to him. Stieglitz retained a desk at the old gallery address. "In the desolate, empty, filthy, rat-holed, ill-smelling little space," he sat or paced up and down in his overcoat and hat for warmth. He did not know where else to go. No longer fighting his "battle" through 291 and *Camera Work,* he felt "somewhat as Napoleon must have on his retreat from Moscow."[1]

When Dove next wrote to Stieglitz, he had not yet given up farming, but he was discouraged by the nation's agricultural problems. At the time, he was living mostly in his studio on the farm, while Florence and their child lived in the apartment behind the Tea House so the farmhouse could be rented for the winter.

1. Stieglitz, quoted in Norman, *Alfred Stieglitz,* 134.

<p style="text-align:right">[Westport]
[Probably 16 February 1918]</p>

Dear Stieglitz

. . . I find the farmers here quite up in the air now as they have forbidden the killing of some of the stock and are now taking advantage of that to raise the price of feed. If it goes up from now steadily until fall, it will be unbearable and it looks as though Bolsheviki would be the best crop. . . .

<p style="text-align:right">As Ever
Dove</p>

In June, Stieglitz's gloom lifted with Georgia O'Keeffe's arrival. She had been teaching in Texas for two years, but now she accepted Stieglitz's invitation to come to New York, along with his assurances of funds for her to paint full time for a year. At thirty, she was only just becoming a productive and committed artist. Stieglitz had given her a new sense of purpose during the previous couple of years, but before

that her goals had been uncertain. Raised in rural Wisconsin from her birth in 1887 until her last two high school years, when her family lived in Virginia, she had later attended art schools in Chicago and New York. However, she had then entirely renounced painting because she was discouraged about what she could express in her art. She backed into painting again rather tentatively by attending a summer session at the University of Virginia in 1912. After that, she taught in Virginia and South Carolina, as well as in Texas, and studied again in New York, at Columbia University's Teachers College, with Arthur Wesley Dow. As a visitor to 291, she was quite overwhelmed by Stieglitz long before he saw her work and recognized its quality by including her drawings in a 1916 group show and then giving her a solo exhibition in 1917. However, her self-sufficient appearance disguised the intense attraction she felt for the photographer, who was nearly twenty-four years older than she.

In fact, over the years the complexity of O'Keeffe's personality was masked by an impeccably maintained persona of wraithlike aloofness—inviolate, singular, mysterious. Whatever the dynamic power of this self-image to O'Keeffe herself in later years, when she came to Stieglitz she was youthful, rambunctious, funny, distinctly original, and passionate. At last Stieglitz had met his match in wit, physical exuberance, and creative power.

In his next letter, Stieglitz betrayed his infatuation with O'Keeffe. Although she was indeed ill when she got off the train in New York, Stieglitz probably overreacted to her condition (although influenza was a genuine threat in this epidemic year of 1918). His insistence on her fragility, here evident from the outset of their relationship, foreshadows a theme in his attitude toward her for years. At times, he almost insisted on treating her as an invalid.

[New York City]
18 June 1918

Dear Dove: I have just come in—a walk with Strand from 11 until now—1:30 A.M.—

—These last 10 days have been very full ones—possibly the fullest I have had in my life.—And I have had very full ones so often.—

I was more than sorry to have missed you yesterday.—I was out with Marie.—She leaves for the summer tomorrow.—I'll tell you about it when I see you.—

Of course the important thing during the last 10 days has been O'Keeffe.—She is much more extraordinary than even I had believed.—In fact I don't believe there ever has been anything like her.—Mind & feeling very clear—spontaneous—& uncannily beautiful—absolutely living every pulse-beat.—

She has to be very careful—& is in bed much.—And I'm a strict nurse.—Tomorrow I take her to my brother.[1]—I wonder what he'll have to say.—It's very important to many—much depends upon those few minutes.—

—When I see you I'll tell you much.—Of course I hope you'll meet her. That must be.—

I have been thinking frequently about you.—I wonder how the Mrs. affair has developed.—I hope to your & her satisfaction.—And everything else I hope is becoming a little less worrisome—although these days seem to delight in keeping everyone more or less on uneasy street.—

Still some very much less—& some much too much undeservedly more!—

Kitty got back from College[2] on Thursday.—Everything is running without friction.—I seem to have the situation in hand for the present.

Remember me to Mrs. Dove.—As for yourself you know what you mean to me.—

<div style="text-align: right">Stieglitz</div>

I ate some of the eggs—O'Keeffe the balance.—They were delicious.—I took lessons from Seligmann how to boil an egg—I think he taught me "coddling."—

1. Leopold Stieglitz, a physician.
2. Stieglitz's daughter had just completed her first year at Smith College, from which she graduated in 1921.

In July, Stieglitz left his wife of twenty-five years to live with O'Keeffe. According to his own account, he simply packed and moved one day while she was out of their apartment.[1] For the first two years, Stieglitz and O'Keeffe lived in a studio at 114 East Fifty-ninth Street, relinquished to them by Stieglitz's niece, Elizabeth Stieglitz, who married Donald Davidson soon after.

1. Stieglitz to Marie Rapp Boursault, 9 July 1918, Collection of American Literature, Beinecke Rare Book and Manuscript Library, Yale University, New Haven. Lowe, *Stieglitz,* 216–17, gives a somewhat fuller account.

[New York City]
[Late July 1918]
Friday

Dear Dove: It's about the maddest time of my life these days.—Tragedy & comedy—all the same it seems. Death seems to mean less than ever—I sometimes wonder what I'm made of.—Whether I have any real feeling of any kind for anyone or anything.—Whether I'm not like nature itself—just a force—relentless.—Isn't that what everyone really is.—

—I was sorry to have missed you—I have been photographing much—& wonderfully at moments.—O'Keeffe is working.—I was virtually "kicked" out of home—like I was "kicked" out of the Camera Club 10 years ago.[1]—The Club wishes me back.—Home already "regrets."—

—I don't know how it will all end.—But I know I'm living & I know that the human race is mad these days & that perhaps I'm mad too—but it's a sane madness—so damn sane that it sometimes frightens me. O'Keeffe is truly magnificent. And a child at that.—We are at least 90% alike—she a purer form of myself.—The 10% difference is really perhaps a too liberal estimate—but the difference is really negligible.—

—I was glad you met her as you & she did.—She goes to 291 little.[2]—

—I don't know when we leave—everything is at sixes & sevens—owing to "home."—So I hope to see you soon.—

. . . —Perhaps you'd like to come up to the studio where we work—in case I'm not at 291.—

All is so uncertain.—

—I hope your affairs are no worse than they were—rather better. Not worse is really better.—

Heartiest greetings from two mad ones—

Your old
Stieglitz

1. In 1908 Stieglitz was publicly expelled from the Camera Club of New York by the conservative faction of its membership.
2. The office Stieglitz retained at 291 Fifth Avenue, not the gallery that had existed at the same address.

In August, Stieglitz took O'Keeffe with him to Lake George, where she had to cope for the first time with his large and eccentric family. The Stieglitz clan—an extended family of siblings, cousins, in-laws, and their guests—had been vacationing at Oaklawn, their estate on the shore, since 1886.

<div style="text-align: right;">

Lake George
15 August 1918

</div>

Dear Dove: You have been in my mind a great deal. —A great deal more than usual since the meeting in the studio. And that is saying much for you are ever in my mind.—

—It is all very wonderful.—The day is one of great deep blue clarity—a gentle Northwester, invigorating, embracing—the greens never fuller, deeper—more sensuous—the Lake always the Lake.—

Since I saw you I have been living as I never lived before.—I have gone through a great deal—some very painful hours—but all intensely real.—O'Keeffe is a constant source of wonder to me—like Nature itself—& all fine humans—& there are some.—I know some.—And every moment I am full of gratefulness that I am a great fortunate.—

O'Keeffe & I are One in a real sense.—

The family like her hugely—& we are as free as 291—the real 291.— Everyone laughs at us.—We came up two weeks ago.—She painted some.—I photographed some more.—Some day I'll show you.—We have no plans.—Every moment is a happy eternity—sometimes— rarely—the moment is of intensest pain—but even that turns into a great glory. —We are both either intensely sane or mad children.—It makes no difference.—

—I wonder how you are faring.—Strand wrote that he & [Donald] Davidson had spent a weekend (or was it a Sunday?) with you & enjoyed it hugely.—

—Do you ever get a chance to paint?—You don't know what the "Cow" meant to O'K. & me.—It outlived virtually everything else we had about us.—We often talk of it.—

—The Lake is our great Companion.—It is virtually neglected this year—the War.—So we have it nearly to ourselves.

Both of us want you to know you are with us here.

<div style="text-align: right;">

Stieglitz

</div>

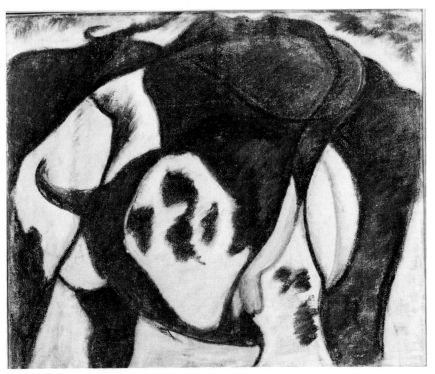

Arthur Dove, Cow, c. 1912/13. Pastel on linen. This work, which remained in Stieglitz's collection, was given by O'Keeffe to the museum after his death. (Alfred Stieglitz Collection, Metropolitan Museum of Art, New York.)

Finally, in the fall of 1918, Dove gave up farming and turned to illustration once more for his livelihood. He spent winters in New York City and returned to Westport in the summers. Therefore, for the next several years, letters were generally exchanged only when Stieglitz and O'Keeffe were at Lake George.

7 Livingston Place
Stuyvesant Square
[Early October 1918]

Dear People—
I heard of a Frenchman who came here a few days ago on a furlough instead of going to his family a short distance from where he was fighting in the trenches, said he did not want to see them until it was

over. It may be that feeling that kept me from answering your last letter, it was the best news you have written, that feeling and the dread of what happens sometimes between lines when hands are necessarily soiled.

It was a great joy to know that you were being what was inevitable from the start. O'Keeffe knew it, if you remember a bit of color in a letter. It was just a case of the two strongest forces. I realized it the minute I saw her and I am glad, very *glad*.

You have been *actively* in my mind at least fifty times a day since I saw you—and there was a joy in feeling that you knew it. I will tell you about some things that have happened later.

Things have changed rapidly—sometimes quite hopeless, but there is something behind it. Brilliant "green and yellow" spots on a black ground. It is good to go through these things though. There is a feeling that it is not at all permanent and that the whole scheme is to be changed soon.

We are moved in town now, Billy is going to the "Friends" School across the Square. Have the same address we had twelve years ago.— Circles.—A floor overlooking Stuyvesant Square. There is one under it I wish you had. Richards has it now. He ran the Whitney-Richards Gallery in the Holland House. Has closed the gallery and is now engaged in experiments in *secret writing*. $32 with heat and all conveniences. This is the most reasonable spot in the country to live in and doesn't smell much worse than any other part of New York. I wonder if you would like it down here? Think I could scare him out with a nail on a string in a few nights.

I wish I could share your lake with you. This is the wonderful month on any of the fresh water lakes.

Let me know when you come back.

With love to you both

<div align="right">

As ever
Arthur G. Dove

</div>

<div align="right">

[New York City]
9 December 1918

</div>

Dear Dove: Just to tell you *We* are still amongst the Living—*Very Living*—& nearly every day we tell each other: Tomorrow we *must* call up Dove. But for a time the phone number was mislaid.—Then again we have been going it hard—very—in fact.—

I have been printing.—O. painting—And there have been other things.

—I'll call you up in a day or two. We want to come down to see you.—Hope all is well with you & yours.—

<div style="text-align: right;">

Always your old
St.

</div>

<div style="text-align: center;">

[Westport]
[16 September 1919]

</div>

Dear People,

. . . I have not written hoping that there would be something cheerful to speak of but as yet it has been one steady grind trying to learn to do these things as decently as possible under the circumstances. They are improving however and think the "convalescent" stage of growing another set of feelings has passed. If the illustrators had been chemists, they would have blown their heads off long ago. There seems to be plenty of work going on now so that affairs financial are picking up a bit again.

Had about arranged a plan to drop in on you for the day some time this month. We have some friends on Lake George with whom Florence was thinking of staying while I took Billy to Geneva to see the family. We thought of taking the Ford which is still holding together and stopping to see you. Our plans however have changed and I shall probably take Billy and spend a few days early in October in Geneva and then go back to New York, as it is late and there is so much to be done.—

When do you come back? It must be beautiful there. It is here.

Have you done more with the closeups? And were they more satisfying?

And the [O'Keeffe] paintings. I am wondering if they do not abstractly feel the same force. Am anxious to see them.

Dasburg dropped in Sunday. Wanted your address. He seems to have changed his attitude to some extent. Said he was "going out and sitting down in front of it." I didn't have much of a chance to talk with him. He is teaching at Woodstock.[1]

Let me hear from you if you can. It is after 12 so good night. With best wishes for you both.

<div style="text-align: right;">

As Ever
Dove

</div>

1. Andrew Dasburg (1887–1979), born in Paris but raised in the United States, was one of the first American modernists. He produced nonobjective works throughout most of the teens, but about the time this letter was written, he turned toward representation influenced by Cézanne.

<div align="right">
Lake George

18 September 1919
</div>

Dear Dove:

. . . —All day I have been at my photography.—A great day of activity. And a perfect day of autumn—cold & clean. For a month or more the weather was more than trying. Gray—rain—penetrating dampness. . . .

—The summer has been very full.—Several happenings very different—very wonderful—nature always a constant revelation. G. & I enjoying together. . . .

I have no idea when we'll return—whether early or late in October.—We both have still much we hope to do here.—But we live from day to day—with no plans of any kind. . . .

Strand is here at present.—Was in Canada after his release [from the Army] and on his way to N.Y. came here.

—Have had letters from Germany & today a long letter came from there from my brother-in-law [George Herbert] Engelhard who is over there on business.—

I'm trying to get into touch with my old friends[1] about reproductions & printing as in spite of *No Cash* I am mad enough to occasionally dream of more numbers of "Camera Work."—I wonder.—

Habits perhaps.—Hard to get rid of.—Still—??—

Georgia has been having an awful time with watercolor.—She has done a few things in oil which, as I think I wrote you, are worthy to be added to her good things of last year & before.—

She claims to be having a hellish time to get her mind clarified!—

This is primarily a greeting from us both.—We want to be remembered to your wife & also to the boy. As always your old friend

<div align="right">
Stieglitz
</div>

1. Presumably, Stieglitz had in mind the German printers who had done illustrations for *Camera Work*.

Dove spent the winter of 1919–20 illustrating. Neither of the corre-
spondents was publicly active. The following July, while the Doves
were in Westport, Stieglitz and O'Keeffe moved out of the Fifty-ninth
Street studio that they had inhabited for two years and went to Lake
George until November. As he frequently did in years thereafter,
Stieglitz complained of feeling exhausted by the time he went to Lake
George.

[New York City]
18 June 1920

Dear Dove: There seems to be a fatality in getting to Westport.—I
doubt our ability to leave the city for the present.—Yesterday all the
tenants of 114 [East 59th Street] were notified to be out of it by July
15th.—
—I knew it was coming but hoped it would be somewhat later. There
is so much I must still do in the studio—so much undone because of all
the illness—& bad weather.—So the pleasure of getting to see you &
yours at W. must be postponed a while.
—I hope Mrs. D. is well again & that news from your father &
mother is as good as it could be.
—Heartiest greetings from us both to all of you.
Stieglitz

Lake George
29 July 1920

Dear Dove: Here we are.—Two weeks already gone.—Both arrived
pretty well played out. I, more than played out.—Both are in fair shape
now, although [O'Keeffe] is slightly ailing.—She seems fated to be
tortured in one way or another—much like myself, that is, physically.—
Certainly a great handicap.—We are eager to work, but somehow or
other the moment has not yet arrived.
The weather has been so cold and autumn-like that it is difficult to
keep warm.—But I guess we'll get enough heat to suit us before the
summer is over.—The Lake is not so near as in other summers,[1] not so
ready, so intimate, but the cold weather has prevented our missing the
intimacy greatly.
I suppose you are kept very busy—between the Farm and *the* Work—

and the family is undoubtedly more satisfied than in some years.—The kid must be in a sort of heaven. . . .

This is above all a Hearty Greeting from us both to you & your family—

always your old
Stieglitz

1. He had moved to a house farther from the lake.

Dove's next letter, reporting on social life in Westport, gives some indication of the caliber of his friends there and belies the impression that he was isolated in the country. Sherwood Anderson, whom Dove mentions in this letter for the first time, was a frequent visitor in Westport because his brother, Karl, a painter, lived there. Anderson had only recently become a public figure; *Winesburg, Ohio,* published the previous year, was his first work to win critical acclaim. Anderson thought that Dove was the most important painter of the modern movement in America, and the two remained friends—though they rarely saw each other in later years—until Anderson's death in 1941.

Westport, Conn.
[26 August 1920]

Dear People,

It has been a busy time keeping up to a summer that is going so fast.

Friends and people, you know, Westport is full of them.

There is quite a lot of "291" here too, so you see it was not a place. . . .

We see Paul Rosenfeld quite often and the Kanes [the Melville Canes]. Strand and Seligmann were here, and guess who else one evening, Sunday, with a lady—Walkowitz. Haskell is married again. A school teacher from California. They were in Maine.[1]

Suppose you have heard from Strand and Seligmann. They are in Nova Scotia yet I believe.

We had a very nice evening with Sherwood Anderson, Rosenfeld and Van Wyck Brooks at the Kanes.

We are trying gradually to get the farm back, poultry and asparagus mostly now but am going slowly as they are expensive to buy this year.

Have debts down to $250. And a note so things look more promising than for some time, unless the much talked of "fall panic" drops.

Have you been working? Is the lake as still as that painting of it by "O'K."? And is she painting?

Let us hear.

As Ever
Dove

1. Ernest Haskell's first wife Elizabeth had died of influenza during World War I. He met and married his second wife, Emma, in San Francisco.

Stieglitz's next, high-spirited letter shows the kind of athletic exuberance with which he and O'Keeffe enjoyed Lake George in the 1920s. However, in 1920, after two summers with Stieglitz's family, O'Keeffe asserted her need for some privacy by renovating a "shanty" into a studio, a project that accompanied relocation of the family's living quarters. Oaklawn had been sold late in 1919, its expense having become too much of a drain on the estate Edward Stieglitz had left upon his death in 1909. The family retained a large farmhouse, on what Stieglitz often referred to as "The Hill," and a passageway down to the lake. In the mid-1920s Alfred's brother Leopold built a bungalow nearby, and, later still, another small structure. Thus, not all the family and guests stayed in the main house, which had about eight bedrooms, but they usually ate together. In all, quite a crowd could be accommodated.

Eventually, for O'Keeffe, even her studio became insufficient protection. Despite Stieglitz's frequent remarks about the peacefulness of The Hill, others, including O'Keeffe, found the atmosphere there more stressful. Probably at O'Keeffe's insistence, she and Stieglitz increasingly scheduled their sojourns so as to avoid family. They often went to Lake George before the others arrived, and they nearly always stayed on well into the fall after everyone else had left. This autumn respite was generally an important period of creative activity for both of them.

Despite his pleasure in life at Lake George, Stieglitz confides rather gloomy feelings about the future. This attitude is part of a continuing tendency in Stieglitz's thought after the closing of 291; what he now sees as the "enigma" of the future was later expanded into a melodramatic perception of things to come. At this particular point, his uncertainty

may have been intensified by the fact that he and O'Keeffe had no place to live. Having been forced by the landlord to vacate their studio residence, upon their return to New York in the fall, they moved into the home of Stieglitz's brother Leopold, at 60 East Sixty-fifth Street. They stayed for four years.

Lake George
28 August 1920

Dear Dove: For a week or more I have been wishing to drop you a line. . . . But letter-writing seems not to come.—The final arrival of the summer—warm weather & dry, which both of us enjoy so much— set us agoing—painting, photographing, swimming, mountain-climbing, etc.—And thus writing became entirely sidetracked.

—I have gotten up particularly early today—G. is still abed—to get off a few letters. . . .

Yours of yesterday gave us both much pleasure. . . . You have worked like a Trojan & have earned some peace of mind—the greatest of "luxuries."

—Georgia & I are feeling stronger again. Plenty of food—lots of fresh air—good beds—& a minimum of vexations.—And sufficient exercise.—The Davidsons were up here for 10 days (you know my niece [Elizabeth] who married the "farmhand") & during the time an old shanty on the place was salvaged.—G. always had had her eye on it.— So Davidson, a tremendous worker, got busy & infected us all with "hustle." The shingles of the roof were torn down—they were rotten— & in their stead was placed tar paper. You should have seen Georgia astraddle the rooftop working with a vengeance. She certainly enjoys hammering & plastering, etc., etc.—She in bloomers & as little else on above her waistline as possible—for the sun was hot.—And my niece & I were laying the floor—& oiling the old rafters—& Mrs. Waldo Frank [Margaret Naumburg],[1] emptying the shanty which had been filled with old shingles from the old Farmhouse.—The Women worked as few men work.—And Davidson set the pace.—It was all great to see & be part of.—And finally Georgia & I have our own shanty.—And G. began painting.—And is enjoying it.—And I am glad. For at one time I wondered would she paint at all this summer.—Or even soon thereafter.—Or ever perhaps.—

The Franks are near here for a few weeks.—He busy finishing up some books.—Yes, I had heard about many of the folks who had seen

Alfred Stieglitz, Waldo Frank, *Lake George, 1920*. (Alfred Stieglitz Collection, Art Institute of Chicago.)

you.—291ers in a sense.—Have had letters from Marin (finally happily back in Maine)—Hartley (East Gloucester)—Bluemner (a rich letter)—Strand & Seligmann (Nova Scotia)—letters from old friends in Europe (England—The Tyrol—also several from Germany).—Reports from the other side not overpleasant reading.—In a way I wish I could go over for a while—

The Winter—! —It's hard to realize that autumn is knocking at the door. . . . And that before we realize it New York will force itself into our thoughts—I don't look forward to even the thought.—New York does an ugly thing to me.—I feel less & less a part of it. . . . Being there is ugly.—But I have made up my mind positively to get that "property" in order. . . . So I'll make it *my job*—every day a few hours in the sub-cellar of Kennerley's.[2]—I started before I came up here. Getting rid of books.—Up here there is storage room.—But with freights up & up & with cash lower than ever—& with the future for us an enigma—why keep anything not really of real need or real pleasure-giving?

With the quiet of this morning it is hard to believe that there is greater Hell in the world than during the War—& that sooner or later something must "happen" dramatically and positively over here.—The expected "panic"—I wonder whether any of the expected things can happen—in view of all expecting.—Nature likes to play—have its fun with its Wise Ones.—I refuse to worry.—Of course my weather-eye is occasionally open in my sleep.—

Georgia is coming downstairs.—She joins me in sending both you & the Lady many hearty greetings and both of us also wish to be remembered to the Boy. I'm sure he is having a great time.—

<div style="text-align: right">Your old friend
Stieglitz</div>

No painting for you in sight yet? —If you see Maurer—our regards. . . .

1. Margaret Naumburg, a progressive educator, directed the Walden School in New York City. She and Frank were married in 1916 and divorced ten years later.
2. Mitchell Kennerley, president of the Anderson Galleries, where Stieglitz used the subbasement for storage at this time. (See Glossary of Names.)

Early in 1921 at the Anderson Galleries, Stieglitz presented a large retrospective show of his photographs, the first exhibition of his work

since the 1913 survey at 291. The 1921 show included twelve from the 1913 display, but the remaining 145 prints were new to the public. Drawing the most comment were nearly fifty of O'Keeffe, the first publicly shown prints from Stieglitz's monumental "portrait," which comprised about 500 images when Stieglitz stopped photographing in the late 1930s. While his own show was on display, Stieglitz also was helping to organize an *Exhibition of Paintings Showing the Later Tendencies in Art,* which was shown at the Pennsylvania Academy of the Fine Arts in April and May. This was the first significant exhibition of modern American works to be shown in any museum. However, the Academy did not officially sponsor the show; it simply made space available so that the organizing artists could show their selection.[1]

Dove was included in the Philadelphia show, but through this winter he was still spending virtually all of his time illustrating. In June 1921 his father died, but Dove received no inheritance. Soon after, he and Florence visited Stieglitz and O'Keeffe in New York, shortly before they left for Lake George.

1. For information about the Philadelphia show, see Carolyn Diskant, "Modernism at the Pennsylvania Academy, 1910–1940," in *In This Academy: The Pennsylvania Academy of the Fine Arts, 1805–1976,* by Richard J. Boyle, et al. (Philadelphia: Pennsylvania Academy of the Fine Arts, 1976), 205–28.

[Lake George]
[July 1921]

Dear Dove: Georgia & I have had you much in mind since you & Mrs. Dove dropped in on us. . . . We both more than realized what you were experiencing.—Don't we ourselves know all about the artist & his status in the community?—In one's own family!—The absolute lack of sympathy.—There is more for a dog—or cat—even a stray diseased cat. . . .

I came up here virtually all in.—There were two weeks of torrid heat.—There was no Lake George the first time for me. I hardly seemed to exist. The heat & steaming vapors merely intensified what was before.—There are but few cheery faces this year up here.—And still all is outwardly peaceful—& my mother is doing very well.[1] —The Mountain Shapes have become solid once more—the Lake once more inviting.—Georgia is painting.—Spends much time in her Shanty. . . .

Alfred Stieglitz, Hedwig Stieglitz, *Lake George, 1921.*
Stieglitz here portrayed his mother at their summer home
the year before her death. (Alfred Stieglitz Collection,
Art Institute of Chicago.)

I hope you are busy—& above all getting a chance to paint.—We both
send love to your & yours—

always your old
Stieglitz

1. Hedwig Stieglitz had suffered a stroke in September 1920. Although she had
 improved by the following summer, she remained partially paralyzed.

Though the letters to Dove do not reveal the doubts he voiced to
others, Stieglitz had feared that Dove would never paint again. Then,

abruptly, in the summer of 1921, Dove once more began to paint. He was exuberant when he next wrote to Stieglitz, and his momentum as a creative artist never failed again. Perhaps his father's death, which ended years of conflict, made it easier for him to proceed. Probably a new love also gave him energy, for he was seeing Helen Torr, who was to become his second wife, in Westport this summer.

[Westport]
[August 1921]

Dear People,

This is a preliminary note to let you know that I have been too strenuously interested in life and work for the last few weeks to write at any length about it. So many things nice and otherwise have happened that I have been trying to put them all into action. Consequently have not written but have five or six drawings for paintings that are almost self-portraits in spite of their having been done from outside things. They seem to me more real than anything yet. It is *great* to be at it again, feel more like a person than I have in years. Trying to develop an ego— purple or red. I don't know which yet.—Think that is what has been lacking. You will understand. At any rate, it must be done in spite of everything.

At present am camping out near Westport with Billy, the Van Wyck Brooks boy [Charles] & Robt. Fuller and am writing this on a board in front of the tent. They are nice kids—wash dishes etc. while I do the cooking. Painted all the morning in spite of it. Have promised them a trip for a year and am making four days of it now.

Florence Cane has been very fine to me lately.[1] . . . She showed me the O.K. painting. It was *good* to see it again.

Hope you are both working hard. That seems to be one of the few roads to gladness.

It is quite peaceful here and almost too much on the side of beautiful scenery—but there are some stronger things. A sluice gate for instance of rusty used iron, warm grey weathered wood, and a strip of blue grey water which I have been at this morning.

. . . . This winter may see a change in things. So many people who had peacefully decided that there was nothing in the new things, have begun to worry all over again. We see a lot of it here.

Sherwood Anderson was out Saturday but missed him as I have gone on strike against so many parties. The painting of Alfy's he bought

nearly disrupted the Karl (his brother) Anderson family. Mrs. "A." refused to go to bed until it was taken down. She finally had to take it down herself.

Let me know what you are doing soon as I am anxious to hear. Have been thinking of you both many times a day.

As ever
Arthur G. Dove

1. She helped financially and shortly after wrote an impassioned plea to Dove's mother, attempting to enlist support for him.

Lake George
28 August 1921

Dear Dove: I was in town for a day. . . . In the afternoon went to see Kennerley. Came in time to have him take me to an invitation affair of the Dempsey-Carpenter Film.—He wouldn't have gone alone.—And I wouldn't have gone either. But both were ready to go together.—The fight itself most interesting. But the trimmings wasters of time. For us. . . .

Chased back here.—And found several letters.—Yours.—Great.— The news of your painting. Both G. & I more than elated.—I'm sure you're letting out.—And most fully enjoying it. Yes, Florence Cane is a real fine person.—That she is something to you I don't doubt.—You must be much to her.—

—Georgia is painting and feeling fine.—For a long time she suffered much from her eyes.—We had to go to town for a week.—The oculist there has really done much for her. It was a great source of worry not to know what ailed the eyes. To see her suffer. And not to be able to work. Or enjoy anything.

—The summer although peaceful & summerlike has not been conducive in much production as yet.—I haven't made a single negative.—A few prints.—Several good ones. But my "heart" has not been in anything much, I don't seem to have any ideas. And still I have not been entirely stale.—Something will come out of the indulgence. . . .

—The air here is full of aeros—They are a nuisance with the noise they make.—

With the disappearance of the Season they will disappear too & Lake George will become itself. We have no plans. Have no idea how long will be our stay.—

If there is work here we'll do it.—If there is none we'll return to town when house permits.—I do hope Georgia will find more "inspiration" later on when Nature begins to turn color. —She (G.) has not been feeling brilliant colors all summer—Nor have I.—Natural reactions from life.—True registrations.—

—I have gotten away with several novels.—Proof of my own lack of creative desire.—Enjoyed, in a way, Hamsun's "Growth of the Soil" & "Hunger."—[1]

—Hartley's book[2] is about to go to press.—It has been a mean job to work with a sloppy publisher & sloppy printers. Thanks to Seligmann I think the outcome will be halfway a presentable one.

From Hartley I've had but one sign of life.—Marin is tinkering with a discarded motorboat he found somewhere on the Maine beach! So he has become a real Mariner.—

—This is a rather stupid scribbling.—But I do want to tell you how the knowledge that you are finally painting makes me feel real cheerful—stronger.—Most hearty greetings to you & all yours from us both

Your old friend
A.S.

1. Norwegian novelist Knut Hamsun (1859–1952) had won the Nobel Prize for literature in 1920, the previous year. *Growth of the Soil,* published in 1917, is his best-known work. *Hunger* had been published in 1890.
2. Marsden Hartley, *Adventures in the Arts* (New York: Boni and Liveright, 1921). Seligmann did the final editorial work on the book while Hartley was in Europe. The volume is dedicated to Stieglitz.

In the autumn of 1921, Dove's private life changed dramatically. He left his wife in Westport and moved to a houseboat moored off upper Manhattan. To the surprise of the Westport art colony, Helen Torr went with him. "Reds," as most friends called her, had been sketching frequently with Dove that summer, but apparently no one anticipated their departure.[1]

When Reds left Westport, she abandoned a witty and convivial husband, Clive Weed, an artist known primarily for his newspaper cartoons. The auburn-haired woman, a few years younger than Dove, temperamentally complemented the forty-one-year-old painter. She shared his desire for privacy and his sense of good humor about the world. Both were warm to individuals but uncomfortable in large social gatherings. They were both matter-of-fact about daily life and

willing to sacrifice physical comfort for the psychological rewards of art. Most important for Dove's career, as an artist herself, Reds understood and supported his work.

Reds was originally from Philadelphia, where she had gone to art school. She continued to paint through most of the 1930s, but because she was intensely self-critical about her work and because she deferred to Dove's talents, she spent much of her own time making it possible for him to work. As a result, she was not very productive, and her work never became well known. She remained disappointed all her life that Stieglitz did not like her paintings, and she tended to take his judgment at face value. Although both Dove and O'Keeffe encouraged her, she seemed unable to seek her own audience at another gallery. Her work has received a small amount of belated attention in recent years,[2] although her talent never developed fully. In her lifetime, she remained entirely in Dove's shadow and seemed happy enough to share a life in which he managed to be productive despite difficult, time-consuming, and sometimes impoverished circumstances.

While Dove and Reds were putting together a new way of life during the winter of 1921–22, Stieglitz's primary concern was a new magazine, *MSS,* which he helped to edit during its six-issue life in 1922 and 1923. He also arranged, at the Montross Gallery, an exhibition showing the evolution of Marin's work.

1. Interview with Lila Howard, Westport, Connecticut, July 1976. She remembered going sketching with them.
2. Her work has been shown at the Heckscher Museum in Huntington, New York, and at the Graham Gallery in New York City. Hilton Kramer pointed to her work as one of the "real discoveries" in a group show of woman artists at the Graham Gallery ("Does Feminism Conflict with Artistic Standards?," *New York Times,* 27 January 1980, sec. D. pp. 1 and 27).

Lake George
12 July 1922

Dear Dove:

We came up here all in. Both of us.—Perhaps I—the privileged so much older one—a little more so.—For some days body—head—internals—all seemed numb with fatigue.—Everything became physically painful. Every move so.—Life really seemed non-existent.—But there was real quiet—A peacefulness.—Vegetation so overrunningly green—

The waters higher than ever.—And brooks wildly capering where usually there is dryness or a lazily flowing noiseless tiny stream of water.—

—But after a week or so we began feeling "alive" once more.—And walking was no longer quite an effort. Being seemed so entirely absurd.—And now we both are about starting to putter about.—Ideas may be taking form.—For a while neither G. nor I seemed to have a thought—or an idea—in our so-called heads.—As I said mine seemed like a sucked-out egg. . . .

—My mother of course is a most pathetic sight.[1] She stood the trip well. . . .

And how are you faring? and the Lady? I hope all is well.—I wonder too how is Herford getting on with his problem.[2]—There is a new number of "The Little Review" out.—There is an article by Apollinaire which would be helpful.[3]—But I suppose it is too late to be of any use to him now.— . . .

—This is primarily a greeting most hearty—from us to the Two of You.—

<div align="right">Your old
Stieglitz</div>

1. Hedwig Stieglitz died later this year.
2. Oliver Herford's "problem" was an article that he was preparing for the *Ladies' Home Journal*. It appeared in the January 1923 issue under the title "The Crime Wave in Art." Besides occasional pieces on art, Herford wrote humorous material and did illustrations. (See Glossary of Names.)
3. Guillaume Apollinaire (1880–1918), French poet, writer on art, and friend of the Cubist painters. His article in *The Little Review* was the first installment of the original English translation by Mrs. Charles Knoblauch of his book *Les Peintres cubistes: méditations esthétiques* (Paris: Figuière, 1913).

<div align="right">[New York City]
[Probably 25 July 1922]</div>

Dear Stieglitz

That letter was a help coming just as it did on the rise of a wave. Some very fine things in it which I shall save and read back to you some time. There had been hot dry spots and letters from mothers, sons and others, but yours was better and we liked it.

Things here are running well and I hope next month will bring a

higher turn in the tide. The debts are being reduced—$642 now plus the note. That is better.

And "The Little Review"—that was a help too—and Apollinaire.— Yes—by all means. About the plastic virtues—and nature.—It was very pure.—We saw some tall black birds at the Bronx [Zoo] yesterday with black "bamboo bills" as Reds described them, which made us wonder— if we had seen all of nature. They are amazing. Almost portraits of thoughts. You must see them when you come back. There is a crosstown car which lands us right at the gate.

Reds is painting now—the same quality as the drawings—learning to organize. She looks better—7 lbs. better.

We have our groceries delivered in wooden boxes now and use the ends for panels after they have been shellacked. "Life" is letting me do some pages of small sketches now which are not so deadly boring.

Herford is still laboring with his problem, it had been postponed and he gave me the feeling that he was having a hell of a time doing it. . . .

We will be glad when you both come back.

I telephoned Mamaroneck, and found that the Davidsons were in the Adirondacks. Has anything happened yet[1]—or when?

Will get "The Little Review" for Herford.

Our best to you both

<div align="right">

As ever
Dove

</div>

1. Donald and Elizabeth Davidson, who lived in Mamaroneck, New York, at this time, were awaiting the birth of their second child, Sue. Their elder daughter Peggy had been born in 1919.

Once he felt more rested, Stieglitz turned his attention during the summer of 1922 to his own photography and to helping Strand compile a special issue of *MSS*, for which he solicited answers to the question "Can a photograph have the significance of art?" Dove's contribution was among those published.

<div align="right">

Lake George
7 August 1922

</div>

Dear Dove:

. . . . Georgia has not done much so far.—As for myself I have been very busy using up material, but as far as results are concerned I really

don't know.—Everything strikes me these days as not particularly good.—I smashed my large camera the other night.—My own stupidity the cause. I miss it because I was making a series of impossible experiments—nothing to do with art—just technical photography. I'm trying the same thing with a smaller camera now. So far I have been successful. That is I'm proving to myself that even I can't always achieve the impossible. I was trying to hypnotize some apples in the rain—& on the tree—in [to] keeping still for 50 seconds.—The apples seemed very human-like—they would move in spite of that intent gaze of mine, intensity keyed up to 999 degrees of Will.—

—The Sun was peeping in & out of slowly moving cloudlets—flirting with my particular apples—that's why that 1° turned achievement into total failure. And so it goes these days with nearly every-

Alfred Stieglitz, Apples and Gable, Lake George, *1922. Stieglitz wrote of his frustration in photographing this subject in his letter of 7 August 1922.* (Alfred Stieglitz Collection, Art Institute of Chicago.)

thing—that *one* degree—& the Sun flirting behind tiny cloudlets.—I wonder if Lloyd George[1] knows all that.—And poor Oliver Herford & all the other wise men trying to solve the problems of today—& yesterday.—

I've been reading Clive Bell's "Since Cézanne," short essays published in magazines during the last few years. I had seen them but in book form they make amusing reading.—Easy reading.—And he says some very good things.—It's not a heavyweight affair but worthwhile nevertheless.

—Bluemner, [Thomas Hart] Benton, [Thomas] Craven & others (not as many yet as I hope for eventually) have sent in their bits on Photography [for *MSS*].—It's going to be a real amusing affair. Did I write you that [Gertrude] Stein had sent in? Really a very fine thing. Very simple. And gentle. —[Hutchins] Hapgood sent something about me. Very fine of its kind. . . .

Georgia joins me in sending very hearty greetings to both of you.—

<div style="text-align:right">

Your old
Stieglitz

</div>

I hope both of you are more productive than we.

1. The colorful British Prime Minister David Lloyd George (1863–1945) was besieged with difficulties that led to his resignation in the autumn of this year.

<div style="text-align:right">

[New York City]
[Probably 21 August 1922]

</div>

Dear Stieglitz

This is a very fine clear-cut day and life seems to be getting more that way for both of us.

Reds has been painting and I have been "not sparing myself" on illustrations. It has been our best month so far—plenty of work and some ahead. Am trying to make September a painting month, if possible. . . .

Davidson spent the day with us Saturday and we were glad to hear of you all. He certainly leaves something very fine with one. He and Elizabeth are taking us to a Hindu restaurant tonight for dinner. . . .

Herford's article is not yet finished. He spends his time getting more

and more material, and now says that there is a light side of it that interests him very much that he may go in for.

Gave him "The Little Review." He would like to write on Photography for "MSS" if you care to send him one of those notices.

He did a terror of a cartoon on Hearst in last week's "Life" which is a hopeful sign that he is fighting with something anyway. I am not so sure that it is Hearst.

Mother is still hopeless. Am writing today in a last effort to make her see things more clearly. It takes so much energy that might be used otherwise. Suppose it is the same desire you speak of to achieve the impossible, that keeps me trying to make the blind see.

Mrs. Torr, Reds' mother, has written us some very nice letters lately after talks with a very pro us sister.[1]

—There are still goings on in Westport proper, which is still at war with Westport improper, and Westport is not the only place.

"Only fooling" station husbands spoils the tires.

Many innings make a bad, bad game.

Where "red and green tablecloths are expensively boring."

Out in the open is not "under the rose."—

On a porch where two or three are gathered together there is no screen, and seeing through a glass dimly might make a magazine.

Sherwood is there.

Our best to you both

As Ever
Dove

1. Reds's younger sister, Mary (later married to journalist George Rehm), who saw them often.

Lake George
30 August 1922

Dear Dove: Your letter certainly sounded full of life. . . . I often think of your work.—And it always gives me pleasure thinking of it. You know there are but very few artists in this country whose work means anything to me. It is all too still-born—& "ART." Yours, & Marin's, & Georgia's is never that.

—As for your mother & her feeling about you don't forget it is *impossible* for her to change, just as *impossible* as it is for you to change.

She has moments of seeing hazily—& moments in which she actually *wants* to see.—But—but—The eternal conflict.—And few work out of it. If they do, it is one of the miracles. . . .

Georgia is pastelling just at present. She's certainly most at home in that medium. That is, is most free to put down just what she wants to. She's feeling fine. I did a new portrait of her a day or so ago. The first this summer. It promises to be an addition. I never quite know until the print has been made. That because of the treachery of the papers nowadays. Formerly, before war times, I had some inkling at least where I was at in that respect.—I am also experimenting with small prints, doing all kinds of foolish bits—pictorial many. Merely pictorial—but experiments (exercises).—Always learning. And always with a grin. Rarely swear any more at failures due to causes outside of myself. Still I did swear the other day, lost a wonderful sky picture—& because of my own laxity.—Had a whole day of mishaps—bad emulsions, leaking darkroom—gritty water—electric light turned off without warning—& other trifles like that.—

"MSS" (Photography Number) continues to take form. We are still waiting for Anderson & [Leo] Ornstein.[1] Had Strand write to Herford.—It would be fine to have his say. . . .

There's no news. And just as little gossip.—We both send our "Bestest" to both of you. I'll be curious to see what the Lady has done!

<div style="text-align:right">

Your old
Stieglitz

</div>

1. Leo Ornstein (b. 1895), an American composer.

<div style="text-align:right">

Lake George
15 September 1922

</div>

Dear Dove:

. . . . Georgia is eagerly awaiting the advent of autumn color.—Yesterday she painted a fine apple.—Really good.—

My photography is not progressing very fast these days.—But I don't mind.—There is much to weigh mentally.—That will eventually show in the work & in other ways.

Strand's wife is up here, and she is real good fun. Certainly a live young one. Peace in the house continues. And the house is full up.—In about two weeks the family goes to town. And then our *real* season begins. At least that is our hope.—A few more contributions for

"MSS" have come in. And Sherwood Anderson writes he is busy on his little piece. Georgia has had a terrible time with hers. Is still to "polish" it.—Marin too is struggling.

Have you heard that James Rosenberg & Florence Cane's father are to open an Art Gallery on Madison Avenue—opening soon.—!!—To further art—international—& help the artist!! Soul-savers.—Ye gods.—

Friday Night
21 September [1922]

I ran across this. Had imagined it finished & mailed. That will give you an idea of the state up here—a full house. Bad weather until yesterday. Georgia not quite well. Colds abounding.—I very active—furnacing, printing, photographing, all with excessive energy. I seem always about in form towards the end of the season. Whether I have done much of value I don't know. But I feel I have learned much—& perhaps I have an unusual print or more. Georgia has painted small canvases. Some very good. Not many paintings. Autumn colors are just about commencing. In a week the family leaves.—Strand's wife will be with G. & me for a week or so. She's a lively girl & nice to have about. She knows how to laugh.—

—I suppose you have seen "Vanity Fair"—Rosenfeld on Georgia.[1]— Wonder what you think about it.—Some day soon I'd like to see you in those pages. *Faute de mieux!* . . .

Georgia joins me in greetings to you & the Lady.

Your old friend
St.

1. Paul Rosenfeld, "The Younger Generation and Its Critics," *Vanity Fair* 19 (September 1922): 53, 84, and 106. The piece is actually a theoretical one, and O'Keeffe is mentioned only briefly.

Reliance Boat Co.
207 St. West
N.Y. City
[Late September 1922]

Dear Stieglitz.

Your letter and Davidson arrived simultaneously. We all enjoyed it.

So many things are happening this month or I should have written you before. It has been continually on my mind.

I know you would like to hear that it had been a month of painting.— Well, some has been done, and we have a fine batch of 3-ply wooden panels all coated and ready.—Painted all the morning yesterday and did a "Life" drawing in the afternoon, besides having a delightful talk with a friend of yours—Dr. Bakelund (spelling?).[1] You will probably know, invented Velox paper etc. He has a boat near us here. He seemed to light up with joy when you were mentioned. Of course I liked him. . . .

The house in Westport is sold I hear. Billy has had an operation also of which I was not informed. Tonsils. He is all right now.—"Mrs. D." has a beau and ring, I believe. So hope things are clearing up.—Am not banking on that however. . . .

I learned through Florence Cane that the painting (large one) Alfy gave me has been sold to Mrs. Baer. Rather amazing isn't it? Paintings, personal gifts, easel, Ford, tools, everything of mine.—Just as well.—

The "Camera Work," I had put away and have sent for it. I brought with me from W[estport] in March all of your letters, which I had saved, so have those here. This thing has become quite a matter of politics now out there.—There is a cleavage.—Tradespeople so far are fine to me.—Have plenty of work in N.Y.

We have just read Herford's article, which he asked me to do. Did not see him yesterday when I returned it, so the painful duty of telling him what I thought of it is postponed. He is to send it to you, he said. It is terrible. He is sore and sick, so it has no humour. The editor of the "L.H.J." [Ladies' Home Journal] told him it was over people's heads. It is just too complicated. He rails about artists who write about art, and there is the article.

He has an article in mind. . . . A wholesale attack on the art dealers. He seemed anxious to get material from you on the subject.

Am glad you are both working and your letter shows more joy in spite of everything—

You asked about the O.K. article in "Vanity Fair."—It seemed to me too much from the outside in and not enough from the inside out.—

We met Hodge [Kirnon][2] with his little girl on the trolley here at 207 St. He was just as fine as ever, and is evidently keeping in touch with everything that is going on. . . .

Reds is looking fine—and working again. We have been very happy despite all the other things.

Did you read the article in same "Vanity Fair" by Nancy Boyd on friends?[3] Your idea of friends.—

Hope to paint more from now on. Will let you know how things are going.

Davidson seems to think they are going to disgust me so out there that I will just move on. Billy perhaps home with my mother. Perhaps I have more patience than he realizes—perhaps less than I think.

Have just paid more on debts and have them under control now so that if they do not all come at once I can take care of it.

Will be glad when it is clear again.

Our best to both of you.

As ever

Dove

1. Leo Hendrik Baekeland (1863–1944), a Belgian-born chemist, was the inventor of Velox paper, which revolutionized the production of photographic printing paper in the 1890s, and of Bakelite, the first commercially successful plastic.
2. Hodge Kirnon had been the elevator operator at 291 Fifth Avenue.
3. Nancy Boyd, "No Bigger Than a Man's Hand," *Vanity Fair* 19 (September 1922): 48. This is a humorous "domestic melodrama."

Lake George

24 October 1922

Dear Dove: You have heard about my flying visit to town. Its cause, etc. I did hope to get a glimpse of you. But notwithstanding only 13 hours in bed out of the 96, I was under fullest pressure all the time. Couldn't squeeze in another thing. I knew you'd understand.—One thing after the other turned up I didn't "expect." Amongst them Herford with a rush (important) request. I managed to let him have the things he wanted. Hope the "Ladies' H. J." finally was satisfied.—I was up in the "Life" office & delivered the prints myself. It was the quickest way.—I haven't seen the article. I suppose you've seen [Sherwood] Anderson in "The New Republic" on Alfred Stieglitz.[1] I think it unusually fine. Naturally I'm amused (& tickled) to be the other pole to Henry Ford.—

The meeting with Child Bayley[2] was extraordinary. Real men are scarce in the U.S. Bayley is a Man.—

—"MSS" is getting on beautifully. It will be a great issue.

—You are undoubtedly still disentangling.—That will be part of your job for quite some time to come. Gradually you will become more &

more amused at the imbecility of the average person. Or rather of their entire absence of a sense of humor.—

—Of course the Lady (not your "official" wife) is the one who suffers most & can only gradually become accustomed to her "false" position.—The injustice of the situation is what she must accustom herself to—& will.—It's a gradual process. And rightly so.—

—O'K is very busy painting. And cooking too. I am playing about much.—Both feeling fit. If the gods be willing we'll remain here until Nov. 15 at least. A few days of town were sufficient for a while. I *started* quite a few things.

Our heartiest to both of you—we are due for a walk—to breathe some air.—

Your friend
Stieglitz

1. Sherwood Anderson, "Alfred Stieglitz," *The New Republic* 32 (25 October 1922): 215–17. Anderson saw Henry Ford as the progenitor of a mechanical age that suppresses the spirit of man. He found a contrasting type in Stieglitz, who fought "to make machinery the tool and not the master of man" (p. 217).
2. Roger Child Bayley (1869–1934) was an English writer on photography and editor of photographic periodicals.

Because Stieglitz and Dove were both in New York during the winter of 1922–23, there are no letters from these months. Besides illustrating for magazines, Dove finished his drawings for Ellis Parker Butler's *Jibby Jones; A Story of Mississippi River Adventure for Boys,* which was published in 1923. A sequel to this popular book, *Jibby Jones and the Alligator,* also with illustrations by Dove, appeared the following year. Both Stieglitz and O'Keeffe held exhibitions of their work at the Anderson Galleries during the season, and Stieglitz organized another Marin show at the Montross Gallery. Stieglitz's own show comprised 116 prints from 1918 to 1923. A group of cloud prints collectively titled *Music—A Sequence of Ten Cloud Photographs* forecast his famous *Equivalents,* a cloud series that eventually numbered about four hundred small images, mostly four-by-five inches, taken during the next fifteen years.

During the summer of 1922, Stieglitz's daughter Kitty had been married to Milton Stearns, Jr., of Boston. After the birth of a child in the early summer of 1923, she succumbed to unanticipated severe depression and had to be hospitalized for the rest of her life. Although

Stieglitz—who never saw her again—was so crushed that he rarely mentioned her, he alluded to the painful news in his next letter to Dove.

Lake George
18 July 1923

Dear Dove: In a way it seems incredibly long since we came away from New York. And yet it's a day over four weeks. Not so long.—Not that we miss town. On the contrary it seems nonexistent. Except for a few people there that mean something to us the city becomes less & less of ourselves.

—I heard from Rosenfeld yesterday. In the letter he tells me that he has finally started the chapter on you [for *Port of New York*].—I'm very glad. He likes you. He likes your work. And I feel it as most important that you finally appear properly in print.—It's time. And you deserve that "people" know more about you than you [they?] do. You are one of the few painters really counting as painters—as men.—I know that. And it is not because of partiality of any kind I say it. Oddly enough but a few hours before Rosenfeld's letter came I had hauled out proofs of the new negatives I made of you. I wonder what you'd think of them. Too bad you moved in the most interesting. I have a profile which is ghastly in a way—but which I consider an "addition." Whether it has anything to do with you or not I don't know. I'm in an impossible condition.— There is a full face might be used for the book. The first shot we made with your painting as "background." It just misses fire. Is photographically very fine. Well, I'll get to printing soon—I hope—& you are to come first.—

—I have done nothing so far but tried to put myself physically & psychically in halfway decent working shape. Georgia is finally painting. My condition naturally affects her greatly. And that worries me even though I know it would be unnatural were it different.

—On the day we came away I got a staggering telephone message from my brother the Dr.[1]—When I had put the three exhibitions on the map during the "season" & had done a great deal of hard work otherwise trying to help people who came to me for help—meaning giving myself—time & thought—much—why I looked forward to the summer feeling I'd be able to work real quietly for the first time in years. Right after Marin's Show trouble set in—from right & left—& from every other direction—& I was physically much lower than anyone but myself knew.—And so until the last moment there was less & less rest in

sight—when out of the clear sky came the message. And with it other "messages" enough to knock the pins from under anyone. So I came up here more dead than alive. Actually dazed for weeks. If I had a mind to lose—I guess it would have gone for good.

—On top of all my feet gave way. So I was forced to sit & finally look after them. They are on the mend. Neglect on my part. And the darned arm still bothers. And eyes raising hell. Still I read. Have been reading & rereading the "Autobiography" of John Stuart Mill. Full of meat— solid stuff. Marvellously clear thinking & writing. Much fitting into my own condition.—Digging into roots without sentimental twaddle spoken or unspoken.—And I have read some other things less important to me. . . .

—I don't seem to have an idea in my head. And am still too tired to feel.—

Marin has arrived in Stonington [Maine], car & family.—Had a beautiful letter from Anderson—truly a Soul. You & Reds are naturally frequently in my mind. I had hoped that G. & I could have come up to the boat. But there was no sense in trying to drag myself there just because I really wanted to go.—

—I wonder are you painting.—Reds I suppose is working.—And I wonder how are affairs.—I do hope not more trying although they must be trying for a while yet.—That's because you can't be but you.— That's the damnable part about it all—& "others" less sensitive "trade" on that fact. They know. It's what makes it all so rotten.—

—It's very quiet here.—Marie [Rapp Boursault] & her two-year-old kid—the livest proposition imaginable—& Marie's husband on vacation—are here. For me the place abounds with ghosts—the past—the present. It's fifty years here. It's 40 years photographing!—Anniversaries.—

—We all send our heartiest greetings—to you & to Reds—

<div style="text-align: right">ever your friend
Stieglitz</div>

1. Leopold Stieglitz. Presumably, his message had to do with the onset of Kitty's illness, postpartum dementia praecox.

In November 1922 Dove had bought a sailboat, the *Mona,* on which he and Reds then lived year round. Through the 1922–23 winter, they remained moored at the upper Manhattan marina where they had been

Mona, *Long Island Sound, 1920s. Dove and Reds lived on this boat for several years in the 1920s.* (William C. Dove, Mattituck, New York.)

living on the houseboat. The following summer, after much labor, the boat was ready for excursions.

[New York City]
[Mid-August 1923]

Dear Stieglitz

Well, things are progressing. We have just finished the boat and are to make our trial trip this morning. Thought I would drop you a line to let you know that I would write later. It was fine to get your letter. And feel the sunlight getting at you in spite of all you have been going through. We have kept in pretty close touch with you although there has been no time to write letters. Having work done on a boat and doing most of it yourself means that we have had to keep up a terrific pace—but we are under the wire on this first lap and going strong. Did all the wiring, gas connections, etc. on the engine myself and it ran as soon as we turned it over—am not betting on it however.—

It is fine that things are coming on so well with Kitty.[1] Her husband must be a very fine person from what I gather through Davidson and

the others. We may take the boat to Mamaroneck harbor next week for a day or two.

We had lunch with Rosenfeld, talked mostly of his book. Sherwood Anderson's address is 33 Liberty St., Reno.[2] Seligmann came up. Read his article, which seemed just about the right thing to be done in that place at this time.

If we can find time to do all the things we have done and make a living, am quite sure now that they are done that we can do some painting in a few weeks.

Am glad O'Keeffe is working.

The Strands were here. Hope they did not take our difficulties too seriously.

Reds is fine and we both send our best to both of you.

<div style="text-align: right">

As ever
Dove

</div>

1. She temporarily appeared to be improving.
2. Anderson was living in Reno long enough to obtain a divorce from his second wife, Tennessee Mitchell.

<div style="text-align: right">

Lake George
29 September 1923

</div>

Dear Dove: I was surprised that your photograph for the Mather book[1] wasn't in his hands long ago. Several months ago the request came to you care of me & I forwarded the letter to you. I assumed you'd attend to the matter at once.—

—You probably overlooked it—or something went wrong.—At any rate you must be in the book. . . . In the Spring I wanted to have some of your things photographed but the "messiness" was so great that many things I wanted to do—felt the need to do for practical purposes—I did not do. My vitality had been so much sapped.—I was at the breaking point for a long time.—

—Georgia was in Maine for 3 weeks & has just returned in much improved condition. You'll see my prints in time. They are my history. The "history" of many today. . . .

Rosenfeld is doing finely. He is maturing rapidly. . . .

I'm in "fighting" shape once more.—There is much work to be done.

I've had a rare pleasure, D. H. Lawrence's book, "Studies in [Classic]

American Literature."[2] Read it.—You'll have a great time. So will Reds.—I wrote to Lawrence & I've heard from him. An amazing person.

—All send "bestest" to you both.

<div align="right">Your old friend
A.S.</div>

1. Frank Jewett Mather, Jr., was already working on a book that did not appear until four years later: F. J. Mather, C. R. Morey, and W. J. Henderson, *The American Spirit in Art* (New Haven: Yale University Press, 1927). (See Glossary of Names.)
2. Recently published by Thomas Seltzer.

<div align="right">New York
7 October 1923</div>

Dear Stieglitz,

One morning about four o'clock, it occurred to me that it would be interesting to write down all the experiments in painting that I have made, and to publish them in book form illustrated with the specific paintings.[1] Concrete examples might be a more direct way of making people see. At eight o'clock I went into the office and they had just bought a new typewriter, offering me the old one for $4.

Mr. McKee who is arranging the paintings for Prof. Mather had told me that there would be plenty of time to get that photograph of the painting in, so I had used all the available time making money enough to keep out of jail. I went to see him the other day and there is still plenty of time to put in one of the O'Keeffes if you care to. He is writing Prof. Mather who is in Europe suggesting that he use more of the moderns.

I took the liberty of showing him the O'Keeffe, Marin, and Hartley photographs that Herford had given me that morning. He picked the "Lake George" of O'Keeffe's as one he would like to use. Marin was on his list, but the one he spoke of was an early Paris one. They are interested in "Abstractions" as he felt they had come to stay. . . .

We have about decided to take this month to paint in on Long Island Sound rather than try to get South for the winter. There might be more trouble with the engine, as we have had it all summer, with a long walk to New York between us and any means of paying for it. At any rate we have something that moves if any necessity arises for using it.

Georgia O'Keeffe, Abstraction. *Dove purchased this painting in the early 1920s.*
(Private collection.)

The O'Keeffe painting looks better than ever, especially in the boat here by the light of our lantern.

Reds is painting again after our strenuous summer and I hope to get at it now in a few days.

Have not had a spare moment to get Lawrence's book, but am looking forward to it. . . .

Have heard from Strand and the Davidsons so keep in pretty close touch with you. Our best to both of you, and Rosenfeld, if he is still there. What do you think of my book idea? Perhaps it would be better for me to paint about some of these "writings" than to write any more about paintings? The evenings are longer now, we may find time.

<div align="right">As ever
Dove</div>

1. Dove never actually did any serious work on such a project.

<div align="right">Lake George
9 October 1923</div>

Dear Dove: Great. You must do the book. Just the thing needed. And *you* are the one who *can* do it. I see no one else. It is essential. There will be many books—good, bad, & worse on Modern Art shortly. None will help bring about the clarity yours would. In Europe, Metzinger, Gleizes, Picabia,[1]—other artists write to enlighten—why not here? Hartley doesn't, Marin doesn't, not in the way you can. So get busy. For quite a while I had been hoping for just that to happen. It does not need to be a big book.—

A publisher can readily be found. The typewriter is in your possession at no great sacrifice. You'll have evenings free—undisturbed—in sympathetic surroundings.—So begin soon. Of course I want you to paint more than to write—for myself—but for all concerned, including yourself & myself & everybody—the writing now is essential.

—I have written to McKee & made suggestions as per your suggestions. Mather is too far away.—All you've done meets with my approval. Our spirit is the same. You can never be far off. . . .

—Georgia & I are alone now. She painting with pleasure. I fussing away at little prints. There are some to make you smile with satisfaction. I have really gone myself one "better."—From within without

choice—life compelling.—Rosenfeld left looking very fit. His stay here was very complete for all. He is growing rapidly.—

—I'd like to see what Reds is doing.—Perhaps we'll see this year.— There are no plans. The weather continues incredibly perfect.—

Georgia joins me in more than hearty greetings to both of you.—

<div align="right">

Your old
A.S.

</div>

1. French Cubist painters Jean Metzinger (1883–1956) and Albert Gleizes (1881–1953) coauthored the first book on Cubist theory, *Du cubisme* (Paris: Figuière, 1912). Picabia's explanations of modern art had appeared in periodicals, including *Camera Work*.

Alfred Stieglitz, Equivalent, *1923. This is an early photograph from the cloud series that engaged Stieglitz for many years.* (Alfred Stieglitz Collection, Art Institute of Chicago.)

24 October 1923

Dear Stieglitz

It is now 3:45 A.M. in the midst of a terrific gale and we are anchored in the middle of Manhasset Bay held by a 3/4 inch line run through a shackle to a mooring. We have been fairly pounding the bottom out of the boat for 24 hours and just hoping that line will have the decency not to cut through. Sheets of rain drive across the cabin roof and we are taking turns at watch and nursing a light fire in our stove until morning on a small pail of charcoal. Life has seemed this way for the last month. So full of contrasts that even they become somewhat monotonous. We think we would like a little rest for a few days—by that I mean a chance to paint.

We left Thursday at 7 A.M. and by the time we were well out in the Hudson that storm which you may have read of overtook us and we could not make headway against it and the tide so went with it until we made it behind the lighthouse at Ft. Washington, 172 St. Pounded there all day & night and rewired the engine to be sure there was no leakage. Needed full power to get round the Battery the next day. Well, we made it, but felt a trifle as though we were creeping through 42 St. on a kiddie car. This boat is no speed demon. The ferrys, tug boats, etc. were very considerate.—Hardly noticed our efforts to keep out of their way. They make about 15 miles an hour so suppose our four didn't seem so important to them as it did to us. The engine held until we were in the East River at Brooklyn Bridge. After two hours of being hurled against a canal boat in a slip where we tied, found the trouble in a water valve that had stuck and heated up the cylinders. Also climbed the mast, fixed loose rigging and a bobstay under the boat that had broken.—We made time in Hell Gate as the current runs at about 5 miles and things fairly flew by. We made the Sound and this bay just as things started up again. The man at the gas station evidently thought we had been through the mill and came over in his motorboat to offer us a mooring instead of our anchor. I see a radio out there so guess he had had storm warnings. One of the nicest human beings we have seen so far. Standard Oil at that.

. . . . We have been able to catch two fish each afternoon just before dinner so our food is not expensive. I don't see much else that can happen to us unless this rope breaks.—

Have been trying to memorize this storm all day so that I can paint it. Storm green and storm grey. It has been too dark and nerve stained to paint, so did three illustrations this morning just to keep from cutting that rope through by thinking so hard about it.

Was afraid Reds might not be able to stand the rough seas. She has been a wonder. Really has done the work of a sailor. This unity of interest is marvelous, so we are very happy.

Will probably stay here and work until weather is fit to go back.

. . . . They [Florence Dove and her partner] are clearing over $1000 a month at their inn [Manor House] in Westport so am still hoping for the miracle to happen. —

Had Chinese dinner with the Strands and wondered how you could be so thoughtful with such a summer as you must have had. They both look much better.

Suppose the Davidsons are a bit worried about us as I called them up just before we started.

The storm seems to be letting up a little. I hope it will stay that way. . . .

Our very best to you both

As ever
Dove

Morning.

Storm breaks and we have just been able to get another rope through the mooring and the coal boat has promised us coal today. What a relief. We find that we can worry just about so long over dangers and then something stops you from overdoing it.

Dove

Lake George
3 November 1923

Dear Dove: We are super busy—I even more than Georgia.—That's one reason your fine letter from the storm-tossed boat hasn't been acknowledged sooner. . . . It happened that Georgia & I walked to the P.O. (1¼ [miles] away from the Hill) & the Sky was black & the Lake black & near the horizon southward there was a dirty yellowish cloud.— Georgia said she didn't like the feeling—I thought it wonderful.—It looked as if the Day of Judgment had come—and there wasn't a breath of air—but it was cold. The Lake looked particularly forbidding. I had never seen it that way. Well, it was during this sort of "Light" I read your letter at the P.O.—a perfect setting for what I was reading. . . .

I suppose you've heard that by June 1st, 1924 there'll be no 60 E. 65.[1] And as for the Hill I don't know its future. But I'm not worrying.

There is too much to do—too much to enjoy.—Every day is a life in itself—as a matter of fact every hour has become that—moments each possessing their eternity. . . .

Georgia's sister Ida is here for a week or so. The nurse. She is quite a wonder. So healthy—so able—cooks well, and knows how to laugh.— They are out walking now after a hard day's work. I made a lot of half-successful prints—Some negatives are giving me endless trouble. Old negatives. The Boston Museum is to have 10–12 of my prints & I want them to be AA1.—Marin's portrait is giving me endless trouble.

—I sometimes don't know where my head is working so concentratedly.—Light these days is bad. And my poor hands between acids & freezing waters!—

But the "job" is on—I know I won't get much chance, if any, to do anything of my own in New York this winter.—Getting ready to wind up much—& the usual getting pictures amoving—that is, getting people half awake. Oh New York.—I don't look forward to the grind there. But there's no escape. It is the contact.—Of course I am looking forward to seeing you & a few others.—

—Georgia joins me in all sorts of hearty wishes & greetings for & to you & Reds.

<div align="right">Your old
Stieglitz</div>

1. The address of his brother Leopold, who sold his house. Stieglitz and O'Keeffe had been living there since the fall of 1920.

Early in 1924, Stieglitz organized a third Marin show at the Montross Gallery. Soon after, he and O'Keeffe opened a simultaneous exhibition at the Anderson Galleries. Stieglitz showed sixty-one photographs, most taken within the previous year and including *Equivalents* for the first time. During this winter, expressions of public recognition came to the photographer. He was awarded a Progress Medal by the Royal Photographic Society of Great Britain, but a second honor held more meaningful implications for the future of photography: the Museum of Fine Arts in Boston accessioned Stieglitz's gift of twenty-seven prints. This acquisition of photographic prints, arranged by Ananda Coomaraswamy of the museum's staff, was the first by a major American museum.

Meanwhile, Dove produced more during 1924 than he had for years.

Arthur Dove, Alfred Stieglitz (Portrait), *1924. Assemblage of lens, photographic plate, clock and watch springs, and steel wool on plywood. This work, exhibited in the* Seven Americans *show of 1925 at the Anderson Galleries, exemplifies the artist's witty approach to materials in his assembled works of the 1920s. It was not purchased during Dove's lifetime. (Museum of Modern Art, New York.)*

He took fourteen finished paintings to Stieglitz in April and fifteen more shortly after the beginning of the next season.

<div align="right">

[New York City]
19 February 1924

</div>

Dear Stieglitz

Have been trying to get in to see you for the past week but have been working out the intricacies of laying silver leaf on frames and waiting for a painting I have redone to dry.

Am enclosing $50 of the $100 I owe you on the O'Keeffe painting which looks just as fine as ever. Hope I can get the rest to you early next month.

Have had Bluemner on my mind a lot lately and would like to get one of his next, after this one is paid for. The things we have here on the boat must necessarily be about the size of the O.K.

Have had to do my frames over several times as it is hard to handle so many things in such small quarters. Have two or three that I think you will like, if I can only get them down there before they get ruined.

Our best to you both.

<div align="right">

As Ever
Dove

</div>

<div align="right">

[New York City]
21 February 1924

</div>

Dear Dove: Montross ill. That means I have been in charge of Marin at 550 [Madison Avenue]! Once more 291 on deck. Very amusing the happening there. The Show greatly interesting.—Georgia's & my Catalogues are on the press! With new colds . . . & the shows, we have been none too idle.

—It was good to hear that your paintings are coming along. I have heard all sorts of "rumors"—I hear & don't much listen for I see with my own eyes. So I'm ready whenever you are. Of course I am delighted that the seeing is not far off. The months are slipping by. It might frighten an old gent like myself. But somehow I don't seem to frighten much.—But it does seem queer to feel some real changes coming along like tidal waves & yet go on as if nothing were happening but the usual.

Maybe it's stupid, for one may get one's head battered in consider-

ably.—In the meantime there is no choice. Because one lives in fooldom doesn't mean one is foolproof. . . .

Thanks for the check for Georgia.—I know the little painting is true to itself—& that means to time too.—I'm glad you have it. . . .

Our love to you both

<div align="right">

As ever your friend
St.

</div>

<div align="right">

Lake George
23 June 1924

</div>

Dear Dove: You & Reds have been in my mind all along. And I have been wanting to drop you a line. But in the beginning I was so down & out that there was no use writing.—But I'm once more human—or approaching the state.—The Hill—in spite of the closed barn door—& the heroic Chestnut Tree being completely dead—& the grapevines dying too—(everywhere up here they say)—& the dying pine trees— well, the Hill remains the Hill. It is very quiet. And in a way very different. Georgia is in her element. She is boss. And she is happy. And paints diligently. And cooks sufficiently to keep us from starving.[1] And there is a man comes occasionally at 50 cents an hour to help put in ice—we between us are not strong enough—& to fix the dock & do odds & ends. A real person with blue eyes—all sinew—57 years old—a worker—talks little. But was not born up here. And he has a wife who comes once a week & helps & laundries. She equals her man in working capacity. Two wonders & so modest. A relief to find such people. A dying race I fear. No children.

—I've been reading a lot for me. A proof positive that I'm in a very non-creative state myself which may be good.—I've read Brandes's "Voltaire," 2 vols. in German. A great book. Amazing in a way. I'm glad I read it. I'm busy on another German book, Count Keyserling's "Diary of a Travelling Philosopher."[2] Deals with the Orient—a good contrast to Voltaire.—

Then as third in the trinity there is Joyce's "Ulysses."[3]

—I feel about ready to photograph. Anything. Something. I wonder what it will be.

—And I have been thinking of your work. And the coming winter. I am certainly desirous of presenting it somehow. . . . I don't feel that Marin, Georgia or I should show this year. Even if we should have

"extraordinarily" (!) good work ready.—But I'm "*fixing*" nothing in my mind. Everything is much in a state of flux as far as I am concerned.— I hope your mother continues to see a little light—above all for the satisfaction of knowing that Light eventually must get in everywhere.—One sometimes does wonder.—In reading about the 18th Century (Voltaire) & thinking about today one wonders what has changed in the inner man. Isn't the human heart much the same as then—in those "terrible" times.—I'm just about to read two little books, "Science & the Future" by J. B. S. Haldane, & "The Future of Science" by Bertrand Russell.—"Daedalus" & "Icarus" are the titles.[4] They are being much discussed. . . . There is the meal call.

So good night. Georgia joins me in sending Reds & you heartiest of greetings. The Hill is there anytime you should decide to come. The Davidsons have booked themselves for the last two weeks in July.—

Ever your old
Stieglitz

1. Here and in subsequent correspondence of this summer, Stieglitz's letters do not tell the whole story. Soon—in early July—O'Keeffe went "on strike against housekeeping" (Lowe, *Stieglitz,* 267) to protest the stream of visitors and lost enough weight to frighten the overanxious Stieglitz. He arranged for his mother's former maid to be installed as cook and pressed the Davidsons to come earlier than originally planned to lift her spirits. See Lowe, *Stieglitz,* 267.
2. Hermann Alexander Keyserling (1880–1946) was a German philosopher popular in the years after World War I. Stieglitz was reading his best-known work, *Das Reisetagebuch eines Philosophen* of 1919 (published in English as *The Travel Diary of a Philosopher* in 1925).
3. Published in 1922.
4. Bertrand Russell, *Icarus: The Future of Science* (London: K. Paul, Trench, Trubner, 1924); J. B. S. Haldane, *Daedalus; or, Science and the Future* (New York: E. P. Dutton, 1924).

In the summer of 1924, Dove and Reds sailed *Mona* to the north shore of Long Island, where they found a permanent mooring at Halesite. Until 1933, except for one winter, they stayed in this small community on a narrow inlet upstream from Lloyd Harbor. Huntington, a mile and a half away, was the nearest center for shopping and services. There, Dove and Reds caught the train when they made the thirty-four-mile trip into midtown Manhattan.

[Halesite]
30 July [1924]

Dear People,

. . . . Have been using every minute to get fixed up and make our voyage. Both your letters were amazingly calm and beautiful as were the photographs. All the same spirit. Hope to use a good part of August painting.

It is beautiful here and so clean—Lloyd's Harbor—upstream.

With love to you all

As Ever
Reds and Dove

Lake George
3 August 1924

Dear Dove & Reds: The Hill is as glorious in its Silence as ever. More so. There have been trying days. Georgia not well. And I up against rotten paper made by Eastman.[1] Am nearly frantic. Someone at the Kodak Monopoly ought to be murdered.—I was prepared to do a thousand prints—I have no idea what will now happen. And the days are fast slipping away. Great days for work. Yes, murder as self-defense!—I wish there were "Camera Work." It's time to raise hell in many fields.—I feel like one chained & not quite powerful enough physically to snap the damned chains, for I'm sure they are as rotten as the paper—American manufacture!!—

[Carl] Zigrosser[2] has just put [in an] appearance. Is already busy with G. getting beans ready for dinner. He'll stay a night.

It was great to have the Davidsons here. . . . Peggy is a wonder. And Davidson fits here. The Hill is made for him. And E. is always E.—on the job quietly.—

. . . . This is primarily a Greeting from a Perfect Day.

Your old
Stieglitz

1. George Eastman (1854–1932), founder of Eastman Kodak, which Stieglitz held responsible for the disappearance of the subtle photographic paper he had used in his youth and its replacement by slicker commercial stock.
2. Carl Zigrosser (1891–1975) was director of the Weyhe Gallery from 1919 to

1940. After that, he was on the staff of the Philadelphia Museum until 1963. He was the author of many books, most of which deal with some aspect of the graphic arts, in which he specialized. According to Stieglitz, Zigrosser was the agent of salvation in both cases when Stieglitz threatened to jettison important personal collections—one of books on photography, the second of prints by other photographers. Both collections were accepted by the Metropolitan Museum of Art. See Norman, *Alfred Stieglitz*, 235–36 for a full account.

<div align="right">

Lake George
6 August 1924

</div>

Dear Dove & Reds: The Hill continues to be very wonderful to me in spite of its "personal" ups & downs. For a while Georgia worried me much. She was losing weight horribly. The Davidsons set her on the upgrade.—And I am grateful for every pound she gains. And for every moment of real peace we all receive.—

G. is painting again. To have the D.'s here was a treat. . . . I am mounting some few new & old prints. A few very fine ones. But relatively the 1924 crop is decidedly short. Somehow time slips away and so little achieved. It does give one (or me) the ache. . . .

<div align="right">

Your old
Stieglitz

</div>

I suppose you know [John] Quinn[1] is dead. Maybe his collection of paintings will be sold in N.Y. so Kennerley writes.—

1. John Quinn, a banking lawyer, was the most important American collector of European and American modern art up to the time of his death. Sales of his collection were held in 1926 and 1927. See Aline B. Saarinen, *The Proud Possessors* (1958; reprint, New York: Random House [Vintage], 1968), 206–37.

<div align="right">

[Halesite]
[15 August 1924]

</div>

Dear Stieglitz and Georgia

Your letters have been fine and encouraging, and I see by the last one that your hair is sticking up straight and you are showing all the signs of a good winter's fight.

The amount of work Reds and I have done on the boat and gathering the wherewithall has been sending us to bed as tired as truck horses, have been at it from six until dark regularly and now and then a storm that on Tuesday gave us our hands full. "It's an ill wind" though and I grabbed one of my best paintings out of it. Reds liked it as well as the "Lantern." The workmanship is certainly better than anything yet, almost "mathematics." Am finding something quite clear. On Tuesday's blow we picked up a 300-pound mooring, an anchor chain and all and started drifting up this narrow harbor. A neighbor helped me put out another 100-pound one that held us until it was over.

Your sky has been really quite wonderful here. It seems as though I could think into those clouds and you would get the thought.

Phoned the Davidsons and they are to bring Peggy over in a few days but we are so far from the post office that we have not been able to communicate. It is a three-mile run in the dingy to market. But that has its compensations in not being called to the phone and few interruptions. Water clean and everything on the boat is white as white paint can make it. . . .

We had a great trip up here. Made them open all eleven of the bridges in the Harlem river and hold up N.Y. traffic to let us through. At least the government did something about modern art for once in its life. Through Hell Gate and then put up sails and had both engines running. Did everything but row. Landed in this harbor 9:30 pitch dark. Found an old tower against the moon and a red lighthouse that showed on the chart. It is beautiful here. Mostly large estates on shore. We are anchored near the Marshall Field place. They have a whole city of men, gamekeepers, architects, trucks, etc. working on the place and 38 houses, I believe, for the owner, his wife and two children. The servants seem very pleasant. Woods full of game and gamekeepers.—That is the beauty of a boat. We can pick any estate we want to live by. And are probably far happier on the outside looking in.

Have been using everything but dynamite on the family now but as usual when trying to make an especial effort about painting, they become more hopeless.

We are going up early this morning to Halesite while the weather is good so am sending this to let you know we are still at it—life I mean.—

If Quinn's things are sold, it ought to stimulate interest. Sherwood Anderson I see has decided to live & work in New Orleans. (Writing an autobiography.)[1] Have you heard from him? . . .

We are planning to work here and then back to N.Y. to fill another sock and perhaps work up the Hudson later. Would like to come as far

as Albany and then to see you all and the hill which you all like so much.

Am trying not to notice that there is such a thing as time but it certainly bobs up now and then.

Love to you both, as ever

<div align="right">from
Reds and Dove</div>

We have met a strange intensely honest man. Was at one time chief engineer on European fleet. A workman. . . . He has a boat at the Reliance Co.[2] Came all the way from N.Y with a large roll of sheetlead and his tools and specially made bolts to fix our centreboard trunk where the boatyard had done it badly. He was thrown through the window in that Long Island wreck, hurt his back, helped in the rescue, was taken back to N.Y., and came right on the next day and did a beautiful job, helping us to haul out at just the right moment of the perigee tide and now we have no leaks.—He was shot through a torpedo tube into the ice in the Harlem River and swam with his clothes in a rubber cloth to see his girl whom he had not seen in two years. Captain had refused shore leave. His present wife is an Am. Indian. They are not very happy together. He seems to be terrifically in love with his first wife who is dead. Is working night & day to try to make his living honestly. He hates the grafting system that N.Y. lives by.

1. This was published as *A Story Teller's Story* (New York: B. W. Heubsch, 1924), dedicated "To Alfred Stieglitz, who has been more than father to so many puzzled, wistful children of the arts in this big, noisy, growing and groping America. . . ."
2. Dove's previous mooring on upper Manhattan.

<div align="center">[Halesite]
[Probably 3 October 1924]</div>

Dear Stieglitz and Georgia

Just to let you know I have corralled five or six more paintings two of which I could guarantee to start a riot in almost any gallery. I am wondering what you will think of them. Have certainly broken through something. They are *awfully* beautiful. . . .

Have decided to stay here in Halesite.

Our studio is a "glass house" about 30 ft. square and 10 ft. high for

which we pay the sum of $25 a year.[1] It would be wonderful as a studio for you. That price by the way includes the use of a car and stove if we want them.

It is wonderful to be painting. Have to do two more drawings and then I hope another month solid of painting. Expect at least 12 new ones before Christmas. One of the new things—don't know what to call them—this is of a woman—was so—well, I don't know what—that Reds said she almost felt jealous of it. From that you can get an idea of what they might be like if it were possible for me to describe them.

Want to do several more before you see them.

We are delighted to have here in the boat opposite the O'Keeffe an absolutely beautiful photograph of Peggy. Have written the Davidsons how we felt about it so will not attempt to say it again.

Our love to you both.

 Reds and Dove

1. They rented it only until the following spring.

 Lake George
 4 October 1924

Dear Dove: We are more than delighted that there are such fine paintings & so many.—I never doubted you'd do great work this year after what you had done in the Spring & last Winter & Autumn. . . .

—Here we are in October—both working like ones possessed. Georgia turned out five paintings this week. She's painting fairly large canvases. She did a marvel today.—September was a marvelous month for us—Ida O'Keeffe, Catherine (my mother's old maid), & we in the house. Each one really a free soul & all in harmony—natural coopera-tion—no words or theories—no tension—much work each in his own way—much laughter.—Ida is a gem—so is Catherine.—I've been busy—printing, printing—printing—over & over—& experimenting. No large negatives. All small. I think there are a few wonders. G. says so. And best of all is Georgia's feeling so much better. Has reached 120 lbs after having been at 110½ on July 4th!—She's living more sensibly—keeps regular hours & sleeps (or is in bed) quite her 9-10 hours. Then too, having Ida & Catherine here has made housekeeping very easy for her.—I keep in touch with the world. Naturally the Winter is in the back of my head But I have no plans—am ready. All I need is that

Alfred Stieglitz, Peggy, *1924. Elizabeth Davidson, Stieglitz's niece, sent this pho-tograph of her daughter to Dove and Reds in August 1924.* (William C. Dove, Mattituck, New York.)

we keep in fair health.—Something is bound to happen with so much fine work ready. . . . Of course there's the Election.—If Coolidge is elected the Winter ought to be "good" in business—should LaFollette upset "calculations" business is in for merry hell. But we go right ahead either way. It's all a question of how & when.—

—I have the advance sheets of Anderson's latest book, "A Story Teller's Story," dedicated to me—a very generous dedication. It's a splendid performance—full of humor & fineness—a great simplicity & loveableness—broad—a living thing. And of today. No "artiness."—

—Rosenfeld was up here for five days after his return from abroad. He has matured greatly. . . .

<div style="text-align: right;">

As ever your old
Stieglitz

</div>

Upon their return to New York, Stieglitz and O'Keeffe were married and moved into a studio apartment at 38 East Fifty-eighth Street. Dove was working productively in the later months of the year in anticipation of a show that would once again give cohesion and public identity to Stieglitz and some of the 291 group. Titled *Seven Americans* and held at the Anderson Galleries in March 1925, the exhibition comprised 159 "paintings, photographs, and things recent and never before publicly shown" by 291-ers Stieglitz, Dove, O'Keeffe, Marin, Hartley, and Strand and one newcomer, Charles Demuth.[1] Dove showed his first group of assemblages, as well as paintings executed during the previous few years. In his next letter, Dove gave Stieglitz his thoughts about the catalogue for the exhibition. After that, he included some down-to-earth information, of the sort that he frequently and unselfconsciously sent to Stieglitz.

1. Demuth had visited 291 but had not exhibited there. After the *Seven Americans* exhibition, he showed his work at Stieglitz's two later galleries. (See Glossary of Names.)

<div style="text-align: right;">

[Halesite]
[January 1925]

</div>

Dear Stieglitz

. . . . There are lots of notes, here, but think the catalogue should be terribly simple.

We cannot show any resentment. The crest of the wave is where the power is. Use it.

Waldo Frank might do it wonderfully but it would be an appeal to the intellectual. People must be led to see for themselves. A few words will do that better than an explanation. The public is the first person we happen to meet and he must have just as good a time with these things as we do.

About customers you will know when the time comes. Zuloaga,[1] the dealers, etc. have too much space already. We can't waste ours. Let's talk about ourselves.—

You know all these things so much better than I do that it seems superfluous to write it except towards a catalogue simplification.—

Am sending for some athletic shirts—Sears Roebuck—which I think are what you want. Cotton 55¢ each. Me too. Guess we'll be able to hold our own for any exhibition.

As Ever
Dove

1. Ignacio Zuloaga y Zarbaleta (1870–1945) was a Spanish figurative painter then popular in the United States.

[New York City]
27 January 1925

Dear Dove: If it weren't for the fact that the newspapers must have "something" to start them I never would dream of any Foreword to this coming Show. As it is I had rejected all sorts of things written—by myself as others—savoring of any resentment—or suggesting anything like Zuloaga, etc.—I had even decided to print: "Our Foreword is: There is no Foreword."—I have decided nothing yet except that the Catalogue must be the simplest kind of affair & that the Public should be given its own chance unguided. And as for Customers—well—So you & I arrived at much the same conclusion.

Rönnebeck is working at a page which may serve a purpose.[1] I don't know. He has been sweating over it for more than a week.

All I know is the Show <u>must</u> be a go. It will be a worthy one. Things are beginning to move.—There is much interest in your work. I'm having a fine time with it. I think there'll be some sales.—There must be.

—Sherwood Anderson has been asking for you. He hasn't seen any

of the work yet. Is very tired from "over-reception."—
Our heartiest to you & Reds.—

<div style="text-align:right">Stieglitz</div>

Later.—It has been a great day. Anderson was at 303. He is going to write something for the Catalogue, offered to. Enjoyed greatly your work & Georgia's. . . . Everything moving along rightly now—assuming form.—Feel much relieved.

1. Rönnebeck's "page" did "serve a purpose" for the *Seven Americans* catalogue.

Dove had sent a poem, "A Way to Look at Things," for the *Seven Americans* catalogue. After slight revisions, it was printed as follows:

A Way to Look at Things

We have not yet made shoes that fit like sand
Nor clothes that fit like water
Nor thoughts that fit like air,
There is much to be done—
Works of nature are abstract,
They do not lean on other things for meaning
The sea-gull is not like the sea
Nor the sun like the moon
The sun draws water from the sea
The clouds are not like either one—
They do not keep one form forever.
That the mountainside looks like a face is accidental.

Stieglitz's next brief letter was written shortly after he received the poem from Dove.

<div style="text-align:right">[New York City]
5 February 1925</div>

Dear Dove: A classic right off the bat. Truly a wonder.—We have "literature" now that will count—a solid front of four strong.[1]—Some photographs have been made so the matter for the Catalogue is nearly

ready for Kennerley.—The Show will be a wonder. May the Stars be favorable!—

Our love to you & Reds.

<div align="right">Stieglitz</div>

1. The printed pamphlet for the *Seven Americans* show had only three "literary" statements: Dove's "classic" and contributions from Sherwood Anderson and Rönnebeck. Four photographs illustrated works by Dove, Marin, O'Keeffe, and Hartley.

<div align="right">[New York City]
22 February 1925</div>

Dear Dove: I hope you are keeping in mind that on the Evening & Night of March 8th & on Sunday, March 9th, you will be needed to supervise (direct) the hanging.—Everything is ready for the day. Invitations & Catalogues will be ready in a day or so.

—May the "gods" smile broadly on "our" 3 weeks!

I have been having a tooth out & tortures before & since.—One mean gnawing physical discomfort after another! Still I'm [keeping] "things" somewhat moving. It's ever uphill work—a mean job. The Show promises to be quite a wonder. All we need is to have the people come.—

Our love to you & Reds.

<div align="right">Ever your old
St.</div>

Of course we are counting on you & Reds to stay with us at 38 E. 58.

After the exhibition, Stieglitz was ill with kidney stones and did not regain his normal health until summer, when eye trouble caused him further discomfort. Simultaneously, O'Keeffe was virtually incapacitated for several weeks by severe reaction to a vaccination, which caused her legs and feet to swell painfully.

<div align="right">Lake George
5 June 1925</div>

Dear Dove: Enclosed is the promise made good.

—We got up here yesterday A.M. having left town the night before.—

It's hot here but we're more than glad to be here & no longer in the city.—It was a tough Winter & Spring—maybe the Summer will put me on my feet once more. More soon.

Our heartiest greetings to you & Reds.

Stieglitz

[Halesite]
[June 1925]

Dear Stieglitz

You always do such wonderful things that thanking you seems superfluous. The only way is with work even though it be "sticks and stones." I seem to get on with them better than "words." Tried three times to call you up. Wanted to see you before you left but thought it was to be about the tenth.

Have done a few new "things"[1] and have a painting underway. One of the "things" of the sea[2] is as good as "Rain" I think. Reds is working too—is finding some things.—Color very clean and clear.

We have been out for a few days and found a new place—windswept—free from people and a good anchorage. . . .

Your letter here on our return and it is great to feel that we can go on painting a while longer. The living is so reasonable with the seafood we catch, we hope to make it last. This food is better for us than the things we buy and is fresh right out of the water. It cuts our living down about a third.

A letter from Elizabeth telling of their new home.[3] Donald goes there tonight and they take possession on the 15th.

We are both getting to work again after a struggle with painting the boat—overhauling engine etc. At this season something new turns up every day that has to be done. The beauty of it is though that it is all done out where we can be using our eyes and feelings on other things while we work.

Rosenfeld told me of some of Georgia's fine new things. He brought Miss Naumburg out for a Sunday. . . .

We have bought one of those iron life boats, 24 feet long x 7½ wide, for a storeroom—$25. We can tow it or leave it here, thereby eliminating all rent as soon as I can get a canvas cover and open up a few of the iron air tanks for stowing paintings. That is better than paying $50 a year for the glass studio when we find most of the work is done on the boat.

Decided not to let you buy that rowboat I telephoned Georgia about. It was quite a beauty in line, but was "factory built." That means iron nails instead of copper fastenings and a good deal of putty had been used. She would dry out in shipping to Lake George and might not come back right. $25 was a bargain but not under the circumstances if you had to have her done over.

Our love to you both and we hope you are getting that much needed rest after all the strain.

As ever
Dove

1. Dove nearly always referred to the assemblages he produced in the 1920s as "things."
2. In May, Dove did two similar "things" inspired by the sea, *The Sea I* and *The Sea II*. In each of these, gauzy material is mounted on a scratched aluminum panel.
3. At Monsey, New York, in Rockland County.

Lake George
7 July 1925

Dear Dove: It's a great north wind blowing morning after a few sultry languor-breeding days. Georgia is finally rounding to be herself again after a mean siege consequential to vaccination! Naturally her perking up affects me beneficially. I believe I'm much better—that is not so totally lacking in all energy as I seemed to be for so long. Most disheartening.—So far the summer has been unproductive. True, I have a print or two—rather amusing & I haven't the slightest idea what they express! So much the better I guess. The prints are beautiful nevertheless. So I'm at the game once more—chronic—incurable.—

—I hope you're at work & Reds too.—I have been trying to get next Winter clear in my mind.—How to protect that spirit which means all of life to me—to keep it protected from the multiple breeding Iagos which seem to be more the fashion than ever.—I must see to it that the press gets to see nothing—that is the professional Press—the Henry McBrides[1] & Luther Careys[2] & all the rest of that unspeakable crowd. It's really too bad about McBride. I believe he is becoming senile.—His recent article in the "Dial" was about the last word.—Demuth writes why don't we all go on a "strike."—So you see he feels much as I do.—

I, for one, know that my own work is for very few who "know" anything about Art.—And that I really don't care to have it seen by more than a few—if by those.—And I can imagine Georgia beginning to feel that way about her work. And Marin has always felt more or less that way.—And I know your feelings.—Hartley wants admiration—& Cash!—Cash!—?—Gosh! it's an awful Spectre—ever growing.—

I realize it more & more.—One is trapped.—

—Rosenfeld is here working hard. Having quite an undisturbed time.—There isn't much theorizing going on—not even much talking.—[Alfred] Kreymborg lives in a place just below us. He too is hard at work. Came up a wreck—at the end of his tether—so discouraged because his book hasn't sold well at all.—

—I feel more than ever that it is too bad there isn't another little place like "291" where things could be shown as they were there. Room 303 [at the Anderson Galleries] has absolutely nothing to do with any of us.—It isn't even a good storage room.—But I see no way out.—Will have to make it a go.—If my health were only halfway decent.—The [*Seven Americans*] Show last year would have been all right if I had been half fit at the start—or even before.—But it's looking ahead now.—I know that I *must* husband the little energy left me—so as to be able to use the little without stupid waste.—Still I feel the Show was by no means a failure. And it had to be held, all things considered. Some mistakes were made.—

[Emil] Zoler writes he is going to see you.[3] He is a rare person when all is said & done.

—There is no news.—

Georgia sends greetings to you & Reds—as do I.—

<div style="text-align: right;">

Ever your old
Stieglitz
</div>

1. Henry McBride, who wrote for the New York *Sun,* continued for years to come to review shows that Stieglitz presented. (See Glossary of Names.) In the "recent article" to which Stieglitz refers ("Modern Art," *Dial* 79 [July 1925]: 84–86), McBride summed up the "art season just past as the dullest within recollection," although he had praise for a summer show of Whitney Studio Club members at the Anderson Galleries.
2. Elisabeth Luther Cary (1867–1936), an author, wrote art criticism for *The New York Times.*
3. Zoler visited the Doves 7–11 July. (See Glossary of Names.)

[Halesite]
[August 1925]

Dear Stieglitz

Just back from a short voyage to Port Jefferson and an experience with high seas such that there was hardly time to do much more than keep ourselves and the boat afloat. Seem to need that sort of thing, and had a good strenuous dose of it. It may come out later. The summer has not burst into prolific(k)ness as last autumn but seems to be working that way—perhaps the autumn will bring it.

Have 8 things done nevertheless and 3 or 4 of them are far beyond anything of last year's. I cannot go on making paintings out of what I already know. I prefer growth to effort and both take time.

I wonder if you and Georgia have felt new things. While I do not like any effort I feel that if you could both fly this year it would be a help. The wings are there if responsibilities do not interfere. Am wondering too about Marin. If Rosenfeld is still there give him our love. He has had some very fine thoughts of the whole thing, quite as fine as paintings. Reds has been working and letting go of past which is so hard for us all to do. The future seems to be gone through by a spiral spring from the past. The tension of that spring is the important thing.

Have had battles with the family—calming down. Bill is to go to school this fall in Massachusetts. That is a relief to the situation.

As ever
Dove

Lake George
27 August 1925

Dear Dove: I was wondering about you & Reds. And I would have written long ago. But there has been a very hard time. For several weeks my eyes tortured me so that virtually they were of no use except to torture—torment me.—So there was no reading or printing or even letter-writing. For months they were acutely bothering me. But I can stand a lot of pain & hoped they'd gradually let up. They didn't. So I had to see an oculist in New York. For a few days around that time they were better.—And I was in town to have my lungs X-rayed at my brother's request—for safety's sake. I was looking rotten & feeling worse.—The winter & spring had been just a little too much for me.

And then getting here & going to bed with kidney colic—& eye trouble & other worrisome troubles—physical—not to speak of the worries about Georgia—& my daughter—not to speak of Marin who was ready to go to Canadian Rockies—had ticket—when he caved in—stomach—is in hands of a doctor!—Georgia is fine now.—Nine weeks she was virtually on the shelf!—And when she's normal you know she isn't particularly strong.—As for myself since five days my eyes no longer torture me—the treatment seems to be effective—I hope "lastingly" so. At any rate I'm working at a great intensity—am enjoying it.—There's nothing like it—a sort of free feeling—and I'm getting off some letters—& reading some—& doing all that without paying the frightful price of agony day & night.—And Georgia is painting too.—She has little to show—nothing comparable to last year. What I've done I think is good.—Growth?—I don't know. Perhaps. It's certainly similar but different.—And I like some of it much. So does G. She feels it's growth. But she is partial.—

—So you've had another experience at sea.—We've had no inspirational excitements—Georgia may need them—I don't so much.—There are enough inside of me. But I am aged. You are all youngsters still. And that is no fault—nor virtue. Just a fact of Nature's.

. . . Rosenfeld is still here. He works daily at least 8–10 [hours].—He seems to have to work hard for all he gets.—Nothing seems to flow readily.—

I have no ideas for the future—all depends upon our health.—Of course there is Room 303 and I do want to follow up the Exhibition if possible. Reap any fruits if there are any to be reaped.—It will be difficult. There are many active destroyers—few friendly ones—& they not active—unless persuaded into activity. . . .

—Our love to you & Reds.

<div style="text-align:right">

Your old friend
Stieglitz

</div>

<div style="text-align:right">

Lake George
9 November 1925

</div>

Dear Dove & Reds: Town will see us next week. Horrible thought but there is no escape if 303 is to function at all.—We are working our heads off not wasting a moment. I've been going great guns & finally feel fit to enjoy activity—lots of it.—And so I'm putting in 18 hours daily—

destroying hundreds of prints after making them—keeping few. East-
man is a fiend—& I'm not always Master.—

—Georgia is going well too.—And feeling accordingly well.

I hope all is OK with you. And we hope to see you soon. I can be
reached at 489 Park Ave.[1]—We have no domicile as yet.—As soon as we
have we'll let you know.

<div style="text-align: right">

Ever your old
Stieglitz

</div>

1. Address of the Anderson Galleries.

4

1925–1929

Between the closing of 291 in 1917 and the opening of Stieglitz's Intimate Gallery in December 1925, the American art environment had changed. By the mid-1920s, modern European art had become stylish and was beginning to reach mass consciousness through art deco design. However, wider acceptance of nonrealistic art was paralleled by loss of the utopian fervor of the prewar years. Experiments with abstraction ebbed, and few younger artists developed radical styles in the 1920s. The earlier enthusiasm for photography as a fine art had died; during the rest of Stieglitz's life, his gallery was the only showplace for serious photography—and there, only occasionally.

From December 1925 through the spring of 1929, Stieglitz directed The Intimate Gallery, where his vision of modern art was more constricted than it had been at 291. A mere handful of artists appeared here. More than half the exhibitions at The Intimate Gallery were shows of the work of Dove, Marin, or O'Keeffe. Demuth had two shows. Hartley, Bluemner, Strand, Gaston Lachaise, Peggy Bacon,[1] and Picabia (the only European exhibitor) had one each. Stieglitz's exhibition policy at this gallery reflected his belief that acceptance of the European modernists had been achieved. Also, Stieglitz wished to combat native philistinism, epitomized in the very year of the *Seven Americans* show by the President of the United States; upon invitation from the French government for American participation in the international *Exposition des arts décoratifs,* President Calvin Coolidge answered that this country had no arts to send.[2]

With a gallery once more bringing attention to them, Stieglitz and

120

Dove became newsworthy again, and both men's lives took on a seasonal regularity disciplined by the gallery schedule. During the winters, Stieglitz was "on deck" all the time, as he had been at 291. His own photographic work was for the most part relegated to summers at Lake George. In these years, Dove illustrated for about half the year, then concentrated on painting to prepare for a show. However, he was increasingly unable to count on a comfortable income from his illustrations. Ironically, the newly "modern" appearance of mass-circulation magazines—which now preferred photographs for their visual material—caused the demise of the vigorous illustration tradition that had provided Dove with steady work whenever he wanted it. As a result, Dove's finances settled into chronic crisis. Toward the end of this period, he borrowed money, and after his 1929 show he quit making the rounds of magazine offices because he felt that the effort was no longer worth the time or carfare.

Although Dove saw Stieglitz from time to time at the gallery or sometimes talked to him by telephone, the letters from 1925–29 are more abundant and more regularly spaced throughout the year than they had been previously.

1. Peggy Bacon (b. 1895), a figurative artist and caricaturist, worked less experimentally than the Stieglitz "regulars."
2. Richard McLanathan, *The American Tradition in the Arts* (New York: Harcourt, Brace and World, 1968), 408.

★ ★ ★

When Stieglitz and O'Keeffe returned to New York for the winter of 1925–26, they moved into the Shelton Hotel at Lexington Avenue and Forty-eighth Street. Their rooms thirty floors above the sidewalks gave them dramatic views of architecture and of the East River, since the new hotel was the tallest building in the neighborhood. O'Keeffe often painted these views, as well as the hotel itself, and Stieglitz photographed its lofty vistas. Soon after they were settled, Stieglitz opened The Intimate Gallery in the Anderson Galleries' Room 303 at 489 Park Avenue. The inaugural exhibition, a show of Marin's work, opened in December 1925. Dove's first one-person show since 1912 followed in January. Exhibitions by O'Keeffe and Demuth completed the season.

From his show, Dove sold two paintings to Duncan Phillips, who was to become Dove's only significant patron. By the time he purchased *Golden Storm* and *Waterfall,* Phillips was already among the few

Alfred Stieglitz, From the Shelton, *New York, mid-1930s. As subjects of their art, Stieglitz and O'Keeffe often chose views of the city from the Shelton Hotel, where they lived for a decade.* (Alfred Stieglitz Collection, Art Institute of Chicago.)

important early sponsors of American modern art. Several years earlier, in his Washington, D.C., home, he had opened a small museum, the Phillips Memorial Gallery, which is today the Phillips Collection.

Heir to steel wealth, Phillips spent his life tending to his collection and writing about art. His wife, Marjorie, a talented late-Impressionist painter whose work reflected the graciousness of her personality, showed her work in New York and actively participated with her husband in making purchases for the gallery. Her influence on Phillips was probably considerable, as he was timid about his own preferences and often vacillated when making choices.

Inherently conservative in his taste, Phillips began to accept modern painting only after the shouting was over, but he grew steadily in his appreciation of contemporary work. Within a few years of the incorporation of his museum in 1918, he began to add Marin, O'Keeffe, and

Arthur Dove, Golden Storm, *1925. Purchased by Duncan Phillips from Dove's 1926 Intimate Gallery show, this work's soft and vibrant surface results from Dove's use of metallic paint, along with other pigments, on a wood panel. (Phillips Collection, Washington, D.C.)*

then Dove paintings to his collection of Impressionists and Old Masters. To his great credit, he believed in supporting living artists, and he providently spent his money on works of art rather than on a building to house them. As a result, the Phillips Collection today has fine holdings of the artists sponsored by Stieglitz (including the largest group of Doves anywhere), as well as important works by other American and European painters of the twentieth century. The collection is comfortably and unostentatiously shown in the large residence (with later additions) that the Phillips family inhabited from the 1890s until 1930. There, the congenial atmosphere of a private home has been retained. The collection itself has a unified character, determined by the taste of Phillips and his wife. The tone of refinement, harmony, and warmth does not accommodate brashness, crudity, or perversity. The collection well represents the founder who loved beauty and wanted to share what he chose to collect.

Notwithstanding what he ultimately accomplished, Phillips as a collector was often difficult, and he soon became a major topic in the letters between Stieglitz and Dove. While he did not have an unbounded fortune, Phillips apparently never realized how tactless it was to complain about his cash-flow problems to people with much more pressing financial problems of their own. In addition, he was often thoughtless about paying his debts to artists, who needed the money, and about keeping paintings tied up so they could not be sold to anyone else. He continually asked Stieglitz to send him one painting and then another, so he could "live with them"—then, often as not, after some months sent them all back. Phillips frequently tried to obscure his faults with words, as if genteel language could excuse his behavior. Especially to Stieglitz, he wrote endlessly tedious letters, filled with complaints and embellished with pretentious appeals to high-mindedness. It was difficult not to become exasperated with Phillips—and yet, no one ever accused him of not meaning well.

The incident to which Stieglitz alludes at the end of his next, brief letter typifies Phillips's demands. Paul Rosenfeld had spoken for *Waterfall* before Phillips had visited Dove's exhibition. When Phillips insisted on having it, Stieglitz persuaded Rosenfeld to contribute to the "cause" by relinquishing his claim[1] so that the painting could go into a public collection.

In his letter, Stieglitz also mentions that O'Keeffe had been in Washington. She had gone there at the invitation of an old friend who was an officer in the National Woman's Party to address a dinner sponsored by that organization. O'Keeffe herself had belonged to the party for a

decade, and she maintained her membership until after Stieglitz's death. Although she rarely made appearances such as this one before nearly five hundred people, O'Keeffe steadfastly supported the independence of women, in keeping with the self-determined style of her life.

1. Stieglitz to Duncan Phillips, 1 February 1926, Phillips Collection, Washington, D.C.

> [New York City]
> 6 March 1926

Dear Dove: Georgia says that your two pictures look very beautiful in Phillips's place. She had a great time in Washington.

The "right" thing took place even if Friend P. R. is still peeved & acting "kinder foolish."

Love to you and Reds.

> Ever your old
> Stieglitz

Dove's next letter was written after the season was over. In it, he mentioned Henry Raleigh for the first time in several years. An illustrator who had been Dove's neighbor in Westport, Raleigh left his family there and showed up on Long Island to be near Dove. With him was his teenage companion, Holly MacDonald, whom he married the following year. The Raleighs remained actively involved in Dove's life for the next few years but faded out in the thirties. Dove probably never even knew of Raleigh's suicide eleven years after his 1933 divorce from Holly.

> [Halesite]
> 17 May 1926

Dear Stieglitz and Georgia,

For the first time since seeing you, I have felt like writing. That state of mind comes with the feeling that there is something more to say in work, and of course all that is left to do is to say it.

Things have simplified in the last few days.

"Thousands of people" have been here. Friends and Relations, Brothers? Mothers? and the others?

Also myself. And when yourself has found something more there doesn't seem to be so much bother.

We read the "New Yorker" and see something familiarly new every week of your doings in some part of the paper.

Lots of work on boat, on family, and on work, so far this spring. Hope more work will come soon. And that I shall be more prolific. No hope for or from the family. Brother here the other day as ambassador from Mother to get me to come home to see her. And "to smooth things over," but with too coarse sandpaper. Family first, safety first, duty first, and spirit last.

Raleigh and Miss MacDonald, "Holly," have been here several times. He has just bought a sailboat here. She is very direct—has written some quite remarkable things, one of you, which I will send when she brings them out Wednesday. She is all for the O'Keeffes. Does not like Gertrude Stein. Raleigh does not like the O'K's as well. Says they're too complete in themselves, doesn't feel struggle enough. He doesn't like "Penetration" (a reversed title by the way). It was a more generous giving-out thing. I told him you would be glad to change it I thought.[1]

They held an anniversary party for the studio building[2] at 1 W. 67 St. They all own their studios.

Christy, Fisher, Benda, John Flannagan[3] etc. were photographed for the papers from 10:30 to 1 A.M. They asked Raleigh to give them a talk on Art. He can do without models in a few minutes what it takes them weeks with them and gets paid as well, so they asked him to talk on Art. He declined but said he would show them a beautiful drawing downstairs in his studio. The whole push trooped down to be shown an ink and oil sketch I had given him. Faces all dropped.

"They could do it themselves." He got out paper, etc. No one tried. "Why did he like it"—?—etc.

It must have been—nothing.

. . . . We had sort of a nice scientific research day with Alfy. The Strands couldn't come, will write them soon.

Reds is working, "space," spirit and more color in the real sense. Alfy was very enthusiastic over them.

We have been thinking of Norfolk, Va. for the winter. There is a nice harbor there to keep out of the ice. Any move takes some energy from work. We are considering all those things. A new anchorage always gives us many more things. Here ice pulls out the caulking. That also takes a lot of energy. We could haul the boat out here and jack it up or

perhaps find an open place up here in the creek where it would be hard to get ashore and water not so good. If we can find something that ice will not stick to, that would be the simplest as our dock here with an artesian well beside it is convenient. At the end of a trolley that goes to the train. From Norfolk the fare is $25 on the boat round trip to N.Y. so we would not be exactly commuting. We had also thought of a larger boat that is for sale here, great big engine, quite a little more room, and much safer. Showed it to Raleigh. Thought he might want it.

He offered to buy it for us and then sell this.

This one is far more beautiful but has not the power.

He also offered to buy a larger engine for this one. Has been very generous. His expenses being $3000 a month. Supporting mother, two sisters, wife, three children, two aunts, and Holly on salary as secretary. I do not feel like adding anything to such a procession.

He made $75,000.00 last year (confidential) so can do as he pleases. If he starts to paint, I imagine there will be quite a change.

Giving wife $1000 a month, $20,000 place in Westport, $40,000 in Florida and almost as much in cash. Supporting the children separately.

Has supported mother and two sisters since he was 12 years old, so guess he must have been born that way, or is it a gift?

From what I hear a lot must have happened in the way of new interests at Georgia's show. How about Demuth's?

Are you going to show your photographs?

Our love to you both.

> As ever
> Dove

Am working here for a new boating magazine "Fore an' Aft." Wm. Atkin, editor, and Henry Bixby of shoe blacking fame philanthropic owner for a year anyway. Have just done their cover. . . . Also did three drawings for them and have written an article. No one as yet mentions pay so perhaps I am a philanthropist also.

Sold Bixby's last year's boat to Raleigh. They build a new one each year. Am going to try to send the Bixbys to 303. They buy paintings, and of course I do not know what kind. She can sail a boat anyway better than we can. They are nice.

> AGD

1. Raleigh had bought *Penetration* from Dove's 1926 Intimate Gallery show. He did not exchange it, despite Dove's suggestion that he could.

2. Hotel des Artistes.
3. Howard Chandler Christy (1873–1952), Harrison Fisher (1875–1934), and W. T. Benda (d. 1948) were illustrators. (Christy was also known for his portrait paintings.) Sculptor John Flannagan (1895–1942) is best known for his animal carvings, in which naturalistic detail is subordinated to generalized forms.

Stieglitz left for Lake George early in June but soon returned to the city because of another kidney stone attack. Finding his friend asleep at Mount Sinai Hospital, Dove left a note with wishes for "pleasant dreams and hopes that you will be out soon." Stieglitz spent two and a half weeks there, then went back to Lake George to recuperate.

> The Mount Sinai Hospital
> 5th Ave. & 100th St., New York City
> 25 June 1926

Dear Dove: Thanks for your inquiries. I have had a tough deal. 16 awful days. But I'm up. And we expect to leave for Lake George today midnight. I need much quiet—much peace. . . .

> Your old
> Stieglitz

> [Halesite]
> [30 October 1926]

Dear Stieglitz and Georgia

These are the verses that "Holly" wrote and will tell you much of her.

They, she and Raleigh, have been here several times this summer. Have bought boat here.

He has a divorce, good in Connecticut, Florida, and some places but not in N.Y. They are installed in the studio at 1 West 67. If you feel like writing her about these, she is anxious to have an opinion she values. Crowninshield has offered her a page of them in "Vanity Fair."

"If Raleigh will illustrate them."

They are not interested in that nor in publicity.

They have waxed enthusiastic over a "thing" of mine being done from Gershwin's "Rhapsody in Blue" not as yet completed, but I feel it will make people see that the so-called "abstractions" are not abstract at

Arthur Dove, George Gershwin's "Rhapsody in Blue," Part I, *1926–27. Exhibited in Dove's 1927–28 show, this musical interpretation did not sell during the artist's lifetime. (Private collection. Geoffrey Clements photo.)*

all. R. said that in describing it to some people who had heard the music, he found that they understood this even though they had objected to my other "things." It is an illustration.

Have, after spending much time, given up any hope of family helping me through for the next three or four months.—Have fought all summer and succceed merely in irritating them completely. "Foolish"—of course. I was foolish to try, but now I am *sure* I was foolish to try.

Have been in town getting work. Have plenty. "Pictorial Review" back again paying same for two drawings as for four or five but they must be done to a finish. Thought best to start while we still have about

$500 left, before getting haled to Court. We can probably do more painting out of jail than in.

Mother has invited us "both" to Geneva for the winter, but the enthusiastic refusal seems to have made family sore.

It seemed as though I spent the whole night dreaming of you and things going on at 303. To have *worked* all night might have been more to the point, have been wanting so to have something done, may be able to make it. Four under way.

Summer rather hit by family, boat work (earning the rent), friendly interruptions, and illustration. However, last year [work] began mostly about this time, but there was more leisure then.

We are getting electric lights for night work here at the dock. In a small cabin, the gasoline lamp burns up the oxygen.

What are you and Georgia doing? Hear that Georgia has accomplished much.

Love to you both

<div style="text-align: right">Reds and Dove</div>

<div style="text-align: right">[Lake George]
31 October 1926</div>

Dear Dove and Reds: I can't tell you how much you have been in my mind all summer & still more so recently. Frequently I have been on the point of writing. But I felt there was no use writing in a minor key—& of illness, etc.—And it has been one thing after another since we came.—I, physically at least, as chief fool—for I know one must [be] a particular fool not to know how to protect oneself, at least occasionally. So I didn't write. And hoped you'd understand. As I understood your silence.—This is our last day here this season. Cases are gone. Trunks are packed ready to accompany us tomorrow early. And fewer parcel post packages than usually are also ready to go. There'll be no feverish rush like other years. . . .

When one has been as ill as I have been one has much time to do some very direct thinking.—

—Georgia of course had anything but an easy time.[1] She has painted. Not as much as in other years. And not in as "vivid" colors. But some things are very fine.—I haven't made a large photograph. Hadn't the strength. But have a handful of small prints—also not so many, for I had but few working days, but some are a further development. Maybe

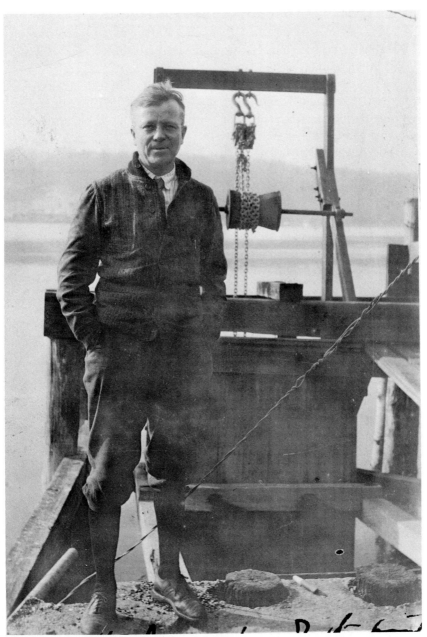

Arthur Dove on the dock, Halesite, New York, 1920s.

a realization in several that goes beyond anything I ever did along the particular road. . . .

—I'm glad to have Miss Holly's writings. They are as unusual as she is. . . . Rosenfeld, Kreymborg & Co. are busy getting out an Annual—"The American Caravan."[2] I wonder whether these folks shouldn't have a chance at her work. . . .

Did I ever tell you, Dove, that there is to be a big International Show of Abstract Art in the Brooklyn Museum beginning in a few weeks?—It is run by the Société Anonyme. Three of your things will be in it, one being "The Nigger Goes A'fishing" [*Goin' Fishin'*].[3]

—Duchamp[4] is back from Europe & is interested in the affair. As I said, I'm hoping to do my share this Winter. All I need is a bit of health.—

Our Love to you both—

<div align="right">

ever your old
Stieglitz

</div>

Arthur Dove, Goin' Fishin', 1925. Assemblage of bamboo, denim shirt sleeves, bark, and pieces of wood on wood support. One of Dove's most appealing and best-known works, this was held by Stieglitz until 1937when he sold it to Duncan Phillips for two thousand dollars—the highest price paid to that date for any Dove work.
(Phillips Collection, Washington, D.C.)

1. Stieglitz fails to mention (possibly Dove knew, or Stieglitz thought he did) that O'Keeffe had been so uncomfortable at Lake George this summer that in late August she had escaped to York Beach, Maine, for a month.
2. The *American Caravan* "company" included Lewis Mumford and Van Wyck Brooks. Intended as an annual publication of recent writing, it was issued five times (1927, 1928, 1929, 1931, and 1936).
3. *Goin' Fishin'* was first shown in Dove's 1926 exhibition with the title *Fishing Nigger*. Herbert J. Seligmann, who knew both Dove and Stieglitz personally and who was frequently present at the gallery during Dove's 1926 show, wrote of this work: "It should be stressed that the title of Arthur G. Dove's painting 'Nigger Fishing' was given in accordance with the colloquial use of the time. . . . Both Dove and Stieglitz were entirely free of color prejudice" (*Alfred Stieglitz Talking* [New Haven: Yale University Library, 1966], 18). Dove's son has corroborated Seligmann's opinion, pointing out that the word "nigger" did not imply contempt to Dove's generation, as it did later, when Bill helped persuade him to change the title to one without racist overtones.
4. The French artist Marcel Duchamp (1877–1968) lived in America for many years. A director of the Société Anonyme, he knew Dove's work—as Dove knew his—and probably was passingly acquainted with the painter himself. Duchamp's *Nude Descending a Staircase, No. 2* of 1912 (Philadelphia Museum of Art) had been the sensation of the 1913 Armory Show. He had known Stieglitz since the time of his first residency in the United States, 1915–18.

During the season of 1926–27, Dove was busy with illustration assignments and did not have enough new work for a show. However, as Stieglitz had mentioned in the previous letter, three earlier works were included in the important Société Anonyme *International Exhibition of Modern Art* at the Brooklyn Museum. In his next letter, Dove referred to this show, which was on view from November to January.

[Halesite]
[December 1926]

Dear Stieglitz and Georgia

This seems to be about the only so-called leisure we have had for months and so am celebrating same by a temperature and a touch of grippe. Reds is going to disinfect this note so that there will be no danger of passing it on. Hope it will be over by tomorrow. This being in bed on a boat seems somewhat inconsistent. Had been going at one time at

the rate of fifteen drawings in five days. And in the last two days started what we think is the best "thing painting" yet. We had intended going to Brooklyn and then on in to N.Y. yesterday but cold and the start on this painting changed that. I see Pemberton praises it [the Société Anonyme show] very well in today's "New Yorker," incidentally saying amusingly about as much as anyone has as yet about the Academy.[1]

A note from Holly tells me they had been in to see the Marins. . . .

There is another snowstorm on now and Reds has the job of getting water & coal. She doesn't seem to mind as it is right beside the boat at high tide and 8 feet above us at low. We have added electric lights and an electric heater wired from the power house here beside us.

Have been worried about you as Alfy was out last week and said you had not been very well. Hope by now that is not so.

Did you read the Gertrude Stein thing in October "Dial"?. . .[2]

<div align="right">As ever
Dove</div>

1. M.P. [Murdock Pemberton], "The Art Galleries," *New Yorker,* 11 December 1926, 98–99.
2. Gertrude Stein, "Composition as Explanation," *Dial* 81 (October 1926): 327–36.

As in the year before, Marin's show had opened the 1926–27 exhibition season at The Intimate Gallery. These openings set the pattern for most subsequent seasons in Stieglitz's lifetime. In January and February 1927, O'Keeffe's show followed Marin's. During the next two months, Gaston Lachaise had his only show with Stieglitz.

<div align="right">[Halesite]
[March or early April 1927]</div>

Dear Stieglitz

. . . . A man has promised to bring me in with the few paintings I have, soon, whenever that is. Am occasionally adding something and in the meantime doing all so-called business over the phone. It saves a lot of wear and tear, and composes things in bigger hunks.

Have been reading about Georgia and Lachaise.

Reds (Helen Torr), Halesite, New York, 1920s.

It takes a long time to simplify life down, or up, to one thing especially when one has to live so many of them in one.

Love to you all

As ever
Dove

In his next letter to Dove, Stieglitz alluded to a bitter personal argument that erupted in the spring of 1927 as the result of press reports that Duncan Phillips had paid a record six thousand dollars for a Marin painting. Phillips energetically objected that the figure misrepresented his purchase. He pointed out that he had agreed to the price only because Stieglitz had offered a greatly reduced price on another Marin and had given a third one to Mrs. Phillips, all in the same transaction. As a regular patron of Marin's work, Phillips did not want to see Marin's prices established at so high a level and did not want other dealers to know he would pay that much for a Marin painting. On the other hand, Stieglitz saw that it would be to the artist's benefit to have the highest price possible on the public record. As a result of the fracas, the relationship between Phillips and Stieglitz was severed until the end of the year.

The incident serves to point up the enormous difference in price between Dove's work and that of the financially more successful Marin and O'Keeffe. By the end of the twenties, those two regularly sold paintings for several thousand dollars each, prices that Dove paintings only began to approach at the very end of his life. (O'Keeffe went on to outstrip Marin's prices by far in the thirties and forties.) Dove rarely received even a tenth of the controversial six thousand dollars at this time and for years afterward.

[New York City]
6 April 1927

Dear Dove: At last—I guess I have been writing to you daily for months. I have been in harness 157 days without a break! Pretty fair record after five rotten months of illness—suffering.—303 has been rioting with results. At present there is a nasty mess owing to the moral cowardice of a mutual friend—Art-patron.—In a week I'll be at my own work—the Exhibition Season will be over.—The 3 exhibitions were equally wonderful.—

—Next year?—I'm looking ahead—a stupid thing for a man of 63 today. . . .

Georgia has not painted as much as last year.—But she is again at it.—

Our love to you both.

<div align="right">Your old
Alfred Stieglitz</div>

Reds was briefly very ill in June 1927 and remained somewhat unwell through that summer. On 22 June, Stieglitz wrote a short letter to inquire about her health. Dove promptly answered with the letter that follows.

<div align="right">[Halesite]
[23 June 1927]</div>

Dear Stieglitz and Georgia

Your letter was lovely. It drew tears of thanks from Reds. You see she is just beginning to really know you. . . .

The doctor said it was acute indigestion. Gave three hypodermics—camphor & oil and morphine. We are trying to find out what she can take, have found out many things she can't. Has been up one day, Tuesday, but now is in bed again.

Am going to try peptonized milk today. White of egg and orange juice is all right but a whole egg coddled is all wrong. She is not able yet to get to New York to have the blood tests made. So in the meantime we are trying to solve the situation intuitively and with the help of a rather good doctor who leaves town today. . . . Many symptoms of tired nerves. Turpentine in the white lead and sandpapering those frames in the small cabin may have started it.

As soon as she is well we may go to Raleigh's studio [in New York] for a few days (they come to the boat in a week) or ashore here in the hotel might make a change while I have the boat out and get the painting done.

If the blood tests included the one for illustration, I have no doubt of the reaction. Reds says a good painting would help a lot.

She sends love. So do I.

<div align="right">As ever
Dove</div>

With the preceding letter, Dove enclosed another, one that he had written to Stieglitz earlier but had not mailed. On the envelope of the earlier letter, which follows, Dove noted, "This is a letter I wrote you the day after we saw you. Did not send it then as I wanted you to see Holly freshly if she came of her own accord."

<div style="text-align: right">

[Halesite]
[May or June 1927]

</div>

Dear Stieglitz

Have asked Holly to bring you two of her books for Rosenfeld and Kreymborg. Most of all I wanted her to come to you and Georgia. She needs something now very much and you will know what it is when you see her.

Had a long talk with Raleigh on the way out from New York and suggested what you talked to me about through an opening he gave me. He had been thinking of something of the kind.

He is sensitive, super-sensitive in fact and suspicious of everyone.

From what he says Georgia may be an exception but I doubt it.

He feels that they must have separate places while he has to do these things he dislikes. Sends his mother and sisters $400 besides the $1000 to his former wife. He says that his present intolerance would destroy anyone if in too close contact. There is nothing anyone can do under the circumstances unless you can perform a miracle?

They have both talked to us again in such different ways about something they would both like to feel more calm about.

It is almost impossible to talk to them together. They have gone to town for a few days, she much dejected. "May never write again." "He doesn't believe in words," etc. As to paintings I think Georgia's are the only ones that interest her. He is interested in the Marins.

The other day when I came into 303, and saw you and Janette and Reds there together, something very fine happened. That could not be anywhere else. It was something that one could love entirely.

Perhaps with all that was going on, the photograph of the clouds, you know the one I mean, made me feel like having it pass through me most.

To absolutely trust a soul is a great thing and to absolutely trust four or five or seven is a living power.

<div style="text-align: right">

As ever
Dove

</div>

Lake George
26 June 1927

Dear Dove: Illness is such a miserable affair.—I was very misera-
ble myself for 3 days—I thought Hell—all of it—had been let loose.
Fortunately I'm better again. But this ailing constantly business is
worse than trying—particularly when one has something to do.—Of
course I had been doing all sorts of things I had no business to do.—
And undoubtedly Reds in a way did many "foolish" things. But isn't
that the main thing in living—to do "foolish" things.—

—I'm glad to have *that* letter you hadn't mailed.—I have had Raleigh
in my mind a great deal. Too bad he & I hadn't had a talk—but maybe
the "time" hadn't arrived. I think I "see" Holly—& maybe "see"
him. . . .

Holly sent the two books.—I'll see that they reach their destination in
due season. Just at present Rosenfeld is with [Sherwood] Anderson &
deeply engrossed in his (R.'s) novel which he has been working on for
some years.—Had a very fine letter from Anderson. Hadn't heard from
him in quite a time.—I'm wondering what Phillips is going to do—a
payment to Marin is due on July 1st. Will he have to be sued?—I do
hope that we'll be spared all dirty business. I can't quite reconcile
myself to the fact what a foolish man P. has shown himself to be in this
matter.

—As for work, Georgia has two paintings done.—And I have a few
old (small) prints mounted. And I'm trying some printing.—With not
much success so far.—No new work as yet. Until I know what papers
will do, making negatives (if I had ideas, which I haven't at present) is
stupid.—Every breath costs so much these days of thrift.—

. . . . I'm glad that Reds finally feels that her life means something
very definite to me. Has all along.—My love to her & to you.—
Georgia's too. She's out weeding.—

Ever your old
Stieglitz

[Lake George]
19 July 1927

Dear Dove: . . . a few things are in the making.—My ailments hold me
back so much. And Georgia is handicapped with her rheumatism in the
right hand! So there is always something pulling down—or away.—

But all in all it's quiet—& that is very much. . . .

News there is none whatever. I'm merely sending you this to send you & Reds our love.

As always

<div align="right">
Your old
Stieglitz
</div>

<div align="right">
[Halesite]
[21 July 1927]
</div>

Dear Stieglitz: Reds is better! You have seen Reds' work and know by now what she is made of. She is anyway what I have always felt. Beyond that, she hopes as well as you and I.

"Handicapped," yes, we all are—*sick* or *well.*

Families, if I could only be interested, seem terrible, but that is their own concern. They do not seem terrible to me when I am thinking of what you know I am thinking of. The past is so present at times that it makes what is called a family—Hell. We love a few. You and some other men and four women. You will know them by your lights, not "theirs."

We are saving up and have a chance to work, if we can only get Reds back to health. She has been through a lot.

Am sending you some of Holly's poems. Would like to send you her letters. They are fine but pertain too much to what I feel is a rapidly changing situation [with Raleigh], so have not the privilege, without her suggestion, except through the explanation you can get from the enclosed. It is all there. Told her I would send book and poems to Marianne Moore,[1] but do not know her as well as you and Georgia do.

We hope Georgia's right hand by now is even more useful than it has been, and that you can go on being what you are.

With love to you both

<div align="right">
As always
Reds & Dove
</div>

1. Marianne Moore (1887–1972), American Imagist poet, was editor of the *Dial* at this time.

Lake George
24 July 1927

Dear Dove: . . . we are both finally "working" & feeling better.—If my eyes would behave themselves I'd feel fitter than in some years. But I suppose without some torture to remind me that Life is not & cannot be an unadulterated Joy, I'd be apt to do many more foolish things than I do & have done.—There is still not so very much to show for 7 weeks— still what's done is good. New negatives are very slow in the coming.— But the few are different—or rather developments of old motives. Paper continues tantalizing. Old paper marked "Guarantee ceases July 1–1924" is golden compared to the fresh lots now made & supposed to be similar to the old. But Eastman stock is soaring—& isn't that the goal?—So what the Hell? Long live the Manufacturers of "Just as Good Goods"— produced by the new crop of Experts annually sent out by our Schools of Education.

—But why kick. I really don't—but somehow one can't help "thinking" still a little—occasionally. And thinking is a rotten antiquated habit—particularly while examining the products of prosperity.—

—Later: I was interrupted before.—Breakfast.—Zwieback & Hot Water called Tea by me.

Holly's Poems are fine—very much her own—herself—a state of incompletion—just about to arrive fully at a point but slipping away just before.—She is certainly a rare young person. Yes, I'd like to see her letters to you if she didn't mind. I have a feeling she wouldn't.

—As for her books, Rosenfeld is so busy with his novel & travelling about I haven't as yet sent the copy to him. And as for Kreymborg, he too is I don't know where. I don't want to have the copies lost or ruined. They are too handsome. But I'll see to it they get eventually in the hands of R. & K.—Marianne Moore might be interested.—Ought to be. But she is enigma when it comes to "literature" re—the "Dial." Still I'd try her out.—I do think Seligmann should have a copy. He might write a review of [it for] the "Sun."—At present he is in Maine. But will be back in town after Aug. 1st. . . .

We had quite a (a very) wonderful visitor—unexpected. Six days. I don't know whether you ever heard of him. We never had known him before except a casual meeting at my First Photogr. Exh. at the Anderson in 1921. He has just returned from Europe after a 4 years' stay.—Is a painter now. Passionately one. Was a well-known scientist—is an author too—has been around the world 3 times—has shot lions, etc. in the

jungle.—Really an extraordinary person. Mature—measured. Has lived. And is without theory. A very sad person in a way.

His name is C. Kay Scott, also is husband of Evelyn Scott, authoress.[1] His painting (only saw some watercolors) are like himself.— Otherwise we have had no guests. . . .

<div style="text-align: right">

As ever your old
Stieglitz

</div>

1. Cyril K. Scott (d. 1945), had been a bacteriologist; by this time, he aspired to the versatility of a Renaissance man. Although all but forgotten today, his wife, the "authoress" Evelyn Scott (1893–1963), then had a reputation as a major literary figure; her most enduring work, a novel titled *The Wave,* was published in 1929.

<div style="text-align: right">

Lake George
3 September 1927

</div>

Dear Dove: The sun is out this morning.—So we send you & Reds its greetings—our greetings too. Georgia is gradually becoming herself again—a bit stronger.—I plug along.—I hope Reds is on the mend too—much better. And that you are at "work."—

Greetings also to Holly—to Raleigh too.—I think of both often.—I hope she's writing.—

It has been a very cut up summer—so much illness.—

<div style="text-align: right">

Your old
Stieglitz

</div>

<div style="text-align: right">

[Halesite]
[8 September 1927]

</div>

Dear Stieglitz and Georgia,

We have certainly been out of the world as far as any communication with friends is concerned. Have been waiting and hoping each day for good news to write you. Reds has been so ill that there was little to write except a drive for money and health to paint with again.

We are both much concerned about the way this summer has been acting toward you and Georgia. It is really a shame.

Well, for good news. We hope now to paint for a straight month or

two if not interrupted. Have worked now for three days and have two, and what is something, we have saved up another $1000 to work with.

This going bankrupt every six months and then trying to become a "success" is rather wearing, but if some paintings that are worthwhile are accomplished, we probably can keep it up. That is the only thing to do anyway.

"Billy" has decided to be an artist[1] just about the time I am deciding to be a workman.

Holly has been ill with quinsy,[2] so Raleigh said some time ago, but all right now. They have been west, are married, so I hope that will make things more peaceful. She needs that. We have not seen them for two months. . . .

In the September "Dial" there is a beauty by Gertrude Stein.[3]

Reds is going to a Dr. Beck in N.Y. He knows of you. He is connected with the Fifth Avenue Hospital and is fine. Says she has anemia and a "dropped" stomach. He is using light rays that sunburn her in five minutes, we haven't had the time and weather to get much of a burn from the sun.

Our love to you and Georgia and much regards to Mr. Scott—he sounds fine.

As ever
Dove

1. He had left academic schooling in order to study at the Art Students League in New York.
2. Suppurative inflammation of the tonsils.
3. Gertrude Stein, "Long Gay Book," *Dial* 83 (September 1927): 231–36.

Lake George
14 October 1927

Dear Dove: Received your wire a few moments ago.—Glad to hear that some paintings are done both of yours & Reds.—Pleased too to know Reds improved.

Up here some work has been done too. Georgia has some very fine canvases. And my tinkering continues. Georgia is stronger & I feel better a bit. The Hill is at peace. And that's nearly everything as far as I am concerned.

Packing has begun.—We hope to remain here till Nov. 1st.

As soon as I get to town I'll have my hands more than full. Head is full already.

We have had grand weather for 8 weeks. Not a rainy day—two rains at night.—Both dandies—deluges for several hours.

No special news.—

Our love

Your old
Stieglitz

Our love to Reds too.

Early in November 1927, Stieglitz returned to New York to open Marin's show, first of the season at The Intimate Gallery. Dove's exhibition followed from 12 December to 7 January 1928. After that, Steiglitz mounted shows by O'Keeffe, Bluemner, Peggy Bacon, and Picabia.

[New York City]
24 November 1927

Dear Dove: Your Show comes next.—About Dec. 12.—The struggle continues.—1200 visitors[1]—all very alive. Two pictures bought—not much for energy expended. But interest very healthy—very sound.— The "Rich" still protesting.—I very quiet.—But fighting every inch of the way.—

Your Show will be very fine.—I hope the "Lord" will be kind. I'll do my bestest. . . .

Our love.

St.

1. To the Marin exhibition, which opened 9 November.

In part because of Reds's extended bout of ill health—which, as Dove had noted in his 23 June letter, might have been triggered by painting and making frames in a tiny enclosed space—Dove and Reds decided they had spent their last winter on the boat. In the middle of November, they moved into a house in Halesite.

In his next letter, Dove sent Stieglitz a statement (which he had

already read to Stieglitz over the phone) for the gallery brochure of his next exhibition. Dove also suggested wording for a letter to Phillips, whom they were conspiring to lure back to the gallery after the many months since his break with Stieglitz over the six-thousand-dollar Marin painting.

Two weeks before he wrote this next letter to Stieglitz, Dove had taken paintings to the gallery. At that time, Stieglitz had pronounced Reds's work too "frail" to be shown with Dove's. In her diary the next day, Reds expressed her disappointment by noting that she was "feeling rather sunk" over her work. However, on the same day that Stieglitz's last letter arrived, one (now lost) also arrived from Stieglitz for Reds. This letter reported that O'Keeffe was arranging for fifteen of Reds's paintings to be shown at the Opportunity Gallery.

<div style="text-align: right">

[Halesite]
[25 November 1927]

</div>

Dear Stieglitz

Here is the idea I read you over the phone. If you and Georgia can suggest any simplification, please do.

You spoke of writing Phillips.

What do you think of the following?

> Dear Mr. Phillips
>
> There will be a book enclosed which may be useful to you apropos of our correspondence of a while ago. It may be useful anyway as it has to me. You may already have it.
>
> Knowing that you were interested in my painting I am sending also a line as to the most recent. If you care to see them, I can meet you in the Gallery, alone, if you prefer.
>
> You may enjoy them and I should be much pleased to have you.
>
> Be perfectly free to say what you feel as this is entirely a belief in the future which is concerned with time only. If that could be eliminated we should all know everything.
>
> <div style="text-align: right">Very truly yours,</div>

Aren't words the devil? I should enclose a book. Toch's "How to Paint Permanent Pictures"[1] speaking of "mat" varnishes about which he was so concerned in connection with the "Golden Storm."

Hope you will like "An Idea." It was condensed from a sheet of six feet in length.

Reds is writing Georgia. That was fine of her. Reds understood. We are all working for the same things.

Love to you both.

As ever
Dove

1. Maximilian Toch, *Materials for Permanent Painting; A Manual for Manufacturers, Art Dealers, Artists and Collectors* (New York: D. Van Nostrand, 1911).

Dove had spent several days, including Thanksgiving, writing "An Idea," which Reds described as "a difficult job."[1] It appeared in the gallery brochure in the form that follows.

1. Diary of Helen Torr Dove, 24 November 1927.

An Idea

Why not make things look like nature? Because I do not consider that important and it is my nature to make them this way. To me it is perfectly natural. They exist in themselves, as an object does in nature.

The music things were done to speed the line up to the pace at which we live today. The line is the result of reducing dimension from the solid to the plane then to the point. A moving point could follow a waterfall and dance. We have the scientific proof that the eye sees everything best at one point.

I should like to take wind and water and sand as a motif and work with them, but it has to be simplified in most cases to color and force lines and substances, just as music has done with sound.

The choice of motif has been departed from in some of the paintings to express sentimental humor and a strained condition.

The force lines of a tree seem to me to be more important than its monumental bulk. When mariners say "The wind has weight," a line seems to express that better than bulk.

The colors in the painting "Running River" were chosen looking down into a stream. The red and yellow from the wet stones and the green from moss with black and white. The line was a moving point

reducing the moving volume to one dimension. From then on it is expressed in terms of color as music is in terms of sound.

As the point moves it becomes a line, as the line moves it becomes a plane, as the plane moves, it becomes a solid, as the solid moves, it becomes life and as life moves, it becomes the present.

<div align="right">Arthur G. Dove</div>

<div align="right">[New York City]
7 December 1927</div>

Dear Dove: Demuth enjoys your work.—We were looking at it today.—I enjoy it too. I hope others will too—& some sufficiently to enjoy giving up some cash in exchange.

I hope Reds is OK again.

Our love. In haste

<div align="right">St.</div>

Invitations [to Dove's show] have gone out.

Phillips had replied to Dove's letter that it would be "out of the question" to visit his exhibition at The Intimate Gallery because he was busy in Washington and because "Mr. Stieglitz and I had a serious misunderstanding last year and he treated me in a way which I cannot easily forgive." He went on to say that "perhaps in time he will feel like telling me how sorry he is and if that time comes I shall be able to resume my active and wholehearted interest in the work of the artists who exhibit under his patronage." Phillips then invited Dove to "send down one or two little things which are particularly fine in color and design and not 'too difficult'" after the exhibition closed. "I shall be glad to study them and enjoy them for a while," he added. "I would not promise to purchase any because I have spent so much already that there are no funds available for a long time to come."[1]

Dove shared the letter with Stieglitz, who wrote to Phillips on Christmas morning. "I can assure you that I regret exceedingly that I appear to be the cause of your not being able to see his [Dove's] work in The Room," he stated. "If you will let me know what I have done which is to be forgiven I will certainly ask your forgiveness."[2] That was enough for Phillips. He wrote back saying that he did not wish to revive

the "unfortunate controversy" and that he and Mrs. Phillips would visit
the Dove show.[3]

1. Duncan Phillips to Dove, 19 December 1927, Collection of American Liter-
 ature, Beinecke Rare Book and Manuscript Library, Yale University, New
 Haven.
2. Stieglitz to Duncan Phillips, 25 December 1927, Phillips Collection, Wash-
 ington, D.C.
3. Duncan Phillips to Stieglitz, 29 December 1927, Collection of American
 Literature, Beinecke Rare Book and Manuscript Library, Yale University,
 New Haven.

Stieglitz's next letter was written on the last day of Dove's show, just
after Phillips and his wife had put in an appearance. At the time,
O'Keeffe was in the hospital, recuperating from surgery performed just
over a week before; although cancer had been feared, only a cyst was
found.

[New York City]
7 January 1928

Dear Dove: Phillips has just left. His wife too. Here nearly two hours.
Much excited. A real debauch. Looks badly. So does Mrs. P.—Saw your
things. Also asked for Marin & O'Keeffe. Too bad he has spent all his
money so far ahead. He would have bought much. As it is he has taken
the small "Huntington Harbor." Wanted "Something in Brown, Car-
mine & Blue"—and "Rhythm Rag" & "Just Painting"—but felt he was
going beyond his depths in taking one.—I don't know when he'll
pay.—

Raleigh & Holly were in day before yesterday afternoon. . . . All in
all, you will net more than the thousand you said you'd take for the
lot.—

Georgia is still in the hospital. But much better. A question now of
"nerves" building up.—

As long as I stay on my feet, everything can be kept going.—

—Well, I'm glad the Phillips matter has been cleared up. I dislike
animosities.—Life is too short. . . .

Stieglitz

[New York City]
13 January 1928

My dear Dove:

. . . . News there is none. Georgia is gaining strength slowly. Her Show has hardly begun. But all who have seen it feel it is magnificent.—

Our love to you & Reds.—

In haste
Stieglitz

[New York City]
27 March 1928

Dear Dove: Enclosed [check] speaks for itself.—I know it will help you towards a bit of peace of mind.—Strand has taken the painting.

The Bacons are up.—There is much surprise & amusement ahead. Our love to you & Reds

Stieglitz

In May, Dove and Reds move back onto the *Mona,* their sailboat, but Dove continued to do much of his painting on shore. He worked in a small yacht club where they later spent three winters.

During the previous months, they had occasionally seen Stieglitz at the gallery. On 19 May, when they stopped there briefly, Stieglitz was already preoccupied with things he needed to do before his intended 3 June departure for Lake George.

[New York City]
24 May 1928

Dear Dove: I was terribly sorry that I was in such a rush when you & Reds were in.—I was at my wits' end.—There is so much to be done before June 3rd. I had no chance all Winter to attend to anything for myself.—Now I must.—And ever the damned packing & storage.—

I hope that you are getting a chance to paint.—I wonder.

My love to you & Reds

Stieglitz

[Halesite]
[20 or 21 June 1928]

Dear Stieglitz and Georgia

Have you become used to the country yet? We have so much so that it becomes a terrible strain now to go to New York. Have to start in looking for work to do tomorrow. Hope they have not forgotten my existence.

Reds captured a beauty yesterday and has discovered that she is a miser. That is, when the materials cost nothing the work is much freer. She was making what she thought a sketch for a painting in oil on paper. I told her the first thing she knew something fine would happen, and sure enough, there it is on paper. She is doing it over on wood with some changes she has in mind.

As to my collection—There are five large paintings, some as large as $3' \times 4'$. One oil, three pastels and one in both mediums. One of these I showed Reds after she came back from Hartford where her mother has been very ill.—Heart. She rather gasped and said it was the biggest surprise she had seen. It is to me and is about as complete as anything I've ever done. Have been making the pastels to do them with. About four dozen carefully graded ones for each painting. That of course all takes time.

These new ones have what Brancusi[1] would call "The shock of reality."

There are also some "Things" in wood which I have hewn out of nature.

Two of the large paintings, I feel have the sensation of sound in them. As though some primitive had hit a tree with a club. They are not as yet framed but I can do that while doing other things, and wanted to get as much as possible done while this new feeling and the money lasted. . . .

You two have certainly earned some leisure to do with as you please. I hope you will both break through again to even higher light and I am looking forward to the work. Please do not let friends interrupt.

Had a fine note and two photographs, also catalogue from Lachaise yesterday. I wrote him at the time of his show[2] and he answered.

Have had several letters from Holly. They are in San Francisco with [Raleigh's] daughter. Dorothy is married again.[3] Everyone in the telephone book in Westport seems to have remarried and moved to each other's houses. Things are not that simple for us as yet.

My mother had a fall. Caught her crutch and says the expense of the

extra nurse hurt her worse than the fall. They are optimistic as a large factory has opened with a new financial backing near their 200 acres of city farm. It will take a lot of ice to keep their butter from melting, especially as they are using it.

Haven't worn glasses for over two months. It works and I can read fine print. Hope illustrating will not drive me back to them.[4]

Reds is better now. We have been getting more exercise and sunburn. Trust you and Georgia are.

Our love to you both.

<div style="text-align: right">As ever
Dove</div>

1. Brancusi had seen Dove's 1926 show.
2. At the Joseph Brummer Gallery in February and March 1928.
3. Raleigh's first wife, Dorothy, married Bruce McClure. He worked for *Elks* magazine, for which Dove often did illustrations.
4. Dove had been practicing a popular technique for improvement of vision, as espoused by Dr. W. H. Bates in *Perfect Sight Without Glasses,* published in 1920. O'Keeffe, who never had to wear glasses, also used the Bates method. Aldous Huxley's *The Art of Seeing* is based on the same technique.

Early in the summer, Stieglitz injured a finger, which was in a splint for weeks. He had strained it while pulling on his underwear.

<div style="text-align: right">Lake George
4 July 1928</div>

Dear Dove: My finger still in a splint you'll forgive any penmanship which may seem a bit peculiar.—

—Your letter came some time ago.—I have no idea whether days or weeks.—I know it can't be a month as we're not here that long. Our life is uneventful. Due to ourselves without doubt—unless you want to call a constant battling with batteries of ailments—old & new—physical & psychic—eventful!—I'm just beginning to feel a bit human—if permitted to function that natural—natural for me.—"Work" seems out of the question.—Georgia has painted a bit—not much. Much fussing about house—& place. All necessary I suppose.—I have mounted a few large prints that have been flying about for years. That's about the sum total of my "achievements" for the time up here. And I had *definitely* made up

my mind all Winter to come up here & let nothing interfere with getting to work at once.—So much for definite[ly] making up one's mind!—With me, it doesn't seem to work.—Not when it comes to my "own work."

. . . The coming season looks as it if were to be the last in Room 303. And so I want it to be still more intensely effective than former seasons.—That won't be easy.—What after this year heaven knows. My own problem is far from simple.—My own particular one may be simple enough—but—Well, I can see—but I refuse to worry about many things that would have driven me frantic formerly.—Energy for concentrating is not overplentiful these days.—

It is good to be away from the City. Whether it is good to be here or not I don't know.—So far I can see no substitute—so one scrapes along.—Maybe at best one is always relatively just scraping along.—

—My eyes being on a rampage, I read but little—& write but little too. . . .

—Well, Dove, you'll forgive these miserable lines & the minor key— My love to you & Reds.—

I hope the summer will not be particularly difficult for either of you.—

Your old
Stieglitz

Dove's next letter suggests his emerging difficulties with finances and illustration. Within the year, he came to the conclusion, only hinted at here, that scrounging for assignments at the magazines was not worth his time. However, if there were difficulties, the fortuitous appearance of A. W. Pratt solved the immediate problem of what to do for the winter. At the end of September, Dove and Reds took their boat across Long Island Sound to the Connecticut littoral, where they spent the next eight months rent-free as caretaker-tenants of Pratt's waterside cottage. This location at Noroton, just east of Stamford, is about the same distance from New York as Halesite. Regular train service made access to the city convenient.

[Halesite]
[23 August 1928]

Dear Stieglitz and Georgia
Have just been over looking at the paintings we have stored in the

Yacht Club closet. Put them all out in a large sort of dance room and here is the verdict for mine. Reds does not want me to talk about hers yet. I think however that they (hers) are by far the best, much bigger in size and dimension. There were some of mine there that I think would stop traffic anywhere. Two of them I do not think now that I would trade for all the past ones. Hope nothing happens to them before you see them.

Reds has been "overhauled" again by Dr. Beck and he is giving her atrophine to get after the circulation which is more or less disturbing her.

How is your finger getting on?

Reds is trying to do some advertising things. They are liked but it will be Labor Day before people get back from their vacations.

I have been "promised" lots of work.

Hauptmüller—"McClure's"—promised me a definite story which editor did not buy, but I can rely upon him later. Has always done as he said, if possible. (German.) Steinmetz, "Pict. Review" likewise. (Jew.) Am trying the "New Yorker." Part of them liked one, but you have to run the gauntlet of four of them before landing. Practically working on speculation. They want me to work for them however. There is quite a field for humor such as the "Sat. Eve. Post" publishes which the "New Yorker" people call "unbelievable," but that is a whole business in itself. And requires hearse, frock coat, white gloves and the whole outfit.

Even financially I could make more painting.

The rub is to be able to last through another month until the "promising" people get back from their vacations when I do not anticipate much trouble in getting work. It seems such a waste of time now to be peddling a lot of silly jokes.

"Life" is getting hopeless, trying to keep pace with "Punch" and the "New Yorker" at the same time.

I wonder if the Strands could easily spare the remaining $75. They have been too fine about it all to ask them for it without knowing their situation. If that seems not best, is the room in shape to loan $25 each on four large paintings—3 pastels, 1 oil? Valuing them according to the ones that have been sold, should set two at $1000 each and the other at $600.

I can get by probably all right without any advance but it is just what seems most practical to all concerned—mostly yourself.

There is a man here I believe who is thinking of buying our boat. We have advertised it for sale. Need a bit more room. What follows happened yesterday so am sending it along.

[Dove's typed enclosure follows]

This is a strange day.

Waking at 3:30 A.M. the whole thing became a sort of questioning of spirit.

Last night I told two men where to anchor. One a sensitive type of Jew, and one an American looking more or less like Sherwood Anderson. This morning I met them again in the grocery store.

They had a beautiful boat.

The Sherwood-looking man asked me if I lived on the boat. I said "Yes all the year round for seven years, except last winter." The person whose name I knew not as yet said, "If you like the water that much, come across the Sound. I should like to have someone there. I have several cottages and two islands."

That he knew some friends was a fact unimportant.

He said, "I am not in business. I'm a retired fool." A rather sad, strong humorous person who is very fond of the sea. An human naturalist if that would be a description.

There was some sort of spirit about them, some might call it psychic strength. Well anyway, the tall one turns out to be a rather husky idealist, more interested in all sorts of action than art.

He described some rescues off the point there that were amazingly real. It is hard to give the simplicity of the telling. Diving for people who looked near under water, but were too far away, then coming to the surface and diving again.

He insists upon coming for us either in his boat or car to move us into one of his houses for the winter, just to keep a light burning in his house so that the islands will look inhabited. There is everything there including light, heat, water and enough to pay for food, if we "Are not too proud to take it." "Ways" to haul the boat, and a yacht basin. Some of the coincidences were strange. For instance on a birthday I had told Reds that I might like a "Protractor," a sort of course-finding instrument that I has seen advertised. He makes them and presented me with one, and now we are supposed to be agents for them.

We are hauled out this afternoon. Have to paint the hull tomorrow. . . .

There is a causeway to these Pratt Islands just east of Shippan Point.

Rather near to Norwalk etc. Perhaps that is well on Bill's account. Shall have to hold back the hundred this month for the first time.[1] It may be all working out. The inn [in Westport] is sold I hear. Bill says he

will wait until later to look for work as N.Y. is not so good now. He may understand.

We told this Mr. Pratt about not liking to illustrate and what we were trying to do. He spoke of interior decoration and offered us a house to work on, also a job at painting (house) if we needed it. He is a friend of Duncan Phillips. Said they make the Milk of Magnesia in their backyard near them. . . .

It is late so must to bed for tomorrow is a hard day's job. Everybody in N.Y. away on vacations so am trying to get the boat work done to be free to work again.

With love to you both from us both

<div align="right">

As ever
Dove

</div>

1. Support payment for his son Bill.

For Stieglitz and O'Keeffe, events of the 1928 summer presaged much to come. Around the first of September, Stieglitz suffered what may have been a heart attack; in any event, angina signaled the onset of the gradually debilitating heart condition of his elder years. Before his illness, O'Keeffe had spent a month in Wisconsin, visiting two beloved aunts and a brother and a sister. This trip, to another part of the country, foreshadowed her future habit of spending summers away from Stieglitz. In years to come, she nearly always went off on her own (usually to the Southwest) early in the summer. Normally, she rejoined Stieglitz toward the end of summer (about the time the rest of the family left) and remained at the lake with him until October or November.

<div align="right">

Lake George
25 August 1928

</div>

Dear Dove: I hasten to answer your letter which just arrived. First of all I'm enclosing a check for $200.—Your "account" can be straightened out in time.—There is no need to "bother" Strand nor for you to give collateral in shape of paintings.

. . . . Georgia was in Wisconsin for nearly 4 weeks—her old home & very old aunts.—Hadn't been there in 12 years.—The Hill has been peaceful. We've had no visitors. While G. was away I was virtually

alone.—My finger bothered me very much. Couldn't write for weeks without agony.—Even now the finger is in bad shape. A surgeon will have to get at it in town. But it doesn't pain as it did.—A bit more of me crippled. That's all.—So I have done no new photography.—I have mounted about 100 old prints. That's all I have done so far this summer. And I had looked forward to many things!—But it's all right. I have no kick coming.—

Of course The Room—the coming season—the probability of the end of that place by June next.[1]—Another place?—Kennerley's interest made this one possible. As Haviland's saved "291" in 1908[2]—But I'm not worrying.—I want the Winter to be a full one.—Will there be people who'll give the artists some cash so that they can go ahead & work?—I never know.—I'll do my best for all.—As always—even tho' many doubt this to be true.—

Our love to you & Reds—

<div style="text-align:right">

Your old
Stieglitz

</div>

1. It was expected that the building would be torn down.
2. Paul Haviland rescued 291 financially in 1908.

<div style="text-align:right">

[Halesite]
[27 August 1928]

</div>

Dear Stieglitz and Georgia

Your fine response to the letter just came and while I can't say that I am surprised—being used by now to your ways of doing things—I surely am very grateful.

The people who give out work on the magazines are usually nice but when I see some of the hard-boiled owners stalk through the buildings like heavy armored trucks I think we are pretty lucky to have any chance at all. As I was waiting in the "Pict. Rev." the other day Anheldt, the owner, did that and I spoke to the man at the desk saying "That is the owner isn't it." He said "Yes, doesn't he look it?" The editors make the promises but he just turns his thumbs up or down. Suppose I should have more respect for "Gift horses." . . .

Reds has really been hungry in the last few days for the first time in more than a year. It may be the circulation.

Am wondering if Georgia wanted to see how far she had traveled in

12 years. Just can't imagine her playing with aunts. Of course I do not know the aunts.

Mary, Reds' sister, has just married a George Rehm, newspaperman in Paris. He sounds good. They are very happy.

We are wondering when our new Mr. Pratt will show up. Think it would be wise to accept as soon after Labor Day as possible and get settled. It may never happen, but we all seem to hope that it will, including Mr. Pratt.

Our love to you both and many thankful thanks to you and for you.

As ever
Dove

Pratt Islands
Noroton, Conn.
[Mid-October 1928]

Dear Stieglitz and Georgia

It all seems to be happening. This thing of these beautiful islands just as was said.

We have moved here, there is the yacht basin to keep the boat in, a quite beautiful house to live in, and Mr. Pratt seems to be a willing taxi and general handyman. Does most of the worrying except about work of which he seems not to have any idea as yet.

Have not told him our situation[1] but do not think it will make a difference.

The four paintings I took to 303 before we came. Found a truck driver who took the paintings and myself in for 2.00. It took all day but was worth it.

Here is a bit of the conversation with the truckman.

T.D. "What kind of paintings do you do?"

D. "They call them "modern"—"abstract"—etc. I'm working on an idea."

T.D. "Are you acquainted with the drawings of William Blake?"

D. "Yes—And the poems?"

T.D. "They are absolutely beautiful".

His wife made us some sandwiches at their store. He gave his wife and a very small dog a ride as far as the gate. Said the dog would be just as happy as though he had ridden all day.

We then picked up a lot of trunks and furniture and fruit and laundry

at some country place and then went back for a glass of paint he had promised some woman to do over a chair with.

D. "Aren't you quite interested in some philosophy?"

T.D. "Yes, I am. It is my whole life. I live in this world but am not quite a part of it."

Told him more about the painting and he said he was trying to do the same thing with his life. Seemed to understand each phase with no effort.

We moved furniture again. It was a hot day and the trunks were heavy. The fat man, a very pleasant German who owned the trunks, couldn't lift one end. So the truck man, Mr. Eckert, and I carried the things in and out of places.

By now my collar and shirt had wilted and I was becoming quite unmagazine office in my appearance. Had intended to hunt for work.

We went to have his brakes fixed. He thought it would take 15 minutes. It took two hours and a half. But he hoped it would not inconvenience me.

Of course in between trunks, folding beds etc. we talked philosophy. Reds and I felt something sensitive in the way he loaded the paintings and wrapped them, before we started. He owned most of the works of Nietzsche, Bergson, had read the Hindu, Chinese, and Eastern philosophy, all of the modern Russians. Goes to Brentano's and gets the things that he can't get at the N. Y. library.

We arrived at the Gallery at 4:30. He wants to come in some day. Told him you would be glad to have him.

Raleigh, by the way has offered me $5000, for as long as I want it. Says I am very foolish to struggle so hard when it is not necessary. They have bought a place in Monterey, Cal. and everything is peaceful so Holly says.—When they are there. They want us to take a trip out to see it. And work. What do you think of it? Of course he may change his mind.

As to mine, I have a whole new, for me, line of thought I want to work out. It is a continuation of the last show with what has been done this year in solidity along with contrasts that should give some results in dimension. Am very eager to try it all out. So much so that any hesitancy about making it possible seems almost nil.

Have been waiting to know Mr. Pratt before telling him all about ourselves. Perhaps he knows. It may be the same situation for all I know. There is a lady and he owns land in Westport. He is intent on saving money for us (Stamford is about one-third cheaper than L.I.), is

rather thoughtful about these jobs he offers not interfering with our other work.

The house here is old and fine, as is the island. He has been offered $2000 for it for next summer so we feel rather luxurious even though it may not be as warm in the winter. . . .

Love to you both from Reds and me.

This place is making a new woman of her. Wish you could see it in this weather.

<div style="text-align: right">As ever
Dove</div>

1. Not being married.

<div style="text-align: right">Lake George
18 October 1928</div>

My dear Dove: I'd accept the $5000 if he [Raleigh] really means it. And feel under no obligations.—I know it's ticklish business this acceptance of moneys. But I feel that if it will give you & Reds a chance to work as free men never mind the ticklishness. You have gone thru' your apprenticeship. So has Reds. And you & she have "given" very much to Raleigh & Holly they can never "pay" for in dollars. Of course if you see your way clear to be "free" without, so much the better.—I would not, under any conditions, lose complete contact with the publishing game. But I would give up being a slave to it if I had some other work I felt I *must do*.

I have been ill for 6 weeks.—Heart trouble.—Over 3 weeks in bed—2 nurses, Dr. sometimes twice a day—etc., etc.—Absolute isolation.— But I'm on the mend—still pretty shaky.—Am doing all I can to build up to report for duty early in/or middle of November. I'll have to spare spending myself too lavishly on Tom, Dick & Jane. It will be very difficult but I'll manage.—Naturally Georgia has had a trying time because of me. I was in shape to use my hand—& that very same night my heart started off on trot, pace & gallop simultaneously—& at a record-breaking speed.

Well, I guess the years & years of strain did bring about the Halt.

—So my "summer" has been without anything to "show" for it. Georgia has done some fine things—mostly small sizes.—It's a wonder she has anything.—

I mustn't write more now.—
Our love to you both

As always, your old
Stieglitz

[Noroton]
[20 October 1928]

Dear Stieglitz

It is certainly amazing, or would be from anyone else, to have a letter answered so promptly and so impersonally thoughtfully after the summer you have spent. We were both hit quite hard by your letter. Really loved it. It is a relief to know that you are better.

Looking out through the oak and pine trees I seem to feel that you are all right, anyway that is the way we want to feel and know is so, no matter what.

Am sending you a book Reds found that we like. [James] Joyce is certainly quite a person. "transition" gives quite an idea of what is going on. . . .

He [Raleigh] was very fine about it all. Seems in quite a different frame of mind again. Said his disposition would have been much finer had he accepted help instead of trying to do it all himself. Spoke of things he had done at 15 that were quite pure. Feels perhaps that life has hardened him.

I told Raleigh practically the same thing you have suggested, with the added thing that it should be put in "trust" so that if anything happened it would not be misdirected from the use he had intended.

He really seemed delighted that we were willing to accept.

Shall keep trying with the magazines. They have all changed. "Me too" of course.

It is fine that Georgia has been able to work. Her things looked quite beautiful in the room the day I went in.

Do not try to write, if you need rest.

Everything seems to have cleared this month. I only hope it will with you.

Much love to you and Georgia from us

As ever
Dove

If Georgia could drop a postcard as to how you are now and then we

should appreciate it. It is the first we had known of your illness. Hope it has gone.

Lake George
22 October 1928

Dear Dove & Reds: . . . I am much stronger. But still with several brakes on.—Your letter just to hand.—Also "transition" No. 13. Am returning latter. Thanks very much.—Have a copy. When I was put (ordered) to bed & Georgia asked is there anything you wish done, one of the few things was (perhaps first) "write to Brentano's & ask them to send up any new 'transition' that might be out."—I "felt" one must be out & "transition" has always interested me as a live thing—one of the very few printed ones. . . .

—I'm glad you decided about Raleigh's offer as you did.—It's fine.—Raleigh is all right—given half a chance. Who isn't? given a fraction of a chance.

But it takes patience (lots of it) & a bit of something else, to let the living thing actually develop.—

—We have set no day for our return.—I'd like to slip into N.Y. unannounced & as a "well" man—ready to continue on the job (self-imposed willingly).—

The days have been warm & full of rich color—& peaceful.—

There is gradual packing.—

I read a bit—just finished quite a remarkable MS of [Jean] Toomer's.[1] Write a few letters—starting the contacts—which really I never lost. . . .

Our love to both of you.—

Stieglitz

It will amuse you to hear too that when I saw your package I knew what was in it.—Of course, that was "easy."—

1. Jean Toomer (1894–1967) was a racially mixed American writer associated with the Harlem Renaissance. His major work, the experimental novel *Cane,* was published in 1923.

[Noroton]
[6/8 November 1928]

Dear Stieglitz and Georgia

. . . . Went to the "transition" agency here to get the last number for you but they said "Joyce was late with his copy so there was no publication as yet." Sent the one you had to the Davidsons. It *is* interesting. To Europeans leisure is a necessity. It would seem that in so prosperous a country as America, that there should be more. . . .

This place is really in a way "The top of the world." Mr. Pratt seems a very sensitive person more or less controlled by his aunt who was, I imagine, fine with a vivid respect for "artists." He is 100% Am[erican] with possibilities. Nice—thoughtful, practical, and in any emergency on the water—all man.

Rather diffident about ideas. You will know when you see him. Reds breaks out with "His aunt's artists worked on the 'Delineator.'" Having worked for worse magazines myself, it looks as though she wins.

From what I have seen recently, rather think that there is some of that first thing you felt in Holly. It will do no harm to save it.

Well ground might mean well grounded, if the so called mills grind fine enough.

Have just heard from Raleigh. I told him I had told you about the loan. He does not want it to go further on account his families, mine, and many other reasons. So, if you have not already spoken of it, it would be just as well not to. They are urging us to come out there for a few months. Living cheap and everyone says Monterey beautiful. Not this winter anyway.

Just finished [illustrating] a story[1] that went better than any in the last ten years. So many things have happened to take a load off the old bean, that I hope it will show in the painting. Trying to start again today.

The way to start is to start, isn't it?

Hope you are much better. Will write soon. Love to you both from us.

As ever
Dove

1. For *Elks* magazine, for which he often worked in the twenties.

Early in November, Stieglitz and O'Keeffe returned to New York. Despite the need to "spare" himself, Stieglitz was well enough to open

the Marin show within a few days. In this last season of The Intimate Gallery, Stieglitz presented six exhibitions—the work of all of the "Seven Americans" except himself. Marin, Hartley, O'Keeffe, Strand, Dove, and Demuth appeared in that order. Since Stieglitz really did not intend to go on in the gallery business, the season's schedule was his final salute to the six other artists who had paved the way for the opening of The Intimate Gallery by making an impressive showing at the Anderson Galleries in 1925. At the end of the 1928–29 season, Stieglitz put into storage hundreds of paintings remaining at the gallery. Only later did friends prevail upon him to continue with his third and final gallery.

[New York City]
11 November 1928

Dear Dove: The Marin Show is ready!—Opens for Press tomorrow.—I shall try to keep "fit." I have come to the conclusion that Georgia & I together hardly make up one "fit" human.—She is in bed today. Sinus! So it goes.—The vicious circle. I have lived in it for the last 35 years.—It's trying for all concerned.—So all that's left is for me to make an effort to achieve a bit of Common Sense!—

No one knows anything about Raleigh's fine bit of friendship. That is, no one but Georgia.—And no one will hear anything from us.—So please tell him.—I'm glad you & Reds are fairly well situated. Our love.

Stieglitz

[Noroton]
[Early 1929]

Dear Stieglitz

Sunday noon.—We have several of the paintings out and are looking at them. Thinking of everything that is best to do. Also have been reading of you in the "Times"—rather good.

Told you I would be in tomorrow or Tuesday. Think it would conserve more time to stay right here and work. Something gets finished every day or so or a new one started. There are two up here now that are better, I am sure, than anything yet of mine. One just didn't work with the copper frames so evolved one from plastic wood. It is quite a beauty—will I think stand white walls and clean severity.

Have four more going. So even think best not to let even the finest person I know draw me from the thing or to the thing that time makes so important just now.

Somehow have always felt or had to feel two things. One and its results now should be sufficient. Life is more simple & quite some chores are done. You need not worry about 15–16 or perhaps 20 within the month.

It was rather humorous, in one way, that in a few words over the phone that I should have spoken of a French painter, however. When I see McBride talk of [Stuart] Davis's "painting French"[1] and never thinking of the French painting Congo, well I guess that just isn't done. The toys are too old for the people. They play a while, get enthusiastic and then go back to the ones they are used to. What we need is more generations. That too takes time.

Shall I bring in some things soon, so that you can be looking them over, or would it be better to bring them all in at once?

Every day I feel that I should come in for so many reasons and the next morning, "Well these things must be done now."

With love to you and Georgia

<div style="text-align: right">As ever
Dove</div>

Letter from Sherwood Anderson last night. He is single again, in the South. "No hearth, no clock to wind" & son is running the papers.[2] . . .

1. Davis had been in Paris for some months. (See Glossary of Names.)
2. Anderson's third marriage, to Elizabeth Prall, was breaking up at this time. Two years before, he had bought the two weekly newspapers in Marion, Virginia, and had edited them since then.

<div style="text-align: right">[Noroton]
[27 February 1929]</div>

Dear Stieglitz

Here is a list of the paintings so far since last year's show. Things are moving quite a bit faster and work is beginning to feed itself now that the illustrations are off chest for the time. One week out for flu, and quite a bit of worry over Bill who is in a condition[1] such as yours was last summer.

Am sending you this list so that you can decide what is best. Think, if there is a chance of even a short show, I mean less than a month, that I can have plenty for a larger one next year. You will know what to think. Am just telling you this end of it in case there is a chance. If you understand the chances financial etc. I have to take and the factor that time becomes, you will know why there is only time to announce results with hardly any for explanations, or even to be in New York to talk about it.

About Raleigh keeping on, hope for the best. Part came and more promised, but they are in quite a jam again. Holly in hospital in N.Y. trying to keep child that she now at this late hour does not want. He talking divorce and she through. That was a few days ago. By now they may be happily on their way to California again in an airplane. He was going to fly to her at Christmas time but did not like the aviator's hat to whom check for $3200 had been made out.

Am just saying this for you and Georgia so that if anyone comes to you, you will have three "observations" by which to make a "fix" of the ship's position nautically speaking.

Mr. Pratt still fine to us. Should have brought him in before to 303 but he is not that kind of a wealthy person. Just wants paintings of boats (but for about what the paint and canvas would cost).

Strands and Lachaises spoke of coming out, but have just worked up to the last minute hoping I could get enough done, should there be room for a short show.

No. 15 [*Distraction*] for instance is new again (or old). Just hope I can keep it that fresh.

Have the frames ready except soldering. A few days will do that.

If you are too busy please do not bother to answer as I shall go on anyway for another month probably. They are evolving at the rate of one every few days. Anything may happen of course, but hope it will be mostly paintings.

Reds is working and happy—looks better than I have ever seen her.

Hope to bring in some paintings someday soon and see the O'Keeffes.

Our love to you both.

As ever
Dove

Have pages of typewritten *ideas* in the form of a diary at present.

1. Bill suffered from a thyroid gland disorder known as Graves' disease; he
fully recovered.

Stieglitz's next letter to Dove skirts difficulties in his and O'Keeffe's
lives. While his own health had improved gradually since his heart
problems in 1928, O'Keeffe had been unable to paint much of the
winter. Her 1929 show included some canvases from previous years,
and despite Stieglitz's report to Dove, the show was not well received
by the critics.

<div align="right">

The Room
1 March 1929

</div>

Dear Dove

Too bad that you too must be surrounded by illness. The whole
country seems afflicted in one way or another. Georgia has just gotten
over the flu. Has virtually done no painting all this winter so far but
feels much better.

I've been on the job in the Room. All my energies are focussed on
that. I am glad to know that you have been working in spite of
handicaps.

Too bad about Holly and Raleigh and their idiosyncrasies. Without
them I suppose life would mean nothing to them.

As for showing your pictures this spring, I wonder. So many people
are sick. Or away. Although over 6000 people have been to see the
O'Keeffes[1] and they are considered "better" than ever, if it weren't for
one man acquiring several, nothing whatsoever would have happened
so far. Happened in a practical sense which means dollars and cents.

There is still no evidence that we'll have the Room beyond June 1, and
as for next year I have no idea unless the Room still be ours. If I were
sure that the Room would be ours I would advise you under all
conditions to wait till next year and then make a big splurge. For I have
decided that no matter what happen[s] there will be no O'Keeffe show
next year.[2] I would then make your exhibition the feature after the usual
annual Marin performance. But as next year is so uncertain maybe
you'd prefer to take a chance this spring.

In order to bring about a real break after Georgia's show I am going
to put up Strand's photographs for a couple of weeks. . . . If you want

to come after Strand and take your chances you will have the right of
way. . . . You need not decide now. There is still two or three weeks'
time to come to a decision. Maybe by that time we'll know more about
the Room as far as next year is concerned.

　With our love,

<div align="right">Stieglitz</div>

1. O'Keeffe's exhibition at The Intimate Gallery had opened 4 February.
2. Nevertheless, O'Keeffe did have a show at Stieglitz's new gallery, An
American Place, in February and March 1930.

<div align="right">

Pratt Islands
Noroton, Conn.
[18 or 19 March 1929]

</div>

Dear Stieglitz

　Thank you for your fine letter. You left me two or three weeks in
which to decide about having a show now, that is on the 7th, or waiting
for next year to have a big one. Have about decided to do both and
think I see the way clear unless something unusual prevents.

　Have twelve things here now, two of which need a little more work,
two or three days. They are all framed, the frames "buffed" and
lacquered. Buffed them in the machine shop of a friend of Mr. Pratt's.

　. . . . We so regret not having seen Georgia's things all hung but have
just stuck at it here with the exception of Saturday afternoon and
Sunday morning when the Raleighs telephoned they wanted to come.

　Everything peaceful now as they have decided not to try to populate
the earth and he seems much relieved. Think he intends to keep up the 5
"grand" idea.

　Hope to get about three more paintings before the 7th. The canvases
are ready, stretched canvas while the visitors were here. The Raleighs
quite raved over them and thought them far ahead of anything before.

　If all these can be accomplished in one month of "freedom" think I
ought to have 50 by next fall if can be *free*.

　Reds is doing quite a bit, some that are fine in pure design.

　Our love to you both

<div align="right">

As ever
Dove

</div>

[New York City]
27 March 1929

Dear Dove: Very fine.—Am looking forward to the paintings. When I see them I'll decide upon dates.—You'll probably come next.—Ought to make a grand Show—but with Wall Street in a smash—& many people away—I wonder about the possible happenings.—I'd hate to see a real live Show ignored! Or relatively ignored. But I understand how you feel—so I'm ready to accompany you.—

Our love to you both—

ever your old
Stieglitz

Dove and Reds took his recent paintings to The Intimate Gallery on 29 March 1929.

[Noroton]
[31 March/3 April 1929]

Dear Stieglitz and Georgia

Just telephoned the gallery and Strand tells me you are home with a cold. We were worried about you the other day. Had told Reds we must not stay and let you talk any more than necessary. We do hope this is not one of those continued flu things. It stuck to me for some time after.

Have one more painting, pastel 20 × 20, which is not as yet framed. Just done in fact. Brilliant blue, brown etc.

The effect of 303 on the paintings was quite amazing. The red tree [*Red Tree and Sun*] is twice the size at 303 that it was here. The "Silver Sun" about ¾. The "Reaching Waves" about ½ as to here. Sea Gulls [*Sea Gull Motif,* or *Violet and Green*] were about 5 to 1 as to that house in Halesite where it was done. "Distraction" 1 = 1. Of course, the room is high, superbly so in spirit.

Think I shall use outdoors as a studio this year, to be sure that the ceiling is high enough.

Could see by the polished nickel and perfection of the cars on the way home how true you were in saying that the tendency of today was "classic" and that I was going against it, but the truth is that I am probably trying to do it in a harder way. Seem always to take the hardest way to do things.

Arthur Dove, Distraction, *1929.* (Whitney Museum of American Art, New York. Geoffrey Clements photo.)

Still feel a certain strain in trying to produce when I see my things there. Hope that will disappear this year. Cannot call it absence of protection, because, if it had not been for your tenacity these so-called "children" might have had no age and still be stillborn in the mind. As we left the gallery, Reds said to me, "He is the greatest man I have ever known." Do not usually carry tales, but thought this worthwhile carrying. . . .

As ever
Dove

[New York City]
4 April 1929

Dear Dove: I was back at The Room again today.—A bit washed out but on the job. Had a rotten time of it for a few days—coughing my head off.—Should have been in bed all last week. But when I'm not on the job—what then?—

Your Announcements will be out tomorrow—delayed a day but still in time. Your "Show" will look fine. I'm looking forward to it.

When I remarked that you were moving "contra stream" I didn't wish to infer that you should follow any way but your own natural one. I did wish to say that one dare "expect" damned little support from picture buyers.—Not that there are many coming to The Room at best. With just a tiny bit of luck you may find a few admirers who will back up their admiration. But I know nothing. And I am a poor prophet these days.—I do like your work & your spirit. And I'll do my best. I can't fight as hard as formerly but if anything I'm more determined.— May be wiser that way.—Again I don't know.—The Room will look very alive.—Fighting Marin's battle has been relatively simple. He is a much simpler person than you are. That is, his life less complicated.— And as for Georgia, "fighting" for her has been still easier. "Fighting" for Hartley has been nearly an impossible job.

This all means nothing. At best it's all a most difficult problem. But that's why it is so fascinating.—To "win" is next to impossible—but to keep going is possible—& in itself quite a triumph—which doesn't mean a success!. . .

—So Reds thinks I'm the "greatest" she has ever met. I guess she doesn't know so many people. Maybe she means I have an endless stamina. That is true.

<div style="text-align: right">

Your old
Stieglitz

</div>

Dove and Reds went to the gallery on 19 April 1929, taking with them the *March, April* pastel that Dove had finished just after their last visit in New York. They saw Lachaise, Beck Strand, and Donald Davidson there, as well as Stieglitz. In the afternoon, they went to a Grand Central Palace show, *National Alliance of Art and Industry—100 Important Paintings,* where they discovered that Dove's entry was hung on its side. Before returning home, they bought ten copies of the *New Yorker,* which had a write-up by Murdock Pemberton about Dove's show. Dove wrote the next letter to Stieglitz on the day after their outing.

<div style="text-align: right">

Pratt Islands
Noroton, Conn.
[20 April 1929]

</div>

Dear Stieglitz,

Your talk about the "Red Tree" was so keen a criticism that I have

been wondering what you felt. It was as true as everything else you do. You were right. You said you did not know why. I think I do.

Here it is. This is also life.

There was some Blockx's Vermillion which was left from those paints that Florence Cane gave. That seemed to be the only color that had the solidity that was needed. Cadmium and Vermillion do not mix, so I used another color on the ground. If I could have used the Cadmium and Vermillion to get the brown orange, the balance would have been perfect, that is in color.

The experience is worth what you felt.

We had a delightful day.

Went to Allied Arts and found pastel on end. Asked lady about it and she said "Are you sure?" Said that I ought to know as "I did it." It was changed.

Did you see announcement in forepart of New Yorker? Do anything you feel about Pemberton. They are yours as much as mine. Always act with that in mind. . . .

> As ever
> Reds and Dove

"Volunteers," "Conscription," "By hook or crook,"—Yes, we had a good time. Thank you.

> As ever
> Reds and Dove

> [New York City]
> 20 April 1929

Dear Dove: I'm glad that you & Reds liked the way The Room looked. But I'm chiefly writing you this to let you know that "March-April" has already been carried off—$200.—You were willing to take $100.— So with The Room's $800 in cash assured you, you have $1000 in cash ahead as far as The Room is concerned. This may help clear up some of your immediate problems. With love to you & Reds—

> ever your old
> S.

Pratt Islands
Noroton, Conn.
[22 April 1929]

Dear Stieglitz,

Your welcome letter just came. It is all beginning to get exciting. By that I do not mean that I have any hopes that we can go on freely.

That "New Yorker" article is certainly the noisiest little bit that has been done. Have been trying to write Pemberton a letter. So many people in all directions have called up and asked, "Have you seen the 'New Yorker'?". . .

Mrs. Trimble who was there the other day said she inquired in the Macbeth gallery where my paintings were and three men jumped up simultaneously and said "Room 303 Anderson Galleries." Your marvelous persistence in your beliefs or rather directions is really going to make me feel that sometime life after all is going to be really possible. You will understand that I mean.

We have been offered some houses in Westport, three in fact (too many friends), and an island in Maine, but this moving thing takes so much of time. Am now trying to get the top floor of the yacht club in Halesite for say $15 a month to save all this energy used in moving. When we can get a roomier boat we can be moving all the time without moving.

Have been wondering if Frank took the "March, April." Did he like the things this time?

A few days might tell at the end of this show, if you can spare it, weather clearing etc. You always know what to do.

Lov from us both, as ever,

Dove

[New York City]
23 April 1929

Dear Dove: . . . No, it wasn't Frank who bought your painting. It was Mrs. Norman.—Frank said he'd come again. Is full of his own problems.

Your explanation about the "Red Tree" is undoubtedly valid.

Our love. In haste.

Stieglitz

[New York City]
2 May 1929

Dear Dove: Georgia has gotten away & I am gradually getting settled down. . . . There is interest in your work.—Every day it is shown.—I have sent something to Phillips.—I feel one may happen there. Maybe two. At any rate whatever happens $1000 is guaranteed you by us.—You'll get some money shortly.—I do hope you'll be housed for the summer so that you can work—not necessarily at illustration!—I wish The Room question were settled one way or another. It would be so much easier all around.—

> Love to you and Reds
> Your old
> Stieglitz

Dove and Reds went to New York and had lunch with Stieglitz two days before Dove next wrote.

[Noroton]
[20 May 1929]

Dear Stieglitz,

Many thanks for the check. And all the other things you have done and are doing. Resolved to make my paintings "fool proof."

We are glad you thought we looked fit, didn't quite feel so as our train killed a young fellow as we pulled out from Stamford. Was in too much of a hurry.

. . . about the Strand thing. There was $75 due on that when I wrote you last summer, saying that I did not want to ask Strand as he had been so fine and might not have it. You advanced $200 which just about saved our lives—but as I see on the check ($200 Strand / $400 The Room) want to be sure that the account is straight. . . .

We loved being with you and listening but you must not try to do so much of that "except for us" as all the rest of the the world thinks. They will save you from everything but themselves.

Friends and the boat seem to be our most difficult problems. Perhaps we shall have to put distance between them.

If we get a place on shore and a smaller boat, your things that you want are always on shore when you need them. A large boat with a small storage place ashore would seem to be the solution. If we have no boat, I miss something of the storms and weather that seem to give me more.

We have about decided to go to Halesite and take the top floor of the Yacht Club. Keeping this boat will mean less work until fall in that combination and that is important just now.

If I can be of any help in 303 next week please let me know. That would be between the time of changing locations and the hauling out and what may come of the summer's painting.

Love to you from Reds and me

<div align="right">As ever
Dove</div>

Dove and Reds returned to Halesite on 23 May. There, they were able to live in the dockside boathouse that serves as the Ketewomeke Yacht Club. However, the boat remained their primary residence during the summers. After his show in April 1929, Dove did not again resume illustrating. As earlier letters suggested, the market for his drawings had been declining; now, except for rare assignments, Dove's career in illustration was over.

<div align="right">Halesite, N.Y.
[Probably 8 June 1929]</div>

Dear Stieglitz

. . . . Well, we are back here. It is much bigger country here on the whole and we are feeling more at home if that is possible. I wrote the secretary of this little yacht club here and offered them $15 a month for the top floor which is practically unused except for occasional dances. They called a meeting and gave us the top floor and use of the rest rent free just to have someone there. The room is full of light—about 30' × 40'—a bedroom off—toilet, lavatory, etc.—gas and electricity—and a wonderful view of the whole harbor, so our wish for a house on a dock where we could tie boat has come true. And we think it will work out for winter too. Have been enclosing stairway, doing floors etc. Was trying to get in to see you today but by the time all chores are done for Sat. & Sunday it is just noon. Have been trying to call you up at 303. . . .

The Raleighs have bought a place here. That cottage or barn has turned into a $14,000 place with speedboat that burns 35 gals. of gas per hour. He seems when well going to want to make her leave him, has told her that. Haven't seen him in action but saw the wreckage after he had gone to N.Y. She on the dock at 6 A.M. yelling for me.

I do not see how that house even is going to hold them and colored maid & 4 dogs.

The doctor who saw him told her it was not safe.

So as little as we are forced to absorb of their troubles will seemingly be the only handicap to a summer of work. This letter is drawn rather than written with pen and ink firing on about three cylinders. I fire, they fire, we fire, you fire, plan.

Nice letter from Sherwood Anderson. . . . Hope I can do my part this summer. That seems to be making me run between chores, as you are probably doing also. . . .

<div style="text-align: right">As ever
Dove</div>

Ever since her disappointing show in February, O'Keeffe must have been thinking seriously about going to the Southwest, where she had felt exuberantly alive years before. Her interest in the area was prodded by the titled Englishwoman Dorothy Brett, a writer and artist, who had followed D. H. Lawrence to Taos, New Mexico, and who now lived on his ranch outside of town. Visiting New York for several weeks during the winter, she urged Stieglitz and O'Keeffe to visit her. Further, Mabel Dodge Luhan and her silent, illiterate, brightly dressed and black-braided Indian spouse had showed up from Taos, where they always welcomed interesting visitors. O'Keeffe's passion for the spaciousness of the Southwest rekindled, she persuaded Beck Strand to go with her. The two arrived by train in Santa Fe early in May and were soon settled in a guest house on Mabel's property. Although their hostess actually spent most of the summer back in New York (she had returned there for surgery), O'Keeffe stayed until late August.

<div style="text-align: center">[New York City]
11 June 1929
[Probably should have been dated 9 June]</div>

Dear Dove: I leave for Lake George Friday A.M. . . .

—I'm frankly very tired. You shought to see this [Shelton Hotel]

Room (3003)—the floor covered with a Mountain of torn papers—the beds full of boxes & papers—the sofa covered with bags & valises— ditto chairs. An all-day job of things I hate to do. And Sunday at that— & I dislike Sundays.—I'll be glad to get away altho the Hill will seem a bit forlorn with Georgia not there. Still I'm glad she is where she is. Lake G. is not for her. . . .

Love to you & Reds.—

<div style="text-align: right">Stieglitz</div>

<div style="text-align: right">[Halesite]
[6 September 1929]</div>

Dear Stieglitz

It would seem that a report at least might be in order from me after all you have done. Have written just two letters since seeing you [on 12 June]—thought best to devote all time to finding out more things. It is not so damned easy to outdo the best of the past and then add something to even one's own work. Think perhaps I am getting over this rather personal conflict. And things are coming more easily as October comes nearer.

There are now about 12–15—not all finished but pretty well along. This month and next ought to tell.—Have one, now two that Reds thinks the best that have been done. Raleigh says one is a "masterpiece." Hope not.

The Yacht Club is a great help and all rent free.

The Raleighs are getting on fine, comparatively so. They like it here. Have bought home and lot next on the water, speedboat etc. He is much better. Holly is well along past the worst stage and as intent as ever on the child. Has written some—a bit more calm than before. They are still impatient. Very thoughtful and understanding.

Reds is in fine shape, about 10 pounds huskier. Doing some paintings—richer color, also some designs she hopes to sell for materials.

I am trying to work very slowly just now so that each bit will have thought and feeling—it gives just as much "speed" and more dimension. May not be as productive for the moment but probably will in the course of two more months. Have just been looking at some Negro sculpture reproductions—amazing what the Frenchmen have almost lifted from them.

We talk of you so often—wonder if you have a chance to work. It is

fine to be able to breathe freely for two months more. Hope nothing happens.

Can feel that Reds wants this pen as it is the only one in the Yacht Club.

With love to you and on to Georgia, best to Zoler, if there.

<div align="right">

as ever

Dove

</div>

Despite O'Keeffe's absence during the summer, Stieglitz felt reinvigorated at the lake. His next letter suggests a youthful fascination with the mechanical progress of the twenties. At sixty-five, he learned to drive a car, took his first airplane ride, and enjoyed listening to his favorite music on a phonograph.

In Taos, O'Keeffe, too, experienced an expansive summer. Not only had she been thrilled by the landscape, but she had met stimulating people and had acted on her new independence by learning to drive and buying a car. In late August, she joined Stieglitz at Lake George, where he had been since June, and they spent about two months together there.

<div align="right">

Lake George

9 September 1929

</div>

Dear Dove: It has been a very curious time for me.—Maybe the most trying in my whole experience. With Georgia away—and no Room—the Future—very ???—I took to flying.—Flew to New York.— If I were young enough I'd certainly get a machine.

I have also learned how to run a car.—So did Georgia out in New Mexico. And there is a very fine Victrola here & I have Brahms & Beethoven & Bach entertain me.—

It's all a new way for me.—And Georgia is finally here. Looking grand—had an amazing time—but is happy to be with me again—& I happy to have her.—

—Her paintings she sent to town.—So I have seen nothing.—She'll someday tell you & Reds about her trip. She certainly went a mad pace. Needed to.—

Says she is amazed at the "change" in me. Finds me so much younger & very different.—I also walked The Mountain. Doctors & everyone amazed at my activities.—Have photographed a bit—but material is

really so rotten to photograph is a torture. And I'm avoiding "torture" these days.—When I came up here spent several weeks burning up books & paper—negatives & prints. A wonder I didn't burn up cameras & even house— And collect no insurance. Just a real cleaning up.—And all without any resentment.—In a few days the Dr. & his wife leave & we'll be alone. The "summer" gone—hard to realize.

We have no "plans."—I'm "ready" for anything.—

It's good to hear that Raleigh & Lady are more adjusted—also that the Lady is writing. Of course she wants a baby.—Perfectly natural that she should want one.—I have had very much time to cut out all theories— "ideas" & "ideals" & look at life very squarely—without fear of self—or for self.—No one has ever been more relentless towards self than I have been all summer.—It is the only Teacher! It does take some nerve.

. . . Marin is still in Taos.—

Hartley returns to U.S.A. in February.[1]—And will paint in New England!!—

Strand spent several weeks here with me.—Was fine to have him.— Zoler here for 4 weeks from June 14th on.—

[Louis] Kalonyme[2] here a week.—Had just returned from Europe where he was with [Eugene] O'Neill. K. is a rare person.—Was a treat to have him.—

New York & No Room!—I wonder.—We'll see.—

Our love to you both.—

<div style="text-align: right">Your old
A.S.</div>

1. He had been in Europe since 1921, except for two visits.
2. Louis Kalonyme was an American writer and art critic.

<div style="text-align: center">[Halesite]
[10 or later in September 1929]</div>

Dear Stieglitz

I hereby challenge you to a swim to Europe with a pair of water wings and a ham sandwich each, and am rather worried lest you take me up. Think what you have been up to is amazing. Reds had to read your letter three times to be certain of it all. It is fine. We are both delighted at the contrast from last summer.

Glad Georgia is so well and can drive. Suppose we shall soon be more surprised to see you driving back and forth in a car. . . .

We still have the little 1925 Ford Coupe that we had in Pratt Islands— were 4–5 miles from anywhere. These millionaires' chauffeurs down here drive like such fiends that they fairly blow our little outfit off the road. The whole thing was $50 so we are now quite amphibious. Just looked in the dictionary to see that I had spelled it right and find that while our meaning is "able to live on water or land," the Greek meaning is "living a double life." Didn't know that Webster was so subtle.

Suppose you have read of the new "Luxembourg"[1] to be started in the Heckshire [*sic*] Bldg with Mrs. Rockefeller. And Crowninshield at the head, for "modern art only."

Have letter here from "Revue du Vrai et du Beau" wanting reproductions, expression of ideas, thoughts on paintings, personal data, likes, dislikes, etc. Wonder if it is worth bothering with. . . . Some French magazine, the rest probably have them so you may have seen it.

Our love to you both and many congratulations on your fine good healths.

As ever
Dove

1. Museum of Modern Art, opened originally in the Heckscher Building. The Luxembourg Museum in Paris displayed state collections from the later nineteenth century. More recently, most of those paintings have been shown in the Musée du Jeu de Paume.

In September 1929, Dove and Reds were "pretty much flabbergasted"[1] to receive a letter from *Liberty* magazine asking Dove to come to the New York office with his drawing proofs. He did so and received a $1000 assignment that occupied nearly all his time for about the next five weeks.

Only a few days after he accepted the job, Dove's estranged wife, Florence, died unexpectedly in Westport. Upon receiving the news by telegram, Dove immediately left on the train for Westport. There he did what he could, including paying $250 in funeral expenses. He returned to Halesite the same evening, considerably distressed and unable to sleep. After that, he sent flowers but did not return to Westport or attend the burial in Geneva. Instead, he continued to work steadily on

the *Liberty* commission, since the first installment was due in several days.

Florence's death opened the possibility of reconciliation between Dove and his son, whom he had not seen since Bill was a child because Florence had prevented any contact between them. After an exchange of letters (Dove even sent a photograph of himself so Bill could recognize him), father and nineteen-year-old son met in Westport about two and a half weeks after Florence's death. Dove, obviously excited at the prospect, took little gifts and, beforehand, even made a list of things to talk about. This tentative meeting went well, and they soon began to see each other at intervals, cautiously getting acquainted. Before long, Bill began to share family life with Dove and Reds. Another effect of Florence's death was to make possible Dove's marriage to Reds. Because Florence had refused Dove a divorce, Reds had never begun proceedings for her own. Soon she did so, and after extended legalities was divorced from Clive Weed.

1. Diary of Helen Torr Dove, 21 September 1929.

<div style="text-align: right">

[Halesite]
[Early October 1929]

</div>

Dear Stieglitz

So many things have happened. I tried to write you last Sunday and thinking of all you had had, thought better to wait until this deep pool had cleared. It is all right now.—Will try to tell you simply. Florence died last Saturday. Something that had been coming on for fifteen years. Her liver I believe.—Went to Westport to do what I could and all felt that it would be a strain on Bill's heart to see him for the first time under this circumstance. I still wonder.—Having a 5-part story from "Liberty" to do which was due Monday thought best to be practical. Did all I could there and came back to keep our lives going just as they are.

Am working on my lap now as the light seems to be here. Reds is beside me and sends love to you and Georgia. We keep sending it all the time. You can know that. . . .

—Am more interested now than ever in doing things than doing something about things. The pure paintings seem to stand out from those related too closely to what the eye sees there. To choose between here and there—I should say here. The recent philosophy and fiction also tend to strengthen that idea. It seems to me to be the healthiest idea

that has come from modern painting, or life, if you cannot define "health" or "modern."

Love to you both. When do you come to town?

<div align="right">As ever
Dove</div>

Reds has done some fine things—really beautiful. I may be a bit prejudiced but think I can see straight enough to know that.

In November 1929, Dove and Reds took everything off the boat in preparation for the winter in the drafty Ketewomeke Yacht Club, where they would also spend the next two winters. Dove's next letter suggested some of the labor involved in winterizing their new home. Despite these precautions, one day when the temperature was below zero, Reds noted, "Plumbing frozen stiff—us almost so."[1]

1. Diary of Helen Torr Dove, 17 February 1930.

<div align="right">[Halesite]
[2 December 1929]</div>

Dear Stieglitz

Intended to come to see you this last week, but the weather started to freeze everything in this summer yacht club situation. So pipes had to be wrapped, stoves put up, boats put away for the winter, engines drained and so on ad infinitum.

Have some good paintings.—The color is much richer than ever before—so we think. Spirit, I should say about the same, perhaps more warmth.

The frames are better—no sharp corners. Double folded. Have borrowed an electric motor and have been finishing paintings and frames at the rate of one a day for the past week. Sounds like a lot, but it is not.

Have seen Bill.—He is a very fine person. Is staying with Margaret Cobb, Mrs. Frank Cobb.[1] He was editor of the "World" who died some time ago.—And going to the Art League—Bill, I mean! . . . Bill's tastes are quite simple, spends no money to speak of and does not think about it or clothes. I was delighted with him. I suppose however from now on the plot thickens. He is a bit academic as yet. Naturally enough, but it was certainly a relief to find his spirit so whole. . . .

Do not know that you have any plans. They also must depend upon the results you see.

A change in your idea has taken place. Or is taking place. Am wondering what it all means. . . .

Perhaps the corners of the French crusade are beginning to curl or the propaganda has been spent. It is just beginning to show.

The DeHann Show of Modigliani was rather well done. Kraushaar made the whole damn business look like a pawnshop. Rheinhardt's was between the two, as we saw it with Gellatly[2] in black stock and white pants tottering through patronization. Crowninshield owns a great many of the Modiglianis—$40,000 for the Olympian nude (not his).

Happened to hear the prices reeled off to a prospect. You must have seen the Harry Hansen on Steichen. Oooo!—Bolithos' thing on van Gogh was very real beside it.

Am sending you this before I come in so you will know what I am thinking about. You know my conversational constipation. . . .

As ever love to you both.

Dove

1. Margaret Cobb who had a Westport summer residence, taught at a private school in New York City. Florence had been her housekeeper in recent years.
2. John Gellatly (1853–1931), a dapper collector on a large scale, bought many American paintings, but only premodern ones.

5
1929–1933

At an inauspicious moment in modern history, two months after the stock market had crashed, Stieglitz opened his third and last gallery, An American Place. During the Depression that followed, the art market was understandably bleak; at the same time, a major resurgence of realist painting competed for attention with the modernist art that Stieglitz steadfastly championed. Nevertheless, An American Place quickly was recognized as an important gallery. Stieglitz was totally involved there for the last seventeen winters of his life, while during the summers, he continued to take his habitual respites at Lake George.

From the beginning at An American Place, Dove, Marin, and O'Keeffe dominated the exhibition schedule. Each of them had a one-person show every season. In the first four seasons, 1929–33, the only other exhibitors were Stieglitz, Hartley, Demuth, Strand, and Mac-donald-Wright, who had one show each. (Rebecca Strand showed her paintings on glass while her husband's photographs were on view, and Reds showed her paintings once with Dove's.) In addition, there were four group shows, all various combinations of the solo exhibitors.

Dove managed to continue painting during the Depression, despite his poverty. He was invited to exhibit in many museum group shows, and his American Place shows were reviewed favorably in the New York newspapers and art magazines, but he sold almost nothing. Deprived of the illustrating that had formerly supported him, by early 1933, in desperation, he began to think about moving back to his hometown of Geneva, New York.

Because Dove could not afford to go into New York or to telephone very often during these years, he and Stieglitz wrote more frequently

and fully than ever before. Especially in the first year or so of this period, Dove seems to have been newly struck with the seriousness of art. Besides commenting on esthetic topics more frequently in the letters themselves, he also sent Stieglitz several statements about art. This tendency to verbalize probably was connected with the end of his career as an illustrator. Without drawing assignments for the first time in years, perhaps he simply had more time to write. He may also have been stimulated by the upsurge of negativity toward abstract art, for at one point Reds noted, "Arthur is writing thing on modern art, somewhat in answer to these new outcrys against it."[1] Moreover, and perhaps most significantly, Dove must have felt a new pressure to justify himself as an artist, now that everything, so to speak, depended on it.

1. Diary of Helen Torr Dove, 28 March 1931.

★ ★ ★

On 6 December 1929, the day before the gallery opened officially in Room 1710, Dove first saw the quarters in a new twenty-two-story office building, 509 Madison Avenue, at the corner of Fifty-third Street. The gallery's two exhibition rooms (which were supplemented with three small rooms used as office, storage, and workroom) were maintained in the stripped-down condition in which they had been rented. On days when there was sunlight, it flooded the high-up space through uncurtained windows to fall in clear rectangles on the light gray floor and off-white walls. There was no place to sit and relax. Stieglitz had once again set the pace by creating the first gallery in the contemporary style.[1]

The inaugural show of Marin's work was followed by O'Keeffe's, then Dove's, thus establishing a sequence that would be repeated nearly every year thereafter. Sometimes, additional shows would be inserted into the usual order; other years, they followed the three regular events. In this first season, Stieglitz concluded with a retrospective group show of work by Dove, Marin, O'Keeffe, Demuth, and Hartley.

1. "Marin Show Opens New Gallery," *Art News* 28, no. 14 (4 January 1930): 1 and 7.

Halesite, N.Y.
[December 1929]

Dear Stieglitz

. . . . Have felt all the week that I should be in there helping to settle the new Gallery.—Thought however, if called upon to speak, I might be able to say more by finishing up what there is here. What there are are all framed, backed—titles, addresses, a few comments, written on typewriter and pasted on the back, also directions as to which side up.

Am going on with some more that are started.

May possibly be in tomorrow. Was to see Bill. Have not heard yet.

It was very good for me to see you both the other day.

Love to you from us

As ever
Dove

Dove's son Bill celebrated his first Christmas with Dove and Reds the day after the holiday. He brought his boyhood friend Charles Brooks, son of the writer Van Wyck Brooks. Charles quickly established a friendship with Dove and was in touch with the painter during the rest of Dove's life. Alfy Maurer was there for the day, too. Although Reds wrote that he was "more contented and peaceful than I ever saw him,"[1] and Dove thought he looked fine, Maurer was not well. His health continued to decline until his suicide two and a half years later.

1. Diary of Helen Torr Dove, 26 December 1929.

[Halesite]
[27 December 1929]

Dear Stieglitz

That's the way to feel. Best looking thing yet. The Marin announcement.

Christmas is over anyway. Bill, and Van W. Brooks' boy Charles, and Alfy Maurer were out yesterday.

Alfy says that this year's crop is far better in every way, richer in color, spirit, and much better done than ever before.

He also was very keen about one of Reds' things—liked it as much as any of mine.

Alfy not well, under doctor's care. He looks better than ever, perhaps on that account.

Shall work on for a month or so anyway. And bring them in.

Saying this so you can get two or three angles.

Will see you next week.

<div align="right">

Love to you both
Reds & Dove

</div>

<div align="right">

[New York City]
8 January 1930

</div>

Dear Dove: The Place is ready to receive your things whenever you may choose the hour.—The Place is very simple—very clean—very different because so direct & free.—The usual envy is about trying to destroy but fortunately it does not worry me. It's all so stupid—seemingly growing more & more petty—may be desperately tired. Tiredness of body—& tiredness of spirit. The Marins are fresh—& many incredible.—Our love to you & Reds.—The Place is already on the map!—

<div align="right">

Stieglitz

</div>

<div align="right">

[Halesite]
[23 January 1930]

</div>

Dear Stieglitz

There are now twenty-one. The last ones are going bigger. Am taking a long shot and shall work up to the last minute. Uninterruption is certainly the greatest luxury. One today again.

The Marins are certainly among the very finest I have seen—in any place, or any medium. That one especially as one goes through the door of the second room, the sea and the ship has all the power of spirit of any of the new and I feel now some of the old masters.

It was moving—moving me to the point of control. I thought you noticed.

I wanted Bill to see the big things. He, youth, felt the milder ones. He is however, with all his reserve, I find liking the Marins much more than I thought. Wanted to take "Charles" Brooks to see them right away.

Had Bill overhauled by Dr. Beck, he is a bit careless about his health.

What carefully placed things you said were a tremendous help in the whole situation. It has been difficult.

However it is so much more clear than before with only a divorce for Reds to go through. She is working on designs—paintings too.—

We shall be in in a few days if it is not too cold.—Our summer plumbing facilities get awkward in the winter.

Love to you and Georgia.

<div align="right">Always
Reds and Dove</div>

On 13 February 1930, Reds went into New York City, where she went to the dentist, to An American Place for the O'Keeffe show, to the Museum of Modern Art, and to other art galleries. O'Keeffe took her to lunch. Dove stayed home and wrote a ruminative letter to Stieglitz.

<div align="right">[Halesite]
[13 February 1930]
Thursday</div>

Dear Stieglitz,

It hardly seems as though most of America is really interested in painting.—I mean most of those who buy them.—They are far more interested in the success of the artist. In other words—their own lifting power.—

Raleigh said to me over the phone the other day that he was not so much interested in Art but did want to see me "put this over."

That feeling seems to be prevalent.

Why they suddenly want to see the painters live instead of the old genius-burning attitude I do not know.

There seems to be a certain nervousness as though they might have stepped on one unwittingly.

I am wondering how far those supposedly interested would go in laboratory work in print over their signatures.

Watching and describing a surgeon in an operation is far different from doing one. Especially on oneself. I cannot see how people can go about blindfolded talking about those who see.—Seeing is doing. The onlooker does not see in the real sense. If you are surely in love, there are all sorts of ways of expressing it.

Hope you are not too tired and that things go well for Georgia.

As ever,
Dove

Reds would send hers but she is probably talking to you now.

On 20 March 1930, Dove and Reds went together to New York to assist with the hanging of Dove's first show at An American Place. After they arrived home, Dove wrote to Stieglitz, enclosing a carbon copy of a statement he mailed at the same time to Samuel Kootz, a writer and art dealer, who was then compiling his book *Modern American Painters,* which appeared later in the year.[1] The statement as it appeared in Kootz's book follows the letter.

1. Later, Kootz would be important as one of the first dealers to promote abstract expressionist painting.

[Halesite]
[20 March 1930]

Dear Stieglitz and Georgia
.... What you two did today amazes both of us.
Hope we can send you a great love without any thankfulness. ...
Am going right on painting. Something may happen further for that vacant wall. Seeing what you did today gives me a terrific lot of energy, spirit, or whatever you call it. ...

As ever
Reds and Dove

[The following is the autobiographical portrait provided by Dove for Samuel Kootz's *Modern American Painters* (New York: Brewer and Warren, 1930) as it appeared in that book.]

At the age of nine I painted, studying with Newton Weatherly of Geneva, N.Y.
I was unable to devote all of my time to it until 1907–1908 in France where I was free for eighteen months,[1] working in the country.

Then back to America and discovered that at that time it was not possible to live by modern art alone. Made a living by farming and illustrating to support the paintings.

To understand painting one must live with it. The speed of today leaves very few time to really live with anything, even ourselves. That too painting has to meet.

Then there was the search for a means of expression which did not depend upon representation. It should have order, size, intensity, spirit, nearer to the music of the eye.

If one could paint the part that goes to make the spirit of painting and leave out all that just makes tons and tons of art.

There was a long period of search for a something in color which I then called "a condition of light." It applied to all objects in nature, flowers, trees, people, apples, cows. These all have their certain condition of light, which establishes them to the eye, to each other, and to the understanding.

To understand that clearly go to nature, or to the Museum of Natural History and see the butterflies. Each has its own orange, blue, black; white, yellow, brown, green, and black, all carefully chosen to fit the character of the life going on in that individual entity.

After painting objects with those color motives for some time, I began to feel the same idea existing in form. This had evidently been known by the Greeks, as in going over conic sections again, with this in mind, I found that they were called "Maenechmian Triads." Maenechmus was an early Greek sculptor, and invented these triads.

This choice of form motives of course took the paintings away from representation in the ordinary sense.

Then one day I made a drawing of a hillside. The wind was blowing. I chose three forms from the planes on the sides of the trees, and three colors, and black and white. From these was made a rhythmic painting which expressed the spirit of the whole thing. The colors were chosen to express the substances of those objects and the sky. There was the earth color, the green of the trees, and the cyan blue of the sky. These colors were made into pastels carefully weighed out and graded with black and white into an instrument to be used in making that certain painting.

There were nine others, each with its own different motive. I took them to Stieglitz. He made room for them at '291' in 1910.[2]

It was a place where anything could happen. A remarkable place. People, paintings, photographs, and writings, all working as in a laboratory.

Stieglitz—and had it not been for the patient efforts of this one man modern painting in America might still be in the dark ages . . . for years he fought for the very life of what is today—Marie Rapp, Hodge [Kirnon] (the elevator boy), Marin, Maurer, Haviland, Haskell, [Max] Weber, Walkowitz, Hutch Hapgood, Mabel Dodge, Cézanne, Picasso, Rodin, Matisse, Picabia, Hartley, Demuth, Dewald, Carlos [Carles], deZayas, Strand, Seligmann, Zoler, Paul Rosenfeld, Agnes Ernst Meyer, Baron de Meyer,[3] Steichen, Elizabeth and Donald Davidson, Beckett and Rhoades, John Quinn, Leo Stein,[4] Gertrude Stein—and that magazine called "Camera Work."

Then came O'Keeffe with those burning watercolors.

Later the choice of form motive was reduced from the plane to the line. That happened one day in trying to draw a waterfall. The line was the only thing that had speed enough.

"The Cow" 1911 is an example of the line motive freed still further.

The line at first followed the edges of planes, or was drawn over the surface, and was used to express actual size, as that gave a sense of dimension; later it was used in and through objects and ideas as force lines, growth lines, with its accompanying color condition.

Feeling that the "first flash" of an idea gives its most vivid sensation, I am at present in some of the paintings . . .[5] trying to put down the spirit of the idea as it comes out. To sense the "pitch" of an idea as one would a bell.

It is the form that the idea takes in the imagination rather than the form as it exists outside.

This is no rule, nor method, but leaves the imagination free to work in all directions with all dimensions that are or may have been realized.

1. Other evidence suggests that Dove was abroad for just over a year. John Sloan's diary indicates that Dove departed in the late spring of 1908, probably at the end of May or early in June, and returned in July of 1909. See Bruce St. John, ed., *John Sloan's New York Scene* (New York: Harper and Row, 1965), 220 and 328.

2. Should read 1912. Dove was referring to the "Ten Commandments," a series of ten pastels included in his first solo exhibition, which was held at 291 in 1912. In 1910, he exhibited there in a group show, *Younger American Painters,* but showed only one oil painting. The work he describes is *Nature Symbolized No. 2,* or *Wind on a Hillside,* a pastel in the collection of the Art Institute of Chicago.

3. Baron Adolph De Meyer (1868–1949), a Paris-born photographer who exhibited at 291, is known especially for photographs of fashion, ballet, and flowers.

4. Leo Stein (1872–1947), critic and collector, was the brother of writer Gertrude Stein.
5. Here, he directs the reader to a reproduction of *Distraction*.

[New York City]
28 March 1930

Dear Dove: The Show is very fine but so far few people have come. Everyone who comes likes it. Some very much.—I do hope something eventually happens.
Love to you & Reds

Stieglitz

[New York City]
30 March 1930

Dear Dove: Visitors are scarce.—Phillips wrote. He may eventually turn up. Pleads as always "no funds."—Hopes you are not experimenting with wires & such like—but painting.[1] Have written him.—Poor Jewell with his "Colored Dog"![2]—Have written him too. But he is really kind & not playing a social game. And is growing.— The paintings wear splendidly.
My love to you & Reds.

Stieglitz

1. Phillips disapproved of Dove's assemblages. Later he changed his mind and acquired two of the best.
2. Jewell had misinterpreted "Colored Dwg" on the handwritten gallery list as "Colored Dog." In his review, "Other Artists: Concerning Mr. Dove" in the *New York Times* that day (30 March 1930, p. 12), he had put his foot in his mouth by commenting that to see dogs in the works by that name (one on paper, one on canvas), "you might have to go temporarily ga-ga." He corrected himself in print on 6 April 1930.

[New York City]
9 April 1930

Dear Dove: [Lewis] Mumford was in & was much impressed. Felt it was by far your best.—It's slow "work"—but not completely hopeless. . . .

Ever your old
Stieglitz

[Halesite]
[24 April 1930]

Dear Stieglitz

Here is note written to you right after we talked over the phone.

It's all right even if nothing else happens. This is nothing to what we went through five years ago. It just seems more final as a whole thing than it really is. Please do not let it drop you. I mean the whole thing. These crests have to come to a calm. The people want their spirit scientifically proved. I think though as a whole they are a bit more hungry. The French chefs are a bit too expensive except for the few.

Anyway they can't stand still. Each one is being born as fast as he is being destroyed. Nietzsche & his circles is abstractly true, but when we have a rubber circle and whirl it into forms, truth does not get so important as a whole.

To take you two, Marin, [James] Joyce, [D. H.] Lawrence, what would all that feeling mean to the [Charles] Lindberghs, [Thomas Alva] Edisons etc.? They are interested in "putting over" ideas rather than ideas. Well anyway I have a fine lot of large white canvases and new ideas to go with them.

Have been getting up 4:30–5:30 and working on some drawings and then go over work on the boat. Things have clarified for me wonderfully. This manual labor outdoors gives one a chance to think things out.

Life has been simplified in one way. I do not have to send so much away.[1] And the general spirit is fine. Hope we can make it until fall with what little I can get. . . . I think these new things I have in mind will be quite a surprise. They must be so fine that they will become necessities.

Well—It is seven now so will rush this over to the mail, having left it around for 3 or 4 days. How is that for American?

Love from us to you and Georgia. You have been so patient and thorough and fighting about it all. It's a grand treat.

As ever
Dove

1. For his son's support.

[New York City]
25 April 1930

Dear Dove: Phillips & his wife turned up yesterday. They were much interested in your pictures.—Remained several hours. Old plea: No money!—Couldn't make up his mind which he wanted. So consented to sending 5 to Washington for him to choose from. Will take one. Prices quoted: Your own. Nothing added except in two cases when I added the usual amount for the Place.[1] Five are going down. I hope $400 or so will come out of it for you—not much but something— Rosenfeld too wants one. Another $350 or so should come out of that. I'm waiting to see what Phillips will do as one going to Washington is P. R.'s choice. Still he has other "choices."—"Choices" are moveable! . . .

I'm not only engrossed in what *seems* to be going on here—but am in close touch with Lawrence & all he signifies.—Life is certainly a marvellous institution. It is all so incredible. So clear—so intangible.—And the *seeing* really just beyond the point of focus.—The Place is very fine—very quiet. . . .

Ever your old
Stieglitz

1. Stieglitz himself did not profit from sales at his galleries, but normally he took some percentage of the price of work sold for maintenance of the gallery. Later this operating capital became formalized as the Rent Fund, which was administered by Dorothy Norman. More often than not, Stieglitz sent Dove the full amount of any purchase.

In his next letter to Stieglitz, Dove spoke of the importance of a particular drawing he had just done. Around 1930, Dove began to do preparatory studies regularly. They were most often in watercolor, but sometimes Dove used crayon or pencil. When speaking of these studies, he often interchangeably called them "drawings" or "sketches," even if they were done in watercolor. At some point in the early thirties, he began enlarging these studies into paintings with the aid of a pantograph, a mechanical device with arms so positioned that when one is traced over a pattern, another will repeat the pattern with enlargement or diminution as desired. The small "ideas," as he also sometimes referred to them, thus became central to his normal working procedure for finished paintings. Soon he began exhibiting a group of watercolors in each show. These usually included at least some of the studies for

paintings in that show, but it is not possible to determine exactly which watercolors were shown because Dove normally exhibited them as untitled groups. This practice presumably reflected his belief that they were less important works than the finished paintings.

[Halesite]
[11 July 1930]

Dear Stieglitz

Would like to express to you in a calm way something that I feel has quite something in it.

Just hit a high spot along with labor pains that may be "All too human." Just feel that a small "4 × 5" drawing this afternoon may open up the way to self-portraiture in painting which after all is what painting is. Will enclose some theories about "form" and "color."

Guess we are about through with that though. It is strange what we have to go through to find out that we are through.

You see I am leaving the present idea open to the tests I may throw at it.

As I left you that day by the flower store, there were so many things that I felt, that it would have taken days to express.

It was nice to see you being as fine as that. That too is portraiture. You will have to read between the lines. There is more there than in this black crayon I use on the boat.

Have been waiting to write until the balance started to lift. Am being glad now. . . .

As ever
Dove

[Dove's enclosure of "some theories" follows.]

PENCIL NOTES
MADE ON A BOAT

I have about come to the conclusion that there is one form and one color.—That simplifies to the point of elimination, theory, which might be called the conscience.

The form is the cone. From it we get the conic sections, the spiral, the circle and the straight line.

Whirl the circle and we have the sphere. The cylinder is just a circle moving in one direction.

The cube of course comes from the straight line section of the cone.

A laboratory where forms could be passed through each other under many conditions might yield interesting observations.

The color is White Light.[1] The over balance of one color or the insufficiency of another will bring all of the most subtle "conditions of light." I doubt if the instrument known as the human eye is sensitive enough to see pure white light.

There are so many millions of whites that the slightest feeling of any kind in the human instrument would color it. The same is true of form.

White light and space are perhaps more analogous than pinning it to a form through which we might imagine objects.

Ourselves for instance—We can never quite grasp that.

How often it happens that we seem not to be present when seeing most clearly.

It is possible to die without pain with sufficient concentration, without inconvenience or conscious regret.—

When we pass through the point of nothing we know it not.

We realize when another thing goes through the point but we know nothing of that point in ourselves.

There is nothing to know. Wisdom ceases!

Dear Stieglitz

I know you will smile—

Dove

1. Dove probably derived the terminology of cone and white light from readings in Theosophical literature. See Sherrye Baker Cohn, "The Dialectical Vision of Arthur Dove: The Impact of Science and Occultism on His Modern American Art" (Ph.D. diss., Washington University, St. Louis, 1982), 116–25. Dove unsystematically investigated a variety of philosophical approaches to the life of the spirit over the course of his career.

[Halesite]
[19 July 1930]

Dear Stieglitz

Well, what I wrote about the other day has stood several tests and is bringing forth one or two a day. That is, models to build from. There is plenty of material to work on now if the weather goes unworkable outside.

Getting a certain pace about these things still gives me the same gladness as I hope was expressed in the letter I sent.

Hope that was not re-read to anyone.[1] Not that it really matters, but when saying what you mean in pure spirit, any slight lighting might uncolor any meaning. You know that really loving anything means the incapability of doing anything else.

Marin has that. As to my own work it would have been better had I done that beginning in 1910.

Can see that clearly now.

There is a certain grim satisfaction in grinding out your own truths and knowing that you have to accept them. About calmness—I suppose it will come in time. Still feel a bit forced—"unsparing." Actuality burns that—not however if it is real enough.—It should feed itself.

When I think of you I sometimes feel a terrific strain. That is probably my own.—Am trying to let go. That certainly gives more energy.

This pencil is not black enough and the paper is not white enough but you will know why, if anyone.

Our love to Rosenfeld and Zoler, if they are there. On to Georgia.

As ever
Dove

Raleighs—R's are fine now. Amazingly so.

1. Dove crossed out this sentence and noted in the margin "On 're-reading.' "

Most of the summer of 1930, O'Keeffe was in the Southwest again, while Paul Rosenfeld accompanied Stieglitz at Lake George, as he did once more the following year.

Lake George
25 July 1930

Dear Dove: I have your two letters & an addressed envelope to you has been lying on my table for quite some time. But I am indulging in much laziness & sunlight.—Of course your latest conclusions & ideas interest me immensely.—No, I didn't smile. Didn't even wonder.—Am glad to know you are working.—Also that all goes well with the

Raleighs.—Here all is very serene.—No tension of any kind in spite of Wall Street & my mean heart which is kicking up some. Nothing serious but annoying.—I guess the Spring was a bit more strenuous than I realized at the time. . . .

Rosenfeld is here writing a novel. Kalonyme turned up a few days ago just back from Europe. The sun is beckoning.—

We're about to go on the Lake.—I send this not as a letter but as a Hello—a sign of life.

Love to you & Reds—

S.

[Halesite]
[9 September 1930]

Dear Stieglitz

. . . the work is going fine, much better than I hoped for from the drawings. Had measured off about enough time so that, if the work from the drawings were not all I expected, I could tackle the whole thing over again.

Some of these are quite large. 30×40. After working about 5×7 and then to take the plunge to 30×40 working from those, there was necessarily some wonder. One always wonders how far he can swim, how deep he can dive and see with his eyes open. Have just recovered from a week's "flu" which is no help. Leaves one a bit wobbly. Have been out for two or three days now so am well again. We both think what has been done so far much bigger than last year's—much clearer and there is something new there. One of them will fill this room without a frame where it took about ten of last year's. This is a hard room to see things in so am not worried about the gallery.

A note from Pemberton wanting to come to see me, thinking Halesite was in Conn. near where they are. Have not heard since. He is back on the "NYker" all right.

Did you know that the "NYker" is to have a competitor in Oct. called "Smartage"?

Glad you are getting plenty of sun. Was brown myself until this flu washed me out. Was soaked through three or four times the day of the big storm. It wrecked things around here pretty well so kept me wet all day.

We have had family and friends. Spoke perhaps too soon about the R[aleigh]s.

How can one know more about life than what happens? You almost know what is going to happen, and then there is always the chance of misunderstanding a tiny bit that might change the whole thing into something finer than you even hoped for.

Am glad this time to have something to offer that I feel better about than ever before. Am starting slowly but now they are speeding up to about two a week—with no more interruptions.

This room has tin ceilings and part side walls and one of these stands it—they may even stand McB[ride].—

When do you come to town?

Have learned quite a lot about painting. Hope it all gets into these new ones.

Have just discovered a small machine attachable to what I have that will form any kind of moulding for about $9. That is less than the first frame so we are going up now to look it over.

Reds sends her love to you and Georgia—as do I always.

This season is always a happy part of the year, for me anyway. Hope it is for you

<div align="right">Dove</div>

<div align="right">Lake George
11 September 1930</div>

Dear Dove: Life up here on The Hill is rather hermitlike after all & I feel as if the City did not exist—finally that I myself do not. Life is the great Jester when all is said & done.—Nothing more—nothing less.—I have been busy mounting.—A lot of small prints—many old ones—a few new ones. Not many of the latter. Rheumatic arms keep me out of cold water. And printing here means "ice" water for hours.— All in the game.—I'm looking forward to the Place. It ought to be an interesting year as far as "work" is concerned. As far as money for the workers—ever—? I'll do my best for them as ever.—And for "It."— That "It."—

—Georgia has started to do a little painting.—It's very very quiet here & the weather continues glorious. I have never experienced such a run of sunshine anywhere—& that includes my stay in Italy [in 1887].— Since June 11—the day I arrived here there have been only 3 days without sun.—Of course springs are running dry—there is a shortage of water—& farmers are desperate.—But there is the sun aglee.—Love to you & Reds from us both

<div align="right">Ever your old
Stieglitz</div>

[Halesite]
[13 October 1930]

Dear Stieglitz

Have just been thinking of your letter and reading some things about Lawrence. You say in your letter that life is a jester, nothing more—nothing less. Reds and I have smiled several times over your statement when things turn out that way. Anyway the jokes have to be damn good. Can't seem to see myself being sad over anything. Starvation might do that by physically changing the mind. I do not know. Hunger is always with us, that is different.

I remember of your conversation with [Ernest] Bloch about your mother.—That portrait of you had something in it seen at that time.—Either that day or another time, have forgotten. You were talking of the early days in Germany. There was then a light in your eyes that I have never seen in any human being. The jester thing and that might not coincide. Perhaps you feel it all the more so.

Thought of you and those days on reading an interview with [Albert] Einstein in which he said "Working is thinking." There is a fine thing by him in this last "Forum."[1]

Love may be the path to light. There is no absolute proof. Anyway we keep on going, to find often that we are passing a tree that we marked some years back. These moving circles in which we walk are what we call work and thought.

The two books came from Weyhe—Pemberton & Jewell. Suppose you are responsible. Many thanks.

. . . Reds is doing some amazingly clear things.

Six frames done now, sanded, silvered etc. My, but that all takes time.

The paintings look fine in them. Everyone speaks of their clarity. That is, the few that have seen them. Anyway I am not worried about them—which is a good deal at this time of year. . . .

Love to you both from

Reds and Dove

1. Albert Einstein, "What I Believe," *Forum* 84, no. 4 (October 1930): 193–94. In this regular *Forum* feature, contributed each month by a well-known guest, Einstein spoke for the ideals of "goodness, beauty and truth," stressed the benefits of personal independence, and probably caught Dove's attention with his view that "the most beautiful thing we can experience is the mysterious," which he felt was the "source of all true art and science."

Lake George
17 October 1930

Dear Dove: Here we are back again from town where we got the painters started in [Room] 1710 [An American Place]. In a week we return to town to hang a grand show of Marins. Really grand.—I am eager to start up.—Am feeling a trifle better.—May be the idea of being in harness soon is helping.—Too much isolation for me is no good.— Particularly when I know there is much to do that can't be done here.—

It was good to receive your letter. To hear about Reds & yourself. As for Life the Jester, I had in mind the King & his court fool. Every man considers himself king today & without court fool to speak some truths.—So what I meant was that man today invariably finds himself sooner or later confronted by his own Court Fool (Jester) in the form of Life itself.

1710 is going to look handsome. We have changed the walls some-what—that is the color.

Special news there is none. . . .

As ever your old
Stieglitz

When Samuel Kootz's book, *Modern American Painters,* came out toward the end of 1930, Stieglitz asked Dove to respond to the book's chapter (Dove referred to it as an "article") on O'Keeffe. Dove finished his response on 4 December, the day he returned from a hurried trip by train to Geneva. The next day, he mailed the reply, along with another short letter.

[Halesite]
[5 December 1930]

Dear Stieglitz
 . . . I had to go to Geneva.—Mother has been having three or four hemorrhages a night and rheumatic strains that are too much to talk of. Amazing will power and energy. Came back yesterday and finished this.

I like it and hope you both will.

Love from us both to you and Georgia.

As ever
Dove

[Halesite]
[4 December 1930]

Dear Stieglitz,

Apropos of the Kootz article on O'Keeffe about which you asked me to write.

It would take quite a man to do a better book. Many things happen in it which make it live.

A large area like O'Keeffe cannot be synthetically treated.

In the first part of the book he justly criticizes the *sexless* thinking of the men painters of this country and then proceeds to demand *less sex* of the woman O'Keeffe, saying that "Sex can only impede the talents of an artist." How about the Primitives? Congo? Lawrence? the Bible?

Why should it not be taken for granted, instead of "Propaganda for womanhood?" "O'Keeffe was being a woman and only secondarily an artist." Should she be secondarily a woman?

The terms "Artist" and "Painter" are interchanged, and I seem to feel that may have influenced his feeling along with many others about O'Keeffe. Perhaps we take the very word "Painting" too seriously.

A new form of painting always shocks until it creates its own form of appreciation.

"Is this person a painter?"

Einstein with his celluloid collar is more of a painter than most literature and a great deal of art. I cannot prove it, but can feel it without staring at it as an idea.

Being more aroused by the subject (literary) than by the object (painting as a thing to look at) may have been an American epidemic.

A person's way of painting fits his feeling.

O'Keeffe's is sheer "Liquid air."

The different nebular academies drop off the planets during the race through space.

Another said that she needed "Heavier brushwork." That might end in canvas coating, and colored mortar and a trowel would be the absurdum.

With O'Keeffe there did not happen to be any tradition. There had been nothing to compare her with.

However there were Stieglitz's photographs. There is something close there.

The "Clouds" were an influence. Some of his portraits of her may have influenced the "Cross" paintings through their spirit.

The "Altar Pieces," (shown to a few) as some say preoccupied with

sex, are quite as pure painting as any spiritual experience, if not identical. Shouts of "No. No. No."

Even spirit can become academic as did the Pillar of Salt.

The bursting of a phallic symbol into white light may be the thing we all need.

Otherwise it would not bother them so.

<div style="text-align: right">Dove</div>

<div style="text-align: right">[New York City]
6 December 1930</div>

Dear Dove: Haven't heard from Phillips as yet.—Hope to any day. Everything (& everyone) is hectic beyond wildest imagination these days of Peace and Noble Experiment. So no one seems to know where he (she or It) is at. Nothing new—only more so.—Thanks for the O'Keeffe notations. Swell.

—1710 is wildly busy with nothing much actually happening.

To procure a nickel for a subway ride takes more energy than pulling a subway train from one extreme end of the road to the other!—And this is America—!!—If one doesn't break down it's all a great Lark—a new version of the Dance of Death perhaps.—I'm going strong & all I hope is that I can help you & Marin & Georgia keep up getting some more things done in paint.—

It's Saturday A.M. & the women are arriving—"Catalogues please."—Saturday is a particular kind of torture for me.—School teachers (feminine) & school girls making the rounds—the good looking ones staying away!—Undoubtedly preferring football to "Art.". . .

<div style="text-align: right">Love to you & Reds—
ever Stieglitz</div>

Marin had opened the season at An American Place in November. While Hartley exhibited through the holidays, three of Dove's works were displayed in an important show, *Painting and Sculpture by Living Americans* at the year-old Museum of Modern Art. O'Keeffe, Dove, and Demuth followed Hartley at the gallery after the new year. The exhibition season again ended with a group show consisting of works by the season's exhibitors.

By the end of 1930, Dove's financial position was more difficult than ever. His brother and ailing mother refused repeated requests for help.

Reds tried to bring in a little money by coloring slides at home, mainly for the New York State Education Department, but Dove's resources were virtually gone when Stieglitz bailed him out with personal checks in advance of anticipated payments for paintings.

[Halesite]
[19 December 1930]

Dear Stieglitz

Yesterday another was finished. It certainly is the best piece of painting if not the best thing yet. It is framed as are seven smaller ones. Most of them working watercolors for paintings with glass over them. Another started in the afternoon. A nude of a buttonwood tree. That will be large in oil. It starts out the most promising of all. Things are moving at quite a pace. If I can only keep going—for even another month.

To face things as close as this at your fingertips needs a calm that perhaps poverty does not enrich.

I wonder how close people think we live to a promise. $1000 or 10¢.

Just at present I cannot get more color. Owe Schneider[1] $22. He is fine though. Have in times past owed him as much as $50. Do not like that. Have a small job from "Squibbs," four drawings, $80 in all. . . .

Do not want to worry you about all this when it is so hard for you there, but I am thinking especially of what you will have to show—that really more than anything.

I realize what you have built for every one you have touched. It is amazing. I sense the point where you are at now in my own case and want to do all I can. Am just trying to set the situation in a frame so that it will be clearly understood.

Can stick it out for another week and then if neither Phillips nor Paul R. can do anything, the food stops.

Suppose a grown-up person of 50 is a damn fool to take such close chances, but that seems to be the kind of one I am. Have done it so long that it does not interfere with work quite as much as it used to. Reds is a grand help at that. She is trying to get lantern slides to color. So far, fine-sounding promises which I think are intended. . . .

As ever
Dove

1. Schneider & Co., New York art supplies dealer.

[New York City]
20 December 1930

My dear Dove: Not a word from Phillips altho I wrote him about the urgency & immediate need! Undoubtedly he'll be heard from in time. One must continue to believe that "time" doesn't mean in the near hereafter.—

It's all pretty awful. These rich who have no idea what a man like yourself is doing & how & who profess to be overwhelmed with passionate interest.—Sometimes I wonder how I can continue to battle for just a bit (tiny) of real understanding (feeling)—for that's all it amounts to.—Just for a bit of common decency.—They all mean well & one must be "grateful" for that. Some don't mean as well as they think they do. . . . I'm enclosing check of $200 of my own. I'll refund myself when the Phillips check does arrive. As for Rosenfeld, I know he is strapped at present & is working. I don't want to add to his worries. . . .

Hartley is up & and Show looks surprisingly well.—

I sent Kootz a copy of your O'Keeffe letter. He liked it much.

Our love to you & Reds—

Ever your old
Stieglitz

The same day that his check arrived in Halesite with the preceding letter, Stieglitz telephoned Dove to tell him that Phillips had sent a thousand dollars for *Snow Thaw* and *Coal Carrier (Large),* which he had selected from the five paintings sent to him eight months earlier. Dove returned Stieglitz's two hundred dollars.

[Halesite]
[Probably 22 or 23 December 1930]

Dear Stieglitz

What a day! Reds and I just look at each other now and then and either smile or laugh.

Am convinced that you have a will through living your life as an idea that makes things happen. Treating life as a work of art is a thing that is seldom done. One has to have a terrific love of the sensitive human thing to be able to do it.

That is pure power. I have seen it happen so many times with what you have done.

It happens with the people who need things to happen. The people who just need things just get the things. . . .

Think perhaps I'll write Phillips a note if I can do it well. Otherwise I shall let go of it. Shall do that anyway. Let go I mean.

Should send it to you first so you can park it in the little back room, if it interferes with any of your plans. Anyway he might be made to feel that he made a rescue or perhaps not?

Anyway I felt quite close to him not having met him.

So many thanks for your advance. It was deposited but will send you my check. Had not paid the storage for last time ($12) but will out of the Phillips memorable check.

Am glad the Hartleys look so well.

McBride giggles a bit for a seasoned critic. M. P. [Murdock Pemberton] isn't out on it yet. Jewell has a sense of duty. The collectors are getting better than the critics and are not aware of it. They still listen too hard to hear.

Reds has her job. A trial bunch of slides from the N. Y. State Educational department and I have the first of the four drawings about done for "Squibb." So hope after chores to get to painting by afternoon.

Luck to Hartley—I know the management.

Love to you and Georgia from us both

As ever
Dove

[Halesite]
[27 February 1931]

Dear Stieglitz

Everything ready. Two frames have to be last coated. Dry by Monday. Have five more paintings and fifteen of the color drawings. Will get them in either by express or someone. Eckert[1] was burned out, car & truck. He says God did it as a warning but think perhaps "God" took a cigar out of his hand and dropped it among his rags.

Glad to see we are philanthos for the unemployed. We smile and can't help but wonder where the line forms.

It was a good sporting thing to do, and real. The very people who have criticized prices are not necessarily the first to offer. . . .

We are anxious to see the O'Keeffes. Love to you both. Do hope something has happened for Georgia.

Mrs. Cobb is trying to get Mrs. [Leopold] Stokowski. . . , Phila. conductor—you remember he liked the "Altar Pieces" one day—to come to the gallery. She tried to get him last year, and Bill is trying to get them to Georgia's show. Mrs. S. I believe is rather fine and is able to do what she wishes. . . .

<div align="right">As ever
Dove</div>

1. The Blake-loving "philosopher" who had driven Dove's paintings to New York on previous occasions.

On 5 March, O'Keeffe invited Reds to come to New York as her guest, with Dove accompanying her if he wished to. Since he had already seen the O'Keeffe show when he had taken his paintings to the gallery a couple of days before, Dove decided to stay home to work on the painting that he mentions in the following letter. He was so fascinated with it that he "forgot to eat" the next day,[1] after Reds had left for New York.

1. Diary of Helen Torr Dove, 7 March 1931.

<div align="right">[Halesite]
[6 March 1931]</div>

Dear Stieglitz and Georgia

Am awfully glad to have Reds have such a fine change and for her to be able to see Georgia's room as a whole before it comes down.

There is a rich warmth there. The heights and depths of which have always been felt, but seem now so much more touchable. I mean to the palm of the spirit rather than its fingertips.

Had the doctor overhaul Reds yesterday. She has no cold, but for the past six weeks since she did, there has been evidently a slight inflammation of the intestine.

Will call him again to be sure there is no possible chance of her having a germ in her suitcase. . . .

As for me—am excited over a small drawing that I want to make into a painting.

It is a belt sanding machine that is becoming quite human in its sawdusty feeling. It doesn't need a press view and doesn't care whether anyone sees it or not—with about three exceptions to make the rule.

Have just called the doctor and he says it will be perfectly all right for Reds to come and that she has no germs to carry.

Think I shall tend fires, work on this painting, and if all goes well bring it in Monday A.M.[1] It is started now. Have to get more frame. Love to you both and much thanks.

<div style="text-align: right;">

As ever
Dove

</div>

1. He finished the painting Monday, 9 March, but did not go to New York.

Reds spent the weekend in New York. On Saturday, she was able to see the O'Keeffe show before it was dismantled. In the afternoon she attended a Boston Symphony concert with Paul Rosenfeld. "Stravinsky makes you hold your breath," she commented.[1] After dinner, she helped to hang Dove's show, which opened officially on Monday, 9 March. Except for seeing the Davidsons on Sunday, Reds spent most of that day and the next with Stieglitz and O'Keeffe. On Monday afternoon, she took the train home and in her diary characteristically noted that Arthur "met me at the station, a great thrill."[2]

1. Diary of Helen Torr Dove, 7 March 1931.
2. *Ibid.,* 9 March 1931.

<div style="text-align: right;">

The Shelton, New York
9 March 1931

</div>

Dear Dove: Your Show looks beautiful. Is beautiful. McBride, Jewell & Pemberton were in today. And all seemed to enjoy. We'll see. I feel McBride will be kind. Pemberton certainly enthusiastic. Jewell seemed to have the Henri Show[1] on his mind. We'll see. Reds will have given you a picture of her two days. And The Place, Etc.—We had hoped she'd stay longer. But we understood. . . .

<div style="text-align: right;">

Ever your old
Stieglitz

</div>

1. A memorial retrospective of Robert Henri's work was held at the Metropolitan Museum of Art 9 March–19 April 1931. An American realist painter, Henri (1865–1929) was the leader of The Eight (of which several members are sometimes called the Ashcan School), a group that was considered radical when it exhibited in 1908. He was also an influential teacher at several schools, including his own, and at the Art Students League from 1915 to 1928.

By the next time Dove wrote, most of the reviews of his show were out. McBride, in the *Sun,* called Dove's paintings "the best work he has shown to date."[1] In *The New York Times,* Jewell praised Dove's show twice—first on Wednesday, 11 March,[2] then again the following Sunday[3] in a review Reds thought "quite nice."[4] Other reviews appeared in the New York *Herald Tribune,* the *Springfield (Mass.) Republican,* and *Art News,* which noted that "these latest abstractions are way ahead of anything that this painter has shown us before."[5]

1. Henry McBride, "Attractions at Other Galleries," *New York Sun,* 14 March 1931.
2. E. A. Jewell, "Dove Gives Annual Exhibition," *New York Times,* 11 March 1931, p. 20.
3. E. A. Jewell, "Dove Again," *New York Times,* 15 March 1931, sec. 9, p. 12.
4. Diary of Helen Torr Dove, 15 March 1931.
5. "Arthur Dove: An American Place," *Art News* 29, no. 25 (21 March 1931): 12.

[Halesite]
[18 March 1931]

Dear Stieglitz,

They have done fairly well so far. Pemberton not out yet, and haven't seen the "Art News." Have heard from possibilities with the same old story.

It might be well to get prices above this infernal charity idea. You will know where the balance is. . . .

Reds to Hartford Sunday to "be with her mother" so that divorce papers can be served.

There is something that goes through all that has been said so far. It is entirely new, including two fine letters from the Davidsons.

Jewell was a surprise. You knew the rest absolutely correctly.
The things are beautifully hung. No one else can ever touch that.
Love to you both from us

Dove

Two "so fars" in this letter. I might add a so good. Portraits again.

Dove

Murdock Pemberton's enthusiasm, which Stieglitz had noted in his
letter of 9 March, appeared in print in *The New Yorker* the following
week. Characterizing Dove as "one of the country's great serious paint-
ers," Pemberton evaluated the show as "one of the season's worthwhile
exhibits."[1] Stieglitz sent a clipping in his next letter. He also included an
appreciative letter from the painter and writer Nathaniel Pousette-Dart,
who had visited An American Place on 18 March. "Your special kind of
creative imagination and your plastic feeling for form and color are
delightful," Pousette-Dart wrote. He concluded his letter with the
observation that the exhibition "places you on the top, with the few
really creative and significant artists in this country."[2]

1. Murdock Pemberton, "The Art Galleries," *New Yorker* 7 (21 March 1931):
 68–70.
2. Nathaniel Pousette-Dart to Dove, March 1931, Collection of American
 Literature, Beinecke Rare Book and Manuscript Library, Yale University,
 New Haven.

[New York City]
20 March 1931

My dear Dove: Enclosed means much. Pemberton is genuine. There
are not many visitors[1] but many of the few are very real & feel as
Pousette-Dart does. Maybe something will happen soon.—It is silly to
hope.—One can be ready. That's venture these days!—So far not a
dissenting voice—as there were no dissenting voices with Marin &
Georgia.—But that does not produce a loaf of bread.—Your son was
here yesterday A.M. & we had a fine talk. He is a very fine person.—
Georgia is having a difficult time starting to paint.—Our love to you &
Reds—

Stieglitz

1. By contrast, Stieglitz estimated that the preceding O'Keeffe show had drawn 7,200 visitors. See E. A. Jewell, "Dove Gives Annual Exhibition," *New York Times,* 11 March 1931, p. 20.

Reds was in Hartford for five days in the latter part of March 1931, attending to divorce proceedings. Dove noted even more emphatically in a diary entry than in the next letter to Stieglitz his irritation with the leisurely pace of legal action: *"Sheriffs are snails!"*[1]

While Reds was gone, Dove went on painting, experimenting with materials and techniques, as he often did. The information he sent to O'Keeffe via Stieglitz in the next letter is typical of the carefully tested hints he often passed on to her.

Dove was always very attentive to technical aspects of painting. He often ground his own pigments, and he experimented with wood and metal panels as supports in place of canvas. By the 1940s his own diaries look like an alchemist's notebooks, with their day-by-day entries about mixtures for paints, varnishes, sizing, and so forth. Dove's next letter mentions Jacques Blockx, whose *Compendium of Painting* (Antwerp: J. E. Buschman, 1926) he frequently consulted. His other major reference at this time was Maximilian Toch, *Materials for Permanent Painting* (New York: D. Van Nostrand, 1911). Sometimes he even went back to Cennino Cennini, whose late-fourteenth-century treatise was the first practical book of methods for painters; Dove had owned a copy of the 1899 translation since 1909. The year after it was published in 1934, Max Doerner's *Materials of the Artist,* translated by Eugen Neuhaus (New York: Harcourt, Brace) became his standard authority. In the last years of his life, he also had a copy of Ralph Mayer, *The Artist's Handbook of Materials and Techniques* (New York: Viking, 1940).[2]

1. Diary of Helen Torr Dove, 24 March 1931. Dove wrote this entry, as he occasionally did in the later twenties and thirties. Because Dove and Reds thought of the diaries as records of their life together (not as intimate journals), they sometimes both contributed to the same one. Earlier, and again in his last years, Dove himself was the primary diarist.

2. These books belong to the artist's son.

[Halesite]
[24 March 1931]

Dear Stieglitz

Have tried experimenting with some of those [exhibition] notices.
Sent several to some of the grown-up college boys whom I knew in
Ithaca,[1] Geneva. A few of them Stock Exchange members—and the
well-protected type. Do not think the ground very fertile as I re-
member, but just thought I would try it.

McGovern brought in some others. Suppose they all have wives by
now that may have daughters that are more alive than the memory I
have of them. You see I do not expect so much from the males for
another generation.

Reds still in Hartford.

Sheriffs are slow.

Tell Georgia to try the raw canvas with two coats of casein size,
allowing one to dry first. "Casco" glue or LePages new waterproof,
follow directions carefully to make glue, then 1 part glue & one water.
Have tested the glue with litmus paper. When this new glue is dry you
can throw it in salt water and nothing touches it. You can see that it
waterproofs the back of the canvas at the same time. When dry one or
two coats of Permalba white that comes in 3 lb. tins—$3.00. If two
coats are used, sandpaper between. This is a neutral white.

Of course I like to paint right on cedar panels, and mahogany. No
coating. Blockx recommends it above everything. The last one I
brought in was done on the wood. Collectors seem to have the idea
however everything should be a "canvas."

Have been working on an "article" since 5 A.M. and stretching can-
vas. Now 6:30 P.M. The article is on the present situation.—The canvas
is on the future.

Love to you both
Dove

―――――――――
1. At Cornell University.

[New York City]
26 March 1931

Dear Dove: Phillips was in twice. In the evening. And in the morning
following. Was much impressed. Left in the evening without taking

Arthur Dove, Sand Barge, *1930. Duncan Phillips bought this painting from Dove's 1931 show at An American Place.* (Phillips Collection, Washington, D.C.)

anything. Had no money—prices high, & the usual performance. Well, I felt I'd write to him & tell him to make his own prices without money.—Naturally was delighted that no letter was needed as he & Mrs. P. walked in early when the light was just right.—After the Show is over he wants the "Sand Barge" & the "Two Forms" sent to Washington—I quoted him $600 for the "Two Forms"—$800 for "Sand Barge."—And if he took both, $1200 for the couple. I feel that is decent all around. He is interested. The yellow one he didn't like—nor she.— All sorts of folks are lovers of art.—!! Am glad you are writing. It's important. McBride might print what you write—"Creative Art." If not, someone else. It will be printed. . . . Georgia bought up 7 of her paintings from Kennerley. A great story. Nothing but great stories. It's awful really.—Your things continue *to live* thru all the mess. The Room is a very handsome affair. Our greetings & love

Stieglitz

[Halesite]
[End of March 1931]

Dear Stieglitz

Here is some of that article, perhaps enough. May be better short.

Thought better not to say too much of the rest of us so that it would not seem like propaganda to the many who are not able to treat things impersonally.

Wonder if there have been many who balked at prices. Do as you feel. If I have to go back to trying to get jobs at illustrating, it means skipping another year, which just in here would not be good. And besides that, as I hear, there are no jobs. . . .

The bread lines outside must make your task quite hell.

Know you are thinking of everything that can be thought of, so will not add more.

The Davidsons want us to take their house for the winter. Moving everything . . . takes up lots of time and energy. So does this place with its cold floors.

Reds' mother & cousin also have an apartment over their garage in Florida.

Tropical is not quite my idea of dimension.

As yet I do not know my fate, so will patiently wait. Expect to be in sometime next week.

Love to you both.

As ever
Dove

[Dove's enclosed article was the essay that follows.]

THE 20TH CENTURY LIMITED
OR
THE TRAIN LEFT WITHOUT THEM

When a few people all over the world have been fighting for an idea for years and bestowing all the care they can imagine on that idea, it would seem that it might by this time be understood, at least that the intention in direction might in the present civilization be known. If they refuse to read the writing on the wall, the part of art that is most alive will move on without them.

There are many things next door that we do not see when we look so near.

Light is always present, if we are not blind. Even the blind feel it, whether they know it or not.

The reaction is just different in different cases.

For those who try to weave the idea of comfort, by that I mean not endlessly trying to go beyond the last thing they have done for something further on;

For those who have no further wish than the expression of the thing at the roadside;

For those who feel they must go back to the classic to realize themselves;

For those who have given up hope of anything beyond;

For those there is no hope.

It must be your own sieve through which you sift all these things and the residue is what is left of you.—

They accept Bach, understand his idea, and refuse Marin and Klee.

I sometimes wonder whether these three are not grounded on the same love.—One in his own realm of sound, one in his own sensation of space, and one in a colored measurement of life trying to combine the other two. They seem to be held just at the point where all the arts become identical. It is the love of the sort of beauty that is above being so real that the fingers may be stuck in its side.

There could be no desire to change a perfect thing, no desire to clip off the edge to see how it was done.—

One takes delight in leaving a perfect thing alone.—

I sometimes wonder whether these violent antagonists can possibly understand the *architectural idea* that has gone to the making of the men they admire.

If these "modern" things are as bad as they think, there should be no real worry for them. If that were the case the moderns would be the troubled ones.

When people find things "baffling," "defeating," "putting obstacles in their way" (and that is putting it mildly), they will usually find that they themselves are the obstacles, and their vocabulary becomes merely a stronger portrait of themselves, and I for one am amazed at some of these portraits.

I know an old weather prophet who intensely dislikes the word barometer.

It should be time after all these years that the value of the new findings should be recognized.

People have more to do who are of today than those who are of the past. Very few welcome ideas that are destructive of their own. If they are destroyed they naturally want to do the destroying themselves.

Enjoyment is easily distinguished from enthusiasm. Enthusiasm is flat, and enjoyment is round, one is a projection of the other. The heightening of all those feelings gives a hunger that is beyond the moment.

Am wondering in connection with the discussion of mensuration and the time-space thing of the fourth dimension, of the difference in the substance measurement on the surface of a hen's egg and a china one.

Can a line be so pure, so that the shortest distance is the same to one mind as another. It would seem that a perfect conception presupposed a norm that is the thing as in color to whose eye the light is reflected.

The one thing that seems so far to me to remain is the condition of existence which can be followed through any further existence by knowing definitely the other existences that have had their influence upon it. We can blow up a rubber band with dynamite & they both continue with their residues which could be traced back or unblown so to speak.—That seems to me to be the answer to this so-called infinite thing.

If we start with three elements, the combinations are never the same, that is with time considered—and if we could trace them back, we might come closer to what we call God than we yet have.—

There is a thing going on now that is not related to beauty in the old sense. It has nothing to do with masterpieces, & yet it has. It has the sense of dimension in common with the old things, but a sense of dimension more in the imagination. It is a bigness of spirit that has burst its ties to all that has gone before.

It has nothing to do with perfection. There is such a thing being too big to perfect an idea. We Americans can understand that with difficulty—the Chinese might easily.

This spirit that I am trying to describe is the beginning of the instincts that prompted works of art before—the first flash that has nothing to do with the perfection of an object. It is perhaps too old & too simple to be what we call modern.—

In his reply, Stieglitz addressed himself to Dove's most urgent concern. He had not yet read the article. In this same letter, Stieglitz's remarks about the Museum of Modern Art reflect his antipathy to institutions. The effects of the standoff between Stieglitz and the Mu-

seum of Modern Art have yet to be measured, but—because of him or in spite of him—it is true that the museum enshrined a European version of modernism until after World War II. With few exceptions, when it showed American painters, it promoted the view that the best twentieth-century art was representational.[1]

1. On the Museum of Modern Art, see Russell Lynes, *Good Old Modern* (New York: Atheneum, 1973), and the special fiftieth anniversary issue of *Art News* 78, no. 8 (October 1979), especially the articles by Milton Brown, "From Evangelical Tent Show to Modern Museum," pp. 74–81, and Irving Sandler, "When MOMA Met the Avant-Garde," pp. 114–25.

 Dove's work first appeared at the museum when three paintings were included in *Painting and Sculpture by Living Americans* (2 December 1930–20 January 1931), the museum's second survey of contemporary work in the United States. Later, he was occasionally represented in other group shows, but he has never been given one-person honors there, as were, within Dove's own lifetime, Marin, O'Keeffe, Hartley, Strand, Lachaise, and Stuart Davis. Stieglitz's only solo appearance occurred in 1947, the year after his death.

[New York City]
2 April 1931

My dear Dove: What "advice" can I give you. Job? or Paint?—Of course I'd like to see you paint—yet—yes, a million yets.—I just don't know what to say. . . . I heard about the inside goings on in the Mus. of Mod. Art. Of course, nothing was unknown to me. I know the gang called Trustees. None but the Rich need apply—& of course those who bend the knee to their arrogance are the only welcome servants.

In the meantime one continues!!—

Our love to you & Reds—

Stieglitz

[New York City]
5 April 1931

Dear Dove: I'm sure your Show has put you on the map in a very positive way even if it has been a failure so far as a money-getter. There is still a possibility. [Alfred H.] Barr, director of Modern Museum, saw it yesterday.—Much interested. . . .[1]

Ever, etc.
Stieglitz

P.S. I have just read your article aloud (twice) to Georgia. It is fine. . . .
It ought to go out in some magazine, not "art." . . .

1. Barr's interest did not result in action. The Museum of Modern Art did not
 buy any of Dove's work during the artist's lifetime. In the last few years of
 the painter's life, it accepted Dove's *Grandmother* assemblage as a gift from
 the architect Philip Goodwin and his *Willows* painting from Duncan
 Phillips.

Though Stieglitz commended Dove's article, there was no more talk
about it, and it was never published. Dove was unusually full of words
this season; in his very next letter he sent another exposition of his
thoughts. Stieglitz's copy of the enclosure was lost. The version in-
cluded here, after the next letter, was Reds's handwritten one, found
among Dove's papers.[1]

1. Collection of William Dove.

<div align="right">

[Halesite]
[6 April 1931]

</div>

Dear Stieglitz,
 The enclosed is an evening talk with Reds which she took down
apropos of what is going on in the papers.
 You and Georgia become finer all the time.
 Have been so in hope that I too might do something for the room this
year.
 Glad Barr was interested.
 If he could do anything just now with any of us, it would be the
psychological moment to get Pemberton and some of those who have
been pounding the museum to do some glad shouting. Wonder if he
sees that? . . .

<div align="right">

As ever
Dove

</div>

[Dove's enclosed statement follows.]

ON READING THE CURRENT PAPERS—

Among all that is being written just now about painting there seems very little that lives in itself as pure writing.

It is hardly possible to go on living from other people's ideas without adding some of one's own.

In trying to save a few souls they are not quite so practical as the Salvation Army.

There is being so much written that the public is forced to think more of what is said than of what is done, and gets its aesthetics as it does its politics through the editorials.

When people damn Picasso and Joyce and save [Thomas Hart] Benton and [John] Sloan along with Michaelangelo they get to the stage of breaking plate glass windows.

Religious people going back to their forefathers cannot quite dismiss their contemporaries. You cannot dismiss a Cézanne by looking at an Ikon.

One step further in that direction and all Art except the purely religious would become graven images and life one long prayer.—

This religious instinct which appears to many to dwell in the past or the future can appear in a pear, a seated woman, or a mountain as well as in a madonna.—

Now for instance Stuart Davis is alive. He writes well-meaning things, says what he means and means what he says.—One of the few who can do that thing well.

He is there anyhow, and I like the latest McBride on him.

Craven is the Big Bertha and I don't think they're going to be used after the war.—

[Halesite]
[19 April 1931]

Dear Stieglitz

Should have been in this last week, but for a terrible tooth—teeth—tooth—teeth. Will have to have it out probably and a couple of days to heal. Working on boat mid-days and drawings afternoons.

What a difference in people. There are so few. Reds went down for dinner with Holly last night. I refused to go with him [Henry Raleigh] away as we had refused several times before.

Holly has two of them in *her* studio. One of them, the "River" one

[*Penetration*], has been ruined. Reds blew up of course and said that life was all like that.

It was either carelessness or a smash at the painting. Holly took the blame.—Much weeping on her part. Reds said she became very real. He is a rather miserable person now. "Feels he can't talk to me." Gradually cutting everyone off. "Would be first to do what he could as he likes me more than anyone, but would be just as mean right after."

He has tried to paint, Sheila[1] laughed at them—he rubbed them all out.

Such hellish shoes to be in.

Reds told Holly there were only a very few who cared, and we might as well stay by ourselves.

It is a long story and I can see but one ending. Just have to go on now more than ever.

Jewell on Demuth is just as hopeless as on Sterner[2] in today's "Times."

You are more like earth to me than any mother or father I have ever known. The more I see, the more I feel that way.

You can know that anyway.

Love to you both from us.

As ever
Dove

1. Raleigh's daughter from his first marriage.
2. Albert Sterner (1863–1946), American realist painter, was better known as an illustrator. Edward Alden Jewell's two reviews, "Demuth" and "Albert Sterner," appeared on this day, 19 April 1931, in *The New York Times,* sec. 9, p. 18. Dove's comment was presumably provoked by Jewell's contention that Sterner deserved to be called a modernist rather than an academic on the basis of the quality of his work, and by the critic's treatment of Demuth, which was essentially descriptive and lighthearted, not very probing.

[Halesite]
[24 April 1931]

Dear Stieglitz

. . . the tooth is behind me but not quite all the trouble. Out yesterday. After pulling for half an hour, he had to drill it out. Was certainly attached to that tooth.

Found myself really enjoying seeing him puff. How small we become under some circumstances.

Very much bigger in the face however. Have written to two editors who are interested in my painting, no jobs as yet.

Peddled my way through one panic years ago with jokes, humorous ideas, etc. Now editors will not see anyone unless it is someone that everyone is after.

Reds is taking a course in coloring photographs, they guarantee work. "Will send all you can do." May try it, in a pinch. Magazines all leaning that way. Hope we are not forced to stop painting. Reds has done some fine things in the last week or two. . . .

<div align="right">Dove</div>

<div align="right">[New York City]
25 April 1931</div>

Dear Dove: . . .

How to scrape along, that's the great question. . . . The "Place" is dead as far as people coming to see things are concerned. Phillips (& Mrs.) came in the other day. Were here quite a while. Had decided nothing yet about your paintings but I have a feeling he'll keep the "Sand Barge." But one dare not count on anything (or anyone!) these after-prosperity days. . . . Georgia is busy getting away.—[1]

I'm pretty tired.—

Georgia doesn't want to leave me. And in a way I hate to see her go.—But I feel she must go. There is no choice. She's fine. I want to get at my photography. I hope my health (!) won't play me pranks this year again.

<div align="right">Our love to you both
Stieglitz</div>

1. She left for New Mexico on 27 April.

<div align="right">[New York City]
2 May 1931</div>

My dear Dove: Why don't you apply for a Guggenheim Foundation Fellowship?[1] Now is the time you must apply for next year's.—I have

written to Phillips whether he had come to a decision. Also to McBride asking whether his Museum would want the Sea & Wind piece [*Clouds and Water*] for considerably less.[2] So I'm on the job as best I know how. I'm hoping something may happen. You certainly deserve the change.—Love to you and Reds.

Stieglitz

1. Dove was intrigued, at least briefly, with Stieglitz's suggestion that he apply for a Guggenheim grant, but in the long run he was diffident. Despite the urging of other friends as well, Dove never applied.
2. Stieglitz hoped at this time that the Gallery of Living Art at New York University might purchase this "Sea & Wind piece" (*Clouds and Water*) because McBride was involved there. McBride was then also editor of *Creative Art,* which had published a reproduction of the work in its April 1931 issue. However, despite McBride's interest in Dove's work, Stieglitz's hopes were not realized. He acquired the painting himself, and O'Keeffe donated it to the Metropolitan Museum of Art after his death.

[Halesite]
[5/7 May 1931]

Dear Stieglitz

Thank you for all you have done. I know how hard it is to do. One would have to have the soul of a College President to really enjoy it. They are born that way and it does not seem fair that you should have to ask for so much on my account. I must try to solve the thing myself. We were a trifle too hopeful this year. It is the only year I did not worry after seeing the paintings hung. And the very year there was most to worry about.

You know as I have said before, that the paintings are as much yours as mine. We shall do the best we can with them. Hope I am not presenting you with just more responsibility. Will try to make them worth it. This cannot last forever. In the meantime, not being able to sell the boat, have decided that it is best not to sell it, but to get a pilot's license and take out fishing parties etc. Have had many chances at $25 a Sunday. The responsibility is unlimited unless every point of the law is covered.

Anyway I can be looking and thinking while the rest of the world fishes.

It will take time out, but I see people here who expect to make a

living by it this summer. The investment is there so might as well capitalize it.

Have a job promised from the "Elks" magazine as soon as they get a suitable story, but when that will be I do not know—and it [payment] takes a month or two after the job is done.

About the Guggenheim fund, I looked in N.Y. telephone directory (last year's) but found no address. Do you know how to go about it? Cortissoz[1] being on the board would probably mean one thumb down. However Hartley survived.[2]

Do not like the idea of having to leave the country.

It looks as though not being willing to pay artists to stay in the country, they even go as far as paying them to get out. Not being able to choose, one accepts.

I go all around the countryside here and come home to find finer things than had been seen elsewhere.

The place to find things is in yourself and that is where you are. . . .

Always
Dove

1. Royal Cortissoz (1869–1948), art critic for the New York *Herald Tribune,* was an opponent of modernism.
2. Hartley had recently received a Guggenheim Fellowship to paint in Mexico.

[New York City]
8 May 1931

Dear Dove Phillips returned the "Two Forms."—Not a line from him. So I have a right (I imagine) to assume that he has kept the "Sand Barge" at $800. But nothing is certain with these people until definite (& then? sometimes). That would be great if my assumption comes out true. I'm writing him again to make sure.—McBride says Gallatin[1] is in Sicily. G. buys (has the cash) for their Museum.—McBride says he'd write G. to acquire your painting (the Wind, etc.) for the $750 I offered it.—So may be once more.—

I have your letter. Any chance of any kind these days must be grasped. My little capital is shrinking fast. And I didn't speculate!! As if living today wasn't the worst kind of speculation for the likes of me.

Georgia is in New Mexico. I had a line when she arrived. Not a word since. I can't afford to be nervous.—She is 30 miles (or maybe 70) away from the post office.—[2]

Demuth so far has had no "luck" but the Show will eventually bring him returns. As I feel yours will too.—Your optimism will not have been entirely misplaced. . . .

It's all very different from what I see it "should" be.—Could be.— And certainly must be some day—& not so far off.

—Love to you & Reds,

> Ever your old
> Stieglitz

1. Albert Gallatin (1881–1952), American painter and art historian, was director of the Gallery of Living Art.
2. O'Keeffe, who had been gone for only about ten days, spent this summer in a rented cottage on a ranch at Alcalde, some forty miles south of Taos, where she had spent the previous two summers.

> [Halesite]
> [13 May 1931]

Dear Stieglitz

They have had me on the run for the last few days. These yachtsmen get the idea every spring of rebuilding everything on the place so have to do my bit at that, and of all things they have elected me treasurer so that I have more money that isn't mine than I have that is. It all takes time.

Had a letter from home saying they have to send one of the horses to Cornell for treatment, and want my advice about the business etc. Told them that someone had suggested shooting the horses and sending me their income. They are also drilling for gas on the farm.

Gas has been struck quite near them. That would be funny, wouldn't it?

It is fine of you to keep on plugging at all these people for so long, and everything seeming to count in some way.

Elizabeth [Davidson] told me something you had said that moved me much and made me glad to know you felt that way. It came to me sort of on the carom. It is nice to see you draw the balls into the corner on a long shot.

Chaplin has said some good things lately in interviews. Have you seen them?

Have made a lot of drawings. Am going slowly this year as last. Want to be sure of means and material. . . .

Holly just phoned—another operation. Harbor Sanitarium, N.Y. Fallopian tube this time. He has not been near her. Swore at her over the phone until she fainted yesterday it seems. Colored servants came here last night at midnight looking a bit white.

I phoned their doctor and we decided it was job for the police. Doctor having been torn up once. Servants left for N.Y.—After having kept the community up for the night, police go down there and find him sleeping peacefully in his room. Ought to have been waked up and put to sleep again. She was lucky to be in the hospital.

Begged them not to be married, knowing what would happen and think my job was over then. So can't be bothered anymore.

To speak of fine things as a contrast. We had a lovely visit with the Davidsons.[1]

Love from us both to you and Georgia.

<div style="text-align: right">

As ever
Dove

</div>

1. Dove and Reds visited the Davidsons at their home in Monsey, New York, 29 April–1 May.

<div style="text-align: right">

[New York City]
18 May 1931

</div>

Dear Dove: Did I write you that Phillips finally took the "Sand Barge"? I have been laid up for a week with sinus—but am all right again. 4 days in the hotel, the Demuth Show was over, set me up in many ways. Tough times & tougher to come.—Georgia is having a fine time.— That's a lot. I hope things aren't too hard your way.—I can advance you a couple of hundred when you need them. Don't hesitate to let me know. May be you won't have to do so. I may send you a check before.—Love to you & Reds—

<div style="text-align: right">

In haste
Stieglitz

</div>

<div style="text-align: right">

[Halesite]
[Probably 11 June 1931]

</div>

Dear Stieglitz

There has been a letter started to you here since the day after I

phoned. Things began to happen so fast about in there that my occupation was changed to mechanic. Runways that cool the exhaust became worn through, so had to take the 750-lb. engine all apart, have it welded, put it together again only to find that they shouldn't have undertaken the job as they had not proper equipment.

That was the time they did not just get the money. Made them give it back, all but the time.

Find I can do all that now and install another engine with less effort than it took to change cylinders five or ten years ago.

Life is so much more enjoyable after being allowed to go on painting. There is a Scotch-Indian, born on the lighthouse, fisherman who helps me with the heaviest lifting. The one who said "How much money do you have to have to be broke?"

$4.00 a day, by the hour.

We lowered a 400-pound engine off the dock into a rowboat and hoisted it back into the big boat in an hour. Found an old 2-cycle "Lathrop" such as the fishermen use for $20. Hope to be ready in two or three days. If I can make $100 a month, even that will help and not take too much time.

No illustrating as yet.

We are not hungry as yet either. A fine box of eggs today from the Davidsons, fish and vegetables from the neighbors. $11 pays the rent for year. (Club dues.)

In spite of it all the money is getting low. Storage $28.00, the doctor who has practically rebuilt Bill, the dentist, color and engine seem to heap up quite suddenly.

Holly is suing for separation and $500 per month. She has the house etc. Too tired of the whole shooting match to be very sympathetic.

My brother is being made to feel he cannot afford to be married. Mother writes serenely that he has everything he wants but a wife. I wrote back that he had about as much freedom as a mouse in a cement room with a cat.

Have some new watercolor drawings that we think quite a bit ahead.

This weather is none too good for your trouble. Reds is down with a cold today. The sun was almost through and barometer gradually going up so look for it to clear tonight. These northeasters can certainly hang on.

Love to you and our best to all who see you more often than we can.

As ever
Dove

Sort of an "enginey" letter, but that is what this week is.

With his next letter, Stieglitz enclosed one from Sherwood Anderson, who suggested that Dove and Reds might be interested in serving as caretakers on the Maryland country property recently purchased by Anderson's friend Maurice Long of Washington, D.C. Anderson described Long as "a big headed Irishman of about fifty, who has made a fortune running big laundries." Noting that Long had "long been interested in literature and poetry," Anderson explained that he was beginning to be interested in painting and was "fascinated with the idea of having a painter on the place." Long had given Anderson permission to suggest the scheme to Dove and invite a reply from the painter if he was interested. Dove wrote to Long right away and dictated to Reds "a wild letter to Sherwood."[1]

1. Diary of Helen Torr Dove, 14 June 1931.

[New York City]
12 June 1931

Dear Dove: Enclosed from Anderson speaks for itself. He sent it to me wondering was he crazy. Asked me to decide whether you were to have it or not. . . . I'm enclosing check for $250.00. That can be repaid to me when you get your riches from poor man Phillips.—

I'm sending you a copy of "Letters of John Marin,"[1] just out.—You & Reds will enjoy them when you find time to read. . . . Georgia seems happy. Is working & seems to be feeling better.—N.Y. is no place for one like her. As for me—I leave for Lake George on Tuesday, Stars, God & Co., Ltd. willing.—Formerly one never could tell—now one can tell even less. Rosenfeld accompanies me. But I'm prepared to go alone. One is supposed to make the trip to heaven (or hell) alone. Or may be that is changed.

As for Holly—that was inevitable before they got together.—You can't afford to be mixed up any more in such a mess, sorry as you may be for her & him & it.—You have your hands (& head) just full enough without.—

My love to you & Reds—

ever your old
Stieglitz

1. Edited by Herbert J. Seligmann and privately printed for An American Place.

[Halesite]
[5 July 1931]

Dear Stieglitz

The Marin letters are delightful.—You can pick them up, read, be happy, put them down, and be happy, and be happy to pick them up again.

I love the spirit of them, and it is fine to see you behind his finest feelings.

"The Letters" are certainly a welcome addition to our lives and a great American event. In case of fire I would surely grab them. . . .

Have captain's license and boat in running order. It was amusing. Had heard that they delay you for tips. Clerk of customs said I would have to come in again for it. Said I couldn't very well—asked if $5 would push it along. He said "be careful." I had to as he nearly clawed my hand for the $5 like a 5th Ave. bus machine takes a dime.

Have just had the watercolor drawings out. Find there are 37 of them so far. We both think they are ahead of last year's similar preliminary and as to time, two months earlier.

Trained off about 10 lbs. lifting engines during those hottest days and feel a lot better always for good hard labor out-of-doors. Love to you, Georgia, Paul R. and all others who are there in both senses of the word. Bill is driving to the Yellowstone with young Brooks, where they have a summer job. He was 21 July 4th so gets his $6,000 from his mother. Said, if I got badly stuck he would be glad to let me have some. Swell of him. I would not take it of course. It was a nice idea. He protects much of his real feeling with humor. Also has a better job when he comes back in Sept. at the school.

Dr. Beck has practically rebuilt him as he did Reds. She is fine now and sends her love with mine.

As ever
Dove

[Halesite]
[9 August 1931]

Dear Stieglitz

I have an idea that this is true about my last show. There was just something in those frames that did not blaze the way it should. Think I have found out that thing. It was the effect on the eyes, and after two

years of using Japan gold size that they sell in the stores, I have found out how to do it better with a varnish ground so that the same frames have twice the speed. Have taken one of the large frames that was left and redone it with the leaf. One of these professional yacht letterers told me he could not do a gilding job with the commercial size.

The frames have more the same feel as the paintings. It makes as you probably know an amazing difference. Should like to take a few of them and redo the frames. They look so much more brilliant.

This thing of experience is rather time-taking to the person who has to find out inch by inch. As you say it comes to a matter of money and in my case time has to take the place of that. Feel quite heightened to be able to make the sort of thing I want to go with the paintings.

Not a word since from Long. Strange that all that enthusiasm should vanish if that be the case.

Bill is here with us. A week in Geneva fairly did him up. With Paul's southern girl from "Loo-ville, Kentucky" and her father, a preacher, Bill calls him "a Basteurized Evangelist," the prospectors looking for gas. It must have been a strain.

Am writing them today insisting that, if they can borrow money for themselves whenever they need it, they will have to for me. Have never been able to do it yet, and they have more excuses to barricade their consciences with than ever. . . .

As ever
Dove

Before the end of the summer, Dove seemed without financial prospects once again. His family would give him no aid. Although he had obtained his pilot's license so that he could take parties out on his boat, he had not had the business he had hoped for. Since April, Reds had been taking correspondence lessons in coloring photographs. Although Dove had opposed enrolling, she had spent nearly fifty dollars, an investment she probably never recouped in payments for work. As he had so many times previously, Stieglitz sent Dove an advance check.

[Halesite]
[Probably 20 August 1931]

Dear Stieglitz,
Have wrung the stone again—and no blood. It leaves one wondering

in what way one can possibly be related to any relative. Just do not feel acquainted.—They are there and cannot move. Of course I should have planned years back to do the whole thing with no expectations from anyone but myself. You see he is the guy we are sore at when we get sore. Guess he'd better shut up and go to painting until he can't wiggle any longer or get a plain everyday job and learn a little more about business, if any.

Should I write Phillips? Would that be good business or is all business bad now? Or should I mark everything down and have a bargain sale?

Would any of those who were shouting about selling the paintings for $100 each be willing, be glad, to get them at that?

If I could get 10 people to give $100 for any ten you see fit to let go— or even five, or three, or one, I could go on with these. Have four of the large paintings going.

If I could put one of those $100 men at the first of each month for five months there ought to be 20 more and better paintings. Some frames done for paintings and drawings. That should be good business if it is true that business has "turned the corner."

Trying to sell boat. No one buys boats now. Fishing parties have about stopped on the Sound as there is so much bait now that fish do not bite. You see it is just like business—so much money no one buys.

Funny part of it is that I cannot get a job as easily as the working man because a bit of education, class, or whatever stands in the way.

Trying to make frames for a few outsiders—local.—You know.

Clams are $2.00 a bushel this year. Takes a day. Can do better trading them to friends with gardens for vegetables.

Of course people have always considered me able to make a living.

Rebuilding burned bridges is ten times as hard as building new ones. And when the new ones are on speculation and the recent unpaid for— Hell—similes do not do anything to facts. Do they?

Wrote family that they had been so long using what they say is "as much mine as theirs" to borrow on, use, sell parts of to put back into their business(?) that I expected them to do as much for me in the same spirit. That their attitude put me in position of sharing all losses eventually and no profits.

They refused with loving blindness.

Would give me a swell funeral, but not in Geneva, if I can help it. . . .

Hope you have been able to work.

They say that is what makes the world go round—like a chicken with its head off.

Wish we knew what did make it go round.—We'd tell all the real people to dig themselves in and stop it until the rest fell off.

Lots of love to you both from us both.

Bill sends his too.

<div align="right">As ever
Dove</div>

<div align="right">Lake George
24 August 1931</div>

Dear Dove: Here is a check [$250]. I'll advance it on what's due you from Phillips. . . . All is well here.—But I'm in no state to write letters just now. Love to you & Reds

<div align="right">Stieglitz</div>

<div align="right">[Halesite]
[3 September 1931]</div>

Dear Stieglitz

So much finer than just friendship is this which comes through fighting for the same idea. I never shall be able to express it.—Perhaps by doing better work.

Such a world where so few mean what they say. Your present lift certainly let in air to some work that was gasping for breath. So on it goes.

This last painting we think is the high spot. Hope it can be held until finished.

They have a pile driver out here this morning that shakes the whole building at every drop of the hammer. Almost through however. My brother finally sent carfare—$50.00—to Geneva at mother's insistence. She has had a slight stroke but is much better. He had borrowed $1500 from the estate security to do business with, seems quite surprised that he should be asked to spare any of that.

Carfare is edible and I do not see why feed Oedipus with it. So am working.

Reds is quite cheered that the painting can go on now—is very fond of the last two 30 × 40's.

Am trying to make them so real in themselves so that you know where everything is going and what it is doing. To express an emotion in the colored drawings is one thing, but to take that and make every

part of it do all that, keep its feeling, and exist in its own space is another.

Guess I'll have to paint that pile driver to get the better of it.

A man—Wm Pinkham—was here and spent the morning questioning. He was from the National Cyclopaedia of Biography. Suppose they have been to you and Georgia and Marin. He took all names. Had an article written by someone. They never tell where they get their information. There are 27 volumes of this thing so far and it is in all important libraries in England, Germany, Russia, Japan, France, etc.

He spent 3 weeks with Ford finally finding someone else in Detroit built a car before Ford and gave him parts for his car. . . .

He carefully went over photographs and information on you all. Was quite pleased as to our state of affairs. Is holding that open for a month. He had been through the same thing. He was an actor and his affairs were "front paged from coast to coast."

Was making $3000 a week and had $2 left when they finished with him.

I do miss your letters, but please do not write until you feel just like it. Writing is such a strain unless it gives you something in the doing of it.

What this year's situation and situations within situations must be doing to one in so close touch with so much I can well feel and understand.

I try to think how impersonal the laws of nature are, but that does not change the situation.

We have tried to talk things of our worries out loud instead of trying to save each other the other's worry. It helps in planning action. We have cheered up a bit anyway. That is mostly your fault, I know, but it all helps.

Think it is going to be a bit healthier to work harder and not expect so much for each thing. I doubt if the Europeans will be able to do it this year unless this country has gone solid damn fool.

Our best love to you both

> As always
> Dove

> Lake George
> 14 September 1931

Dear Dove: Having nothing definite to do I have become a greater procrastinator than ever.—And I hate all procrastination. . . . I never

heard of the book you speak of.—Hope it really informs.—A week from today I'll be in town for 24 hours seeing about the painting of 1710. About 2 weeks later I return for the season. . . . Georgia is fine. And I am doing a little printing. But in spite of all quiet on all fronts everything is really at sixes and sevens!—Superstitious persons turned 13 into that !!—

> Our love to you both
> Stieglitz

[Halesite]
[28 September 1931]

Dear "Old Stieglitz"
 Youngest of us all.
 That is still true. I mean that.
 In this battle with life (myself of course) I learned something Sunday A.M. about 3 o'clock that makes me want to do all my paintings over again. The only thing to do is to do what you are going to do the way you would have liked to have done it.
 Would have been in to see you on the 21st but the boat had caulking pulled out—three inches of water over floorboards. So two days of hard labor. . . .
 Paintings going fine. Alfy out yesterday—tried to stop me from doing anything more to the one I like best. I had scraped some of it on account of the color. It is all right to make a good shot, but how about the rest of the game? I still cannot believe that life is an entire accident.
 Am expected to go to Geneva for two weeks in Oct.[1] while Paul gets married in Kentucky to "Just a woman." Your quotes. Bill roared when I told him what you had said. He was there with them for two weeks.
 Bill says that Van Wyck Brooks is fine now all right.[2]
 Have an idea that may not be so at all, but may cheer you. I think that by winter people are gong to get tired of economizing. American psychology such as it is.
 Love from us both to you both with wallop

> Dove

1. Dove actually went to Geneva for only a few days, 16–20 October.
2. Van Wyck Brooks had been released after four years in mental hospitals.

Stieglitz returned from Lake George early in October. He opened the gallery with the usual Marin show, followed by O'Keeffe's. Early in 1932, an exhibition of 127 Stieglitz photographs featured his recent large images of New York City. Dove's show was next, opening in March. The next month Paul and Rebecca Strand had a joint show of his photographs and her paintings on glass. The season ended with an impromptu group show of works by Dove, Marin, O'Keeffe, Demuth, and Hartley.

Dove's financial difficulties continued to be severe. In Stieglitz's next letter, he found out why the interest of his potential benefactor, Maurice Long, had suddenly disappeared.

<div style="text-align: right">

[New York City]
10 November 1931

</div>

Dear Dove: I have a check from Phillips. . . . It has been a tough job collecting.—But all is well. I'm still in the doctor's hands but am pretty fit all things considered. Marin's Show is a grand one—much interest & so far not a sou.—The U.S.A. pleads poverty again. . . .

<div style="text-align: right">

ever your old
Stieglitz

</div>

I heard the fellow who wanted you [Maurice Long] died!!!—

His only chance.—As I said yesterday while in the dentist's chair, & I have a new epitaph (No. 111) for myself—

> He lived for better or worse
> He's dead for good.

I hope all is fairly well with you & and that you are painting.—It's a terrible wish to wish on any American—but I wish it on you all the same. —

<div style="text-align: right">

[Halesite]
[11 November 1931]

</div>

Dear Stieglitz

Great! We were just beginning to wonder how much farther our rubber band would stretch without breaking and slapping our heads off.

. . . . Have been working day and night, paintings and this frame factory.

Davidson was out yesterday and seemed quite amazed by the amount of work.

Right in here was, as you usually manage, the psychological moment. . . .

Too bad about Long. There was quite a spirit in his letter. Perhaps his idea was better than the result might have been had the rest of his research workers been as difficult as we are. . . .

Have quite a few large paintings all ready, expect to finish up the 20–25 small ones with their frames by tonight or tomorrow. They certainly look much happier with the leaf than last year's powdered bronze.

We are much amused by your epitaph. Have you read Paul Morand's article "Bulls and Bears in the Art Galleries?" Current "Vanity Fair."[1] He certainly echoes what you have said about the French. Is Georgia still commuting from Lake George in the Ford? Hope she brings paintings each time. Hear there have been some great photographs from the window at 1710. . . .

Think with this we can make it all right again this year. Close shave. Shave myself and now cut my own hair with safety razor.

Reds is doing fine things and Bill has come on in strides I only hoped for.

<div style="text-align: right">

Love as ever
Dove

</div>

1. Paul Morand, "Bulls and Bears in the Art Galleries," *Vanity Fair* 37, no. 3 (November 1931): 44 and 86.

<div style="text-align: right">

[Halesite]
[7 January 1932]

</div>

Dear Stieglitz

Suppose the Davidsons have told you about the paintings that I have here better than a letter. Have about ten new ones under way, a series in fact, named after the days of the week, getting at the different conditions of each day.[1]

Holly called Reds today and told of her talk with you and of your being low. I can well understand the many sources.

Know something of my own. Have found that subject matter does

not matter. It is always the same. If a child hurts a mother or father, it takes some time for love to grow with quite the same vigour.

I would not have any of you all hurt for anything in the world and yet you are. I do not get this from anything that has been said, just from the way I follow you day by day in thought. Of course I ought by now to know our feelings as being real. They do not change to me so I know it takes two people who do not change not to change.

Have just had a long letter from Phillips. . . . offering retrospective exhibition next summer or fall when he returns from Mediterranean where he sails in February. "Hard hit by depression." Of course that hardly touches my background but I suppose it is true that it is much cheaper to live in a French hotel than to run well the place in Washington.

Hope he will come to Georgia's show. Doubt however of his intention of buying anything this year. Will show you the letter when I get in with the paintings.

Want you to see them as I feel sure they will give you cheer. I know they are the finest yet and working to that point is the reason for my not getting to town. Am painting until I see the whites of the creditors' eyes.

Hear you have photographs next and mine about March first. That ought to give me time for the new series although I have enough for a show now. . . .

Wish you could have been here—a fine lunch on 28¢ worth of Maine smelt. Living on $90 a month since March. No clothes or rent, of course, and have sent Bill some.

Much love to you as you know

<div align="right">

Always
Dove

</div>

1. This project apparently ran to only three completed paintings. They were shown in Dove's 1932 exhibition with the titles *Black Sun, Thursday; Wednesday, Snow;* and *Sunday.* Another painting, *Breezy Day,* on which Dove was working in December 1931 and which was included in the 1932 show, may have been related to the series idea.

<div align="right">

[New York City]
9 January 1932

</div>

My dear Dove: I'm not low. I'm just damned tired. Have been on

the "job" day in day out including "holidays" on an average of 14 hours a day—some days 19 hours!! All very alive—but ye gods—terrific.—And after all I'm still a bit human—too human perhaps for my own "good" & so for those closest to me. Holly came at a moment when all sorts of people were trying to have me do all sorts of incompatible things at one and at the same time. And I'm not yet equal to that. May be some day.

Very much is happening yet nothing seems to be.—Cash grows less & less. And every one smells wealth in this clean place. A man may have on a newly laundered shirt & yet be starving to death & the shirt frayed & in shreds but only the still whole parts shown.—Well, I'm still on the bridge and I'll stay there till I drop—at least as long as 1710 is afloat.—

I'm sure your paintings are the best yet.—Am eager to see them. Georgia's show is swell, may be she can get a few dollars. Marin in spite of all the "lovers of Marin" did not get a sou. His first experience. Phillips was "crazy" about Marin. Has no money (!?) and offered to exchange an early Marin for one of Marin's finest recent ones.—I asked him where Marin would come in—he seemed not to know.—Yes, Phillips is "broke"—but his "broke" after all can't arouse my sympathy. I have yet to know him not broke. It's all very funny (!) when one knows all the facts.

In prosperity days everyone was building houses, so broke, now closing them—too expensive to run.—Ye gods.—It's all so humorously ghastly—or ghastly humorous.—Everywhere divorces—and sui-cides.—Life is fuller than ever.—

I had announced a show of some of my photographs.—I don't think I'll hold it.—Too much expense to present them properly, besides which I'm really not interested in listening to the tommyrot of the audience.—I'll see.—The Place is really too small to do myself justice. Or rather do photography justice. . . .

<div style="text-align: right">

Ever your old
Stieglitz

</div>

<div style="text-align: right">

[Halesite]
[1 February 1932]

</div>

Dear Stieglitz

. . . . We want to see Georgia's things. Bill Dove, who has not up to the present liked the O'K's as much as I thought he would, just raves about them through his whole letter. It must be rather difficult these days listening to the rich groan about their poverty. Am a bit tempted to

say this year that everything except my last painting will be $100, the last one [*Sunday*], $500.

What puts that in my mind is that the one I did yesterday has found something.

Decided to let go of everything and just try to make oil paint beautiful in itself with no further wish. The result is that this thing, to me, exists in light & space as something decidedly itself. It seems to have the joy in the means that music does. What I have been trying to do is to make what would be called an abstraction be self-creative in its own space and not be confined to a flat canvas for its existence. May look otherwise to a person just looking at it but at least I have had as much joy from it as anything since the first ten you showed at "291.". . . .[1]

You by all means should show your photographs while that beautiful place is available.

No one knows what can happen now. And I do not think they would be much surprised if the sun rose pure red or a red ball with red stripes as rays on white.

We have bought all the rest airplanes & guns and expect them to fight it out on dotted lines.

Can bring in the paintings any time now. Of course the longer I wait the more there will be. If you want them in soon, let me know.

White of cr[editor]s' eyes not so far off.

Paid something on storage & color man. Grind own color now. Much better, purer than any but Blockx's. Probably Schneider thinks I am running a bill elsewhere, but I can make about $25 worth of cadmium for $1.60. Have found out how to burnish silver, gold etc.

We enjoy each other so food & coal are about the main necessities, but they certainly get to be necessary.

Love to you and Georgia from Reds and

<div align="right">Dove</div>

1. Dove showed ten abstract pastels, later collectively known as the "Ten Commandments," at his first one-person show, held at 291 in 1912.

<div align="right">[Halesite]
[17 February 1932]</div>

Dear Stieglitz

. . . . Will talk things over about the coming year when we see you. Not much hope from Geneva at present, but there are possibilities.

The paintings are all ready, and quite beautifully framed—mostly in silver. . . .

It is almost too cold here to write well. It was 10 above in this room the other morning when I got up. And a fire going.

. . . [The paintings] can be brought in at any time that is convenient to you—with a few days' notice. Am less worried about them this year than before.

Have eliminated the beaverboard backing on the paintings as it is so expensive. There is nothing lighter that is large enough and buyable here. It can be done to any you think best, in town—before or after the show. We have weekend privileges of an apartment near, so can attend to that. . . .

<div align="right">
Ever

Dove
</div>

Dove's next letter was written the day after he had taken his paintings to An American Place. Reds, who had already seen Stieglitz's show there, had stayed home.

<div align="right">
[Halesite]

[10 March 1932]
</div>

Dear Stieglitz and Georgia

Would have enjoyed staying for dinner with you so much last night, had to figure on trains and the weather. One at 8:10 would have meant leaving at 7:30, and the other reaching here after 1 A.M. so I knew that Reds would be an icicle. Or fires out. In these gales from the N.W. with cold we might as well have a bench with a stove in Battery Park. One has to move fast to get time to work between stoking.

It was a beautiful show. As [Waldo] Frank was admiring the portrait in the book there, I wondered, not in connection with him, but the people in general, if, after 50 years the so-called familiarity of the object does not dim enough for them, so that the inherent beauty of the photograph becomes more vivid. It is the same old story. Whether it becomes them, and it seldom does. The portraits are too beautiful to be becoming, too far above, and the clouds they would think out of sight, which would be true. . . .

Our love to you both

<div align="right">
Dove
</div>

Dove and Reds went to New York on 23 March to take one more painting and see Dove's show, from which several watercolors and a couple of paintings had already been sold. Dove wrote a grateful letter the next day.

[Halesite]
[24 March 1932]

Dear Stieglitz,

Have always felt that, if your work was the farthest on you knew and the finest thing in you, that it eventually would be seen by some few others. For the last two weeks or so I have realized that eventually is a pretty long word, and the one time suggested sign over the door at "291," "Give up hope ye that enter here," was pretty true. Yesterday at the gallery has made a terrific difference in my feelings. I mean that you have taken the less out of hopeless. Not financial any more than that we should as usual be allowed to go on gradually making the impossible possible. This is the precise moment for you to do just what is being done.

We took the postmaster here out fishing one afternoon about three years ago. We threw in some oatmeal and started. . . .

A school of mackerel came. We caught two at a time until in an hour we had the rowboat half filled (about 1500). Something had happened to us as well as the fish. Even Reds, we were as excited in catching them as they were in being caught. They even bit on the boat mop when I cleaned decks.

The people in a rowboat not ten feet away caught none.

We fed the whole village that evening. The news went round in half an hour.

The hanging is perfect—many thanks to you three or more. . . .

Always
Dove

[Halesite]
[28 March 1932]
Monday evening

Dear Stieglitz

Since your saying the other day that you wished you had a hundred

more of the sketches, I have looked through a large box containing all the drawings that had been put aside to make paintings of, and some that have been painted from the last two years.

Have picked out twenty of them and mounted them. . . .

Want to get a flying start this year before the spring chores begin.

Hope it, the race, will not be called off, by *all* the starving, rich, I mean.

Would like to have a dictaphone at 1710 to hear the talks. . . .

Love to you and Georgia.

<div align="right">Reds and Dove</div>

Early in the spring, Reds finally received her divorce from Clive Weed. After more than ten years together, she and Dove were married in April. Her diary for the day gives a brief account: "Both to N.Y. on 8:13 to City Hall, and were married. . . . Stood in a little room and it was done. A ten-cent store ring. Outside all very charming, pigeons and flowers. Did errands in neighborhood, . . . taxied to Penn Station, had lunch at counter, and home on 12:55. Arthur stopped in Huntington & made ours a joint account at Bank. We liked it very much." Dove wrote to Stieglitz that afternoon.

<div align="right">[Halesite]
[22 April 1932]</div>

Dear Stieglitz

Have a long letter written for you which will be sent later.[1] This is just an Announcement of the marriage of Reds and me.

We have had to do so many things twice in the last few years that we decided to try *once* last night and went right to city hall, New York, this morning and it was fine and simple. This divorce and marriage thing is more wholesale in City Hall and there were no reporters. Three $1 bribes and we were first called.

There was a Jewish clerk who looked at me over his glasses rather doubtingly when I gave my occupation as frame maker. However it was too much true, but enough to get the license plates. I did not want to bring in Clive and all the possible "artist" talk. Had two frames to make locally and an awning to paint so we rushed home on the 12:55.

Expect to come in the first or middle of next week to see you and the Strands' show. . . .

Love to you all and much of it

As ever, Dove

1. Now lost, if indeed it was ever mailed.

[New York City]
25 April 1932

Dear Dove and Reds: So it is done. It is simpler.—I am glad.—It makes no "difference"—yet it is simpler. . . . Things are very quiet here. Beck Strand has had some luck.—I'm fighting a cold & sinus.—Georgia is painting.—Dorothy Norman continues on her job trying to save the Place or bits of it at least. And so it goes.—It's a steady pull against a mean and increasing gale to which there seems to be no let-up.—

Here's to luck!—

Our love,
Stieglitz

[Halesite]
[May 1932]

Dear Stieglitz

Those we love the most we seem to write to last. . . .

Your letter was like one of your photographs. There is a certain quality that I have never otherwise known. . . .

Heard from Mrs. Rankin[1] in Washington today of a talk she had with Mr. Watkins,[2] Phillips' secretary.

Quotes from her letter.

"I had heard in the late winter that they were going to ask A. down to give a talk and then Mr. Phillips had to go away and it was postponed.

"It seems, that he wanted to give a big show for Dove. When A. comes down, also he wants to write a book about A.—He thinks A. a great modern and not sufficiently appreciated."—The terms I hear are expenses, including the "May Flower (Hotel) and $50" etc. for me to give a talk on painting.

Reds allows that if they can get $50 worth of talk out of me they will be doing well. . . .

Had you heard that Alfy has had 2 operations? Is in Beth Israel Hospital. . . . Last one Saturday. We are to meet the Strands Friday so will see you then. . . .

Suppose it is possible to see Georgia's mural? . . .

Hope Phillips doesn't ask me to talk to Hoover or a congressman on painting. The idea of coming from the nice quiet water and landing in all that excitement makes me a trifle *nervous*. . . .

Hope Mrs. Norman can manage to save more pieces of 1710 than any of us may realize.

Our love to you all always.

<div style="text-align: right">Dove</div>

1. Dorothy Rankin, an old friend of Reds, lived in Washington, D.C.
2. C. Law Watkins, painter and associate director of the Phillips Collection.

In the previous letter, Dove referred to "Georgia's mural," which she had been commissioned to do by the Museum of Modern Art for a special exhibition. Dove and Reds saw it at the museum on 6 May, after they had lunched with the Strands and the Marins. Reds pronounced *Murals by American Painters and Photographers* "awful,"[1] and Dove commented on O'Keeffe's "decoration" in his next letter to Stieglitz.

1. Diary of Helen Torr Dove, 6 May 1932.

<div style="text-align: right">[Halesite]
[30 May 1932]</div>

Dear Stieglitz,

. . . . This is about 5 A.M. so hoped not to be interrupted. My "G. D. Yachtsmen" as Bill Dove calls them are beginning to arrive however.

Bill said a rather fine thing out of the clear sky of his own accord last night. McGovern had just written that Reds and I should make new wills now that the situation had changed. Told Bill he ought to also. He has $6,000 from his mother & $5,000 according to my mother's will which comes first. He said he thought he would make it so that it would go to Stieglitz, if anything happens to him.

About two years ago I had written a statement to be made into a will

making Reds, Georgia, you, Bill, the Davidsons, and Mrs. Norman executors of what might be left, if any. That seemed to have a bit of the "white elephant" idea. Thought out of that array there ought to be some of us left to carry on, but a lot of farmland in the city of Geneva is not very promising at present, so that I can smile along with you about all the hopes.

Thought the letter I wrote home might be too much for my mother, put in what you said over the phone and many other incriminating statements, but, as I remained calm throughout, she thought it a very nice letter and proceeds just the same along her impervious way. My brother also wants a salary for some time back, I believe.

These spring chores are like climbing a rope hand over hand. Took boat up the creek here last fall to save hauling out so have as usual to earn the difference putting in new rib, some planking and rudder-post repair. . . .

Want to get the boat in shape to use, as it gets you places where cars are not allowed, so have left the old Ford on its orange crates rather than buy a license. . . .

Marin was encouraging about the way they [Dove's paintings] held in Washington. Reds thought he was great. He was. Bigness and humor are so rare.

Georgia's was by far the best of the decorations. Wouldn't you know that after all the crimes I have committed, I didn't care for the gardenias in the painting.

Has Phillips shown any signs of coming home? He should have some Marin oils, as Reds was saying there is going to be just as much difficulty in seeing them as there used to be with the watercolors. . . .

Boat is ashore now here and the kids are terrible. They had it partly untied and were peeling off their clothes to board it and leave for somewhere. "Pirates!" Have to watch it for a few days more.

<div style="text-align: right">

Love to you all from us
Reds, Bill & Dove

</div>

<div style="text-align: right">

[Halesite]
[2 or 3 June 1932]

</div>

Dear Stieglitz
 While these chores are being done I am "hankering" as they say for a more close up thing in the paintings.

Feel it coming on.

Canvases ready, wood for frames and plenty of powdered color and oil. Saw to that first. Hope what I feel can be done.

. . . . Rosenfeld, the Schwabs[1] and [Fairfield] Porter[2] are coming down Saturday.

You say you are quiet but I know what that quietness means—by experience.

I hope Georgia finds more. It might be a nice shock to see a new surrounding. These same elements are always the same. . . .

<div align="right">

Always
Dove

</div>

1. Arthur Schwab and his wife, Edna (Teddy) Bryner, who was a novelist and writer of short stories.
2. Fairfield Porter (1907–75), the premier American realist painter of his generation, was also a distinguished writer on art.

By the end of May, O'Keeffe was at Lake George, intending to leave for the Southwest in June. She changed her mind, however, and spent most of the summer at the lake. In August she went to Canada.

<div align="right">

[New York City]
7 June 1932

</div>

Dear Dove:

I am full up trying to get things in some sort of shape but it is slow work. It's a lone job—more and more so. On Thursday I am to have a small operation on my eye again. Won't keep me from the job. But it's always something pestering me.

Georgia has decided to remain East this year. I was at the Lake a few hours on Friday. She was still undecided then. Wired me Saturday evening she had come to a decision. That's that.—She'll miss the Wild West.

Love from her and from me to you and Reds.

<div align="right">

Ever your old
Stieglitz

</div>

Dove's next letter was written five days after the suicide death of his good friend Alfy Maurer at the age of sixty-four. Maurer had normally

visited Dove at least two or three times a year and had often spent Christmas with him and Reds.

Dove saw in Alfy's circumstances a more intense and tragic version of his own conflict with family. Alfy's father, Louis Maurer, also an artist, had died less than three weeks before at the age of one hundred. As the result of rising interest in Americana in the 1920s, he had been honored in his old age for his illustrations of American life, published many years before as Currier and Ives lithographs. This acclaim surpassed any attention that Alfy ever received and must have intensified his feelings of failure. The esthetic breach between traditionalist father and modernist son had made their personal disharmony all the more pointed. Nevertheless, Alfy never openly broke with his father. He lived with his loneliness under the same roof in New York City all his life, except for the years in Paris before World War I. Apparently, his father's death, coming at a time when his own health was poor, overwhelmed his troubled mind.

[Halesite]
[9 August 1932]

Dear Stieglitz and Georgia,

. . . . The things are going fine for us both. Have about 25 watercolors quite beautifully framed in matte silver. Am aiming at a finer quality in the frames and not that spick and spanness that the trade puts in gilding. Something more rugged but finer.

Made Seligmann's by the way. Nice letter from him and check for $3 which I had not intended that he should do. Needed it though so kept it.

The watercolors are bigger in spirit and size.

We have some money left but most of it is what Reds' mother sent on for divorce. . . .

Have many canvases ready, quite a bit of color and oil, and no color bill so, if we can exist for a few more months, hope to be ready.

It has been a terrific summer, accidents, family complications. We have been watching how families reinfect themselves and all finally ending with Alfy. Went to see him about ten days ago. Could see that he could not stand it to live. The wound was so slow. He had two nurses but the operation was such a depressing one. Talked with his sister about watching him every minute, she said the doctor had said to be careful. Should have been kept at the hospital. He is gone now. He told

me that his father's death did not bother him. They did not tell him at the time. He saw it in a paper at the doctor's on his first trip out. Not telling him probably made him feel that he was in worse shape than he thought. It would not have made much difference to him. It is of too long standing. We both miss him more and more. . . .

Just saw in the paper that Gertrude Stein is derived from The Song of Deborah and Barak—Judges Chap V. Especially verse 27. Papers have funny detectives. It is worth looking up however. Quite beautiful.[1]

In spite of Oliver Herford, "Tender Buttons"[2] is from Shakespeare.

Mary, Reds' sister is in America. Coming to see us on the 20th with the "Perfect Child."[3] Reds said he was perfect at the boat while they searched for trunk from which he had torn all the labels and now in two weeks is spoiled by family and surroundings. . . .

We wonder about you all. Elizabeth says you are quiet. A good sign. Maybe the storm will be a good one. We shall have to have prosperity before election, whether it sticks or not. . . .

Yours
Dove

1. Judges V, verse 27: At her feet he bowed, he fell, he lay down: at her feet he bowed, he fell: where he bowed, there he fell down dead.
2. The title of a volume of experimental verse by Gertrude Stein, published in 1914.
3. John Rehm (b. 1931), nicknamed Scoop because of his father's career as a journalist.

Lake George
11 August 1932

Dear Dove: The suicide of Alfy Maurer came as a great shock—particularly the irony of it, he having waited for years for the death of his father!—I saw him last just before his operation.—I wonder what will happen to his paintings. What I regret most with his passing are the thousand and one stories about [Dr. Albert C.] Barnes, his father, etc. that are buried with him. Valuable stories if Barnes, his father or anyone else have any value at all.—

Georgia is in Canada painting some Canadian barns she has been wanting to do for some years. And she is to go to N. Y. to paint a room in Radio City.[1]—Just gets enough to cover costs. And costs at a minimum!—She wanted a chance.—And here it is—a room 18×20 or

thereabouts.—So she is and has been on the jump.—The Hill has been quiet—subdued might be better. All sorts of "queer" things happening.—As for myself I have been on deck—have been photographing some—even tho' my heart has been on a rampage the last weeks. The big camera is a strain. And there is plenty to "worry" me altho' I like the Hill—am "quiet."—Self-disciplining ought to be added to the Olympic Games—I would be eligible.

. . . . Marin is in Maine. Zoler is contemplating.—The summer is fast slipping away. And I have little to show for the time. . . .

<div align="right">ever your old
Stieglitz</div>

1. O'Keeffe had been commissioned to decorate a powder room.

<div align="right">[Halesite]
[12 August 1932]</div>

Dear Stieglitz

. . . . A note from Alfy's sister.—Wrote her speaking also of his work. His studio will have to be taken care of etc. She is in a pretty bad state, is going away. Will let me know when she gets back.

Thought of Weyhe[1] of course.—There is another man who has a gallery and is interested. W.'s place not so good. Have you any suggestions? . . .

<div align="right">As ever
Dove</div>

We sold the Ford about a month ago—$15.—$5 was considered the limit. We could not get license etc. and do not feel I have a right to drive at the mercy of the general public without complete insurance.

1. E. Weyhe had been Maurer's principal dealer.

<div align="right">Lake George
13 August 1932</div>

Dear Dove: Amused at the Ford incident. I suppose if my heart continues to kick up, translated into English it means get a Ford. That

would be a joke on me. My pet aversion is Ford with Eastman dead or alive running him a close second. I use Eastman goods—& finally will have to use Ford. Georgia has paved the way!

Rosenfeld is here. Joins me in sending love to you and Reds.

<div align="right">Stieglitz</div>

I don't know what to say about Alfy Maurer's belongings. I can only see Weyhe. I know he didn't help Alfy any the last years. Really didn't know how to put him on the map for his true worth. . . .

An American Place ought to have some of his very best & show them. But only his very best as 291 really introduced him simultaneously with Marin—that is the "New" Maurer.[1] I'm willing to do that if you feel it would be acceptable to the family & they not expect cash.—If any were forthcoming of course they'd get it.

<div align="right">Again your old
A. St.</div>

1. In 1909, Marin and Maurer had made their 291 debuts in a joint show. This exhibition featured the "new" *fauve*-inspired work of Maurer, who in previous years had already made a reputation with more conservative paintings.

<div align="right">[Halesite]
[August 1932]</div>

Dear Stieglitz and Georgia

It seems as though everything hasn't happened that is possible. Getting short pieces of rope on credit and tying them on "the end of *our* rope." They are nice to us yet, but "It won't be long." . . .

Prosperity may play a return game around November. We shall have to see.

News from our Washington correspondent, Mrs. Rankin, does not point that way. Quotes—"One bleak thing is that the Phillips gallery is to have no activities of any sort next winter. I believe even the gallery is not to open. The young man who had charge of the painting groups last winter, all winters in fact, is opening a little cooperative school, or really just studios with models this fall. There were 118 people working at the P. gallery last year, so that makes a good start for what he calls the 'Washington Art League.' Mr. Watkins of the gallery has a summer school at Chatham." . . .

Have been promised a story from the "Elks" magazine, but that is just a renewal of an old promise. He said he had gotten to the point where he had to buy new stories and I have the assurance of being "kept in mind." Nice man [Bruce McClure], however, married Dorothy ex-Raleigh. R. is ill with an attendant all the time, so Holly says. She is taking a 50% cut. Dorothy is in Europe with son John who is hoping to be an opera singer, basso.

To touch for a moment on my own troubles, lightly, if possible. The paintings are going fine. Do a watercolor a day at least and the oils are beginning to keep pace, two in the last three days.

Reds has just finished a fine new one. Imaginative. Our own money is gone and some of the divorce money Reds' mother sent. The Bridgeport lawyers now want that. Even Bill Dove offered to get one of the watercolors for $50, said he had been intending to for some time. Fine, wasn't it? . . .

I know that it has been impossible for anyone to keep anywhere near expectations, but if I can only keep going for two or three months! Have about enough of the watercolors now. 25 framed and about 10–15 to be framed. Some of them are 15 × 16—some 14 × 18 & the rest 10 × 14, and the oils well on the way.

Am wondering just what to do. Haven't the wherewithal to get to N.Y. & hunt work and could not get much.—Might perhaps land a pulp magazine story, but it would cost more than I would get. Could do better selling the watercolor sketches at $5 unframed. Or, if you know of anyone who wants to buy me at $50 a week and take the consequences, one a week guaranteed, or no pay, just tell them to show me where the out bin is and I will go to work.

W. W. in the "Mirror"

French and German dealers are buying all local art collections at auction prices and taking them to Europe to hold until after the depression. . . . The idea is then to sell them back to the Americans at new highs.

Mary [Rehm] says none of the French are selling now with possible exception of Soutine.

Saw this in Sunday "Tribune"

MAURER WORKS FEATURE OF BROOKLYN SHOWING

The third of a series of exhibitions of paintings by American artists under the direction of Robert Ulrich Godsoe will open on September 1 at the Towers Hotel, 25 Clark Street, Brooklyn. . . . The featured display at the Hotel Towers exhibit will be eight pictures by the late Alfred Maurer. Of

particular interest will be a large abstraction finished just before Mr. Maurer's death. . . .

Alfy's sister called and wanted us to come in Tuesday. We couldn't go to the funeral. Alfy said not to come in again on account of expense. I didn't know then that he had almost accomplished it [suicide] by gas. They brought him back.

Well, we went there and went over all that was left at the house and studio. His brother, Charles, had sorted out what he thinks the best and put them in storage on account of appraisal. Does not want it known how many there are.

I had no idea how much work Alfy had done in the last 2 or 3 years. It is amazing. There were a few fine ones left at the studio and portfolios of oil and watercolors on charcoal paper. Some beautiful pencil drawings of nudes and landscape. And many new abstractions.

His sister has in her room four of the finest I have ever seen. They are beautiful and completely framed. Finest workmanship Alfy has turned out.

The things in storage are supposed to be the choice. Would love to see them.

Weyhe has about 600 I believe—300 of his own—others on consignment. His brother thinks W. treated Alfy badly and would just try to sell his own. I feel that the brother has rather large value ideas, whereas his sister is thinking only of Alfy and the work.

Brother and Godsoe have plans. Told his sister that it would be best, if you felt it from the things (I am sure you will be completely surprised by those his sister has) for you to do the perfect thing first. His brother has insured the things in storage for $10,000 so you see he has ideas.

The estate has shrunk of course. They have had nurses night and day—operations—have had to borrow ahead to run things. Estate not settled. They can't sell the house yet. Her husband who found Alfy has refused to come near the place. They are living at Green Pond Hotel, Green Pond, N.J. She comes in once a week. They wanted us to take everything, almost, of Alfy's. Even the house until it is sold. We couldn't heat it at $30 a month. It would be fine to be near you all this winter.

We hoped to go to the Davidsons' apartment [in New York] for a week or two before school opened but we do not even go to Huntington only a mile away very often. That Maurer house is amazing. 3 nations, 6 including nurse and cat (a wonder)—3 or 4 generations. Furniture made by Alfy's grandfather for his little 100-year-old son

Louis to keep his shell collection intact. Or at least that is the way it sounds and looks. There are stories about the old man that no one has heard that Alfy has told us, and about himself that explain everything.—His sister of course did not know his life in Europe. He delivered a long oration, in delirium, that she said was amazing. Partly French, she couldn't understand. I could go on for hours, but must get the day started.

My mother is up in arms against Paul's wife's family who seemed to have moved in. Baptist minister, who is writing his own memoirs, brother who plays guitar, and married sister, part-time. So of course there is no money. I wrote and raised hell, but as Alfy used to say "You might as well show them your pictures." Paul's wife has developed a sort of psychological tantrum—doesn't speak every two weeks. Southern girl.—Probably needs a kick in the pants more than a trip to Europe.

As you once said, you wouldn't want to be in P.'s shoes.

Mother being quite formidable in the role of the "jealous old lady." She wants us to come there to live. What a place! And all grown-ups?

Reds and I send love always to you all—the Davidsons and P[aul] R[osenfeld] if there.

<div style="text-align: right">Dove</div>

Once again, Stieglitz sent a check—$100 this time—after receiving Dove's last letter.

<div style="text-align: right">[Halesite]
[About 20 September 1932]</div>

Dear Stieglitz

That just about saved us. That never failing thing has been so true for so many years. . . .

So much is going on. Have written no one but the Telephone Co. That we still keep as fire and life insurance in case of accident. It may be that insurance is silly and that there are no accidents. Only miracles. Mary has been here with the most real personality of a 20-months-old child. Came back to say so long and bring her sister-in-law out.[1] An alive person. They tried to get you on the phone. Her husband one of the few untouched by the depression in Wall Street. He collects reproductions of the moderns so far.—You may build him into a "prospect."

The name is Rehm. They have offered us their place for weekends in town, so that makes still another "roof over our heads." . . .

Long letter from Alfy's sister yesterday. The old man seems to have worn them all out.

Alfy told me he was a mental murderer.—They all feel the same.

There is a fine old head of a woman that Alfy did, and his father could not stand the ease of the neck piece so repainted it and spoiled it all. The portrait still hangs downstairs.

We are both working. Still hoping there is life for a while anyway. . . .

<div align="right">Always
Dove</div>

1. Louise Rehm, wife of George Rehm's brother Lane.

Stieglitz and O'Keeffe had returned to New York late in September. Stanton Macdonald-Wright, who had shown at 291 in its last season, opened the exhibition year at An American Place. This was his only show with Stieglitz after 291 closed. Marin's show followed in November and December. After O'Keeffe's show, which ran from January to March, Dove and Reds had their only joint show. An exhibition of early works by Marin, O'Keeffe, and Dove closed the season in May 1933.

<div align="right">[Halesite]
[Probably 11 November 1932]</div>

Dear Stieglitz,

This is one of those days! When sometimes you have done a good day's work, you get a satisfaction.

Have probably done the best painting yet and learned more than before—but I shall just have to wait until tomorrow to enjoy it. Coated 5 frames. We did the washing on the porch in the downpour. That was helpful and fun, but nevertheless it is one of those days. Have tried to *do* too much. Getting too damn primitive on account of barking to keep animals you do not care for out of your cave. It's all right about doing everything yourself but one has to give in somewhere.

You can sew your clothes, weave the wool and make the cloth but when it comes to making the sheep you have to let the ram do it. Maybe I'm just a terrible example of frustrated reincarnation.

Shall be glad to see the Marins.[1] Looked through the side of the Wright canvases and thought I'd save my fare for the Marins. Marin is *really* great. He makes you enjoy life as a child enjoys living. . . .

As ever
Dove

1. Work and lack of money prevented Dove from getting to New York to see this Marin show.

[Halesite]
[17 November 1932]
8 A.M. & Check![1]

Dear Stieglitz
"Whew"! That was a close shave that time. <u>Much!</u> obliged. Almost spoiled a painting yesterday, but think it will come right when I go at it a bit more cheerfully today. When you get down, your mind begins having dialogues with itself while you're working. Like trying to establish a new form. And the old form bobs out and takes a crack at you and you say—"To hell with form, it is just a medium of exchange, like money,—go on painting—but you need some. Care just about as much about money as you do about their old monumental bulk. If they were logical they would paint the earth flat. That's the way they see it. Paint what you know—well, you know the earth is round. There's their old form again. All right. Paint what it does to *you* like the 'Dawns' only *go on painting*. You'll think it's flat if it bumps you hard enough. Well, you're trying to make a painting out of a drawing. What of it? You thought the last 3 paintings were better than the drawings. However, a woman came in and liked the watercolors better. Wants to buy them so she says. She said in the next breath that she wanted always to have a 'long clothes' baby to hold. Maybe the watercolors were smaller, she could hold them. Anyway the frames on the oils were as yet just wood, not finished. And she liked them, so she said, as well as the drawings when I took them out of the frames. *Go on working!*—Well, maybe it's speed—a little more speed wouldn't hurt you. Forget about time. It's there all the time, whenever you need it, when you want it, bend it round and read it." And so on.
Declined Mrs. Force's invitation—to her party[2] as our carfare is paint and silver leaf and our evening clothes pajamas. . . .

Dove

My brother has brought from Maryland the "Biggest Horse in the World," exhibiting him and the owner at the "Dove Block"[3] in Geneva—10¢ for grown-ups, if any, & 05¢ for children. Hope he gets a kick out of it. Shetland ponies or white mice might be better. He has to feed them both! Now!?

1. From Stieglitz, for sixty dollars.
2. Presumably, the "party" was the opening of the Whitney Museum's *First Biennial Exhibition of Contemporary American Painting,* which included Dove's *Red Barge, Reflections.* Juliana Force, who died in 1948 at the age of sixty-seven, was the director of the Whitney.
3. Commercial building on the main corner of downtown Geneva. Built by Dove's father, it remained family property.

[Halesite]
[12 December 1932]

Dear Stieglitz

Well, we are flat again, and out of silver leaf, light, coal etc. Paid some bills out of the $60 so it didn't take long to finish the rest. Expected to bring in the three "Dawn" things and their framed drawings with what else I could carry this week to see you and the Marins. The *time* and carfare is so very important just now that perhaps it is better to wait or, rather, necessary. Bill may come over later and might drive me in with them.

These last are the best yet by far, we think. The Davidsons did also when they were here and saw them.

Will sell anything I have for whatever is offered within reason.

There were two or three left-over offers. Suppose none of them have come through. Will have to find something some way, if there are to be more "Doves." They are going fine now—3 last week and two frames besides many drawings. Chores. Work on boat.—Do wish I could sell it.

No one will offer anything now.

Even the "Sat. Ev. Post" I hear is hiring young girls to illustrate their stories. And those gay steamship ads in the "New Yorker" etc. are mostly complimentary. They pay for one and expect four. May have to try that scheme of Dr. Wm. Howard Hay's. He says it is possible for a family to exist on a bushel of wheat for a winter. Think however we

should have to take our bu. wheat to some spot much warmer than this Yacht Club.

Am a plumber among other things since our water line here broke and we had to put in a new one. . . .

These last ones I have do open up a whole new idea and form, so I am more than anxious to be allowed to do them. . . .

As ever
Dove

O'Keeffe's contract to decorate the walls and ceiling of a Radio City powder room was canceled after she went to inspect the location, found that some of the wall covering was peeling off, and abruptly declined further involvement.[1] Her dramatic reaction followed months of worrying about the project—so unlike anything she had done before—and concern that the six weeks that remained before the Music Hall was scheduled to open allowed insufficient time for her to complete the task. The altercation was all the more enervating because she had defied Stieglitz's disapproval of her participation.[2] Furthermore, these tensions came on top of the most stressful period ever in her relationship with her husband. Although the letters to Dove give no hint of it, for at least two years Stieglitz had been deeply involved (perhaps infatuated) with the idolizing young Dorothy Norman.[3] They saw each other daily at An American Place where she was his gallery assistant, fund-raiser, photography student, and nude model. Shortly after pulling out of the Radio City contract in November, O'Keeffe retreated to Lake George. She returned to New York the following month in a state of severe nervous depression accompanied by debilitating physical symptoms, as Stieglitz reveals in the following letter. It was a year and a half—during which she was away from Stieglitz most of the time[4]—before she recovered sufficiently to paint again. Meanwhile, Stieglitz's guilt and genuine concern for O'Keeffe, in combination with Dorothy Norman's maturing sense of purpose about her own career, drained much of the romance from their relationship.

1. Ultimately, the decoration was done by Yasuo Kuniyoshi (1893–1953), a Japanese-born American who combined representational and abstract elements in his paintings. For this room, he used a magnified flower motif reminiscent of O'Keeffe's distinctive series.
2. Lisle, *Portrait of an Artist,* 204–6 gives a detailed account of the incident.
3. *Ibid.,* 195–200; Lowe, *Stieglitz,* 310–22.

Alfred Stieglitz, Dorothy Norman, *1932.* (Alfred
Stieglitz Collection, Art Institute of Chicago.)

4. Their only sustained period together for the next two years was three
months in the summer of 1933 at Lake George.

[New York City]
13 December 1932

Dear Dove: Everything seems to become more and more crit-
ical.—Georgia is ill in bed—kidneys & heart.—And her Show to go up
next!—Well, I'm at the Post. What good it does I don't know.—Have
heard no "rumors" about the Whitney purchases.[1] I dare not hope for
you.—They are fools if they don't acquire your painting [*Red Barge,
Reflections*].—I sent it because last year McBride and others felt "it ought
to be in the Whitney Museum." . . . But the stars—or the gods—or the

Ladies—whoever may be running things these days of Art—have your fate in their hands—not I.—Even tho' I'm ready to plead "Guilty" to whatever & lose my head for it. But maybe I no longer have a head to lose. No head—no cash—no Virginity—& still called alive to entertain "Appreciators of Art" roaming the Earth. . . .

I wish I could come to your rescue but can't now.—

> In haste
> Stieglitz

I can imagine that your work is developing wonderfully. How keep going?—I don't know a soul ready to buy at any price. Don't imagine I let the slightest chance slip by. . . .

Phillips is "broke" (!) so he says. But still has 3 chauffeurs.—

That belongs to the "Daily Bread" in the Lord's Prayer, I suppose. Paintings don't unless: Deliver us from Evil, etc.—

1. From the *First Biennial Exhibition of Contemporary American Painting.*

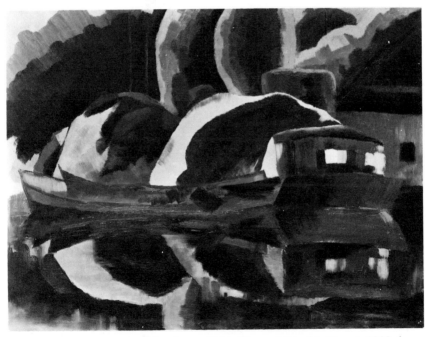

Arthur Dove, Red Barge, Reflections, *1931. First exhibited in Dove's 1932 show at An American Place, this painting was purchased a year later by Duncan Phillips.* (Phillips Collection, Washington, D.C.)

[Halesite]
[Mid-December 1932]

Dear old Stieglitz,

We are terribly worried about Georgia. It is a shame she has to be hit when she needs all the endurance of an Amazon to stand what it looks like we shall all have to go through right now. Reds is writing her.

And you I know are almost trapped with all our ideas. It's probably harder for you to stand not being able to do things for those you feel for around you than it is for those around you just to take the punishment first-hand.

Thanks for your prompt letter. It was encouraging to feel your energy in spite of the "Gods, stars or Ladies." There is no reason for you to feel responsible for what we have headed for knowing what we might well expect. I know you are always on the job so know please that there is no disappointment because you cannot do what the whole world put together finds impossible.

We are just fortunate in not expecting anything.

Sometime we may get what old hopes there are off the shelves and dust them off, throw them overboard, and start in life over under absolutely new conditions.

Thought of writing Phillips with offers but know you have already done more than any human being could in that direction.

My mother was rather lofty because the bank would not loan them money on the farm property, so now it is about at the point where they can't get it on the home.—The same old story.

Well, I am going to paint until the canned stuff is gone, then try for a job with the town or something.

So glad that Bill has a lot of small jobs and can get by and support some beautiful wood carvings he has done.

Our love to you and *hopes*—you see they still exist—that Georgia will be soon better, and that your endurance is the same.

Our thoughts of you both are finest, if that can help.

Love again from us.

Dove

[Halesite]
[22 December 1932]

Dear Stieglitz,

Wondering how you all are. Do hope that Georgia is recovered to

some extent anyway. Haven't tried to use the phone as we shall need anything left of the deposit at the end of the month. . . .

If anything comes up would be glad to take anything edible for paintings at any value. Have written home two or three times—the last time begged them to mortgage something, but if they did they would spend it all for taxes. Mother speaks of sending Reds some jewels to keep as family treasures instead of any money for Christmas. A bag of wheat would be far more interesting than jewels or Christmas.

The paintings are coming along fast now, and this morning I simplified the same frame down to one piece instead of 2 or 3 that I can build out of stuff I have here.

Have 9 or 10 more canvases all drawn in and some painted, that is in addition to what were already done.

Our love to you all. Did Georgia try any of that eating scheme? There is some sense in it, but it may not be the absolute solution he claims for it. Any more than "Technocracy" will make all the people fine. Well, there's plenty of room, as they say. Suppose I can see some Marins, if I can get in but it is not like seeing them hung.

Reds sends love with mine

Dove

[Halesite]
[24 December 1932]

Dear Stieglitz,
 Reds' cousin—Mrs. Henry Bonnell of Phila.—sent her $25 for Christmas. We were quite rejoiced—when I had to work over a drowned child of four trying to bring him back to life with the directions for artificial respiration which I had pinned on the wall for such an emergency. They are still working on him with pulmotors. Yes, as was said—"We still have hopes."[1]

The new frames are finer and more delicate.—

Mary sent us some "Cahiers d'Art" for Christmas. They seem to be working along the lines we showed in the music things, the "Cow," etc. some years ago. Only the French cling to the object. The intellectuals to the subject.—

People seem bound with thongs so that they are just forced by some power to go on doing just what they have always done. Even this child's grandfather when he overcame being stunned could not act. Just accepted the worst and went on talking when there was so much to be done.

Do so hope Georgia is improving. Give her our love. We shall keep the phone another month now anyway. It was important today. . . .

<div align="right">
Always
Dove
</div>

1. Reds's diary reports that Dove "did everything" to no avail, and the child died. Diary of Helen Torr Dove, 24 December 1932.

By the time Stieglitz wrote the next letter to Dove, the O'Keeffe show was up, as he mentions. However, he avoided the difficult news—that O'Keeffe had moved to the Park Avenue apartment of her sister just before Christmas. Even this change did not help, however, and her condition worsened in the new year.

<div align="right">
[New York City]
5 January 1933
</div>

Dear Dove: Well, I see the Whitney Museum has remained true to its blindness. And I fear ever will.—The average price paid for the 28 pictures bought is about $800. So the $700 asked for yours was below the average. Undoubtedly a few of the "fortunates" like Speicher,[1] Glackens[2] & Co. received several thousand for their products.—I had hoped against hope that something might happen for you. And so something for their Museum. Your painting was certainly near the top in the whole Show. Georgia's painting I knew was above their heads & hearts—then too they have several O'Keeffes.—

How you will manage to struggle along I don't know.—I let it be known amongst certain people that you were willing to let your things go for a pittance, being forced to. But so far nothing has happened.—Georgia is still very weak & mostly abed. Her Show is hung & will create a stir. If she should have some luck (that's what it amounts to) she could help you.—It's all pretty awful & more than rotten.—I am on the job virtually day & night. In off moments I rush to doctors—oculist—skin—chiropodist (the floor of the Place raises hell with my feet) & see Georgia for a few minutes.—A merry life.

—Well, here's to "May Be" without hoping or despairing.—With love to you & Reds.

<div align="right">
Your old
Stieglitz
</div>

1. Eugene Speicher (1883–1962), an American realist painter, concentrated on portraits.
2. William Glackens (1870–1938), an American painter whose work derived from Impressionism, had exhibited with The Eight.

[Halesite]
[5 or 6 and 7 January 1933]

Dear Stieglitz

Fine to hear you so up and doing. You were right about the prices and all on the Whitney thing. And now is the time while "What they might have done" is still on their minds—to keep them moving.

Out of the corner of my eye on the porch I see a night shirt, flannel, that my family sent, that Reds has washed and hung in a full breeze. It could well have come from the Macy parade.

Do wish Georgia would improve more. Do also hope that what has to be done just has a fighting chance, or a calm one anyway, to "Do its do."

Hope Marin can survive the year anyway.

Am surprised on all sides by the critics. Except Cortissoz.—He never did surprise anyone or anything except by the reproductions—without the text.

. . . . Do not know who picked the W[hitney] "Acquisitions," but as my mother writes every now and then, they have undoubtedly "done the very best they can."

Life sort of like a rubber band—just depends on who lets go first. . . .

Paintings going fine—two more and some frames in the last two days. Ought to have some new ones and all of these in the next three weeks. The drawings are better than last year's and everyone, that means Reds, Bill and the Davidsons, says the paintings are far better than before.

Reds says "More pure beauty," and Bill says that I have perfected that thing which was in the one the Davidsons have [*Scenery*]. As a whole, there will be much more luminosity. Do hope nothing interrupts. . . .

As always
Dove

[Halesite]
[14 January 1933]

Dear Stieglitz

. . . . How is Georgia? Do wish she and you and everyone would try this new scientific eating.

Your lemon in the morning—if you eat bread is not so good. Have given up bread, potatoes and sweets, starchy foods and have practically cured a cold in two days that I have had for two months. There is something in it. "Plenty of good food and exercise" evidently means nothing. As we have learned otherwise—it is the choice of combinations. . . .

Love to you both
from Reds and Me

Paintings about done which have been planned and frames going fast.

Am interested in some portraits of people and things just now. Can work on them when these things are complete and brought in. Reds' things are fine. Will bring in a few (4 or 5) with mine so you can see for yourself without any other feeling. Would not do it did I not know the quality.

[New York City]
16 January 1933

Dear Dove: Georgia's Show is creating a stir as usual. But I wish she were well again & that the "stir" would crystallize in a form to let her live & work.—As I wish that someone would come along & do a bit for you & for Marin, etc.

—Phillips was in. He spoke of your painting at the Whitney. Said he liked it better than anything there. Thought it "important."—I suggested—that as you were in real need & wished to continue working—he give $100 down & then $10 a week to you until $700 was worked off. He smiled. Felt the price low!!—So there you are. What can a poor man do?—I'm referring to him.—I fear he has too many loves—& perhaps debts too.—I don't know. And it's none of my business I suppose.

—It's a queer world—with some of us just a bit queerer—that's the rub.—

The Rockefeller Chimes are ringing so everything must be all right.—

> With love to you both
> Your old
> Stieglitz

The Phillipses responded after all to Stieglitz's suggestion about buying *Red Barge, Reflections* on the installment plan. They sent two hundred dollars.

> [New York City]
> 19 January 1933

Dear Dove: It's fine of the Phillipses to act. I had given up hope. . . . It's one load off my mind for a while. Georgia is very very sick & I am really worried more than I dare admit.—Life is certainly a series of ironies.

With love to you & Reds—

> Stieglitz

Negotiations with the landlord have begun for another year of the Place.

I'll send Phillips' letter tomorrow. It's fine. You are to receive $500 for the "Red Barge"!

It's really Mrs. Phillips who has made all this possible. . . .

Georgia is in very bad shape. It is ghastly.—She may see no one. I may not see her for a week & then only for 10 minutes.—Talk about a living death.

> [Halesite]
> [20 January 1933]

Dear old Stieglitz!

How on earth you have accomplished what you have feeling as you do about Georgia is greater than any of the great ones I have known of. We had no idea of the seriousness of Georgia's condition. It made Reds sick. She said "That shows you what we think of O'Keeffe as a

woman." And I, well, am just quietly weeping. We shall be so happy if we can only hear of any change for the better. Worlds of love to you both from us. . . .

We are working like mad on our frames and finishing up.

Reds has beauties. About as many as I. I have 19 (as usual) paintings, 15 large watercolors (15 × 16 etc.), 16 smaller water colors (10 × 14) framed complete. 8 or 9 frames have to be silvered. And the customary last touches on the oils.

We have been talking of our not being able to come to see Georgia, the work, and you and yours which I hear is fine this year. Suppose it is best to go on rushing the frames through and laying the mileage of silver leaf.

You will know how we feel so much better than I can say in words.

Great love to you from Reds and me

Always
Dove

A week before Dove wrote the next letter, his mother died. He and Reds went to Geneva immediately to attend the funeral and begin what was to be a long process of settling the estate. Dove's inheritance did not provide any cash, so his financial plight continued. He saw that his only hope was to move to Geneva, where he could live rent-free, and try to rescue something from the estate, which included a small mansion (Dove usually called it "the home") at 512 South Main, Geneva's most fashionable street; farmland and two farmhouses on the edge of town; a third house in the vicinity of the farm; the commercial Dove Block in the center of Geneva; and brick and tile plants.

[29 January 1933]

Dear Stieglitz

Writing on the train up here in the mountains around Manch Chunk. Some frozen waterfalls—evergreens, a light fall of snow. And a green stream following the train.

Mother finer than I had realized in many ways.

Quite beautiful a few minutes before the end and afterward. Absolutely conscious up to the last 3 or 4 breaths.

The people at a time like that are rather barbarous with their looks

and thoughts.—I suppose we will be as much so to the next generation. Hope not.

Has Marin been up here at all? He would like it, I think. Have made two watercolors in the last 50 miles.

Attended to the probating [of] will etc. Paul & I are executors.—

It is all in the red.

If the home can be sold it should bring $35–40 thousand. Which would lift the weight on the farms, city "Dove Block" ($12,000 mortgage) and some other properties. They are all like the present administration. A certain amount of moral dignity with no realization.

We were all to drive down but papers are not returned with any power until Wednesday.

Realized what a waste just now these few days to speed up the frames would mean, so came on ahead. This cold snap might cause trouble at the Yacht Club. Reds, Billy, Paul & his wife—(pleasantly disappointed) will drive down later.

Could work up there. It is good painting ground. Many lakes and if we can sell house we may all live on the farms—plenty of houses and room to be apart, barns, studio, etc. Everything built to last forever.

I wonder. . . .

Hope 2 or 3 weeks will see us "ready." I can keep at frames even with guests for "a day or two."

There is a gilder in the Block who is a bit back in rent who was fine about telling me all he knew about laying gold leaf.—

Reds would join me in love if she were here. We could only get enough cash there for me to get home without pouring in the Phillips contribution which I felt was not meant that way.

The whole estate is really worth about $100,000 less $12,000 mortgage and a lot of unpaid debts, taxes, and a $2000 mortgage on another house. (Assessed property value about $80,000.) $5000 in the will to Billy, $3000 extra to Paul for tile plant etc.

For the last five years they have had to borrow more every year for taxes. Same old story.

There are gas wells now within ¼ mile, but no "cash" within many miles.

I can get enough to eat out of the land there—have proved that.—The paintings ought to pay for paint. And they can be brought to N.Y. in Paul's car as well as from Halesite. The work should take no more time than this Yacht Club responsibility.

Will sell the boat at cost of it, as it has paid for itself many times. More love to you and Georgia

<div align="right">

Ever
Dove

</div>

When Dove next wrote, O'Keeffe had been in Doctors Hospital for treatment of psychoneurosis for more than a month. Released late in March, she went directly from the hospital to a ship sailing for Bermuda.

<div align="right">

[Halesite]
[8 March 1933]

</div>

Dear Stieglitz

 I am very hopeful for the whole outlook. Think the spirit stands about the same but that *vision* is clearing. We need that.

 Hope Georgia is out by now and love to you all

<div align="right">

As always
Dove

</div>

<div align="right">

[New York City]
4 April 1933

</div>

Dear Dove: McCausland[1] was in Sunday. She bought a watercolor & is going to give it to the Springfield Museum. The Museum has just been built.—A man left it $60,000 (now shrunk to ⅓) to be spent annually on *oils only*. She will write more about you. Took "Sea Gulls on Island."—I think two other little ones are placed. Maybe an oil for $75.00. There is interest. No one has priced any of Reds' but her things are admired.—It's all very slow work. And the weather has been fierce besides.—One plods on.—Thanks for the two sendings of bread. The loaf will last a long while. . . .

 Georgia reports slow progress. Zoler still comes Saturdays & doesn't speak.—Ought to join Hitler.

 In the meantime anyone wanting my job can have it for the asking.— And that even tho' none other is in sight for me.

 I wonder will Phillips turn up. I doubt it.—I'd just like to see what he'd have to say.—Maybe something not particularly bright.—

There are more exhibitions opening than ever.—Five of the eight Guggenheim Awards went to women!—Nearly all the new galleries opening are in the hands of women.—

It is certainly a state!—

My love to you both—

<div align="right">Stieglitz</div>

1. Elizabeth McCausland was at this time a reporter for the *Springfield Republican* in Massachusetts. (See Glossary of Names.)

<div align="right">[Geneva]
[9 April 1933]</div>

Dear Stieglitz

It is a great world. Your letter was an oasis. We have been here a week and seem to have accomplished some few things. It remains to be seen. We have a man who is very keen about renting the brick and tile plants.—The brick plant representing about $60,000 outlay is just a blown-down wreck. Tile still in more or less running order. No system—pocket bookkeeping.—

Among friendly letters, letters of condolence, love letters and ads, I picked out about $5000 worth of bills and a few accounts receivable and have put it all into a 30-column cash journal & then into ledger.—This does not include Bill's $5000 in the will nor Paul's $3000 nor the inheritance tax and interest on unpaid taxes. We are trying to mortgage the home to get enough to move with.—There is no other choice. There is also no other choice but to come here for this year anyway. . . .

The farms are tremendous things. 180 acres partly in the City.

As fast as any rents come in, they go out for living. Had a long "conference" last night. All that about eating the cake, frying pan and fire, as an excuse for not changing. Well, the cake has been eaten and I allowed I preferred the fire. At least it might produce some action—

Reds said it was very thoroughly and carefully done. Seemed to be accepted in toto. It was a help to have everything arranged in hunks in books. . . .

Want to read Mrs. Norman's book [*Dualities*][1] as soon as we come back. This house seems to be no place for that.

Reds and I are planning on the little farmhouse at least until something is sold. Then perhaps somewhere along the Hudson near Yonkers-Peekskill where we enjoyed it most on the way up.

Being here would give us a chance to see you at Lake George for the day sometime during the summer. Feel that I can make a living, if anything happens at all at 1710. The rest here will undoubtedly go on living. And if they do, we do. That is, if we are here to jog a memory or rather a convenient forgetfulness.

Am glad Georgia is improving. It [Bermuda] is a grand place for it.

Amusing about Zoler. Take it that he toils not, neither does he speak. . . .

<div align="right">

Always
Dove

</div>

1. A book of poetry, privately printed for An American Place, 1933. Dove had taken a copy of it to Halesite 10 March, the day he delivered his paintings to the gallery.

<div align="right">

[New York City]
11 April 1933

</div>

Dear Dove: This morning Phillips & wife were here for 1½ hours. Enjoyed your things immensely. Thought them the best yet. Has "no money." Am to send 5 to Washington next week. Wants to live with them. Also to have them photographed. Expects to write an essay on you.—Quoted him very low prices. Well, it's well he was here.—I met Gallatin on the street this A.M. Told him he must see the Doves. Said he'd come. Met McBride last night. Said he thought your Show was fine. Liked Reds too. Neither P.'s said anything about her. He too excited about you. . . .

<div align="right">

ever your old
Stieglitz

</div>

Phillips is eager to meet you & have a talk. There is no hurry. Still it will be well.

Although the real content of most of Dove's next letter is indecipherable, his anger must have been sparked by an incident that had occurred while Dove was at the gallery the previous day. As in other letters, Dove sometimes expressed strong emotional reactions in highly generalized terms.

[Halesite]
[3 May 1933]

Dear Stieglitz,

It is fine to have gone through enough to have left enough destroyable reminiscences unregretfully behind. I feel glad to see go those things which we no longer love.—

I certainly did love that gallery just as is.

When you call a man more or less of a "liar" and his voice sounds as though you had poured clear cold water on hot gravy and he had to pull it off the stove, I feel the same old thing about you. There was such a clarity in the water that it was hard to stand there and hold one's temper. There was an instinct to fight about you as well as for you with the work which I have always done.—In fact, about myself with people who irritate *me* beyond words.

Perhaps that is the only way to attack. One can only spring from one point—initially.

One would give one's life for the right spring—hoping that it might be Beauty.

Am reading Mrs. Norman's book again. They [the poems] are as fine as anything that has come from 291.

Shall write to her. . . .

And to you—whom I have grown to love more truly than all, I am sending this to let you know that. . . .

Dove

Dove was so infuriated at the "Phillips business" referred to in the next exchange of letters that he never did forgive the indiscretion. Phillips had decided that the right half of Dove's *Bessie of New York,* which he had purchased from Dove's 1933 show, was in itself a superior composition to the whole painting. He therefore proposed dividing the horizontal *Bessie* in order to make a new, vertically oriented painting from the right half.

When Reds had been in New York a few days before Stieglitz wrote the next letter to Dove, she had showed the photographer Phillips's letter outlining the proposal, along with a preliminary draft of Dove's reply. Stieglitz told Reds that Dove's letter would have to be done over. In a subsequent letter, Dove managed to convey his refusal without offending Phillips. Four years later, Phillips traded the painting back to Stieglitz for Dove's *Reminiscence.*

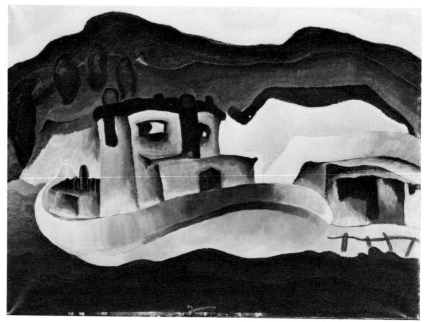

Arthur Dove, Bessie of New York, *1932. Duncan Phillips bought this painting from Dove's 1933 show. Shortly thereafter, he enraged the artist by proposing to divide it in order to make a new painting from the right half. In 1937, he traded it for another painting, and it was not sold again until after the artist's death.* (Edward Joseph Gallagher III Memorial Collection, Baltimore Museum of Art.)

Despite Stieglitz's solicitude in the next letter, Reds was indeed not feeling better. She had not been well for some time and did not recover until summer. She might have picked up more quickly had Stieglitz been less negative about her painting. In her diary, she reported upon her return from the gallery, "Stieglitz said my work was good, some of it very good as pictures—no search, and I'd never tried anything too hard for me. Rather 'sinking,' and I suppose true."[1]

1. Diary of Helen Torr Dove, 9 May 1933.

[New York City]
16 May 1933

Dear Dove:

I hope you have gotten the Phillips business off your chest.—I suppose everyone, in one form or another, is stark mad these days of peace. We, as well as every one else. I hope Reds is feeling better. Georgia seems to have been too frisky & has had a slight relapse. I must believe it's only slight.—It's quite an ordeal to have her so far away from the Battery.—

Love to you both.

Stieglitz

[Halesite]
[Probably 18 May 1933]

Dear Stieglitz

. . . . Well, the letter to Phillips is off anyway. —How far off I know not.

The City Editor [Walter Lister] of the N.Y. "Eve. Post" was here last night trying to get me to let him make a story of it [the *Bessie* incident] in some way. Seemed to think it could be done so that even Phillips would like it. . . . He thinks it a grand news story, but do not think we want that just now. . . .

This Geneva situation is certainly "mad"-dening. If we only didn't have to go there to live for the summer.

There is something terrible about "Up State" to me. I mean that part anyway. It is like walking on the bottom under water. I did that once there to keep from hitting a boy who thought he was helping me and he was only holding me down.

When I look at the map, I find that Lake George is almost as far as N.Y. [from Geneva].

A man here wants to trade a house for the boat. Wouldn't you know that someone could think of even more property. Another just called from N.Y. about the boat. There are two or three a day but they will not go over $500 and that is the amount of the mortgage that McGovern holds on it. It is about worth sinking at that price. . . .

Think Reds is better. It is not very evident however.

We shall be here seeing doctor for a half month longer anyway. . . .

As ever
Dove

When O'Keeffe returned from Bermuda, Stieglitz took her to Lake George, where he rejoined her in mid-June. She remained unwell, and he was frustrated much of this summer by a hernia that prevented him from carrying his large camera.

[New York City]
24 May 1933

Dear Dove:

Georgia returned from Bermuda on Friday. On Sunday A.M. I accompanied her to Lake George.—I returned last night. Feel as if suspended in a vacuum.—Georgia progresses slowly. Is well cared for on the Hill. Alone with the girl in our family for 25 or more years.—A fine girl about Georgia's age [forty-five]. . . .

Matisse was here while I was away.[1] Dewey brought him. Tough luck.—Fatality.—I dare not weep.—Walkowitz it seems played host!! Funny. But all right if there can be any right in such a situation when I'm not here. And I without a break here from September 26/32 to May 21st/33. On the 22d it must happen!—Well, the gods are queer. . . .

In haste
Stieglitz

1. Stieglitz had been introduced to Matisse by Steichen in 1909. He visited the painter again in Paris in 1911.

[Halesite]
[25 May 1933]

Dear Stieglitz

Thank you much for the letter, clippings and checks.—One is made out to you. So please sign it and put it in enclosed envelope. Hope I am not a bother—just being an artist is bother enough. . . .

What a shame about Matisse! Well, anyway, you can feel that Georgia's health is more important. . . . The boat is still unsold, many to see it, offers of the price of the mortgage—$500. Will take the next one. Let one go as I picked off him that his wife was going to raise hell when he came home, and I did not want one rubber sale to spoil the possibility of a good one. . . .

Life is a circus now with all there is to be done. Have made 15 watercolors and am beginning to feel "oily." . . .

If Matisse is still here wouldn't he be urged to come again?

Love to you—all.

Ever

Dove

[New York City]
26 May 1933

Dear Dove: Matisse can't come. Sailing.—Pity. Wrote me a letter. Asks me to look him up in Nice. Has an idea I guess that I'm rich & travel like all "art dealers" & others too. I'm busy without travelling. See a world that autos do not reach.—Nor do aeroplanes. . . .

Phillips may be pondering.—He is as slow as he is quick.—

My love to you both

Stieglitz

Having decided that there was no alternative to moving to Geneva, the Doves prepared grimly. Neither of them wanted to go, and much of their time was absorbed by packing, selling the boat, and other chores. Reds was half-sick all the time. Depression about the move probably exacerbated her ailment, as did the fact that financially they were again at the bottom of the barrel.

In a bit of good news six weeks before they left Halesite, Phillips proposed to pay Dove directly in twelve monthly installments of fifty dollars each for three paintings. Dove accepted but assured Stieglitz in his next letter that he would follow the customary procedure of donating a percentage of the sale price to An American Place for support of its operation.

Phillips's practice of installment buying, initiated at this time, was repeated annually for the rest of Dove's life. Although Phillips came to call his checks to Dove a "subsidy," they were in fact payments on paintings that he already possessed. Moreover, because the agreement had to be renegotiated every year, the arrangement never provided Dove with the peace of mind that a true subsidy might have. On the other hand, Phillips deserves great credit for his continuing support of a "difficult" artist during a period when his work was not widely admired. And, after some years, he may have felt obligated to renew the

annual agreements because Dove so clearly depended on them. (In Dove's last years, when he was very ill, Phillips twice continued the payments without taking paintings until Dove was well enough to produce some new ones.) In any event, Phillips's consistent patronage benefited them both: Dove unquestionably needed the money, and Phillips amassed the largest collection of Dove paintings anywhere, including many of the artist's most impressive works.

[Halesite]
[26 May 1933]

Dear Stieglitz indeed,

More Miracles.—Very friendly letter from Phillips—wishes he could help me more but as yet has sold none of his paintings for funds— nevertheless has decided to take three new ones. "Harbor Docks," "Tree & Covered Boat" and "Sun Drawing Water" on condition that he be allowed to pay $50 each month at the price you gave him of $200 each. Speaks of sending checks directly to me, and that you and I can arrange that to suit us both. Perhaps we'd better let him have his own way and I will do whatever you say by the Place.—

We thought he would forget about the "Bessie," but no! He is still persistently at it. (I referred to it rather tactfully in a P.S. in my letter.) Wants to hold it and make a copy of the part he likes to "learn about color"—from *her,* I suppose. . . . If I would consider his making an upright of the "Bessie," he would take that instead of one of the others and allow me $300 for it instead of $200 for one of the others.

Speaks enthusiastically of being "delighted with Reds' things, they wanted to see them again."

Wants us to stay with them in Wash. next year when the gallery will be intact and they will return from Chicago with the paintings.

I mentioned that friends in W. had just asked us there for a visit but we couldn't do it now as we were trying to get Reds well enough to take hurry trip to Geneva. So he "Prefers that I postpone the visit." That suits me perfectly.

A couple of thousand thanks to you and much love from us both.

Will write and accept the $50 per month, if that is satisfactory. We might as well let him store the "Bessie" for the summer? The funny part of it is that he may write in his article about his desire for cutting the "Bessie" and make it that much more important!

Love ever
Dove

[New York City]
27 May 1933

Dear Dove: . . . I had hoped Phillips would do what he has proposed to you. I had suggested his doing something like that.—As for "prices"—you had "wanted" $350.00 for the three he wants.—I added $250 to your estimate—of which $150 was to go to the Place & 100 extra to you.—But I want you to have *all* the money as I want you to have the whole $500 for the "Red Barge." For the latter, I had given you $150.00 & said that if sold at any time I'd refund myself the $150 & divide the "profit" between you & the Place. Translated—as Phillips is to give you $500 for that painting—I would get my original $150 back & the balance $350 would be halved—you getting $175 & the Place $175. But I am going to let you keep *all* the money. *You must have cash.*—I shall take the equivalent of what the Place & I should receive from you in cash in your work at your figures. I wonder is that clear. I don't want you to feel in any way under "obligation" to the Place in view of Marin & Georgia supporting it, etc., etc. My way is very simple so seems devilish[ly] complex.—With me it's always: the human being (artist) first!!—The rest I'll attend to. When the human becomes a pig automatically he disappears into space as far as the Place is concerned. If I should become a pig, why there'd be no Place—so according to the modern Scriptures there would be Business.—(Perhaps.)

. . . Marin had a bit of luck too. Georgia's star is still hidden. . . . As for Bessie, keep her uncircumcised. And as for visiting Phillips, the longer you wait the better. Life is damn queer when people try to "force" it. . . .

Mabel Dodge appears this A.M.!—Returns to Taos this P.M. Mother died.—So it goes—& they go—we eventually too. My love to you both

ever your old
Stieglitz

[Halesite]
[3 June 1933]

Dear Stieglitz

. . . . Being confronted with a chance to live is a strange sensation for which many thanks to you.

We are trying to learn to look upon going to Geneva in a happy frame

of mind, anyhow I am not going to let myself be interrupted by Republicans and grown-up college boys any more than necessary.

Your letter was grand and your mathematics beautiful and I understand.

Wrote Phillips that it was all right to send check to me direct as you had never accepted for the Place what I had always hoped to be able to do. . . .

Do you suppose they will want to investigate me now that I have an income of $50? Perhaps that will not put me in the "Just here on business" class and I will not have to pay a tax.

In Roosevelt's dictum on hoarding, he made some exception in the case of art. . . .

As ever
Dove

[Halesite]
[June 1933]

Dear Stieglitz

Have just written Phillips an S.O.S. as there is no word from him yet. Probably in Chicago.

I tried to draw a small check on the estate and my brother says it will come back as he has drawn it all out to plant barley. 45 acres. When we were there we asked the advice of two of the best farmers in that section and they said just keep the weeds down this year. It will not pay to plant. So he has planted.

He says they "have to eat, pay the man, to feed the horses," etc. We had agreed to let the man go 2 months ago. $15 per week. I notice they all eat before we do. It is the same old story. He's still being my father, father of the whole world, but the shoes are a bit too large. He agreed to send statements once a week, but naturally there have been none, as the books show that it costs them twice as much to live as it does us.

There is a man there who will give us a $6000 mortgage, if we mention the Block. I have to be there to sign. Paul speaks of "money used away from Geneva." Nothing counts unless it is in Geneva. The dread of going there is almost an obsession. They are all the same—like the monkey with the looking glass. Maybe it is a blessing to be that way. Who knows!

When do you leave for the lake? I do want to see you. My first "rubber check" leaves us with $5 but he is to try to collect $25 to send us

to come up with. Think I'll spend part of it for gasoline and the rest for dynamite. If anyone goes to N.Y., it should be Reds for one more trip to the doctor. . . .

We are spending *days* packing, but it is a good thing to eliminate now and then. . . .

This letter is a sort of wail, but I hope to be smiling soon again in Geneva—God damn it.

Our love to you all.

<div align="right">

Ever
Dove

</div>

<div align="right">

[Lake George]
25 June 1933

</div>

Dear Dove: The gods grind slowly it is said.—Phillips is still Phillips. What you are up against with him has been my lot all these years.—His intentions & impulses are fine enough but he has no idea of the other fellow—& particularly when a nickel at a particular moment may mean the other fellow's life! . . . I do hope that he has sent you the money by this time. I'd send it to you as a loan but I'm about all in.— Georgia's condition is pathetic. I'm certainly far beyond my depths. Georgia's condition is psychic & cardiac. The former is the thing to unravel. She is at the age.—I see no light of any kind. I dare not hope nor dare I despair.—At times I feel like a murderer. There is Kitty. Now there is Georgia.—And I hear my wife (I) fell & broke her arm.—It's another great story.—As for your brother—yes, that's your brother— your father & mother & the American laissez-faire & individualistic attitude—called character & righteousness. Ye gods.—I have no idea how it will evolve. And still may be I have too clear an idea for the comfort of any of us. . . .

We are virtually alone here. I dare not ask anyone. Everything gets on Georgia's nerves.—As for work, I try to kick myself into a mood but the kicks are faint ones.—

The weather has been perfect.—And if Georgia were on the upgrade just a tiny bit I'd feel equal to anything—even to remaking Phillips & your brother—& all of us. . . .

My love to you both.

<div align="right">

Stieglitz

</div>

Stieglitz's letter had not yet arrived when Dove next wrote. When he did so again, on 28 June, he reacted to the preceding Stieglitz letter.

[Halesite]
[23/27 June 1933]

Dear Stieglitz

Just a note to tell you that Phillips is taking the "Bessie" and adding $100 instead of "Covered Boat and Tree." A nice handwritten letter saying he is distressed that checks had not already come. Was leaving that afternoon with Geo. Biddle[1] & another painter for Chicago. Check would come right away & another July 1. . . .

Our love to you all.

Dove

1. George Biddle (1885–1973), American realist painter, muralist, and lithographer, was later known for his work with the WPA Federal Art Project.

[Halesite]
[Probably 28 June 1933]

Dear Stieglitz and Georgia

What a letter. We do hope you, Georgia, are steadily improving. And Stieglitz! I am sorry to have let you know any of my worries with all you have of your own. Hope the second letter took my troubles off your mind.

Fortunately yesterday we sold the boat—on the installment plan— which just covers the mortgage & interest.

Did it to get first payment of $50 down & $10 per month, as Phillips Properties Inc. has not as yet sent the check. I sent P. a special and Treas. & Secy. also one in event of his being in the mountains or Chicago.— Or in the air.

We have to stay here until we hear either from them or my brother. I have to be there on the first to take back that privilege of signing checks all one way.

Well anyway, Reds is better. Another thorough overhauling yesterday—gave her much more confidence. He said for her to go to bed for a week, eat six times a day & drink 1½ quarts of milk. So I suppose we shall hibernate in Geneva. They have planted us a garden beside the

house and when we divided I chose the 6 hens & rooster so we shall have a start in edibles, especially the rooster if he is not too old. I remember him I think about 5 years ago.

Moved 3 loads of freight to the station yesterday, giving away a lot of stuff and sinking more in the harbor. So suppose we go as far north as the truck will carry us. In the meantime waiting. Paint things go with us so I can use them until the last moment.

Suppose it will be a good thing for us to get away from these terrible tin ceilings. Bill's friend, son of a Boston psychiatrist, here the other day looked up and said, "What a curious type of mind, to have conceived of a border like that."

Bill has been doing some very sensitively felt watercolors. I haven't seen the oils. He looks fine and is in love but allows the girl is a bit too golf club, is in California now so that will save him some trouble.

<div style="text-align: right">As always
Dove</div>

. . . . I see you are having a bankers' convention on the lake. Better lock your doors nights.

<div style="text-align: right">D.</div>

<div style="text-align: right">Lake George
27 July 1933</div>

Dear Dove & Reds: Yes, I'm still amongst the living. Somehow the days & nights get away & nothing particular seems to be achieved by me. The weather remains unpardonably good to us. Georgia is finally mending some—very very slowly. And that's the most important thing in my present life. I "intend" to do many things & virtually let them go at that.

My truss broke & I had to go to town for a day. Stopped in at The Place. Seemed unusually beautiful to me. So dignified in its bareness & in its proportions. And it was cool there while the streets were about 100° or more.—

Good for Phillips to keep "Bessie" & give you an extra $100. I notice his preferred Jones & McLaughlin[1] has gone up considerably. I own 2 *(say two)* shares of it myself. I hope you are getting your allowance regularly. Don't forget he owes you $300.00 on that "Red Barge." You'll have to remind him. His memory is a peculiar one.

I wonder have you gotten off to Geneva.—I hope you & Reds get

some sort of peace there & the semblance of a chance to work—really to live.—

I am fairly well—& extremely lazy!—

Our love to both of you—

Your old
Stieglitz

1. Jones and Laughlin Steel Company, of which Phillips's grandfather was cofounder.

The previous letter from Stieglitz had to be forwarded from Halesite, as the Doves had finally left for Geneva. Phillips's check had arrived right after Dove had written the last letter to Stieglitz. Since they were already packed, Dove and Reds went around to friends and neighbors saying good-bye, but at the last minute they had to postpone departure a couple of times because Reds was not well enough to travel.

6

1933–1938

Dᴜʀɪɴɢ ᴛʜᴇsᴇ ʏᴇᴀʀs, ᴛʜᴇ Dᴏᴠᴇs ʟɪᴠᴇᴅ ɪɴ ᴜᴘsᴛᴀᴛᴇ Gᴇɴᴇᴠᴀ. ɪɴ ᴛʜᴇ first year, they were almost completely occupied with getting settled and resolving estate problems. Gradually, Dove had more time to paint, and later years were productive ones in which his work took on greater ease and breadth. Although they had visitors—sometimes all too many in the summers—the Doves felt isolated in the provincial, small-town environment. They were able to go to New York only once in five years because they did not have the money to travel. However, they were never so desperate as they frequently had been between 1930 and mid-1933, and as the Depression eased, their financial situation also slowly improved.

At An American Place, where Steiglitz remained rooted except for summers at Lake George, Marin, O'Keeffe, and Dove continued to dominate the schedule. Hartley, who had two shows, was the only other major American painter to exhibit during these years. Two little-known artists also appeared on the roster: Robert C. Walker and the young William Einstein. George Grosz's exhibition was the only one in the history of the gallery by a European artist, but Grosz was by this time living in New York as a refugee from Nazi Germany. Photographic exhibitions were limited to one of Stieglitz's own work and one by Ansel Adams,[1] in his only show sponsored by Stieglitz. In addition to the individual presentations, there were two group shows of familiar names.

Letters abound during this period because they were generally the

writers' only communication. They are intensely conversational, filled with professional and personal news.

1. Ansel Adams (1902–84) had met O'Keeffe in Taos in 1929, and they became good friends. (See Glossary of Names.)

<p align="center">★　★　★</p>

On Friday, 7 July 1933, Dove and Reds set off for Geneva, little dreaming that they would stay there for five years. They took their truck across Long Island Sound by ferry and made their way to the Davidsons' house in Monsey, New York. After breakfast the next day, the Davidsons followed them as they continued toward Geneva, in order to have lunch together. After that, there were mechanical difficulties with the truck, so the Doves did not arrive in Geneva until Sunday. There, they moved into a small house under the trees on the family's farm property just north of the city limits. It was hardly more

The Doves moving to Geneva, New York, 1933. Left to right: *Arthur Dove, Donald Davidson, Reds (in car), and unidentified man.* (William C. Dove, Mattituck, New York.)

elegant than the homes to which they had become accustomed, as it needed repairs and had no electricity.

[Geneva]
[Probably 10 August 1933]

Dear Stieglitz and Georgia,

Well, we have all the symptoms of being in Geneva. Your letter was a fine oasis, the first from outside or rather the inside world.

We do seem to see more friends than when on L.I. The Davidsons came on the way back from Chicago with the Swami [Nikhilananda][1] and Moffett. And made an all-too-short visit.

This little farmhouse is getting settled gradually. Am wondering whether it is worthwhile doing all this work. . . .

In mail, I found a letter addressed to W. G. Dove Estate with about 6 tax bills of 1932 all nice with red ink etc. saying this was final and the whole business except the Block would be sold. Had the lawyer write the County Treas. Find there is so much red tape that they will not get to advertising it in papers until middle of next month. Talked with 3 bank presidents and a *shoe dealer* who may take a mortgage on the home. . . . Find the Home Loan is about to appoint a man here. And am going to try the Federal Land Bank. It is amusing to find that the shoe dealer offers more hope than all the banks.

In the meantime they have drilled down 800–1000 feet for gas on the farm here.

The Davidsons have offered us their place for the winter. Might be best to just paint all the time now and go there to make frames etc. The $40 truck we have has saved us an enormous amount of carting and carfare. Reds was ill during and after the trip but it was not as hard as we expected.

This working your head off at haying poor oats & badly planted barley at a loss is just nonsense. We had to have the barley to use a tractor that Paul had just traded a team for.

All this back taxes was news to me. Some one must have hit them on the head with a mallet with a $ sign on it and for many years it has been a case of arrested development. They still think there is plenty and that it must be the depression. . . .

Brother returns Sat. but it will not change the situation. If I could control the whole action, we might get somewhere. Found an Italian

last night who will buy a lot. Could make a Little Italy here easily. Maybe that is the solution. They are all over the place anyway.

Can walk east here for a mile on our land. It is just a waste. . . .

Our love to you both.

Reds joins me and is much better.

<div style="text-align: right">Glad.
Dove</div>

1. Something of a public figure at the time, Swami Nikhilananda (1895–1973) was a personal friend of the Davidsons. Peggy and Sue Davidson were at Lake George, rather than traveling with their parents, who had gone to Chicago to see the Century of Progress exposition.

<div style="text-align: right">[Geneva]
[18/25 September 1933]</div>

Dear Stieglitz and Georgia,

Have finally gotten started.—This has been an experience.—Think we are just beginning to understand.—I mean human nature.

We thought we were going to be isolated here but did not know that so many real friends could come from all directions and then again disappear with space.

Such contrasts from the atom to the elephant (white).

A live little farmhouse on the outskirts of what I should call a dead city.—Just walking around.

If you could be here it would be complete.

On about the first day we met a new friend—Bernard Nebel—a German Botanist.—He and his wife are working together at the State [Agricultural] Experiment Station—really sensitive. Think I shall give him a letter to Weyhe about his brother-in-law's work. Same name, Nebel. Meaning fog [in German] I believe, but he is far from it.

Well, have been plowing with the tractor this morning, plowing under my brother's attempt at barley.

Tractoring is like reading a detective story—I read part of one last night. It so soon becomes monotonous, and you know so well how the machine that is made for millions is going to behave. I could take to it like lessons in prize fighting and can accept the sock on the so-called mental jaw, but I do not believe that any human instrument can give out its best when its ass is being shaken off on a tractor.

The skies are fine here and are big with these fine stretches, a mile of these worn-out farms behind us.

The family—well, you know we are refraining from mentioning the pathologic as much as possible. Have given over the job to time to change that sort of thing.

It is fine here—in this house—but have a feeling we shall not be here long. . . .

Wrote Phillips a letter as he has slipped this month, and mentioned storage. They have given me until the first of Oct.

Sunbeams shine on all alike unless you have a mirror or a magnifying glass. . . .

As ever
Dove

Lake George
29 September 1933

Dear Dove & Reds: I have been silent. There was so much to say that couldn't be said that Silence became automatic. But I don't want to leave Lake George—I leave on Sunday—without having sent a final Hello & Love from The Hill.—Don't think I haven't been living your life with you, for I have. That may sound like words—but it isn't words—it's flesh & blood—dripping at that.

It has been *one* summer—fortunately not two of the kind.—Georgia finally seems on the mend. A bit at least. It still is a long pull. She remains here.—Everything is more uncertain and problematical than ever.—Not many weeks ago I was about to cave in—heart & whatnot—but somehow I'm still about & tinkering the best I know how.

. . . One of your paintings went to Springfield for the opening of the Art Museum there. If they'd only buy.—And so give the artist a show.—God they are a dumb lot virtually all of them—those museums.—But to escape dumbness I guess means suicide. One's own dumbness one escapes too. The chief man of our "town" blew his brains out on the street in broad daylight.—He was a real worker. At the same moment Ochs's ("Times") car smashed into another car nearby—Ochs wasn't in his car. And at midnight, a little after—the fire siren started up an ungodly howl.—The Night Sky was red. Houses near the Catholic Church were burnt to the ground. So you see Lake George can have its lively days too. I have worked hard but have little to show. Left my large camera out in the rain all night night before last. So

you can imagine what a state I must be in. Some weeks before I had left it out overnight too & ruined the shutter. All fits in with a Day in Lake George. . . .

As for your storage I was tempted to write for the bill but haven't the cash now. I'll call up on Monday & guarantee the payment.—Phillips is really the limit. Whether it's $5.00 or $50,000 or whatever it's always the same story. I'll be glad to get into harness even if it is shabby & rusty but I hate the idea of leaving Georgia alone. New York is no place for her in her condition.—Well, this is merely a message of love to you both.—

<div align="right">Stieglitz</div>

<div align="right">[Geneva]
[30 September 1933]</div>

Dear Stieglitz

. . . . "Family" affairs are going much better. . . . the first gas well on this place only gave enough to heat the house and is half a mile away.

Have you read the "Autobiography of Alice B. Toklas" [by Gertrude Stein]? You are in it. McCausland just sent us a copy. . . .

<div align="right">As ever
Dove</div>

P.S. P. has evidently forgotten about the "Red Barge" or thinks the $200 covered that also.

<div align="right">D.</div>

<div align="right">[Geneva]
[12 October 1933]
Thursday</div>

Dear Stieglitz

. . . . Well, am getting some work done. Get up about 5 and drive about a mile to Dove Block and start the furnace fires going. And for the last few days have been working along the lake shore and canal until 9–10, then home for breakfast and more fires. No heat here as yet. Am getting small oil burning heater. Fireplaces and stoves will burn it as fast as I can saw and chop. There are tons of wreckage from the old plant here that would save to burn, but time is getting so important!

So guess I'll let Sears Roebuck worry along on the installment plan. We have a bid on the farm from the gas people.

Brother & I had a long discussion. I said $20,000 for the whole thing. The lawyer said the same, but Paul wanted $15,000 more for the tile plant.

Well, we finally agreed at $20,000 for the farm with tile plant out. So he goes and quotes 25 for the farm and wants to reserve gas rights & tile plant. Half in cash. It is impossible to change them, and that is why the city is dead. They have scared away dozens of big concerns by being as my brother says "grabby."

Well anyway, things are moving. Have fired enough help to make up for our living here.

Our love to you all and much of it.

As ever
Dove

Stieglitz left O'Keeffe at Lake George when he returned for the art season in the fall. He opened with *Twenty-Five Years of John Marin—1908–1932,* then showed Marin's new work. Dove's show was the last in the season, after O'Keeffe's, which was retrospective, due to her health. Dove's too was partly retrospective, owing to the year's interruptions.

[New York City]
18 October 1933

Dear Dove: Finally. I have been going the limit. Got down Oct. 1—P.M.—outside of [Cary] Ross[1] I worked single-handed at The Place. Dumped all the Marins in here from storage.—Had the Show up by Thursday last. A bang-up one. Went to Lake George Friday night to see Georgia. Returned Sunday night. No press as yet. All at Pittsburgh.—

The absolute seclusion is wonderful for me. Damn aristocratic. And these days are not cake days. Hardly bread days. An occasional straggling visitor other days.—Had my first shoeshine in 3 months! An event.

Phillips' letter. My feeling is that if your paintings go down there for storage they'll be more buried than if in storage here.—Heaven protect me from the Rich & their Good Intentions & their kind of Protection. But you must follow your intuitions. I'm so out of touch with the constantly changing moments of the times & of people that to give

advice would be ridiculous. In the long run I wonder would you save money & wouldn't you lose more than you might gain.—

I was told Phillips paid one hundred thousand (yes 100,000!) dollars for his Bonnard. I guess $95,000—or more—went to Durand-Ruel.[2] It makes one sick.—He says he is crazy about Marin & you. Think what he could have had of yours & Marin's for $50,000!!—& what you two could have done. Yes sickening. And he would have had $50,000 to blow in in "safe investments" which would have become worthless. It's all too ghastly. At times I feel "living" becomes unbearable. But I fight on.—Fight an invisible horde.—Stark madness I suppose. . . .

I have been nowhere since I'm back—here & at the hotel. . . .

I had a glimpse of Elizabeth the other day.—So far the only member of the family.—Marin is ever Marin. Is really an extraordinary person. Few words.—You must forgive me for keeping you waiting so long. It is an effort to write these days.—

My love to you & Reds

<div style="text-align: right">Your old
Stieglitz</div>

1. Cary Ross was a widely acquainted young man of ideas; he then worked as an unsalaried aide to Alfred Barr, director of the Museum of Modern Art, and often helped Stieglitz at An American Place.
2. Durand-Ruel art gallery, founded by Paul Durand-Ruel (1831–1922), who is particularly known for promoting the Impressionists.

<div style="text-align: right">[Geneva]
[15 November 1933]</div>

Dear Stieglitz

Am sending two telegrams from the Rankins [Washington, D.C. friends] about showing some watercolors [at Phillips's gallery]. I do not want to send the new ones from here as I am using them [as studies for paintings], and anyway they should appear first in their own home [An American Place]. If there are any you will care to send, they will pay charges. . . .

<div style="text-align: right">Love
Dove</div>

. . . 8° above 0 this A.M. Ink and watercolors froze while working. Had to keep breathing on pen & brush. . . .

[Geneva]
[16 or 17 November 1933]

Dear Stieglitz,

. . . . Thought of calling you on the phone today, but it is so expensive. And the mails are fairly fast. I can post a letter here within a quarter mile at the station and the "Black Diamond" takes it at noon and is in N.Y. about 8.

Things are going a bit better here. I have a good lot of watercolors anyway and they have plenty of vitality—they all say more than ever.— It may be that my attitude about the whole thing here has crept into the painting. If so, it will be a good thing. Three today.—One anyway the best yet.

This zero thing makes fires an hourly chore.

The Block fire is off my hands anyway—a man who has a room there is doing it. So I get up at five and do things as the daylight brings them out.

It would [be] encouraging to see you now. I want, however to bring many things when I come. Could drive them in the truck. It would be quite an undertaking in the winter, if cold. . . .

It must be quite a weather test for Georgia, if she is still at the lake. . . .

As ever
Dove

[New York City]
16 November 1933

Dear Dove: Just returned from the Lake—4:50 P.M.—

Left 48 hours ago. Wanted to see Georgia for myself. Also birthday yesterday—hers. We usually don't notice such events or holidays.—And today 40 years ago I was married the first time. . . .

Everyone & everything is hectic—more & more so.—Only the Place seems absolutely quiet & going its own pace.—McCausland was in. She took away some watercolors of yours to "place" if possible. Also sent two to Boston at her request. Phillips was in last Saturday. In a rush. Also hectic. Now writes a letter full of "wants" (Marin) & no money. And tells me what he is doing for you!!—Don't forget about the "Red Barge." He owes you $300 on that. You see it's all out of my hands so I can't keep tab like I did formerly—I hope you won't let him get

away with B.M. (Blue Murder) in all his innocence. Lord, those folks are *innocent*—all of them. Our last drop of blood doesn't mean a damn to any of them. They have been professionally kind so promiscuously for as many years.—As I said recently: The American has so many irons in the fire that he doesn't notice the fire is out. And it's a fiendish job to get it started again. And is it possible to start it again?—

In Lake George this A.M. it was 2 below. But the cold was dry. The only trouble was I still had a summer suit on. . . .

<div style="text-align:right">

In haste
Stieglitz

</div>

<div style="text-align:right">

[New York City]
6 December 1933

</div>

Dear Dove: An attack of sinus, etc., etc. & illness all around me have had me a bit beyond my wits' ends. I haven't missed a minute at The Place but was all but in for a few days. I enclose a small check [twelve dollars for a watercolor] that came for you. A dollar looms up like an Everest on the plains.—What a world.—Phillips wrote me a lengthy letter about 4 weeks ago wanting this & wanting that & many others write similar letters. All wish to help along the Cause. Ye gods.—I could keep several secretaries going just answering imbecile requests. It's a wonder no one has at last asked what particular kind of diaper does a genius wear. Isn't there a special mark somewhere on such a diaper. Crystal gazing will be superseded by diaper Adoration & Diaper Contemplation. That will be Hyper Surrealism with a vengeance. I'm told Prohibition is over.[1]—Well, I hope drinks will be good & that those who want a drink will get the price from the Gov't. It's the easiest & straightest way. And I'm sure the Gov't is kindly disposed towards all & one.

Love to you & Reds

<div style="text-align:right">

Stieglitz

</div>

1. As a teetotaller, Stieglitz was not rejoiced by the end of Prohibition. Dove, a drinking man, was presumably pleased, though repeal did not change his habits significantly—any more than Prohibition had.

[Geneva]
[8 December 1933]

Dear Stieglitz

. . . . I have 60 more [watercolors] all mounted but not framed as yet. Went this morning to get electricity put in upstairs here at least so I can run the small motor.

Reds sends love. She too has sinus and at the present moment is smoking a thermometer.

Just for a joyous contrast. By the looks of the barn way out back here someone came with trucks and stole half a barn of hay which was put in at great pains and with the paid effort of the man who has now been fired, my brother, and others and myself—not counting the horses. It was evidently done in the middle of the night and relieves me greatly. If it had been sold I would have had to help get it all out of the barn again after having helped put it in. Now that it is stolen, it saves a lot of trouble and someone has it that needs it. . . .

Nebel was here last night. I admitted my wealth about a check from you. He said, "If you are letting them go for anything so ridiculous, I will take 12 and I want a painting also, even if it costs $500." Sometime. . . .

As ever
Dove

. . . . It would be a Godsend to be born without relatives.

Dove

[New York City]
11 December 1933

Dear Dove: As for relatives, 40 years ago I said: Everything is relative except one's relatives & they are absolute. So you see, I agree with you. . . .

All these endeavors & hopes & promises—all the energy spent in correspondence—packing & unpacking—why can't a person in the art business simply say I believe in these. I'll take 5 for $100. But no, it's exhibition, exhibition, exhibition & more exhibition & women running them. Bless them for what they really can do better than we can—or we can't do at all—but for the rest—well, I'm rather fed up with good will & appreciation & all related to the two.

—I had a letter from Phillips ages ago but somehow I haven't my book of logarithms around & without it there is no use to answer him.—He has a secretary & whatnot—& altho' he still sings the new National Anthem: I have no money—I have a feeling he still has a good many doors between him & the historical wolf. . . .

<div style="text-align: right">

ever your old
Stieglitz

</div>

<div style="text-align: right">

[New York City]
9 January 1934

</div>

Dear Dove: About a week ago I finally shipped 8 of your watercolors to Washington.—Also sent two of your oils to Budworth for the Pennsylvania Academy Show. The Jury of Selection for New York met at Budworth yesterday. So I do not know as yet what happened. I hate all that sort of business for I feel that for you & Marin & Georgia it leads nowhere.—But what leads anywhere if one does an honest job all the way through?—There has been quite some life at the Place but nothing "happens."—It becomes tougher & tougher going.—

Georgia is still at Lake George. Is much improved. Is better off there than she would be in this mad town. I was up there Xmas Eve & Xmas Day.—

—I hope you are managing to keep afloat in spite of the icy weather we have been having.

My heartiest to you & Reds.—

I wonder will 1934 be tougher than 33?—

<div style="text-align: right">

Ever your old
Stieglitz

</div>

Phillips initiated discussion of Dove's possible participation in the WPA artists' project, a federal relief program during the Depression. Soon, Dove was offered a WPA position, but for reasons he worked out with Stieglitz by letter, he declined to participate.

<div style="text-align: right">

[Geneva]
[Probably 10 January 1934]

</div>

Dear Stieglitz,

So many thanks for keeping up the grand fight.—It is great encour-

agement even if "Nothing happens" and in amongst this isolation here, self-imposed, to avoid the curious, your interest and love of doing things so perfectly shines like the north star. . . .

Another letter in the mail with yours from Phillips. I wrote an answer to his long letter saying that I had to stay here or everything would go back to a state of inaction and said that anything to do with Mrs. Force[1] would come better from him. He writes as though he had read the first line of the letter & guessed the rest. Says Mrs. F. has not heard from me.

If they are enthusiastic enough to pay me $42.50 a week to go on with a big long painting I am starting that I hope will reach round the gallery at 509 and then buy it from us, as Phillips suggested in a former letter about older things, it ought to be satisfactory.

The thing is Geneva, but it is also the rest of America.

Just finished a 25 × 35 yesterday & guess I told you I have about 60 watercolors in spite of this stupid circus that surrounds us. It is not as bad as it started out being, but there is still room.

P. wants Gordon Washburn[2] to come to see me about decorations in Buffalo. I do not want to use any gift horse as a mirror, but expect to go on working as usual and have what there is shown at 1710 first. After that we shall see.

I think that '34 ought to be good, especially if they are going to have all the artists on stepladders at $42.50 a week. There will be more room on the ground. . . .

Was interviewed by "Rochester Democrat & Chronicle"—reporter[3] a cousin (?) of a Frances O'Brien[4] who had I believe visited Georgia. I talked a lot of you and gave him much material. He took 16 [photographs] of us & me. He is trying to do something in Rochester but is up against editors who "know not." It will be out some Sunday soon. . . .

Nebel again. He would rather have a painting than watercolors—is also thinking of an airplane. We could fly to NY with the paintings and if there were a spill the paintings would be the more valuable. The plane idea was last summer but trust it has been reduced to a painting. He is very fine and of course Germanly thorough. . . .

Reds has been much better than she has at all since we came—although she does not like Geneva as an idea, which it ain't.

Our love to you, all of you, and all of you all.

<div style="text-align: right">

As ever
Dove

</div>

1. Juliana Force of the Whitney Museum of American Art was the first New York chairman of the WPA art project.
2. Gordon Washburn headed the WPA art project in upstate New York.
3. Emmet O'Brien, journalist and author. His story appeared a few days later: "Leader of Modern Artists Paints in Geneva Farmhouse," *Rochester Democrat and Chronicle,* 14 January 1934.
4. Emmet O'Brien's cousin Frances O'Brien, a magazine writer and artist living in New York, knew Stieglitz and O'Keeffe.

[Geneva]
[12 January 1934]

Dear Stieglitz

As a result of Phillips and Mrs. Force, a Mr. Duane Lyman phoned from Buffalo & wants to put me on the gov't payroll at $34 a week. P. in a former letter said $42.50 per wk. and suggested they might purchase some old work. Wonder if we could substitute some of my work in storage and keep the present and use the $34 for materials. It would help a lot, but I could not think of giving them all present work, that would hardly buy paint and canvas, and the "committee" would have to be satisfied.—How nice! And all your years of building to go for nothing at a Government auction. If they hang these paintings in place of historical prints or what they have now in schools etc. what becomes of Geo. Washington etc.?

Do they know how much it costs to paint a 30-hour week for materials alone?

They pay the man who lives in an old shanty here on the farm 50¢ an hour for road work, and most of them sit on the bank and smoke so he says.

I cannot see how they are going to pay for creative work by the hour. This morning for instance a slat in the bed broke. We had to get up and get the carpenter tools and fix it. So from two o'clock on I lay awake and painted mentally and learned a lot. Would I get credited with that time and how could I explain to a committee? He said I could do anything I wanted—portraits or anything and work at home. Could not imagine their hanging some of the things in the Geneva High School and, if they did who is going to answer questions? Editorial in local daily says Jo Davidson the famous sculptor thinks it is great—Jo could spend the $34 for lunch.[1]

The only way I can see it is to trade them some of the past instead of the present. It sounds quite mad as you say.

Well, love to you all anyway.

Always
Dove

Have just been loading hay for a cow near and was thinking the bull gets paid better than that for creative work.

D.

1. Jo Davidson (1883–1952), an American sculptor who specialized in portraits, had a reputation for lavishness. Dove had known him in Paris and the pre–World War I days in New York.

[Geneva]
[15 January 1934]

Dear Stieglitz

. . . . Finished another small painting this morning. Think the means is getting more prolific.

Getting some work done makes us feel better here. It has been so dark. Haven't seen the sun for at least two weeks. Dec. in fact. It's good for one though. Gets you in the frame of mind of painting under any conditions.

Our love to you all

Always
Dove

[Geneva]
Friday, 2 February 1934

Dear Stieglitz

. . . . This is like living in exile. . . .

Three fires are calling for coal, so will stop for a minute. . . .

A very nice letter from Phillips saying that they were to see you and offering to continue this same $50 a month arrangement another year, which would be great.

Finished one of the best oils I have done yesterday, and beginning to feel better about this cloudy country. The fogs from the Great Lakes keep it dark all winter. . . .

I see by the Hartford paper that Philip Goodwin is having a special car to go to the opening of the Museum there to hear and see the Gertrude Stein play.[1]

Well, now I have to play white wings to a couple of huge horses that my brother wants twice as much as they are worth for. They weigh 1800, aged 11 and 15 respectively, and he wants $325. I prefer the animals to the roller-skating, prize fights, wrestling, and mobs at the Dove Hall.[2] The roller-skating at its height brought in almost enough to buy food for one month. Now it is dropping and ends in about another month.

Our love to you all.

Always
Dove

1. The initial performance of *Four Saints in Three Acts* took place at the Wadsworth Atheneum in Hartford, Connecticut. The architect Philip Goodwin, codesigner of the 1939 Museum of Modern Art and a longtime trustee there, visited Stieglitz's galleries and bought a few of Dove's works.
2. The top floor of the Dove Block was a single, large room used at various times as an arena for profitable amusements. The Doves later lived there for about a year.

[New York City]
17 February 1934

My dear Dove: I may seem to have been delinquent but I haven't been neglecting you.—As a matter of fact I haven't missed a day—nor an hour.—And I am still in doctor's hands—sinus, etc.—neglected "colds."—

I sent watercolors of yours to Washington as requested. They were returned with a letter saying that the prices were too high—couldn't be used. Ye gods!!—Then as you know I submitted 2 of your paintings to the indignities of the Pennsyl. Academy Art Jury—Karfiol[1] et al.—You know what happened. They were swell pictures, too good for the swollen heads of an inane Jury. Why did I send?—Don't think I wanted to.—Great times there. Imbecility fast & furious—madness of the academic taint rampant. I sent two of your things to the Municipal Show.[2] The drawing didn't go. It hadn't come back from Washington.

Neumann has a place in this building.[3] He is to have a show of [Max] Weber & [Yasuo] Kuniyoshi & I let him have 6 Doves—oils—large ones.

Prices low. So will see. He is an enthusiast about you.—But when something happens it will have happened—not before. So you see I'm on the job. It's a mean one.—Georgia is on The Hill—40 below—average zero for a week.—She is coming down & I guess will go to Bermuda to thaw out.—I'm absolutely alone. Ross is in Tennessee for a while. Dorothy I see occasionally but every one is pretty busy with their own affairs.—

The Place is assured another year. That's Dorothy's work single-handed. Georgia's Show is swell & again attracting crowds. But as for money—well, The Place is too true to attract that animal.—Marin's Second Show was a grand affair but a complete frost—even McBride cut it.—He hasn't been any too kindly inclined to us this year. We are not exciting enough.—Well, press or no press—friends or no friends—alone or not alone—money or no money—somehow we push on to the bitter (or sweet) end.—

There is a tempest in a teapot about that [Diego] Rivera Mural being destroyed. I have to smile. The "artists" do more to kill ART than all the Rockefellers in the world.—It's a damn shame I don't know how to write. No one really says anything.—Not about the true art situation.

Love to you & Reds

Ever your old
Stieglitz

1. Bernard Karfiol (1886–1952), an American realist painter, was known especially for nudes and still lifes.
2. The *First Municipal Art Exhibition* at Rockefeller Center was New York City's attempt to aid artists suffering in the Depression. Its "mile of art" consisted of works for sale.
3. Contemporary New Art Circle, 509 Madison Avenue.

[Geneva]
[19–28 February 1934]

Dear Stieglitz

It was great to hear again from you. Too bad about the sinus colds and all. It is hard to keep going when the bones of one's face ache. . . .

Better let Georgia thaw out slowly. "40 below for a week!" It penetrates after the 3rd day. This farmhouse was so cold we couldn't undress for two of those nights—busy all night running between 3 fires. . . .

What has happened to McB.? Is the ophthalmia social, political, financial, moral or what?

A long letter from P. wanting me to tell him all about my ideas & send sketches for mural etc. Maybe he could oversee it himself etc. & if things go well this spring, he will double the $50 per mo.! if he can have first choice. I am going to believe it anyway just for luck.

We do not see N.Y. papers much here. They never get the Sun. "Times" [until] around noon Sunday. And it isn't worth cranking your head off on a car this cold weather.

There seems to be an epidemic of wall trouble now. Think I should enjoy a floor better covered with glass. Most of these wall frescoes look like huge watercolor illustrations.

Finished a fine one [*Sowing Wheat*] yesterday. Reds said it was the cleanest-cut one yet. Nebel said he loved it. My brother and his horses seeding 9 acres of wheat. You should see the horses.

Am a bit worried about frames. Have no electricity, money all seems to go for pathologic work on brother & wife.

Phillips wants retrospective show in Apr. or May.

Reds doing a fine self portrait.

It is really too cold for her. Could actually feel my nose bend as I breathed that one day. She is in bed with cold now. Spent 3 days in, myself—worked outside today at 2 above. Huge straw stack covered with snow. . . . Anyway, there is sun now, even if you do have to watch it from the bulb of the thermometer. . . .

<div style="text-align:right">

Always
Dove

</div>

<div style="text-align:right">

[New York City]
2 March 1934

</div>

My dear Dove: As for Phillips, the letters he writes to me I ignore. He becomes more & more impossible as far as I am concerned. Of course I get no letters any more from him regarding you as he is "dealing" (!) with you directly. He would like to with Marin but in that he has struck a snag. I find Phillips absolutely irresponsible—full of ideas & good intentions—but somehow he is like virtually all rich people—they cannot see the poor man's problem nor his position. Everything he—the rich man—does is a blessing from God he believes—that is, a blessing for the poor man. You see, I sent your watercolors to Washington after much correspondence. I knew the

uselessness of it.—I put half prices on everything—as low as $25.00.—Remember they were to deduct a commission for sales on that.—But such prices were much too high! A Dove was to be put on a par with a Xmas card done by some tenth-rater—a discovery of Phillips. He is always discovering someone amounting to less than zero.—Whom has *he* discovered? Not a soul.—If I were to write the history of Phillips it would be queer reading. Remember, I don't forget his very good qualities but ye gods one has to pay extortionately for them. He made an offer to Marin which was worse than his suggesting cutting your painting in two.—That showed up the man for once & for all time as far as I am concerned. Of course I knew him all along ever since he lied about me in regard to the $6000 Marin. . . . All I say is: Look out.—Try to keep your dealings with him straight if possible. By that, I mean simple. He is interested in your work. There is no question about that. But that's no reason why he should get all your paintings for nothing or virtually nothing. As for a retrospective Show of yours in Washington, what earthly good will it do *you?* His business is to buy your work & show what he buys. . . . All else is waste & vanity. And you pay the price. . . . I see by this morning's paper that the watercolor sent to the Municipal has been sold. The price was $80.00. So you ought to get at least $60.00. If Phillips hadn't had that drawing, I'm sure it too would find a buyer at the Municipal. It's just that sort of mix-up that is sickening.—Insurance, packing & expressage get all the cash—or the major part of it—as far as Phillips is concerned. Of course he means well by all men—starting with himself—naturally!!—

As for your new work, why not show it as is—frameless. I'll hang it that way.—It will look all right & it will make a story!—I have hung many O'Keeffes that way.—As for McBride, well he has become quite a snob I fear.—I'm wondering what will happen at Neumann's—press-wise!—Of course McB. is a marked man—heart.—I rarely see him.—

Georgia has arrived in Bermuda.—I'm glad she'll get sun. . . .

Please don't get me wrong about Phillips or even McBride. I feel Phillips has done good work through me really. But when let loose, well the work isn't quite as good. That's all. And as for McBride, he is just plain human—too. And we can't compete with wealth & women who control it & "Art" in this country of ours.

It's all so plain to me—& The Place is more wonderful than ever for those who really have eyes—& are not social climbers. . . .

Ever your old
Stieglitz

Do you happen to know the name of Raleigh's son-in-law? He interviewed Georgia & said he writes for the "Evening Post." . . . He seems a decent sort.

[Geneva]
[7 March 1934]

Dear Stieglitz

Lord! What a letter! It is great. All the fine old fire! Do not think that there is any chance of my "getting you wrong" about P.

We have both known for some time what he is trying to do. Muscle in for Phillips' sake. It is a relief to know that you have no feeling for a retro-show in Washington.

You are right.—It could do no earthly good—at the worst they would be better off with the Lincoln Storage.

The man's name you wanted is Archer Winsten.[1]—Husband of Sheila Raleigh.—He is a great friend of Bill's. And thinks the hair in your ears is wonderful.

If P. wants "first" choice of anything, he can pay past debts first.—I am keeping a very careful account of the whole business so there can be no more disputes.

Am wondering what he could have done to Marin that could be worse than cutting a painting in two.

It is so cold in here this morning I can hardly write. Wonder how we have lived through it let alone getting any work done. Having the morning chores done, I have been interrupted 3 times since I started this by the damn stoves. We have both been in bed with grippe that takes time, and now here comes my brother with a man who wants to get a piece of ground. A regular morning. Well. That's that. Sold. One piece of ground to an Italian for $500. It will just keep the city from selling us out again. We know the City Treasurer and he left our names off the list to be sold for taxes.

Brother having wife trouble. She has left him for 2 or 3 weeks and I hope it sticks. He trying to get her back. I told him yesterday that if his marriage were a house on fire and he were trying to save it, I'd put gasoline in the fire extinguisher.

Isn't that perfect publicity—selling the one in the Municipal Show? Have heard from all comers about it, even the postmaster in Halesite. . . .

Think so far I have made two slight errors with P. One in not telling

him to go to hell when he wanted to cut the "Bessie" and another in telling him that I was at present working on trains.—We can soon tell.—As his discovery you mention will probably start working on "trains."

You told me to take him on and not let him put over the "Red Barge" etc. I thought it might lessen correspondence for you. In the spring when he blossoms into a philanthropist instead of a debtor I shall send him an account statement to let him know that I have not subsided with what he now calls a "subsidy." . . .

What is the last date you will want the things? There cannot be so many oils, unless I surprise myself again, as I have for the last three years. However, it may come to pass. . . .

Of course, if I hadn't made that first error with Phillips I could not now be buying materials to paint with. He's sending the $50, but I earn it twice.—He says he's "Earned the right" to make suggestions for work in Washington for me. Forgets that it was his father who "earned."

Hope the Wash. people read that the watercolor was sold for $80. They'd probably just put up the price of their Christmas cards.

Well, I should like to have about 100 paintings here to send now, as things are looking a bit brighter this year for the Dove paintings as I seem to sense it.

Of course, I think the "gang" have it in for all of us. It may have hurt Marin a bit. You know how much spirit those heavyweight oil painters have and how they regard a sensitive watercolor—Marin or not. Maybe it doesn't make any difference except a few dollars for Marin. But that again is of prime importance. Hope he is all right. I wonder.

Nebel brought in a psychiatrist from the State Hospital Sunday to see the paintings. A. Dr. Loynes[2] and she was a wonder. Wants either an oil or watercolor. She has a delightful touch of understated humor, and keen, and big.

Will have to put down this pen and take up brush or you will just get letters. . . .

Always
Dove

1. Archer Winsten (b. 1904) was married to Sheila Raleigh in 1931. They were divorced many years later. He became the film critic for the New York *Post* in 1936.
2. Dr. Dorothy Loynes soon established a close and lasting friendship with the Doves.

[New York City]
20 March 1934

Dear Dove: I'll be ready any time from April 1 on. I have set no date as I didn't want to inconvenience you.

—I haven't written as the pressure here has prevented.—I am frankly a bit tired.—

The rush seems over as far as O'Keeffe is concerned.

I hasten this off to you.—If for any reason you feel you'd prefer to wait, with your things I could get enough Doves together to have a Show of "Olds."—So it's entirely in your hands, what you'd like best.—

I know the terrific pressure you are under.—That's why I write as I do.—Goodwin I hear brought that watercolor of yours.[1]—Well, he could have had it here last year for $65.00. He liked it then. Now he paid $80.00. We (I) have the reputation of being extortionate. It is a peach of a world. A—— L—— said yesterday that all people were pigs.—I asked why insult pigs.—She lost her ideals at 18.—I believe about 12 years before she lost her hymen. Had she lost her hymen at 18 she might have kept her ideals a bit longer. But who can tell.—

I wonder did you see Sunday's "Herald" with the Mrs. Force-Sloan-Zorach[2] WCA episode. Unsavory business.—And so stupid.—All is quiet here. It's good Georgia is away. New York is not for her. I'm an old sinner so can stand it.—My love to you & Reds

in a rush
Stieglitz

1. Shown at the *First Municipal Art Exhibition*.
2. William Zorach (1887–1966) was a Lithuanian-born American modernist sculptor.

[Geneva]
[30 March 1934]

Dear Stieglitz

Your letter was even more thoughtful than ever. Understanding like that is almost unbelievable.—That is if I hadn't known you.

Another finished today. Have three more under way. I can send these and take measurements and send frames as I get them done. They could be put on the paintings and hung on same nails, if done in time. There

will probably be about 15 new oils. Hope to get them to you by the 10th.

There are about 60 watercolors. Will frame what I can & send others in portfolio.

Tenants have moved out of other house here so we move there next month unless it is taken for taxes. Upstairs here is like a boat cabin. Much more room there for workshop etc. . . .

Always
Dove

[Geneva]
[10 April 1934]

Dear Stieglitz,

Have just shipped the oils and the 10 × 14 watercolors. Will get the 7 larger watercolors off in the morning.—

They laughed at the values at the Railway Express Office. It is strange how we all appear to the ordinary mind. Have made packing as simple as possible. The insides ought to come out whole.—We thought it a good job.

The values I put on the outside made them stick a lot of Glass! labels on them. That seems to be the extent of vision.

This has been a mad three days trying to get them off as promised. . . .

Always
Dove

Nebel dropped a check for $50 as an "option" on the "Brick Yard Shed." I am giving it back to him.—Apologies. Wife having another baby & not liking paintings as much as he.—So there you are. I am, and he is in the same old situation.

More love

As ever
Dove

[Geneva]
[11 April 1934]

Dear Stieglitz

Am just taking last case to the express office. . . .

The frames [for watercolors] were picked up at a sale except the black & silver (15¢ a foot). I have found a place in Rochester where they will get out any moulding I design for 4¢ a foot if I take $10 worth. Worthwhile knowing.

What a relief not to be freezing for a change.

You should have had these things before, but we have had so many sets of visitors from all over, nearby, family and chores that I am happily surprised to have them done by now. . . .

<div style="text-align: right">

Always
Dove

</div>

<div style="text-align: right">

[New York City]
16 April 1934

</div>

Dear Dove: Your Show is up. Hung today.—There are 8 new oils—10 new watercolors hung. And then "old" things. In all, making a very fine & solid Show. All in one room.—Felt it wisest to do that.—The town is reeking with pictures & what I have done I believe is advantageous all around. . . .

I had strips put around your new oils. And painted them with aluminum bronze. Look right.

With love

<div style="text-align: right">

in great haste
Stieglitz

</div>

<div style="text-align: right">

[New York City]
21 April 1934

</div>

Dear Dove: McBride here yesterday. We'll see. People are gradually appearing. Beginning very slow. Place looks fine. Everybody feels that.—Will anything "happen"?—I have no idea. I seem to be living further away from "everywhere" than ever.—New York is deluged with paintings so the tiny bit of art seems to have a rougher time than ever.— God, the madness of it all everywhere. . . .

<div style="text-align: right">

As ever
Stieglitz

</div>

In the spring of 1934, the Doves moved again, this time to a larger

farmhouse on the family property. In June, Bill returned from eight months in Europe and came to Geneva for the summer.

Early in May, O'Keeffe passed through New York on her way from Bermuda to Lake George. After a month there, she went to New Mexico, where she stayed until October.

[Geneva]
[1 or 2 May 1934]

Dear Stieglitz

We have just moved to the larger farmhouse. And it is like living in a warehouse. After saying we didn't want to own anything, here we are with a lot of furniture. So we haven't been able to find anything for two days.

You have surely done the thing perfectly. Really great. Many, many thanks. And more for sending the "Times" article.[1] Someone brought the "Tribune" article[2] yesterday.

Didn't McCausland do finely by us?[3] She is a great one. Such energy. Have lifted so much heavy furniture, stoves, etc. that my hands are all stiff for writing. We moved the other people back, so there was plenty of turmoil. The last thing Saturday night three of us lifted a 900-pound motor into my truck and out—on a plank of course.

You couldn't have picked a finer show—as far as I am concerned— and just the right ones as a contrast to what must be going on in N.Y.

If I were to give a prayer of thanks I would just make a list of you all.

Had a letter partly written to you and there were so many interruptions, including moving, that the letter sounded like it. Every cow and horse in the city seems to be out of hay, so by working half a day you can get about 8 dollars back of the 25 the hay has cost, that is when they pay for it.

This is the first time in years that anything has gone back on the land. The whole town is that way. I mean "Geneva Proper." It is divided into two parts: Geneva Proper & Geneva Improper. The ones that had incomes are all broke and helpless. The Italians are the only ones who pay cash.

I wrote Miss Bier, Phillips' secretary, that the show was on. . . . Miss B. writes a very friendly note when she sends the check. She too paints. . . .

We made all those frames, cleaned the glasses and cut the backing &

put them in in two days. . . . Reds is a wonder—a bit all in from all the rush. . . .

Our love to you all and tons of thanks for all you have done and tons more love for the way you do it.

<div align="right">

Always
Dove

</div>

1. E. A. Jewell, "Exhibition Shows Dove's Early Art," *New York Times,* 21 April 1934, p. 13.
2. Carlyle Burrows, "A Retrospective Show by Arthur Dove," *Herald Tribune* (New York), 29 April 1934, sec. 5, p. 10.
3. Elizabeth McCausland, "Dove's Oils, Water Colors Now at An American Place," *Springfield Sunday Union and Republican,* 22 April 1934.

<div align="right">

[New York City]
3 May 1934

</div>

Dear Dove: Just a rush note. Phillips has been here 2 hours.—Hopes to give you $100 a month for coming year & for it wants 4 oils for $850 & 6 watercolors for the balance.—I let him make his own prices & felt what he offered was fair in view of there being no commissions, etc.—Now I don't know whether he ever settled for the "Red Barge" or not. He said he did. I know I received one check & that's all. And it was for $200 or $250 which I mailed you at once.—You must have the records. So you will have to square accounts with him, as it's all between you & him when it comes to money "affairs."—He was fine but I don't always trust his memory. . . . O'Keeffe is back from Bermuda. . . . Looks well but has very little strength.—Expects to go to the Lake soon.—I'm on the bridge day & night. That's not a great exaggeration.—

My love to you & Reds—

<div align="right">

Stieglitz

</div>

<div align="right">

[Geneva]
[4 May 1934]

</div>

Dear Stieglitz!

What news! It is almost magic, but knowing the magician, I know it is truth. . . .

It is queer that even up here in what I thought was the wilds of "Up

State" N.Y. that news reporters[1] with close-up-to-the-eye cameras are "shooting" the house and us today. . . .

[Phillips] paid $200 and said that if he didn't pay the balance $300, they would take a smaller one. That is about the "Red Barge." I have the records. So of course he probably feels that it has been done.

I am going to say that you advanced me that on the "Red Barge" and that that is the reason I am being financially frank about it in spite of all he has done. So—I want *you* to take the *$300* for the place.

You cannot give and give and give forever. If I could only get anything out of this 180 acres here I might do what I have always hoped to. I have brought in so little to 1710. Think I can write P. so he will understand.

About the frames. Shall I go on and make them to size or go on painting while it is good here? Have a few watercolors already for next year. . . .

<div style="text-align: right">Always
Dove</div>

1. From the Syracuse *Post-Standard*, which ran a story headed "Few Genevans Aware Artist of Prominence Is Resident."

<div style="text-align: right">[New York City]
9 May 1934</div>

Dear Dove: . . . Do keep your accounts with Phillips straight.—He is apt to rely on his memory which is not always accurate & his "errors" are never against himself.—I suppose that's an inherent law of self-preservation with most people. I haven't been "blessed" with that idiosyncrasy.—Yes, "Blessed."—Ye gods.—I do know [Phillips] wants to do the straight thing by you. So help him achieve it.—As for your wish to help along The Place I understand.—We'll see. Get straightened out first.—Some people come. Not a crowd. The Show wears well.— That's the real test.—

In a rush with love to you & Reds

<div style="text-align: right">As always
Stieglitz</div>

Georgia left for The Hill day before yesterday.—

[Geneva]
[15 May 1934]

Dear Stieglitz

This has been a great week. You have done such wonders. We are still moving, getting the house ready. Expecting McCausland in a few minutes.[1]—

This room here is rather fine, the kitchen. The walls were gone to pieces so we used linseed oil and aluminum paint, over old paper, plaster, holes and all.—Silver has covered many sins. . . .

There are white ceilings here, white doors, a black surbase and what shall be a Mars Violet floor.

The neighborhood children seem to flock here just now especially.— Reds gave one some candy so now there are ten.—The grown-ups are the same. . . .

I get up about 4-5 and go to bed about 8 but still there does not seem to be time for the main thing. However, have several watercolors all done. They are fresh again for next year. . . .

What an amazing amount has happened this year compared to others! Of course I can see the thing you have done.—Almost every action— move.—I am working on more now to give you ammunition for next year.—Maybe it has to come to that. I mean ammunition that makes *life*.

Reds is quite happy here but, as I, does not feel it permanent.—This is a larger house and there is breathing space.—The taxes where we were are paid. Here, they are not and when the showdown comes— one, I believe, can write the president and he writes the local powers and they hesitate to move. So we may hatch two birds out of one egg.—It has been done.

Keeping moving—ones sees different things—and gets ideas. "The rolling stone"—you *know* how much we want "moss." . . .

Always
Dove

1. She visited 15–23 May.

[Geneva]
[Early June 1934]

Dear Stieglitz,
 A letter from P.'s secretary enclosing carbon copy of letter to you.—"Subsidy!"—as I told her, I thought it was a *bargain*. . . .
 It is just as mad here as you say it is in N. Y. We flew the other day for a few minutes.[1]
 A man came to the door, wanted work. Said he was a "parachute jumper." I kept his address in case of need.
 I keep telling them that the Chinese say that three grown-up people cannot live in the same house. Nevertheless, the house is full of them half the time. *"Nevertheless."* Alfy's favorite story.—The man on the stage announces that Miss Smith will sing.—From the gallery—"Miss Smith is a ——— ——— ——— ——— whore."—"Nevertheless, Miss Smith will sing."
 Bill is on the way home. . . .

Always
Dove

1. They took their only airplane ride 30 May.

[Geneva]
7 June 1934

Dear Stieglitz,
 Am sending you a copy of the letter I wrote to Miss Bier—Phillips' secretary. Hope it doesn't spoil his summer. . . .
 Our records are quite complete, but do not know how he [Phillips] will take it. . . .
 It might have been better to write Phillips, but he would naturally want to forget the records, get excited, and nothing would be done.— She probably has them and *may* do something or at least show them to him.
 Our love to you always.

Dove

When do you migrate?
Can write to you in 5 minutes. It takes 5 days to write P.

[New York City]
8 June 1934

My Dear Dove: I wrote a long letter to Phillips & called a spade a spade. His generosity is Scotch.—Whether he is intentionally tricky I don't know but ye gods he does suck the blood out of one with his arrogance. This ménage à trois, you, he & I simply was bound to mess up matters with a man like P.—No one else in my whole experience has shown such little real sportsmanship. I wrote him that his generosity he speaks of has been met by at least an equal generosity on your part & on my part.—That as a matter of fact I thought he did very well for himself when all was said & done altho' I fully realized what role he played in letting you "live."—It's all ungodly.—The rich. The rich.— What a fuss they make about their dollars.—I am enclosing check for $40.00. A working girl bought one of your watercolors.—I have been wiring & expressing to Phillips. All eats up money.—He sticks to no agreement. Perverts everything. Means well, I suppose.—One always hopes decency will eventually win out. It's a foolish hope I guess.—He first said he'd give $100 a month if possible. Then wrote it would be a thousand [for the year].—Now it's $900—& he asks for this picture & that picture—irrespective whether it belongs to you still or not—acts [as] if no one else had any rights & he were giving you a kingdom plus a horse for what he demands as his *rights* for his unbounded limitless generosity.—And yet, what can one say or do? There it is: Phillips—art lover—art sadist—art messist. . . .

Your old
Stieglitz

Georgia has left for New Mexico. I saw her off.—I hope to get to the Lake about the 18th. But I'm not sure. Am rushed beyond capacity.

N.B. McCausland was in last Sunday.—You are to get $45 out of that source. She took a watercolor for $50.00. I have had quite some outlays re—you—which unfortunately I can no longer pay for at present—or take the "equivalent" in pictures—so I'm deducting the minimum possible to refund actual moneys laid out. . . .

[Geneva]
[10 or 11 June 1934]

Dear Stieglitz
 It is a shame to see you bother so much about Phillips.—It is not the

all the way through honesty that we mean. He could never do that.—In a way we do not speak the same language. I do not think he trusts his own judgment. Except when told to do so by dealers. That type of person always acts on advice.

My mother told my brother what to do at home and the farmer told him what to do down here on the farm. They will do anything anyone tells them. He awaits our advice.—I suppose it has to be done—I have to do it. That sort of control sickens me. But it is the only way the situation can be saved.

Don't you give P. any of the things you saved out.—Your choice is too fine to let him try to build any spoiled child's ambition on. Feel free to do and say what you want regardless of me. . . .

Oh well, let's not let it get us.

We can go on.

I am sending that check you sent and want you to use it for the Place. If he comes at all through with the "Red Barge," I want you to use that too.—If a miracle should happen here, you know what I would want to do. . . .

> Always
> Dove

[New York City]
12 June 1934

My dear Dove: Well, I finally have Phillips straight. He acknowledges that he owes $300 on the "Red Barge." Thought I was to get the money & so could wait!—Wrote he was sending it to you now & that you could count on $75 a month for a year from him.

The letter was Phillips at his "best."—My letter was too clear & kind to give him any chance to be otherwise. What a man & how he must have been done by dealers & is being done by them. Well, I know we all have a clear conscience that he has had his money's worth. Time will show.—

As I write, your letter is handed to me. Now, I cannot accept the enclosed check for the Place. I appreciate your feeling & Reds'.—The money is not needed just now.—As for the "Red Barge," half of the $300 the Place will accept when you receipt the money from Phillips. If you ever should strike "oil"—well then, that will be another matter.—What you say about Phillips is only too true. . . .

—I had hoped to hear from Georgia by this time that she had arrived

in Santa Fe.—I am trying to pack up but nothing much seems to move. Hectic business all around me.—

Sometimes I wonder that not everything comes to a dead halt. Yes, one goes on—or is pushed on—kicked on.—

My love to you & Reds—

<div align="right">In a rush
Stieglitz</div>

<div align="right">[Geneva]
[13/17 June 1934]</div>

Dear Stieglitz

A grand achievement and what a relief.—Hoped I had not in any way interfered with your plans when you told me to take Phillips on. Your ideas are woven into a big piece of cloth and it takes a rather delicate hand to "stoppeur" a tear. It is best that it is back again where it belongs in your hands. When I can put all the work and love in your safekeeping, I always feel sure—that it will be well done.

Amazing things are happening here—moving—where nothing has moved for years. Have as I said to tell my brother what to do twice a day.—I hope Reds can stand it. A little while anyway.

Bill is home and coming in a week.—Am going to pay him—if he wishes—to take my place in the farm work so that the painting can go on.—It will give him a chance to acclimate himself after quite a hunk of leisure. Or am I taking anything from him?

Thank you about the check. I so much want to do something for the Place. . . . I will put it on storage anyway.

Well, you know how I feel.

<div align="right">Always
Dove</div>

Despite his original intention of sending Dove one hundred dollars a month in the 1934–35 year and his subsequent promise of seventy-five dollars a month (nine hundred dollars total), Phillips once again revised his "subsidy" downward. He outlined his new plan in a letter to Dove on 15 June 1934. Three days later, Dove sent Phillips's letter on to Stieglitz with his own, which follows here. Phillips wrote that he could "only afford" six hundred dollars (for three major oil paintings chosen from the exhibition). He proposed to add another one hundred dollars

and take the oil *The Train* in order to bring the total for the year up to one thousand dollars by including the three hundred dollars so long owed on *Red Barge, Reflections.* He also wanted to keep four oils through the summer before he made his final decision about which three he wished to purchase, and he wanted to keep two watercolors to think about. Phillips frequently exerted this privilege with paintings from Stieglitz's gallery. Inasmuch as he kept them in his own hands for months at a time, he apparently never realized that he might be depriving the artist of a sale when the work was not available at the gallery. Though thoughtless, the action was not malicious and was no more reprehensible than the similar practices of other collectors and even museums today.

[Geneva]
[18 June 1934]

Dear Stieglitz

I do hope you can be allowed to enjoy your summer in spite of things like the enclosed [Phillips's letter].

A fine letter from McCausland in the same mail with P.'s. He should have seen it. She says, "But the thing I hate most to think of is Phillips. God. I hate that guy's guts."—"He is a slitch." . . .

Wouldn't be surprised to pick up a paper some day and read that P. had been shot by lady art critic.

Our love to you always.

Dove

By June 1934, after a busy season without O'Keeffe, Stieglitz was ready to go to Lake George. A major project of the summer and early fall was the preparation of a book, which was published as *America and Alfred Stieglitz* by Doubleday, Doran, under the sponsorship of the Literary Guild. In 1933, Paul Rosenfeld and Waldo Frank had initiated the idea of this book as a tribute to Stieglitz on the occasion of his seventieth year. They, along with Dorothy Norman, Lewis Mumford, and Columbia University Professor of Education Harold Rugg, formed the editorial board that solicited contributions from Stieglitz's acquaintances, including Dove. Although the volume was conceived in his honor, Stieglitz was heavily involved with the tribulations of producing it. In his next letter, Stieglitz briefly reported on its status. When he

wrote, he had not yet received Dove's letter of the day before about Phillips.

[New York City]
19 June 1934

Dear Dove: Phillips sent me a copy of the letter he wrote you. Well, I see he made another change. I hope it is final. He is certainly the limit in a way.—Think of all the packing & express expenses & wires, insurance, etc. he pays for a year.—So much of it is waste—"good for business" I suppose, seen as they see business.—Ye gods.—I thought I'd get away tomorrow, but now it seems it will be Thursday or even Friday. Things & people keep piling up.—And I refuse to *rush*.—The pace is brisk enough as it is.

But I do want to get away. These kind of days are particularly trying. Is it a waiting for death or birth—or both?—

The Book seems to be coming along. Sherwood Anderson has sent a beautiful contribution. Very beautiful. If the printer doesn't make a botch of it, it ought to be a handsome affair when done—that is the book as a whole.—My next will be from Lake G. My love to you & Reds.

Ever your old
Stieglitz

Lake George
23 June 1934

Dear Dove: . . .

Thanks for letting me see Phillips' letter. What should one say? One accepts graciously for there is nothing else to do. What at one time sickened one seems gradually to become a commonplace. One is speechless.—And one must say: Amen.—

I got up here night before last.—Feel as if in a trance.—Alone in the house. Of course there is Margaret who is very kind & solicitous.— And the place is lovely as ever, devoid of all excitement as I write. Georgia [in New Mexico] as devoid of excitement as the blue sky.—

It's fine what Phillips feels about your work but why isn't he equal to that feeling.—I suppose he is all snarled up in many ways—emotionally & otherwise.—How many people aren't.—These are times.—

—[Ralph] Flint[1] comes tonight.—He has been out of a job for the whole winter so I suggested he might come here for a while if there were nothing else in sight for him. The house is empty & the extra food he may share with me, what is it? . . .

Reports from Georgia are favorable. . . .

> Ever your old
> Stieglitz

1. Ralph Flint was a painter and art critic, who wrote for the *Christian Science Monitor* and *Creative Art* and had been coeditor of *Art News*.

> [Geneva]
> [16 July 1934]

Dear Stieglitz

. . . . The [Dorothy] Brett book[1] came today. What I have seen so far is fine.

Bill is back with his watercolors, much finer [than] I expected.—And what's more there is an idea there.

As to me, I have many watercolors & some oils. Much further along than at this time last year.

The hay, wheat, etc. is running us to death. Bill is a help. . . .

You would like this old house, much more room and just as many inconveniences as last year. . . .

> Love Always
> Dove

1. Presumably her most recently published work: Dorothy Brett, *Lawrence and Brett* (New York: Lippincott, 1933).

Reds was again unwell during the summer of 1934. In September, a hysterectomy brought her back to health, but only after a long recuperation. Even by the spring of 1935, she had not regained her full strength.

[Geneva]
[4 September 1934]

Dear Stieglitz,
 This is a grand day for us. Reds' operations are successful. One preliminary, & one fibroid, *not* infected, so hope her troubles are over except coming out from the ether, she is still under. It is a great relief. . . .
 This seems to be what has been the trouble for some time. . . .

Always
Dove

[Geneva]
[17–21 September 1934]

Dear Stieglitz,
 Things are going amazingly better than I could have hoped for. Reds is way beyond the point when things began to lower before she went to the hospital. She has been worrying about you for the last two days. Hope you are well and just storing up energy. These human beings as you say will certainly "trade" on the more sensitive.
 It would hardly do to try to express anything about Geneva much. It would take a long train of many freight cars
 This was started Monday, now Friday and Reds has been home since Tuesday. Improving daily. The doctor & nurses say it is remarkable how quickly she picks up.
 Work is being done and I believe I have something more to add this year. . . .
 It was terribly fortunate about the operations. I do not know what we could have done had the doctor there on Long Island been keen enough to know what was the matter.
 Financially too, as a friend just handed out the money for the expense so that the work could go on.[1]—Said she would take a painting some time. Hospital here the best I·have seen—all graduate nurses etc.
 We hope this A.M. to sell enough to an Italian to pay city taxes.— They are threatening to take it.
 The Italian says, "Mr. Dōves, Geneve she's a dead Kōntry," and then knocks $300 off his offer.
 The rest just dress & undress. . . .

As ever
Dove

1. Presumably Dr. Dorothy Loynes.

Besides working on *America and Alfred Stieglitz* during this summer, Stieglitz ran across twenty-two of his early glass-plate negatives and delightedly printed them anew. These reinterpreted images, printed on the commercial paper that had come into existence since the original prints had been made, were included in Stieglitz's last one-person exhibition, in December and January of the next season.

In his next letter to Dove, Stieglitz speaks of a "heart attack." As the context here suggests, Stieglitz used the phrase more loosely than is common today, for what actually ailed him was angina. Nevertheless, heart problems—and anxiety about them—constantly attended Stieglitz in his seventies and eighties.

Lake George
23 September 1934

Dear Dove: Last night I got back from New York. Was there five days.—Came back about all in.—Ye gods.—Before I left—a little while before—your letter came telling me about Reds' operation.—I addressed an envelope to you immediately. But Lord I was working overtime & fighting sinus & much else—& the letter I wanted to write wasn't written.—And in New York I hoped to write but ye gods it's a wonder I found a chance to breathe. It's a long story.—But your letter reminds me I must write or bust now.—A heart attack this A.M. was a warning to let up for a day. So you see that's why I find time to write these few lines.—Or rather the chance than time.—I am glad Reds is doing well.—I was shocked when the letter came telling of the operation.—I know the brave fight both of you are putting up—& operations don't add to the pleasure of the fight. I'm glad to know, though, that there seems to be some daylight.—

I was in town some weeks ago to have the Place painted. The last visit was because of various things including the book [*America and Alfred Stieglitz*] which is gradually killing me. It's all a long story.—If it ever comes out it will be fine. The publisher went back on his words.— If I live, the Book will appear even if it busts me. But I do hope some publisher will have the vision or whatever you may call it to pitch in.[1] This is the time. When I published Gertrude Stein 22 years ago, no publisher would have her, now she can sneeze on to a sheet of paper & it

will appear in a million edition—every publisher ready. Same old story.—I go to town Oct. 2.—I don't know when I'll open. Everything uncertain.—Marin not ready. Georgia still in the Southwest. Somewhat better. I may open up with a show of my own photographs—50 years ago—& now.—Have new prints of 50-year-old negatives I found in the attic.

My love to both of you.—

<div style="text-align: right">Stieglitz</div>

1. The original publisher reneged on his agreement. In the fall, Doubleday, Doran agreed to publish the book after it was accepted by the Literary Guild, which planned to distribute it to members as a Christmas volume.

<div style="text-align: right">L. George
4 October 1934</div>

Dear Dove: Tomorrow I leave for town. Am packed. Ready for whatever the "Job" demands.—The Book should create a stir.—Yes, it's all a miracle. And no politics, no wire-pulling.—Georgia is still away. Seems to be on the mend. Is painting some. I do hope she'll get back some vitality. . . .

<div style="text-align: right">Ever your old
Stieglitz</div>

The publication of *America and Alfred Stieglitz* early in the 1934–35 season attracted new attention to An American Place and its director. Both Stieglitz and Dove were delighted with the book, although its undistinguished makeup betrayed the rush of producing it.

Marin's usual opening show was on at An American Place when the book came out. Stieglitz's show of sixty-nine photographs opened in December. Dove again had the final exhibition of the season, after O'Keeffe and George Grosz. Earlier in the season, Dove's work had been included in major shows at the Whitney Museum: the *Second Biennial Exhibition of Contemporary American Painting* and *Abstract Painting in America*. However, despite such institutional recognition, Dove's own show at An American Place was, as ever, sparsely attended.[1]

Personally, Dove's year was more settled than the previous one, and he completed a normal amount of work. Reds was painting, too, as the next letter indicates. Unfortunately, she was setting herself up for

another disappointment. Although she sent her paintings to New York along with Dove's the next spring, Stieglitz refused to show them.

1. Stieglitz to Elizabeth McCausland, 25 April 1935, Archives of American Art.

[Geneva]
[9 December 1934]

Dear Stieglitz

About the book [*America and Alfred Stieglitz*]. Reds has been so enjoying it that I have had a small chance of reading as yet. I just haven't had a chance to get *hold of it.*—One or two things. They are amazing.—It is a new form, revelationary. From what I have seen, you might be twins. Will write Dorothy Norman as soon as I see it in the round.

I enjoyed sitting there with you [i.e., the book] for the few moments. Loving to love is so scarce—loving to love some thing—more scarce—and loving to love to be—in the non-self way or finest-self way like the few great ones.—Shall I say Christ, Einstein, Stieglitz—naming my own experience. Of course if I put them in order of time I should have to name my friend Mr. Weatherly[1] soonest. He knows nothing of human nature except what they have done to him, but he knows nature. If he could have done to humans what they have done to him.

Could when a boy crack a chestnut burr with his bare heel, so father told me, so there would go a lot of humans.

I want another copy of Maria Rilke's "Letters to a Young Poet"[2] for Bill Dove. It says so clearly many things that Bill should feel.

You know how difficult it is to tell a child in an adverse world, and Rainer Maria Rilke has done it so beautifully.

Reds made two lists of her paintings and we each set down prices. Will send them (they are amusingly coincident) with her list as decided from the result.

Expect to arrange to help you hang the things, if we can arrange with the people who have offered their apartment for the weekend.

If we can do that, with Ross' thoughtful help—he and I might arrange that room that worries you.

Elizabeth [Davidson] sent $25 before Christmas to apply on one of the sketches she liked. With that thoughtfulness, I want them as before to have a choice.

Georgia's things made me very happy. I still love the mountain one

you had in the office.[3] And that one of Marin's of the buildings—in the centre, black and white with a touch of yellow—is about the most superb piece of control in the variation of beauty I have seen.

The sea things as I said before create their own sensation of space.

Well, I am delighted to have known you all so well and so long.

Love from us both

Dove

1. Newton Weatherly, Geneva truck farmer, naturalist, and amateur artist, died as an old man in 1935. He interested Dove, as a boy, in both nature and painting.
2. The English translation, by M. D. Herter Norton, was published by W. W. Norton in 1934. Dove must have been impressed by Rilke's tone of dedication to art and to the life of the spirit.
3. At this point in the letter, Dove is presumably returning his attention to *America and Alfred Stieglitz* to comment on some of the illustrations.

When Dove mentioned, in the previous letter, that O'Keeffe's paintings made him happy, he may have been thinking of the previous summer's work, which she had presumably with her when she stopped in Geneva on her way to Lake George in October. She traveled by automobile from New Mexico with Spud (Willard) Johnson, a Taos poet whom she had met through Mabel Dodge Luhan in 1929. Four months earlier, upon arrival in New Mexico, O'Keeffe had gone first to the ranch at Alcalde where she had stayed on her last trip to the area, in 1931. Soon, however, she moved to Ghost Ranch, which was then an expensive dude ranch in an isolated area west of Abiquiu. She had seen the beautiful spot from a road on a plain above it during her first visit to New Mexico, and this year she found it after a determined effort. Her intuition turned out to be unerring, as Ghost Ranch, where she later purchased her own house, was thereafter the place where she felt most inspired to work.

Although Reds noted in her diary that O'Keeffe "looked like a husky Indian,"[1] after joining Stieglitz in New York she was again ailing before the end of the year. The following April she had surgery to remove her appendix and an ovarian cyst. In May, Stieglitz took her to Lake George to recuperate. Two months later, she headed for the Southwest and again stopped to see the Doves on the way.

1. Diary of Helen Torr Dove, 17 October 1934.

[New York City]
18 December 1934

Dear Dove:
Georgia has been down with the grippe. And I have been driven day in day out. 1400 people last week.[1] Today there is a lull. And I'm not sorry.
I hope you & Reds are well.—That's finally the only asset there is. . . .

As always
Stieglitz

1. During the exhibition of Stieglitz's work

In November 1934, Reds had spent two weeks in Hartford, Connecticut, with her mother. While there, she had met people connected with the Hartford Atheneum, as Dove reported in the next letter, after rhapsodizing once again over *America and Alfred Stieglitz*.

[Geneva]
[19 December 1934]

Dear Stieglitz
What a book! to go into what a world! It is like shooting a bomb with roots. Roots that will grow where they land. It gives me a sensation of peace.—Peace with the scruff of my neck raised toward those who do not see—see the core of the whole idea. I mean the people who think in values. It is really fine to have had happen. For you to have made happen.—
It is an amazingly worthwhile happening. You would be amazed at what is going on in these upstate outskirts.
Eagerness seems to have taken place. The place of waiting for something to happen. Where usually nothing happened.
All these things about the book are very welcome when they have time to look up from their values
Reds saw Austin (Hartford Museum) [A. Everett Austin, Jr., director of the Wadsworth Atheneum]. He seemed to feel that [Thomas] Craven had done much harm. I wonder if anyone can do harm.—Certainly not he.—

There is a man there who has a collection of moderns named [James Thrall] Soby, who has shut himself up for three months to answer this Craven man.

Reds' mother & cousin are connected in a contributive way with the museum so wanted Reds to meet them. They had quite a talk. Interesting.

By Reds' diary we are two and a half months ahead of last year. Many watercolors and eight paintings going so far. Whereas Jan. 15 was the beginning last year—of the paintings.

She is so much better.

Georgia looked deliciously fine and brown. It was good and a lift to see her. We are so far out of things here. Although we see more of our friends than when on L.I.

Bill has had a bit of what they call success. One with Weyhe & another.[1] Says he is "Trying to keep the planes from stopping in roundness." It is agreeable to see him going on.

An awful lot has happened here.—These animals have such long tales—too long to write about.

We traded the truck for a little '30 Ford so can drive down now with the watercolors & ship paintings. Hope I can carry out the present idea for frames. It would be grand. . . . Am working rather than writing these days so will say goodnight to you all with love to you and Georgia and Dorothy Norman and all who in any way reach in that direction.

<div style="text-align: right">

Always

From us both

Reds & Dove

</div>

1. Presumably Delphic Studio, where he had a show.

<div style="text-align: right">

[New York City]

20 December 1934

</div>

Dear Dove: . . .

Yes, the Book is a Wonder. I'm glad you feel about it as you do.—As for me, it is impersonal, as if it had nothing whatever to do with "me." Naturally, I'm glad it has happened. It may bring life somewhere somehow or give courage once more where courage was beginning to wane. I could say much but am too rushed, & altho Georgia is so much better, there is ever an ailment to pull her down. Grippe for 4 days.

Now a nasty tooth. Sinus, etc.—I do wish she'd be given a bit of peace for a while. . . . Georgia goes up end of January. In March you & maybe some Reds. . . . I live from day to day. That is the only possibility. But all days are closely related. . . .

<div align="right">

Love. Much to you all,
Stieglitz

</div>

<div align="right">

[Geneva]
[21/23 December 1934]

</div>

Dear Stieglitz
 Much thanks for your last letter.—The one with checks arrived all right. . . . Anything marked Geneva gets us.—It surely does. . . .
 We are glad Georgia is better. Teeth—I am sorry. If one is sensitive at all they are awful. Dentist pulled one of mine & put on one of those impulse machines to check up X rays.—Held it way down so that no one else in Geneva would feel it. And I jumped. Nothing to brag about, but such are nerves in Geneva. . . .
 What can be said doesn't matter except that it may help allow the one doing things to have the enthusiasm to live to do them. The things do not change. It is the others that change. "It is the others that die." So eventually it comes to matter.
 Our love to you all and much more

<div align="right">

Always
Dove

</div>

<div align="right">

The Shelton, New York
25 December 1934

</div>

Dear Dove: Georgia is in bed again.—Cough, etc.—Tough on her.—New York is really not the place for her. But what is she to do?— Ever the problem. Sickness is certainly fiendish.—That is, when it doesn't seem to let up. Crowds still come to the Place.—And the Book seems to be selling steadily in spite of the asininities of professional critics. . . .

<div align="right">

Ever your old
Stieglitz

</div>

[Geneva]
[27 December 1934]

Dear Stieglitz—

We are worried about Georgia, she looked so marvelous when here. . . .

A terrible wind blizzard last night.—Froze everything but the plumbing of which we have but one set piece, so we can smile at luxury for once anyway.—

Reds sends love to you and Georgia.

And I always
Dove

[New York City]
28 December 1934

Dear Dove: It's hard for me to locate papers [with reviews of shows], as I am really alone. Ross said last night, "I have never seen one so deserted as you are. It's really terribly funny." It is. But I seem to go on. Have no choice.—

Crowds still come. Bill was here yesterday. Seemed to enjoy it.

Georgia is a bit better. Love to you & Reds.

Stieglitz

[Geneva]
[31 December 1934]

Dear Stieglitz

. . . . I cannot see that you are deserted.—With half the finest people in the country loving you and the other half centered on you as a fine energy or what.—That is not desertion just because you happen to sit there alone—even for not long.

We are getting just a little of aloneness—and we love it. The people here seem to want to come here—curiosity perhaps.—A College Professor & wife came in the other day.—They said "with fear & trembling" wanted to buy the "Red Barge" sketch. They had been at 509. Told them [Frank Jewett] Mather had it. Safe again.

A great many people have asked my brother to bring them here including the "Professor of Art" in the College here[1] and we have kept

saying we couldn't work & see people. Even my brother is getting trained.

We will probably pay in the end for all that ego but it will be paid in paintings, so they will never know. . . .

<div style="text-align:right">Always
Dove</div>

1. Hobart College (now Hobart and William Smith Colleges), in Geneva.

<div style="text-align:right">[New York City]
2 January 1935</div>

Dear Dove: By deserted, Ross meant holding the physical fort here single-handed day in day out—& ever more so. . . . I rather enjoy it. It's a sort of supreme test of my own self.—

—Have you seen the slop pail [Thomas Hart] Benton has poured over me & the Book? In "Common Sense."[1] It's a wonder.—Even has aroused Barnes who is going to attack Craven & Benton.—Gangster-dom in every field is in the ascendancy.—It all makes me smile. I'm accustomed to all that sort of thing. One can't escape envy—malice—being hit below the belt by bullies & cowards.—Great sport.—It is too bad "Camera Work" no longer exists.—That's the one thing I do miss. A weapon in the form of one's own printing press.—And I hear the "Times" (one Chamberlain) has taken up Benton's line of slops[2]—"All the news that's fit to print"—etc., etc.—The "Atlantic Monthly" has a sympathetic review.—But so far none of the [reviewers] have gotten the real spirit of the Book.—It will stand up. It's that alive in spite of its "failings."—Yes, I don't doubt you are becoming another "Centre" but *work* & "entertaining" are not very compatible. At any rate, people are beginning to realize that there is someone named Dove. And that's something in these days of Who-the-hell—cares for anything. Love to you & Reds.

<div style="text-align:right">Your old
Stieglitz</div>

1. Thomas H. Benton, "America and/or Alfred Stieglitz," *Common Sense* 4, no. 1 (January 1935): 22–24. While critical of the idolatry and imprecise thinking in *America and Alfred Stieglitz*, Benton gave Stieglitz credit for his importance during the inception of modernism in this country.

2. John Chamberlain, "Books of the Times," *New York Times,* 31 December 1934, p. 11. Chamberlain, who cited the Benton review that Stieglitz mentions, objected to the "exceedingly nebulous" tone of most of the affirmations in the book. "The book is a yearning book" he wrote. "One doesn't mind yearning, but one hates to see flapdoodle written about it." Edward Alden Jewell, the *Times* art editor, had previously published a lengthy and even-handed review of the book: "Alfred Stieglitz and Art in America," *New York Times Book Review,* 23 December 1934, p. 4.

[Geneva]
[4 January 1935]

Dear Stieglitz

. . . . While at the dentist's yesterday, I saw Benton's self-portrait in "Time."[1] If the people, in *general* even, do not see through that, they <u>are</u> dumb. The dentist drilled way down through a *tooth* & finally had to pull it—and that was nothing to B.'s portrait.—The dentist was a good dentist.

Wonder what the Craven mixture will think up next. Maybe they're all actors, and we didn't get it. They may respect Barnes obviously—but the whole thing is a self give-away. Huge colored illustrations. Holly used to say that all of Grant Wood's[2] things looked like sweetbreads. I hear she is married to an Italian musician, haven't heard from her since last summer.

If you want to make B. sore tell him his things look like him. At any rate, it ought to. Does he squirm in occasionally? That was my impression at the Anderson Galleries. Just give them rope enough.

Is Georgia over her cold? We have been fortunate so far this year.—We do not go into public places except the 5 & 10 & right out.—So most of our diseases are private like operations, dentists, "relatives" etc. . . .

Always
Dove

1. Thomas Hart Benton's self-portrait had been reproduced on the cover of *Time* 24, no. 26 (24 December 1934). That issue's art section, titled "U.S. Scene," featured the work of Benton and other regionalist painters.
2. Grant Wood (1892–1941), an American regionalist painter who specialized in scenes of Iowa farm life, is particularly known for his double portrait titled *American Gothic.*

[Geneva]
[End of January 1935]

Dear Stieglitz,

Ink is frozen, but painting is going fine with both of us. . . .

This house might well be built of latticework when the wind blows at 10 below.—

Well, anyway, these cold days keep the others away.—

Reds has five and I expect to make the formerly usual 19 & the watercolors. Have the framing all worked out, but not yet accomplished. . . .

Bill is necessary here so that we can get a mortgage on the home to pay taxes before we lose it.—Saved it by two days last time.

Bill & Charles Brooks are to drive up soon. That will take a little time but has to be done.—Have put them off a little.

Man across the road has a carpenter shop, so hope we can get moulding done there.—If not, in Rochester they turn it out by the mile. . . .

Our love to you all.

Reds & Dove

[Geneva]
[Probably 25 February 1935]

Dear Stieglitz

Seventeen about done, with frames made and several coats toward the finish—24 watercolor frames cut for the pick of the watercolors.

Reds has a portrait of herself and one of a church and they just *are*. And four or five others.

Brooks & Bill left a week ago.

Charles was amazed at the amount of work with so many interruptions. He would sit looking at the paintings by the hour when I had to be out on "business."

Some personal finance co. claim they have a chattel mortgage on the Ford we traded for, from some four months back. So far, we have the better of it. O'Brien, the lawyer for the estate, is very good. And I have just lost the car among friends here so that they cannot take it until they have shown him their papers and released it on our terms rather than theirs.

Possession being, I believe, 9 points of the law.

Helen Torr, I *(self-portrait),* *1935.* (Graham Gallery, New York. Ken Cohen photo.)

The young people we bought it from of course lied. Well, it is too long a story.

These paintings are better than any in the last few years. I am quite sure of that for both of us. Can send most of the oils on in 3 weeks—They will have to be shipped anyway. Can drive down with watercolors, if we still retain car.

Want to jump this real estate early in spring so that we can get out of here. It would be fine here if it were fine here. As Reds says, the lake here looks like a postcard of the salt water. It has been a good thing in a way—we just paint and see each other. . . .

Hope Georgia is in trim again.

She told me her paintings were no good this year. She was certainly good to look upon. And now a retrospective show.[1]—

May be this change. Reds had hers in the hospital and it is going fine so far.

It is getting dark now.—So love to you all from us both

Always
Dove

1. Her partially retrospective show, then at An American Place, included works from 1919–34.

[New York City]
27 February 1935

Dear Dove: Another crumb [$5 check] enclosed.

. . . . After Georgia comes down, I am putting up George Grosz for about 3 weeks. This is something I had in mind for 3 years. And this is the time to do it. It's quite a long story but very simple. I must show that the Place is not addicted to Marin—O'Keeffe—Dove to the exclusion of every "outsider."—There is already a hubbub over "my" selection of Grosz.—"There are so many young & deserving Americans," I'm told. Ye gods. But they all want money & fame & what not. I'm too old to adopt youngsters. Grosz is in line with de Zayas. That's what I'm after. I fear this country has already taken the *bite* out of Grosz & I regret it but I understand fully how it has come to pass. He is close to being an Illustrator. But that does not deter me.

28 February 1935

. . . . Georgia is going to Washington for a week or so. New York is too much for her.—She thinks she might get a little letdown in a different milieu. This is a pretty terrible one even for a very well person.

Love to you & Reds.

S.

[Geneva]
[Probably 2 March 1935]

Dear Stieglitz

Much thanks for your letter and the "crumb."—We "et" it.

I like your idea of having Grosz now.—It will be a fine thing all around. Really a fine touch, as you are prone to do, throwing an impersonal gas bomb.

Well, Reds has a few fine ones and I have about 17 now, frames practically done, but for some silver leaf. Finished the best one, I think, today.

. . . hope this winter is over.—While not as bad as last, it has been strenuous. I get sore and sometimes tired of the people who think only in values trying to use another sort of person's ideas. Fortunately, we are by ourselves now most of the time.

Feel that if I cut out the farming this spring it will mean much towards work.—

As far as I can see, these people here work for nothing most of the time because they have always done so. That is why New Yorkers say "Up State Stupid."

The little grocery store across the road has three people tending it and takes in *$300*, meaning *$60* profit without overhead. That is the way the estate has been run for the last 30 years. Of course, they are all very kind and nice. And there are hardly any crowbars to use to pry them loose because the crowbars are just like the natives.

Maybe we all have some of that in us. God, I hope not too much.

Love to you all from Reds and

Dove
Always

[Geneva]
[29 March 1935]

Dear Stieglitz,

Mirabile dictu, the paintings are gone. And what is more I have confidence in them more than usual. What a job! Ten cases.—We just took the watercolors to the "Railway Express." We expected to drive down with them but I am sure Reds is not yet able to stand the trip and excitement. . . .

Thanks for sending the Grosz thing by Hartley, it was well done.[1] Have also read the one in "Art of Today" by Dorothy Norman.[2] That has a great value.

Dr. Loynes of the State Hospital, Ovid,[3] was speaking of a *psychology* she was interested in. She is psychiatrist there. So I handed her Dorothy N.'s article in which you had practically summed up the whole thing. Nebels were a bit prejudiced about Grosz from Germany but were impressed by the Hartley thing you sent, so am glad it came just then.

Phillips has come through with a really fine letter—wanting to continue "Our little arrangement." So that is that for next year.

I expect to answer his letter tomorrow. You do as you think best. Always. Anyway because you always think best. . . .

Our love always to you all.

Reds and Dove

1. Hartley had written the introduction for the brochure printed for Grosz's American Place exhibition.
2. Dorothy Norman, "Alfred Steiglitz [*sic*] Speaks and Is Overheard," *Art of Today* 6, no. 2 (February 1935): 3–4.
3. Near Geneva.

[Geneva]
[1 or 2 April 1935]

Dear Stieglitz

I woke up at 3 A.M. April 1 dreaming that my mother had called from N.Y. and said you wanted to see me. Thought My God, has the packing stuck to the silver? For me to "wake up" April 1 was the psychological moment. Hope the paintings arrived in fair condition. If anything is very wrong I could drive down & fix it, leaving Reds with

the Nebels for 3 days. Or maybe she will feel better. She has been improving by the minute since the strain of packing has stopped.

Wonder how you got on with Gertrude S.?[1] She seems to be on the outs with everyone. . . . I still have a grand time with her whether she writes for the "Tribune" or Art or Gertrude Stein. . . .

Am invited to compete for murals in Washington.[2] Phillips is on the jury—or Committee, but there are so many terrible gentlemen of the jury included that I wonder. Suppose there are thousands of others invited.

When you have time, and I know you will want to take time, let me know how you feel towards the paintings.

Love always

Reds & Dove

1. Gertrude Stein, who lived in Paris after 1903, came to the United States for a lecture tour in 1935.
2. He did not enter the competition.

[New York City]
3 April 1935

Dear Dove: Your cases are finally unpacked. I have simply glanced at the things. Have been overwhelmed with people & work. I expect to open your Show on April 18. As for Reds, I don't think you realize that the room in which her things were shown last time is no longer available. It is used primarily for storage.—Then too I think Reds ought to have a Show of her new & old work in the Delphic Studio or some place like that. There might be a chance to sell a thing or two somewhere else as well as just show. Bill left a little while ago. I spoke to him about it. . . .

As for Phillips, good. I'm glad he is to continue. And as for muraling in Washington, well that's a problem for you to solve. I'm completely out of touch with all that Washington (& elsewhere) game.—I'll take a square look at your things in a day or two.—I did see a few very good things.—But I must have a bit of quiet to give a real look. . . .

ever your old
Stieglitz

Reds felt "rather a drop" about Stieglitz's decision.[1] Although she continued to paint for a few more years, she did not have a show.

1. Diary of Helen Torr Dove, 3 April 1935.

[Geneva]
[4 April 1935]

Dear Stieglitz

Glad to hear from you that things arrived safely.

Reds thinks you are right for her and would not have sent the things had you not written that you would show "possibly a few of Reds." . . . Reds doesn't seem to care for the Delphic. Probably right. However, we shall try some other than the Delphic. . . .

We shall have to come and look about a bit. This being so disconnected with everything's wearing on us.

The idea of just being working always is not enough. . . .

If we could only be there—would destroy all that would go through the sieve and keep the bigger ones. . . .

Always
Reds & Dove

[New York City]
16 April 1935

Dear Dove: Bill, Zoler & I have rehearsed hanging your Show. It will look swell. Many things I like immensely. . . .

Georgia is in the hospital. Was operated on on April 5—appendicitis & ovarian cyst. She is doing well. Had arranged to leave for the Southwest on April 9!—So it goes. I have been on the job as usual.—

Offer no alibis. My love to you & Reds

Your old
Stieglitz

[New York City]
17 April 1935

My dear Dove: Your Show is hung & I believe it looks very well.—Oils in main room. Watercolors in the White Room. . . .

I wonder will Phillips turn up & what will he think he is "entitled" to?

Stieglitz

[Geneva]
[22/25 April 1935]

Dear Stieglitz

So many thanks for all the catalogs, checks and all.—The and all covers a multitude of work. It would be nice to be able to pay your debts and to act human with those you care most for—for a change.

We are much concerned about Georgia. . . .

Claire O'Brien[1] may be in N.Y. . . . She and my brother seem interested in each other. She asks if we do not think it is "cosmic."—I am waiting for Gabriel to blow his horn and see what really "cosmic" is.

It stopped snowing yesterday I hope.

If Bill comes in, tell him to send his address. Have papers for him as to his house, taxes, rent, etc. Nice of him to help with the show. . . .

As ever
Dove

1. Claire O'Brien was the sister of newspaperman Emmet O'Brien.

[New York City]
25 April 1935

Dear Dove: So far only Mumford & Burrows ("Herald") have been in. That is, of the press. Mumf. was enthusiastic. Burrows too. . . . I wonder where Jewell is staying. He is usually pretty prompt. . . . Show wears splendidly.—

O'Keeffe's progress is very slow.—Operation all right. But digestive tract on a rampage—& she has so little power of resistance. . . .

<div align="right">ever your old
Stieglitz</div>

<div align="right">[Geneva]
[28 April 1935]
Sunday</div>

Dear Stieglitz

. . . . We do hope Georgia is better. . . . If the operation was a serious one—it takes so long to get over the effects. Reds walked up a 200-ft. cliff on Lake Ontario last Sunday and is not over it.

"Tribune" rather good today. Mother Goose, but he has something. Nothing by Jewell yet? The "N.Y.ker" had nothing in the upstate edition except Art Directory, but there was an article by Mumford on Architecture, so may hear next week.[1]

Am enclosing a letter from Am. Society of Painters, Sculptors and Engravers. I accepted. I wonder if they have just written everyone to get a large membership and are trying to make a gang racket of it and control the works.

Think the best thing to do is to write them that my relationship with you and some others prevents me from entering into any business agreement. So think the only thing for them to do is to leave me off the list. They have said nothing about dues etc. so think I'd better start economizing right now. I should prefer doing the wrong thing to being suspicious. . . .

<div align="right">Always
Dove</div>

1. Mumford's review did appear the next week ("The Art Galleries," *New Yorker* 11 [4 May 1935]: 28–34), as did Jewell's ("Three Shows Here of Abstract Art," *New York Times,* 3 May 1935, p. 22). Both were favorable. Jewell thought enough of the show to write about it again, briefly, two days later ("In the Realm of Art: A Week of Pointed Contrasts," *New York Times,* 5 May 1935, sec. 9, p. 7).

[New York City]
27 April 1935

Dear Dove: Phillips—he & she were in.—Quite a while. Enjoyed your Show immensely.—He decided to give you $1000 for a year. Says he owes you still $100. For the $1000.00 he wants: "Fantasy," "Morning Sun"—"Electric Peach Orchard"—"Red Sun."—I couldn't dicker with him. I feel he is getting a terrific bargain but that for you it is a godsend to get $1000 instead of $600. Besides the paintings will be cared for & seen.—It must be remembered that $1000 means $1500 if a dealer had sold them at a commission of 33⅓%. The "Sunrise" is the popular picture. Maybe something more will happen.—No "crowds" as yet.—
 I told Phillips I'd let him write to you. That I wouldn't. But I thought you might as well know at once. With love to you & Reds—

ever your old
Stieglitz

[Geneva]
[29 April 1935]

Dear Stieglitz
 Your letter just here. It is quite grand that the Phillipses have really something good. Of course they are bargains compared to the ones he hangs them with. I almost saw all the others but "Fantasy." His "Passion for Painting" undoubtedly accounts for that.
 A fine note from Van Wyck Brooks came with your letter. Suppose they were all connected with it, but let Charles make the move.[1]
 Talked with Charles when he was here by the hour. Bill thought, "No use," but if you had thought no use 25 years ago or twice that, Bill would have been right. . . .
 Am amazed of course, as much at being able to get work done as at the turn it has taken. You know pretty damned well about all except the work until it is done. That is the x quantity.
 Love from us both

Always
Dove

1. Charles Brooks purchased a watercolor, *Carnival* (1934), from the exhibition and gave it to his parents.

The Shelton, New York
28 April 1935

Dear Dove: Georgia came to the hotel today. Has a day nurse for another day or so.—But she has quite some ground to retrace.—I do hope she'll pick up & be able to get something out of the summer. Nothing seems to become "easier" no matter what one may do. . . .

Your old
Stieglitz

[New York City]
5 May 1935

Dear Dove: Georgia's first outing brought her to the Place.—She liked your things immensely.—She asked me what I'd let anyone have 6 of your small things for. I said it depends upon which. She showed me 6.—I said $150.00. She said I'll take them with the understanding if they bring [more] Dove is to get the bonus.—So I'm enclosing check for $135.00, this time keeping $15.00 for printing, postage, etc.—I hope you feel it's all right.—I do.—Much love to you & Reds—

Your old
Stieglitz

[Geneva]
[6 May 1935]

Dear Stieglitz

Today's news is the best yet. I was very pleased to hear from the Rehms that you were glad about the show, and now that Georgia is out and really enthusiastic makes us both very happy.

That is the test of true sports—to do the finest thing at the most difficult time—in other words doing as you good and well please in spite of hell. Know what a relief it must be to have Georgia out from under.

Thanks . . . so much and often for letters, McB. article[1] and all you always continue to do.

Bill is here now, arrived Friday. Now concentrating on an enlarging camera, has combined parts of Reds' old sun lamp, my Kodak, an old

bed, the ladies' toilet in the Dove Block, wanted the windmill this afternoon, and many other items including our workshop. First one he made wasn't accordion enough. Not enough reach.

Always
Dove

1. Henry McBride's review had appeared the previous Sunday: "Attractions in Other Galleries," *Sun* (New York), 4 May 1935.

[Geneva]
[Probably 10 May 1935]

Dear Stieglitz
. . . . McCausland did a speedy one.[1]—I have but the one copy.—Of course she sent you one.
P. has put my name in for a decoration in Washington. Let's not let them get that going again—Haviland started that at "291," if you remember. They seem to think because I am conscious of the flat surface and do not paint in light and shade that it must be decoration.
Am planting garden now—and it is not "Landscape Gardening" either. . . .

As always
Dove

1. Elizabeth McCausland, "Authentic American Is Arthur G. Dove," *Springfield (Mass.) Union and Republican,* 5 May 1935, sec. E, p. 6.

[Geneva]
[10 June 1935]
Monday noon

Dear Stieglitz.
I feel like hell about not getting to see you after all the time you have devoted to the work. The results this year are amazing to me.
The facts are that the two months of summer that Genevans have are crowded for us. It is quite beautiful here if we could have time to look at it. In the winter the world is one coal stove, and in the summer, as Reds says, one meal.

Have a good watercolor from this morning—done the shopping, helped the lawyer dictate letters to government about income tax for 1933 on estate which goes in the hole for about 3 or four thousand, but we have to spend a week getting up proof when the income tax inspector said it would be useless. However a check came from government for $13.36 for doing nothing about wheat.—Heard of a man in Texas that they paid 8 or 10 thousand for not planting cotton. He wasn't going to anyway. Neither were we—so that is efficiency.

Our garden is fine though. Gambled with the weather this year and won by a week unless we have another snowstorm.

Have been bathing in the creek now for about three weeks, and every morning Bill & I take a quarter-mile run out on the farm to a tree and back. . . .

You spoke of having taken the printing from Georgia's check. If you have paid for the good catalogs, it is up to me to pay for the others.[1] Anyway want to be sure the printer is all right even if the printing wasn't.

. . . McCausland is in Virginia with Berenice Abbott[2] writing and photographing. . . . Phillips writes that the "Red Sun" is his favorite now.

They are off for England for short trip.

As ever
Dove

1. Stieglitz had the exhibition pamphlets redone because of poor workmanship.
2. Berenice Abbott (b. 1898), the photographer, later knew the Doves casually.

The Place
12 June 1935
Midnight: 15 A.M.

Zoler & I are sitting here waiting for the photographer Smedley to get through with a job begun at 4 P.M.—A great life! . . . That bum printer is certainly another one. Ye gods. . . .

Reports have it that Georgia is progressing nicely [at Lake George].—I had written to Phillips Marin liked your "Red Sun" best. Maybe that "guided" P. a bit.

My love to you & Reds—

S.

Lake George
23 June 1935

Dear Dove: . . .
My stomach went back on me, & so I am starting here in Dr. Jenks'
hands.—The season was a bit much.—Very alive though. . . .

Ever your old
Stieglitz

[Geneva]
[26 June 1935]
Wednesday

Dear Stieglitz
. . . we have just finished paying for the divorce. They, the Conn.
lawyers, were suing Clive for $125. It was to cost less than $500 and we
have paid $485 so I wrote one of sockastic letters enclosing $15 marked
"In full." They took it with apologies. Donald [Davidson] is doing a
job on the garden that is a wonder. Hope the results will keep the gang
the whole summer.—He did another fine one yesterday. Young fellow
here had what he thought was sinus. Donald put his hand on his neck
and told him it was his appendix. His pain began at 9 AM. We saw him at
10. They operated at four. . . .
Your friends the Kimbals of Buffalo were here for lunch Sunday a
week ago. . . . [They] asked at the big hotel here where we lived. They
told them that "His brother lives up on So. Main St. but he lives out
there all alone."—The K.'s found a house full when they came and
thought it a good story.
Have some painting done and a lot of watercolors. Am not farming
this summer. We lost $600 last year so think best to economize. . . .

Always
Reds & Dove

Stieglitz had taken O'Keeffe to Lake George toward the end of May.
She recuperated there for two months, then set off for New Mexico.
On her way, she stopped to see the Doves in Geneva.

[Geneva]
[1 October 1935]

Dear Stieglitz

What a summer! I just haven't written any letters all summer. One gets rather chore minded with so much "business."

Anyway I have over 110 watercolors all mounted and ready for frames which are being made. Some oils going. Am at least two months ahead of last year. Reds has done some beauties in tempera just recently.

Am reading every inch of Max Doerner's book.[1] Wish I had it years ago. Georgia said she reads it like the Bible. It was grand to see her. Hope she stops again on the way back.

Davidson's garden is still going strong. Has fed the neighborhood, and they in turn hand us pies, soups, pickles—and spaghetti with meat balls. (We sold some lots next door to an Italian.)

The city is excited about buying most of one farm for an airport. That will save the situation. We borrowed from the Government Home Loan $2000 to make 4 apartments of the home. It ought to almost take care of itself. Last year it lost over $800. . . .

It is darker than Geneva here today. Snow in Rochester & Buffalo yesterday.

Hope you are feeling fit. Am myself better than in some years. Still run every morning for a half mile. Had to give up bathing in the pool yesterday, as the frost brought down the leaves and left me nude, unless I wear one. . . .

Always
Dove

1. Doerner, *Materials of the Artist.*

Marin's show hung on the walls of An American Place for a long time this season, from October until after the new year. O'Keeffe's show opened in January 1936. It was followed by exhibitions of work by Robert Walker, Hartley, and Dove.

Affairs in Geneva continued to occupy Dove, but the situation slowly became less chaotic. For a number of months in 1935, Bill stayed in Geneva. In December, he married Marian Craib, whom he had met

there. They moved to Washington, D.C., around the beginning of 1936 but returned to New York City in the spring.

<div align="right">

[Geneva]
[24 October 1935]
</div>

Dear Stieglitz

Have heard through Davidson that you have not been so well. We only hope that you are all right again.

Thanks for sending the Marin notice. It sounds fine and salty. We have been far away from the salt water so long that the letter was refreshing. . . .

We have been alone for two days since early spring. Paul has gone to Florida on a sailboat with Max Wheat and Bill is up at the home.

The paintings are going fine. In some of them I am using tempera as an underpainting for oil, which Max Doerner praises so highly. "Holbrook's Bridge" and "The Cross in the Trees" were done that way last year. It is about the most permanent form of painting—and according to the old law "Fat over lean." Doerner is the only one I have read who seems to give such complete scientific information, and what a mass of it. He makes even some of the Germans seem almost careless.

Have been going over the watercolors again and find about 35 good prospects for paintings.

I want to be there this year. Think we can as Bill can take care of it here for a week or two.

Much love to you from us both.

<div align="right">

Always
Dove
</div>

<div align="right">

[New York City]
25 October 1935
</div>

Dear Dove: Just a rush few lines. Yes, I have been far from well—sinus—antrum—(Dr. every other day)—heart—etc. But am on the job.

. . . . Two great losses within a few days: Lachaise & Demuth!¹—I suppose you know. So it goes, I suppose. . . .

<div align="right">

Your old
Stieglitz
</div>

1. At fifty-three, Lachaise died of acute leukemia, only months after the triumph of his career, a retrospective show at the Museum of Modern Art. Not quite fifty-two, frail Demuth succumbed to the diabetes from which he had suffered severely for at least fifteen years. He left all his oil paintings to O'Keeffe, who had been one of his favorite friends.

<div align="right">

[Geneva]
[6 November 1935]

</div>

Dear Stieglitz

. . . . We had heard of Lachaise through a clipping Davidson sent.

We did not know about Demuth. Reds and Clive knew him personally better than I did.[1] Except through the work which I was glad to see. And I enjoyed his mental spirit so much as it held its hand up for Marin who writes so beautifully of that hand.

When people die I feel that they grow younger until they are born again. It must be something like that or nature could not breathe, as it does. It is not a sad thing to me as much as it is a part of a natural continuance. Of course I get lumps in my throat, but when I do, it is at the point of the realization of a fine truth. Alfy's case seemed to me to make the spiritual coming of age a trifle longer, but what has time to do with eternity? . . .

A whole painting this morning. . . .

<div align="right">

As always
Dove

</div>

1. They had been students together at the Pennsylvania Academy of Fine Arts.

<div align="right">

[Geneva]
[November 1935]

</div>

Dear Stieglitz,

Hope you are feeling fit again. We are, and the paintings are going fine. Have eight framed. There must be 125 watercolors, which will be picked off to about 75, maybe more.

Meant my last letter more in the light of elements than time. The second childhood of some growing young beforehand rather helps my surmise. . . .

The government has helped us buy an elephant but does not allow anything for hay, so we are having a time arranging this apartment idea in the home at 512. . . .

<div align="right">Always
Dove</div>

<div align="right">[Geneva]
[22 December 1935]</div>

Dear Stieglitz,

It must be a job to tend to all of those things yourself when you have so much going on. Thanks for sending on the Marin books.[1] They have arrived nicely in time.—We wanted to give one for Christmas to Bill and *his wife,* if you please. She has a good job and they are living in a nice little place in the basement of the new apartments just finished. He fine about taking care of furnace and all. She is nice and capable. No tenants as yet but many prospects. Government loan. It was the only chance left. Bankers are pretty fussy and important.

We are freezing here but working hard. Have eleven paintings about done and six more on the way. Frames all built and some silvered. There will be about 35 framed watercolors and a stack of mounted ones. . . .

Davidson has prognosticated this whole month[2] and most of his turned out pretty well. Slipped a little today as he said a "Socially expensive" Sunday. Our only caller was the hound whom we sent 8 miles out to the country to keep him from biting young Italians. They tease him, and he forcibly resents it. He found his way back. Our expense was mostly dog meat, as I gambled 10 cents on a punch board across the road here and won a duck. . . .

<div align="right">Always
Reds & Dove</div>

1. Presumably, copies of E. M. Benson, *John Marin, the Man and His Work* (Washington, D.C.: American Federation of Arts, 1935).
2. This was something Davidson liked to do for his friends, and from time to time, he sent his day-by-day predictions for the month to the Doves.

[New York City]
21 December 1935

Dear Dove: Fortunately, a few of the ailments are letting up a bit. And that is much to be grateful for.—And I am that.

"Holidays" mean nothing to me. It's *all* "holidays"—or "work days."—Take your choice as far as terms are concerned.

I do hope you & Reds are well—and that you will remain well this coming year. And thereafter too—stars willing.

With love

Your old
Stieglitz

[Geneva]
[Probably 23 or 24 December 1935]

Dear Stieglitz,

. . . . This winter has been so far much better than the other two here. We may realize more of our hopes.

Reds is better now, . . . after spending a strenuous week at 512 carrying the moth-riddled savings of all the family and its relatives out to be thrown into a big pile and burned. Why the place didn't go up, I do not know. Oily rags, in excelsior. An incendiary couldn't have done better. Bill did well too—he is one of our best eliminators. . . .

Always
Dove

[Geneva]
[23 March 1936]

Dear Stieglitz

Millions of thanks for sending on the Hartley writing and catalog.[1] That is beautifully done. I had written him a letter about it but burned it this morning—not thinking what I had done fine enough.

Went through the desk and destroyed many unmailed letters to you, Georgia and others. A beautiful note at Christmas from Georgia. It made me very glad but as yet I haven't been able to say exactly why. Perhaps too fine to talk about.

Fixed the backs of watercolors yesterday. Everything is done but titles and packing.

Sold the safe at the home. Cleared out about 100 empty envelopes—say a thousand shares of worthless stock carefully kept. One bushel of "expired" at 1930 etc. insurance policies and a diamond & a clogged .38 revolver. $10 in trade from the colored man who takes out ashes for the safe. Just sold this house & barn for $1000 to pay taxes—brother thought it should be worth 2750.

Marian and Bill will be in soon probably and yowl about the situation.—They leave Washington today, Monday, I believe. Please do not let them worry you with our troubles. The whole thing can go about so far and I will not give any more. Seem to have the reputation of being a "good businessman" downtown. No compliment—just contrast.

Want to get where I can be of more use in the world.

Love from us to you and all you love

<div style="text-align: right">Always
Dove</div>

1. Brochure for his show at An American Place.

<div style="text-align: right">[New York City]
25 March 1936</div>

Dear Dove: I'm glad you like what Hartley wrote. His Show is good. Very, in a way. Will anyone give him a pittance for anything? Ye gods, I certainly don't know.—

Marin's Show materialized in nothing. Georgia's ditto. She has had the good fortune (I hope it's good) to have received an order for a painting at a fair figure.—Walker received $60.00 for 3 drypoints. So that's the Place's picture as far as "sales" are concerned.—

Hartley is on the Government's hands. Get[s] a bit over $20 a week.[1]

"Interest" in art in this our country has become so great that the Place seems to "belong" less than ever.—And yet it is by no means dead. It's certainly one grand world we are living in.—I'm glad you found a way to pay taxes.—It's easy enough for anyone to stand around & say what should have been paid, etc. Why don't such people get busy & teach or show a fellow *how* the should be, etc. can be made a reality. Such people never do anything except possibly talk nonsense. For a while I felt pretty rotten, healthwise, but somehow I'm feeling less so the last few

days. Nevertheless, I'm on the bridge daily, not having missed a minute in years. That's a great gesture if nothing else. What a mess everywhere.—Floods & wars—hate—& Art! ye gods & little fishes.—My love to you & Reds.—One goes on fighting—windmills (oneself) I guess.

<div align="right">Your old
Stieglitz</div>

1. From late January until May 1936, when he quit in dissatisfaction, Hartley was on the payroll of the easel painting section of the WPA's Federal Arts Project. He was paid $95.44 per week, according to Barbara Haskell, *Marsden Hartley* (New York: Whitney Museum of American Art, 1980), 143. Lowe, *Stieglitz,* 331, reports that his salary was $55 per week.

In March 1936, Stieglitz sold Dove's 1932 painting *The Gale* for a record high price of one thousand dollars. Dove was able to bank his payment. For the first time in years, his financial outlook was not bleak.

<div align="right">[New York City]
30 March 1936</div>

Dear Dove: A great bit of news.—When Phillips took the "Red Barge" from me, I took another picture of yours & you got all the money he gave. Well, this other picture of yours ("mine") I have just let the Minnesota University have. You had $350 on it during your Show 2 years ago.—It was the boat & sea one. Well, you are to receive a check for $500.00 as soon as Minnesota sends the check. . . . $250 goes to the Dorothy Norman Rent Fund—& the $250 which goes to me for the original outlays I am also turning over to The Place!! I'm merely minus a Dove.—Now I hope all this will seem right to you for it is right. The original idea was, you know, that when I bought something from you, & anyone was ready to pay more, that I'd reimburse myself with the original outlay, & the surplus after that would be divided between you & the Place. In this case that would mean a surplus of $750—half of which would be $375.00 for you. But I prefer to do as I propose. First of all a "record" has been established for you. Phillips can no longer consider himself as the "*Only One.*"—This event has been a real one. A State Affair. . . .

<div align="right">Your old
Stieglitz</div>

[Geneva]
[6 April 1936]

Dear Stieglitz

It was wonderful news. Of course it is all right. Perfect.

Just now drove last nail in the boxes—9 of them. Bill will be in to take them apart and send back cases.

May see you Saturday if Reds is well. Thinking of trying Easter Excursion Friday.

Brother is here—Reds a bit allergic. . . .

Always
Dove

As Dove indicated they might, he and Reds went to New York on the train that Friday for their only sojourn in the city during the five years they lived upstate. Dove's annual exhibition opened during their two very sociable weeks. At the gallery, during the show, they finally met Duncan and Marjorie Phillips, who had been buying Dove's paintings for ten years. This was the only time Dove and Phillips ever met. After their encounter, Phillips decided to take three paintings and four watercolors for $1,150, to be paid over fourteen months.

Besides seeing Bill and Marian, they saw Stieglitz almost daily and O'Keeffe frequently. O'Keeffe invited them, along with Bill and Marian, to dinner at her new penthouse at 405 East 54th Street. They also had meals, some of them at Italian or Chinese restaurants, with the Davidsons, Charles Brooks, Elizabeth McCausland and Berenice Abbott, Marin, and other friends. At the gallery they saw a number of other people, including Cary Ross, Lewis Mumford, Waldo Frank, Malvina Hoffman,[1] and Ralph Flint. The most important exhibition they saw was Alfred Barr's landmark *Cubism and Abstract Art* at the Museum of Modern Art.[2]

1. Malvina Hoffman (1887–1966), an American sculptor, had studied with Rodin and was particularly known for her portraits.
2. Particulars on their excursion are recorded in Diary of Helen Torr Dove, 10–26 April 1936.

[New York City]
27 April 1936

Dear Dove: Your visit to this big town was undoubtedly a great success. So I believe. As for Phillips, do you know you received $175 more than the "prices" you gave me? I feel the right & splendid thing happened for him as well as for you. No "sacrifices" have been made.

I suppose you saw Jewell in the "Times."[1]—How does it feel to be back at home? To me, everything seems more or less dreamlike—unreal—and Lord so real after all.

Your paintings continue to look swell.—It's the best lot ever.

Don't fail to write to Phillips.—And be careful to keep the statement simple & very clear.

My love to you & Reds.—

Ever your old
Stieglitz

1. E. A. Jewell, "Attractions Group and One-Man—Procter, Dove, Crosby," *New York Times,* 26 April 1936, sec. 9, p. 7.

[Geneva]
[28 April 1936]
Tuesday

Dear Stieglitz—

Your letter just here. Was about to write you and Georgia to thank you for the way the perfectly hung show was done. As for all else—it would take me the rest of my life.

Yes, we saw Jewell's article. Hope Hartley doesn't treat him too roughly. McB. was all good enough.[1]

Here is quite a contrast from there—Reds was a new woman after we left here. The salt water is better for her than this lake region. The trees are just where we left them. Warmer today.

After running up to your place for breakfast the other morning, realized I would better keep it up, so started in Monday, and feel fine for it.

The Phillipses were much less difficult than I expected, and we enjoyed them.

Reds is worrying about our mathematics on the Phillips thing.

As we remember, you said $1150.00—Fourteen months at $83.33 per mo.

Well—14 |1150.

82.14 per month.

Want to be sure before writing so that if any reluctance should enter in later, it could not have the usual financial influence on mathematics.

Your warning about keeping the "statement simple and very clear" prompts me to write this first.

My brother has just fixed himself a place in the Dove Block. Foreseeing the situation three years before he was divorced, we stressed the old Chinese idea that more than two grown-up people cannot live happily in same house.

Am ordering 12 more watercolor frames.—They will be made Saturday and it will take a week to silver them so ought to get them to you before show closes.

It was great to see you all. Liked N. Y. better than ever before outside of what happened to the paintings. . . .

<div style="text-align: right">Always
Dove</div>

1. Henry McBride in the *Sun,* 25 April 1936.

<div style="text-align: right">[New York City]
29 April 1936</div>

Dear Dove: I'd write to Phillips arranging that he pay you $83.33 per month as heretofore for one year. That makes $1000. And then $83.33 for month 13 & the balance ($66.66) for month 14. That makes $1150 in all.[1]—If he prefers to pay $95.83 per month for 12 months, he should have the privilege to do so—that amounts to $1149.96. . . .

In haste with love to you & Reds—

<div style="text-align: right">Stieglitz</div>

1. Actually, five cents short of that. Dove would have made an extra cent on the one-year payment alternative that Stieglitz goes on to suggest.

Arthur Dove, Cows in Pasture, *1935. This sonorous, bucolic scene was purchased by Duncan Phillips from Dove's 1936 American Place show.* (Phillips Collection, Washington, D.C.)

[Geneva]
[Probably 6/10 May 1936]

Dear Stieglitz,
. . . . About 25 people have invited themselves to spend the summer. What does one do? Start a hotel, or move out?

Dove

[Geneva]
[11 May 1936]
Monday

Dear Stieglitz
. . . . We are getting to work again. Have a few watercolors so far.
. . .

Running mornings—bathing in pool—feeling fine. And the trees are finally coming out.

Mumford was grand.[1] . . . Mrs. Mumford we both thought quite lovely. . . .

As ever
Dove

1. Lewis Mumford, "The Art Galleries," *New Yorker* 12 (2 May 1936): 43–45.

[New York City]
21 May 1936

My dear Dove: Enclosed a couple of billets—doux.[1]—The most welcome kind. . . . I'm enclosing a Phillips letter to hand yesterday. Up to the same old tricks. Well, I am shipping him the 3 he bought[2]—also 4 watercolors he bought—also "Cow"[*Cow I*]—his wife preferred to "Tree Forms." Wrote I couldn't send "Lake Afternoon." Also that "Cows in Pasture" could have been sold hadn't he reserved it. Also "Tree Forms," etc.—Said we would not complicate the situation in dragging in "Nigger Goes a Fishing." That could be considered some other time. He is not to have it.—Phillips the Generous is quite a swine & only realizes his own Generosity, etc., etc. Turns my insides. If I had a bit of money I'd have wired him: Dove deal off. Keep your hard-earned money—others will buy the paintings. Goodwin I'm sure would have given $600.00 for "Cows in Pasture." Well, whatever Phillips may do—he'll do something, I'm sure it will be all right. . . . He has a convenient way (for him) to work out "intricate" problems to his decided advantage & at the same time trying to make the other fellow believe that he (P.) is making a great sacrifice in the name of art patronage. Ye gods.—And still he counts. And—

Oh Hell—Don't people like that ever see what they are doing? And why wait till your exhibition is over & so rob you of the chance of selling the "reserved" (!) paintings? Well, I have learned something. That is, a new technique for the future. Of course he means well. . . .

ever
Stieglitz

1. Two checks, one for forty dollars, one for fifty dollars, for watercolors.
2. *Wind, Cows in Pasture,* and *Tree Forms.*

[Geneva]
[Probably 25 May 1936]

Dear Stieglitz

Many thanks for your subtle convictions of Phillips and the enclosed checks. . . .

If P. had wanted to be a real one, he might have let Goodwin have the "Cows in Pasture"—and we could have had an up-to-date glazier fix our glasses and fill the places where teeth are missing.

After all that has been said as to "Nothing but oils," why talk of "Nigger Goes a-Fishing"? Is that Mumford influence?

As to Phillips' letter—the outline I gave him of yours included the remark that "He should have the privilege" of paying one of the two ways you suggested. It may have gotten him a little—so now he bargains like an old woman at les Halles over a shawl. If "Marins were only priced like Doves"[1]—he would be trying to do the same thing to Marin, and be buying $40,000 modern French. All of which refreshes the Teddy Bryner remark, when someone at the Gallery asked her if she were Mrs. P. and she said "Thank God No!"

Later—This evening I have been learning quite a bit about Phillips. It may not be news to you. Mrs. Rankin, a neighbor of theirs, is here. Five years ago he paid $500,000 for the house & $500,000 for the ground.[2] Live extremely well—quail, etc. Champagne in individual frigidaires in all guest rooms, etc. I should prefer the $150 in my frigidaire—not caring for champagne as I remember. He is just trying to keep down to $1000 and get a quick collection of Marins & Doves and then be through if anything more raises values. Do not know how he feels about Georgia. If he comes here,[3] will take pains to find out. "Subsidy" is his favorite word. Maybe it runs through his whole life—I hope not. He ought to consult Mrs. Phillips more. Will send his letter back, if you want to bother with it. Think I'd better copy it first in case he arrives here. "Lord, how I dred it."

Mr. [C. Law] Watkins said he "Wanted to get the technique." When I talked with Alfy about it—he said, "That's the thing Cézanne didn't know." It has taken me five years to begin to use it. . . .

The work is going fine—about 12 watercolors. Reds joins me in thinking that they are starting off bigger than the end of last season's. Anyway there is a bit of new idea added which is always a stimulus.

It is funny that the critics never write much about painting—probably do not care to take chances—guess they are right.—It *would* be pretty bad.

Our love to you and Georgia and tell Marin there is a letter here for him from me that only needs a couple of periods or so.

Hoping that Phillips can get his mind off one round number is hoping for the better, not the best.

As always,
Dove

1. In the letter Stieglitz sent on with his own preceding one, Phillips had written: "If Marins were only priced like Doves what a gorgeous collection I would have."
2. In 1930, the Phillipses moved from their downtown home (just off Dupont Circle), which continues to house the Phillips Collection, to a large new house they had built on Foxhall Road, which was then virtually in the country.
3. The Phillipses were thinking of visiting Dove in Geneva on their way to Cleveland late in June, but they did not.

[Geneva]
[7 June 1936]

Dear Stieglitz,

No anything from Phillips so far this month. He can afford to wait. Perhaps is going to try nothing on me for a while and see what effect it has.

Expect the Baermanns[1] for a few days sometime this week. He is rather alert—likes Mondrian.—Think[s] my things fine but can't see Marin. I asked him why because I liked them so. He said, "That worries me." It should. She we thought fine, a Viennese swimming champion.

Often think of Dr. Walker. Should have seen his things at the gallery. He is much more than his painting—piece by piece.—Seeing the whole thing would have given me a better idea of his whole personality.

We are in training again. Reds has several fine ones and I have somewhat over twenty watercolors. Find now that I can run a mile more easily than I can walk it. Having lost 8 pounds in the process . . .

Nice letters from Marian about their situation and work in Maine. . . .

The younger Doves are enjoying your clouds.[2] She says you are New York to her. . . .

Always
Dove

1. Walter Baerman, a painter, and his wife Ada were friends of Elizabeth McCausland in Massachusetts. They later lived in Pasadena, California, but kept in touch with the Doves.
2. Marian had purchased one of Stieglitz's *Equivalent* cloud photographs. She and Bill were spending the summer in Maine.

[Geneva]
[8 June 1936]

Dear Stieglitz,
. . . A note this morning from Mrs. Chouteau. She was the riotous newspaper lady in Halesite, now in N.Y. . . . The (her) children have taken it [her Dove painting] to Texas as a present to their guardian, a "millionaire merchant and outstanding citizen." Children say it is much too good for him and made their mother promise to buy another. The one she wants is a pair now.

What a year! I can hardly believe it.

We are just going down to the optometrist—to be sure that one of us sees straight anyway. . . .

I doubt if Miss Bier has any violent disagreement with Phillips' opinions. Probably Watkins helps shape them also as he travels every-where—Europe, etc.—with them. . . .

Always
Dove

[New York City]
8 June 1936

Dear Dove: . . .
Am getting the Marin Show ready [for the autumn, at the Museum of Modern Art]. Some job, as there is last-moment framing, etc. undertaken by Georgia & [William] Einstein. If the Show goes off as it should, I think it might "help" you & Georgia & Hartley, etc., etc., including the Place.

My love to you both.

Stieglitz

[New York City]
14 June 1936

Dear Dove: Einstein who is deeply interested in your paintings is

getting a collection together of your things to show people.—Some of your paintings show crackings. I hope the cracks won't go farther. Einstein says they will. When you come again you can take a look. . . . It looks as if Georgia would get away sometime this week. And I to Lake G. by Saturday.

Stieglitz

Lake George
8 July 1936

Dear Dove: Enclosed speaks for itself.[1] Josephy does all the printing for An American Place. He is a friend.—Is not a printer but lays out books for some of the biggest publishers.—Is A1.

I'm not very well. Darned heart. Always something. Otherwise everything "OK."—My love to you & Reds.—

Stieglitz

1. Josephy's offer of an illustrating job.

[Geneva]
[9 July 1936]

Dear Stieglitz

Am terribly sorry you have not been well. Hope this heat is not as bad where you are. It was 107 here yesterday and hotter this morning. I hope it is cool near the lake for you.

Fine letters from Marian, Bill & Einstein. They are enjoying Maine and "hordes" of guests. Einstein's note of thanks for including him in Bill's birthday—has a very fine clear quality. We both liked it so much . . .

Baermann just stopped here on his way west again. He is very fine, and a fighter when he believes.

You probably remember his wife—a swimming champion—swam 18 miles down the Danube.—A beautiful dancer. He picked up some Beethoven & Bach on his car radio, and she danced on the lawn one evening. . . .

(Just looked at the thermometer—it says 120° and that is as far as it will register.)

Phillips was taken short and had to go to Italy for a short trip about Giorgione.[1] He must have gotten my letter before he left. Wanted to copy it for you but it was long and had color diagrams, etc., so just rushed it to the train. . . .

Marian is sculpting in wood. She says your photograph has much to do with it. Bill is proud of her and says Einstein likes them . . .

<div align="right">Always
Dove</div>

1. Phillips soon published a book on the Venetian Renaissance painter: *The Leadership of Giorgione* (Washington, D.C.:Phillips Memorial Gallery, 1937).

<div align="right">[Geneva]
[11/17 July 1936]</div>

Dear Stieglitz,

I didn't thank you for forwarding the Josephy thing nor the book from Gallatin. We bought one of the "Gallery of Living Art" books when we were there in town. I will write and thank him for it. Suppose it's some more of what you have done.

Please be well by now! . . .

<div align="right">As Ever
Dove</div>

. . . I can see why you like Einstein so much. He is fine.

While O'Keeffe and Stieglitz spent the summer apart as usual—he at Lake George, she in New Mexico—the Doves also were separated, but not by choice. In August, Reds had to go to Hartford to take care of her mother who had been severely injured. She did not return for two and a half months, by far the longest period that she and Dove were ever apart. Not surprisingly, Dove and Reds wrote to each other virtually every day. It is perhaps more astonishing, considering the amount of time they chose to spend apart, that Stieglitz and O'Keeffe normally wrote to each other just as frequently.[1]

1. The correspondence between Stieglitz and O'Keeffe, consisting of several thousand letters, is on deposit at the Beinecke Rare Book and Manuscript Library at Yale University.

[Geneva]
[14 or 15 August 1936]

Dear Stieglitz,

 Elizabeth [Davidson] gave me a pretty good report about you. I hope you are still as well or better and pacing the younger ones to the post office.

Mrs. Stieglitz[1] was going to pace me out to my tree and back, but the bridge was partly washed away so she gave it up. Just as well for me probably.

Are you getting a chance to work? And Georgia?

Reds is in Hartford. Her mother very low in the Hospital. . . . Stepped on a chair to reach for something and fell.—A bone in her spine was cracked and other serious internal injuries. Plaster cast as soon as she is able. . . .

Josephy telegraphed for the sketches, so sent on what I had—3 watercolors & one sketch. Haven't heard since. Maybe he hardly knows what to say.

The book was quite a book, "Sea"—but they just cut out the love chapter and seem to want a deluxe edition of that—a bit like Phillips and "The Bessie." When I wrote accepting, I thought the markers he put in the book were to mark places for illustration as no letter came with it. . . .

As ever
Dove

1. Elizabeth Davidson's mother.

Lake George
16 August 1936

Dear Dove: My heart has been pretty rotten, but I think it's somewhat on the mend. I hope so.—Haven't heard from Georgia in a week. Can't quite make it out. May be off on a trip.

A crazy life. This—our only one I guess.—Hope so. . . .

The Davidsons are OK. Zoler left 30 days ago after having had the time of his life as he said. Haven't had a sign of life from him since his leaving. These are peculiar times, so why not people so too. . . .

ever your old
Stieglitz

[Geneva]
[3 September 1936]

Dear Stieglitz

. . . . There has been so much lately that it is hard to get any leisure.

Think I shall be able to talk to you as long as I want soon. We have a broadcasting station at the Block now & roller skating. This man Thomas is an electrical wonder and has all sorts of privileges. Can talk over phone free anywhere in N.Y. State. . . . He is extending a phone to my brother's room down there, so when he does, I'll see if I can use it to keep in touch with you all. . . .

They put the plaster cast on Reds' mother Wednesday. Will know the answer soon. I hope. They let no one see her yesterday but she seems to improve steadily. They have had seven Drs. working over her. Am not sure whether that would be as good as the best *one* or not.

Have had much excitement here. Especially Sundays. A week ago Sunday we had a real twister cyclone, that broke off trees 3 feet in diameter, tipped over buildings, filled the hospital. We lost seven trees and part of the front porch here. I didn't go down [into] cellar as they say one should, but the old house shook so I didn't see how it could keep it up any longer. Last Sunday I had a burglar. Went downstairs at 5:15 with a glass pitcher of water in my hand. Heard someone come in the woodshed and try to force the door. I flung the door open and threatened to crash the pitcher over his head if he didn't go. He turned round, nonchalantly lit a cigarette and walked down the drive across the street & tried the grocery store. I phoned there so guess he heard it and went on.

We have had an airplane tri-motor here for two days. And it seems as though a quarter of Geneva has gone up from our field. It is raining this morning so that will probably end it. They start in the morning at 30¢ so all the kids have been flying. They get to 75¢ by dark. We had 5% so divided in two, it doesn't mean much.

Have taken to rope jumping. More all-around exercise than running. Can do it in the barn instead of out in the rain and mud.

Have 80 watercolors and have started the painting. Have 22 canvases coated and a few large long ones to do.

Can almost live off the garden & mushrooms & fruit here now.

Cap't invited me to fly yesterday, but we had flown before and a heavy storm was coming, so I thought Reds had trouble enough. . . .

As Always,
Dove

Reds (Helen Torr), Hartford, Connecticut, 1930s. (William C. Dove, Mattituck, New York.)

[Geneva]
[Probably 8 September 1936]
Monday A.M.

Dear Stieglitz,

It seems rather out of the world up here now. Haven't seen a white person for a month and a half. When Reds rushed to her mother, Nebel was here for two nights but they worked from 2 A.M. until 11 P.M. packing their laboratory. He has a year off at half pay & is working in Phila. with some well-known scientist, best living in his line—same race of course as the best photographer and best mathematician in the world. . . .

Hear you are back in town and very busy, via Bill & Marian from Einstein. Give him my best.

Reds' mother is improving. Of course her back is still broken and she is in a cast. . . . Her cousin who really lived on Mrs. Torr's energy became a robot again as soon as he could not depend on her. Well, the other day the mainspring let go and they are planning to put him away somewhere. Reds has had all that to contend with besides keeping family posted and writing me every day.

We are having electricity in a few days and have two new pairs each of glasses so will be able to work evenings now.

The paintings are coming fine. So far I am over a month and a half ahead of last year. And all canvas stretched and coated and several frames made.

We have a new roof and side on the house by the new owner so will be 50% warmer this winter which will save much time also. We have it until March & can rent after that if we wish. . . .

As ever
Dove

[Geneva]
[4/13 October 1936]

Dear Stieglitz,

A postal from Marian saying you are not feeling so well but working hard. Hope by now you are better. Einstein must be a wonderful help. . . .

[Clifton] Fadiman's article in this week's "New Yorker" doesn't give Sherwood Anderson so much on his last book [*Kit Brandon*], but it will

create a sense of curiosity which will make people buy the book anyway.

The paintings are coming fine. October is always my favorite month. Reds' mother is improving but still in the cast so I am still a bachelor. The electricity is now in, so that is a grand help, and a new roof. . . .

<div style="text-align: right;">Always,
Dove</div>

After Marin's retrospective exhibition opened at the Museum of Modern Art, Stieglitz sent Dove a copy of the catalogue, which had Stieglitz's portrait of Marin on the jacket. In his next letter, Dove thanked Stieglitz for the book.

Meanwhile, Stieglitz postponed Marin's usual autumn show of new work until January. Before that, he put up a show of Ansel Adams's photographs, accompanied by a small group of William Einstein's paintings and drawings, and then a group show of regular exhibitors, including Dove. After Marin's show in the new year, O'Keeffe, Dove, and Hartley, in that order, had one-person exhibitions.

Dove was included in a major show opening late in 1936 at the Museum of Modern Art—Alfred Barr's *Fantastic Art, Dada, Surrealism.* While Dove's new work was up in March and April at An American Place, a retrospective selection of his art was displayed at the Phillips Gallery in Washington.

<div style="text-align: right;">[Geneva]
[24 October 1936]</div>

Dear Stieglitz,

That is a beauty.—Thanks very much for the new Marin book. A grand one on the jacket. It does all the things that Marin does and that you do. The show must be a fine one. Bill & Marian say Georgia is pleased with this year's work. Good.

Am still alone here—for a week longer probably—until Reds' mother leaves hospital. Has to stay in that damned plaster cast for 5–6 months longer.

My brother is south, left his radio here. The moment I turned it on, it played Beethoven, and Bach right after. Nothing since but trash and politics. They should extend that 200 feet from the polls to the whole country for electioneering. Have given it up except at 6:30 A.M. when you get the time and weather. It cheapens silence so.

Have 8 or 9 paintings pretty well along, and quite a few framed besides the watercolors.

Would like to have been at the Marin opening with you all. Also wanted very much to go over there[1] last spring when he asked us. Will try again this next time. Will start wearing wooden shoes 2 weeks before we hit the pavements so that the combination will not ruin us. We usually wear moccasins here.

This is a beautiful day. Am tempted to go out looking, but almost finished a 25 × 35 sunrise yesterday. It gets dark here so early. So would better stick at that. Weather shouldn't be so important to a modern painter—maybe we're still "too human."

A letter from Reds just now. Mother not so well, cystitis again. Mary [Rehm]—you liked her—may come for good soon with family. The situation in Europe in the last few days looks as though they had "matches on the table legs and sandpaper on the cat."

Must get up to work. Have been trying to since 5 A.M.

Always,
Dove

1. To Marin's house in Cliffside Park, New Jersey.

[Geneva]
[29 October 1936]
Thursday A.M.

Dear Stieglitz,

So glad to hear you are feeling better. The Marin show must have been quite a strain to get two floors and a fine yellow room of etchings. They tell me it is packed, including Phillips. Do hope something great will happen for Marin. Some museum ought to take enough to make him independent. It is good that it will go on well beyond this political madness. One might think the country had never before had a president.

Did a whole 25 × 35 yesterday. Have several real estate deals hanging fire now, and, if any luck, think we should move about more. Hope to finish the ones planned for this year and start next in another place.

Reds expects now to come home in a day or two. Her mother is better and being wheeled about in the hospital to see some friends.

The Marin book is here beside me. It is certainly beautiful.

The weather here is quite black again. The fogs blow over from the

Great Lakes, so that there are but three months here that are worth-while.

Would like to see what you have there now and know what an Einstein is.

If Marian & Bill can get four rooms with sun and hot water in N.Y. for $23 a month, there is no use staying in this house for $20. It would be better to commute to Geneva when necessary. R.R. fares are so much cheaper. . . .

As ever
Dove

[Geneva]
[21 December 1936]

Dear Stieglitz, Georgia, Einstein and everybody,

. . . . Have been trying to get rid of this awful real estate between brushstrokes as it appears. Hope to have an offer on this whole business out here today. Wouldn't it be marvelous. Think we would move as soon as the work now begun could be finished. Finished the best one yet Saturday. Reds has been doing much since she came back from Hartford. Richer. Her mother improving slowly.

We have a strange character running a roller-skating rink at the Block. I like him from the first. He told about different things he could do. He is psychic also. The other people in the building thought him a "liar" and a "nut," "dumb" etc. He is just telling the truth and they will not believe him. He is a graduate engineer—pilot, radio broadcaster, and dozens of other things. Printer & frame maker among them. He came out here one day to help me measure some land. He has a surveyor's license. He surveyed the place with an instrument he made here with a carpenter's spirit level with two spools tied to it. Came back here afterwards and showed us his credentials plus a gold badge with six stars on it. In other words he is a 6 Star G.-man. Told us what some of the stars were for. Captures etc. He has the job at present of investigating the city police. . . . One of our tenants . . . is among those being investigated, a lawyer. The one who called him a nut to me. Lawyer called me the other night, complained about noise. . . . Went up to the skating rink & brought G.-man down. Introduced him to lawyer. He slid into the office with an old dress coat on, unshaven, four-in-hand tie, an old pair of pants and shoes, plunked himself down on lawyer's desk with a laugh—he looked half doped—and suddenly became an-

other person. And told him who he was. You should have seen the lawyer. Can't be nice enough now and I have heard no more complaints. They have to be able to do anything but paint. He slipped a bit there.

I find letters to you in several drawers. Since hearing from Bill that my letters to them were more interesting, I have been trying to wait for a good one. We are going to Lehigh to mail others so will send this whatever it is like.

<div style="text-align: right">

Love to you all
As always,
Dove

</div>

<div style="text-align: right">

[Geneva]
[18 January 1937]
Monday

</div>

Dear Stieglitz,

. . . . Would rather have you feel out what you think best about a retrospective show in Washington. His [Phillips's] secretary mentions it in her letter. Mrs. Rankin—Washington friend—is doing colored slides of "Red Barge," etc. Miss Bier tells her "Red B." is as voluptuous as a Titian.—Something more to live up to.

Sold a watercolor to Dr. B[oswell] & wife for fifteen. They are the ones in "Lake Afternoon."[1] He, a doctor of philosphy here in Hobart [College].—I can get it if we want it for show. Gay and light of Reds' lingerie on the clothesline.

Someone gave me one of those write-ups in Rochester paper. Butcher boy said, "I'd a thought you was Jesus, if I hadn't knowed you." Now everyone paints in the neighborhood.—He said his sister-in-law was so keen about painting that she would go without her lunch. Told him she would go without all her meals if she kept at it.

Have frames for all paintings and canvases, also for 34 watercolors so far. Not silvered as yet except a few. Suppose we can use as many watercolor frames as he can make out of the cuttings from large frames. . . .

<div style="text-align: right">

Ever
Dove

</div>

1. The Boswells are not actually represented. *Lake Afternoon* (1935) was inspired by an afternoon the Doves, the Boswells, and others spent together.

[New York City]
12 February 1937

My dear Dove: You had better get ready. You are next. About March 18 you will "hang."—Georgia's Show is very fine but I'll be surprised if anything happens for her. Marin has finally had a little luck. Certainly deserves it. I'm struggling along. Pretty tough going. I hope you & Reds are well.—In a rush.

Your old
Stieglitz

Mumford is quitting the "New Yorker."

Early in 1937, Bill took a WPA job in Washington. Stieglitz referred to the move in his next letter.

[New York City]
28 February 1937

Dear Dove:
Georgia's Show continues to bring crowds but very very little besides "Appreciation." The latter is a drug on the market. . . .
I wonder how Bill & his wife will like Washington. Einstein joins me in the greetings.

Stieglitz

[Geneva]
[5 March 1937]

Dear Stieglitz
What a day! Packed all of those paintings and watercolors from 9 A.M. to 3 P.M.—took them down to station, 8 cases—4 paintings and 4 watercolors. I insured them for $2000. Couldn't spend more on insurance. Enclose list—with our usual code values.—You will know how to turn the dial to get the correct volume. . . .
Those cases from last year are worth a fortune to me, so please tell Andrew[1] to send them back again via Railway Exp.
This next week or so will be hell's scrabble to sell enough to pay taxes

again. After that, will know better what we can do about coming down. . . .

As ever
Dove

1. Andrew Droth was a gallery assistant to Stieglitz. (See Glossary of Names.)

[Geneva]
[17 March 1937]
Wednesday

Dear Stieglitz,

Glad to hear from Einstein over phone that the paintings are liked. Said he would write when they were up.

Thank you all much for hanging them again this year. And thank heaven that they are safe there before this blizzard came. Can't even get the Ford out of the chicken house. The cases arrived back all right except 2 watercolor cases & one of the smaller oils. Imagine you used them to send on to Washington or somewhere. There were but 5 cases on the bill coming back—8 on the down trip.

Would give anything to see six months ahead. I am stuck just now here with this new kind of taxes. On account of County relief they are making them impossible. Nothing pays—but the Italians, and they are usually on relief & on the street so they do not dare own anything—talk rather large & then back out. Well, so do the Americans. Man whom I hoped would take all these 138 acres is backing now because the N.Y.C. R. R. is taking up a switch that he wanted to use. The switch has been here for 50 years. I have some more prospects so have to do some hustling before March 30 when they begin to talk higher mathematics at the town hall.

You wrote last year, "N.Y. trip was a success."—It was great after so long.—We have to move again May 1. Canvas and all that to be stretched and coated. We are a month ahead of last year and do not want to lose it. And we are not sure of where to go until we see what can be sold. Like L.I. and have written there, but may go and live in the "Dove Block" in some dressing rooms & a huge dance hall for a studio, about 60 × 70. . . .

I hear that the Phillipses are very anxious to have us there while the Show is on. It would probably take two or three weeks TIME. And

what little we have left out of the Minnesota thing banked in N. Y. We managed to keep that fairly untouched—$100 out.—And be social. I recognized my dress clothes, frock suit, silk hat, & opera snapper in dusty boxes around the dusty hayloft on South Main St., so imagine I must have discontinued membership some time ago.

It will take some time to move to the "Block" if we do. There is a bigness about it.—A large roof overlooking lake, etc. I've never been up there.

We want to see you all, Bill and Marian in Washington and all the things there.

It is the first time in so many years that we haven't been down to nothing. I dread getting there again for anything not absolutely necessary. Work is so much better when one can breathe. . . .

Reds is not so well. If warm weather ever comes, she will be all right, but these cold winds blow through here and she gets sinus and other echoes. . . .

> Always from
> Reds & Dove

> [New York City]
> 19 March 1937

Dear Dove: I am having the main room painted white. We felt your new work looks best on white. It sings.—Looks very beautiful. Will be hung tomorrow.

. . . . In a great rush with love to you & Reds—

> Stieglitz

The next day, Stieglitz sent a telegram, which read as follows:
YOUR SHOW HUNG GRAND WONDERFUL WHITE WALLS OKEEFFE EINSTEIN AND MYSELF SEND LOVE TO YOU AND REDS =

> STIEGLITZ

> [Geneva]
> [20/26 March 1937]

Dear Stieglitz,

You have made us very happy. Your letter, telegram and announce-

Arthur Dove, 1930s. (Mary Rehm, Washington, D.C.)

ments are very exciting and inciting to go on, which is being done and that is the most important thing. Have been working again today. . . It is fine again to hear that vital enthusiasm. Always know what it means. You have made a real situation after your years of building. I know what it has meant to you—and realize now more and more what it does and has to me.

Creating opportunities allows creative people to be, which existence comes nearer to birth as it was intended. The real parent becomes more important than the apparent parent.

The air and ideas are being bridged over so that they can be lived upon, and it enables a few thoughtful ones communication and mental peace which has heretofore been denied.

Much love to you all and thanks for all the help.

As ever
Dove

[Geneva]
[27 March 1937]
Saturday

Dear Stieglitz,

. . . . Sent you a special this noon with copy of Phillips' letter in it. . . .

We are hoping to come. Have to arrange for mortgage to pay taxes, etc., and my brother is cook on a millionaire's yacht, eating his way back from Florida. . . .

As ever
Dove

[The following letter to Dove is the portion of Phillips's letter that the painter copied and sent to Stieglitz.]

25 March 1937

Dear Arthur Dove,

I hope you will be able to come to Washington during the Retrospective Exhibition in our Gallery. It is contained in four rooms. Two of them are devoted to the watercolors, one to the important early works in collage, pastel and metals, and the fourth to a selection from our

large number of oils painted within recent years. The whole show is splendid and I only hope that many people will come and that they will be able to appreciate the subtle distinctions and original inventions of your style. It is interesting that your annual show at An American Place is going on at the same time in New York and it will be helpful to me to see your new pictures before deciding what to get for next year. We happen to have made some very costly purchases this past season, opportunities which came at an untimely moment but which I could not disregard. That means that we cannot do more than we have in the past. I did want to supplement our representation of your work, most of which is of recent vintage, with one or two fine things of earlier years. Mr. Stieglitz has made this almost impossible for me by putting on prohibitive prices and by ruling out trades. "A Nigger Goes a Fishin' " belongs to Stieglitz and he would have to be paid at least a part of the price. Personally he doesn't wish to part with this fascinating creation and I do not blame him. I want it very much myself and after seeing the show in New York, where, by the way, I hope to meet you, I will try to decide what to do. The little picture called "Car" is another favorite of mine.

[New York City]
28 March 1937

My dear Dove: I cannot say what you should do about Phillips.—He has misinformed you when he says I want something for myself. I gave him a figure for which he could have "The Nigger Goes a Fishing"— half to go to you & half to Dorothy Norman's Rent Fund. Now what that has to do with me I don't see. I bought that picture from you[1] at the time Phillips advised me to advise you not to do such things [assemblages]. Felt, he said, it was a waste of your gifts. Etc. Etc. Now he wants that picture.—He has the money. Has bought a Rembrandt the other day.—He just [doesn't] seem to understand.—He has certainly not been overpaying you.—I do wish you'd let him know I'm not keeping anything for myself. But I know he'll never know what it's all about.—No, I won't start the exchanging game with him. It is too complicated & needs a special staff. I personally haven't the energy to waste.—News there is none.—People like your Show but not so very many come. The Press has been niggardly.—With love to you & Reds—

Your old
Stieglitz

1. As he does here, Stieglitz referred from time to time to paintings he bought from Dove for his own collection; and in fact, he did acquire Dove's work regularly. Curiously, however, neither the letters nor other sources (including the detailed diaries) ever give any information about these purchases. It does not appear that Stieglitz informed Dove which paintings he took for himself, nor how much he paid for them. Presumably, these acquisition costs were simply included in the checks that Stieglitz sent from time to time from his own pocket. Their mutual reluctance to enter into a businesslike relationship was the consequence of an aversion to assigning monetary worth to anything that incorporated spiritual values.

[Geneva]
[Probably 31 March 1937]

Dear Stieglitz,

Of course you cannot say what I should do about Phillips. I shouldn't bother you with all that, but you have to know his ideas definitely, to answer them definitely, so he may get it, if any.

It is amusing about "The Nigger Goes a Fishin'."—I have always told you, as you know, that the things were as much yours as mine.—Think I said that to Phillips at one time.

The Press is rather unfortunate. Jewell evidently does not come anymore, may be afraid of Hartley.—Jewell must have set the headlines and the man who saw them [the paintings] just knows not.[1]

I will try to make it clear to Phillips that you are not trying to sell paintings, especially at a profit, and do not take anything out of it and that it goes to the rent fund and the artists half & half.

It is well nigh impossible to talk about ideas when figures enter in.—We may be even quaint to imagine that our ideas could be thought of in their terms. Have seen so well here how people are willing "To trade on" one's finer instincts.

The things this year are the best, but, if next year's are still better—we may find ourselves still further away from the public.—

One would think that after all the modernity shown, it would have made some impression. But they are not as far from where they started, as we might have hoped.

A purer beauty would seem to be more moving—but when they said "What beauty," they damn well mean it—considered in terms of expense and its impression on their friends.

We want to see you all, but just now do not feel that we can go to Washington.

You said "Hope the Lord will pay your taxes." Have had to let them go over at 1% until June, then 5%. "Then everything is the Lord's."

This heirloom is hell but there may be still some beauty yet.

Love to you all.

> Always
> Reds and Dove

1. The lukewarm *New York Times* review was by Howard Devree: "A Reviewer's Notebook; Comment on Some of the Newly Opened Shows—Arthur Dove and Others," *New York Times*, 28 March 1937, sec. 11, p. 10. Reds thought it "a silly meaningless piece" (Diary of Helen Torr Dove, 28 March 1937).

> [New York City]
> 2 April 1937

Dear Dove: First of all, I enclose a check which may come in as handy.—Phillips or no Phillips you can count on at least $1100—of which the $350 enclosed is a part.—This may relieve your mind a bit.—McBride was here. Mumford too. So we'll see. Mumford seems still to be writing. Why he said nothing about Georgia's beautiful Show will always remain a mystery.—I don't think "The Place" is very exciting—or exciting at all—to the blasé gentlemen & ladies in the guise of critics or any other guise. There is no doubt that your things look & are very beautiful. The best lot yet. Georgia returned from a week's stay in Palm Beach.—Our love to you & Reds

> Ever your old
> Stieglitz

> [Geneva]
> [5 April 1937]

Dear Stieglitz!

Another day in our lives.

We, last night, were talking of you and Sherwood Anderson, and this morning's mail brings letters from both of you. We both choked a bit. It is just another of those miracles. There have been so many. . . .

Will send you a copy of Sherwood's. It is quite beautifully simple. Bill is so fond of his work—says it "Talks to him."

We cannot understand Georgia's Show not appearing in the "New Yorker." There is something strange there somewhere.

All of this happening is also mysterious but I get strange hunches now and then. The great things are so few, one knows where to look.

Have 33 canvases stretched & coated for next year. Am learning more of that sort of thing all the time, about the little subtleties [of not overdoing it.

Do not think we [had] better come down now. Teeth have also to be done. Lean years have gradually to be caught up with.

Have been building plans for L.I.—if I can only "swing" this thing. Love always to you all.

<div style="text-align:right">Dove</div>

The thing that has the most Value is time.

<div style="text-align:right">[Geneva]
[7 April 1937]</div>

Dear Stieglitz,

Was just about to write Phillips when the following night telegram came. . . .

> Going to Cleveland Saturday to fill lecture engagement, back to edit book to go to press. Can't miss your show at an American Place, so return to New York Sunday night to see it. Hope your show in Washington can be extended and that you will be able to get down to see it by end of April. Am sending you catalogue with my preface. Greetings.
>
> <div style="text-align:right">Sincerely
Duncan Phillips</div>

I wanted to help make it clear to him about the way you have always conducted finances. Maybe I can get a note to him, if I get it off with this.

Had a nice letter from Elmira Bier, "Assistant to Director," at the Phillips Gallery. Perhaps you talked with her when she was in 1710? Spent about an hour there. Preferences—"Me and the Moon," "East from Holbrook's Bridge," "Cow" [*A Chewing Cow*], "Silo" [*Leaning Silo*], "Happy Landscape," "Slaughter House."

Preferences for ones you loaned Wash.—"The Telegraph Pole," "Grandmother," and "Nigger Goes a Fishin'."

Arthur Dove, Grandmother, *1925. Assemblage of wood shingles, needlepoint, page from a Bible (Concordance), and pressed flowers and fern. First exhibited in Dove's Intimate Gallery show of 1926, this painting appeared in the Museum of Modern Art's important* Fantastic Art, Dada, Surrealism *show of 1936–37, as well as the 1937 Phillips retrospective; it was purchased for the museum two years later by architect Philip Goodwin.* (Museum of Modern Art, New York. Gift of Philip L. Goodwin, 1939.)

"The Lord" hasn't paid the taxes yet—had to let them go over. Am advertising, seeing prospects, etc. this week, hope to get a break. Weather no good here now.

Am writing about two or three L.I. possibilities so that if anything does happen we can move once.

It is a relief to have so many nice white canvases all ready. . . .

<div align="right">Always
Dove</div>

Dove's financial situation continued to ameliorate, largely because of Phillips. He not only extended the annual arrangement with a raise to one hundred dollars per month, but also bought *Goin' Fishin'* for two thousand dollars, the highest price Dove had received for any work. At the same time, Stieglitz allowed him an even trade of *Bessie of New York* for *Reminiscence*.

<div align="right">[New York City]
12 April 1937</div>

My dear Dove: Well, the Phillipses were here & much impressed.— You are assured another year.—He has kept "A Nigger Goes a Fishing"—&, now don't faint, is giving $1000 to you & $1000 to Dorothy Norman for the Place. Besides, you will eventually receive another $1000.00. I wrote you you could count on $1100 surely. Now, as all this Phillips has come about, the record stands $2000 for you from Phillips & about $500 besides.—The $1100 were a sort of personal guarantee from Georgia & me in case nothing else happened. For the "Nigger" I'll take the "Me & the Moon" & hold it in trust. This all sounds rather complicated. But it's really very simple. I feel you have $2000 for the year. And at least $500 for the year following. Maybe there'll be more. At any rate, you should feel relieved. Congratulations all around. Of course Dorothy Norman will be elated.—Love to you & Reds

<div align="right">Stieglitz</div>

<div align="right">[Geneva]
[14 April 1937 or shortly after]</div>

Dear Stieglitz,

Holy Smoke! I didn't faint, but—what a relief! I knew and told Reds

Arthur Dove, Rise of the Full Moon, *1937. Exhibited in Dove's 1937 American Place show as* Me and the Moon, *this painting was reserved by Stieglitz for himself at that time. Two years later, he allowed Duncan Phillips to purchase it for two thousand dollars.* (Phillips Collection, Washington, D.C.)

when your letter came—the first one[1]—that you and Georgia were at the bottom of that beautiful plot. Wrote Phillips so he probably got it before he left Washington what the situation at 509 was. . . .

They have begun work on this house for the new owner, so it is like living in a boiler. I more or less became used to it last summer when Reds was in Hartford. Learned to catch the things as they fell from the walls and shelves. They put in new sills in this old house with a sledge hammer. Keep one eye on the ceiling. It all fell in my bed last summer. . . .

Bill sent a very good review of the Wash. Show [at Phillips Collection] in the "Wash. Post" Apr. 11.[2] . . .

<div align="right">Always
Dove</div>

Reds is on way to have color field taken of her eyes to find out what causes temperature every day. They can tell from eyes where trouble is located. Quite remarkable. All for $3.

<div align="right">D.</div>

1. Stieglitz's letter of 2 April 1937, in which he assured Dove of the eleven hundred dollars and sent a check for three hundred fifty dollars.
2. Alice Graeme, "Paintings of Arthur G. Dove in Various Media at Gallery Here Show Artist's Mature Style," *Washington Post*, 11 April 1937, p. 9

In May 1937, the Doves moved into the loftlike top floor of the late-Victorian, three-story Dove Block, where they remained for their final year upstate.

[Geneva]
[5 May 1937 or after]

Dear Stieglitz
 We are in the throes of moving again, to the "Dove Block." . . . Have studio 70 × 60 with ceilings about 15 feet high. It has just been a skating rink, other tenants kicked so thought I'd take bull by horns instead of tail for a change and use it.

Wonder what you said to my brother.[1]—He was sick all the way up & is a changed (I hope) person? It seems that every time we move, the place is sold. So we're trying the Block.

The taxes are paid, not entirely by the Lord however.—The change will relieve about three hours' chores, however, and it will be dry which will be a help to Reds. We have been living in wet and cold for so many years. We do not realize anything as yet, but if I can only keep it balanced for another year, we may be able to get out.

Have quite a lot of working watercolors done. And perhaps a little more peace or piece of mind to go on with.

Will write as soon as I *can*.

Always with love from us both to you all.

As ever
Dove

1. On his way home from Florida, Paul had stopped in New York to see his brother's show at An American Place.

<div align="right">

[Geneva]
[Probably after 17 May 1937]

</div>

Dear Stieglitz

We are moved—but not quite settled. Walk about 10 miles before noon around this huge hall. It is on the top floor so plenty of ups and downs. It is dry and healthy. Reds is feeling better, or will as soon as she can rest. Have shut ourselves in so that people have to telephone first which is rather satisfactory.

We overlook the lake from the rear and are on one of the city's main corners on two other sides which have 19 windows ten feet high so we have *light*—and heat. And a fine roof on top which we haven't had time to see as yet.

Have been repaired by the dentist—Reds says it makes me look 10 years younger. Maybe it is second childhood.

The McCauslands[1] want to come for a weekend. E. is just out of the hospital.

They dug the cellar at the farmhouse deeper so the water all ran in and the north wall caved in. Sold it to force ourselves out but didn't know it was going to act so suddenly & hard.

Margaret Cobb is writing for some magazine that goes all round the world.—Wanted that "Very nice Einstein" to contribute something to an article she is writing on my paintings. Thought "Sunrise II" the finest modern painting she had seen. Will find her letter soon.

Much love to you, Georgia and Einstein from us.

<div align="right">

As always
Dove

</div>

Address is just "Dove Block," Geneva, N.Y. We have 6 or 8 deliveries a day here.

1. Elizabeth McCausland and Berenice Abbott.

<div align="right">

[New York City]
12 June 1937

</div>

My dear Dove: I'm enclosing first pay't of Phillips. There are to be 12 monthly instalments. I'm enclosing my personal check to you for $318.75 so that you have $500 to start with. I'll refund myself that

amount as I see fit—(that is refund myself $318.75).—I know you'll feel more comfortable with a little actual cash on hand than waiting for the driblets to come in.—I'm kept on the job (I don't know what it is—but there is one) pretty much all the time. Since Sept. 22, I haven't taken a day off unless one considers all the days as days off. One might.—

—I have set no date for leaving for Lake George. Georgia is up there now for a couple of days. She does the "travelling" for the two of us. And I am satisfied when she is.—That's simple. Isn't it?—Undoubtedly you & Reds are kept with your noses to the grindstone in some form or another pretty much all the while. The walls of the Place have been bare for the last 3 weeks.—That includes the "office."—They look fine. So does the Place.

—I often think of your Show.—It lives. Was really swell. Too bad Americans are so dumb (*busy!*) in so many futile ways.—But the Lord (& Roosevelt & [John L.] Lewis) is with them I'm told. I wonder sometimes [if] it is really true about the Lord. It's all OK as far as R. & L. go—but even as far as they are concerned, aren't they trusting a little to the Lord after all? It's a beautiful day. I'm alone.—Am alone much. Don't particularly enjoy my own company but I can imagine worse.

My love to you & Reds.

<div style="text-align: right">

Your old
Stieglitz

</div>

Dorothy [Norman] is seething with magazines[1] & matters pertaining thereto.

1. Dorothy Norman was planning *Twice A Year*, which began publication in 1938 under her editorial direction.

Before the arrangement between Phillips and Dove was finalized, Stieglitz made excuses about Dove's need to separate his personal income from the financial affairs of the Dove family in order to insist that Phillips send his monthly checks via An American Place. After this time, Stieglitz served as watchdog for Dove's account with Phillips (as he had always done for O'Keeffe's and Marin's). As a result, the correspondence thereafter includes many brief notes from Stieglitz, as he rarely forwarded a check without an accompanying personal word.

Dorothy Norman, Alfred Stieglitz, *1930s.*
(Collection of Dorothy Norman,
Philadelphia Museum of Art.)

[Geneva]
[14 or 15 June 1937]

Dear Stieglitz

More wonders. How in hell or heaven you ever did it I do not know. Phillips sent statement to me. It nearly bowled us over[1]. . . .

He wrote a fine letter.

Quotes: "No doubt Stieglitz has written to you about his preferring that payment be made to Arthur Dove Fund and sent to him to be relayed to you. He told me it would be to your advantage to do this because of personal considerations connected with your affairs. I hope that everything is satisfactory and would like to hear from you assuring us that you are pleased. In a way it is a disappointment here not to deal

with you directly since it gives us an opportunity to write and receive answers in sending checks." Etc.

I wrote him why you had said what you did about my personal affairs, probably rightly as I saw it. Maybe I'd better make more sure of it by depositing part of this in Corn Exchange in N.Y. Do not want to bother you with forwarding statements, but these damned Federal Housing Acts make you hock your soul to save what there is. And the N.Y. Central R.R. may hop us for something that father signed 60 years ago about paying for labor in removing switch to old brick yard.

Had the 138 acres all sold when they came early in spring and took the whole thing up without my knowledge. The man would not take it *sans* switch. We owned the ties so there is some chance of counter-charge. Lawyer says not to notice them. How last year's work ever became, I do not know either. With carpenters walking off the scaffolds in and out the windows of the little studio, Georgia saw it, hammering and talking and *looking!* The look that the herd has for something different is appalling. . . .

Reds is improving in health by the minute so of course I am cotangently but do not know about the whole thing as yet. Think I'd better not *try* to like Geneva. It is swell from 3 A.M. until 6.—Then the people begin to appear. "Buying cheap and selling dear." And trying to grab each others' marbles and lollipops and everyone knows there is not enough to go round. They send flowers from their sons' funerals to those whom they expect soon to die—and the wealthy invite the poor, but respectable, to dinner now and then.

Being high above the street has its advantages.

I wrote Miss Bier a long letter in answer to her many. Enclosing statement for last year to date. It started June 6 '36—there was still the $100 due from '35. I haven't heard this month yet so there is still due $250 on last year.

1935 due	$100
Apr '36 3 Paintings	
4 Water Colors	$1150
	$1250

Have had $1000, to date.

He sent the $100 due from '35 on March 29, '37 but may have counted it in '36 payments.

Well, anyway they know. Better not say more than I already have.

He [Phillips] is interested in "Me and the Moon." He calls it a "Masterpiece that was purchased before I had a chance to get it."

He speaks of a blemish on it, due to one spot drying not as flat as the rest, due to the fact that I did not want to mat varnish that part so soon after painting it. I will do it after the year is up.

Phillips' check came to you just after I had sent statement. Maybe he hurried, not wanting to be caught between the devil and the deep blue sea.—Which of us is which I can't tell.

This room is quite beautiful especially at night, lighted by the city streets. . . .

<div align="right">Always
Dove</div>

Fine letter from Dorothy [Norman]. I have read over some of my things written but think last year's paintings make them not so interesting.

1. In addition to noting the purchase of *Goin' Fishin'* for $2000 and the trade of *The Bessie of New York* for *Reminiscence,* Phillips's statement specified the purchase of two oils, *Car* and *"The Moon was Laughing at Me,"* and four watercolors for a total of $1175.

<div align="right">[New York City]
16 June 1937</div>

Dear Dove: As for Phillips, why don't you write monthly to him? And he to you. Must there be checks to bring that about?—Don't you let up on getting that $250 due you.—As a matter of fact, if I had wanted to insist on our agreement, P. should have sent you $1000 for "Nigger Goes a Fishing" & then monthly instalments for the purchases from your Show.—Well, there is no use making an issue of that.—The reason I wanted checks made out to me (Arthur G. Dove Fund) was that I could keep check on him. He is less apt to play pranks on me than on you.—He has his own little ways. As for "Me & The Moon," I set that aside, taking it in exchange for "my" share of "Nigger Goes a Fishing."—In reality I didn't want to give P. a chance to take it as one of the 3 for $1000.00—& I didn't want to have any bargaining, etc.—The important thing was for him to get "Nigger," etc. this year. "Me & the Moon" he can have someday at a decent figure.[1]—I know you will understand. He just doesn't see me & sees himself still less.—The artist's human problem doesn't exist for him. Except possibly through a dense haze. The rich have their peculiarities but so have the poor, the

rich tell me. So it goes. . . . I know Dorothy wrote to you. She has a magazine in her mind. For some years already.—A great idea, but there are to be no reproductions. No pictures.—So it seems the word is to dominate once more.—I do hope she will realize some of her dream.— It is a wonderful one. But as an aged sinner, I do wonder!—

The problem of the Place becomes more & more difficult.—That is, the Place becomes more & more isolated. . . .

<div style="text-align: right">

Your old
Stieglitz

</div>

1. Phillips did purchase it—in the spring of 1939 for two thousand dollars (the same price he had paid for *Goin' Fishin'*).

<div style="text-align: right">

[Geneva]
29 June 1937

</div>

Dear Stieglitz,

A fine letter from you. I wrote right away, but on reading my letter over, I didn't like it, so here it is several days later. Haven't heard yet from Miss Bier in answer to my accounting. She may be away, but checks ceased promptly with the $1000.

Your idea of P. having "Me and the Moon" "someday at a decent figure" is classic. At least you have proved it already.

This place here is beginning to get worn in better, or we are. Of course, it is in the work. There were so many things to be done. Have gotten down to it now. We think them much stronger. Richer.

Haven't answered Dorothy's letter yet. Am not sure that there is material enough for a purely literary magazine. You came nearest with "Camera Work." It was beautifully done, but take out the reproductions from "Camera Work" and "Cahiers d'Art," and commentary would have to enter in. If it is fine enough, of course, anything can exist. Modern Music & Painting have come through. I can see the possibilities in words—and of course that should be the next battleground. But most of the warriors are so accustomed to writing *about* things that they can't believe it can be done on account of the word associations. Have heard some of the ones in "transition" talking. . . .

Well, anyway, am way ahead of last year, in time. Have many watercolors.—Canvases all stretched. And quite a few frames made.

Get up early and usually go on the water here. We have a small boat.

And by 8 or 9, I have almost a day's work done. Did one in a misty rain yesterday, and I think "The Lord" improved it considerably. . . .

<div style="text-align: right">

As always
Reds and Dove

</div>

Stieglitz went to Lake George near the end of June for what was to be his last artistically productive summer. In future years, he was not strong enough for the physical activity of photographing. O'Keeffe spent a couple of weeks with him at the lake, then departed for the Southwest. Again, she was among the Doves' summer visitors as she made a brief stop at their new quarters in the Dove Block.

<div style="text-align: right">

Lake George
30 June 1937

</div>

Dear Dove: Came up here on Saturday. The change is welcome. Georgia & I are here alone. The Perrys[1] drove her up & were here two days. I followed per train the day after they drove up.—Georgia intends going southwest about July 15.—All I hope for is a quiet summer. From Sept. 22, 1936 until June 26th, I was in harness uninterruptedly—day in day out. Pretty good for an old duffer.—For surely I am that.—

I hope you & Reds are doing as well as the gods (your gods) permit. Our love to you both.

<div style="text-align: right">

Your old
Stieglitz

</div>

1. Barton Perry was a friend of Bill Dove and Charles Brooks. He and his wife Harriet bought several Dove paintings. They soon moved to California, but remained in touch.

<div style="text-align: right">

[Geneva]
[2/4 July 1937]

</div>

Dear Stieglitz,

Much thanks for your letter and the P. check. You must have done some miracle again as, in the same mail, came the $250—and—what's more, he bought two of Bill's—$60 in all. And took Bill's friend to the ball game. . . .

Hope Georgia can stop off here around the 15th. She would enjoy arranging this huge place. If we could only paint it all white, we could make one of the finest galleries in this section.

Bill tells me Phillips is worrying about "Cows in Pasture." Doesn't like glass & the public *"especially artists"* scratch it with their fingernails, etc. He doesn't want it varnished—I suppose he thinks varnish means shine. I can put a coat of Mastic with wax that would make the same surface as was before. . . .

A long serious letter from Bill wanting to know many things.

"Quite a time with Phillips Sat. morning. He is quite a guy, very nice but still likes Tack."[1]

"The Place, for example, is just there, and knowing what it means by being there at least gives a feeling of belonging to something, a part of time, well you have some space in the whole scheme. That helps the 'follow through.'"

"Anyway, I think I know more what Stieglitz means to you and by the same token what you all mean to him. A place for people is so necessary."

Of course you have done wonders for them, and Marian has helped a lot where Bill couldn't help being prejudiced with all that he had been taught.

She thinks of the whole thing in a religious way. Spoke of coming to the house out there [on the farm] as "Like Going to Church." Well, it wasn't, I hope. They have their job for six months longer anyway.

The Rehms, Mary, George, & "Scoop," the child, will be here around the end of the month.[2] The child is quite remarkable. Evidently captivates boat & train crews and passengers. Gave a French lesson on the way to Michigan and earned a nickel. Starting moderately like that, he will be all right I think. . . .

Always
Reds and Dove

1. Augustus Vincent Tack (1870–1949), a romantic painter of religious subjects and abstractions, was held in high esteem by Phillips, his major patron.
2. Recently returned from France, the Rehms visited before settling on Long Island.

Lake George
5 July 1937

Dear Dove: Georgia tells me to tell you that she intends leaving Lake

G. a week from today & may pass through Geneva & stop in to see you & Reds but that she doubts her staying overnight. She is eager to get to New Mexico as soon as possible. . . . As for Bill, he certainly is getting a liberal education & he certainly has a trump of a wife in Marian. . . . I haven't the slightest urge to do anything. Never felt so lazy & useless. Not a thought in my head. Nor a desire in my whole makeup.—Heart behaving fairly well. Really very well all things considered.—Getting old is indecent. A nuisance.—I'm still too damned young in spirit. And that's in a way awful.—

As for the future, I have no picture of it. Georgia needs high altitude & I'll be glad when she is again where she feels most alive. Still, I'm glad that we have these few days together.—There is no question of her painting here.—She'd like to in a way, but nothing happens. . . . Dorothy is passionately at work on her magazine. I hope something will result. Principally for her own sake. Maybe she'll surprise us all.—I'd like that.—She is such a beautiful kid.—Fine soul & fine mind. . . .

<div align="right">

Your old
Stieglitz

</div>

<div align="right">

[Geneva]
[8 July 1937]

</div>

Dear Stieglitz,

Thanks for fine letter. And again for forwarding the Boni one.[1] These requests for information are getting so numerous. . . .

Have spent the morning answering requests for photographs of paintings, "explanations" etc. Also wanted by "Artists Union" of Phila. to give talk.

Mr. Wallace S. Baldinger, State University of Iowa, working with Dr. Ulrich Middledorf of University of Chicago & Mr. Daniel Catton Rich of Art Institute of Chicago on a study of the development of Am. painting since 1900. Wrote him a long letter & sent what reproductions I had. Told him a lot about you and your being the first to show modern painting in America. . . .

I wish we were all as young as you are. It is just plain nuts to speak of being old when you are not that kind.

Much love to you both, from us.

<div align="right">

Always
Dove

</div>

1. Charles Boni wrote on behalf of Living American Art to ask for an "explanation" of *Mars Orange and Green*. In the form of a color reproduction, the painting was being used by the Metropolitan Museum of Art in classes for children.

[Geneva]
[August 1937]

Dear Stieglitz,

It was fine to see Georgia.[1] She had a time getting in here as we rely on the telephone.—It was out of order that day and we didn't know it. She liked the place here so much. Said you would be crazy about it.

We have offers now. Think from what I hear there is a little boom but others say it will drop soon. Can't tell the optimists from the pessimists.

Georgia looks fine and ran up and down these stairways. Told the man who doesn't pay his rent to tear the door down, so he was a bit timid. He pounded hard so Reds came down and I had already begun to search the street & hallway. So we found her simultaneously. . . .

The McCauslands arrived at 12 Midnight the other day. It was a day as we expected them from 3 P.M. on.[2]

They are in Montauk now and E[lizabeth] writes that Berenice has a pain in the middle. . . .

Georgia spoke of wanting to bring Donald [Davidson] along. I had thought of it, but there were the others about to arrive and the Rankins and now the Rehms—Mary's child & husband.

I hope we do not have to move too soon again. It takes so much time. . . .

Love to you, Elizabeth and Donald as always.

Reds and Dove

1. O'Keeffe visited for a few hours on 12 July 1937.
2. Elizabeth McCausland and Berenice Abbott arrived on Sunday, 18 July. The next day, Abbott went to Buffalo while McCausland stayed on. Abbott came back to Geneva on Thursday, and the two women departed together on Friday, 23 July.

Lake George
1 September 1937

Dear Dove: Enclosed [Phillips's monthly check] speaks for itself. Prompt. I am not going to write. My left eye is bandaged up & I'm saving the other. Always something to try me out.—Nothing serious I hope. Just a nuisance. With love to you & Reds

Stieglitz

[Geneva]
[8 September 1937]

Dear Stieglitz

Thank you for your letter. I hope the eye is all right by now. You can see as much out of one as the rest can with two, but it is the rest who are handicapped more than you. Hope you can work.

Things are going fine here now. Have had one session after another of "company." We have asked all other applicants not to come. Have been working outside while they were here. Child on roller skates makes a huge hall small.

Our "relatives" have so many things in common with us that we can hardly bear it. . . .

Bill and Marian just left. Bill is much finer and you are right about her. . . .

Always
Reds & Dove

[Geneva]
[30 September 1937]

Dear Stieglitz

. . . . It has been a continuous session of company in one large room.

Even a pin dropping becomes an explosion,—if you have had company enough. We had a kid on roller skates. Reds is going to be all right with a bit of rest. Davidson will probably tell you all.—He just left this noon for N.Y. Frances O'B[rien] & sister with Emmet were here, but I met them outside as the Dr. [Dorothy Loynes] (We have a peach—one of the heads of the State Hospital—) said Reds shouldn't see any more people. So she and Donald were both here for dinner. I have heard the

story of the Lake for the summer and Donald will probably tell you the story of this lake. Guess I love lakes about as much as Georgia does. They seem as Reds says, like postal cards to the salt water. Of course, one can say a lot on a postcard too. . . .

When does Georgia come back? Hope she comes through here. The telephone is all right now so that she can get in more easily, without "Tearing the door down." That was funny.

<div style="text-align: right">

Love always
Reds and Dove

</div>

<div style="text-align: center">

[Geneva]
[11 October 1937]

</div>

Dear Stieglitz,

Reds has just read me part of what the underworld in art has to say in this last number of "Scribner's."[1] I thought of writing them, I know the whole bunch.—Went to school with Whitney Darrow, one of their vice presidents, and of course have worked for them.

They are certainly two of the swellest self portraits that have been drawn. All one has to do is to quote from the articles but I guess it is better to let it alone.

That "Boy with Dog" as Reds said, "You couldn't turn that dog's head back to save your life." Wrist watch is also needed.—There must be some disease between those two.

And to think that I once worked for "Scribner's"!

Their man on the cover may have, as they say, engraved 5 alphabets on the head of a pin but thought maybe he was doing a portrait of Benton & Craven selling "Feelthy Peectures" on the streets of Paris.

It was nice to hear of you.

Things going fine.

<div style="text-align: right">

Much love,
Reds & Dove

</div>

1. Thomas Craven, "Thomas Hart Benton," *Scribner's* 102, no. 4 (October 1937): 33–40. The illustrations included Benton's *Boy with a Dog*. The cover of the magazine carried a photograph by Leo Aarons of engraver George LeVind, honored by the magazine as a "master craftsman." He did indeed claim to have engraved five alphabets on the head of an ordinary pin.

When Stieglitz wrote the next letter, he had just opened the gallery for the 1937–38 season with a major review of work produced in the

days of his first gallery. The exhibition commemorated the twentieth anniversary of the closing of 291. *Beginnings and Landmarks: '291,' 1905– 1917* presented early work by Dove, Marin, O'Keeffe, Hartley, and other leaders of the first wave of modernism in America. O'Keeffe, Marin, and Dove in that order continued the season with their individual exhibitions.

[New York City]
30 October 1937

Dear Dove: Enclosed Phillips check. Also another check for $100 due you. The Show on now is beautiful. Today is Saturday & 3 P.M. & so far not a soul has been here. A record! Fortunately I am steeled. May be the Place is under the ban of Hitler or Benton.—
 But whatever—

Love to you & Reds
Stieglitz

[Geneva]
[1 November 1937]

Dear Stieglitz
 Fine of you to send on the checks. The $100 I do not understand but suppose I'll find out in heaven if they have bank accounts there.
 Is Georgia back yet? Please tell her I have those dishes ready to send including the white one she admired.
 We are alone for a change and things are going fine. Have the underpainting done on 18–19 of the oils.
 Reds is getting better under our new doctor's care. She is psychiatrist at Willard State Hospital, six feet tall, and likes the paintings. Dr. Loynes. She has taken Reds to the Biggs Sanitarium near Ithaca, gotten a full x-ray report that she is absolutely sound—even the teeth which worried us. A relief. Have had to chase everyone out of here, even my brother. Dr. Loynes offered to give me half her salary the other day so that we could get away from this situation & work in peace. She is that kind of a sport.
 You will probably see Bill & Marian this weekend. You have been a godsend to them. Fine to see it all taking root. . . .

As ever
Dove

Bill Dove quit his WPA job in Washington around Thanksgiving. He and Marian went to Florida until the following March. Paul also spent the winter in Florida. Although he did not approve of the way that his brother handled business and financial affairs, Paul had decided it was more peaceful to go South during winters and let Arthur operate with a free hand.[1]

1. Interview with Paul Dove, June 1976.

[Geneva]
[Probably 3 December 1937]

Dear Stieglitz
 Things going fine here. My brother has gone south.
 Bill & Marian leave today for Florida. Did I write you that Bill quit after a fight over their wanting to paint his job pink? Phillips just bought one of his Maine things.
 The show sounds so fine! We hope to get away as soon as the paintings are finished. They look big on this huge wall. And as each one gets its overcoat they seem to walk forward. There are about 25 now. (Most of them in tempera so far. They have still to get final painting.) May not have so many *framed* watercolors. Have about 14 frames all done for those. It might be just as well to have more space for the oils on the walls and more of the best watercolors in portfolio. . . .

Always
Dove

[New York City]
3 December 1937

Dear Dove: I have been rushed beyond anything yet & have been far from well.—The "load" grows heavier & heavier. Andrew, who is my mainstay—devoid of all intellectualities & curiosities—who doesn't smoke or drink—is absolutely prompt & reliable—a first-class work-man in whatever he is fitted to do, well, he is a pretty sick man & may have to go on the table!—What I'd do without him I don't know. No one can replace him.—So one "waits" to see what will happen & be ready for whatever it may be.—The Show is a grand one, but attracts little attention. I could have made it a howling go for. I know all the

tricks that bring the mob.—All I would have had to do is called the Show "Exhibition of the Original Sin."—Well, it's better this way.—Fortunately Georgia is well & has a good Show ready. . . .

<div style="text-align: right">

Love
Stieglitz

</div>

<div style="text-align: right">

[Geneva]
[5/10 December 1937]

</div>

Dear Stieglitz,

Thanks so much for the letter. It is a shame for you about Andrew. I only wish I could be there to help. I could do the work part with a bit of training, and, if there were a place to paint near, do not think it would be any more distracting than this Geneva. They are spending $2000 putting up lights and Christmas trees which would support two families. They couldn't cheer this goddamn town up with $50,000 worth of lights. From that you can get an idea of what we think. "We" are "I" for a couple of days. Reds is in L.I. with her mother. Her brother hung himself.—Long built-up wife trouble. Mother expected it. He was nice. 4 children—but they always get on somehow.

Painting went fine again today. Maybe we can be able to have an "Exhibition of Original Sin," if our enemies are only good enough. I wonder if you remember one day at the Holland House? That Sweedish critic made that old asinine remark—that "Some of my best friends are Jews." I wanted to get up and yell "All of mine are and they are right there!" But thought best not to spoil an otherwise nice luncheon.

Had a row this A.M. with New York Central R.R. about a suit—finally persuaded the man that they owed us and he decently agreed with me. That sort of thing every day makes it hard here. However, the painting got done.

Give Georgia love and congratulations on her show.

Have been sitting up with the Nebel sick child—adult mind. 6 years. Nurse said within his hearing that he had a "good chance of recovery." He rose up and screamed that if he were that bad off, he wasn't going to try to get well. Called for one of those God-awful chain-store red cut-outs of Santa Claus they had set up at the foot of his bed and tore it to bits. Rare sense! They operated on him for ruptured appendix. It was perfectly all right. They are always sure they are right about the wrong thing. "Be sure you are right and then go ahead." They do. . . .

So much love as

<div style="text-align: right">

Always
Reds & Dove

</div>

<div align="right">

[New York City]
28 December 1937

</div>

Dear Dove: The O'Keeffe Show is open & mob appears. Where it comes from I don't know. And how it knows when, I don't know either. I'm about all in for a change. Still going strong.—
 Our love to you & Reds—

<div align="right">

Your old
Stieglitz

</div>

 Dove's next letter to Stieglitz was written the day he received the gallery brochure for O'Keeffe's show. In it were reprinted some of her letters.

<div align="right">

[Geneva]
[29 December 1937]

</div>

Dear Stieglitz,
 The O'K. notice [came] this morning. The letters are beautiful. And as I told her, I hardly knew that she could read and write. Of course, I remember years ago, as along with the watercolors.[1] And a couple of notes from her since. Hope I can see some of the work before it is gone. . . .
 Probably Dr. Dorothy Loynes will come in to see the show. She is psychiatrist at Willard now and is moving to Brentwood, L.I. on the first. She is about 6 feet tall, or more, & has bobbed premature gray hair.—About 35. You will all like her. Really interested in paintings.
 Have been working today. Another done. . . .

<div align="right">

Always
Reds & Dove

</div>

1. O'Keeffe had purchased a group of Dove watercolors in 1935.

 Dove wrote also to O'Keeffe the same day that he wrote the preceding letter to Stieglitz. She responded to Dove's teasing in a subsequent reply: "Yes, I read and write a little— . . . We had to print those letters because so many thought as you do that I couldn't read or write at all— and it is just as well in these times to be able to do a little of both on

account of the newspapers— . . . I don't like to patronize the printed word—there is too much of it. . . ."

[Geneva]
[February 1938]

Dear Stieglitz

. . . . Do not think we have to worry about the paintings now except for fire etc. Have 24 pretty well done on the big wall here. It will take two or three weeks to polish them and get the frames which are well on the way. Had to stop this A.M. to dispossess one of those Cr[edit] Bureau & Finance Corporations.—So dishonest one could hardly believe it.

Bill & Marian seem to be starved for news of the Place. Einstein wrote them but just that he was going to Italy.

Every one in Geneva dead or dying or just walking around. Guess we'd better get out.

Read Mc[Causland]'s article in "Parnassus" on O'K. This idea of sociological painting is getting to be an obsession with her. About as important to painting as Hitler.

We are trying to get moved for good. Can't keep up this moving and settling twice a year indefinitely. L.I., probably somewhere between Huntington & Port Jefferson. It is big from Cold Spring on.

The things look well here, so think they should in the Gallery.

Always
Reds and Dove

The McCausland "article" on O'Keeffe read as follows:

The evolution of Georgia O'Keeffe, whose fourteenth annual exhibition is on view at An American Place until February 11th, is a striking example of how even the most withdrawn of creative talents must respond to the main currents of contemporary life. The dominant trend of the present day is certainly toward a realistic social art, and certainly O'Keeffe has been at the opposite end of the spectrum from realism and social content. Yet a new direction was indicated in her work when two or three years ago she began to paint horns and feathers and horseshoes instead of unearthly flowers; the Canadian barns being also evidence of this new objectivity.[1]

Dove's strong reaction against this mild attempt to point out connections between O'Keeffe's work and the prevailing realist spirit of the

thirties suggests how wholeheartedly he (and Stieglitz) believed in a personal art, regardless of "the main currents of contemporary life."

1. Elizabeth McCausland, "Gallery Notes," *Parnassus* 10, no. 2 (February 1938): 29.

<div style="text-align: right">

[Geneva]

[22/26 February 1938]

</div>

Dear Stieglitz

A note to let you know that I'll be ready by the 20th [of March], if you need me. Quite a swell wall of 24–5 paintings. My God! How they have gotten done I do not know. Fires, lawsuits, I really was worried about the work last Sunday. Yelled for Reds to call the fire dep't. They were here in 2 minutes, fortunately. Chopped a hole in the floor. . . . A Western Union messenger boy had left a pail with a mop in it in basement on a gas plate.—Just a bit more and we would have been gone. Warning among many others that we should get out of here.

Thursday we had to have a police sale of the Credit Bureau, which I have wanted to get rid of for the last 3 years. Hope I do not get a lawsuit on my hands for doing it, but going cautiously as they are rather considerable crooks. A nice atmosphere for an artist, but, sometimes the contrast is a help. It all takes so much time.

. . . . The things [paintings] look big—different. I am not worrying about them. If they look big here, they should there, as this place is huge.

We want to come during the Show and look around L.I. for a place for the summer or for good.

Another fire, fortunately they only stop here occasionally. We are on the main square of the City so see and hear everything—even Salvation Army concerts every evening. Have listened all winter and are not saved yet. . . .

<div style="text-align: right">

Always

Reds & Dove

</div>

[Geneva]
[7 March 1938]

Dear Stieglitz
. . . . Have 24 [paintings] now—spoiled one last week with that god damn Credit Bureau lawsuit. Am trying not to get ourselves sued by selling their records. Their manager left the day we served them with notice. . . .

Well—Prof. & Mrs. Boswell came in the other day & said they had $100—$50 before. He likes the "Wood Pile." I do not think she really likes any of them deeply. They are the people of "Lake Afternoon." Nice, but she paints and has a small Lawson.[1] And her own water-colors. . . .

We expect Paul back soon and want to get things moving before he tries to block them—then out for us. Perhaps in more ways than one. He has been yacht racing as crew in Fla. A millionaire without a cent. . . .

Think I can do ten times as much work on L.I., if we can only be left alone.

Much love

Always
Reds & Dove

1. Ernest Lawson (1873–1939), a Canadian-born landscape painter who exhibited with The Eight and in the Armory Show, developed a personal, heavily impastoed technique based on Impressionism. He and Dove had been good friends years before, during Dove's New York days.

Dove had sent Stieglitz a Duncan Phillips letter, which Stieglitz returned with his next epistle.

[New York City]
8 March 1938

Dear Dove: Phillips amuses me. He doesn't realize that he took away from me your "Nigger Goes a Fishing," which, when you had made it, he asked me why I allowed you to do anything as absurd as that!!—I told him at the time as he felt that way I'd buy it. And did. When finally he insisted in having *that* Dove last year I reminded him of

the story. So he sent you $1000 & gave Dorothy Norman $1000 for the Rent Fund. As for myself I took "Me & the Moon" in place of "Nigger Goes A Fishing." Now I wasn't going to let P. have that for $333.33. That's what he doesn't see. He is all right. But so am I.—I have always made it a rule never to take anything out of a Show until the public has had its chance. On 3 occasions in all these years I have made an exception & always for reasons like the one in this case. That's that. Have you that thing Phillips wrote about you last year? We might reprint it.—Of course I'm looking forward to seeing your new work & seeing you & Reds.—With love to both of you—

<div align="right">Stieglitz</div>

<div align="right">[Geneva]
[22 March 1938]</div>

Dear Stieglitz,

. . . . They [the paintings] have more bite than last year, naturally. Life must have more than just the beautiful.

Have done two more—one yesterday and one today, I hope—not finished.

I do not know how they got themselves done with all the riot here. Lawsuits, fires, rich man, poor man, beggar man, thief—and relatives. Believe I must belong to the paranoia family, believing in "the *delusion*" that the world is fine and that you should treat your relations as human beings.

Have another 6 or 7 watercolors & maybe 2 oils coming along this week.

Can't leave here before the first on a/c of taxes, New York Central, and other sons of b's. Maybe it will be better to wait.

The Boswells were in again.—Maybe it's investments 50%, Lady bountiful 75%, Art minus 25% =

<div align="right">Always
Reds and Dove</div>

In a letter now missing, Stieglitz informed Dove that Phillips had been to the gallery and had decided to take some paintings. Dove wrote the next letter the same day that Stieglitz's arrived.

[Geneva]
[25 March 1938]

Dear Stieglitz,
 Another masterpiece. You're remarkable! It settles the whole situa-
tion for us. It will get us out of Geneva. I felt it coming, but it was a
complete surprise nevertheless. Am wondering if he [Phillips] took
"Holbrook's Bridge" [*Holbrook's Bridge to Northwest*]? That was a devo-
tional thing to my 100-year-old friend Mr. Weatherly with whom I used
from the age of 5 to go fishing there. And he made a prayer each year
that he would see it again. . . . He was a painter—naturalist. A great
person—five feet tall. Or less. Bill enlarged a photograph I made of him
with a homemade camera. I'll bring it down. He was like cloth and
vegetables and leaves in the woods. The finest soul I have known up to
you.
 Well, anyway this is a great turning point. With peace next year, I
think things will march on. Maybe this strain was good.
 The place here is big.—I want to see them there—with you.
 Thinking of you—life after all is pretty damn swell.
 Love

As ever and ever
Reds and Dove

[Geneva]
[13 or 14 April 1938]

Dear Stieglitz
 A fine letter from the Lane Rehms. Who are about to take one of the
paintings.
 They say McB[ride] wrote something nice.
 One from McCausland, one of the best she has done.[1]
 As the plot thickens, it is getting exciting.
 We hope to come this weekend or first of next.

Love as always
Reds & Dove

1. Henry McBride's article appeared in the New York *Sun,* April 1938. Eliz-
 abeth McCausland's piece, titled "Arthur G. Dove Exhibits at An American
 Place" was published in the *Springfield Union and Republican,* 10 April 1938,
 sec. E, p. 6.

7
1938–1946

During these years before both men died in 1946, poor health circumscribed their activity. The Doves lived once again on Long Island, but Stieglitz and Dove saw each other only seven times in eight years. Stieglitz was less inclined than ever to leave his gallery, while Dove, a semi-invalid, was simply not well enough to travel into the city.

Their professional dedication sustained both, although in different ways. No longer able to pursue his photographic work, Stieglitz became the full-time figurehead of An American Place, now a shrine for his "trinity"—Dove, Marin, and O'Keeffe. Once, in a group show, Stieglitz showed his own photographs and Picasso's work. In another instance, he introduced one last younger talent, the photographer Eliot Porter,[1] and simultaneously showed one last group of the deceased Demuth's paintings. Otherwise, in eight seasons he showed only his three regulars, the mainstays of two decades. Slowed by age, Stieglitz remained driven, even though his compulsion to preside at the gallery sometimes meant that he did so from a cot in the back room. If he was too old to carry on with former vigor, he nonetheless felt that he had to follow through on anything he started; in his mind, this principle justified limiting his attention to Dove, Marin, and O'Keeffe. He could not accept more responsibility. An American Place became a lonely aerie where sometimes only two or three visitors appeared in a day.

While Stieglitz was no longer active as an artist, Dove not only continued to paint despite all odds, but reached the peak of his creative power in stunning abstract works, many of which foreshadowed color abstraction seen decades later. All of this painting was accomplished in a

400

one-room house that he rarely left, on those days when his doctor allowed him to work. Reds virtually abandoned painting; she was busy with housework, errands, and caring for her husband. Sometimes Dove was bedridden; at best, he was not strong enough to conduct normal activities. His few expeditions to New York were by private car to the door of Stieglitz's Madison Avenue gallery and back again in a few hours. Fortunately, with his health a constant burden, Dove's financial position was never quite so abysmal as it had been previously. He benefited from Phillips's unfailing support, and he and Stieglitz had fewer complaints about his benefactor's behavior.

Letters continued to provide a lifeline between them, although Stieglitz and Dove wrote to each other less often than they had earlier. Illness sometimes interrupted the sequence or limited the length of letters, but the correspondence did not diminish markedly until the last year of their lives.

1. Eliot Porter (b. 1901), brother of painter Fairfield Porter, is known for his color photographs of nature.

★ ★ ★

The alteration in both men's lifestyles occurred dramatically in the spring of 1938. In mid-April, while his show was on view at the gallery, Dove and Reds set off from Geneva with the intention of seeking a residence near New York City while they visited there. Dove contracted pneumonia while they were in New York, and he never saw Geneva again. After he and Reds bought the tiny house on the edge of Long Island Sound where he would live the rest of his life, Reds and Bill returned to Geneva to pack and transport the Doves' belongings, while the artist stayed with his daughter-in-law. (Bill and Marian had moved to Cold Spring Harbor, on Long Island, when they left Florida early in the spring.)

Stieglitz also was stricken in April, shortly after Dove. A severe heart attack was followed by pneumonia. Both men were left seriously weakened but at first tried to ignore their disabilities and sometimes exceeded their strength. Dove was still recuperating from the initial illness when he next wrote to Stieglitz.

[Cold Spring Harbor]
17 May 1938

Dear Stieglitz and Georgia,

Hope you are coming on fine. Reds and Bill left this A.M. for Geneva to pack a camp for us until we can get owner's wife to sign up. Marian and I are keeping house here in Cold Spring, L.I. Thought best not to take a long drive with after-effects of almost pneumonia. Have baked in sun today & cured a sinus in *3 hours*, with help of Vicks. Sun will do almost anything. Love to you both from Marian & Me.

Always
Dove

Dove's next letter was written from his new Centerport home, a little frame structure that had previously served as the post office. For this residence on the north shore of Long Island, only a few miles from Huntington and from the Doves' former yacht-club home in Halesite, they paid only one thousand dollars, although additional expenditures were needed to make it comfortable. Its location on an inlet of Long Island Sound afforded views across the water and along the shore, providing much to interest Dove's eye in the coming years of restricted mobility.

[Centerport]
[Probably 30 June 1938]

Dear Stieglitz and Georgia,

Have been telephoning instead of writing, thought it better all around. Now that you are sitting out in the sunshine (?) guess it will be all right. Georgia, you were right when you told me to go to bed in N.Y. We are delighted at Stieglitz's improvement. Our Dr. Loynes told me a week or so ago not to budge off the porch until she came back. This sunshine does make a difference in one's feelings. This porch is fine and I can sit and make drawings—hands a bit stiff even yet.

They are so particular about this harbor, inspectors, etc. Am glad though, at least will be when we get time to enjoy it alone. May call it "NOT INN."

The Perrys were here Saturday. Little Pablo hardly looks like either of them at all. Think they must have rented him. We enjoyed them so much.

This wildlife about here is rather sexy. Ducks seem to be about their father's business most of the time. They hold the lady ducks under the water so long that everyone expects them to drown. The swans are a bit brutal, they try to kill the young ducks. Had a battle royal between the male swan & a mother duck. Mother duck won, but I noticed next day she had one less duckling. We had to stop feeding them. Caused jealousy.

Don't try to do anything. I was stupid about it—came over here and tried to work on ladders etc., so set myself back about three weeks.

We are so much happier here. Inconveniences and everything considered.

Much love to you both

<div style="text-align:right">

Always
Reds & Dove

</div>

<div style="text-align:right">

[New York City]
1 July 1938

</div>

Dear Dove: It was good to hear from you.—I do hope that you will regain your health soon.—

My writing is very shaky. It's the first day in 11 weeks that I'm using pen & ink.—As a matter of fact, I have written but one letter a day—& that in pencil—the past few weeks. Before that, none since my collapse. This is primarily written to send you & Reds our love.

<div style="text-align:right">

Your old
Stieglitz

</div>

By mid-July, Stieglitz was well enough to go to Lake George but not to do any photographic work. O'Keeffe later went to New Mexico and visited Yosemite in September.

<div style="text-align:right">

Lake George
24 July 1938

</div>

Dear Dove: I hope you are your old self again or nearing that state again. We can't afford to lay up we old fellows.—It's too much of a luxury even in these [days?] of super-affluence—for politicians.—It's slow business getting back into harness. Arrived here 10 days ago. My

nurse—a wonderful woman—accompanied me here.—As soon as she arrived her legs went back on her! A day later my brother's wife died[1]—fortunately she had been taken to her old home, Southbury, Conn.—And Margaret's—you know our mainstay for years—son broke his leg—coming down a mountain. Fortunately was found immediately. He had been alone. Then Georgia arrived here with a lame arm—has it in a sling & is being treated for it. And I'm the invalid.—The "patient" took care of the nurse.—She returned to town when Georgia came.

—I may not talk more than 15–20 minutes at intervals.—Hardly see anyone. There is great quiet on The Hill.—Have no camera or any photographic material with me—first time in 55 years.—Read a little. Eyes won't permit much.—My one thought is to become fit enough to run the Place by autumn. Of course spending myself as I have been for years is a thing of the past. Essentials will be attended to. The only trouble is [to] know what essentials are.—

Our love to you and Reds & the kids.

<div align="right">

Your old
Stieglitz

</div>

1. Dr. Leopold Stieglitz's second wife.

<div align="right">

[Centerport]
[Probably 25 July 1938]

</div>

Dear Stieglitz and Georgia,

. . . . Have been trying to get well enough to come to see you, but this God-awful weather is so hard to recover in. Makes one feel as though someone had forgotten to take a grindstone off your chest. Was going to call by phone this morning at P.O., but felt you were at the lake. Walk to P.O. now and drive in the car some. To Northport this A.M. Made a drawing. . . .

Our friend Dr. Dorothy Loynes has done so much for us both. I offered to trade some art for some science last year in Geneva. Dr. Nebel bought one of my watercolors for her. . . . She is now in Brentwood, L.I., psychiatrist & M.D. She was in at show, but never spoke to you as I told her. Very able and very shy—or modest. She likes the small one of the "Park" [*Cutting Trees in Park*] . . . and the one of the "Sea Gulls" (not hung). I thought perhaps the "Sea Gulls." "The Park" being a general favorite. Of course she was mad about the moon [*City Moon*]. And some of the large ones. . . .

Have been doing some work. Began, really, yesterday. Can't work long, as I stand up to paint, on a table.

That hard-boiled duck I spoke of put it all over the big male swan yesterday. He went for some little ones and she flew at him, biting his head & eyes and drove him to the middle of the harbor. He didn't have time to do anything but hiss. Think we could use her sometimes at the "Place."

Much love as always.

Reds and Dove

[Centerport]
[Probably 10 September 1938]

Dear Stieglitz

I am wondering how you are. Am learning gradually to take it easy. Arrived at the stage of feeling fine and then fell for the idea of going clamming, oystering as in the past. They let the floodgates open. Getting to the center of the harbor opposite our place seemed easy, but after getting back with about 75 pounds of clams and oysters over the mud and marsh grass, it did me in for another little setback. I love this swashbuckling around the salt water—we have been used to it and almost lived by it in Halesite for a while.—

A long letter was written just before yours came sending the check. Thank you. It was full of what I should do about wills, the place, the kids etc., but tore it up thinking best not to let you worry about one thing more.

Everyone seems quite delighted with this place. It is beautiful. Part of it is out over the water. We have cemented the foundation and are putting in a double floor. Someone has given us a folding bed which we leave open and has proved to be the best we have had since the boat. Have slept in it two nights and feel 100% better. This was the original post office here. The knots are worn so they stick up from the rest of the floor.

How is Dorothy getting on with the new magazine? I had in mind something to send her that Reds took down in her quick writing. It was a conversation between Alfy and me that was quite remarkable. Alfy was that evening.

I and We think of you all the time knowing how hard it is to recover from this sort of thing. I should have called Dr. Stieglitz—perhaps it would have been final rather than casual. . . .

Probably better not to have your working materials near for a while—I try to keep going—25 watercolors—Dr. Loynes says the best yet. Am happier anyway.

Love to you all

<div align="right">

Always
Reds & Dove

</div>

<div align="right">

Lake George
12 September 1938

</div>

Dear Dove: All the paintings that are your "property" & which are in The Place are labelled on the back "Property of the Artist." Einstein labelled everything in the Place. So he told me.—

I was in town for a day to see a skin specialist. For 3 months I have been sort of tortured.—Aftermath of pneumonia, etc. Very trying & hard to get rid of.—I was at The Place for a few minutes. Andrew told me young (?) Mrs. Dove wanted the "Seagulls" for someone. He said he had no "orders." Well, the painting can be called for. Now he has "orders." I must laugh. But it's good to have someone as loyal & orderly as Andrew. He cannot be replaced.—

—I'm glad to hear you are better & turning out watercolors. I can imagine you are happier where you are than you were in Geneva.— Georgia seems to be having a great time. Is in the Yosemite Nat'l Park, California, at present. Says it's very grand & very different from New Mexico. All I hope is that she remains at least tolerably well. You know that feeling.—

I still have no plans.

Can't have any.—

The Place looks very austere & clean. Ready for "action" at a moment's notice.

Ross is here & is taking down stories out of my life. Not an autobiography. Just episodes, anecdotes or whatever the business should be called. What will or can be done with the series I don't know.—Ross is a fine refined quiet capable young man—very sympathetic. Unfortunately he must leave a week from today.—Some time early in October I'll probably report for "duty"—Hitler willing.—What next?—A great world but the best we know as the Swami said last year.—The best altho' corrupt to the core.—

Elizabeth must be arriving in France tonight on her way to India.— Should she risk it or not? Being Elizabeth she took the chance. Mar-

garet Wilson (President W.'s daughter) & another woman are with her. India awaits them!—Naturally E.'s parents are a bit "nervous."—Donald is in great shape. Lives in the house here. Eats at the Upper House. Sue & Peggy were in Camp nearly 8 weeks. Are here now. Two busters.—The Hill is very peaceful & if I hadn't that damned itch I'd think the world a pretty swell affair in spite of big & little messes everywhere.—In spite of itch & torture, I think it anyway. Love to you all.

<div align="right">

Your old
Stieglitz

</div>

<div align="right">

[Centerport]
[14 September 1938]

</div>

Dear Stieglitz:

Your fine letter here and you sound so much better. We are delighted.

About the paintings.—Please know that I have never given a thought as to which belonged to either of us as I have often told you they are as much yours as mine, and you have put as much work and probably more thought into them. If we went over them one by one I wouldn't know or care.

As it stands I just made a simple will dividing between Reds & Bill. Bill is getting more from Geneva than I am so thought it would perhaps be best to leave everything to the Place to be distributed as everyone saw fit. Finally feared that the Place might be in the same position that I am, so did not want to bestow any white elephants. That is all that has been done—I just do not want to bother you with thinking about it at present.

The "Sea Gulls" was one that Dr. Dorothy Loynes liked. I offered to trade art for science with her and she has done about $200 worth of work for us, has taken Reds to places where we could not have gone. Her services belong to the state so she can't accept money. She has one of the watercolors that Dr. Nebel bought for her.

The last three days are the first time in quite a while I have felt like much. I also have that damed itch, but didn't know it was an aftermath of pneumonia. It hits me worst now just behind the testicles so I have to keep going fast.

Glad Georgia is so pleased with Yosemite.

Shall be interested to see what Ross is doing.

It is fine for Elizabeth to be realizing her ambition. Love to Donald, Peggy, and Sue. I have never heard whether Peggy made her college.

Two more swans flew in 2 days ago so we have six here now. The two young are the largest, and still quite brown. They fight the invasion day and night.

We have a foundation to keep out wind and yesterday I bought 500 sq. ft. of maple flooring for $9.00. New it is worth $55 or so but think after it is sanded by machine we can spend the first warm winter in years. Have one of those station stoves.

The kids are fine & Bill is working. Haven't been back there but once since we moved. Don't dare leave coal fire much. We have had to keep a small one in a laundry stove. Reds is now making up our folding bed which we keep open. It was a gift. Has a black cover and elaborate head. Told Reds all it needed was Cardinal Hayes.

Am off to a place near Greenlawn. Reds has done some fine drawings. Getting at it. Can't quite realize we are settled after so much continual moving.

Much love to you all from Reds and Dove

As Always.

By fall, Stieglitz had sufficiently recovered to launch a normal complement of exhibitions at the gallery. Marin opened the season in November. A simultaneous showing of Eliot Porter photographs and Demuth paintings followed, these being the last one-person presentations at An American Place of any artists other than Marin, O'Keeffe, and Dove. O'Keeffe's show opened in January and Dove's in April.

On 21 September 1938, Long Island was hit by one of the worst hurricanes ever to strike the area. The Doves' new residence escaped serious damage, but Reds and Dove had to spend a night at the inn across the road from their house. Bill came the next day to help them "pour water out of things."[1] and Dove told Stieglitz about the event the next time he wrote.

1. Diary of Helen Torr Dove, 22 September 1938.

[Centerport]
[11 October 1938]

Dear Stieglitz,

We're still here but have been busy picking up the pieces. The trees all missed us but one that went through the roof. Our swell locust tree was uprooted, fortunately in the first part of the storm. Otherwise it might have crashed the house. We had to get out [in] water to our waists. Went to Mueller's Water Mill Inn for night. Their trees were snapped off. Had they been uprooted—the dam would have given way and we would have had an address [of] the "please forward" kind. We came back after the water went down and found all shoes, drawers of clothing etc. had been floating round the room.

One story. I made a bailer to take water out of the rowboat. When the boat was full of water and I thought bailer would float away I hung it on a nail on the wall of back porch. I found it in the boat the next morning. It had blown off wall, gone up the harbor & blown back into the boat full of water.

Bill has been in bed with cold but all right now. They expect the young Van Wyck Brooks today.

Was going to call you up yesterday, but it was rather difficult across the road here as they seemed to have so many guests who sing. No phone here.

The Doves' home after the 1938 hurricane, Centerport, New York. (William C. Dove, Mattituck, New York.)

Reds and Dr. Loynes may come in Tues. or Wednesday. She is taking Reds to oculist. . . .

Will see you soon. Am not entirely well yet.

Much love from

<div align="right">Reds & Dove</div>

. . . Rubbing alcohol on a damp washcloth is good for that itch, I found. . . .

<div align="right">[Centerport]
[30 October 1938]</div>

Dear Stieglitz,

It is so fine to hear that you are looking well and in good spirits. We enjoyed the kids' visit to you as much as they did. They showed us the new magazine [*Twice A Year*] notice.—Am sending check for subscription.

Dorothy asked for material some time ago. I had in mind an evening's conversation that Reds took down between Alfy and myself on the moderns from Renoir, Miró etc. It was interesting—Reds thinks some of my things might be more so.

Marian & Bill were over today. We stretched 5 canvases, 25 × 35, among other things.

This place gets more beautiful as we get more time to relax and enjoy it.

We have the wild ducks so tamed they will flutter at the window to get us to feed them. Of course it "Comes Down to" Food—their form of money. We have Canadian Geese here too. One of the ganders followed a flock north. His mate had a broken wing so couldn't make it. She didn't eat for two weeks until he came back to take care of her.

We want to get in soon but any exertion seems to take it out of me. Dr. Loynes wants me to see Dr. Leo [Stieglitz] & get a complete checkup. Thinks there is some slight infection, and wants to locate it. . . .

<div align="right">As always
Dove</div>

[Centerport]
[Late November or December 1938]

Dear Stieglitz

Thanks for mailing check. I wonder how you feel. The "Twice a Year" is great and your things even finer than ever. I want to read them many many times.

There is so much to be done here just to make it liveable. Water froze this morning, but it was a grand Christmas present when after booming the stove, it began to trickle through. However we are warmer than in any place we have been since leaving the boat. This is Saturday so expect visitors. Have told everyone that we are not at home other days. The place is interesting so people just like to come and look out of the windows, if nothing else. It is so easy to make dependents even of ducks etc. They wake us up at 5:30 every morning for food. And they certainly can raise hell.

Have been better the last week. Have a weakness for action so get temperature & go to bed for a day. We are both working. . . .

A nice letter from Conger Goodyear saying that "In the first extensive presentation of the work of American artists ever made in Europe,[1] we were very glad to include your fine collage 'Nigger Go Fishin'" etc. etc. . . .

Marin mentioned in Kay Boyle article, this last "New Yorker," or one before.

If I could go anywhere, we should have been in long ago to see you.

No one told me in time, except Georgia & Reds, how careful one has to be. Am on the gain now, however, rapidly, I think,

Our love to you all as

Always,
Reds & Dove

1. *Trois Siècles d'art aux États-Unis,* Musée du Jeu de Paume, Paris, 24 May–31 July 1938.

[Centerport]
[December 1938]

Dear Stieglitz and Georgia

It was fine of you to send us all the good candy and to include an

Arthur Dove feeding ducks, Centerport, New York, 1940s. (William C. Dove, Mattituck, New York.)

invitation to dinner. Would have loved it. Have been shut in here again for a few days for getting another setback.

Took woman and sick child to Northport to doctor. Dr. was late and I had to wait in cold 2 hrs. so raised a temperature and went to bed. All right now and work is going fine. Am not worrying about results this year as we have twice the uninterrupted time and we like it so much more on the island here.

Reds is on the way to P.O. and will mail this.—Much love and thanks to you both from us.

<div style="text-align:right">

As always
Reds & Dove

</div>

Dove's chronic "infection" and tendency to run a temperature during the late months of 1938 were the prelude to a massive relapse that incapacitated him for the first eight or nine months of 1939. Precisely what afflicted him at any given moment after 1938 can no longer be described with certainty. Dove talked only about his weak heart, but this condition was aggravated by Bright's disease, a kidney malfunction that tends to elevate blood pressure. Bedridden, then confined to a wheelchair during the 1939 crisis, Dove had a nurse at the house daily.

Stieglitz doubted that Dove would ever paint again,[1] and indeed, he had only three new canvases completed in the spring of 1939. Stieglitz supplemented these with a retrospective selection for Dove's 1939 show. Despite the lack of new work from which to select his annual choices, Phillips generously continued payments, while Bill Dove, Stieglitz, and others conspired to channel money to him through Stieglitz, who could obscure from the ailing artist the exact sources of the funds.[2]

1. Stieglitz to Duncan Phillips, 3 June 1939, Phillips Collection, Washington, D.C.
2. Interview with William Dove, November 1975.

<div style="text-align:right">

[Centerport]
[January 1939]

</div>

Dear Stieglitz: . . . Am still in bed as you can tell by the writing. Tomorrow will make two weeks. Ought to be up in two or three days as temperature has been gone for four. Have excellent doctor Bernstein. Greenlawn. We found him when Reds sprained her ankle a few weeks

ago. She insisted upon a Jewish doctor. Have to store up energy for a few days more. It is *very hard work*. Something to be done every few minutes. I don't know how Reds stands it. Sinus has been keeping the infection up. Our Dr. Loynes is in bed with it in Brentwood. She insisted on my going to Dr. Stieglitz a month ago. Should have done that last May when in N. Y. Is your cure a good and permanent one? I do hope so. The kids said you were fine. . . .

<div align="right">Dove</div>

<div align="right">[New York City]
[21 January 1939]</div>

Dear Dove: It's rotten that you must be ill.—I do hope that doctor will set you up soon.—Don't worry about painting. I'll put up "old" things of yours if necessary. They'll be new even to those who may think they have "seen" them before.—Georgia goes to Honolulu in 8 days.—Much travelling.—She is eager for the experience.—Her Show is up.—Looks well. Isn't as "exciting" as heretofore.—It's a wonder there is anything at all to show.

 Our love to you & Reds.

<div align="right">Your old
Stieglitz</div>

N.B. You might feel more comfortable if you had $100 extra cash.—

<div align="right">[Centerport]
[January 1939]</div>

Dear Stieglitz,

 . . . I gather you are on your toes again. . . . It would be fine to be there but the doctor is keeping me off my feet while working on these large ones. Think the first week in March ought to find what I have planned ready, if all goes well.

 Am certainly in training. . . .

<div align="right">As Always
Reds and Dove</div>

[New York City]
20 February 1939

Dear Dove: Naturally, I am wondering how you are faring. It's often slow work getting on one's feet after a severe illness. I know.—And by severe, I mean chiefly a prolonged one. . . .

But above all you must get on your feet. And as I have said before don't worry about exhibitions. There'll be a Dove Show end of March—a sort of Selected Doves affair.—It will be handsome. I want Georgia back to select & hang. She is better than I am.—Once more this is chiefly a greeting to you all.

Our love goes to you. The men inquire about you.

Your old
Stieglitz

[New York City]
6 April 1939

My dear Dove:

Your Show looks & is very solidly beautiful.—I hung it. The first Show I have hung single-handed in 22 years! Love to you all.

Your old
Stieglitz

[Centerport]
[Late April 1939]

Dear Stieglitz,

. . . . Dorothy Loynes was in Tuesday and had a grand time with you. Thinks you are a "marvelous person."

Miss Perry, the nurse, said she felt like "whispering" when she came in the door [of An American Place] and didn't want anyone to speak. "Much moved." . . . We expect to have her here days for some time. Dr. insists upon her watching me for a while. Wanted to get one of the watercolors. She can't afford it now. Will take care of that.—Dorothy L. is bringing Dr. Mary Holt[1] in on Monday, I believe. Just found out yesterday that she had insisted upon loaning us something over $100. She expressed a desire for more watercolors at the time. I have not been allowed to know anything of finances until now.

Have done quite a number of things here in bed that are ahead. I think, about 20.

Was dragged in a chair out [on] the porch for the morning. Quite a change, as you know. Dr. is practically turning me over to the nurse, except for once a week. . . .

Enclose clipping from "N. Y. Post"—Picabia, Ezra Pound, etc. It is in all the papers, but you might not have seen this about Picabia. . . .

Don't suppose Phillips has been in. I wrote him some time ago. Bill told you what he did. It was fine, and well done. He said that checks would continue.

Hope you are feeling fit with good weather coming. . . .

<div style="text-align: right">Always
Dove</div>

1. A psychiatrist like her friend Dr. Dorothy Loynes, Dr. Mary Holt also became a good personal friend of the Doves.

<div style="text-align: right">[New York City]
3 May 1939</div>

Dear Dove: I suppose you must believe even I have forgotten you. But quite the contrary.—I have become a miserable hand at letter-writing. It is an effort & in a way I have grown very "lazy"(!)—

—Well, I don't want you to continue to believe (very erroneously) that we are not always very aware of you. Of course that doesn't help you I suppose.

—So far there are $1400 in sight for you.[1]—I intended saying nothing but surprise you with checks. But you might as well know.—

I told Bill to tell you about [Philip] Goodwin's swapping a Dove for another Dove & giving $400 bonus.—The painting is to be installed in the Museum of Modern Art, a gift from Goodwin.—I hope you are on the mend.—Regaining "strength" is slow business. I know from experience.

Georgia is back & hard at work.—

I continue to remain on the bridge.

My love to you & Reds.

<div style="text-align: right">Your old
Stieglitz</div>

1. Stieglitz meant four hundred from Goodwin, one thousand from Phillips. Later, Goodwin decided he wanted a different painting and agreed to pay seven hundred dollars.

<div align="right">

[Centerport]
[5/8 May 1939]

</div>

Dear Stieglitz

. . . . Things have been going well here as to health, work, etc. Hope they are with you and Georgia. I don't see how you can stand all the talking. It seems to get me more than exercise, of which I have very little. They push me about in one of those Sears Roebuck roller chairs, so have been in the sun for two or three days and it helps. Walk very little. Work is a lift, if I don't overdo it. Have about 40 watercolors. Think they offer more possibilities than any yet. They are mounted. The conceptions seem more complete to me.

We thought the fair[1] would bring mobs through here, but it fortunately seems to take people away.

It would be fine to see the Show, but it does not look now as though I could make it. . . .

Hope I have learned enough to take care of myself—a bit amateurish up to now but didn't realize how necessary it was. . . .

<div align="right">

As always,
Reds and Dove

</div>

1. The New York World's Fair in Flushing Meadows, Queens.

<div align="right">

[Centerport]
[Late May 1939]

</div>

Dear Stieglitz,

Had just asked Reds to bring me paper when our nurse came from the P.O. with letter [now lost] and check. Have been thinking about you the same as ever every day. I wonder if you get a chance to do any work. And how you stand it being around the Place all day, being up and down. Had a letter started to you the day after Reds & Dorothy were in, but was put in bed again for having a temperature or walking too far, or something. It was a treat hearing from you through them.

Good to be able to be of some help again, via the Phillips arrangement, I mean. Do wish I could see you and the show. They all shout about it. Reds talked much about the way it is hung.

Am working every day and have much material, anxious to get at it but can't stand long enough yet. Pretty lucky to have this swell outlook however.

Enthusiastic letter from Mary, Reds' sister about you and the show.

Bill & Marian do not expect to go to Buffalo, suppose they have told you by now. Just as well.

Brookses go to New Mexico and California. They talked quite seriously about "The Goat" when they came to say goodbye.

Dr. Loynes is interested in the "Cow" [*Cow I*] that hung by your door when it was first hung.

Walked across the yard yesterday. Guess I am getting better as all this delay irritates me more and more. . . .

<div style="text-align: right">As Ever
Dove</div>

Does anyone see Sherwood Anderson?

<div style="text-align: right">The Place
3 June 1939</div>

Dear Dove: It is good to have your letter. I think I can sense your state of mind.—It's quite an ordeal for our kind not to be free to function.— Yes, young Brooks & wife were in & we had a long talk about the "Goat," etc.—I am enclosing part payments from two people who want something of yours on instalment plan.—Every dollar counts these times. But I refuse "to give your things away" to anyone.—At best in view of conditions whatever is given is "too little." And yet I realize more than ever that a real picture cannot be translated into cash!—And I'm not sentimental about it.—

The Place is very quiet. An occasional visitor. Sometimes an interesting one. The such is none too "good" for that damned heart.—But what is "good" for that?—. . . The fellows want to be remembered to you. Einstein reports progress from Mexico! It's good to be young & healthy physically.—

. . . A letter from Phillips telling me he hopes to have some funds in

July.—So it goes. It's all very precarious at best.—One must hope & hope, yet not fool oneself.—

<div align="right">

Your old
Stieglitz

</div>

<div align="right">

[Centerport]
[11 June 1939]

</div>

Dear Stieglitz: It is very early in the morning, but quiet, so thought it a good chance to answer your fine letter. It was like the good old days to hear so much that you put into them. I hope it doesn't take too much of your energy—it is so important that you save yourself.

The nurse drove us over to Bill & Marian's yesterday for two hours. His work has more weight now.

A little change like that makes one feel so much more energetic. Felt I could go right on in to N. Y. but the nurse wouldn't have agreed so came home to the usual rest.

Read a letter of Harriet Perry's saying that they had heard out there in Taos that Georgia had not been so well after Honolulu. Hope that is not so. Love to her.

Bart is having Indian trouble—rather amusing. The Indians want to charge him $10 to paint on their property. There goes another of my clientele turned painter on me. Also Lane Rehm has given up his job I hear and taken a house in the country.

Do you remember Aisen,[1] who gave up his chemical job in Chicago, of dyeing straw hats, to write and came back to N. Y. with his pockets bulging with manuscripts?

Nice letter from Brooks. "Inie"[2] is not overenthusiastic about going west, so imagine they will not stay as long as they expect.

Wonder if they are one of the new installment people (Reds says they aren't) who are taking paintings. The checks, by the way, were not enclosed in your letter. Hope they are somewhere in your pockets. Just one more thing for you to bother about.

Much love to you again from us

<div align="right">

Always
Reds & Dove

</div>

1. Maurice Aisen, Rumanian-born, Paris-educated chemist and poet. He also wrote for *Camera Work*.

2. Inez Brooks, Charles's wife. They were still in California when their marriage disintegrated within a few years.

Until now, Stieglitz had protected Dove from knowing that O'Keeffe had returned in fragile condition once more from her three-month trip to Hawaii. She had gone at the invitation of the Dole Pineapple Company, which offered her the trip in exchange for two paintings it could reproduce in advertising. While O'Keeffe had been quite overwhelmed by the lush beauty of the islands, she and Dole had clashed more than once. By the time she reached New York in April 1939, after a year that had seen Stieglitz's illness as well as altercations over pineapples and an unusual amount of travel, O'Keeffe was exhausted.

[New York City]
16 June 1939

Dear Dove: Stupid of me not to have enclosed check in last. Somehow the old machine doesn't quite function at times.—Georgia has had a nervous breakdown.—Has been laid up for 4 weeks.—Came back in bad condition.—For the present there is no thought of Lake George or anywhere else for either of us. I'm ready to remain right here all summer.—I do hope that Georgia will get on her feet again somehow. There seems no end.—You know how it feels.—

Well, one marches on the best one can.—Some are better at that than others.—But I suppose all according to their lights.—I'm at The Place all day every day.—That seems the best tonic for me.—I haven't told you the Museum of Modern Art is to have "Grandma" [*Grandmother*] instead of "Wheatfield from Moving Train" [*Fields of Grain as Seen from Train*]. And instead of $400 you are to get $700.—As soon as the cash comes in you'll get it. In short there are $700 from that source, $1000 from Phillips. And whatever he has arranged to allow you monthly. But with the latter I have nothing to do. Then there are two "minor" promises but I don't count on them.

—Einstein sailed for Europe day before yesterday. Mexico was too rich for his kind. So flew to St. Louis & then came to N.Y. And after 2 days in town sailed for France.—!!—His way. And fortunately he has a

father who has money & is "kind"—& Einstein has good health. That's that.—And he is young. 30.—

So it goes. And they go.—No other news. . . .

<div align="right">

Your old & rather tired
Stieglitz

</div>

<div align="right">

[Centerport]
[Probably 19 June 1939]

</div>

Dear Stieglitz,

Another early morning. Thank you much for your fine letter with all the news, check and all. We are all concerned about Georgia. Letters she is probably not allowed to read. Love to her anyway. It may work out having locality simplified to one place. That is, if someone else doesn't move into that place. It is so noticeable when that place is one room. We do so hope she will be all right soon.

Your "best tonic" of being at the Place seems to work amazingly well for all concerned.

Am much pleased that the Modern Museum is to have "Grandmother."

About Phillips.—From what Bill said, I understood that he intended $1000 for The Place and to keep up the monthly $100 to the same extent. (That is all he does now.) As for myself, am so glad to be allowed to breathe freely and go on working until we get well, that I do not *feel* like worrying over finances—anyway I am not allowed to, *supposedly*. Breathe freely was quite literally used, as there was some time there that it was impossible.

I do not see how you are able to keep everyone's affairs on your mind and have time to breathe at all.

I suppose Einstein will have the same address, % LeFebvre-Foinet. LeFebvre[1] trusted me with $500 worth of materials, packing, etc. when I came back from Paris. Never asked a thing until the war came when I paid the last $50. Quite marvelous—and I was not the only one.

The work is going fine. Am getting some new directions, so we think. Of course we are always liable to wake up and find the same thing done a few thousand years before. Q.E.D. Much love to you, Georgia and all from the kids and us.

<div align="right">

As always.
Dove

</div>

1. Lucien Lefebvre of the firm of Lucien Lefebvre Foinet, Paris, supplied art
 materials to practically all the American painters in Paris from Whistler on,
 until at least World War I. He also did all the packing and shipping of art
 work from Paris to 291 and to de Zayas's Modern Gallery. See Marius de
 Zayas, "How, When and Why Modern Art Came to New York," with
 introduction and notes by Francis M. Naumann, *Arts Magazine* 54, no. 8
 (April 1980): 124.

Stieglitz's next letter was accompanied by a $125 check from Reds's
sister and brother-in-law.

> The Place
> 24 June 1939

Dear Dove: Well, here is a surprise for you. Mary Rehm (her husband
too altho' he has not yet been able to come) arranged to take some
paintings of yours & pay on the instalment idea. $25 of the $40 I sent
you a few days ago came from them, & now here is this unexpected
surprise. Some girl, Mary. And he must be a fine fellow if he is at all in a
class with her.—Well, I know you can use all that might be coming
along.
 —Georgia seems finally to be mending a little. And I continue on the
self-imposed job. It doesn't become easier as the days roll by, but
somehow it's all very all right as far as I'm concerned. News there is
none.—I am going through my photographs & that's some job. I don't
like it.—The work is good but ye gods. Well, I don't like to think about
it. The Place is very quiet. Marin leaves for Maine in a few days.
Dorothy is in Woods Hole. . . .
 My love to you & Reds & the kids.

> Stieglitz

> [Centerport]
> [3 July 1939]

Dear Stieglitz,
 Much more thanks again for tending to checks and their production.
Now 5:30 P.M. My present bedtime. Am allowed to bathe myself, be in
the sun a bit, and do quite a bit of work, that is once a day. If I drop my

tools, the whistle blows and no more work, or thinking either, for the day. If I am caught at it—that is looking serious—immediately have to change expression to one of complete bliss. Of course, they may be perfectly right. How do I know? They were at first, why not now? Am getting better at it anyhow, and improving rapidly, even in work, and ideas I hope.

This convalescence is quite a game I find—much more subtle than getting one's foot out of the grave. They have a way of getting onto me when I am not in the mood for it, and that makes improvement pretty intricate and even compulsory. The nurse worries because she has so little to do even daytimes, and the doctor thinks it best to keep her, to watch me, as long as we can, which we can't, so life goes beautifully on, and now the only time we have had any finances to think about, I am not allowed to think about them. . . .

Hope you feel as well as I think I do.

It is nice to be out of the doghouse, anyway, if only on a leash.

Quite excitement here the other afternoon. The dam on the lake above us started to give way. Traffic stopped. All emergency departments called. State engineers, fire engines etc. succeeded in saving it and we are now having a new one built where it gave way, so once more it is peaceful, except for July 4, which is tomorrow.

It is also Bill's birthday. He tells me that he was allowed to shoot off but one before the Fourth. (I had forgotten.) They have been doing it here for a week. On the beach under the window seems to be a favorite spot.

Reds and the nurse throw them out every so often, but it is like the water wheel on the dam, I seem to miss it when it stops.

Our love to you both.

<div align="right">

Always
Reds & Dove

</div>

<div align="right">

[Centerport]
[27 July 1939]

</div>

Dear Stieglitz,

Have had you and Georgia both much in mind in this hot weather. It is cool here in this room over the harbor with the breeze blowing through, but the rest seem to feel hot. They will not let me do enough to get warm. Not having someone to watch over you now, you probably tend to overdo. . . .

Hope to get on canvas this month. Ideas get ahead of work with so much leisure. . . .

<div align="right">As always
Reds & Dove</div>

<div align="right">[Centerport]
[Probably 10 August 1939]</div>

Dear Stieglitz,

. . . Things are going fine here. Working almost every day. They stop me on the very hottest ones so that it boils down to blazing the way with watercolors and notes, so that one keeps track of where one has been. They often turn out to be the most interesting things. Fresh anyway.

Have just finished noonday "Rest." And am sitting up against the head of bed so just a note before the nurse comes back, when we move about again. I feel swell, but they are very careful these hot days.

The doctor is overdoing it, he says, as so many who have walked out of the hospitals have done so too soon, so it behooves us to watch our step. We could get by without nurse, but he says it is much better to keep her as long as we possibly can

She has reduced herself to 7–8 hrs. $40. which is a grand financial help. Has an apartment near us so goes home at noon, after lunch. Quite a bit for Reds, but our nurse is not too professional about helping, swell in fact.

Just brought in Apr. "Ken" with article about Marin, Davis and others.[1] Reds hardly knew Marin after your photographs. How is he?

<div align="right">Always
Reds and Dove</div>

1. "Kensight: Art in Progress," *Ken* 4, no. 4 (27 April 1939): 30–38. The feature opened with a close-up photograph of Marin. *Ken* was a shortlived, Chicago-based, mass-circulation magazine edited by Arnold Gingrich.

<div align="right">The Place
12 August 1939</div>

Dear Dove: I'm glad you can do some work. I wish I could do some photography. But no opening at all.

—Andrew is better but still not around. Zoler helps me quite a bit.

Georgia still away.[1]—Reports improvement. I hope it's true.—The Place is very quiet, still "building" in its unostentatious way. . . .

It really is all one & the same thing to me.—The "job" is my obsession. And what the "job" is I'd like someone [to] tell me.—Yet it exists if I or you exist. Or anyone else. And so it be. Amen.—

My love to you all

<div align="right">

Your old still older
Stieglitz

</div>

1. On doctor's orders, O'Keeffe was spending a couple of weeks at a rest home in the country.

Stieglitz and O'Keeffe went to Lake George in August, while O'Keeffe was still recuperating from the exhaustion following her trip to Hawaii. She did not begin to paint again until October. Stieglitz felt uneasy in the country, now that he was relatively well but not strong enough to photograph. Although he had problems with his heart while at the lake, he returned to the physical demands of the city and the psychological shelter of An American Place within a month.

<div align="right">

Lake George
24 August 1939

</div>

Dear Dove: Georgia I believe is somewhat on the mend. It's slow uphill work. As for myself I'm really better off in town even tho' the pure air here has its advantages.—But somehow The Place gives me a kind of quiet (or unrest, have it as you will) which somehow takes less out of me than quiet of The Hill.—I am [able] to walk but little—very little.—And there is no photographing of any kind. Nothing but to sit around or lie about & contemplate.—And there is much to contemplate.—I remain by myself most of the time.—Sleeping is my chief occupation. But I have to take tablets to help me even accomplish that.—You can sit in bed & make a watercolor or so. That's where the writer, the painter, the composer have the advantage over the dub called photographer.

—The drought has raised merry hell with vegetation, but as weather it has been perfect!—I hope you are gaining strength.—I know it takes

patience. Patience aplenty. This is primarily a line of fond greetings to you & Reds & the youngsters if they are around.

Your old
Stieglitz

[New York City]
23 September 1939

Dear Dove: I hope you are holding your own. I go to the Place from 10:30 A.M. to noon 30.—Breaking in gradually.—It's slow business.—I do hope I'll manage somehow. . . .

Your old
Stieglitz

[Centerport]
[26 September 1939]

Dear Stieglitz,
. . . . Take it easy!! I am trying to learn. Much better, starting to paint. Have new glasses. Old ones raised hell.
Nurse left Friday so we are left to our own discretion.
Kids are in N.Y. and will give you news, and I hope bring some back at weekend.
Much love

Always
Reds and Dove

After the disastrous illnesses of 1938 and 1939, Dove had little vigor in succeeding months. His doctor visited him routinely every two to four days. Yet, comparatively his health was much improved by autumn.

Stieglitz opened the gallery's year in the fall of 1939 with two Marin exhibitions. *Beyond All "Isms," 30 Selected Marins (1908–1939)* hung in October and November. New work was on view in December and January. O'Keeffe's show opened in February, and Dove's at the end of March. At the end of the season, in May, Stieglitz put up an impromptu review of the year's Doves, Marins, and O'Keeffes.

In his next letter to Dove, Stieglitz enclosed Duncan Phillips's advance of one thousand dollars.

> The Place
> 19 October 1939

Dear Dove: Well, at last here it is. And all edges have been kept clean!!— That's paramount. . . . You will receive $100 a month still, & he'll take something sometime for what it amounts to. . . .

Love to you & Reds.

> Stieglitz

> [Centerport]
> [22 October 1939]
> Sunday

Dear Stieglitz—

This is Sunday morning and I am just getting back to earth. The O's on that check were more than I am used to comprehending. It is understandable when I think of it in terms of you, as I am beginning to get a bit accustomed to a Stieglitz-eye view of the universe. However, it is still here, I guess, so am not dreaming. Have paid the doctor to Aug 1. And are going to have $20 worth of roof put on the north side, otherwise life continues in the manner to which we are accustomed.

Thank Georgia for her interest. I am still writing her, have gotten to the point of tearing up what I had written at the hot weather time when spirits should have been better. Still fine weather! here, even a heavy thunder shower last night to make it seem more like summer. . . .

It would be fine to see the Place now with you and the Marins about.

Hope the people are not too war-like to enjoy them, or maybe not enough. . . .

> As always
> Reds & Dove

> [Centerport]
> [11 December 1939]

Dear Stieglitz,

Thanks to you for sending the Brooks check. A nice long letter from

them the other day announcing that they are to have a baby July 1. I remember announcing Bill's arrival to [Frederick James] Gregg[1] one evening, and he allowed that the man who shined his shoes had seven. However they are duly excited.

Wondering how you feel. All reports have been good recently. I suppose the doctor goes over you two or three times a week, as they do here.

We are fine, much better after having an operation on a couple of eyelids. Had them scraped and a new pair of glasses and now can see like never before since wearing them. . . .

Working hard.—Have 4 larger ones and 5 small so far. Have kept to the smaller ones until I get going. They are good we feel. At least I have learned a lot during this rest. Have a tendency to overdo at it, so am supposed to take one day a week off. When I do, I seem to work harder than ever thinking about it. So just steady work is as good as anything. Have more watercolors along with these occasionally, so there is no scarcity of material, and I see no reason why this year should not come through tops. It is so far. . . .

I suppose the holidays have interfered with Phillips' promptness. Once before he was very late. Trust *he* hasn't overdone. . . .

It is good to feel settled here. The waves are washing the bulkhead under this place, but we are warm in this gale today. . . .

<div style="text-align: right">

As always
Reds & Dove

</div>

1. Frederick James Gregg, a journalist sympathetic to modernism, handled publicity for the Armory Show.

<div style="text-align: right">

[New York City]
14 December 1939

</div>

Dear Dove: Georgia is painting.—Feels better. Stronger.—That's all to the good. I manage to keep going. Yes, all say I look well. So that too is so much to the good. It's a great world. Very great I guess. At times I wish it weren't quite so great. They tell me Christmas is around the corner. Is it time? I seem completely lost & dazed.

Love to you & Reds

<div style="text-align: right">

Your old
Stieglitz

</div>

By Christmastime, Dove was well enough to enjoy himself, as family visited. Bill and Marian, who had moved into New York City for the winter, came several times during the holidays.

[Centerport]
[25 December 1939]

Dear Stieglitz and Georgia

So this is another Christmas. Quite a gang were here yesterday afternoon.

I could tell by the look on the faces of Mary and George [Rehm] that they had been talking to you and had had a wonderful time. They will be in more often, I think.

We expect Bill and Marian in a few minutes. . . .

We all send much love and a Happy New Year to you both.

As always
Dove

[Centerport]
[9 January 1940]

Dear Stieglitz,

. . . . The work is going finely. Have almost eleven on canvas now that the holidays are over.

They do look well and the ones I have the most hope for, I have saved until now when I am well worked in. The best ones come last usually anyway.

You probably see Marian and Bill and know as to health and such that we are getting all right quite fast now. It is such a help to be able to work.

Mary and George come now and then, as enthusiastic as ever about you. You must have told them something fine about me as Mary gave me a most delightful greeting. Thanks!

Quite an amazing person when she wears her halo. George thinks you wonderful and "By God, everything he says is Gospel." He goes back to work at the Fair by now. Mary has been ill with grippe but all right. Having lived in France so long, they do not bother with doctors until it is time for the priest.

Our good doctor has reduced himself to a flat rate of $4 per week for two calls and one "social" one as he calls it. That is a help.

They have never been so careful of anyone before, I believe, as I am the prize recovery and go in the hospital archives we hear. . . .

It is a grand sunny day here on the water.

Have several small sized canvases.

Love as always from us both.

<div align="right">Reds and Dove</div>

<div align="right">[Centerport]
[4 February 1940]
Sunday</div>

Dear Stieglitz,

Again my "day off" that the Dr. orders. He is in bed and I am feeling fine.—So it goes.

Two large paintings this week and they are going much better, as I go on. Hope in another month from now to have plenty if health and frames do not hold me up. Wonder what your plans are after Georgia. Feel that I can be ready by the usual middle of April or before, if necessary. This is just to let you know that things are going well. . . .

It is very gay here. A tractor has been sweeping the ice, and full-sized cars have been out here doing snap the whips. All the world on skates, and all the dogs on the ice. Quite amusing.

Nice letter from Beck [Strand James][1] in her good old hilarious style. Her "Bill" has some sort of a heart condition as who hasn't?

There ought to be some ray that should fix all that up. Ray of hope, I guess.

Seems better all the time anyway, as I hope you are too. . . .

<div align="right">Love as always
from Reds & Dove</div>

1. Rebecca Strand, who lived in New Mexico, was remarried to a gentleman-rancher from Colorado, Bill James.

[Centerport]
[18 February 1940]
Sunday

Dear Stieglitz,

. . . . This week's output is the best yet, I think. Wouldn't trade it for the large "Holbrook's Bridge" [*Holbrook's Bridge to Northwest*] or anything, the way it looks today. Distance sometimes changes them, but they are improving so fast that the last one seems to be the best, which is not always the case. Have some large ones. 20 × 32.

Dr. here yesterday, b.p. [blood pressure] was 142 and the pump was "the best it has been," so hope he will fire me soon. His wife wants me to help her decorate a home they are buying—from a "Collage" made by her, etc.—with her materials, etc. It would be easier for me to win the European war with a sling shot. Am pretty good with one at that. A little knowledge is so dangerous, that it is practically dynamite sometimes.

Hope we feel as well as now for the next month and then things should be pretty well along.

Thought I would try to keep you posted as to which way the straws point anyway. . . .

As always
Dove

Stieglitz's next two letters describe reaction to the O'Keeffe show.

The Place
22 February 1940

Dear Dove: It has been like a madhouse here. About 1800 people in 17 days. And I forced to "fight" from early A.M. till late P.M.—And nothing "happens"!! What a life.

—Georgia went to Nassau. Needed sun & stillness.—

Your Show is to go up March 28th if the stars remain put & tell me rightly.

—I hope you are getting on. It's all so ironical.

Big Business in the guise of the Museum of Modern Art controls the situation.—

Alfred Stieglitz with O'Keeffe painting, c. 1940. (William C. Dove, Mattituck, New York. Kay Bell photo.)

—Phillips was here. He has bought a Cézanne!!—Poor Man.—Asked about you.—

"News" there is none.

Love to you & Reds—

> Your old
> Stieglitz

> The Place
> 29 February 1940

Dear Dove: Many visitors. Nothing happening. Much appreciation. Great adulation. All together wouldn't give a bird-seed to a pet canary! Spring is knocking at the door.—What has it in store. Eternal hope??—

What an institution life is.—Nearly as wonderful as the Museum of Modern Art & Hitler. The two great forces of today. . . .

> Your old
> Stieglitz

> [Centerport]
> [3 March 1940]
> Sunday

Dear Stieglitz,

Thanks again and again and many of them for sending on all the checks and the thousands of other things you do. Thanks be also that some very large brushes came in that same mail to give me a better grip on that March 28th as a date.

Well, they are going fine and after looking around I find that there are the proverbial "19"—5 of them small canvases. Of the watercolors, thought to frame about 15—would be as many as you would want up anyway. There are plenty of them.

How it all became done, damned if I know. The steady pace without interruption makes a great difference. Was sent to bed last week for doing too much, but one day seems to put things in order again.

Suppose Phillips will be, as you say, poor after the Cézanne. Anyway, it will be safer over here than in Europe for a while.

Hope Georgia likes Nassau. Others have told me it is a marvelous place.

Wonder how you can possibly talk to even a small part of so many people.

Our former nurse has been talking it up to the doctors to let her bring me in to "The Place." Hope it works out soon. Am really much better.

Bill says you look fine. That is good news. . . .

As Always,
Reds & Dove

With his next letter, Dove sent Stieglitz the "menu" of paintings for his show and an evocative sentence that Stieglitz chose to print as the foreword to the gallery pamphlet issued for Dove's show. The statement read as follows:

As I see from one point in space to another, from the top of the tree to the top of the sun, from right or left, or up, or down, these are drawn as any line around a thing to give the colored stuff of it, to weave the whole into a sequence of formations rather than to form an arrangement of facts.

[Centerport]
[17 March 1940]

Dear Stieglitz

This is a factory today. Frames here and glass.

Local sailor here is going to bring paintings in toward end of week.

Am sending in the menu and a sentence which is written somewhat like the things are drawn.

Might interest some of the writers and others who are interested already. . . .

Love as always from Reds & me.

Dove

The "local sailor" took Dove's paintings into New York on 21 March. Stieglitz wrote briefly to Dove immediately after they were unpacked.

[New York City]
21 March 1940

Dear Dove: I have looked at the paintings. I feel they are the finest you have produced.—They seem to have an unusual clarity—truly an inner light. . . .

ever your old
Stieglitz

[Centerport]
[Late March 1940]

Dear Stieglitz,
. . . . Have hopes of seeing you and what the show looks like. Several have offered to bring us in. The Rehms, our doctor, Dr. Loynes, and Perry, the former nurse who is now quite ill in hospital. She plans on an armful of stimulants & sedatives so that I shall not bite the dust on your doorstep. . . .

Am already working on another, but, it will keep. Each one seems better, so may have to bring it in. There are two, 1 watercolor, 1 oil small, that we may want to save on account of their research interest. The "Harbor Bank" watercolor, and the little 6 × 8 "Primaries." It isn't so terribly important and I leave it all to your judgment as to values, etc. . . .

There was a huge flock of geese that landed in the water by the house on their way north and kept the village awake all night. There were three here last summer, so they must have brought all their friends for a visit. . . .

Your opinion means so much to me for so many reasons—and I know where to find you.

Love as always to you from
Reds and Dove

[Centerport]
[Probably 1 April 1940]

Dear Stieglitz,
Well, there are two more paintings here, if you need more, but guess

it is better to have some ahead. Hope you are satisfied with the way they look all hung. I will not be, until I hear how you feel.

I see Sherwood Anderson is in town. Please give him our best, if he comes in. Paul R[osenfield] and all the others.

Am anxious to have some news, but, do not write as I know you have used more energy than you should already.

Our nurse who was to bring me in is just out of hospital today.

Hope to see you soon.

Much love to you

<div align="right">

As Always
Reds & Dove

</div>

Stieglitz saw Dove's show as a dramatic success. It was in fact a remarkable comeback. Not only was there the usual number of paintings, but they constituted his finest showing to date. Nearly everyone who saw the show responded enthusiastically. Phillips "reimbursed" himself for his 1939 advance with a painting and agreed to send Dove a total of two thousand dollars in monthly installments during the coming year.

<div align="right">

The Place
3 April 1940

</div>

Dear Dove: Your Show looks very beautiful. On Friday Zoler & I hung it. Georgia was laid up. Still is.—She felt terrible that she couldn't help me.—Well, Jewell[1] & Coates[2] of the critics have been here. So far a few people. All feel it's the best Dove yet.—By far.—I think so too. The high standard is sustained throughout.—

—I wonder will Phillips turn up & when.—And what.—All a very trying situation. Nothing very new. But somehow not easy to get accustomed to completely.—Yes, the Show is very beautiful.—Well, let's hope & not expect.—

—Dorothy is in Florida.—Her secretary is laid up.—The Place is very quiet.—Very peaceful. Your pictures add to the peace.

—Well, this is just a note.—

Love to you & Reds.—

<div align="right">

Your old
Stieglitz

</div>

1. E. A. Jewell's favorable review appeared the following Sunday: "Potpourri: Shows in Museums and Galleries," *New York Times,* 7 April 1940, sec. 9, p. 9.
2. Robert Coates had become art critic for the *New Yorker.* His review said that the paintings were "well above anything he has done before." See "The Art Galleries," *New Yorker* 16, no. 10 (20 April 1940): 50–53.

Exhibition pamphlets for Dove's show had arrived in Centerport from Stieglitz on 2 April. Dove wrote two days later, after he had also received Stieglitz's previous letter, to express his gratitude. Besides the foreword statement that Dove had sent earlier, Stieglitz had included in Dove's pamphlet an unattributed thought: " '*The geese are flying northward . . . it is a good sign.*' "[1]

1. If this sentence was not adapted from a lost letter from Dove to Stieglitz, it may have been lifted from a letter to someone else. Or did Stieglitz embellish "in the manner of" Arthur Dove?

[Centerport]
[4 April 1940]

Dear Stieglitz,
. . . . It is all so beautifully done, and so complete, even to the masterly touch of bringing in the geese.
And this last letter is so encouraging. No, I never expect anything—except when you turn on the heat—guess that is the way we have kept it up so long.
It is too bad about Georgia. Give her our love and yourself too. It has been such a long time since we have seen you. Hope the spring will pick her up, and that you are not trying to do too much.
. . . . Hope he [Phillips] will be pleased with the results this year.
I will send him one of the notices with thanks, and let the work express the appreciation.
There is someone to go to the post office, so will send this on with as much love as always from us both.

Dove

An American Place
509 Madison Avenue
New York City
12 April 1940

My dear Dove:

Phillips has been here. It was an amazing visit. His wife had been down with a cold in Washington and couldn't come with him. Well, it was a grand visit and all I can say now is that you are assured at least $2,000 for the coming year. I won't go into details at present. It would be too difficult for me to do so just now. Your debt of $1200 to Phillips has been paid off, he taking "The Green Ball" for it. This in itself ought to be a cause for jubilation for you.

The exhibition stands firm. It is about as solid as any I have ever held under my auspices. Every picture counts. It is not a question of the pictures bolstering each other up and giving an appearance to the exhibition of consisting really of greater pictures than they really are when seen alone. . . .

I hope you are feeling relatively well and are painting. I stick to my post and don't flinch. This is a grand world and a hell of a one too.

Your old
Stieglitz

[Centerport]
[16 April 1940]

Dear Stieglitz,

Your letter has certainly made us very glad. It is worth everything to have you feel that way. And about "The Green Ball" I am, bowled over, bumped off, or whatever one gets in times of "Surprise" out of "Not expecting anything." Sounds like a horse race. Well, it was a little to keep from falling into a "break" from overdoing. The doctor has me doped out now in his way. Painting is good for me, but any emotional disturbance is the worst thing. . . .

Would enjoy sitting within earshot of a Saturday afternoon.

Will see you as soon as it is possible.

Our love as always
Reds & Dove

[Centerport]
[28 April 1940]
Sunday

Dear Stieglitz,

Out in the sun again for a couple of days and it makes quite a difference.

Had to stay in bed for a week again with what they said was grip. Getting soft I guess, couldn't take it as easily as before. Sitting up in bed is about the hardest work.

Fine letters from everyone. Georgia's was especially so.

We happened on Paul's article in the "Nation."[1] It was good to read something that was big to think of again.

George and Mary just left a while ago. They were going to try to make the Place this afternoon. George had talked with Sherwood Anderson. Hope Sherwood saw it [Dove's show], and could talk with you.

Have been watching the leaves come out here and hoped to get in as soon as I had attended to that.

Dorothy Loynes has given us our only first-hand account of the show, but she has missed seeing you every time. Some of her psychiatrist friends are quite actively interested in the paintings, we hear.

Reds is having a rather vital engagement with the dentist. Hope it is soon over.

D.'s friend priced one of the smaller ones, I believe, around $900. Andrew may remember. Hope they are not so high that I can't afford to live up to them. . . .

Love to you all as

Always
Reds and Dove

1. Paul Rosenfield, "Dove and the Independents," *Nation* 150 (27 April 1940): 549.

Stieglitz's heart—by now a constant problem—was so weak that he had been put to bed while Dove's show was on view. However, he was back at An American Place when the Rehms went from Centerport to the gallery while Dove was writing the preceding letter.

[New York City]
28 April 1940

Dear Dove: The Rehms were in today. They enjoyed your Show hugely.—Enclosed is the "balance" Rehm says is "due" you.—Well, he knows. I'm glad I caught them as you may have heard I was off duty for a while. Heart setback. Had been going it a bit too youthfully for many moons for one approaching 77!—And you have more paintings done. Great.—Your Show remains a Wonder.—Refreshing to come into the Place after having been laid up & see those pictures.—

Once more love to you & Reds.—

Your old
Stieglitz

[Centerport]
[30 April 1940]

Dear Stieglitz—

We had felt that you had not been quite so well, but no one told us. Perhaps Andrew had told Dr. Loynes and she thought best not to spread any worries. It is hard sometimes to know what is happening as everyone is so protective. Anyway, it was "Too quiet." And a letter was forwarded by Georgia, so thought she might have been doing the honors at the Place.

The letter she forwarded was amusing. Some man hoped it wouldn't be much trouble but would I please draw him a few lines and sign them for his collection. He enclosed a 2¢ stamp. Used to get those on the magazines sometimes but was never honored as a painter before. You see we have even moved the racket up a step.

Thanks again for sending on the checks from Brooks & George. I have a feeling that it is more than the Rehms should afford now. Returned $100 that they sent us when I was first knocked out.

Seem to be able to pay all my debts with one or two checks as the people return them in some form or other. Reds has very thoughtful relatives.

Miss Perry wants to bring us in this coming week. She is a good driver but makes one feel that she is on tracks like a train and that others should make way.

She is a good nurse and quite cheering at times, and when she wants you to cheer up, by Jesus, you cheer up! On another case now, so we

may come with Dorothy early in May. Which is almost now I see by the calendar here. Do hope you are rested up again. It is so hard to get used to doing nothing as the outstanding form of exercise. Expecting to be sent to bed all the time finally gets on one's nerves. When there is so much to be done.

Love from us to you all and thanks again.

Always,
Reds & Dove

The Place
1 May 1940

Dear Dove: Here is another.—So you have had a setback too. One has to grin & bear it patiently.—What else can one do?—Well, I'm here on watch at least.—An occasional intelligent individual drops in.—Occasionally a looking seeing one too.—Don't fear about "prices." Anyone *really wanting* a Dove can get one reasonably. Ridiculously reasonably.— Otherwise no news.—

Love to you & Reds—

Your old
Stieglitz

[Centerport]
[2 May 1940]

Dear Stieglitz—

Again thanks! And it is so good to see you writing so enthusiastic and vigorous again. . . .

Just under the window coming along the shore is one of those "Teeter" snipes, and I have been wondering since I was 5 years old what made their tails go up and down so incessantly. Never have solved that.

Knowing your methods, I am not worried about prices but I know that Dorothy Loynes has her mind set on something.—It is probably "Red, White & Green." It is a "Tops" one of course, but she is a hardworking woman and certainly has to be pretty sane to manage 700 or 800 who *admit* they are mad and hesitate at *Nothing!*

See Mumford's name in this last "Nation." Has he been in? Wondered what he thought. Wish they (the Mumfords) could just stand around the gallery for two days a week, they are so damned good-looking. . . .

A large blimp is just circling over our harbor and house here. But Vanderbilt's hangar is just over the hill. So perhaps it is meant for him.

More love to you

Always
from us—Dove

Dove's next letter was written the day after he and Reds had visited An American Place with Dr. Dorothy Loynes. They saw O'Keeffe and Dorothy Norman there, as well as Stieglitz. This outing was the first time Dove had been to the city for about two years.

[Centerport]
[10 May 1940]

Dear Stieglitz,

It was great to see you, and in such wonderful shape. We all enjoyed it so much. Good for me too, as I slept right through until daylight—for the first time in weeks. . . .

We arrived home to find the youth of Centerport in the arms of the law. Leader being the boy, 12, who does errands and chores for us. Everyone warned us about him. Boy Scouts have tried to lead him on the straight & narrow. We just decided to trust him—with money, etc., when we came, and now find that we are the only ones in town that haven't been robbed.

Suppose that is what the religious call faith.

Apropos of religious, Mrs. Rankin, Washington, will probably be in to see show Monday or Tues. with "her husband." She has just been confirmed in the faith and wants to come to see us with George, her husband. Told Reds to wire her, "We don't mind Jesus so much but don't bring George." Reds is probably too kind to do it.

Will write Phillips when I get up steam again.

It is certainly a grand looking "Place," beautifully hung from one end to the other.

Love to you all

As Always
Reds and Dove

The Place
11 May 1940

Dear Dove: Well, it was certainly grand to see you & Reds. And see both of you so well pleased with how the Place looked with your paintings on the walls.

—I never get through marvelling at the complete satisfaction this Show of yours gives me.—I'll feel better when Friend Phillips will have finally come to a decision in his selection.—I suppose the increasing mess in Europe has most Americans completely haywire. . . .

Well, Dove, we know it's a great life if one doesn't weaken! . . .

Your old
Stieglitz

The Place
16 May 1940

Dear Dove: This A.M. I sent Phillips "Willows"—"Thunderstorm" [*Thunder Shower*]—"Beach" to select the one he said he'd take. Also sent him the watercolor he had bought—ditto "Green, White & Red" [*Red, White and Green*]. Also the gift to Mrs. P.—I wanted the selection settled. It was beginning to get on my nerves, the indecision—the war etc., etc.—A show is rehung. The main wall has 5 of your new things on it. Looks handsome. The watercolors are still as you saw them except a new one replaces the one P. took.—In the alcove is a Dove. On a small wall, 2 of your small paintings.—Opposite the main wall on the office wall there are 3 of this year's Marin oils. In the white room, there are 4 O'Keeffes. No, 5.—Also a Marin watercolor & 2 small Marin oils. In all, a sort of symposium of this season with the emphasis on Dove.—

Your doctor & his wife were here. I think they enjoyed their visit. . . .

Your old
Stieglitz

I see Van W. Brooks has another winner[1] on the market. And I wonder have the young members had their chef d'oeuvre—their expected baby.—

1. Van Wyck Brooks, *New England: Indian Summer, 1865–1915* (New York: E. P. Dutton, 1940). This second volume of Brooks's literary history of

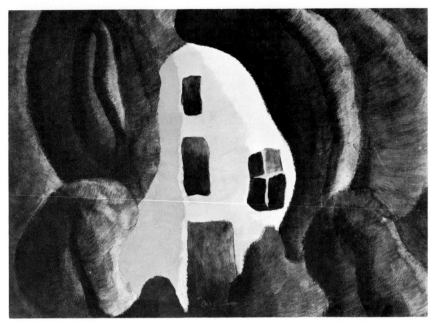

Arthur Dove, Willows, *1940. Exhibited in Dove's 1940 American Place show, this painting was purchased by Duncan Phillips and given to the museum in 1941. It was the second work, following* Grandmother, *to enter that collection. (Museum of Modern Art, New York. Gift of Duncan Phillips, 1941.)*

America followed his *Flowering of New England* (1936), which had won the 1937 Pulitzer Prize in history.

In June, O'Keeffe went to New Mexico, while Stieglitz stayed in New York until nearly the middle of July. Before she returned home in the fall, O'Keeffe purchased the isolated Ghost Ranch house, where she had first stayed in 1937, and about eight acres of land around it. Bill and Marian returned to Cold Spring Harbor for the summer.

The Place
31 May 1940

Dear Dove: Here is the first of the Mohicans. Phillips kept "Willows," which is good.—Georgia leaves for New Mexico on Sunday.—I hope it will restore her health getting away from New York.—Of course, it isn't easy to see her go. But it is to be that way.—

—The Place continues.—An occasional visitor.—Very occasional.—
I hope you are doing as well as the "stars" permit.—
My love to you & Reds.

<div align="right">

Your old
Stieglitz

</div>

<div align="right">

[Centerport]
[Mid-June 1940]

</div>

Dear Stieglitz,
 A note to let you know I am all right again and hope you are.
Suppose you are alone by now, as everyone was leaving in your last
letter.
 They made me sit for a while. I could work all right—have done
about twenty watercolors. And the Dr. says I am in the best shape since
first taken ill. He allows that I would not have had this last setback had a
lady not tried to kill her two boys and succeeded with herself just
outside here in the early morning. Having ears like an animal it was a
bit vivid for me.—Very thankful that Reds didn't waken. . . .
 I see the present show is listed in "New Yorker," but imagine they
have all written about it too recently to have much more to say.
 Love again

<div align="right">

Always
Reds & Dove

</div>

<div align="right">

The Place
29 June 1940

</div>

Dear Dove: I'm still in town as you see. Doctoring & also busy
here straightening out what can never be straightened out. Like the
world. Georgia reports she is doing nicely in New Mexico. . . .

<div align="right">

Your old
Stieglitz

</div>

<div align="right">

[Centerport]
[July 1940]

</div>

Dear Stieglitz
 I said I would not write you again until I had written the Phillipses, to

be sure it was done. Well, it is, and on one of the hottest days, on which I hope you are keeping cool.

Things are going fine here. Best one yet, in the small, yesterday. And something to add.

Reds is about through with her tooth troubles. We have to ask our doctor, if I am well enough for Reds to go to the dentist.

Mary and George were here yesterday. He is getting himself fired from the Fair this next week. Has several things offered. Among them the F.B.I. They are definitely working with the idea of a dictator and Fascism in mind. Doesn't seem to want that job. Wants to write again.

At the German Inn across the way (where my "U.S." was done) they play "Taps" on the bugle when the flag comes down at night. It gets caught in the weeping willow tree at times.

George gets funny angles from the diplomats at the fair. It almost sounded as though war was just a means of keeping the mob occupied while they go on with their intrigue. . . .

<div style="text-align: right">

Always
Reds & Dove

</div>

<div style="text-align: right">

[Centerport]
[26 July 1940]

</div>

Dear Stieglitz,

Do hope you feel swell like we do this clear morning.

I am to be set up again today. All fixed up after a small dose of arthritis. Too much running, etc., in Geneva. Doctor says better than at any time in the last year and a half. Reds has her store teeth and is a new woman all round, quite remarkable. What teeth can do for and against you.

I took a week as nearly off as possible. You know how that is. The kids are here every day or so.

Mary & George go to Bucks County, Penna. to look at real estate today. "Just an idea." Reasonable and near.

My brother getting married in Sept. We are all delighted at the contrast from his last, the last one that chose him. They are to be in Geneva. She is German and has enough to eat and a house on Cape Cod for their honeymoon by a friend. . . .

Marian is scouring the Island for a school-teaching job, and if there is one to be had, she will—believe me, get it, a hustler.

Am to get up today. Dr. just here. This having gout on Coca Cola is

too much like [Harold] Ickes' slogan for [Wendell] Willkie "The Bare Foot Wall Street Lawyer."—It is about time I started on the large paintings. . . .

<div align="right">As always
[Dove]</div>

<div align="right">Lake George
2 August 1940</div>

Dear Dove: I came up here on July 12 pretty much to the bad. I didn't want to come. But finally came.—That's true to form.—It's a long story. Or several short stories, so making a still longer story. . . .

Einstein was here for a week having just returned from Europe.— Zoler had been here 2 weeks hard at work all the time. I still have no "plans" for anything. In this age of planning I am without plan.—Can't have any.—Every moment appears unplanned, yet in all its inevitability. . . .

—I hope Marian finds a teaching job soon. She is a prize. And I suppose [Bill] plods along trying to get orders for book jackets.—

—It's a great life if you are well enough to take advantage of it. If not able to, it certainly gets you with a vengeance—compound interest, 6%, not a measly 1¼% as is the New Deal fashion.—

—It's certainly a "queer" life this togetherness of Georgia & me. She there 2200 miles away & I here 2200 miles away from where she domiciles.—The niggers would like that way of expressing it.— What?—

—In a few days I guess I'll be sending you a more constructive envelope.—Phillips' monthly. . . .

<div align="right">Your old
Stieglitz</div>

<div align="right">Lake George
26 August 1940</div>

Dear Dove: I have no idea when last I wrote to you.—My memory recedes as I have less & less to occupy me.—Old age with a vengeance.—

—And still, I am looking forward to getting back to The Place—It is freshly painted & the shades have been cleaned. With due respect to you

artists, the Place looks best when the ceilings, floors, & walls have just been freshly painted. When even no one has stepped on the floor!—The austerity & clean feeling are refreshing.—

—I wish you could see the Place that bare. That fresh.—[Letter incomplete]

[Stieglitz]

[Centerport]
[27 August 1940]
Tuesday

Dear Stieglitz,

Your letter . . . is the youngest and brightest thing I have had for some time, and I am delighted. I had intended writing you this morning before starting on a painting I had in mind, and so your thoughtful description of it (The Place) is a grand help.

Am getting out in the sun again after three weeks of keeping one foot in the air, maybe it is less, but quite a while anyway.

A good large bundle of watercolors anyway.

A very "devotedly" letter from Phillips two days ago. Speaking of his Dove room. . . .

The Brooksies have a boy who can pee six feet and are very proud. . . .

As ever
Reds & Dove

[Centerport]
[29 September 1940]
Sunday

Dear Stieglitz—

. . . . Would love to see the Place. Have some very brilliant ones to put in it when the time comes.

The kids have been too busy to bring news.

Marian "Got the Job" in the morning and went to work in the afternoon. She will have to tell you about it. An (community-owned) endowed school in Hewlett, L.I., $1000 a year with the chance of building it up—that is—her part of it. She earned it all right. No stones left unturned.

Fine letters from Georgia and Einstein. She is an isolationist all right. I've often wondered what those huge areas do to the sun and moon.

How is Marin coming on? . . .

They are keeping me very close, so there will be no more setbacks— so probably shall stay here and work until some fine day. Dr. is a regular old woman about it. You must have told him I was worth saving or something.

Oil burner man is coming this morning. Coal is too heavy for Reds and I can't throw it around yet. . . .

Always,
Dove

[New York City]
3 October 1940

Dear Dove: For a change I was laid up for a week.—Heart attack. Fortunately wasn't bad enough to lay me up any longer. Miserable business at best.—Too great a strain one day at The Place. There is no escape.—Marin showed up yesterday. Looks fine. His son finally has a job. $30.00 a week!!—And you are being protected. Good.—And painting. Also good.—And Marian landed a job.—Wonderful.—I still don't know when I'll put a Show up.—Soon I suppose. Going it single-handed is not so simple, under the existing circumstances. . . .

Love to you all.

Stieglitz

After a group show of the three regular exhibitors at An American Place, each had an individual show—Marin's opening in December, O'Keeffe's in January, Dove's near the end of March.

During this winter of 1940–41, Bill and Marian lived in Cedarhurst, Long Island, close to New York City.

[Centerport]
[6 November 1940]

Dear Stieglitz,

We both seem to be at it again. Spend what we have saved up, I guess.—It seems so good to be able to move about a little bit, that we overdo it.

Hope you are all right again by now. I am the best yet so they say, seem to have less liberty. They are probably getting onto me. Can work again, however.

These ducks, wild Mallards, certainly take it easy under my window here in the sun, with their heads under a wing. Then washing themselves, and the ladies trying to get themselves raped.

Election is over anyway.

Marian & Bill were here for a few minutes last night. M. rather up against it in any freedom in teaching the little children of the rich. It is all undone at home.

I have gotten so I can take digitalis now. That seemed to be the trouble for a while. Some authorities said to stop it when it made you sick. It seems that it is your condition that causes the trouble. Anyhow it stayed down for a while & everything began to clear. Just now the Dr. said that I am in the best condition at all since the first. . . .

A letter from the Brookses, Einstein, & the Bart Perrys out there in Calif. Perrys expecting again, I hear from other directions. . . .

<div style="text-align: right">

Always,
Reds & Dove

</div>

<div style="text-align: right">

[Centerport]
[Probably 2 December 1940]

</div>

Dear Stieglitz,

Thank you for sending the check and the "Temperol" medium that this doctor in Binghamton makes. The medium is not quite as brilliant as the one I have been making. And not knowing what is in it, I am kinda fussy about using it. Did you order it? Just his name on the bottle, O. H. Boltz. Find it pays to be careful.

Dr. B[ernstein] says now that another doctor examining me would never know that I had had a heart attack. Am going to be allowed salt for Christmas and to walk upstairs to the dentist's. How is that for being promoted?

Well, the work is going fine. Have three more in the last two weeks. Bill tells me that Georgia is back. Love to her.—

When I have to take a nap in the middle of the day—(There is usually too much to be done) it doesn't leave much time.

Lots of love from us both

<div style="text-align: right">

as ever.
Dove

</div>

[Centerport]
[December 1940]

Dear Stieglitz,

Many thanks for sending the books. Have been hoping for a chance to read. A little trouble with eyes so use them mostly for working. They (the books) are fine to have and I enjoy the photographs. Working hard, the best one yet this year finished yesterday.

The Rehms just left raving over this new one and lying awake nights over the one before raving at it, I guess. The ones so far are very clear, clean-cut, and there is something new that I think worth fighting for.

Have another letter from Dr. Boltz of Binghamton with another sample of his medium to come. It is interesting to see people going for things this way.

Anyway here's to a happy New Year for you in all you are doing.

As always.
Reds and Dove

[New York City]
28 February 1941

Dear Dove: Another billet doux.—Certainly a most welcome apparition.—

The Place continues.—The struggle, well, what am I to say?—

It's tough, but I guess I can at best equal an Englishman—

Love to you & Reds.—

Stieglitz

[Centerport]
[5 March 1941]

Dear Stieglitz,

Thank you for your letters and both forwardings. Your handwriting saved the first one. The boy who usually goes for the mail was late for school so his aged father went during the hard blow, and two Boy Scouts seeing that handwriting in the snow rescued it. The school superintendent arrived with admiration. So now I am on the spot to know where to place the reward. Of course it really should be yours.

Enclosed letter[1] came today from Independents. Wrote them. As I

remember I sent one when they opened and later you sent two catalog'd as "Nature Symbolized."[2] Not sure. Do not let it bother you as to records, etc. They were "Abstractions" and as such were much like secrets.—That is, there are no such things. . . .

There are now 16 and maybe more oil paintings, and I have 12–14 watercolor frames. Which will leave as many as you want unframed.

The kids tell me that they are to go up next, so am beginning to put them in the frames.

Had a letter from Phillips wanting me to mark two I had spoken about, one as a watercolor—done last summer—which has turned out to be one of the best of the oils. They both are, really. Will mark them *on* your list.

No. 13 [*Lloyd's Harbor*] was done last year. Painted over this year.

14 [*Green Light*] and 15 [*Shapes*] were done at the end of last year. 16 [*Fire in a Sauerkraut Factory, West X, N. Y.*] was drawn in 1936 and painted a few days ago after "The Moon," No. 12. Going a bit graphic.

George Rehm and Bill may bring them in. If you prefer any day—we will try to meet it as nearly as possible. . . .

<div style="text-align: right">

As always,
Reds and Dove

</div>

1. From the Society of Independent Artists concerning paintings included in the Society's first exhibition, 1917, on the twenty-fifth anniversary of the organization.
2. The catalogue of the exhibition lists two Dove works, both titled *Nature Symbolized*.

<div style="text-align: right">

[Centerport]
[Late March 1941]

</div>

Dear Stieglitz,

Marian tells me you think the paintings "Swell," so that is what I wanted to know. . . .

The paintings that Phillips wanted marked are 1 & 4. 1. "Yellow, Blue Green, and Brown" [*Green, Gold and Brown*]. 4. "Lattice and Awning."

About No. 10 [*Neighborly Attempt at Murder*]—Do not think I would bother to satisfy just curiosity. The drawing was made of a dead tree without remaining consciously aware of the tragedy that had occurred there to which I had listened.[1]

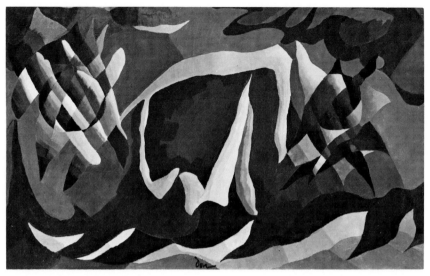

Arthur Dove, Lattice and Awning, *1941. Exhibited in Dove's 1941 American Place show and again in his partly retrospective 1945 show, this painting hung for many years in the home of Dove's Centerport physician, Dr. J. Clarence "Jake" Bernstein.* (Private collection. Richard Di Liberto photo.)

The Dr. has offered to bring us to see you and the show. Some others have also, so we are hoping to see you soon. . . .

Lots of love always to you and Georgia

Reds & Dove

1. See Dove to Stieglitz, mid-June 1940.

The Place
30 March 1941

Dear Dove:

It's a grand Show & very beautifully hung. You'll like it. I couldn't write sooner.—I hope Phillips comes soon. So as to have the "agony" over with. I guess your "average" is higher than ever.—I hope something happens.—Am not feeling very "up" today. So excuse the shortness of these lines. Love to you & Reds.

Stieglitz

The Place
1 April 1941
5:45 P.M.

Well the Phillipses have been here.—And— well congratulations. You are to receive $200 a month for another 2 years! The Place $250 a year for 2 years. He gets No. 1 [*Green, Gold and Brown*]—No. 3 [*Pozzuoli Red*]—No. 11 [*Through a Frosty Moon*]—No. 15 [*Shapes*]. . . . I wonder will anything else happen.—I count on nothing. . . .

Your old
Stieglitz

[Centerport]
9 April 1941

Dear Stieglitz
Well, another unbelievable has been achieved. I never know when I go to bed whether I'm going to wake up sitting on the right hand of

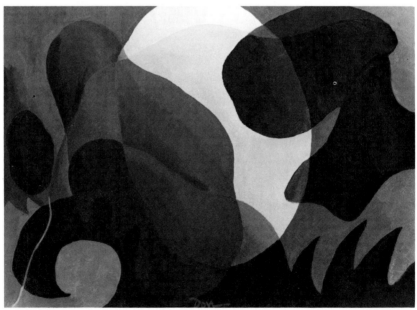

Arthur Dove, Through a Frosty Moon, *1941. Exhibited in Dove's 1941 show at An American Place, this painting was bought at that time by Duncan Phillips who presented it as a gift to an associate after Dove's death. (Private collection. Eric Pollitzer photo.)*

From what the kids say, the show must look fine, they have told us so we can quite visualize it. The doctor wants to bring us in as soon as he returns from Canada in a few days. Dr. Loynes being an M.D., he will allow us to go with her but otherwise he is worried about my walking too much. I feel as though I could run all around this mill pond here. 1 mile. But that is what I used to do in Geneva which was a factor in getting the pump out of order.

A letter from Mrs. Rankin in Washington this morning saying that the Phillipses are to be taxed $40,000 and that they have no vote on the matter. "There is a new tax schedule going into effect in the District & P.'s gallery is listed at $40,000. It makes me sick to have a tax levied on museums & art galleries. Mr. Phillips has protested and I trust that it will not be levied. We have no vote in the district, our affairs are managed by a congressional committee appointed by the President. I have been thinking of writing a letter to the papers" etc. And that some members of the Russian Ballet saw a lot of the "Doves" at the show there at the Gallery & wanted P. to get me to design a ballet for them. It might be interesting to try a ballet with my tail perforce nailed to the chair. My hair—every 10th one or so, is turning dark, so maybe I can be dark or blond or something for my second childhood.

Another fire—we have grass fires about 2 a day now. And with the chief living across the road & more officials near, you are not a good citizen unless you take a lot of interest. . . .

Love as always from us

Reds and Dove

[Centerport]
[25 April 1941]

Dear Stieglitz

Well, the shouting seems to be mostly over—McBride was nice. Coates uses words that are never used around this household.[1] And are quite unlike anything I have ever thought or done that I remember.

The "Art News" seems to have it in for the Place in general.[2] And I am glad I do not see any closeups of the Big Shots in Art any more.

Neighbors are bad enough.

That little 16-yr.-old German girl that was in the other day fought with us for hours the other night to the effect that I "have no right" to do things that do not look like things. She liked the "Fire." *Anyway* she went from here way in there. Will probably be good before she gets

through. It takes it out of you, as you know, to fight for ideas without hitting some people over the head with a mallet. I might say quite a few people.

The doctor is back from Canada, busy, but I am waiting for him to set a day to come in. Dr. Dorothy Loynes is to come in today. But is going on South for a week, so we can't count on her for 8 days more anyway. Was here last night for first time in months. War is taking their hospital staff. Takes care of 1700 patients a day sometimes. Impossible of course, but "They do the best they can." . . .

A letter just here from a sister-in-law of Reds' saying that a teacher of one of her children—Hood College—said it took him four years to understand one of my paintings, so you can see what wonders you have accomplished. It takes quite a lot of my time when I am thinking of you, wondering how it all has happened.

Love as always from us

Dove

1. Robert M. Coates, "The Art Galleries," *New Yorker* 17, no. 9 (12 April 1941): 59–61. Coates complimented Dove's color but felt that overall the show was "disappointing" because of a lack of "justification" for his abstract symbols.
2. Dove was reacting to an exhibition review by James W. Lane: "The Passing Shows: Arthur Dove," *Art News* 40, no. 6 (1–14 May 1941): 28. Lane commented that "there is no particular progress to report" in Dove's art, but at the same time, "there is no retrograding." He also noted that "Dove's imaginative art" would never be widely popular.

For the second year in succession, Dove was able to visit his own exhibition. On 1 May 1941, Dove's physician and friend, Jake Bernstein, and his wife Julia, drove Reds and Dove to the city. Before returning home, they dined at a restaurant, the doctor "allowing" Dove to have a "cocktail, lentil zup, oysters & chili sauce, etc."[1]

1. Diary of Arthur Dove, 1 May 1941.

[Centerport]
[3 May 1941]

Dear Stieglitz,
 You gave us all a grand time. "It was like the good old days."

Our doctor thought you looked very much better and younger than when he last saw you. You *do we* think. Anyway, it was grand and refreshing. . . .

It was fine to see Georgia. Hope she comes out soon. The time was so short there. That western sun certainly seasons her.

A note from Marian yesterday. "Girl gets job" at the Manhasset Bay School, the one she wanted at $1600 which is very good. Fine to have them near, and convenient to N.Y. for Bill. . . .

I want to get in again to study the paintings. There is hardly enough space here to back off and see them with all the orders being carried out. Hope you did not use up too much of your energy on us. I was especially good the next day, so you see what you did.

<div style="text-align: right">

Love as always
Reds and Dove

</div>

<div style="text-align: right">

[Centerport]
[31 May 1941]

</div>

Dear Stieglitz,

. . . . You did just the right thing with Dorothy Loynes after the way she behaved when I was "stricken" as they say. We tried to pay her back in cash, but she would have none of it, wanted a watercolor. Well, she seems quite happy about the painting [*Fire in a Sauerkraut Factory, West X, New York*]. She has taken on so much work, many of the staff having gone to war, that she has become almost a pacifist.

The kids are coming this morning, the Rehms this afternoon. George still out of a job, he's been writing, not much of anything sold yet.

The Dr. is giving us a new kind of [vitamin] B which is working wonders[1] and now with teeth all filled again things are going well with the work. Counted 50 of the better ones yesterday.

Please tell Georgia that the swans have two young.

I may, by way of variety, have all paintings next time. We'll see.

Much love to you both and we do hope the weather is agreeing with you there. It is perfect here.—

Have found a dentist who *doesn't* hurt!—runs his drill at about ¼ speed—Jewish, French, sculptor, & painter. How's that? . . .

<div style="text-align: right">

Always
Reds and Dove

</div>

1. Dr. Bernstein had started giving both Doves vitamin B-complex injections.

[Centerport]
[15 July 1941]

Dear Stieglitz

Things here are going much better this summer with one exception—Reds has to be put through a course of tests at Mt. Sinai for gall bladder etc. beginning Aug. 11. Thought we could get in again before you left, which I suppose you have done.

Have heard of some of your activities in "Vogue" and thereabouts through our psychiatric friends who came over from Brentwood, and I do not mean Dr. Boltz, the one who blew his nose and coughed until he woke you up at The Place recently. A letter came from him as Dorothy and Dr. Holt were here. They wanted to shoot him for waking you up. Dr. Holt has been at 509 several times—very small and sensitive. You may have seen her with Dorothy. She (D.) is pleased very much with the "West X, N.Y." Will probably write you about it. It is quite a relief for them to get away from that place and their "Disturbed" ward as they call it. A colossal understatement. I heard them from outside, waiting in the car.

A pheasant from Dr. Boltz the other day. Whom he had shot when it didn't have a gun last November and frozen. And now I have to thank him for it uninterestedly.

Those mediums he makes are pretty well covered in Max Doerner's book. Dr. B. has it in the German. Offers his medium for $4.00 per qt. Almost everyone knows that tempera medium will mix with oil paints for matte. Also wants me to give his wife lessons. I am too busy now, and painting takes too much time to do his wife justice.—As I read between the lines (in his letter) about your being "pessimistic," I just hope he hasn't bothered you too much. . . .

You need all the rest you have earned and everyone will understand if you don't write. You are always more there than any of us, and we always know where to find you. It is a nice way to feel about you. . . .

As ever
Reds and Dove

Stieglitz was at Lake George from July to September of 1941, while O'Keeffe was in New Mexico. Bill and Marian were again near Dove and Reds in the summer.

Lake George
31 July 1941

Dear Dove: I'm managing to scrape through one day after an-
other. Am pretty sick of myself.—Do absolutely nothing but lie
about—sit about—eat & sleep. Not a thought in my head or
elsewhere—wherever.

—The itch in various places tortures the life out of me.—

What you say of the Rochester [i.e., Binghamton] Dr. [Boltz] is what
I surmised. . . .

Your old
Stieglitz

Lake George
30 August 1941

Dear Dove:

. . . . I hope you & Reds are having some peace.—For 10 days I have
been fighting sinus—antrum—larynx, etc. There is no peace for the
wicked.—I guess I'm very wicked.—The very cold weather with a
stupidly overheated furnace,—& each room a different temperature, are
not particularly good for me.

—I won't be sorry to get back to The Place.—With love to you both
Your old
Stieglitz

The Place
30 September 1941

Dear Dove: I have been in town since the 18th, 6 P.M. And at The
Place since the 19th A.M.

—I have not decided what to put on the walls.—Hard to know. Am
so alone. And The Place so unrelated to all the humbug going on in the
"Art" (!) World of today. In this country particularly. . . .

—The bare walls freshly painted look rather forbidding.—Well, I
suppose I'll get an idea someday & pictures will go up.—It all becomes
more & more difficult—problematical.—Even crazy.—

—I'm glad you are painting.—I'm glad you are "protected" for a
while.—

Well Dove, I'm toeing the firing line as ever.—
With love to you & Reds

> Your very old
> Stieglitz

In October 1941, An American Place opened with a group show of work by Dove, Stieglitz, Marin, O'Keeffe, and Picasso. After this, only work by Dove, Marin, and O'Keeffe was exhibited during Stieglitz's lifetime. Marin's new work opened in December, following the group show; O'Keeffe's was on display in February and March. Before Dove's show opened in mid-April, Stieglitz showed another group of Marins: *Pertaining to New York, Circus and Pink Ladies.* Because of Marian's new teaching position, she and Bill lived in Port Washington during this season.

Dove's next letter refers to a *New York Times* article that suggests how vehemently modern art continued to be opposed throughout the lives of the two correspondents. In a story about reactions to the simultaneous Dali and Miró retrospectives at the Museum of Modern Art, Edward Alden Jewell wrote, "You might think that by this time surrealism would be accepted or repudiated in one's stride without the risk of getting high blood pressure over one's response. But no. It seems that reactions are just as violent now as they were when this sort of thing was new and strange and startling." He quoted at some length from readers, including one who was distressed by the "indescribable filth" of a Miró painting reproduced in the *Times* the preceding Sunday.[1]

1. Edward Alden Jewell, "Dali and Miro Shows Stir Wrath," *New York Times,* 30 November 1941, sec. 9, p. 9.

> [Centerport]
> [1 December 1941]
> Monday

Dear Stieglitz,
 The "Times" was amusing yesterday about the Miró argument. Thought those days were over, but the worst seems always still to come.

These have been great days for work. Last year at this time I was still working on the first one—now there are 7–8.

. . . . My frames are here, same as before. Can't do much else. If there is any next year, maybe I can be on the spot to do them—gaining some time anyway. Have all canvas coated and stretched. They are better than the store ones.

Reds just going uptown, will give this to her to mail—she is much better.

This is the first letter I have written in some time.—Almost forgotten how.

Lots of love as always

Reds and Dove

[Centerport]
[5 January 1941]

Dear Stieglitz,
. . . . Has Phillips sent the "subsidy" yet? I do not like to let it go too long, as the other one that was lost was in a snowbank last year, and the snow reminds us of banks, etc.

Do not bother to answer this unless you have already sent it. The old man who gets the mail when the boy is not here does not see very well, otherwise is too careful.

A swell letter from Beck [Strand James] including a photograph of herself and husband. . . .

As always,
Reds & Dove

Am about to write Peggy [Davidson] to choose a watercolor for her wedding present, if that is all right for you and will not disturb.

[Centerport]
[30 January 1942]

Dear Stieglitz
Things are going fine here. Have some more new paintings that people seem to think best yet. Say they make them happy when they come into our room.

The harbor here is quite happy too with all the ducks starting to

make more ducks for next year. Enthusiasm all right, and right in the ice-cold water. The local ones get immoral from being fed too much.

Reds has been taking another bunch of Sulfathiosol, which is quite upsetting. Hope this is the last of it. Has been getting to work.

A fine letter from Peggy. Do as you feel about it, as you know, we think the world of them all. We have your photograph of her. It is so permanently beautiful every time you look.

See by "Times" that Dr. Barnes has another Renoir.

The Brookses asked for you in their last letter. The Perrys have bought a place out there [California].

It is nice to be able to coat some canvases again. I can move about the room a little and out in the yard but no walking. Would love to get in town oftener, but it is about impossible now—a little later.

Much love to you. Please give ours to Georgia, and those whom we know who come to the Place.

As Always,
Reds and Dove

[New York City]
31 January 1942

Dear Dove: Georgia's Show is about to be hung.—I'm more dead than alive. Everything becomes more difficult & impossible.

—There were not 200 visitors to the Marin Show in 7 weeks. And it was the grandest yet. None of the critics wrote anything worth a tinker's damn.—Well, I'll go on till I drop.—

—Love to you & Reds.—

Stieglitz

[Centerport]
[3 March 1942]

Dear Stieglitz

. . . . You seemed interested in those vitamin B things I spoke of, so am sending the labels. They are not for everyone, so ask the doctor. We read about it in the "Lit. Digest" in connection with eyes. I was having so much trouble and several operations for cysts so Dr. B[ernstein] sent for them. It took some time of course, but things cleared up. It also had a good effect on the heart, so he is trying them on quite a few of his

patients with success. . . . I know lots of doctors have no use for them, my brother's doctor in Geneva for instance, thinks they are non-sense. . . .

We are taking them by mouth and also shots in the arm, two or three times a week in the arm and the pills 3 times a day.

He told me a year ago I could never walk like other people. It may have been to keep me quiet, but I am on my feet about half the day, stretching canvas, coating it etc., and it doesn't affect me. At least he comes every day and listens to the pump and has not said "A trifle rapid" in several months.

Will send you the list of paintings etc. in a few days. Have nothing definite in mind as to literature on the subject. There are some new ideas, but in these days of high pressure, people seem interested in results only. Well, I think we have those also. . . .

> As always
> Reds and Dove

> [Centerport]
> [6 March 1942]

Dear Stieglitz,

. . . . In the throes of income tax. Lucky, I suppose. . . .

Have you used honey? It is good heart food, I believe. We drink it with water and club soda. Coffee in it if you like. . . .

I might write something [for exhibition pamphlet] but think it might be superfluous just now.

As always we are thinking of you

> Dove

During the O'Keeffe show, Dove made the first of two trips to New York that spring. He and Reds took the paintings to the gallery with a young Centerport neighbor who drove them there. They visited with O'Keeffe, as well as Stieglitz. Two months later, Jake and Julia Bernstein took the Doves again while Dove's own show was on display.

[New York City]
10 March 1942

Dear Dove: I hope the trip didn't harm you any. It was good—very good—to see you & have you at The Place for some hours. And your exhibit will be a very fine one. My congratulations.—

Love to you & Reds.

Stieglitz

[Centerport]
[10 March 1942]

Dear Stieglitz,

I had a grand time yesterday. Wanted to talk with you much more than I did, but there was quite a lot going on about you. . . . When one is not able to do things and people stand around telling you how well you look, it does become irritating after a while. Have had that experience.

If you could only get a chance to do your own work, a way must be found. It is the pendulum to the old clock, what puts the whole show in order. And I think it can be done sitting in one's chair, or stool, with all the spirit you have.

Yesterday gave me a good look at the things I brought in. One thing I might hold out—may bring in something to trade for it. No. 20, "The Square on the Pond." I cared for it least. Wonder if you and Georgia agree with me? Thought I saw you give it a dirty look once. Not sure. Have at 'em anyway.

I thought Georgia's things looked fine. The black elephant hills, the one she called "The Gray One," and the deep red one.

The black jug I certainly remember. It is all right to paint things, but to make people remember them is quite a different "Job" as Georgia now calls them. The orchid that gives me ballet dancers with it was fun. I just was very happy looking and want to get in soon before they come down.

The Marin room was big in the way the people began to talk and move about in an intimate old-fashioned fashion. It was fine, and the motorboat was real with its upside down waves on the frame and all to give the feel of the bumps as they do to the bottom. The humor was swell and the blue one was so done, the one with the blue cloud on the left.

I had a good time all day.

Have to go up and pay Uncle Sam what we lost [$28.16 in income tax]. The State gets on without us this year.

Am sending Georgia some of that medium to try, but "Not responsible for hats & overcoats." Am quite sure it [encaustic] is as hardy a thing as I have used. Time has proved it anyway. The boys in Egypt used it.

Hope to be in soon again. The doctor was here to meet me and expects me to live.

Lots of love to you both from us

<div align="right">Dove</div>

<div align="right">405 E. 54
18 March 1942</div>

Dear Dove: Unforeseen events have compelled me to delay the opening of the Dove Show until April 12. It will run then for 6 weeks.—Owing to the "New Yorker" article on Marin together with the Mellquist book on American Art[1] in which you will have a chapter & which is due in a few weeks—& the fact that series of pictures Marin did in 1936 that I had never seen—New York & the Circus, etc.—I decided on the spur of the moment—that is really Kalonyme & Georgia—felt those Marins should be switched in as timely for <u>now</u>.— & that this Show would bring people eventually not only to The Place for Marin but for your Show. Your pictures are grand. I want an audience for them. Georgia has sold nothing.—Everything is precarious. I hope you'll not misunderstand. Nor will Reds. You may depend I wouldn't make the move unless I felt it was an essential one. I really hated to make it.—You'll be satisfied with the course I'm following. So will Reds.—

My love to you & Reds

<div align="right">your old
Stieglitz</div>

1. Jerome Mellquist, *The Emergence of an American Art* (New York: Scribner's, 1942).

[Centerport]
[19 March 1942]

Dear Stieglitz—Your letter is just here and of course you know we would agree with you, I like that time of year anyway. But, the best part of the news is your enthusiasm. It is always there and only needs something to bring it out. Naturally it makes us very happy.

April 12 will be fine and I hope to have one more. Want it to be the best one—so it will take the whole of the more time there is. I think there is "Something added" in this year's show.

Will send Georgia some more of that stuff as soon as it is cleared, which takes about two weeks, unless she doesn't like it.

Reds sends love. She is taking another session of sulfathiasole, but had to stop last night as fever went up. Normal again this morning and she feels fine.

Dr. just here on the run to the hospital to born a baby so life goes on just the same. . . .

Have written nothing as yet. "Don't feel like talkin'." . . .

You know we all love you—so feel happy or glad or whatever you want to feel.

As always
Reds & Dove

[Centerport]
[4 April 1942]

Dear Stieglitz,

. . . . About our mail. Am sending some Special Delivery stamps to put on anything important. Then whoever gets it has to sign.

There seems to be some competition between the father who is 75 & the son, 17, to get the mail and the dime reward.

The son wants the dime for lunches at school, but the father spends his at the corner and is much more interested. It is a large family, but the father isn't the father of anyone in the family. I do not think the wife was true to him in the case of any of the children, some of whom are quite dark. He is a nice old sea captain who never shaves except on Decoration Day for the fireman's parade.

At this time of year the boy skips school and fishes for smelt all night so that the family can eat, so is not so reliable. The mother who, they

say, is attractive presented the father with "John Benham, Jr." (very dark) and left home.

That isn't the ½ of it but enough to give you an idea why the special delivery stamps. Incidentally, the last check is not arrived so thought I'd better let you know.

Thank you much for sending on the Anderson "Memoirs"[1] from his wife Eleanor. It has a fine note on the first page.

Am at work trying to do the best one yet for this year's. Pretty good today. Will see.

Our love to you and Georgia

As Always
Dove

1. *Sherwood Anderson's Memoirs* (New York: Harcourt, Brace and World, 1942). Paul Rosenfeld compiled this volume from Anderson's notes after his death the previous year.

Dove wrote next on the day after exhibition brochures for his show had arrived. Stieglitz had reprinted Dove's poem, "A Way to Look at Things," written in 1925 for the exhibition pamphlet of the *Seven Americans* show. The Dove pamphlet also included brief quotations from the writings of Duncan Phillips, Jerome Mellquist, and Martha C. Cheney.

[Centerport]
[14 April 1942]

Dear Stieglitz,

Many thanks and congratulations to us both for the grand way you did the list of paintings.—Strange, but on the way home from N. Y. that bit of writing I did some time ago occurred to me as a possibility that might be used. Must have picked it off you. You put in just enough.

It was fine of Georgia to do such hanging. Am writing her.

Thank you again for sending "Twice a Year." That thing on you and Marin is fine and fresh.[1] Hope he continues to stay around you. He is the kind of person we need. The only one I have read so far.

Hope that Marin had some luck, and that Georgia's continuous public keeps coming. It is quite astonishing. The sister of the boy who brought me in that day said to him when he came home, "Do you mean

to tell me you talked with Georgia O'Keeffe?" They had had her work for study, at school that day in Huntington.

This year's cold came after the N.Y. trip, so that I did not get in the one more painting—fortunate that it did not come sooner. Gone in a couple of days, so work is going again.—Made four watercolors yesterday and one in bed at night. Don't know whether it is Vitamins or Spring.

The check came in the next mail after sending the stamps. The Captain brought it and the son brought your letters this morning, so the mail service is picking up again.

The willow trees are two or three days late this year according to my log. Still keep one as we did on the boat. They are quite convenient at times. . . .

Dr. Loynes has just had an ear operation but is at work again. Maybe we can come in with her. Cars are not so prevalent this year. One cannot go outside the bridge here in a rowboat without a permit.

Our love to you and again thanks for everything.

<div style="text-align: right">

As always
Reds and Dove

</div>

1. Henry Miller, "Stieglitz and Marin," *Twice A Year* 8–9 (1942): 146–55.

<div style="text-align: right">

[New York City]
1 May 1942

</div>

Dear Dove:

. . . . Mr. and Mrs. P. were here twice last week. P. hasn't decided definitely what he'll take. Is to come again in a few weeks. Liked the "Show" better on second visit. Was a bit bewildered at first.—I'm pretty sure there'll be a $200 per month for another painting or two. Nothing as yet decided.—The pictures wear!—

Visitors are scarce. The "war" is raising hell.—Love to you & Reds.

<div style="text-align: right">

Stieglitz

</div>

<div style="text-align: right">

[Centerport]
[4 May 1942]

</div>

Dear Stieglitz

You have evidently been working wonders again under very trying

circumstances and it will be another swell miracle, if what you say may come true, does.

I was going to write the Phillips again to give them a clue to what I was driving at, in case they had not seen it. Thought better of it though, as I wanted to be sure not to overdo anything you might have said. Realize that what you have done is perfectly balanced and anything else might upset it. After they had chosen something, all right, but before, no.

The kids were here the other night and Bill said P. was "Overcome" by them, so thought probably he had given Bill something to tell *me,* but I know you have done every possible thing, so am always so glad to have you at the wheel, if it isn't taking too much from you. It is. I know. And that is the heart-breaking part of it.

Up and at 'em again. Overdid coating canvases and working on new ideas. Have quite a lot done. Doctor put me in bed for a few days, but I am learning about how much can be done and how much not.

Tried peanuts as a B_1 Vitamin help, but they were too heavy. Would have known that a few years ago, but now, I think anything is possible.—Including hoping that the timing idea in this show would be self-evident. It is comparable to music, but not the same. Didn't want someone to say that I don't know what I am talking about. I don't in the case of music, but I do know what I am painting about.

It is coming out of space rather than drawing "From the eye back" which is still a relic. It can come as a thought, a form, or sensation. Have a small one here that perhaps is even more evident.

Dr. has just been here and says I am so well again, he may be able to bring us in Thursday—if his patient's baby arrives before that. Funny to be held up by someone that is not yet alive.

Lots of love and thanks to you all. Swell to hear from you.

Always—
Reds and Dove

[Centerport]
[7 June 1942]

Dear Stieglitz

. . . . Had hoped for another visit from the Phillipses, but it seems that the mills of the Gods grind exceeding slow. Been grinding quite hard myself, getting a good start on next year.

Have been watching a blackbird drying off after his bath—in tree—in

front of me here. Good for one '43 Dove painting, I hope. Vigorous. . . .

I do not believe I have written you since having the grand day in town. It was wonderful of you two to send the folio to the doctor's wife. They were pleased as anyone could be, came right down with it to show us. We told them that that was the sort of thing you had been doing all your lives.

Reds' mother writes from Miami regretting not being able to see show. Fell and broke her hip while packing to come up. Getting on fine however and will have a much needed rest.

We both feel so very glad to have this fine last number of this "Twice a Year" with the reproductions of the "Equivalents."—Of which we are going to have [one],if anything tangible happens to make it possible. It has been on our minds for some years, and is part of our plan.

Much and more love to you, as always

<div align="right">Reds and Dove</div>

<div align="right">[New York City]
3 July 1942</div>

Dear Dove: Just spoke to Miss Bier, Phillips Memorial Gallery. You will have the usual check ($200) in a day or two. There had been an oversight on their part. As matters stand they owe you $4400 payable in $200 per month instalments. I have looked ahead & tried to protect you as best I could. Love to you & Reds.

<div align="right">Stieglitz</div>

<div align="right">[Centerport]
[5 July 1942]
Sunday</div>

Dear Stieglitz,

That was certainly an achievement, especially at a time like this, and—in Washington where things are bedlam. It must have been a clear contrast to all that is going on.

Miss Bier is a nice person, has a fine wealth of feeling, came to Geneva with Miss McGloughlin [Virginia McLaughlin] once on their way to a vacation. We did not want them to leave. Warm.

The story of the four-leaf clover is amusing—Reds never had found

one before—never looked for them. As she came in the house with two of them she met the messenger with your *special* [the previous letter]. So it was nice to know, and we want to get in to see you, if possible, before you go, to put our first good fortune on one of the "Equivalents."—We have looked forward to that, so long now.

With love

<div align="right">Reds and Dove</div>

<div align="right">

[Centerport]
[7 July 1942]

</div>

Dear Stieglitz

. . . . Am enclosing a check [for $200] as payment—impossible—on one of the "Equivalents," or an "Equivalent" to be chosen by all or any one of us three. Should prefer your choice. We have been hoping for this for years.

<div align="right">

Love Always,
Reds and Dove

</div>

<div align="right">

The Place
8 July 1942

</div>

Dear Dove & Reds:

What in the world have you been up to? Your Special with check came this A.M.—I am still not quite over the shock I received. And it's 6 P.M. now.—

I shall look at my "Equivalents" & see what I would like you to have.—

I haven't made a print in 6 years nor photographed.—Of course, much as I could use the money personally it will go to the Place—Rent Fund & Andrew. [Letter incomplete]

<div align="right">[Stieglitz]</div>

<div align="right">

At 405
17 July 1942

</div>

Dear Dove & Reds:

I have sent you today 2 framed "Equivalents." . . . Had the frames made, therefore the seeming delay.

I wonder what you'll say to the selection. If you might prefer 2 others, I'd gladly make the exchange someday.—

I hope to leave for the Lake on Tuesday A.M.—I have had a bad throat & sinus. And am about used up.—Getting a bit old I fear. My love to you both

Stieglitz

[Centerport]
[Probably 23 July 1942]

Dear Stieglitz

. . . . The work is going fine now. The photographs really are a great help. I am always trying to make my things more real, although it may bring a smile when I say it. My distance from the public seems to be a constant, we both appreciate.

I can truly sympathize with the ordeal of wearing a truss—years of it. The thing that helped most was a handkerchief I rigged across the front of the truss as a sort of hammock underneath, tying corners 1 & 2 to one side of truss and 3 and 4 to the other. It could be changed often and really saved the day until it all suddenly disappeared. It is worth trying. And certainly a relief.—Not too large a handkerchief.

We are enjoying the photographs and loving them.

They have brought up another contingency. We have been hoping to be able to paint our interior all white for some time. It looks now as though it would have to be done soon. The walls of this old post office are supposed to be white, but scrubbing did not make them as pure as they should be.

We had a lovely visit from Elizabeth a week ago Monday. I have a continual floor show here. Everyone *walks* to the beach below here now—and in their bathing suits—some of the most remarkable figures, ranging from the sublime to the god-awful. . . .

Always,
Reds and Dove

Dove and Reds were taken by surprise during the summer when Bill and Marian announced they had decided on a divorce. Soon after, Bill took a wartime factory job.

[New York City]
26 July 1942

Dear Dove: I wonder did I thank you for letter & check. My memory is getting to be awful.—I intended writing immediately but I have a vague notion I failed to make good the intention. The divorce you mention startled me some but in no way surprised on thinking "things" over.

Love to you & Reds.

Stieglitz

[Centerport]
[9 August 1942]

Dear Stieglitz,

I am hoping that you are feeling fine. Tried to call you at the Place and the studio, so suppose you are at the lake. It is a rough Sunday on the water here, one of those northeasters, almost cold.

Not hearing from you on the first, thought I [had] better let you know as our mail system is much better, though not perfect as yet. One of the daughters is doing it now by the week, perfectly trustworthy with everything but her virtue, as far as we know.

Bill seems to be coming on fine with his factory work. Will be over Wednesday. Marian is to be married to a man by the name of Carpenter, sometime soon. Hempstead—left-wing—Labor Party, I believe.

Bill has a job in one of the plane factories at Farmingdale, L.I. Hope he cuts things off short.

The photographs are marvelous things to have on the wall. We have been very happy with them. New ideas have come since they have been here. It is great to have such fine company.

Our love as always

Reds and Dove

Have at least 75 small ones in oil to work from.

Stieglitz finally had left for Lake George at the end of July. O'Keeffe spent the summer in New Mexico.

Lake George
9 August 1942

Dear Dove:

I'm up here since July 28.—Pretty well used up when I came. And am still not much.

—I wonder did Phillips ever send me the August check for you & I forwarded it to you at once. My memory is playing me sad tricks of late. So let me know. I hope the photographs wear.—

Love to you & Reds.

Stieglitz

[Centerport]
[11 August 1942]

Dear Stieglitz,

Your letter just here—Tuesday morning—and I suppose you have mine by now. Reds mailed it in Huntington yesterday. It seems a shame that you have all this trouble when you are supposed to be "resting." Maybe there's no such thing. If it is bothersome to you, tell them to send it to me and I'll scream to you if it doesn't come—but—I know well your perfectly good reasons. It would be so much easier to eliminate me than you—and one of us than both of us.

People seem to grasp, or think they do, three dimensions more easily than two or one, or none. They want to be able to identify themselves as inside the thing and if their opinion of themselves is too large, they get stuck.

Our little nephew came over last Tuesday and wanted to know when I would have some more *large* paintings. It seems that he has told his young friends that I am one of the three greatest painters in America, so he wants results.

Maybe that is how "Murals" began.

Of course the photographs wear.—They have worn the looks of this room to where it has to be redone in pure white. You will hear more from us about them—they are always saying things that mean so much to us.

Love to Donald, if he is there. Much as always to you.

Reds and Dove

Arthur Dove, Untitled Drawing, *19 August 1942.* (William C. Dove, Mattituck, New York.)

Lake George
11 August 1942

Dear Dove: Just had your letter. Must have crossed mine to you. Or is it an answer to mine? Time doesn't seem to exist for me.—And my head? Well, the less said about that the better.—Well, I called up Miss Bier at once. The check will be sent here at once & I'll forward it to you as soon as it comes.—Their Treasurer is ill. A muddle most everywhere. Ye gods & little fishes.—As for God—well—?—

—I must get this off to you.

Love to you & Reds.

Stieglitz

Dove's health had been fairly stable for some time when his doctor left for war duty in the Army. If not in danger, however, Dove was so weak that Dr. Bernstein did not expect to see him again.[1] Nevertheless, Dove optimistically considered the departure to be primarily the temporary loss of a personal friend. The war impinged on Dove from other

directions, too. Shortly after the physician left, Bill was drafted and left behind a new bride, Aline DeLara. Reds's brother-in-law, George Rehm, departed for Europe to work for Allied broadcasting.[2]

Stieglitz, who had not left for Lake George until the end of July, was back in New York for the season before the end of September 1942, but he did not put up the first exhibition—Marin's—until November. Dove's show came next, opening in February. O'Keeffe had a retrospective exhibition at the Art Institute of Chicago before her show of recent work followed Dove's at the gallery. At the beginning of this season, Stieglitz and O'Keeffe moved for the last time, from the penthouse to a smaller apartment at 59 East Fifty-fourth Street, only a block from An American Place.

Dove's next letter was written the day he had received one from Stieglitz saying that a painting had been sold for four hundred dollars—three hundred for Dove, one hundred for the gallery. Dove's reaction suggests what a surprise it still was any time a painting of his was sold.

1. Interview with Dr. J. C. Bernstein, June 1977.
2. Several younger members of the extended Stieglitz clan also went to war, as did the children of several other associates, but none of these were as close to Stieglitz as Bill Dove and George Rehm were to Dove. See Lowe, *Stieglitz*, 406, for a tally of those involved.

[Centerport]
[3 October 1942]

Dear Stieglitz!

They are housecleaning inside, so am out here in the sun *beside* the water, while you are walking on it again with the rest of the miracles. It is great. Anyone with any vision can see it in the photographs. That depth has its reason for being. You follow through anything you do with your whole life.

The news was such a surprise as I stood beside the bed reading your letter that I damn near sat in a painting I had just finished yesterday.

It has been quite a week. Work.

Bill telephoned that he is going to be married again. We do not know the girl's name yet. Hope he does. Says we will like her.

Our doctor leaves for Texas (Capt. in Army) on the 10th. He is trying to have another man stop here twice a week but I have learned to tell pretty close how I am and Dr. Dorothy Loynes may be able to get over

every week or so. Think we can get on without any more doctors to interrupt the work now.

Dr. Bernstein has become very enthusiastic about cameras. We have given him Bill's, a German one, to take with him as a present for postponing my death for so long. I can't walk yet much, but, "I can do other things," as they say. It is a nice camera that Bill bought as a bargain for $45 and I am getting for $15–20. They have a beautiful child, so each want a camera. (The *Bernsteins* I mean!!) . . .

A letter today from Modern Museum, wanting me to tell them the name of "Sitter" for a portrait of Alfy's.[1] His sister (and others) thought I might know. I don't without seeing it. They also want any portraits that I have done.[2] Thought of the one of you—"Grandmother" and "Ralph Dusenberry." They also want "my suggestions" if you please. I can think of a lot. Perhaps you could knock them out with a good one? Exhibition opens Dec. 8, closes Jan 24th. Letter from Monroe Wheeler.[3]

The one of you was on vellum with a smoked lens. Suggesting what I saw about you when you were speaking of your mother to Bloch the musician at your brother's house. It may not do. Do not remember it distinctly.

It is swell to know you are near again.

Will write you again as soon as I can get used to all this light. Something must be going on—may be just you, as usual.

With much love

<div align="right">

As always
Reds & Dove

</div>

1. Alfred Maurer's *Black Parasol,* c. 1904. The work now belongs to the Museum of Art, Carnegie Institute, Pittsburgh.
2. For an exhibition of *Twentieth-Century Portraits.*
3. Monroe Wheeler (b. 1900) had published fine limited-edition books and had assisted the Museum of Modern Art as a member of the Junior Advisory Committee before becoming an important member of its staff. He was appointed director of publications in 1939. Only a year later, his duties were enlarged to include direction of exhibitions as well. He continued in this role until 1967, serving also as a trustee from 1945 to 1965.

<div align="right">

[Centerport]
[Probably 31 October 1942]

</div>

Dear Stieglitz,

Work going fine here for both of us, and we hope for you.

Bill is married to a fine girl, born in Java, part Spanish and part Jewish, so we have some good blood in the family at last. Father was a construction engineer in the Orient with St. oil. Mother very lovely, Bill says, speaks Malay, an American (Yank). Girl is a technician in Flushing hospitals. Bill has a job, lathe worker in Port Washington, so they are all fixed unless he is drafted, in which case she has her job. Her brother an artist, advertising. Donald told Bill he would be married twice, so that's that data. . . .

Bill's wife said she didn't know much about modern painting, but had always been interested in your work. Went right up to your photographs when she came in, so of course we liked her, and her way of looking at them.

George Rehm is in London, broadcasting from there or points south.

Our doctor is in Texas, coming home Tuesday to drive wife and child down there until he is sent overseas.

These seem to be a lot of news items. Might add one more—that I think Adolph [Hitler] is the only artist that has been duly appreciated in his own lifetime. . . .

<div style="text-align: right">

Always,
Dove

</div>

<div style="text-align: right">

[Centerport]
[Probably 17 November 1942]

</div>

Dear Stieglitz

. . . . Have been working hard and trying to "take it easy" in between times which, as you know, is harder.

Quite a lot done however, including dentist etc., glasses which are large and trifocal, designed for artists. They have them for about a dozen different occupations.—Hunting for instance. Which I suppose would do for the Solomon Islands. Haven't tried the new glasses, but these paintings look pretty good so far.

It certainly is a marvelous help—this thing you have perpetrated. I mean by that a little peace of mind. It seems miraculous in these times. Am *learning* so many things! Am wondering what you are thinking of there at the Place. Maybe people are not going to see pictures. Accounts of them have not rocked the nation, as far as we have seen.

<div style="text-align: right">

As always—
Reds & Dove

</div>

Bill and Aline Dove, Centerport, New York, early 1940s. (William C. Dove, Mattituck, New York.)

[Centerport]
[11 January 1943]

Dear Stieglitz,

. . . . They [the paintings] are going fine now—always do after several have been done. Have about 16 and they are improving all the time, so shall keep on as long as there is time and then get more and more particular as to choice.

See by the "Times" that Georgia is having a show in Chicago. It is a very enthusiastic place[1] and I should think this might be a very good time, if the mills of the gods so grind. . . .

Bill is in the army at Camp Upton at present. Aline is going to take her technician job back and live with her mother and brother. We like her more and more as we see her.

Phone call from Marian Christmas morning. It was nice to hear from her and that they [she and her new husband] are happy.

Have ordered the rest of my frames. A taxi driver who was once a prize fighter has promised to take them in—if he is not drafted, so they ought to get there. He has a family so hope he will be able to drive.

Reds is feeling much better now that teething troubles are over.

She sends much love as we always do

As ever
Dove

Have been hunting all over for a soap—non-alkaline, on account of eyes. Have found "Halo" Shampoo, Colgate! Tested it and it is neutral by litmus paper. Thought it might help that itchy thing for you. Might be worth trying. Anyway it is the best, by far, shampoo we have tried. When I made painting medium, the alkali from the ammonium carbonate would get in my eyes, so I wanted something neutral to wash them with.

It seems to help, but it may be the Vitamin B_1 we are taking.

Dove

1. Dove had exhibited in Chicago in 1912 but had not been there since.

[Centerport]
[27 January 1943]
Wednesday afternoon

Dear Stieglitz,

Am waiting now for the packing. They have to collect more than one order before coming out this way from the lumberyard. Here is the list of paintings. Had written something but thought the following might do.

"THE FOLLOWING"

"I was going to write a foreword but thought better of it."

No. 22 [*And Number Twenty-Two*] is very small, about postcard size, one of the best. We decided not to try to let Dorothy Loynes bring them in being that they might take away her ration cards and then she would have to walk miles around those grounds at the Hospital.

Baker boy just here.

B.b. looking around the room, "Is this that Modern Art I've heard about?"

I—"Yes"

B.b. "What is it, sort of a hobby?"

I—"No, I make my living that way."

B.b. "Gee! That's fine."

Now we know what to say.

Just talked to our substitute doctor about taking train to town. He says you have to fight for seats, and I'd better try to ride in on a delivery wagon or with some invalid person that has a permit—(We know of one) to go to see a doctor. Pretty difficult! We'll keep on trying. . . .

Maybe we could fly in and take a taxi from LaGuardia field?

Doctor says there is too much walking in Penn. Station, stairs, etc. Wheelchair?

This has to go to P.O. by gal across road who is married & has 3 children, is very good-looking, has seven soldier & sailor boyfriends, a shell-shocked husband in San Francisco hospital, writes to all of them, entertains them on leave and tells them that the children are her sister's (Mulatto).

See brother coming, so will try to send him. She must have a date. . . .

As always
Reds and Dove

The seagulls are flying by the window and their beaks look like ivory thrown slowly through space. . . .

[Centerport]
[1 February 1943]
Monday Morning

Dear Stieglitz,

. . . . They [the paintings] are all packed with wallboard around them and between each two, and crated with shingle lath, and then roped with clothesline to hold the crates from pulling apart. There are six packages—one small. Six *in all*. I will insure them. Could Andrew do the wallboard up in a bundle and the shingle lath in another and ship them back collect? I can use them again, or for sealing up our bathroom, or bomb shelter,[1] it has no tub. They (the wrapping) cost $9.30 so are quite worth saving. Charged me for cutting etc. . . .

I wish I could be there to unpack them, but doctor says it would be too strenuous and I am not that anxious for publicity. . . .

Well, I think I have found something that will help on a good fresh start or continuance on this next year's work. Have done one, and it is quite rich. . . .

The smallest one, "And Number 22," we would better mark Not for Sale. I would like to keep it, and it is done on cardboard with no ground. Reds, Bill and I like it, so might as well keep it in the family. . . .

As always
Reds and Dove

1. Dove was joking about the bomb shelter; he did not have one.

The Place
3 February 1943

Dear Dove: . . . I am looking forward to your new work.—I know it is fine. Too stupid of me to be so worthless, particularly in times like these. You can't paint your world. And I?—Ye gods. I can hardly write a letter.—

My love to you & Reds.

Your old
Stieglitz

Dove had talked to Stieglitz on the telephone three days before he next wrote.

[Centerport]
[4 February 1943]

Dear Stieglitz,

It was terribly hard to hear you say that you had had another setback.
I know what they are from having to go to bed in the middle of painting
so many times. You just have to cut in half what you are doing, and I
have an idea we have a tendency to cut in half what they tell us we can't
do. It is like resting, even if you are not sleeping, your mind is going in
your chosen direction and when you feel a little more power you can
look into the work.

I was thinking of calling you back and calling the whole thing off so
you could just take a good rest. And then I knew that you would never
do it.

Am glad Georgia's Show [at the Art Institute of Chicago] sounds so
big and fine. It will give her a grand pickup, and the rest of us too.

These are the days when the batteries need all the charging they can
get.

That one of the "Quawk Bird" is a different kind of drawing for me.
Drawing the way one feels about it rather than the way one sees it. . . .

[Unsigned]

Dove did not have the opportunity to see his show this year. When
Stieglitz next wrote, he had not yet heard from Phillips after sending
him several Dove paintings from which to make his annual selection.

An American Place
6 April 1943

Dear Dove: . . . I wonder what Phillips will do.—I have no idea.—I
hope he'll decide soon so as to know where one is at.—If that is at all
possible these days of the Four Freedoms—or whatever it is called.—
I'm pretty slow for these times.—

Love to you & Reds.

Stieglitz

In a Stieglitz letter received on 16 April, Dove heard the news about
Phillips's decision to take three paintings;[1] he telephoned Stieglitz in

Arthur Dove, Quawk Bird, *1942. Exhibited in Dove's 1943 American Place show, this painting has never been sold.* (Estate of the artist, Terry Dintenfass Gallery, New York.)

response. Feeling that the quality of Dove's work justified "quite an increase over our subsidy of last year,"[2] Phillips agreed to pay a total of $4,500 for three paintings. Of that, $3,500 went to Dove, $1,000 to the Rent Fund. Even at this late date, however, Phillips still haggled over prices. With his discount of fifteen percent, the paintings came to $4,675, which he asked Stieglitz to round down to $4,500.

1. Diary of Arthur Dove, 16 April 1943. Stieglitz's letter is now missing.
2. Duncan Phillips to Stieglitz, 10 April 1943, Collection of American Literature, Beinecke Rare Book and Manuscript Library, Yale University, New Haven.

The Place
3 May 1943

Dear Dove:
 Georgia left for the Southwest last Wednesday. Fairly sudden

decision.—So here I am once more alone. Dorothy has been laid up the last 8 days.—Zoler comes. . . .

Andrew fortunately is on the job.—Otherwise—??

<div align="right">Stieglitz</div>

<div align="right">The Place
31 May 1943</div>

Dear Dove: Enclosed [check] will bring [you] & Reds a bit of comfort—temporary peace of mind.—

It's a life these days.—Relatively has never been very different, only we were less aged & possibly could take more punishment.—Or is it the other way around.—I have lost all bearings. But whatever, my love to you & Reds.

<div align="right">Stieglitz</div>

Stieglitz returned to New York on the first of September, after only about four weeks at Lake George, while O'Keeffe did not come back from the Southwest until the end of October. As his eightieth birthday approached on 1 January 1944, Stieglitz was frail and not always able to be at the gallery. Marin, O'Keeffe, and Dove—in that order—had the only shows at An American Place this season.

Dove's next letter was written the day after he learned of Marsden Hartley's death.

<div align="right">[Centerport]
4 September 1943
Saturday</div>

Dear Stieglitz,

Of course you have seen Friday's "Times."

It must be a help to you to know that Hartley achieved some of the fruits you had worked so hard to help him sow. As with the rest, you built the platform from which he worked and spoke, and he must have spoken well. I would much like to have seen these later things, or have had someone whose vision I could trust describe them clearly.

Some of the old ones have stepped off that platform, so it behooves the rest of us to fight the harder.

All of us birds have to go to roost sometime—but the trying to fly is best of all. To have been as articulate as Hartley must have been a satisfaction.

Still trying to untangle that ball of fish line that Mr. Morgenthau tossed in the door.[1] Guess we do it the same as last year and hand in the answers without the explanations, and—if there is anything left in the shooting gallery, we have to pay for it.

It is hard to "Take it Easy" isn't it? Have had the experience just recently but am fine again now.

Our love to you, the same as always.

Reds and Dove

1. Income tax estimate.

[Centerport]
[10 September 1943]

Dear Stieglitz

I wonder if you have heard from Washington? There is no rush about it, but thought I'd better not let it go too long in case it might have gone astray. A shame to bother you about it—just let it go and I can ask Miss Bier later. . . .

The same old "Modern Art" arguments yesterday afternoon with our Washington dentist who was so good about coming here (from Huntington) when I was in bed. Came with a younger man, Zola Marcus, who has been at The Place a lot & here before. There are two or three that come here to fight. I asked him if he married his wife because she looked like someone else.—He may have, at that, "Married his mother." But he was one of those who wants likeness and everything to be pleasant—a large order. The young man is nice.

Lots of love from Reds and

Dove

The Place
11 September 1943

Dear Dove: . . . Miss Bier is on her vacation so the delay or oversight or whatever.

—If I had your phone I'd call you up but although you gave it to me, I'm in such an orderly mess I can locate nothing. So this instead of phoning [to] relieve you of your anxiety. And Reds hers. For I "know." . . .

> My love to you & Reds
> Stieglitz

What a lucky man Hartley to have passed out in his zenith.—I saw him just before he left for Maine.

Dove's next letter, written three months later, reflected the tone of an uneventful autumn and winter, during which he was able to work quite steadily.

> [Centerport]
> [14 December 1943]

Dear Stieglitz,
 . . . this year sounds very good.
 This last one [painting] here is something quite new (I hope) and on the line from the first ones shown at "The Place." Hope I can have some more of them before showing this year. It is just a small addition to the general idea but has possibilities to go on with indefinitely. . . .

> As always
> Reds and Dove

> [Centerport]
> [2 January 1944]

Dear Stieglitz,
 I did not realize it was your birthday (80) until I saw it in the "Times." Congratulations. Aline's brother had a baby and I did the best (maybe) painting yet, I hope, to celebrate. So you are probably having your customary influence on the future. . . .
 I see that Craven had all he could do to wait until you were 80 to say something nice about you. . . . Nice painting weather again. I think this winter may be mild. Hope so. Some squirrels are just putting their nuts under a porch across the road, and that is no way for a squirrel to

take care of his nuts for a hard winter. But maybe squirrels have changed and gotten careless.

That many-colored family across the way have moved out for the winter, so the squirrels have moved in there. There ought to be hundreds, if the house doesn't burn down. The family are fed and warm which they haven't been for several years, so it is quite a relief.

Sears Roebuck Catalog is out and the worst in years. Thought you'd better be informed about the literary efforts of the countryside. . . .

As always
Dove

[Centerport]
[31 January 1944]

Dear Stieglitz,

. . . . Reds was just saying, how Stieglitz can have taken these things you all have brought in for years is amazing. Of course it is, but that is Stieglitz.

Well, get out your war paint. We will have plenty of chance to use it. Want to get in soon. Using all my time now. . . .

Thousands of seagulls in now. Never have seen so many since we have been here. Sometimes mean storms, but this time they act differently.

Anything may happen this year. It all seems different.

Love to you all and your farsightedness.

As ever
Reds and Dove

The Place
31 January 1944

Dear Dove: On Saturday there were 150 visitors. Yesterday about 30.—Georgia's Show this year is unusually beautiful. A lift to the Whole. Everyone feels it at once. And it's not a fleeting thing.—

—You are often mentioned.—By me. By Georgia. And people told what we think about Dove.—Yes, Marin, Dove, O'Keeffe, quite a trio of true values.—

But it's ever a fight for clarification.—Yes, I'm still on the firing line.—An old man, Ex-Pres. Western Union appeared yesterday & told

me I had an evil eye. Whereupon I told him he too had one. Yes, he said that's all that's left of me.—He asked me what I was doing here & when I said waiting for my release, he told me no, it [was] not time for me to go as I was a biological necessity. So finally I have come to know what I am.—Great.

Well, love to you & the Lady.

<div align="right">Stieglitz</div>

<div align="right">[Centerport]
[1 March 1944]
1 February 1944 [misdated]</div>

Dear Stieglitz

The paintings are all packed and I enclose the titles. No. 17 hasn't any frame yet, but, if it doesn't come soon I will have them send it to the Place and bring No. 17 in under my arm when Dr. Loynes brings us in to see Georgia's show, which will probably be the 11th, have been trying to make it on the 4th. She very busy receiving patients at this season. People seem to get queer at this time, or in the fall there is another two or three weeks. Guess I'll be all right this season. Not "Arrived" yet.

Working on some more. One a swan fight—quite beautiful. I started it by feeding them. Then two of them tried to kill another, so had quite a time separating them. They are wicked.

We can come in with the paintings by taxi for $15 or ship them for half that—no insurance, by taxi, but don't want anything to happen to the paintings. Perhaps silence will be as good a medium as any for a foreword this year. Georgia's was fine. Perhaps they keep people's minds off the paintings—unless very beautiful in themselves. . . .

Am going out to sit in the sun—if I freeze. . . .

<div align="right">As always,
Reds and Dove</div>

The next letter was written after Dove and Reds had gone to New York with Dr. Dorothy Loynes to see O'Keeffe's show. Dove did not see his own later exhibition, though his health remained fairly stable through the spring.

[Centerport]
[20 March 1944]

Dear Stieglitz,
. . . . We had such a good time with you last Tuesday. Overdid a little bit getting things together for the trip, but was soon all right. The substitute doctor arrived next day and said the old pump was best yet. And that I could stop taking digitalis. Only keep it up in case I have to start again, as large quantities of it make me sick.
You were all certainly fine in every way, as always. . . .

Always
Reds and Dove

Saw Jewell on Hélion. Has any one of you seen them [Hélion's paintings]?[1] . . .

1. Dove probably asked about the exhibition by French painter Jean Hélion (b. 1904) because Hélion was a friend of William Einstein.

The Place
[13 April 1944]
13 February 1944 [misdated]

Dear Dove:
Here are 2 checks. One from Brooks. I didn't know he still owed you anything! He writes he hasn't paid anything since '40.
I'm a great bookkeeper! Am I not.
—The $80 is from a Cheko-Slavokia girl who has saved for years to get a Dove.—I think she met you in Geneva.—A real live article. You have made her very happy. A great experience all around.—
I hope Phillips materializes eventually. It's a great gamble. Everything.
Love to you & Reds.

Stieglitz

In June, Dove suffered a severe setback and was in bed for four weeks before slowly resuming some activity. Stieglitz and O'Keeffe followed their regular summer pattern—while she was in New Mexico, he went

to Lake George from the end of July into the early fall of 1944. No longer allowed to climb stairs, Stieglitz spent much of his time at Lake George lying in bed.

<div align="right">The Hill
3 August 1944</div>

Dear Dove: I'm here since July 29. Hard to say whether dead or alive.—

The air is pure & that's something. Otherwise I lie about here instead of lying about in The Place or at 59.

In town I am occasionally of use. Here—??—

I hope you are continuing to improve.

Love to you & Reds.

<div align="right">Stieglitz</div>

Again in the 1944–45 season, there were only three exhibitions at An American Place—Marin's, O'Keeffe's and Dove's. As the season opened, these three also figured prominently in an important event for Stieglitz—an extensive show, titled *History of An American; Alfred Stieglitz: "291" and After*, at the Philadelphia Museum of Art. This survey of painting and photography from his personal collection included eleven major Dove works and eight of his watercolors.

<div align="right">The Place
21 March 1945</div>

Dear Dove: Enclosed 2 checks. The Phillips was "due" 4 months ago. "Extra" "dividend"—Excuse enigmatical quotes.—

I hope you & Reds are "managing."—Above all, that you are both relatively OK.

I "manage."—It's all rather difficult.—

<div align="right">Stieglitz</div>

Dove's seriously weakened condition since the previous summer had prevented him from producing new work. Although the opening of his show was delayed until early May, the exhibition had to be retrospec-

tive. Shortly after O'Keeffe hung the show, she left for New Mexico, where she bought a second house, this one in Abiquiu, the closest town to Ghost Ranch.

<div style="text-align: right;">

The Place
23 April 1945

</div>

The Dove Show is up. 16 Doves. Georgia's selection & hanging. It's a very beautiful Show. Very beautiful.—Nothing has been printed as yet. Will be in a few days. Everything becomes more & more difficult.

Love to you & Reds.

<div style="text-align: right;">

Stieglitz

</div>

<div style="text-align: right;">

[Centerport]
[Probably 5 May 1945]
Friday

</div>

Dear Stieglitz,

I don't know what would have happened had we not such friends as you and Georgia.—It is marvelous. I have been used to living in a world where if you didn't produce like a machine you were dropped like a hot potato. Now all these wonders have come to pass. And I am still allowed to have Reds here with me which is remarkable—when all I do is to keep a roof over our heads and buy the food. Our taxes are but $24 a year, so you see it is fairly simple.

. . . . Am working and feeling much better now. . . .

The stock of our great men is getting low[1] now so take good care of yourself. I wonder who is staying there with you now that Georgia is away. Would like to see her at work out there, but guess that climate is rather high and dry for us who are so used to sea level.

Reds still has temperature trouble. 99.8 this morning. It just gives her a dragged-out feeling. Otherwise, she too is much better. Maybe by tomorrow again "The war will be over."

A team of horses just went by so almost anything can happen.

We hope you are free from that sinus by now. Hoping to see you soon.

<div style="text-align: right;">

As ever
Dove

</div>

1. Dove probably intended to call to mind the death of President Franklin D.
 Roosevelt on 12 April 1945.

Stieglitz went to Lake George for the last time this summer. He was there from mid-July until early September; O'Keeffe stayed in New Mexico until November.

> [Centerport]
> [Before 5 August 1945]

Dear Stieglitz

. . . . Dr. says there is nothing of an operation for Reds. No stones. He is making the examination thorough on account of his treatment after it. Mt. Sinai is, as you probably know, pretty fine. Nothing like it here. Wish you could be working.—You probably give so much to the rest of us that it interferes. Am trying not to let not moving about so much cut me down, but, with you (in your work), it is probably more necessary.

Just saw Vanderbilt's plane bank down sideways over the hill and then fire whistles & fire companies all rushing in that direction, so hope he is all right. We must save what we have of millionaires to start with after the war, if it ever stops, or at any rate to start another one.

The dentist just called to say he would come down and fix me up again and the Huntington bus driver knocked to give Reds timetables for her N.Y. trips, so we certainly get service for our living out over the water.

Lots of love to you and to all at the Lake. Thanks again for everything.

> Always
> Reds & Dove

Work going fine.

Although Dove was better during the summer than he had been for many months previously, he was so aged that Bill was shocked by his father's appearance when he returned home from the Army. After Bill's release, he and Aline lived in Flushing, Queens. They were able to see

the senior Doves only occasionally, by taking the train to Centerport. As Dove reported in his next letter to Stieglitz, his friend and physician Jake Bernstein also was released from service. Overseas for nearly three years, he had been stationed most of the time in England and had participated in the invasion of France.

[Centerport]
[Probably 8 August 1945]

Dear Stieglitz,

This has been too hot for comfort or good health. Am told that that is what has been my trouble. Down again a little, but have been working on some small ones. "Jake," our doctor, is back all safe. Maybe that is why I haven't been so well. Seem to think I am safe as long as he is up the hill. Having saved my life a couple of times, I seem to think that is what he is for. . . .

Dorothy [Loynes] and Mary Holt were here Sat. evening. Mary knows what "Getting well" means[1] and the struggle from that place in Poughkeepsie back to Brentwood. They are going to use Mary's car together and let Jake take Dorothy's car. They are always doing things like that. To know them is almost an asset.

Reds says humidity is dropping, so that makes it easier to breathe anyway. We are all trying to get Jake out of the army. He has certainly done his share. Hope you can read this, it is being written in bed.

Aline and Bill were here last Sunday. Am very glad for Bill. She is lovely. They are very happy I think.

George Rehm wants to go farming. Whole family upset. Naturally, when anyone in it wants to keep hands clean. Heh heh heh says the farmer, knowing what he is up against. It is easy enough to make trouble. Can see where I'm the guy whose unwelcome advice is going to be in demand. Going "modern" at the same time would complete the job.

The world is supposed to be better now anyhow. Have you noticed it?

Lots of love from

Reds and Dove
as always.

1. She had just returned from convalescence for tuberculosis in a sanatorium at Poughkeepsie, New York.

Lake George
24 August 1945

. . . . The air is good here. The food is good.—Everything relatively peaceful. And yet I'm eagerly awaiting the day that I return to N.Y. to the freshly painted Place. Habits are my long suit. And The Place my longest. . . .

Your old
Stieglitz

Although Stieglitz returned to New York early in September, he did not open the exhibition season at An American Place until November. Marin had the usual first place and also a second show in April of 1946 after O'Keeffe's show. Dove, who had picked up strength after his collapse of the year before, produced nine new paintings before his show in May 1946.

Both men doggedly kept on working as much as possible during this last season of their lives, but their correspondence dwindled to insignificance. Clearly, neither had the energy to write the long, enthusiastic letters of earlier years.

Dove visited An American Place for the last time in May 1946, while his own work was on display. Stieglitz thought it pathetic to see how Dove had aged,[1] and Dove could not have failed to notice that Stieglitz himself had declined in the two years since their previous visit. Each, of course, must have been only too aware of his own frailty. In the midst of such misgivings, the Doves were heartened by the birth of Bill and Aline's only child, a girl named Toni; they went by taxi to see her at the hospital.

Stieglitz finished the season at An American Place and was still hoping to go to Lake George when he suffered a massive stroke and collapsed on 10 July. O'Keeffe rushed back from New Mexico and was with him at his death in the early hours of 13 July. The following day, she received condolences from mourners at the funeral home, where the casket was closed and draped, before accompanying her husband's body to a crematorium. Later, she and Elizabeth Davidson privately mingled his ashes with the earth at the shore of Lake George, where he had always felt most at peace.[2]

Dove, much distressed by his old friend's death, lived only another four months. In the autumn he failed seriously and was hospitalized for the last few days before his death on 22 November. There was no

funeral, only a brief moment together at the funeral parlor with Reds, Bill, Dr. Dorothy Loynes, and Dr. Mary Holt. Dove's ashes were interred in St. John's Cemetery in Cold Spring Harbor.

Although An American Place remained open until 1950, an era died along with Stieglitz and Dove. Postwar culture reflected a changed world, very different from the one to which they had contributed. Yet their idealism and dedication to art, as well as their generous friendship, survive as vital precedents, intangibles from a living past. Most important, as they would have wanted it, their work has never been more admired than it is today.

1. Stieglitz to Duncan Phillips, 1 June 1946, Phillips Collection, Washington, D.C.
2. For an account of Stieglitz's death and the aftermath, see Lowe, *Stieglitz*, 377–78.

Glossary of Names

ANSEL ADAMS (1905–84), a California photographer, is renowned for his majestic photographs of the natural scenery of the American West. A founding member of the f64 group and a superb technician, Adams published many books and portfolios and was a strong influence in photography for nearly fifty years. He and O'Keeffe became friends in Taos in 1929, and Stieglitz showed his work at An American Place in 1936.

KARL ANDERSON (1874–1955), brother of Sherwood Anderson, was an Impressionist painter who lived in Westport, Connecticut.

SHERWOOD ANDERSON (1876–1941) wrote fiction, poetry, and essays. *Winesburg, Ohio,* a collection of short stories published in 1919, made his reputation. He dedicated one of his books to Stieglitz, who encouraged his work, and was close to Paul Rosenfeld. He and Dove remained in touch over the years, and he purchased a few of Dove's works.

DR. ALBERT C. BARNES (1872–1951), inventor of the antiseptic argyrol, was an important collector, especially of Impressionist and post-Impressionist art. The Barnes Foundation at Merion, Pennsylvania, near Philadelphia, is his legacy.

ALFRED H. BARR, JR. (1902–81), art historian and writer, was the first director of the Museum of Modern Art, where he oversaw the growth of the collection and organized many significant exhibitions, including some that included the work of Dove or other members of the Stieglitz group.

THOMAS HART BENTON (1889–1975) was an American painter, now known for his regional subjects of the 1930s. Earlier, he had been an experimental

497

modernist, whose work was strongly influenced by Synchromism in the teens.

DR. J. C. (JAKE) BERNSTEIN was Dove's physician during the last few years of the artist's life. He and his wife Julia lived not far from the Doves' home in Centerport and became their good friends.

ELMIRA BIER (d. 1976) was the secretary, then the assistant to the director at the Phillips Memorial Gallery (now Phillips Collection) in Washington, D.C.

OSCAR BLUEMNER (1867–1938) was a New York artist, born in Germany. An architect before he was a painter, he produced brightly colored (often predominantly red), cubistically fragmented scenes that are usually architectonic in design.

CONSTANTIN BRANCUSI (1876–1957), a Rumanian-born sculptor who worked in Paris, is known for sleek simplifications of natural form. He exhibited in the Armory Show and had his first one-person show at 291 in 1914. He also visited Stieglitz's gallery on later journeys to the United States.

CHARLES BROOKS (b. 1910), a writer and the son of Van Wyck Brooks, was a childhood friend of William Dove in Westport, Connecticut. As an adult, he became reacquainted with Arthur Dove late in 1929, and they remained good friends thereafter.

VAN WYCK BROOKS (1886–1963) was a prominent and prolific literary critic, cultural historian, and biographer. A Westport resident for many years after 1920, he knew both Dove and Stieglitz.

FLORENCE CANE, a Westport painter, was an avid supporter of Dove in the days when he lived there. She and her husband Melville (d. 1980), a poet and lawyer, also knew Stieglitz and admired O'Keeffe's work.

ARTHUR B. CARLES (1882–1952), an American painter who exhibited at 291, knew Dove in Paris. Living in Philadelphia most of his life, he was rather removed from New York developments after World War I. Exploiting an impressive technical finesse, he worked in several styles until 1941, when an injury forced him to stop painting. His best works are colorful, gestural nudes and still lifes, which sometimes verge on abstraction.

THOMAS CRAVEN (1889–1969) was an art critic whose name is particularly associated with the promotion of Thomas Hart Benton's regionalist paintings in the 1930s. However, he had earlier been a defender of modernism.

Francis Welch (Frank) Crowninshield (1872–1947) edited *Vanity Fair,* the Condé-Nast monthly that epitomized sophistication in the 1920s. Crowninshield discovered a number of new talents—writers and photographers—who appeared in its pages. He also collected modern art.

Donald Douglas Davidson (1878–1948) was an artist, horticulturist, and clairvoyant. His second wife was Stieglitz's niece, Elizabeth Stieglitz, whom he married in 1919. They had two children, Elizabeth Margery (known as Peggy) and Sue.

Elizabeth Stieglitz Davidson (1897–1956), daughter of Stieglitz's brother Leopold, was probably the closest to her "Uncle Al" among all members of the family and also was a good friend of Dove. She studied music and painting when young; later, she was active in promoting Hinduism, to which she was converted through an interest in spiritual experience, which she shared with her husband Donald.

Stuart Davis (1894–1964) was an American painter who developed an individualized abstract style in the 1920s. His sophisticated blend of European style (derived from Cubism) and American subjects was unique in his generation.

Charles Demuth (1883–1935), an American painter, united elements of realism and Cubism in a clean-cut personal style sometimes classified as Precisionist. He visited 291, but Stieglitz showed his work only later, at The Intimate Gallery and An American Place.

Marius de Zayas Enriquez y Calmet (1880–1961), born in Veracruz, Mexico, made a greater contribution to the development of modern art than any one of his accomplishments might indicate. In the few years after his first exhibition at 291, in 1909, he propelled caricature from delightful journalistic commentary to avant-garde art form, as he went from relative realism to "absolute" (abstract) portraits to "psychotypes," which combined typography with abstract forms to "represent" individuals. Besides also writing about modern art and aiding Stieglitz at 291, de Zayas helped to found both the publication *291* and the Modern Gallery. When the latter venture failed, he ran his own gallery in New York from 1919 to 1921. Discouraged, he moved to Europe, where he organized exhibitions, produced films, and painted. In the late 1940s, he returned to the United States, where he spent the rest of his life.

Mabel Dodge. See Mabel Dodge Luhan.

ALINE DELARA DOVE married Bill Dove in 1942. Their daughter Toni was born in 1946.

FLORENCE DORSEY DOVE (d. 1929) married Arthur Dove in 1904 and became the mother of his only child in 1910. They separated in 1921, but she refused ever to agree to a divorce.

HELEN (REDS) DOVE. See HELEN TORR.

MARIAN CRAIB DOVE was married to Bill Dove from 1935 to 1942, when they were divorced.

PAUL DOVE (1892–1979), the artist's brother, resided in Geneva, New York, their hometown, all his life. Until he died, he lived in one of the high-ceilinged apartments hewn in the 1930s from his parents' Victorian home.

WILLIAM C. (BILL) DOVE (b. 1910), the only child of the painter, is also an artist, as is *his* only child, Toni.

ANDREW DROTH, lean, shy, and conscientious, did chores and errands at An American Place from 1934 until after Stieglitz's death.

WILLIAM EINSTEIN (1907–72), a painter, was distantly related to Stieglitz. After arriving in New York in the mid-1930s, he frequently assisted Stieglitz at An American Place for the next several years, during which he became a good friend of Bill Dove. Later, he emigrated to France.

WALDO FRANK (1889–1967), a novelist and essayist, often championed Stieglitz's ideas about the spiritual dimension of America in his writings. He was a frequent visitor at Lake George. His major writings include *Our America* (1919), *City Block* (1922), and *The Rediscovery of America* (1929).

GEORGE GROSZ (1893–1959), a German artist, emigrated to America in 1932. He is known especially for trenchant satirical drawings and paintings. Stieglitz showed his work once, at An American Place, in 1935.

HUTCHINS HAPGOOD (1869–1944), an author and journalist, was an early defender of modernist painting.

MARSDEN HARTLEY (1877–1943) was an American painter who also published poetry and critical essays on art. Hartley's first exhibition, held at 291 in 1909, was the first one-person show Stieglitz gave to an American painter. In Europe between 1912 and 1915, Hartley developed a strikingly abstract mode of painting, which he abandoned before 1920 in favor of an ex-

pressionistic realism. A wanderer until the last years of his life, Hartley lived in Europe or Mexico during much of the 1920s and 1930s. His friendship with Stieglitz cooled in the 1920s, although Stieglitz continued to show Hartley's work into the 1930s and remained in touch with the painter until Hartley's death.

ERNEST HASKELL (1876–1925) was an American painter, illustrator, and printmaker, especially known for his etchings. He knew Dove in Westport.

PAUL HAVILAND (1880–1950), the Paris-born son of the head of the Haviland china manufacturing company at Limoges, met Stieglitz about 1908 when he was the New York representative of the family business. He helped Stieglitz edit *Camera Work,* for which he also wrote articles; aided 291 financially; and took up photography. Some of his prints appeared in *Camera Work* before he returned to France in 1915. His brother, Frank Burty, showed paintings and drawings at 291 in 1914.

OLIVER HERFORD (1863–1935) an English-born humorist, illustrator, and playwright, was acquainted with Stieglitz and Dove.

DR. MARY HOLT, a psychiatrist, became a good friend of the Doves when they lived in Centerport, through her friend Dr. Dorothy Loynes.

E. A. JEWELL, art critic for the *New York Times,* consistently reviewed exhibitions at An American Place, including Dove's.

MITCHELL KENNERLEY (1878–1950) was, from 1916 until 1929, president of the Anderson Galleries, where many important auctions of art and rare books were held. Stieglitz's Intimate Gallery of 1925–29 was located in the Anderson Galleries. Earlier in his career, the English-born Kennerley had been involved with the editing and publishing of several magazines. In 1937, he returned as president of his former business, then known as the American Art Association–Anderson Galleries, Inc.

ALFRED KREYMBORG (1883–1966), poet and editor, was founder with Paul Rosenfeld, Lewis Mumford, and Van Wyck Brooks of an annual literary venture, *American Caravan,* in 1927. His books include *Troubadour* (1925), *History of American Poetry* (1934), and *America, America* (1934).

GASTON LACHAISE (1882–1935), a French-born sculptor, is known especially for his voluptuous and dynamic female nudes. He showed only once with Stieglitz, at The Intimate Gallery, but Dove also saw his work elsewhere and admired it.

DR. DOROTHY LOYNES, a psychiatrist, became a good friend of the Doves during the 1930s, when they lived in Geneva. Later, she too lived on Long Island and saw them there.

MABEL DODGE LUHAN (1879–1962) collected celebrities at her renowned salon in New York during the days of 291. She later lived in New Mexico, where she continued to be hospitable to many artists and writers, including O'Keeffe. She wrote several volumes of autobiography and a life of D. H. Lawrence.

JOHN MARIN (1870–1953) showed his work with Stieglitz from 1909 until Stieglitz's death in 1946. Known for watercolors and prints, as well as oil paintings, he abstracted themes from nature and, less often, from the urban landscape.

FRANK JEWETT MATHER, JR. (1868–1935), who taught art history at Princeton University, also wrote art criticism, as well as occasional essays. Interested in the development of modernism, though not always sympathetic, he bought works by Dove and others of the Stieglitz group.

ALFRED MAURER (1868–1932), an American modernist painter, met Dove in Paris in 1908–9. They remained close friends until Maurer's suicide. Stieglitz showed Maurer's paintings only in 1909 and 1910, but the two men maintained a cordial relationship.

HENRY MCBRIDE (1867–1962) was art critic for the New York *Sun* for thirty-six years. He also wrote for *The Dial* and was editor of *Creative Art* from 1930 to 1932.

ELIZABETH MCCAUSLAND (1899–1965) wrote for the *Springfield (Mass.) Republican* for many years, first as a general reporter, later as an art critic. In the 1930s, she befriended the Doves and wrote sympathetically about his work. Later, she produced major monographs on two other painters associated with Stieglitz—Alfred Maurer and Marsden Hartley. She also published *Changing New York* with her photographer-friend Berenice Abbott in 1939; wrote articles on a number of other painters, sculptors, and photographers; did research for ambitious American art books she never completed; wrote poetry; printed her own limited-edition books; and taught at Sarah Lawrence, Barnard, and the New School for Social Research.

LEWIS MUMFORD (b. 1895), a writer on art, architecture, urban planning, and social questions, reviewed art exhibitions—including those at An American Place—for the *New Yorker* in the 1930s.

ELIE NADELMAN (1882–1946), a sculptor born in Warsaw, immigrated to America in 1914 after ten years in Paris, where he was a friend of the Steins, Matisse, Picasso, and André Gide. The American debut of his stylized figurative work took place at 291 in 1915–16.

DOROTHY NORMAN (b. 1905) met Stieglitz in 1926 and within a few years developed a close relationship with him. At An American Place, she became indispensable by taking care of its finances. Her husband, Edward, was a Sears and Roebuck executive. A photographer, writer, and editor, she memorialized her mentor with a first-hand account, *Alfred Stieglitz: An American Seer.* She still lives in New York.

GEORGIA O'KEEFFE (1887–1986), a painter, first showed her work at 291 in 1916 and began living with Stieglitz in 1918. They were married in 1924. In the two or three years immediately following Stieglitz's death, she devoted much of her time to settling his estate. She chose the Beinecke Rare Book and Manuscript Library at Yale University as the repository of Stieglitz's papers, thereby attracting many related sets of papers from other donors. As a result, the Stieglitz Archive there is an invaluable record of the man and his era. O'Keeffe also selected the National Gallery of Art in Washington, D.C., to house the master set of Stieglitz photographs, a set comprising the single finest mounted print of every one of Stieglitz's photographs, including some that are unique. In addition, she gave lesser numbers of his photographic prints to other museums and divided Stieglitz's enormous art collection among five museums. (Stieglitz himself—who insisted they were not a "gift"—had allowed the Metropolitan Museum of Art in New York to take his collection of photographs by other photographers.) The largest number of objects from his collection, 589 of them, went to the Metropolitan Museum of Art; other groups went to the Art Institute of Chicago, the National Gallery of Art, the Philadelphia Museum of Art, and Fisk University in Nashville, Tennessee. O'Keeffe's solicitude should not be underestimated as a factor in Stieglitz's visibility as an historical figure.

O'Keeffe's own career as a painter flourished for more than three decades after Stieglitz's demise and in the 1970s, she also produced ceramics. She became a year-round resident of New Mexico after Stieglitz's death.

DUNCAN PHILLIPS (1886–1966), Dove's only regular patron, also bought the work of other Stieglitz artists, including large numbers of Marin and O'Keeffe paintings. To this day, the Phillips Collection in Washington, D.C., reflects the taste cultivated by him and his painter-wife Marjorie Acker Phillips (1895–1985), who headed the museum from 1966 to 1972. Their son Laughlin continues as director.

FRANCIS PICABIA (1879–1953), a Cuban-born painter of French and Spanish ancestry, lived in Paris, where he first developed an abstract style based on Cubism, then went on to a proto-dadaist, machine-based art. When he came to New York at the time of the 1913 Armory Show, in which he exhibited, he was the first significant European modernist to visit there. His association with Stieglitz began at the time of this highly publicized sojourn and remained close throughout the decade.

HENRY PATRICK RALEIGH (1880–1944) was a successful illustrator for newspapers and magazines, including *Vanity Fair, Harper's Bazaar,* and the *Saturday Evening Post.* Dove's neighbor in Westport, again during the 1920s and early 1930s, he lived near Dove on Long Island.

MARIE RAPP, a music student, was the secretary at 291 before her marriage to George Boursault.

GEORGE REHM was a newspaperman in Paris when he married Reds's sister, Mary, in 1928. They remained in Paris until 1937. Later, he worked for the New York World's Fair of 1938 and, after 1942, for the United States government in Europe.

MARY TORR REHM, Reds's sister, married journalist George Rehm in Paris in 1928. She had been abroad for several years before that, and they continued to live there until the eve of World War II. While in the United States, they lived on Long Island and were able to see the Doves fairly frequently. In 1945, she rejoined her husband (who had been working abroad for the war effort since 1942) in Europe. Widowed, she lives in Washington, D.C., where she recently moved in order to be near her son John, a lawyer; previously, she had lived in Brooklyn for many years.

KATHARINE N. RHOADES (1885–1965) was a well-born New York painter and poet who exhibited at 291 but destroyed nearly all of her work from this period. After moving to Washington, D.C., she assisted Charles Freer, whom she met in 1915, with the opening of the museum that bears his name. There, she became a good friend of Duncan Phillips but did not maintain a close relationship with Stieglitz after the 291 days.

ARNOLD RÖNNEBECK (1885–1947), a sculptor, emigrated from his native Germany to the United States in 1923. He had been friendly with Marsden Hartley in Germany. Later, he lived in Denver, Colorado, where he taught and directed the Denver Art Museum for several years.

PAUL ROSENFELD (1890–1946) wrote critical essays primarily on literature and music, but sometimes on the visual arts. His best-known book, *Port of New*

York (1924), includes essays on both Stieglitz and Dove, as well as O'Keeffe, Hartley, Marin, Sherwood Anderson, and others. His only published novel, *The Boy in the Sun,* appeared in 1928. He had a house in Westport, Connecticut for several years in the early 1920s. Close to Stieglitz over the years, he was an occasional patron of Dove's work.

HERBERT J. SELIGMANN (d. 1984), American essayist, critic, poet, journalist, and worker for social justice as an employee of the National Association for the Advancement of Colored People, was a close associate of Stieglitz during the 1920s, but their friendship dissolved in the 1930s. His book *Alfred Stieglitz Talking* (1966) is a collection of articles that transcribe Stieglitz's words and report the author's observations at Stieglitz's galleries.

JOHN SLOAN (1871–1951), American realist painter and printmaker, exhibited with The Eight. Dove had known him personally in his New York days of the first decade.

EDWARD STEICHEN (1878–1973), American photographer, was also a painter until the early 1920s. Born in Luxembourg, he resided in France during long periods of his adult life. Instrumental in the founding and early operation of 291, he later became one of the most sought-after photographers of the 1920s and 1930s, as the result of his fashion photographs, celebrity portraits, and advertisements for such sophisticated publications as *Vogue* and *Vanity Fair.* From 1947 to 1962, he was director of the department of photography at the Museum of Modern Art, where he organized many exhibitions, including the classic *Family of Man* shown in 1955. He and Stieglitz were not on good terms from about 1914 until they were reconciled in 1941.

GERTRUDE STEIN (1874–1946), an avant-garde American writer, lived in Paris where her hospitality to artists was legendary. Her experimental prose was first published in the United States in a 1912 number of *Camera Work.* (Only the privately printed *Three Lives* had previously circulated among a tiny audience.)

EMMELINE OBERMEYER STIEGLITZ (1873–1953) married Stieglitz in 1893. They separated in 1918 and were divorced six years later.

KATHERINE (KITTY) STIEGLITZ (1898–1971), the photographer's daughter, went to Smith College, married, and in 1923 gave birth to a son. Soon after, she was afflicted with severe depression and had to be institutionalized for the rest of her life.

PAUL STRAND (1890–1976) was an American photographer whose pioneering "straight" photographs that emphasize abstract design were first shown at

291. He and Stieglitz remained close associates through the 1920s, but their friendship subsequently disintegrated.

REBECCA (BECK) SALSBURY STRAND was an artist but held a full-time secretarial job most of the time during the years when she and her husband Paul were close to Stieglitz. Later divorced, she then married rancher Bill James and lived in Taos, New Mexico.

HELEN TORR (1886–1967), a painter from Philadelphia, left her husband, Clive Weed, to live with Dove in 1921. They were married in 1932 and shared a close-knit lifestyle until his death in 1946. For most of the next twenty years, she stayed on in the little house in Centerport, but she never went back to painting (which she had largely abandoned in the later years of Dove's life). Seemingly living in the memory of her life with Dove, she only went through his miscellaneous papers and ineffectually attempted to sort out his ideas for publication.

ABRAHAM WALKOWITZ (c. 1878/80-1965) was a Russian-born New York painter. His paintings and drawings, some of which were among the most abstract produced in America during the teens, were inspired primarily by the city and the dance, particularly the free movement of Isadora Duncan. Later, he was not productive and fell into obscurity.

MAX WEBER (1881–1961) was an American modernist painter, born in Russia. He was very close to Stieglitz and involved in the activities at 291 from 1909 until 1911, when he broke with Stieglitz.

WILLARD HUNTINGTON WRIGHT (1888–1939), brother of Synchromist painter Stanton Macdonald-Wright and organizer of the 1916 *Forum Exhibition,* was the author of many books, including an important early one on modern art, *Modern Painting: Its Tendency and Meaning* (1915).

EMIL ZOLER, an *artiste manqué* from New Jersey, assisted Stieglitz for decades after his first appearance at 291 in 1909. Although he was never an employee, Zoler's helpful services ranged from packing paintings to fetching Stieglitz's favorite chocolate ice cream.

Cited Works by Arthur Dove

All works are oil (possibly in combination with encaustic or tempera) on canvas, unless otherwise noted. Dimensions are in inches, height preceding width.

Alfred Stieglitz (Portrait). 1924. Assemblage of lens, photographic plate, clock and watch springs, and steel wool on plywood. 16⅜ × 12⅜. Museum of Modern Art, New York.

And Number Twenty-Two. 1943. Cardboard support, with tinfoil. 3½ × 5½. William C. Dove, Mattituck, New York.

Barnyard Fantasy. 1935. 33⅛ × 25½. Yale University Art Gallery, New Haven, Connecticut.

Beach. 1940. 20 × 32. Collection unidentified.

Bessie. See *Bessie of New York*.

Bessie of New York. 1932. 28 × 40. Baltimore Museum of Art.

Blackbird. 1942. 17 × 24. Collection Thyssen-Bornemisza, Castagnola (Lugano), Switzerland.

Black Sun, Thursday. 1932. Collection unidentified.

Breezy Day. 1931. 20 × 28. Archer M. Huntington Art Gallery, University of Texas at Austin.

Brickyard Shed. 1934. 20 × 28. William C. Janss, Sun Valley, Idaho.

Bridge at Cagnes. 1908–9. 39½ × 39½. Herbert F. Johnson Museum, Cornell University, Ithaca, New York.

Car. 1931. 13¼ × 22. Laughlin Phillips, Washington, D.C.

Carnival. 1934. Watercolor on paper. Collection unidentified.

A Chewing Cow. 1936–37. 15 × 21. Collection unidentified.

City Moon. 1937–38. 35 × 25. Hirshhorn Museum and Sculpture Garden, Washington, D.C.

Clouds and Water. 1930. 29⅝ × 39⅝. Metropolitan Museum of Art, New York.

Coal Carrier (Large). 1930. 20 × 26. Phillips Collection, Washington, D.C.

Covered Boat and Tree. See *Tree and Covered Boat.*

Cow. c. 1912/13. Pastel on linen. 17¾ × 21½. Metropolitan Museum of Art, New York.

Cow I. 1935–36. 15 × 21. Randolph-Macon Woman's College Art Gallery, Lynchburg, Virginia.

Cows in Pasture. 1935. 20 × 28. Phillips Collection, Washington, D.C.

A Cross in the Tree. 1934–35. Canvas mounted on panel. 28 × 20. Terry Dintenfass Gallery, New York.

Cutting Trees in Park. 1937. Collection unidentified.

Distraction. 1929. 21 × 30. Whitney Museum of American Art, New York.

East from Holbrook's Bridge. 1936. 13½ × 21½. Private collection.

Electric Peach Orchard. 1935. 20 × 28. Phillips Collection, Washington, D.C.

Fantasy. See *Barnyard Fantasy.*

Fields of Grain as Seen from Train. 1931. 24 × 34. Albright-Knox Art Gallery, Buffalo, New York.

Fire in a Sauerkraut Factory, West X, N.Y. 1941. 10 × 12. Gerald Peters Gallery, Santa Fe, New Mexico.

The Gale. 1932. 25¾ × 35¾. University Gallery, University of Minnesota, Minneapolis.

George Gershwin's "Rhapsody in Blue," Part I. 1926–27. Includes metallic paint and clock spring; aluminum support. 11¾ × 9¾. Private collection.

Goat. 1935. 23 × 31. Metropolitan Museum of Art, New York.

Goin' Fishin'. 1925. Assemblage of bamboo, denim shirtsleeves, bark, and pieces of wood on wood support. 19½ × 24. Phillips Collection, Washington, D.C.

Golden Storm. 1925. Medium includes metallic paint; support is wood panel. 19¼ × 21. Phillips Collection, Washington, D.C.

Grandmother. 1925. Assemblage of wood shingles, needlepoint, page from a Bible (Concordance), and pressed flowers and fern. 20 × 20¼. Museum of Modern Art, New York.

The Green Ball. 1940. 12½ × 20. Phillips Collection, Washington, D.C.

Green, Gold and Brown. 1940–41. 18⅛ × 27¼. Phillips Collection, Washington, D.C.

Green Light. 1940. 15 × 21. Watkins Gallery, American University, Washington, D.C.

Happy Landscape. 1937. 10 × 14. Smith College Museum of Art, Northampton, Massachusetts.

Harbor Bank. 1940. Watercolor on paper. Collection unidentified.

Harbor Docks. 1932. 12 × 17. Collection unidentified.

Holbrook's Bridge. 1934–35. 20 × 28. Collection unidentified.

Holbrook's Bridge to Northwest. 1937–38. 25 × 35. Mr. and Mrs. Roy R. Neuberger, New York.

Huntington Harbor—I. 1926. Assemblage of canvas, sand, wood, and oil paint on metal. 12 × 9½. Phillips collection, Washington, D.C.

Just Painting. 1927. Private collection, St. Louis.

Lake Afternoon. 1935–36. 25 × 35. Phillips Collection, Washington, D.C.

Lantern. c. 1922. Medium includes silver paint; support is mahogany panel. 21⅜ × 18. Art Institute of Chicago.

Lattice and Awning. 1941. 22¾ × 36¾. Private collection.

Leaning Silo. 1937. 20 × 28. Collection unidentified.

Lloyd's Harbor. 1941. 20 × 30. Detroit Institute of Arts.

The Lobster. 1908. 25¾ × 32. Amon Carter Museum, Fort Worth Texas.

March, April. 1929. Pastel. 20 × 20. Private collection.

Mars Orange and Green. 1936. Collection unidentified.

Me and the Moon. See *Rise of the Full Moon.*

The Moon. 1941. 12 × 16. Regis Collection, Minneapolis.

"The Moon Was Laughing at Me." 1936. 6⅛ × 8. Phillips Collection, Washington, D.C.

Morning Sun. 1935. 20 × 28. Phillips Collection, Washington, D.C.

Nature Symbolized No. 2 (Wind on a Hillside). 1911/12. Pastel on paper mounted on panel. 18 × 21⅝. Art Institute of Chicago.

Neighborly Attempt at Murder. 1941. 20 × 28. William H. Lane Foundation, Leominster, Massachusetts.

Nigger Goes a Fishing. See *Goin' Fishin'.*

Penetration. 1924. Wood support. 22 × 18⅛. Private collection.

Pozzuoli Red. 1941. 22 × 36. Phillips Collection, Washington, D.C.

Primaries. 1940. Gouache on paper mounted on canvasboard. 5¼ × 7. Private collection.

Quawk Bird. 1942. 15½ × 24. Estate of the artist, Terry Dintenfass Gallery, New York.

Rain. 1924. Twigs and rubber cement on metal and glass. 19½ × 15⅝. Estate of Georgia O'Keeffe (on loan to the University Art Museum, University of New Mexico, Albuquerque).

Ralph Dusenberry. 1924. Assemblage of wood, page from a hymnal, paper, folding ruler, and oil paint on canvas. 22 × 18. Metropolitan Museum of Art, New York.

Reaching Waves. 1929. Medium includes silver paint. 19⅞ × 23⅞. Metropolitan Museum of Art, New York.

Red Barge. See *Red Barge, Reflections.*

Red Barge, Reflections. 1931. 30 × 40. Phillips Collection, Washington, D.C.

Red Barge, Reflections. 1931. Watercolor on paper. Collection unidentified.

Red Sun. 1935. 20¼ × 28. Phillips Collection, Washington, D.C.

Red Tree and Sun. 1929. 31 × 23. Fisk University, Nashville, Tennessee.

Red, White and Green. 1940. 15 × 21⅛. Phillips Collection, Washington, D.C.

Reminiscence. 1937. 14½ × 20½. Phillips Collection, Washington, D.C.

Rhythm Rag. 1927. Pastel. Collection unidentified.

Rise of the Full Moon. 1937. 18 × 26. Phillips Collection, Washington, D.C.

Sand Barge. 1930. Beaverboard panel support. 30 × 40. Phillips Collection, Washington, D.C.

The Sea I. 1925. Chiffon on scratched aluminum panel. 13 × 21. William H. Lane Foundation, Leominster, Massachusetts.

The Sea II. 1925. Chiffon and sand on scratched aluminum panel. 13 × 21. Barney A. Ebsworth, St. Louis.

Seagull Motif, or *Violet and Green.* 1928. Metal support. 28 × 20. Dr. and Mrs. Harold Rifkin, New York City.

Sea Gulls. 1938. 16 × 26. Heckscher Museum, Huntington, New York.

Scenery. 1932. Masonite support. 8¾ × 12. Private collection.

Shapes, or *Shells.* 1940. 11 × 18. Phillips Collection, Washington, D.C.

Silver Sun. 1929. Medium includes silver paint. 21⅝ × 29⅝. Art Institute of Chicago.

Slaughter House. 1936. 15¾ × 26. Lee Ehrenworth, Elizabeth, New Jersey.

Snow Thaw. 1930. 18 × 24. Phillips Collection, Washington, D.C.

Something in Brown, Carmine and Blue. 1927. Tin support. 27¾ × 19⅝. Fisk University, Nashville, Tennessee.

Sowing Wheat. 1934. 28 × 25. Collection unidentified.

Square on the Pond. 1942. 20 × 28. William H. Lane Foundation, Leominster, Massachusetts.

Stuyvesant Square. 1907. 25 × 35. Hobart and William Smith Colleges, Geneva, New York.

Sunday. 1932. Masonite support. 15 × 20. Collection unidentified.

Sun Drawing Water. 1933. 24⅜ × 33⅝. Phillips Collection, Washington, D.C.

Sunrise. 1934–35. 10 × 13. Collection unidentified.

Sunrise II. 1936. 25 × 35. Meredith Long, Houston, Texas.

Sunrise III. 1936. 25 × 35⅛. Yale University Art Gallery, New Haven, Connecticut.

Telegraph Pole. 1929. Aluminum support. 28 × 19⅞. Art Institute of Chicago.

Through a Frosty Moon. 1941. 14¾ × 20⅞. Private collection.

Thunder Shower. 1940. 20¼ × 32. Amon Carter Museum of Western Art, Fort Worth, Texas.

The Train. 1934. 18¼ × 22. Phillips Collection, Washington, D.C.

Tree and Covered Boat. 1932–33. 20 × 28. Private collection.

Tree Forms. 1935. 20 × 28. Phillips Collection, Washington, D.C.

Two Forms. 1931. Beaverboard panel support. 33 × 24. Mr. and Mrs. Selig Burrows, Mill Neck, New York.

U.S. 1940. 20 × 32. Collection Thyssen-Bornemisza, Castagnola (Lugano), Switzerland.

Waterfall. 1925. Masonite support. 10 × 8. Phillips Collection, Washington, D.C.

Wednesday, Snow. 1932. 24 × 18. William H. Lane Foundation, Leominster, Massachusetts.

Willows. 1940. 25 × 35. Museum of Modern Art, New York.

Wind. 1935. 15 × 21. William C. Janss, Sun Valley, Idaho.

Wood Pile. 1937–38. 10 × 14. Private collection.

Bibliography

This list includes material mentioned in the letters or in editorial notes, general sources on the two correspondents, and other references that were useful in the preparation of this book.

BOOKS

✓ Abrahams, Edward. *The Lyrical Left: Randolph Bourne, Alfred Stieglitz, and the Origins of Cultural Radicalism in America.* Charlottesville: University Press of Virginia, 1986.

Anderson, Sherwood. *Sherwood Anderson's Memoirs.* Edited by Paul Rosenfeld. New York: Harcourt, Brace and World, 1942.

———. *A Story Teller's Story.* New York: B. W. Huebsch, 1924.

Apollinaire, Guillaume. *Les Peintres cubistes: méditations esthétiques.* Paris: Figuière, 1913. English translation by Mrs. Charles Knoblauch published in *The Little Review* 8 (Spring 1922): 7–19; 9 (Autumn 1922): 41–59; and 9 (Winter 1922): 49–60.

ᵛ Baur, John I. H. *Revolution and Tradition in Modern American Art.* Cambridge, Mass.: Harvard University Press, 1951.

Benson, E. M. *John Marin, the Man and His Work.* Washington, D.C.: American Federation of Arts, 1935.

Blockx, Jacques. *Compendium of Painting.* Antwerp: J.-E. Buschman, 1926.

Brett, Dorothy. *Lawrence and Brett.* New York: Lippincott, 1933.

Brooks, Van Wyck. *The Flowering of New England.* New York: E. P. Dutton, 1936.

———. *New England: Indian Summer, 1865–1915.* New York: E. P. Dutton, 1940.

Brown, Milton W. *American Painting from the Armory Show to the Depression.* Princeton: Princeton University Press, 1955.

———. *The Story of the Armory Show.* New York: Joseph H. Hirshhorn Foundation, 1963.

Bry, Doris. *Alfred Stieglitz.* Washington, D.C.: National Gallery of Art, 1958.

Camfield, William. *Francis Picabia: His Art, Life and Times.* Princeton: Princeton University Press, 1979.

Castro, Jan Garden. *The Art and Life of Georgia O'Keeffe.* New York: Crown, 1985.

Cheney, Sheldon. *A Primer of Modern Art.* New York: Boni and Liveright, 1924.

✓ Davidson, Abraham A. *Early American Modernist Painting 1910–1935.* New York: Harper and Row, 1981.

Doerner, Max. *The Materials of the Artist.* Translated by Eugen Neuhaus. New York: Harcourt, Brace, 1934.

Doty, Robert. *Photo-Secession: Stieglitz and the Fine Arts Movement in Photography.* 1960. Reprint, expanded. New York: Dover, 1978.

Eddy, Arthur Jerome. *Cubists and Post-Impressionism.* Chicago: A. C. McClurg, 1914.

Farnham, Emily. *Charles Demuth: Behind a Laughing Mask.* Norman: University of Oklahoma Press, 1971.

Forum Exhibition of Modern American Painters. New York: Mitchell Kennerley, 1916.

Frank, Waldo, Lewis Mumford, Dorothy Norman, Paul Rosenfeld, and Harold Rugg, eds. *America and Alfred Stieglitz.* New York: Doubleday, Doran, 1934.

Geldzahler, Henry. *American Painting in the Twentieth Century.* New York: Metropolitan Museum of Art, 1965.

✓Goodrich, Lloyd. *Pioneers of Modern Art in America: The Decade of the Armory Show, 1910–1920.* New York: Praeger, 1963.

Greenough, Sarah, and Juan Hamilton. *Alfred Stieglitz: Photographs and Writings.* Washington, D.C.: National Gallery of Art, 1983.

Hartley, Marsden. *Adventures in the Arts.* New York: Boni and Liveright, 1921.

Haskell, Barbara. *Arthur Dove.* Boston: New York Graphic Society, 1975.

———. *Marsden Hartley.* New York: Whitney Museum of American Art, 1980.

Hoffman, Katherine. *An Enduring Spirit: The Art of Georgia O'Keeffe.* Metuchen, N.J., and London: Scarecrow Press, 1984.

Homer, William Innes. *Alfred Stieglitz and the American Avant-Garde.* Boston: New York Graphic Society, 1977.

————. *Alfred Stieglitz and the Photo-Secession*. Boston: Little, Brown, 1983.

————, ed. *Avant-Garde Painting and Sculpture in America, 1910–1925*. Wilmington: Delaware Art Museum, 1975.

Hormats, Bess. *Retrospective for a Critic: Duncan Phillips*. College Park: University of Maryland, 1969.

Johnson, Dorothy R. *Arthur Dove: The Years of College*. College Park: University of Maryland, 1967.

Kootz, Samuel M. *Modern American Painters*. New York: Brewer and Warren, 1930.

Lawrence, D. H. *Studies in Classic American Literature*. New York: Thomas Seltzer, 1923.

Levin, Gail. *Synchromism and American Color Abstraction 1910–1925*. New York: George Braziller, 1978.

Lisle, Laurie. *Portrait of an Artist: A Biography of Georgia O'Keeffe*. New York: Seaview Books, 1980.

Lowe, Sue Davidson. *Stieglitz: A Memoir/Biography*. New York: Farrar Straus Giroux, 1983.

Lynes, Russell. *Good Old Modern: An Intimate Portrait of the Museum of Modern Art*. New York: Atheneum, 1973.

Mather, F. J., Jr., C. R. Morey, and W. J. Henderson. *The American Spirit in Art*. Pageant of America, no. 12. New Haven: Yale University Press, 1927.

Mayer, Ralph. *The Artist's Handbook of Materials and Techniques*. New York: Viking, 1940.

McBride, Henry, Marsden Hartley, and E. M. Benson. *John Marin: Watercolors, Oil Paintings, Etchings*. New York: Museum of Modern Art, 1936.

McCausland, Elizabeth. *Alfred Maurer*. New York: A. A. Wyn, 1951.

————. *Marsden Hartley*. Minneapolis: University of Minnesota, 1952.

McLanathan, Richard. *The American Tradition in the Arts*. New York: Harcourt, Brace and World, 1968.

Metzinger, Jean, and Albert Gleizes. *Du cubisme*. Paris: Figuière, 1912.

Mellquist, Jerome. *Emergence of an American Art*. New York: Charles Scribner's Sons, 1942.

Morgan, Ann Lee. *Arthur Dove: Life and Work, with a Catalogue Raisonné*. Newark: University of Delaware Press; London and Toronto: Associated University Presses, 1984.

Naef, Weston. *The Collection of Alfred Stieglitz: Fifty Pioneers of Modern Photography*. New York: Viking Press, 1978.

Newman, Sasha M. *Arthur Dove and Duncan Phillips: Artist and Patron*. Washington, D.C.: Phillips Collection; New York: George Braziller, 1981.

Nordland, Gerald. *Gaston Lachaise*. New York: George Braziller, 1974.

Norman, Dorothy. *Alfred Stieglitz: An American Seer*. 1960. Reprint. New York: Random House, 1973.

————. *Beyond a Portrait*. Millerton, N.Y.: Aperture, 1984.

O'Keeffe, Georgia. *Georgia O'Keeffe*. New York: Viking Press, 1976.

————. *A Portrait by Alfred Stieglitz*. New York: Metropolitan Museum of Art, 1978.

Phillips, Duncan. *The Artist Sees Differently*. 2 vols. New York: E. Weyhe; Washington, D.C.: Phillips Memorial Gallery, 1931.

————. *A Collection in the Making*. New York: E. Weyhe; Washington, D.C.: Phillips Memorial Gallery, 1926.

————. *The Leadership of Giorgione*. Washington, D.C.: Phillips Memorial Gallery, 1937.

Phillips, Marjorie. *Duncan Phillips and His Collection*. New York: Little, Brown, 1970.

Reich, Sheldon. *Alfred H. Maurer, 1868–1932*. Washington, D.C.: Smithsonian Institution Press, 1973.

————. *John Marin*. 2 vols. Tucson: University of Arizona Press, 1970.

Rilke, Rainer Maria. *Letters to a Young Poet*. Translated by M. D. Herter Norton. New York: W. W. Norton, 1934.

Rose, Barbara. *American Painting Since 1900*. Rev. ed. New York: Praeger, 1975.

Rosenfeld, Paul. *Port of New York*. New York: Harcourt, Brace, 1924.

Rubin, William S. *Dada, Surrealism, and Their Heritage*. New York: Museum of Modern Art, 1968.

Saarinen, Aline B. *The Proud Possessors*. 1958. Reprint. New York: Random House (Vintage), 1968.

St. John, Bruce, ed. *John Sloan's New York Scene*. New York: Harper and Row, 1965.

Seitz, William. *The Art of Assemblage*. New York: Museum of Modern Art, 1961.

Seligmann, Herbert J. *Alfred Stieglitz Talking*. New Haven: Yale University Library, 1966.

————, ed. *Letters of John Marin*. New York: An American Place, 1931.

Solomon, Alan. *Arthur G. Dove*. Ithaca: Andrew Dickson White Museum of Art, Cornell University, 1954.

Stein, Gertrude. *Autobiography of Alice B. Toklas*. 1933. Reprint. London: Arrow Books, 1960.

Toch, Maximilian. *Materials for Permanent Painting: A Manual for Manufacturers, Art Dealers, Artists and Collectors.* New York: D. Van Nostrand, 1911.

Wight, Frederick. *Arthur G. Dove.* Berkeley: University of California Press, 1958.

Wright, Willard Huntington. *Modern Painting: Its Tendency and Meaning.* New York: John Lane, 1915.

ARTICLES

Multiple entries by a single author are arranged chronologically.

Anderson, Sherwood. "Alfred Stieglitz." *New Republic* 32 (25 October 1922): 215–17.

"Arthur Dove: An American Place." *Art News* 29, no. 25 (21 March 1931): 12.

Ballerini, Julia. "The Incomplete Camera Man." *Art in America* 72, no. 1 (January 1984): 106–13.

Benton, Thomas H. "America and/or Alfred Stieglitz." *Common Sense* 4, no. 1 (January 1935): 22–24.

Boyd, Nancy. "No Bigger Than a Man's Hand." *Vanity Fair* 19 (September 1922): 48.

Brown, Milton. "From Evangelical Tent Show to Modern Museum." *Art News* 78, no. 8 (October 1979): 74–81.

Burrows, Carlyle. "A Retrospective Show by Arthur Dove." *Herald Tribune* (New York), 29 April 1934, sec. 5, p. 10.

Chamberlain, John. "Books of the Times." *New York Times,* 31 December 1934, p. 11.

Coates, Robert. "The Art Galleries." *New Yorker* 16, no. 10 (20 April 1940): 50–53.

———. "The Art Galleries." *New Yorker* 17, no. 9 (12 April 1941): 59–61.

Corn, Wanda. "Apostles of the New American Art: Waldo Frank and Paul Rosenfeld." *Arts Magazine* 54, no. 6 (February 1980): 159–63.

Craven, Thomas. "Thomas Hart Benton." *Scribner's* 102, no. 4 (October 1937): 33–40.

Devree, Howard. "A Reviewer's Notebook: Comment on Some of the Newly Opened Shows—Arthur Dove and Others." *New York Times,* 28 March 1937, sec. 11, p. 10.

de Zayas, Marius. "How, When and Why Modern Art Came to New York." With an introduction and notes by Francis M. Naumann. *Arts Magazine* 54, no. 8 (April 1980): 96–126.

Diskant, Carolyn. "Modernism at the Pennsylvania Academy, 1910–1940." In *In This Academy: The Pennsylvania Academy of the Fine Arts, 1805–1976,* by Richard J. Boyle, Frank H. Goodyear, Doreen Bolger, Louise Lippincott, Mark Thistlethwaite, Joan M. Marter, and Carolyn Diskant. Philadelphia: Pennsylvania Academy of the Fine Arts, 1976.

Einstein, Albert. "What I Believe." *Forum* 84, no. 4 (October 1930): 193–94.

Forgey, Benjamin. "The Odyssey of Duncan Phillips." *Portfolio,* November–December 1981, pp. 66–71.

Gallati, Barbara D. "Arthur Dove as Illustrator." *Archives of American Art Journal* 21, no. 2 (1981): 13–22.

Graeme, Alice. "Paintings of Arthur G. Dove in Various Media at Gallery Here Show Artist's Mature Style." *Washington Post,* 11 April 1937, p. 9.

Greenough, Sarah E. "From the American Earth: Alfred Stieglitz's Photographs of Apples." *Art Journal* 41, no. 1 (Spring 1981): 46–54.

Herford, Oliver. "The Crime Wave in Art." *Ladies' Home Journal,* January 1923, pp. 8 and 98–102.

Jewell, E. A. "Other Artists: Concerning Mr. Dove." *New York Times,* 30 March 1930, sec. 8, p. 12.

———. "April Offerings in Art Galleries of New York." *New York Times,* 6 April 1930, sec. 10, p. 18.

———. "Dove Gives Annual Exhibition." *New York Times,* 11 March 1931, p. 20.

———. "Dove Again." *New York Times,* 15 March 1931, sec. 9, p. 12.

———. "Albert Sterner." *New York Times,* 19 April 1931, sec. 9, p. 18.

———. "Demuth." *New York Times,* 19 April 1931, sec. 9, p. 18.

———. "Exhibition Shows Dove's Early Art." *New York Times,* 21 April 1934, p. 13.

———. "Alfred Stieglitz and Art in America." *New York Times Book Review,* 23 December 1934, p. 4.

———. "Three Shows Here of Abstract Art." *New York Times,* 3 May 1935, p. 22.

———. "In the Realm of Art: A Week of Pointed Contrasts." *New York Times,* 5 May 1935, sec. 9, p. 7.

———. "Attractions Group and One-Man—Procter, Dove, Crosby." *New York Times,* 26 April 1936, sec. 9, p. 7.

———. "Potpourri: Shows in Museums and Galleries." *New York Times,* 7 April 1940, sec. 9, p. 9.

———. "Dali and Miro Shows Stir Wrath." *New York Times,* 30 November 1941, sec. 9, p. 9.

"Kensight: Art in Progress." *Ken* 4, no. 4 (27 April 1939): 30–38.

Kramer, Hilton. "Does Feminism Conflict with Artistic Standards?" *New York Times,* 27 January 1980, sec. D, pp. 1 and 27.

———. "Rediscovering a Quintessential Dadaist." *New York Times,* 3 February 1980, sec. D, pp. 25 and 27.

Krauss, Rosalind. "Alfred Stieglitz's 'Equivalents.'" *Arts Magazine* 54, no. 6 (February 1980): 134–37.

Lane, James W. "The Passing Shows: Arthur Dove." *Art News* 40, no. 6 (1–14 May 1941): 28.

"Marin Show Opens New Gallery." *Art News* 28, no. 14 (4 January 1930): 1 and 7.

McBride, Henry. "Modern Art." *Dial* 79 (July 1925): 84–86.

———. "Attractions at Other Galleries." *Sun* (New York), 14 March 1931.

———. "Attractions in Other Galleries." *Sun* (New York), 28 April 1934.

———. "Attractions in Other Galleries." *Sun* (New York), 4 May 1935.

———. "Attractions in the Galleries." *Sun* (New York), 25 April 1936.

———. "Attractions in the Galleries." *Sun* (New York), March 1938.

McCausland, Elizabeth. "Dove's Oils, Water Colors Now at An American Place." *Springfield (Mass.) Union and Republican,* 22 April 1934.

———. "Authentic American Is Arthur G. Dove." *Springfield (Mass.) Union and Republican,* 5 May 1935, sec. E, p. 6.

———. "Dove, Man and Painter." *Parnassus* 9 (December 1937): 3–6.

———. "Arthur G. Dove Exhibits at An American Place." *Springfield (Mass.) Union and Republican,* 10 April 1938, sec. E, p. 6.

———. "Dove Retrospective at An American Place." *Springfield (Mass.) Union and Republican,* 2 April 1939.

Miller, Henry. "Stieglitz and Marin." *Twice A Year* 8–9 (1942): 146–55.

Morand, Paul. "Bulls and Bears in the Art Galleries." *Vanity Fair* 37, no. 3 (November 1931): 44 and 86.

Morgan, Ann Lee. "An Encounter and Its Consequences: Arthur Dove and Alfred Stieglitz, 1910–1925." *Biography* 2, no. 1 (Winter 1979): 35–59.

Mumford, Lewis. "The Art Galleries." *New Yorker* 11 (4 May 1935): 28–34.

———. "The Art Galleries: The Independent Show." *New Yorker* 12 (2 May 1936): 43–45.

"Museum Buys Four Arthur Doves from Show." *Art Digest* 9 (15 May 1935): 16.

Norman, Dorothy. "Alfred Steiglitz [*sic*] Speaks and Is Overheard." *Art of Today* 6, no. 2 (February 1935): 3–4.

O'Brien, Emmet. "Leader of Modern Artists Paints in Geneva Farmhouse." *Rochester Democrat and Chronicle,* 14 January 1934.

O'Keeffe, Georgia. "Stieglitz: His Pictures Collected Him." *New York Times Magazine,* 11 December 1949, 14–30.

Pemberton, Murdock. "The Art Galleries." *New Yorker* 2 (11 December 1926): 98–99.

———. "The Art Galleries." *New Yorker* 7 (21 March 1931): 68–70.

Rosenfeld, Paul. "The Younger Generation and Its Critics." *Vanity Fair* 19 (September 1922): 53, 84, and 106.

———. "The World of Arthur G. Dove." *Creative Art* 10 (June 1932): 426–30.

———. "Dove and the Independents." *Nation* 150 (27 April 1940): 549.

Sandler, Irving. "When MOMA Met the Avant-Garde." *Art News* 78, no. 8 (October 1979): 114–25.

Stein, Gertrude. "Composition as Explanation." *Dial* 81 (October 1926): 327–36.

———. "Long Gay Book." *Dial* 83 (September 1927): 231–36.

Stieglitz, Alfred. "Regarding the Modern French Masters Exhibition; A Letter." *Brooklyn Museum Quarterly* 8, no. 3 (July 1921): 107–13.

Tomkins, Calvin. "Profiles (Georgia O'Keeffe)." *New Yorker* 50, no. 2 (4 March 1974): 40–66.

"U.S. Scene." *Time* 24, no. 26 (24 December 1934).

Yeh, Susan Fillin. "Innovative Moderns: Arthur G. Dove and Georgia O'Keeffe." *Arts Magazine* 56 (June 1982): 68–72.

Ph.D. DISSERTATIONS

Butterfield, Bruce. "Paul Rosenfeld: The Critic as Autobiographer." University of Illinois, 1975.

Cohn, Sherrye Baker. "The Dialectical Vision of Arthur Dove: The Impact of Science and Occultism on His Modern American Art." Washington University, St. Louis, 1982.

Hoffman, Katherine Ann. "A Study of the Art of Georgia O'Keeffe from 1916–1974." New York University, 1976.

Metzger, Robert P. "Biomorphism in American Painting." University of California, Los Angeles, 1973.

Morgan, Ann Lee. "Toward the Definition of Early Modernism in America: A Study of Arthur Dove." University of Iowa, 1973.

Pumphrey, Martin L. "Art and Leadership in America: The Quest for Synthesis." University of Iowa, 1977.

Risatti, Howard. "American Critical Reaction to European Modernism, 1907–1918," University of Illinois, 1977.

UNPUBLISHED SOURCES

New Haven. Yale University, Beinecke Library, Collection of American Literature. Papers of Charles Caffin, Arthur B. Carles, Charles Daniel, Elizabeth Davidson, Marius de Zayas, Charles Duncan, Marsden Hartley, John Marin, Lewis Mumford, Marie Rapp (Boursault), Paul Rosenfeld, Herbert J. Seligmann, Paul Strand, Rebecca Strand, Abraham Walkowitz, and others, as well as miscellaneous files of gallery material, clippings, etc.

Washington, D.C. Phillips Collection. Correspondence files.

Washington, D.C. Smithsonian Institution, Archives of American Art. Downtown Gallery files and Elizabeth McCausland papers.

Philadelphia. University of Pennsylvania Library. Van Wyck Brooks Collection.

Chicago. Newberry Library. Sherwood Anderson papers.

New York. Whitney Museum of American Art. Clipping files.

New York. Metropolitan Museum of Art. Clipping files.

New York. New York Public Library. Clipping files.

Privately owned papers of William Dove, Sue Davidson Lowe, Charles Brooks, and Paul Dove.

Interviews with Dr. J. Clarence Bernstein, Julia Bernstein, Aline Dove, Paul Dove, William Dove, Dr. Mary Holt, Lila Howard, Sue Davidson Lowe, John Marin, Jr., James McLaughlin, Dorothy Norman, Emmet O'Brien, Georgia O'Keeffe, Marjorie Phillips, Mary Rehm, Herbert J. Seligmann, Archer Winsten, and, by telephone, with Holly Raleigh Beckwith and Claire O'Brien.

Index

Page numbers in boldface refer to illustrations.

Aarons, Leo, 390

Abbott, Berenice, 339, 348, 379n, 388n, 502

Abstract expressionism, 188n

Abstract Painting in America, 318

Adams, Ansel, 281, 282n, 362, 497

African art, 39, 41n, 42, 164, 176, 201

Aisen, Maurice, 419

America and Alfred Stieglitz, 313–14, 317–19, 320n, 321–23, 325

American Amateur Photographer, 32

American Art Association–Anderson Galleries, Inc., 501

American Boy, 57

American Caravan, 132, 133n, 501

American Place, An, 167n, 183–88, 193, 198, 200, 207, 220, 232, 236, 238–41, 248, 252, 255, 263, 268, 274–75, 281, 288n, 289–90, 292–93, 297, 307, 317, 337, 346–47, 351, 362, 371, 374, 377, 378n, 380, 390, 400–401, 404–7, 415, 418, 420–21, 425–26, 434, 436, 439–40, 442–45, 449, 451, 453–55, 458–60, 462, 464–65, 473, 476, 478, 484, 486–87, 489, 491, 495–96, 497, 499–500, 503; description of, 184, 447–48

American Society of Painters, Sculptors and Engravers, 335

Anderson, Eleanor, 467

Anderson, Elizabeth Prall, 164n

Anderson, Karl, 68, 76, 497

Anderson, Sherwood, 57, 75, 83–85, 87, 90, 92, 106, 111–12, 113n, 139, 154, 164, 175, 226, 314, 361, 373, 418, 436, 439, 467, 505. Works: *Kit Brandon,* 361; *A Story Teller's Story,* 106, 107n, 110; *Winesburg, Ohio,* 68, 497

Anderson, Tennessee Mitchell, 92n

Anderson Galleries, 44, 72, 88, 99, 110, 116, 119n, 141, 163, 326, 501

Apollinaire, Guillaume, 79–80

Archives of American Art, 13

Armory Show, 33, 35, 37, 39, 133n, 397n, 498, 504

Art Institute of Chicago, 387, 476, 483, 503

Art News, 208, 315n, 455

Art of Today, 331

Art Students League, 143n, 208

Ashcan School, 208n

Association of American Painters and Sculptors, 33

Atkin, William, 127

Atlantic Monthly, 325

Austin, A. Everett, Jr., 321

Bach, Johann Sebastian, 177, 214, 356, 362

Bacon, Peggy, 120, 121n, 144, 149

Baekeland, Leo Hendrik, 86, 87n

Baermann, Ada, 354, 355n, 356

Baermann, Walter, 354, 355n, 356

Baldinger, Wallace S., 387

Barnard College, 502

Barnes, Albert C., 246, 325–26, 462, 497

Barnes Foundation, 497

Barr, Alfred H., 216–17, 288n, 348, 362, 497

Bates, W. H.: *Perfect Sight Without Glasses,* 151n

Bayley, Roger Child, 87, 88n

Beckett, Marion, 43, 45n, 190

Beethoven, Ludwig van, 177, 356, 362

Beginnings and Landmarks: '291,' 1905–

1917, 391

Beinecke Rare Book and Manuscript Library, 13, 503

Bell, Clive: *Since Cézanne,* 82

Benda, W. T., 126, 128 n

Benson, E. M.: *John Marin, the Man and His Work,* 344

Benton, Thomas Hart, 82, 218, 325–26, 390–91, 497, 498; *Boy with a Dog,* 390

Bergson, Henri, 26, 158

Bernstein, J. Clarence (Jake), 413–14, 426–27, 430–31, 435, 443, 445–46, 449–50, 453, 455–57, 462–63, 465–66, 469, 475–78, 494, 498

Bernstein, Julia, 443, 456, 463, 469, 477, 498

Beyond All "Isms," 30 Selected Marins (1908–1939), 426

Bible, 201, 246

Biddle, George, 278

Bier, Elmira, 305, 309, 355, 365, 374, 382, 384, 470, 475, 486, 498

Bixby, Henry, 127

Blake, William, 157, 206 n

Bloch, Ernest, 199, 477

Blockx, Jacques, 210–11; *Compendium of Painting,* 210

Bluemner, Oscar, 43, 72, 82, 101, 120, 144, 498

Boltz, O. H., 450–51, 458–59

Boni, Charles, 387, 388 n

Bonnard, Pierre, 288

Bonnell, Mrs. Henry, 259

Boston Symphony, 207

Boswell, Foster, 365, 397

Boursault, George, 90

Boursault, Marie Rapp. *See* Rapp, Marie

Boyd, Nancy, 86

Boyle, Kay, 411

Brahms, Johannes, 177

Brancusi, Constantin, 39, 150, 151 n, 498

Brandes, Georg: *Voltaire,* 102

Braque, Georges, 41 n, 43

Brentano's, 158, 161

Brett, Dorothy, 175; *Lawrence and Brett,* 315

Brinley, Daniel Putnam, 33, 38 n

Brooklyn Museum, 133

Brooks, Charles, 75, 185–86, 227, 327, 336, 348, 385 n, 409, 418–19, 420 n, 427–28, 440, 443, 448, 450, 462, 490, 498

Brooks, Inez, 418–19, 420 n, 427–28, 443,

448, 450, 462

Brooks, Van Wyck, 68, 75, 133 n, 185, 232, 336, 409, 443, 498, 501. Works: *Flowering of New England,* 444 n; *New England: Indian Summer, 1865–1915,* 443

Bryner, Edna (Teddy), 244, 353

Burrows, Carlyle, 334

Burty, Frank, 39, 41 n, 501

Butler, Ellis Parker: *Jibby Jones; A Story of Mississippi River Adventure for Boys,* 88; *Jibby Jones and the Alligator,* 88

Cahiers d'Art, 259, 384

Camera Club of New York, 32, 61

Camera Notes, 32

Camera Work, 32, 39–40, 43–44, 50, 53, 58, 66, 86, 96, 104, 190, 325, 384, 501, 505

Cane, Florence, 68, 75–76, 85–86, 171, 498

Cane, Melville, 68, 498

Carles, Arthur B., 33, 190, 498

Carnegie Institute, 477 n

Cary, Elisabeth Luther, 115, 116 n

Cennini, Cennino, 210

Century, 33

Century of Progress, 284 n

Cézanne, Paul, 33, 66 n, 190, 218, 353, 433

Chamberlain, John, 325, 326 n

Chaplin, Charles, 223

Cheney, Martha C., 467

Children's art, 39, 43, 49

Chouteau, Nell, 355

Christian Science Monitor, 315 n

Christy, Howard Chandler, 126, 128 n

Coady, Robert J., 41 n

Coates, Robert, 436, 437 n, 455, 456 n

Cobb, Frank, 181

Cobb, Margaret, 181, 182 n, 206, 379

Collier's, 57

Columbia University, 313

Common Sense, 325

Contemporary New Art Circle, 297 n

Coolidge, Calvin, 110

Coomaraswamy, Ananda, 99

Cornell University, 32, 211, 223

Cortissoz, Royal, 222, 261

Cosmopolitan, 33

Craib, Marian. *See* Dove, Marian

Crane, Hart, 57

Craven, Thomas, 82, 218, 321–22, 325–26, 390, 487, 498

Creative Art, 212, 221 n, 315 n, 502
Crowninshield, Francis Welch (Frank), 128, 179, 182, 499
Cubism, 41 n, 49, 79 n, 499, 504
Cubism and Abstract Art, 348
Currier and Ives, 245

Dadaism, 504
Dali, Salvador, 460
Daniel, Charles, 52–56
Darrow, Whitney, 390
Dasburg, Andrew, 65, 66 n
Davidson, Donald, 60, 62, 70, 80, 82, 85, 87, 91, 95, 98, 103, 104–6, 108, 114, 162, 170, 190, 207–8, 213, 224–25, 234, 243, 250–51, 254, 261, **282,** 283, 340–42, 344, 348, 358, 388–89, 407–8, 474, 478, 499
Davidson, Elizabeth, 60, 70, 80, 82, 95, 98, 103, 104–6, 108–9, 114, 162, 190, 207–8, 213, 223–25, 234, 243, 250–51, 254, 261, 282–83, 288, 319, 348, 358, 388, 406–8, 472, 495, 499
Davidson, Elizabeth Margery. *See* Davidson, Peggy
Davidson, Jo, 34, 294, 295 n
Davidson, Peggy, 80, 104, 106, 108, **109,** 284 n, 407–8, 461–62
Davidson, Sue. *See* Lowe, Sue Davidson
Davis, Stuart, 164, 216 n, 218, 424, 499
DeLara, Aline. *See* Dove, Aline
Delineator, 162
Delphic Studio, 322, 332
De Meyer, Baron Adolph, 190
Demuth, Charles, 110, 115, 120, 127, 147, 163, 183–84, 190, 202, 219, 223–24, 233, 342–43, 400, 408, 499
Denver Art Museum, 504
Devree, Howard, 373 n
Dewey, John, 272
de Zayas, Marius, 33, 39, 43, 190, 329, 422 n, 499
Dial, The, 115, 134, 140–41, 143, 502
Dodge, Mabel. *See* Luhan, Mabel Dodge
Doerner, Max, 210, 342, 458; *Materials of the Artist,* 210, 341
Dorsey, Florence. *See* Dove, Florence Dorsey
Doubleday, Doran, 313, 318 n
Dove, Aline, 476, 478, **479,** 480, 487, 493–95, 500
Dove, Anna C. (mother), 67, 76, 83–84, 87, 103, 126, 130, 150–51, 200, 202,

225, 230, 242–43, 251, 258–59, 264, 311, 331
Dove, Arthur, **34, 131, 282, 369, 412;** birth of his son, 37; death of, 495–96; death of his father, 73; death of his first wife, 179; death of his mother, 264; early life of, 25, 32; education of, 32; his European trip, 33; exhibits first abstract paintings, 21, 33; farms in Westport, 37, 46, 48, 52, 54–55, 57–58, 62–63, 68; his final illness, 400–405, 407, 410–11, 413–14, 416–19, 422–24, 430, 434, 438–39, 441, 445–46, 448–50, 463, 468, 475, 486, 489–93, 495; and hurricane, 408–9; as illustrator, 25, 32–33, 57, 63, 67, 73, 82, 86, 88, 121, 127, 130, 150, 152–53, 159–60, 162, 174, 179–80, 184, 203, 205, 213, 249; lives in Centerport, 400–402, 405; lives in Geneva, 183, 264, 273, 281–83; lives in Halesite house, 144; lives in Ketewomeke Yacht Club, Halesite, 174, 181; lives in Noroton, 152; lives on houseboat, 77; lives on sailboat *Mona,* 90, **91,** 103; lives with Reds, 77; marriage to Florence Dorsey, 32; his marriage to Reds, 240; meets Duncan Phillips, 438; meets Stieglitz, 21, 25; Duncan Phillips becomes patron of, 121; his reconciliation with his son, 180–81; his separation from Florence, 77; Stops illustrating, 121, 152, 174; and WPA, 292–94; his writings on art, 40, 93, 95, 112, 146–47, 184, 188–90, 194–95, 201–2, 213–15, 217–18, 434. Works: *Alfred Stieglitz (Portrait),* **100,** 477, 507; *And Number Twenty-Two,* 481–82, 507; *Barnyard Fantasy,* 336, 507; *Beach,* 443, 507; *Bessie of New York,* 269, **270,** 271, 274–75, 278–79, 301, 358, 376, 383 n, 507; *Blackbird,* 469–70, 507; *Black Sun, Thursday,* 235 n, 507; *Breezy Day,* 235 n, 507; *Brick Yard Shed,* 303, 507; *Bridge at Cagnes,* **35,** 507; *Car,* 371, 383 n, 507; *Carnival,* 336 n, 507; *Chewing Cow,* 374, 508; *City Moon,* 404, 508; *Clouds and Water,* 221–22, 508; *Coal Carrier (Large),* 204, 508; *Cow,* 62, **63,** 190, 259, 508; *Cow I,* 352, 418, 508; *Cows in Pasture,* **351,** 352, 386, 508; *Cross in the Tree,* 342, 508; *Cutting Trees in Park,* 404, 508; *Dawn,* 253–54, 508; *Distraction,* 165, 168, **169,** 191 n, 508; *East from Holbrook's Bridge,* 374, 508; *Electric Peach*

Orchard, 336, 508; *Fields of Grain as Seen from Train*, 420, 508; *Fire in a Sauerkraut Factory, West X, N.Y.*, 452, 455, 457–58, 508; *Gale*, 347, 508; *George Gershwin's "Rhapsody in Blue," Part I*, 128, **129**, 508; *Goat*, 418, 508; *Goin' Fishin'*, **132**, 133n, 352–53, 371–72, 374, 376, 383, 384n, 397–98, 411, 508; *Golden Storm*, 121, **123**, 145, 508; *Grandmother*, 217n, 374, **375**, 420–21, 444, 477, 508; *Green Ball*, 438, 508; *Green, Gold and Brown*, 452, 454, 508; *Green Light*, 452, 509; *Happy Landscape*, 374, 509; *Harbor Bank*, 435, 509; *Harbor Docks*, 274, 509; *Holbrook's Bridge*, 342, 509; *Holbrook's Bridge to Northwest*, 399, 431, 509; *Huntington Harbor—I*, 148, 509; *Just Painting*, 148, 509; *Lake Afternoon*, 352, 365, 397, 509; *Lantern*, 106, 509; *Lattice and Awning*, 452, **453**, 509; *Leaning Silo*, 374, 509; *Lloyd's Harbor*, 452, 509; *Lobster*, 33, 190n, 509; *March, April*, 170–72, 509; *Mars Orange and Green*, 388n, 509; *Me and the Moon*, 509; *The Moon*, 452, 509; *"The Moon Was Laughing at Me,"* 383, 509; *Morning Sun*, 336, 509; *Nature Symbolized*, 452; *Nature Symbolized No. 2*, or *Wind on a Hillside*, 190n, 509; *Neighborly Attempt at Murder*, 452, 509; *Penetration*, 126, 127n, 218–19, 509; *Plant Forms*, **37**; *Pozzuoli Red*, 454, 509; *Primaries*, 435, 509; *Quawk Bird*, 483, **484**, 509; *Rain*, 114, 510; *Ralph Dusenberry*, 477, 510; *Reaching Waves*, 168, 510; *Red Barge, Reflections*, 254n, 256, **257**, 262–63, 275, 279, 286, 289, 301, 306–7, 311, 313, 347, 365, 510; *Red Barge, Reflections* (watercolor), 324, 510; *Red Sun*, 336, 339, 510; *Red Tree and Sun*, 168, 170, 172, 510; *Red, White and Green*, 441, 443, 510; *Reminiscence*, 269, 376, 383n, 510; *Rhythm Rag*, 148, 510; *Rise of the Full Moon (Me and the Moon)*, 374, 376, **377**, 382–84, 398, 510; *Sand Barge*, **212**, 220, 222, 224, 510; *Scenery*, 261, 510; *Sea Gull Motif*, or *Violet and Green*, 168, 510; *Sea Gulls*, 404, 407, 510; *Sea Gulls on Island*, 266; *Sea I*, 114, 115n, 510; *Sea II*, 114, 115n, 510; *Shapes*, or *Shells*, 452, 454, 510; *Silver Sun*, 168, 510; *Slaughter House*, 374, 510; *Snow Thaw*, 204, 510; *Something in Brown, Carmine and Blue*, 148, 510;

Sowing Wheat, 298, 510; *Square on the Pond*, 464, 510; *Stuyvesant Square*, 64, 510; *Sunday*, 235n, 237, 511; *Sun Drawing Water*, 274, 511; *Sunrise*, 336, 511; *Sunrise II*, 379, 511; *Sunrise III*, 363, 511; *Telegraph Pole*, 374, 511; *"Ten Commandments,"* 190n, 237n; *Through a Frosty Moon*, **454**, 511; *Thunder Shower*, 443, 511; *Train*, 313, 511; *Tree and Covered Boat*, 274, 278, 511; *Tree Forms*, 352, 511; *Two Forms*, 212, 511; *U.S.*, 446, 511; untitled drawing, **475**; *Waterfall*, 121, 124, 511; *A Way To Look at Things* (poem), 112–13, 467; *Wednesday, Snow*, 235n, 511; *Willows*, 217n, 443, **444**, 511; *Wind*, 352n, 511; *Wood Pile*, 397, 511

Dove, Florence Dorsey, 32, 39, 51–52, 56, 60, 65–67, 72, 73, 77, 86, 98, 179–80, 242, 400

Dove, Helen Torr. *See* Torr, Helen

Dove, Marian, 341–42, 344, 346, 348, 354, 355n, 356–57, 361–62, 364, 368, 386–87, 389, 391, 395, 401–2, 410, 418–19, 421, 426, 429, 446–50, 452, 455, 457–58, 460, 469, 472–73, 480, 500

Dove, Paul, 32, 126, 202, 225, 228, 230, 232, 251, 265, 267, 276–78, 291, 298, 311–12, 342, 350, 362, 367, 378, 391–92, 446, 500

Dove, Toni, 495, 500

Dove, William C. (son), 16, 37, 40, 51, 64–66, 68, 72, 75, 86–87, 117, 133n, 154, 164, 185–87, 192, 206, 209, 210n, 225, 227–28, 232, 234–36, 242–43, 249, 254, 258, 261, 265, 267, 279, 300, 315, 322, 324, 327, 332–34, 336, 346, 348, 354, 356–57, 361–62, 364–65, 373, 385n, 387, 389, 391, 395, 399, 401–2, 407–10, 416, 418–19, 421, 423, 426, 428–29, 446–47, 449–50, 452, 455, 457–58, 460, 469, 473, **479**, 482, 494–95, 500; his Army service, 476, 480, 493; his divorce, 472–73; lives in Geneva, 337–39, 341–42, 344–45; his marriage to Aline, 476, 493; his marriage to Marian, 341; his reconciliation with his father, 180–81; returns from Europe, 305, 309, 312; studies at Art Students League, 143; and WPA, in Washington, 366, 368, 377, 386, 392

Dove, William G. (father), 32, 50, 67, 73

Dow, Arthur Wesley, 44–45

Droth, Andrew, 366, 367n, 392–93, 406, 425, 439–40, 471, 482, 485, 500

Duchamp, Marcel, 132, 133n; *Nude Descending a Staircase No. 2,* 133n

Duncan, Charles, 44, 45n

Duncan, Isadora, 506

Durand-Ruel, Paul, 288n

Eastman, George, 104n, 119, 248

Eastman Kodak, 104, 141

Edison, Thomas Alva, 192

Eight, The, 208n, 261n, 397n, 505

Einstein, Albert, 199, 201, 319

Einstein, William, 281, 355–57, 361–62, 364, 366–68, 379, 395, 418, 420–21, 447, 449–50, 490n, 500

Elks, 151n, 162, 222, 249

Engelhard, George Herbert, 66

Engelhard, Georgia, 49

Ernst Agnes. *See* Meyer, Agnes Ernst

Eugene, Frank, 50; *Stieglitz and Emmy,* **28**

Everybody's, 57

Exhibition of Paintings Showing the Later Tendencies in Art, 73

Exposition des arts décoratifs, 120

Fadiman, Clifton, 361

Family of Man, 505

Fantastic Art, Dada, Surrealism, 362, 375

Fauve painting, 33, 248

Fellows, Laurence, 33, 38n

First Biennial Exhibition of Contemporary American Painting (Whitney Museum), 254n, 257n

First Municipal Art Exhibition, 296, 297n, 299–300, 302n

Fisher, Harrison, 126, 128n

Fisk University, 503

Flannagan, John, 126, 128n

Flint, Ralph, 315, 348

Force, Juliana, 253, 254n, 293–94, 302

Ford, Henry, 87, 88n, 231, 248

Fore an' Aft, 127

Forum, 44, 199

Forum Exhibition, 44–46, 506

Frank, Waldo, 57, 70, **71,** 72n, 111, 238, 313, 348. Works: *City Block,* 500; *Our America,* 500; *The Rediscovery of America,* 500

Fraser, James Earle, 50n

Fraser, Laura Gardin, 50

Freer, Charles, 504

Fuller, Robert, 75

Futurism, 49

Gallatin, Albert, 222, 223n, 268, 357

Gallery of Living Art, 221n, 222, 223n, 357

Gellatly, John, 182

Gide, André, 503

Gingrich, Arnold, 424n

Giorgione, 357

Glackens, William, 260, 261n

Gleizes, Albert, 95, 96n

Godsoe, Robert Ulrich, 249–50

Goodwin, Philip, 217n, 296, 302, 352–53, 375, 416, 417n

Goodyear, A. Conger, 411

Graham, Katharine, 45n

Grand Central Art Galleries, 170

Gregg, Frederick James, 428

Grosz, George, 281, 318, 329–31, 500

Guggenheim Foundation, 220, 221n, 222, 267

Haldane, J. B. S.: *Daedalus; or, Science and the Future,* 103

Hamsun, Knut: *Growth of the Soil,* 77; *Hunger,* 77

Hansen, Harry, 182

Hapgood, Hutchins, 82, 190, 500

Harlem Renaissance, 161

Harper's Bazaar, 504

Hartley, Marsden, 32–33, 39, 42, 43n, 44, 46, **47,** 49, 50n, 51, 54, 72, 93, 95, 110, 113n, 116, 120, 163, 170, 178, 183–84, 190, 202, 204–5, 216n, 222, 233, 281, 331, 341, 345–46, 349, 355, 362, 391, 485–87, 500, 502, 504–5; *Adventures in the Arts,* 77

Haskell, Elizabeth, 69n

Haskell, Emma, 69n

Haskell, Ernest, 42, 43n, 68, 190, 501

Haviland, Frank Burty. *See* Burty, Frank

Haviland, Paul, 39, 41n, 43, 156, 190, 338, 501

Hay, William Howard, 254

Hayes, Cardinal Patrick Joseph, 408

Hearst, William Randolph, 83

Hélion, Jean, 490

Henri, Robert, 207, 208n

Herford, Oliver, 79–80, 82–83, 86–87, 93, 246, 501

History of An American; Alfred Stieglitz: "291" and After, 491

Hitler, Adolf, 266, 391, 395, 406, 433, 478

Hobart College, 32, 324, 325n, 365

Hoffman, Malvina, 348

Holt, Mary, 415, 416n, 458, 494, 496, 501

Hood College, 456

Hoover, Herbert, 242

Howard, Lila, 38n, 78

Huxley, Aldous: *The Art of Seeing,* 151n

Ickes, Harold, 447

Illustrated Sporting News, 33

Imagist poetry, 40, 140

Impressionism, 33, 123, 261n, 288, 397n, 497

International Exhibition of Modern Art (Société Anonyme), 132–34

Intimate Gallery, The, 120–21, 134, 136, 144, 147, 152, 156, 158, 163, 165–74, 177–78, 375, 499, 501

James, Bill, 430, 461, 506

Jewell, Edward Alden, 191, 199, 205, 207–9, 219, 326n, 334–35, 349, 372, 436, 460, 490, 501

Johnson, Willard (Spud), 320

Jones and Laughlin Steel Company, 280n

Joseph Brummer Gallery, 151n

Joyce, James, 102, 160, 162, 192, 218; *Ulysses,* 102

Kalonyme, Louis, 178, 197, 465

Kandinsky, Wassily, 26, 35

Karfiol, Bernard, 296, 297n

Ken, 424

Kennerley, Mitchell, 72, 76, 156, 212, 501

Keyserling, Hermann Alexander: *The Travel Diary of a Philosopher,* 102, 103n

Kirnon, Hodge, 86, 87n, 190

Klee, Paul, 214

Kootz, Samuel, 188, 204; *Modern American Painters,* 188, 200–201

Kraushaar, C. W., Art Galleries, 182

Kreymborg, Alfred, 57, 116, 132, 138, 141. Works: *America, America,* 501; *History of American Poetry,* 501; *Troubadour,* 501

Kuniyoshi, Yasuo, 255n, 296

Lachaise, Gaston, 120, 134, 150, 165, 170, 216n, 342–43, 501

Ladies' Home Journal, 79n, 86–87

Lafferty, René, 44, 45n

LaFollette, Robert, 110

Lane, James W., 456n

Lawrence, D. H., 93, 95, 175, 192–93, 199, 201, 502; *Studies in Classic American Literature,* 92–93

Lawson, Ernest, 397

Lefebvre, Lucien, 421, 422n

LeVind, George, 390

Lewis, John L., 380

Liberty, 179

Life, 57, 80, 83, 86–87, 153

Lindbergh, Charles, 192

Linked Ring, 28

Lister, Walter, 271

Literary Digest, 462

Literary Guild, 313, 318n

Little Galleries of the Photo-Secession. *See* 291

Little Review, The, 79–80, 83

Lloyd George, David, 82

Long, Maurice, 226, 228, 233–34

Lowe, Sue Davidson, 17, 80, 284n, 407–8

Loynes, Dorothy, 301, 317n, 331, 389, 391, 394, 402, 404, 406–7, 410, 414–15, 417–18, 435, 439–42, 455–58, 468, 476, 481, 489, 494, 496, 501–2

Luhan, Mabel Dodge, 175, 190, 275, 320, 502

Luxembourg Museum, 179

Lyman, Duane, 294

Macbeth Gallery, 172

McBride, Henry, 115, 116n, 164, 198, 205, 207–8, 212, 218, 221–22, 256, 268, 297–99, 304, 337, 349, 373, 399, 455, 502

McCausland, Elizabeth, 266, 267n, 286, 289, 305, 308, 310, 313, 338–39, 348, 379, 388, 395, 399; *Changing New York* (with Berenice Abbott), 502

McClure, Bruce, 151n, 249

McClure's, 33, 153

Macdonald-Wright, Stanton, 49, 183, 252–53, 506

McGovern, Terry, 211, 242, 271

McLaughlin, Virginia, 470

Manor House, 98

Marcus, Zola, 486

Marin, John, 32–33, 43–44, 49, 50n, 51, 72, 77–78, 83, 85, 88–90, 93, 95, 99, 102, 110, 113n, 116–18, 120–21, 123, 134, 136, 138–39, 144–45, 148, 163, 166, 170, 178, 183–84, 186, 190, 192, 196–97, 200, 202, 209, 214, 216n, 226–

27, 231, 233, 236, 242–43, 247–48, 252–54, 259, 261, 264, 275, 281, 287–89, 292, 297–301, 318, 339, 341–44, 346, 348, 353–55, 362–63, 366, 380, 391, 408, 411, 422, 424, 426–27, 443, 449, 460, 462, 464–65, 467, 476, 485, 488, 491, 495, 502–3, 505

Marin, John, Jr., 449

Mather, Frank Jewett, Jr., 92–93, 95, 324, 502

Matisse, Henri, 32, 190, 272–73, 503

Maurer, Alfred, 32–33, 46, 49, 50n, 51–53, 75, 86, 126, 134, 185, 190, 232, 242, 244–52, 309, 343, 353, 405, 410, 477, 502; *Black Parasol,* 477n

Maurer, Charles, 250

Maurer, Louis, 245, 251–52

Mayer, Ralph: *The Artist's Handbook of Materials and Techniques,* 210

Mazzanovich, Ann, 52n

Mazzanovich, Lawrence, 52n

Mellquist, Jerome, 467; *The Emergence of an American Art,* 465

Metropolitan Museum of Art, 105n, 208n, 221n, 388n, 503

Metzinger, Jean, 95, 96n

Meyer, Agnes Ernst, 43, 45n, 190

Meyer, Eugene, 45n

Michelangelo, 218

Middledorf, Ulrich, 387

Mill, John Stuart: *Autobiography,* 90

Miller, Henry, 467, 468n

Miró, Joan, 410, 460

Modern Gallery, 43, 45n, 422n, 499

Modigliani, Amedeo, 182

Mondrian, Piet, 354

Montross Gallery, 78, 88, 99, 101

Moore, Marianne, 140–41

Morand, Paul, 234

Morgenthau, Henry, Jr., 486

MSS, 78, 80, 82–85, 87

Mumford, Lewis, 57, 133n, 191, 313, 334–35, 348, 352–53, 366, 373, 441, 501–2

Mumford, Mrs. Lewis, 352, 441

Murals by American Painters and Photographers, 242

Musée du Jeu de Paume, 179, 411

Museum of Fine Arts, Boston, 99

Museum of Fine Arts, Springfield, Mass., 267, 285

Museum of Modern Art, 179, 202, 215–16, 217n, 242, 288n, 296n, 343n, 348,

355, 362, 375, 416, 420–21, 431, 433, 444, 460, 477, 497, 505

Museum of Natural History, 189

Nadelman, Elie, 43–44, 503

Nation, 439, 441

National Alliance of Art and Industry—100 Important Paintings, 170

National Association for the Advancement of Colored People, 505

National Gallery of Art, 503

National Woman's Party, 124

Naumburg, Margaret, 70, 72n, 114

Nebel, Bernard, 284, 291, 293, 298, 301, 303, 331–32, 361, 393, 404, 407

Neumann, J. B., 296, 299

New Republic, The, 87

New School for Social Research, 502

New Yorker, 126, 134, 153, 170–72, 197, 209, 254, 335, 361, 374, 411, 445, 465, 502

New York Herald Tribune, 208, 222n, 249, 302, 305, 332, 334–35

New York Mirror, 249

New York Post, 271, 300, 301n, 416

New York Sun, 116n, 208, 502

New York Times, 163, 208, 219, 298, 305, 325, 326n, 349, 460, 462, 480, 485, 487, 501

New York Tribune, 48

New York University, 221n

New York World, 181

Nietzsche, Friedrich, 158, 192

Nikhilananda, Swami, 283, 284n, 406

Norman, Dorothy, 172, 193, 241–43, 255, **256,** 267, 297, 313, 319, 322, 331, 347, 371, 376, 380, 383–84, 387, 398, 405, 410, 422, 436, 442, 485. Works: *Alfred Stieglitz: An American Seer,* 503; *Alfred Stieglitz* (photograph), **381;** *Dualities,* 267, 268n, 269

Norman, Edward, 503

Oaklawn, 62, 69

Obermeyer, Emmeline. *See* Stieglitz, Emmeline Obermeyer

O'Brien, Claire, 334

O'Brien, Emmet, 293, 294n, 389

O'Brien, Frances, 293, 294n, 389

O'Brien (lawyer), 327

Ochs, Adolph, 285

O'Keeffe, Georgia: her early life, 59; her education, 59; her exhibitions, 44, 49,

53, 59, 88, 99, 120–21, 127, 134, 144, 149, 163, 183–84, 202, 206–7, 233, 235–36, 242–43, 252, 256, 260, 262, 281, 287, 297, 302, 318, 323, 329, 341, 346, 362, 366, 373, 391, 393–95, 400, 408, 414, 426, 431, 433, 443, 449, 460, 462–63, 465, 476, 480, 483, 485, 488–89, 491, 495; her health, 60, 67, 76, 104–5, 108, 113, 115, 118, 139, 148–49, 163, 166, 256, 260, 263, 266, 271–72, 277, 285, 292, 306, 320–23, 333, 335, 337, 339–40, 404, 420, 422, 425, 428, 436; lives with Stieglitz, 60; her marriage to Stieglitz, 110; her relationship with Stieglitz, 58–59; her travels, 133n, 155, 175, 196, 220, 222, 223n, 244, 246, 299, 305–7, 310–12, 318, 320, 330, 333, 340, 356–57, 373, 380, 385, 387–88, 403, 406, 414, 416, 420, 431, 444, 450, 458, 473, 484–85, 490, 492–93, 495; as widow, 13. Works: *Abstraction,* **94,** 95, 101, 108; *Altar Pieces,* 201–2, 206; *Cross paintings,* 201; *Gray One,* 464
O'Keeffe, Ida, 99, 108
O'Neill, Eugene, 178
Opportunity Gallery, 145
Ornstein, Leo, 84

Painting and Sculpture by Living Americans, 202, 216
Palomar, Torres, 43, 45n
Parnassus, 395
Pearson's Magazine, 33
Pemberton, Murdoch, 134, 170–72, 197, 199, 205, 207–9, 217, 219
Pennsylvania Academy of the Fine Arts, 73, 292, 296, 343
People's Art Guild, 50n
Perry, Miss (nurse), 415, 434–36, 440
Perry, Barton, 385, 402, 419, 450, 462
Perry, Harriet, 385, 402, 419, 450, 462
Perry, Pablo, 402
Pertaining to New York, Circus and Pink Ladies, 460
Philadelphia Museum of Art, 105n, 491, 503
Phillips, Duncan, 15, 121, 123–24, 132, 136, 139, 145, 147–48, 155, 173, 191, 193, 202–5, 211–12, 217n, 220–22, 224, 226, 229–30, 233, 235–36, 241–43, 257–58, 262–63, 266, 268–71, 273–79, 285–90, 292–301, 305–7, 309–14, 331–32, 334, 336, 338–39, 347–55, 357, 363,

365, 367, 370–74, 376–77, 379–86, 389, 391–92, 397–99, 401, 416, 417n, 418, 420–21, 427–28, 433, 436–38, 442–45, 447–48, 452–54, 461, 467–69, 474, 483–84, 490–91, 503–4
Phillips, Laughlin, 503
Phillips, Marjorie, 123, 136, 148, 193, 212, 220, 263, 268, 274, 336, 348–49, 353, 367, 376, 438, 443, 445, 454–55, 468–69, 503
Phillips Collection, 123–24, 242n, 248, 288, 362, 370, 374–75, 455, 470, 498, 503
Phillips Memorial Gallery, 123. *See also* Phillips Collection
Photo-Secession, 32
Picabia, Francis, 39, 43, 95, 96n, 120, 144, 190, 416, 504; *I See Again in Memory My Dear Udnie,* 45n
Picasso, Pablo, 33, 41n, 43, 190, 218, 400, 460, 503
Pictorial Review, 57, 129, 153, 156
Place, The. *See* American Place, An
Porter, Eliot, 400, 401n, 408
Porter, Fairfield, 244
Post-Impressionism, 32, 52, 497
Pound, Ezra, 416
Pousette-Dart, Nathaniel, 209
Pratt, A. W., 152, 157–58, 162, 165, 167
Precisionism, 499
Princeton University, 502
Prohibition, 290
Prosser, Margaret, 404
Pulitzer Prize, 444n
Punch, 153

Quinn, John, 105–6, 190

Radio City, 246, 255
Raleigh, Dorothy, 127, 138, 150, 151n, 249
Raleigh, Henry Patrick, 48, 125–29, 137–40, 142–43, 148, 150, 158–63, 165–67, 175–76, 178, 187, 196–97, 218, 249, 300, 504
Raleigh, Holly, 125–28, 132, 134, 138–43, 148, 150, 158, 162, 165–67, 175, 178, 196–97, 218–19, 224–26, 234, 236, 249, 326
Raleigh, John, 249
Raleigh, Sheila, 219, 300, 301n
Rankin, Dorothy, 241, 242n, 248, 288, 353, 365, 388, 442, 455

Rankin, George, 442
Rapp, Marie, 42, 43n, 59, 90, 190, 504
Reds. *See* Torr, Helen
Rehm, George, 83, 157, 363, 386, 388, 422, 429, 435, 439–40, 446, 451–52, 457, 476, 478, 494, 504
Rehm, John (Scoop), 246, 251, 363, 386, 388, 504
Rehm, Lane, 251–52, 337, 399, 419
Rehm, Louise, 251–52, 337, 399
Rehm, Mary Torr, 83, 157, 246, 249, 251, 259, 363, 386, 388, 418, 422, 429, 435, 439–40, 446, 451, 457, 504
Reinhard Galleries, 182
Rembrandt, 371
Renoir, Pierre Auguste, 410, 462
Revue du Vrai et du Beau, 179
Rhoades, Katharine, 43, 45n, 190, 504
Rich, Daniel Catton, 387
Rilke, Rainer Maria: *Letters to a Young Poet,* 319
Rivera, Diego, 297
Rochester (N.Y.) Democrat and Chronicle, 293
Rockefeller, Abby Aldrich, 179
Rockefeller Center, 297n
Rodin, Auguste, 32, 190
Rönnebeck, Arnold, 39, 111, 112n, 113n, 504
Room 303. *See* Intimate Gallery, The
Roosevelt, Franklin Delano, 276, 380, 493n
Rosenberg, James, 85
Rosenfeld, Paul, 57, 68, 85, 89, 92, 95–96, 110, 114, 116–18, 124–25, 132, 138–39, 141, 190, 193, 196, 203–4, 207, 226–27, 244, 248, 251, 313, 436, 439, 467, 497, 501, 504. Works: *The Boy in the Sun,* 505; *Port of New York,* 89, 504–5; (ed.) *Sherwood Anderson's Memoirs,* 467n
Ross, Cary, 287, 288n, 297, 319, 324–25, 348, 406–7
Royal Photographic Society of Great Britain, 99
Rugg, Harold, 313
Russell, Bertrand: *Icarus: The Future of Science,* 103

St. Nicholas, 33
Salvation Army, 218, 396
Sarah Lawrence College, 502
Saturday Evening Post, 153, 254, 504
Schwab, Arthur, 244

Scott, Cyril K., 142–43
Scott, Evelyn: *The Wave,* 142
Scribner's, 390
Second Biennial Exhibition of Contemporary American Painting (Whitney Museum), 318
Seligmann, Herbert J., 57, 60, 68, 72, 77, 92, 133n, 141, 190, 245. Works: *Alfred Stieglitz Talking,* 505; (ed.) *Letters of John Marin,* 226–27
Seven Americans, 100, 110–13, 116, 120, 163, 467
1710. *See* American Place, An
Severini, Gino, 49
Shakespeare, William, 246
Shelton Hotel, 121–22, 175–76, 337
Sloan, John, 190n, 218, 302, 505
Smartage, 197
Smart Set, 57
Smith College, 505
Soby, James Thrall, 322
Socialism, 41
Société Anonyme, 132–34
Society of Independent Artists, 52, 451, 452n
Soutine, Chaim, 249
Speicher, Eugene, 260, 261n
Springfield Republican, 208, 267n, 502
Squibb's, 203, 205
State University of Iowa, 387
Stearns, Milton, Jr., 88, 91
Steichen, Edward, 29, 32–33, 182, 190, 272n, 505; *Kitty and Alfred Stieglitz,* 29
Stein, Gertrude, 82, 126, 134, 143, 190, 191n, 246, 317, 332, 503. Works: *Autobiography of Alice B. Toklas,* 286; *Four Saints in Three Acts,* 296; *Tender Buttons,* 246; *Three Lives,* 505
Stein, Leo, 190, 191n, 503
Sterner, Albert, 219
Stieglitz, Alfred, **28, 29, 100, 381, 432;** and An American Place, 183–84; birth of his daughter, 28; and *Camera Work,* 32, 53; his death, 495; death of his father, 69; death of his mother, 79n; discovers O'Keeffe, 44; his early life, 25–26; his European study, 26; his exhibitions, 28, 37, 72–73, 88, 99, 183, 233, 236, 238, 281, 317–18, 321, 400, 460; his health, 24, 89–90, 113, 117–18, 128, 130, 136, 139, 141, 151, 155–56, 159, 168–69, 177, 224, 233, 244, 247, 260, 272, 290, 317, 340, 342, 345–47, 356,

358, 361, 387, 389, 401, 403–4, 406, 425, 428, 439–40, 445, 447, 449, 459, 472, 483, 485, 491; and Intimate Gallery, 120–21; lives at Shelton Hotel, 121; lives with his brother Leopold, 70; lives with O'Keeffe, 60; his marriage to Emmeline Obermeyer, 28; his marriage to O'Keeffe, 110; and *MSS*, 78; museum accessions prints of, 99; and Dorothy Norman, 257; and 291, 32, 53; as photographer, 28–29, 65–66, 76, 80–82, 84–85, 89–90, 95, 99, 104–5, 108, 115, 118–19, 121, 130, 132, 139, 141, 151–52, 156, 177–78, 198, 232, 234, 247, 285–86, 317, 385, 400, 404, 422, 424–25, 471; his portraits of O'Keeffe, 73, 84, 201; his separation from Emmeline, 60; and *Seven Americans*, 110–13. Works: *Apples and Gable, Lake George,* **81;** *Arthur Dove,* **36;** *Clouds,* 201; *Dorothy Norman,* **256;** *Equivalents,* 88, **96,** 99, 355, 470–71; *From the Shelton,* **122;** *Hedwig Stieglitz,* **74;** *Lake George Parlor,* **44;** *Marsden Hartley,* **47;** *Music—A Sequence of Ten Cloud Photographs,* 88; *My Father,* **27;** *Paula (Sunlight and Shadow),* 29, **30;** *Peggy,* **109;** *Steerage,* 29, **31;** *Waldo Frank,* **71**
Stieglitz, Edward (father), 26, **27,** 69
Stieglitz, Elizabeth. *See* Davidson, Elizabeth
Stieglitz, Elizabeth Stieffel (Mrs. Leopold), 178, 358, 407
Stieglitz, Emmeline Obermeyer (Emmy), **28,** 60, 277, 505
Stieglitz, Hedwig (mother), 26, 43, 73, **74,** 74n, 79, 199
Stieglitz, Katherine (Kitty), 28, **29,** 60, 88, 91, 118, 277, 505
Stieglitz, Leopold, 60, 69–70, 89, 90n, 99n, 178, 404n, 405, 407, 410, 414, 499
Stokowski, Leopold, 206
Stokowski, Mrs. Leopold, 206
Strand, Paul, 44, 55–56, 59, 62, 66, 68, 72, 80, 92, 95, 98, 110, 120, 126, 149, 153, 155, 163, 165–68, 173, 178, 183, 190, 216n, 233, 241–42, 505
Strand, Rebecca, 84–85, 92, 98, 126, 153, 165, 170, 175, 183, 233, 241–42, 430, 461, 506
Stravinsky, Igor, 207
Success, 57
Surrealism, 460

Symbolism, 40
Synchromism, 498, 506
Syracuse (N.Y.) *Post-Standard,* 307n

Tack, Augustus Vincent, 386
Theosophy, 195n
Thurber's Gallery, 33
Time, 326
Toch, Maximilian: *Materials for Permanent Painting,* 145, 210
Toomer, Jean, 57, 161; *Crane,* 161n
Torr, Helen (Reds), **135, 282, 328, 359;** her career as an artist, 78; her diaries, 13, 16; her divorce, 180, 210, 240, 340; her early life, 78; her exhibitions, 145, 183, 252, 266, 268, 270, 319, 332–33; her hysterectomy, 315–16; I (self-portrait), **328;** lives with Dove, 77; her marriage to Dove, 240; her separation from Clive Weed, 77; as widow, 506
Torr, Mary. *See* Rehm, Mary Torr
Torr, Mary (Reds's mother), 83, 150, 208, 213, 245, 249, 321, 357–59, 361–64, 393, 470
transition, 160–62, 384
Trois Siècles d'art aux États-Unis, 411
Turnpike Tea House, 52, 58
Twentieth-Century Portraits, 477
Twenty-Five Years of John Marin—1908–1932, 287
Twice A Year, 380n, 387, 405, 410–11, 467, 470
291: 45, 50, 72, 110, 116, 120–21, 156, 189, 190n, 237, 239, 252, 269, 338, 391, 422n, 498–99, 504–6; closing of, 53–54, 57, 58; description of, 25–26, 38n; exhibitions, 32–33, 37, 39, 43–44, 49, 53, 248n, 498–501, 503; as idea, 40–42, 55, 62, 68, 101
291: 43, 45n, 73, 499, 501

Ullman, Albert, 49n
Ullman, Eugene, 48, 49n
University of Chicago, 387
University of Minnesota, 347

van Gogh, Vincent, 182
Vanity Fair, 85–86, 128, 234, 499, 504–5
Vogel, Hermann, 26
Vogue, 458, 505
Voltaire, 102–3

Wadsworth Atheneum, 296, 321–22

Walden School, 72
Walker, Robert C., 281, 341, 346, 354
Walkowitz, Abraham, 33, 39, 44, 48–49, 50n, 51, 68, 190, 272, 506
Washburn, Gordon, 293, 294n
Washington Post, 45n, 377
Water Mill Inn, 409
Watkins, C. Law, 241, 242n, 248, 353
Weatherly, Newton, 188, 319, 320n, 399
Weber, Max, 33, 190, 296, 506
Weed, Clive, 38n, 77, 240, 340, 343, 506
Weichsel, John, 50
Weyhe Gallery, 104n, 247–48, 250, 284, 322
Wheat, Max, 342
Wheeler, Monroe, 477
Whistler, James A. M., 422n
Whitney Museum of American Art, 254, 256, 260–62, 294n, 318
Whitney-Richards Gallery, 64
Willkie, Wendell, 447

Wilson, Margaret, 406–7
Wilson, Woodrow, 407
Winsten, Archer, 300, 301n
Wood, Grant, 326
World's Fair, 417, 429, 446, 504
WPA, 292–94, 347n, 366, 392
Wright, Frank Lloyd, 33
Wright, Willard Huntington, 44, 46; *Modern Painting: Its Tendency and Meaning,* 506

Yale University, 13, 503
Younger American Painters, 33, 190n
Youth's Companion, 57

Zigrosser, Carl, 104
Zoler, Emil, 116, 177–78, 190, 196, 247, 266, 268, 333, 339, 358, 425, 436, 447, 485, 506
Zorach, William, 302
Zuloaga, Ignacio, 111